ART, CULTURE AND SPIRITUALITY

*A Prabuddha Bharata Centenary Perspective
(1896–1996)*

Mandava Venkateswara Rao
Marxeea Samithi

Compiled & Edited by
Swami Atmaramananda
Dr. M. Sivaramkrishna

Advaita Ashrama
(Publication Department)
5 Dehi Entally Road
Calcutta 700 014

Published by
Swami Mumukshananda
President, Advaita Ashrama
Mayavati, Pithoragarh, Himalayas
from its Publication Department, Calcutta

First Edition, September 1997
3M3C

ISBN 81-7505-189-2

Printed in India at
Swapna Printing Works Private Ltd.
52 Raja Rammohan Ray Sarani
Calcutta 700 009

PREFACE

The present anthology contains some of the outstanding articles published during the last one hundred years in *Prabuddha Bharata or Awakened India*, one of the English monthlies of the Ramakrishna Order. The occasion that prompted the work is the celebration of the centenary of this journal, which was started by Swami Vivekananda in 1896.

Previously, in connection with the centenary, we brought out two special illustrated issues of *Prabuddha Bharata*—one in January '95 (with 61 articles, poems, etc., in 416 pages), marking the journal's entry into its one hundredth year, and another in January '96 (with 26 articles, poems, etc., in 168 pages), marking the completion of its one hundredth year. For both of these issues we received warm support from many eminent writers, who sent outstanding articles.

But then some of our friends wanted something more. They suggested we also bring out an anthology, and we agreed—especially because one of them, Dr. M. Sivaramkrishna, former Head of the Department of English, Osmania University, Andhra Pradesh, offered to help us in the task with able assistance from one of his colleagues, Dr. Sumita Roy, Hyderabad.

But there was another reason why we accepted the proposal. The two special issues mentioned above contain articles that are, one might say, somewhat outward-looking. They are *Prabuddha Bharata's* present view of the world's last one hundred years, with some thoughts on the possible shape of things to come. This anthology, on the other hand, is the fruit of *Prabuddha Bharata's* internal exploration. It reviews some of the valuable ideas that have been entrusted to it since its inception.

Even for us, the work turned out to be an unexpected revelation. We were aware in a general way that the journal's standard has been high. And we knew that there were articles contributed by many of the great thinkers of the time—Dr. Pitirim Sorokin, C.G. Jung, Aldous Huxley, Prof. M. Hiriyanna, plus some of our monks such as Swami Shuddhananda and Swami Yatiswarananda, to name just a few. But when it came to evaluating the contents before finalizing the list of articles for the anthology, those involved in the project, especially the compiler-editors, found the work extremely rewarding—more than they had anticipated.

As you will see in the following pages, many of the articles draw the reader into another milieu—a milieu that was the precursor of today's. There we discern the hopes, fears, and anxieties that moved powerful minds. And there we find the solutions they proposed and the hopes they cherished regarding humanity's future. We see a recent past through some of the clearest eyes of that period, and we also get a glimpse of the world they thought would soon emerge. Thus we are able to compare all that with the present, understand better what is happening now, and ponder over the future. In addition to these articles, some studies in comparative culture and some biographical sketches of great religious personalities have been included.

A study of this anthology is a study of life—of science, art, psychology, philosophy, etc., as the titles show. And what better study could there be? Now we are glad that the proposal came and that we got the opportunity to materialize it. We convey our grateful thanks to those friends.

As this publication had to be made both accessible and interesting to all types of readers, we can appreciate the difficulty Prof. Sivaramkrishna and Swami Atmaramananda (who was editor of *Prabuddha Bharata* from January '94 to December '96) had in selecting the articles—for each of the past volumes has at least a dozen superb articles. The forty-four articles included here were taken from thirty

volumes—between 1897 and 1987—and have been minimally edited. Since many of the authors are no longer alive and we cannot provide their biodata, we decided to exclude that item from the anthology. In the SOURCES, however, we have mentioned the year and the issue in which the articles originally appeared in *Prabuddha Bharata*—in case readers would like to have a look at other articles in those volumes.

Rather than adding a résumé of the articles, or mentioning certain articles as being particularly noteworthy, we leave it to our readers to enjoy exploring this anthology on their own.

4 July 1997 PUBLISHER

CONTENTS

SECTION III: *Comparative Perspectives*

LIST OF ILLUSTRATIONS

Section I

SCIENCE, PHILOSOPHY, PSYCHOLOGY

Section 1

SCIENCE PHILOSOPHY PSYCHOLOGY

THE SPIRITUAL PROBLEM OF MODERN MAN

C.G. Jung

The Modern Man and the Modern Problem

The spiritual problem of modern man belongs to the type of question which is invisible because of its modernity. The modern man is the man who has just emerged, and a modern problem a question that has just arisen and whose answer still lies in the future. The spiritual problem· of modern man is therefore at best but the placing of a question, which would perhaps be put in altogether different terms if we had only a slight inkling of the future answer. Moreover, the question involves something so extraordinarily universal, not to say vague, but something which so immeasurably transcends the grasp of an individual, that we have every reason to approach the problem with the greatest modesty and caution.

This explicit recognition of the limitations involved seems to me necessary, for nothing so tempts toward filling the mouth with empty words as the handling of a problem of this sort. We shall be forced to say apparently audacious and daring things that can easily blind us.

Who Is a Modern Man?

To begin at once with these, that is to risk audacities, I may say that the man we characterize as modern, the man living in the immediate present, stands on a peak, or on the edge of the world, above him heaven, below him the whole of humanity with its history lost in primordial

mists, before him the abyss of all the future. Modern men, or better said, men of the immediate present are few in number, for their existence demands the highest possible degree of consciousness, the most intense and widespread consciousness, with a minimum of unconsciousness—for only he is wholly in the present who is completely conscious of his existence as a man. It is to be well understood that it is not the man merely living in the present who is modern, else all men of this day would be modern, but it is a term which applies only to the man most completely conscious of the present.

Whoever achieves consciousness of the present is of a necessity lonely. The so-called 'modern' man is in all times lonely, for each step toward a higher and wider consciousness removes him further from the original *participation mystique* with the herd, further from immersion in a common consciousness. Every step forward means a tearing away from this all-inclusive maternal womb of original unconsciousness in which the mass of people for the most part linger. Even in a cultured people the psychologically lower levels have an unconsciousness of life little distinguishable from primitives. The next higher strata live in essentials, in a stage of consciousness corresponding to the beginnings of human culture, and the highest stratum possesses a consciousness resembling that reached by the century just passed.

It is only the man who is modern in our sense that lives in the present, because he has a present-day consciousness. For him alone are the worlds of past levels of consciousness faded; their values and strivings interest him only from the historical view-point. Thus in the deepest sense he becomes 'unhistorical', and thus does he also estrange himself from the masses, who live only in traditional ideas. He is only completely modern when he has gone to the furthermost edge of the world, behind him all that has been discarded and conquered, and before him a void out of which almost anything can grow.

These words are so large-sounding that they approach perilously near banality, for nothing is easier than to affect this consciousness. Actually there is a great horde of misfits who give themselves the air of modernity, because in a deceptive way they leap over all the stages that represent just so many of the most difficult tasks of life, and suddenly arrive as uprooted, vampire ghosts, by the side of the really modern man, discrediting him in his little-to-be-envied loneliness. And so it comes about that the few really modern men, only seen by the undiscerning eyes of the masses behind the cloudy veil of these ghosts, the 'pseudo-moderns', are confused with them. It cannot be helped. The modern man is dubious and suspect, and has always been so in times gone by as well.

Uprightness the Sole Criterion

The confession of modernity means the voluntary choice of bankruptcy, the oath of poverty, and abstinence in a new sense, and the still more painful renunciation of the halo of sanctity, for which the sanction of history is always necessary. To be unhistorical is the Promethean sin. In this sense the modern man is sinful. Higher consciousness is therefore guilt. But a man cannot attain the maximum degree of present-day consciousness unless he has passed through the various levels of consciousness belonging to the past, unless, in other words, he has satisfactorily fulfilled the tasks set for him by his world. Thus he must be a virtuous and upright man in the best sense, one who can do just as much as anyone else, and still more besides, by virtue of which he is able to climb to the next higher levels of consciousness.

I realize that the concept of 'uprightness' is one especially hated by the pseudo-modern man since it reminds him in an unpleasant fashion of its betrayal. But that cannot prevent us from selecting uprightness as an essential criterion of a modern man. This criterion is indispensable,

for, without it the modern man is nothing but a conscience-less adventurer. He must be upright in the highest degree, for, being unhistorical is merely faithlessness to the past, if it is not supplanted by creative capacity on the other side. To be conscious of the present only by giving the lie to the past would be a pure swindle. The present has meaning only when it stands between yesterday and tomorrow. It is a process, a transition, that parts from yesterday and goes towards tomorrow. Whoever is conscious of the present in this sense may call himself modern.

The Disappointment of Thousands-of-Years-Old Hopes

Many people call themselves 'modern', especially the pseudo-moderns. By the same token, we often find the really modern people among those who call themselves old-fashioned. They do this on the one hand in order to compensate in one way or another for that sinful vanquishing of the historical by a heightened emphasis of the past, and, on the other hand, they call themselves old-fashioned in order to avoid being confused with the pseudo-moderns. Cheek by jowl with every good thing is to be found its corresponding evil, and nothing good can come into the world without bringing forth at the same time its correlated evil. It is this sad fact that makes illusory the feeling of elation that comes with a full consciousness of the present, the feeling that one is the fulfilment and result of uncounted thousands of years. At best it is the confession of a proud poverty, because one is also the disappointment of thou-sands-of-years-old hopes and illusions. Nearly two thousand years of Christian history, and instead of Paradise and life everlasting, we have the World War of Christian nations with barbed wire entanglements and poisonous gases— what a *debacle* in heaven and on earth!

In the face of such a picture, we do well to return to modesty. The modern man stands indeed upon a peak, but

tomorrow he will be out-distanced; he is indeed the product of an age-old evolution, but at the same time the greatest conceivable disappointment of all humanity's hopes. The modern is conscious of this. He has observed how rich in blessings science, technique and organization can be, but also how catastrophic. He has also observed that well-meaning governments, following the saying, 'In time of peace prepare for war', have so thoroughly protected peace as very nearly to destroy Europe. And when it comes to ideals, neither the Christian Church, the brotherhood of man, international social Democracy, nor the solidarity of economic interests has withstood the fire-test of reality. Ten years after the war we see again the same optimism, the same organizations, the same political aspirations, the same phrases and slogans at work, which, taking a long view, are preparing further unavoidable catastrophes. Agreements to outlaw war make one sceptical, although one wishes them all possible success. At bottom, there is a growing doubt behind all these palliative measures. Taking it all in all, I think I am not saying too much if I compare modern consciousness with the soul of a man who has suffered a fatal shock, and who, as a result, has become essentially uncertain.

From this exposition you can see that I am handicapped by reason of being a physician. I cannot cease to be a physician. A doctor always sees illnesses, but an essential part of his art lies in not seeing them where they do not exist. I will therefore refrain from saying that Western humanity in general, especially the white man, is ill, or that the West faces a downfall; such a judgement goes far beyond my competence.

I know the spiritual problem of modern man, as is self-evident, only through my experience with other men and with myself. I am now familiar with the intimate spiritual life of many hundreds of cultured people, both sick and well, and from a field covering the whole of white civilization, and it is out of this experience that I speak. Doubtless

it is only a one-sided picture that I can draw, for it all lies within the soul, that is, in the inner side of us. I must add at once that this is a peculiar state of affairs, because the soul does not always and everywhere lie within. There are peoples and times in which it has been outside. There are peoples and times that are unpsychological, as for example, all ancient cultures, and especially Egypt with its grandiose objectivity, and its similarly grandiose, naive, negative confession of sin. No personal spiritual problem can be imagined as being the cause of the Apis Tombs of Sakkara and Pyramids, any more than as being the source of Bach's music.

The Importance of Psychology

As soon as there exists an external ideal and ritual form in which all the strivings and hopes of the soul are taken up and expressed, for example, a living religious form, then the soul lies without, and there is no spiritual problem, as there is also no unconscious in the narrower sense. The discovery of psychology was therefore necessarily deferred to the last centuries, although previous centuries had enough intro-spection and intelligence to recognize psychological facts. In this respect the course of events has been similar to what happened with regard to technic. The Romans, for instance, had knowledge of all those mechanical principles and physical facts which could have enabled them to build a steam-boat, but it never came to more than a toy of the tyrant Nero. The reason was that no urgent necessity existed. Only the great division of labour and the specializa-tion of the last century brought about this necessity.

It took the spiritual need of our time to induce us to discover psychology. Obviously the psychological facts were present in former times also, but they did not make them-selves felt, and no one heeded them. It was quite possible to live without taking note of them. But today we cannot

get along without the soul. The physicians were the first actually to discover this truth, for, to priests the soul can only be something that must be fitted into the already recognized form in order to represent an undisturbed function. As long as this form really does insure the possibility of life, psychology is merely an assisting technique and the soul is not a factor *sui generis*. As long as a man lives in the herd, he has no soul, nor does he need one, excepting a belief in an immortal soul. But as soon as he outgrows the circle of his local religion, that is, as soon as his religious form can no longer embrace his life in its entirety, then the soul begins to be a factor which can no longer be dealt with by the ordinary methods. Therefore we have today a psychology based on experience, and not on articles of faith, or philosophical postulates.

At the same time, I see in the fact of our having a psychology a symptom indicating a deep-seated disturbance of the collective soul. For it is with the soul of the people as with the individual's soul, that is, as long as all is well and all psychical energies find regulated and satisfying application, nothing disturbing comes to us from within. No uncertainty and no doubts assail us, and we cannot be at war with ourselves. But as soon as some of the channels of psychical activity are destroyed, phenomena betokening a damming-up process begin, the springs overflow so to speak, the inner side wills something different from the outer, and the result is that we become at odds with ourselves. Only in this situation, that is, in this state of need, does one discover the soul as being contrary-minded, something strange and even hostile and disunited. The discovery of Freudian analysis shows this process in the clearest possible way. What was first discovered was the existence of perverse sexual, and criminal phantasies, which, taken literally, cannot be assimilated by a cultivated consciousness. If anyone tried to maintain such a standpoint, he would unquestionably be a revolutionist, a madman, or a criminal.

It is not to be assumed that only in modern times has the background of the mind or the unconscious developed this aspect. Apparently it has always been true and in all cultures. Every culture had its destructive counter-tendency. But no culture heretofore has found itself forced to take this psychic background seriously. The soul was always merely part of a metaphysical system. But modern consciousness can no longer ward off recognition of the soul despite the most strenuous and dogged defence against it. This differentiates our time from all earlier ones. We can no longer deny that the mysterious things of the unconscious are effective powers, that psychical forces exist which can no longer be fitted into our rational world order, at least not for the present. We even build up a science on these things—one more proof of the seriousness with which we take them. Previous centuries could throw them to the jackals unregarded, but to us they are a shirt of Nessus of which we cannot get rid ourselves.

A Great Upheaval of Faith

The upheaval of modern consciousness by the immense catastrophe of the World War is accompanied within by the moral upheaval of our faith in ourselves and in our virtues. Formerly we could take foreigners politically and morally as scoundrels, but the modern man is forced to recognize that politically and morally he is just like everyone else. If formerly I believed it my God-given duty to set others in order, I know now that I myself am just as much in need of the call to order. I need it all the more in that I realize only too clearly the wavering of my faith in the possibility of a rational organization of the world, that old dream of the kingdom eternal where peace and harmony rule. The scepticism of modern consciousness in this respect permits no more political or world-reforming enthusiasm. In fact, it makes the most unfavourable imaginable basis for an easy

out-flowing of psychical energies into the world. By reason of this scepticism, modern consciousness is thrown back upon itself, and the counter-thrust following this backward-flooding makes conscious subjective psychical contents which were always present, but which lay in deep shadow as long as everything could stream outward without any friction.

How totally different did the world of the medieval man appear! Then the earth lay in the middle of the universe, forever fixed and at rest, circled about by a careful, heat-spending sun; while men, all children of God, were lovingly cared for by the Most High and educated for eternal happiness, and all knew exactly what ought to be done, and how one ought to behave, in order to pass from an earthly mortality to an eternal joyous existence.

Of such a reality we can no longer even dream. Natural science has long ago torn this veil of innocence. That time lies behind us like infancy, when one's own father was still the most beautiful and the mightiest of men. All the metaphysical certainties of the medieval man have vanished for the modern, and the latter has exchanged for them the ideal of material security, universal welfare, and humanitarianism. But whoever retains this ideal unshaken has at his command a more than usual amount of optimism.

Moreover, the security vanishes as the modern begins to realize that every advance in external things brings about an ever-increasing possibility for a yet greater catastrophe. Expectation and phantasy turn aside from this possibility in terror. What does it mean, for example, that big cities today already prepared defences against attacks of poison gas, or actually mimic such attacks? It means nothing other—following the proverb *si vis pacem para bellum*—than that these gas attacks have already been planned and prepared. Let man heap up the necessary materials, and the latter will unquestionably take advantage of what is devilish in humanity and set it in motion like an avalanche. Weapons, it is well known, go off by themselves whenever enough of them are gathered together.

The dawning intuition of that law regulating all blind happenings, for which Heraclitus formed the concept of *enantiadromia*, fills the background of modern consciousness with a chilling horror and lames all belief in the possibility of meeting this monster effectively and permanently by social and political means.

Dreary Shadows in the Background of the Mind

If after this terrifying glance at a blind world in which construction and destruction eternally balance each other, consciousness turns back to the subjective man and looks within at its own background, it discovers dreary shadows, the sight of which everyone would gladly avoid. Here also science has destroyed a last refuge, and has made a place of horror out of what promised to be a protecting cave.

Yet one is almost relieved to find so much evil in the depths of his own soul. Here at least, we believe, is to be discovered the cause of all the evil in mankind in general. Although we are at first shocked and disappointed, yet we have the feeling that just because these mental facts are part of our own psyche, we can have them more in hand and therefore place them properly, or at least repress them effectually. If this could succeed, one gladly assumes, at least a part of the evil in the external world would be eradicated. With a general spread of knowledge of the unconscious, practically everyone could see if, for instance, a statesman was being guided by unconscious evil motives, and the newspapers could then shout him down with: 'Please have yourself analysed, you are suffering from a repressed father complex.'

I have purposely chosen this grotesque example in order to show to what absurd consequences we are led by the illusion that, because something is psychical it is therefore under our control. It is certainly true that a great part of the evil in the world comes from the boundless unconsciousness of mankind, and certainly it is also true that,

through increased insight we are able to do something against the psychical sources of evil—just as science has enabled us to resist external injuries adequately.

Man Turns to Inner Life

The immense, world-wide increase of psychological interest in the last two centuries shows unmistakably that modern consciousness—or let us say more modestly, curiosity—has withdrawn somewhat from material externals and has turned instead to the subjective, inner life. Expressionist art foretold this change prophetically, just as art always intuitively grasps in advance the coming changes in the general consciousness.

The psychological interest of our time expects something from the soul, something the outer world has not given, something without doubt which our religions ought to contain but do not or do not for the modern man. To the modern, religions no longer seem to come from within, from the soul, but to have become inventory-lists of the external world. No transcendental spirit seizes him with inner revelation, but he tries instead to select religions and convictions, putting them on like a Sunday-dress, only to take them off again finally as discarded clothes.

However, the dark, seemingly almost pathological subconscious phenomena of the soul fascinate the interest in some way or other, although we can scarcely explain why it is that something all previous ages have thrown aside, now suddenly becomes interesting. But, that these phenomena are generally interesting is a fact not to be denied, although not readily reconciled with good taste. By this psychological interest I do not mean merely the interest in psychology as a science, nor that still narrower interest in Freud's psycho-analysis, but the quite wide-spread increase of interest for psychical phenomena, spiritism, astrology, theosophy, para-psychology, etc. Since the end of the

sixteenth and seventeenth centuries, the world has not seen anything like it.

For a comparable phenomenon we must turn to the flowering of the Gnosis in the first and second centuries after Christ. It is with this latter period that the modern spiritual currents have the deepest connection. There is actually today an *Eglise gnostique* in France, and in Germany I know two Gnostic schools that explicitly declare themselves as such. Numerically the most important of these movements is without doubt theosophy and its continental sister, anthroposophy, a Hindu revision of Gnosis of the purest sort. By comparison, the interest in scientific psychology is negligible. But Gnosis is built exclusively on subconscious phenomena, and morally also it penetrates dark depths, as, for example, is witnessed by the Hindu Kundalini Yoga, even in its European form. The same is true of the phenomena of para-psychology, as every person informed on the subject will testify.

The passion invested in pursuit of these interests is without doubt psychical energy which has been turned back from obsolete religious forms. Therefore these things have inwardly a truly religious character even when externally they have a scientific hall-mark. If Dr. Steiner explained his anthroposophy as 'spiritual science', and Mrs. Baker Eddy discovered a 'Christian Science', such efforts at concealment only show in what bad repute religion has become, as much suspect in fact as politics and world-reform.

New Outlook of Religion

I have not gone too far when I assert that modern consciousness, in contrast to the nineteenth century, now turns with its most treasured and deepest expectations to the soul, and not in any recognized traditional way of faith, but in the Gnostic sense. That all these movements give themselves a scientific character is not merely grotesque, nor just a

mask as I indicated above, but a positive sign that they mean 'science', that is, knowledge, and mean it in strict contrast to the essence of Western forms of religion, namely faith. Modern consciousness has a horror of faith in dogmatic postulates, and also of religions based on them. It accepts them only in so far as their knowledge-content apparently harmonizes with the subconscious phenomena that have been experienced. It wants to know, that is, to have basic experience. As you have perhaps read, Dean Inge of St. Paul's has called attention to a similar movement in the Anglican Church.

The age of discoveries, whose close we have perhaps reached with the complete investigation of the earth, no longer wants to believe that the Hyperboreans dwell in a happy land of sunshine, or something of the sort, but it wants to know and to have seen for itself what existed beyond the boundaries of the known world. Apparently our age sets itself the task of discovering what are the psychical facts beyond consciousness. The question of every spiritistic circle is: What takes place when the medium has lost consciousness? The question put by every theosophist is: What will I become on higher levels of consciousness, that is, beyond my present consciousness? The question of every astrologer is: What are the effective forces and determinants of my fate over and beyond my conscious view? The question of every psycho-analyst is: What are the unconscious mainsprings of the neurosis?

The age wants to experience the soul itself. It seeks original experience and therefore sets aside all pre-suppositions, and at the same time makes use of all existing suppositions as a means to the end, and thus it uses recognized religions and science. Formerly, a slight shudder ran down a European's back if he looked a little more deeply into these pursuits. For, not only did the objects of this so-called investigation seem dark and uncanny to him, but the methods appeared to him as a shocking misuse of his finest spiritual achievements. What does the technical astronomer

say, for example, to the fact that today at least thousands
more horoscopes are made than three hundred years ago?
What does the philosophical interpreter and teacher say to
the fact that the modern world, in comparison to the
antique, is not poorer by one superstition? Even Freud, the
founder of psycho-analysis, has taken the utmost pains to
bring out into garish light the dirt and darkness and evil of
the subconscious mind, and to show that the world should
give up any pleasure in seeking there anything other than
nonsense and trash. He has failed in the attempt, and it has
even happened that the warning has had the opposite effect,
and has caused wonderment at the filth, a phenomenon in,
and for itself, perverse and inexplicable, were it not that for
these people too the secret fascination of the soul lies
behind it all.

There can be no doubt but that since the beginning of
the nineteenth century, since the memorable period of the
French Revolution, things pertaining to the psyche have
gradually, and with ever-increasing power of attraction
pressed to the foreground of the general consciousness. That
symbolical gesture of the enthronement of the goddess
Reason in Notre-Dame seems to have meant to the Western
world something similar to the hewing down of Wotan's
oak by the missionaries, for then as now, no avenging
lightning struck down the transgressor.

Light from the East

It is indeed more than a mere jest of world-history that
just at that time, a Frenchman, Anquetil du Perron, was
living in India, and at the beginning of the nineteenth
century brought back a translation of the *Oupenk'hat*, a
collection of fifty Upanishads, which gave the West its first
glimpse into the mysterious spirit of the East. For the
historian this is an accident independent of any historical
causality nexus. My judgement as a physician, however, can

see nothing accidental in it, for it all happened according to the psychological rule that is of unfailing validity in personal life: For every important element that is robbed of its value in the conscious, and is therefore lost, a compensation arises in the unconscious. This occurs according to the law of the conservation of energy, for our psychical processes are also energetic phenomena. No psychical value can disappear without being replaced by its equivalent. This is the heuristic, fundamental principle in daily psychotherapeutic practice, never failing and repeatedly confirmed. The physician in me finds it impossible to look on the psychical life of a people as being outside fundamental psychological rules. To him, the soul of the people is merely a somewhat more complex structure than the soul of the individual. And moreover, looking at it from the other side, does not a poet speak of the 'peoples' of his soul? Quite correctly as it seems to me, because our soul contains something that is not the individual, but the mass, collectivity, humanity in fact. Somewhere or other, we are part of a single great soul, a single great man, to speak in Swedenborg's terms, and just as the dark thing in me an individual calls out what is light, so too does it happen in the psychical life of the people.

The dark nameless force that streamed together destructively in Notre-Dame commanded the individual also; it struck Anquetil du Perron, in whom it provoked an answer that became part of world history. From him has come the yet incalculable spiritual influence of the East. Let us beware of underestimating this influence! We see little of it on the intellectual surface of Europe—a pair of philosophy professors, some sombre celebrities like Madam Blavatsky and Annie Besant with her Krishnamurthy. These influences seem to be separate little islands rising above the sea of the masses, but in reality they are the peaks of important, undersea mountain-ranges.

The Philistine of culture believed till quite lately that he could smile down on astrology as something long since

exploded, but now coming up from below, it stands today close to the doors of universities from which it was withdrawn three hundred years ago. The same holds true of the ideas of the East. They gain a foothold in the masses below, and grow gradually up to the top. Whence came the five or six million Swiss frances for the anthroposophic temple in Dornach? Certainly not from an individual. Unfortunately there are no statistics which could show accurately how many confessed and silent theosophists there are today. What is certain only is that the number reaches several millions. To this are to be added several million spiritualists of Christian and theosophical denomination.

Renewals from Below

Great renewals never come from above, but always from below, just as trees never grow down from heaven, but always up from the earth, even if their seeds once did fall from above. The upheaval of our world and the upheaval of our consciousness are one and the same thing. Everything becomes relative and therefore questionable. While the conscious hesitatingly and doubtfully looks at this dubious world, where there are rumblings about peace-and-friendship-pacts, about Democracy and Dictatorship, Capitalism and Bolshevism, the soul yearns for an answer to the turmoil of doubt and uncertainties. Those who have most given themselves up to the urge of the soul come from the more obscure strata of society. They are the much derided silent people, less infected by academic prejudices than the more brilliant leaders. Looked at from above, the urge is often a disappointing or laughable comedy, but it is significantly simple, simple like those once called blessed. For example, is it not moving to see even the most patent psychical nonsense gathered together in foot-thick archives? The most inadequate stammerings, the silliest actions, the emptiest flights of phantasy have been brought together as

Anthropophyteia with scrupulous scientific conscientious-
ness by Havelock Ellis and the Freudians. They have been
collected in serious treatises and accorded all scientific
honours, and their reading public spreads over the whole
circle of white culture.

Whence this zeal, this almost fanatical honouring of
things beyond the pale of good taste? It is because they are
psychological, they are soul-substance, and therefore as
precious as handwriting-fragments rescued from ancient
ruins. Even what is hidden and evil-smelling in the soul is
valuable to the modern because it serves him towards a
goal—To what goal?

Freud has given in his *Interpretation of Dreams* the
motto: *Flectere si nequeo superos, Acheronta movebo.* If I cannot
bend Olympus, I will at least set Acheron in an uproar—to
what purpose indeed?

The Goal

Our gods are the idols and values of our conscious
world that have to be dethroned. Nothing so discredited the
ancient gods as their scandals. History repeats itself: we dig
into the mistrusted background of brilliant virtues and
incomparable ideals, with the triumphant cry: These are
your gods, a false front made by mortal hand, and defiled
by human depravity; a whited sepulchre, full of carrion and
filth. A long familiar note is sounded, and there come again
to life words one never digested when being prepared for
confirmation.

I am of the earnest conviction that these are not
accidental analogies. There are too many men to whom
Freudian psychology is dearer than the Bible, and to whom
Bolshevism means more than civic virtue. And yet all these
people are our brothers, and in each of us there is at least
one voice that agrees with them, for in the last analysis we
are all parts of one soul.

The unexpected result of this spiritual tendency is that an uglier face is put upon the world so that no one can love it any more, nor can we any longer love ourselves, and finally there is nothing more in the outer world to entice us away from our own souls. Taken in the deepest sense this indeed is the result that was aimed at. What else does theosophy mean with its doctrine of Karma and reincarnation except that this world of appearance is nothing but a transitory, moral, health-resort for the immature? True it makes the immanent meaning of the present-day world relative by a different technique, in that it promises other higher worlds without making ugly the world as it is, but the result remains the same.

All these ideas, judged by established rules, are extremely unacademic, but they seize modern consciousness from below. Is it again an accident of analogy that Einstein's relativity theory, and the newest atomic theory, bordering on super-causality and invisibility, become the possessions of our thought? Even physics flees our material world. It is no wonder, I think, if modern man falls back inevitably upon his psychical reality, and expects from it the security the world denies him.

Self-Deception of the West

But with the soul of the West things are precarious, all the more precarious in that we still prefer the illusion of our inner beauty to the unvarnished truth. The Westerner lives in a veritable cloud of self-deception, which is designed to veil his real face. But what are we to people of a different colour? What do China and India think of us? What does the black man think of us or those whom we have destroyed with brandy, venereal diseases and general land robbery?

I have an Indian friend who is a Pueblo Chief. We were once speaking confidentially about white men, when he

said: 'We don't understand the whites; they are always wanting something; they are always restless, always seeking something. What are they hunting for? We don't know. We cannot understand them. They have such sharp noses, such thin cruel lips, such lines on their faces. We think they are all crazy.'

My friend had recognized, without being able to name it, the Aryan bird of prey and his insatiable lust for booty, the thing that takes him all over the world, into countries that concern him not at all. The Indian had moreover noted our insanity which, for instance, flatters itself that Christianity is the only truth, the white Christ the only Redeemer. We even send missionaries to China after we have set the whole East at loggerheads by our science and technique and then forced tribute out of them. The stamping out of polygamy by the missions has developed prostitution in Africa to such an extent that in Uganda alone twenty thousand pounds yearly are expensed on anti-venereal measures, and furthermore the campaign has had the worst possible moral consequences. The good European pays missionaries for these refreshing results. Shall we mention the really frightful tale of sorrows of the Polynesians and the blessings of the opium trade?

Thus does the European appear outside his moral smoke-screen. It is small wonder that the digging out of our soul is at first almost like undertaking excavations for a canal. Only a great idealist like Freud could devote a whole life-work to this unclean task. In our psychology, then, acquaintance with the real soul begins to all intents and purposes with the most repellant end, namely, with the things we do not wish to see.

Light out of Night

But if our soul consisted only of things evil and useless, a normal man could not by any power in the world be

induced to find anything attractive in it.This is why people who can see in theosophy nothing but a lamentable intellectual superficiality, and in Freudianism nothing but lust for sensation, prophesy a rapid and inglorious end to these movements. But they overlook the fact that at the base of these movements is a passion, namely, the fascination of the soul which will hold to these forms of expression until they are surpassed by something better. Superstition and perversity are fundamentally the same. They are transition forms of an embryonic nature out of which new, more mature forms will develop.

The spectacle of the Western subconscious mind is little inviting either from an intellectual, a moral or an aesthetic standpoint. With unrivalled passion we have built up a monumental world about us, but just because it is everywhere so tremendous, all that is great lies outside, and on the other hand, what we find in the depths of the soul must necessarily be as it is, namely, impoverished and inadequate.

I realize that I have gone beyond collective consciousness in what I say. The insight into these psychological facts has not yet become a common possession. The Western public is only on its way to this point of view, against which one rebels violently for reasons readily understood. We have been impressed by Spengler's pessimism, but the impression is chiefly felt in pleasant, circumscribed academic circles. Psychological insight, on the other hand, touches on what is painfully personal and therefore comes up against personal resistances and denials. I am far from considering these resistances as meaningless. Far from that, they appear to me as a healthy reaction against something destructive.

All relativism when taken as the superior and final principle works destructively. Therefore, if I call attention to the dismal aspect of the subconscious mind, it is not in order to lift a warning finger of pessimism, it is rather that I point to the fact that the unconscious, irrespective of its

terrifying aspect, exerts a powerful attraction, and not only on diseased natures, but upon healthy positive spirits. The background of the mind is nature and nature is creative life. It is true that nature tears down what she builds up, but she builds up again. What the modern relativism destroys in values in the visible world will be given us again by the soul. At first we see only the descent into what is dark and ugly, but whoever cannot bear this sight will never create what is brilliant and beautiful. Light is always born out of night, and no sun ever remained standing in heaven because an anxious human longing clung to it. Has not Anquetil du Perron's example shown us how the soul drives away again its own darkness? China certainly does not believe that it will be destroyed by European science and technic. Why should we believe that the secret spiritual influence of the East should destroy us?

The East Likely to Overwhelm the West

But I forget that apparently we do not yet realize that while we can shake to its foundations the material world of the East with our superior technical ability, the East with its superior spiritual ability can bring confusion to our spiritual world. The idea has never come to us that while we are overwhelming the East from without it, it can seize us within. Such an idea seems almost insane to us because we can only think of causal connections, when we cannot see our way to making a Max Müller, an Oldenberg, a Neumann, a Deussen, or a Wilhelm responsible for the confusion of our spiritual midway position. But what does the example of Imperial Rome teach us? With the conquest of Asia Minor, Rome became Asiatic, Europe in fact became infected by Asia and is still today. Out of Cilicia came the Roman military religion, the Mithra cult, which reached from Egypt to cloudy Britain, and out of Asia came Christianity also.

3

We have not yet quite realized that Western theosophy is a dilettante imitation of the East. Astrology, the daily bread of the East, we are just taking up again. Sexual investigation, begun for us in Vienna and England, has excellent Hindu fore-runners. Thousand-year-old texts from there instruct us in philosophical relativity, and the summation of Chinese wisdom is based exclusively on a super-causal standpoint only just divined by us. And even certain complicated new discoveries of our psychology are to be found recognizably described in ancient Chinese texts, as Professor Wilhelm himself has shown me. What we hold to be a specific Western discovery, that is, psycho-analysis and the trends of thought stimulated by it, is only a beginner's effort in comparison with what in the East is a practised art. It should be mentioned that the book drawing the parallelism between psycho-analysis and Yoga has already been written by Oscar A. H. Schmitz.

The theosophists have an amusing concept of Mahatmas who are sitting somewhere or other in the Himalayas or Tibet and from thence inspire and lead the spirits of the whole world. In fact, so strong is the influence of the Eastern attitude toward magic that mentally normal Europeans have assured me the good part of what I say is inspired by the Mahatmas, without my knowledge, and that my own personality counts for nothing. This mythology, widely spread and firmly believed in the East, is like all mythology, far from being nonsense, but is a very important psychological truth.

The East seems in reality to be active in the cause of our present spiritual transformation. But this East is not any Tibetan Mahatma monastery, it is chiefly within us. It is our own soul that is at work to create new spiritual forms, forms containing spiritual realities which must put a wholesome damper on the Aryan man's limitless lust for gain. There is indicated something of that limitation of life which in the East has developed into a questionable quietism, something perhaps of that stability of existence

which necessarily ensues when the demands of the soul become just as pressing as the needs of the external social life. Yet, in this age of Americanism, we are still far removed from anything of the sort, and stand, as it seems to me, only at the beginning of a new culture. I would not like to assume the role of prophet, but one cannot try to sketch the spiritual problem of modern man without mentioning the yearning for rest bred out of the condition of unrest, the longing for security in the midst of insecurity. Out of wants and necessities grow new forms of existence, and not out of ideal demands or mere wishes.

A Significant Phenomenon

In the fascination the soul has for modern consciousness, I find the kernel of the present spiritual problem. Looked at pessimistically, it is a phenomenon of decay; on the other hand, looked at optimistically, it is the hopeful germ of a possibly deep change of the Western spiritual attitude. In any case it is a phenomenon of great significance, all the more worthy of attention in that it is rooted in wide reaches of society, and all the more important since it stirs those irrational and, as history proves, immeasurable, instincts of the mind which transforms the life of peoples and cultures in unforeseen and secret ways. It is these forces, to many people still invisible today, which lie behind the psychological interests of our time. The fascination the soul exerts is fundamentally not an abnormal perversity, but so powerful an attraction that it cannot be frightened even by things offensive to good taste.

Along the great thoroughfares of the world everything seems withered and wasted; therefore the searching instinct leaves the well-trodden ways and turns to the bye-paths, just as the man of antiquity freed himself from his Olympian world of gods, and ferreted out the Asiatic mysteries. Our secret instinct seeks this hidden thing outside, in that

it takes up Eastern theosophy and Eastern magics, but it also seeks it within in that it looks reflectively upon the background of the soul. It does this with the same scepticism and the same radicalism with which a Buddha, in order to attain the uniquely convincing primordial experience, put aside his two million gods as irrelevant.

An Optical Illusion?

And now we come to the last question: Is what I have said of modern men really true? Or is it perhaps an optical illusion? Without a doubt, to the minds of millions of Westerners the facts cited by me are quite unimportant accidents, and for very many highly cultured people they are only lamentable mistakes. What, for instance, did a cultured Roman think of Christianity which spread first among the lower levels of the people? To many, the Western God is personally just as living as is Allah beyond the Mediterranean Sea, and the one believer holds the other for an inferior heretic to be endured sympathetically for lack of any other course of action. A clever European is moreover of the opinion that religion and the like is quite suitable for the people and for the feminine feelings, but is to remain absolutely in the background when compared with immediate economic and political questions.

Thus all along the line I am given the lie, like one who, out of a cloudless sky prophesies a thunderstorm. Perhaps a thunderstorm is below the horizon—perhaps it will never overtake us. But the questions of the soul always lie below the horizon of consciousness, and when we speak of spiritual problems, we are really talking about things on the borderline of visibility, of most intimate and delicate things, of flowers that open only in the night. By day everything is clear and tangible, but the night is as long as the day and we live in the night also. There are people who have bad dreams that even spoil the day for them. And the life of the

day is for many people so bad a dream that they long for the night when the soul awakes. It seems to me indeed as though there are especially many people like that today, wherefore I think the modern spiritual problem is conditioned as I have described it.

I must reproach myself with one-sidedness in that I pass by in silence the soul of our temporal world of which most people speak. I do so because it is an open book to all. It expresses itself in inter-or super-national ideals embodied in Leagues of Nations and the like, as well as in sport and, finally, in a telling way in the cinema and in jazz. These are characteristic symptoms of our time which unmistakably extend the humanitarian ideal to the body. Thus sport means an unusual valuation of the body, which is still more emphasized by the modern dance. The cinema, on the other hand, like the detective novel, makes possible a harmless experiencing of all those excitements, passions and phantasies, which in a humane decade must of necessity be repressed.

It is not difficult to see how these symptoms hang together with the psychic situation. The fascination of the soul is nothing other than a new self-consciousness, a retrospective view of fundamental human nature. It is no wonder that at the same time the body, which for so long suffered depreciation in contrast to the spirit, has again been discovered. At times one feels almost tempted to speak of the vengeance of the body at the cost of the spirit. When Keyserling in a grotesque way denounces the chauffeur as the culture-hero of our time, he has not by any means shot beside the mark. The body raises its claim to equal recognition, indeed it exerts a fascination like that of the soul. If one is still caught by the old idea of the opposition between mind and matter, this condition means a split, an unbearable contradiction. But if we can reconcile ourselves to the mystery whereby the soul is the inner life of the body, and the body is the outwardly revealed life of the soul, the two being really a unity, then we can also understand how the

struggle to transcend the present level of consciousness leads through the unconscious to the body, and, conversely, how the belief in the body can only subscribe to a philosophy which does not deny the body in favour of pure spirit. This prominence of psychical and bodily demands in contrast to a former time when they were not so emphasized, although apparently like a phenomenon of disintegration, may also mean a rejuvenation, for as Hölderlin says:

> Wo Gefahr ist
> Wächst das Retende auch*

And we actually see how the Western world begins to strike a much more rapid tempo, the opposite of quietism and world-fleeing resignation. In extreme contrast begins to form a tension between outer and inner, or better, between objective and subjective, perhaps a last race between aging Europe and youthful America, perhaps a healthy or dubious effort to flee the power of darker laws of nature, and to conquer a yet greater, yet more heroic victory of awareness over sleep.

A question which history will answer.

After all these audacities let me return to my original promise of not wanting to forsake modesty. My voice is only one voice, my experience only a drop in the sea, and my knowledge no greater than the limits of a microscopic filed of vision; my spiritual eye is a tiny mirror that reflects one of the smallest corners of the world, and finally my idea—a subjective confession.

*'Where there is danger
The saving thing also grows.'

the universe not merely degraded but also afford an unstinted support to the evolution of the positiveness of man's

So long as science was confined to her hard shell of might unfruitful-looking dogmas
was under the yoke of narrow sensationalism, a reassuring

THE RELEASE OF PHILOSOPHY

Pramathanath Mukhopadhyaya

Promise of a Rich Harvest

Towards the close of the nineteenth century certain signs began to appear in some fields of human enquiry, which indicated, beyond the possibility of doubt, that as a result of man's scientific effort certain seeds had been sown which were destined to yield a new and startling harvest of crops in the near future. And the present century was startled not merely by the novelty of the results but also by the change in outlook and orientation, in methods and hopes, which revealed themselves as soon as a new day broke in clearness settled. We shall not refer to the new discoveries in science, and make particular mention of any of them, though many of them are of an epoch-making nature; we are here concerned with the general tendency of these new facts or rather new appreciations of the old facts.

And we are concerned with the new tendencies in so far as they bear upon and affect what has been of supreme interest to man in all times—an interest that has overshad-owed every other—the meaning and reality of man's free-dom and happiness. The question that has stirred his inmost depths and the problem that has attracted and perplexed him more than any other relate to this. The universe has been made to yield its secrets. But do we know all the secret that is essential, or at least, such part of the secret as seems relevant to the solution of the most engaging problem of man? Is science in a position to insure the satisfaction of the deepest yearnings of man, in the scheme of the world-order that she has been able to draw up? Does the constitution of

the universe not merely safeguard but also afford an unstinted scope for the evolution of the possibilities of man?

Science of the Nineteenth Century

So long as science was confined to her hard shell of nineteenth-century dogmatism, and philosophy was groaning under her yoke of narrow sensationalism, a reassuring answer was not given, and was not thought possible. A nineteenth century man of science was apt to regard his chart of the universe a self-complacently neat and rounded whole—a scheme which left its windows open indeed for the admission of new facts, but its doors barred against the challenge of any revolutionary principles. A constitution of the universe had been drawn up for all time, and all facts old and new were expected to submit to its governance. That a challenge might come from new facts, or that a revolt might arise from a demand for a more adequate explanation of those already known was not deemed possible. We had been permitted to look into Nature's own order-sheet for the rule of natural phenomena, and it was a comfortable assurance of the man of science not only that unruly events do not occur, which even now might be thought a permissible hypothesis, but that the order-sheet in so far as shown to him was sacrosanct and inviolable, and admitted of no question and revision, which is, in any case, a dogmatic position. There are always more things and more truths—relating to facts as well as to principles—than are dreamt of in philosophy.

Science might have to plead guilty to a milder impeachment if she had been content to play the part of Providence in her own house—the so-called physical universe; but not unoften she was also caught poaching upon provinces which are not her own preserves—the realms of life and consciousness. Physics was allowed to overshadow, if not

dominate, the study of both life and mind. She favoured, if not actually required, a mechanistic or deterministic outlook upon these things. Astronomers now tell us of island universes beyond our galactic system; but no one perhaps will seriously contend that these island universes enjoy a domestic monopoly of a new set of mechanical laws and principles. It is not thought that the laws of motion, for example, will not hold good in those outlying regions of space, or that spectroscopy will fail to be an index to the chemical constitution of the stuff of those worlds. Similar perhaps was the attitude of the man of science with regard to the island universes of vital and mental phenomena. They were simply tolerated as an outlying region of phenomena which were suffered to exist, but their right to exist as independent phenomena or facts *sui generis* was viewed with suspicion, if not flatly denied.

Under the official review certain aspects of these phenomena passed muster, and in the Comity of Sciences the sciences of Biology and Psychology were admitted more as a matter of grace than as a matter of right, and they were shown to back seats. The front row was to be occupied by the strictly mathematical and experimental sciences. Biology and Psychology were given domicile, but outside the courtesy and formality of 'law', they scarcely got admitted to the orthodox clubs, and were politely nodded away as aliens as soon as they ventured to trespass into the sanctuary of the exclusive clubs. A correct costume and correct manners were insisted upon in the case of an occasional visitor, but inflexibly stringent were the rules of admission to membership. Biology and Psychology long waited in the ante-chambers hat in hand, but their credentials have, perhaps, not yet come up to the requirements.

The nineteenth century colossus of scientific achievement was not however without its feet of clay. Its forte was also its foible. It had plunged its piers not into the rock of truth, but into the sand of unwarranted assumption. Its first

principles were not axioms but postulates, and its postulates were 'convenient fictions'. Its absolute space and time and mass, its conservation of matter and force, its universal causation and uniformity of Nature were convenient fictions, and were so recognized by some of their first-rank professors. Outside these fundamentals, Science was frankly expected to do her job only by what is called 'limitation of the data'. A real, concrete, live thing is never its subject of study. It presents a problem of unmanageable complexity. The mutual attraction of the three bodies instead of two was a problem for mathematical geniuses to grapple with. But what is this problem by the side of the infinitely complex problem of universal attraction? Science has always to simplify her case by scraping the irrelevant details. But it is well to remember that what are irrelevant in a given frame of reference may not be so in a different frame of reference.

The universe of Science is therefore a universe of convention. Its space and time, its ether and force, its mass and motion are all conceptual models or moulds into which live real facts cannot be pressed whole and entire, and out of which they issue as mangled approximations and dead abstractions. By reason of Science possessing this character, she has been the foster-mother of sensationalism in Philosophy. Things are nothing but clusters of sensations, actual and possible—it was said. Space, time, mass and motion are the causal factors: the universe of perception is an ideal growth out of these causal roots. But are not the roots themselves conceptual? So Science has been believed to lead inevitably to the grave of realism. Its logical outcome in philosophy has been supposed to be either agnosticism or sensationalism.

It is true that fresh attempts are being made to save realism by showing that our knowledge of the external world both implies and requires a substratum of reals that are not altogether falsely presented in experience, and are being, with increasing fullness and correctness, represented

by the facts and principles of science. For my part, this vindication of lay experience and Science has always appeared to be of real value. It is a reassuring gesture that allays our natural misgivings as to the world in which we live, move and have our being, not revolving upon any real and substantial hinges. A world of cobweb has ever failed to bring its appeal home to us. It has lacked points of appeal. It has interested us as a mirage from which escape is sought, and not as abode and habitation where the satisfaction of our vital needs may be attained, and the hopes and yearnings of our advance and betterment are insured.

So long as experience is a phantasm, and Science was supposed to lend a weird and unknown background to this infinitely diversified illusive projection, only a philosophy of transcendence pointing to a way of escape out of the far-flung spell of this film-house was the sort of philosophy that mattered.

A Philosophy of Despair

But such escape has not always been thought possible. A frankly sceptic attitude has often been taken. The question—Is metaphysics possible?—has sometimes been answered in the negative. A religion of Nature or a religion of Hero-worship, together with an utilitarian ethics and social scheme, have been supposed to have met the spiritual requirements of many. But it is idle to pretend that a philosophy or a negation of philosophy which denied the more fundamental values of human existence—man's essential freedom, bliss and survival after death—can meet the central needs and requirements of the human spirit. A sceptical philosophy, whatever redeeming features it may sometimes have presented in its altruistic social sanctions, is a philosophy of despair. It is born out of a disappointment

that our logic has failed to justify our deepest and most essential beliefs.

A philosophy which merely plays to the gallery is not helpful, and may in fact be worse than useless. It is not the proper function of philosophy to frame conventions of thought and behaviour, but to find, or try to find, the ultimate sanctions for all conventions, to examine the foundations of all essential beliefs. Even Science may offer us a house of convention to live in; and ethics and politics may keep our private or public house according to an economy of common sense and common prudence only. The ulterior question whether that house is or is not a rightful or permanent lodging, and whether that economy is or is not of assured worth, remains unresolved. Whether the bricks of that house are facts or fictions, whether the mortar used is objective nexuses or only subjective norms and conventions, is a point which Science itself has perpetually raised and presented, but never has met.

An enquiry has always been thought necessary as to the nature and limits of our knowledge of the external world and also of our minds. And the interest has been not merely theoretical. All the vital issues of life hang on this enquiry. Is the constitution of the universe such as to give us a fair field for an exercise of what is best in us, and for the satisfaction of what is deepest in us? Is it a field indifferent in relation to the moral, aesthetic and religious values, or is it hostile or helpful? Does our experience of the Self, again, possess a background of assurance that it is essentially imperishable, free and blissful? A verdict of an ignoramus has not proved less unsatisfying than a verdict of flat denial or negation. Philosophy has not been happy or even easy by debarring the possibility of knowledge. A Critique of Pure Reason has never laid the matters of vital moment to rest. A Critique of Practical Reason and a Critique of Judgment have been required to meet an insistent demand that cannot be satisfied.

Imprisonment of Philosophy

Philosophy had been in shackles not of her own making. She had abdicated her rightful authority to the sciences, and shut herself in a prison the key of which she had delivered to the gaoler. She had to take her orders from others. She must abide by the findings and decisions of the special sciences. She must not trust intuition and *a priori* ideas, but must depend upon the observations and experiments and inductions of the special sciences. Of these, objective findings were deemed more trustworthy than the subjective. Science is measurement, and whatever phenomena readily lend themselves to measurement are taken as more dependable than those which do not appear to be so pliable. Economics became a science to the extent that the methods of calculus could not be applied to it. So also in the cases of biology and psychology.

There is no doubt an aspect of our universe of experience which is amenable to measurement, and this embraces not only the so-called objective half, but also the subjective half of that universe. But there is also another which is beyond or above measurement, and of which Science as such is not competent to take cognisance. This immeasurable and alogical always eludes the grip of the calculator, and always exceeds the span of the foot-rule and the compass. Philosophy has her justification in the making of an endeavour to satisfy herself that such an ultra-scientific realm actually exists; and if it does, to locate it and survey it, if and so far as that is possible. She is also to correlate it to the realm of Science proper. The task of settling the 'scientific' frontiers of Science is hers, and this burden she can neither lay aside nor shift it to other shoulders. That would be like shifting the judge's office to the plaintiff of his witnesses.

But the key has now turned in her prison door, and her gaoler will presently be in her cell and present her own

release order to be signed by herself. If the new discoveries in the scientific realm, not only as regards facts but also as regards methods and principles, bear any deeper implication, it is this that Science is without any rightful warrant to erect any prison house for Philosophy to be shut up in, to lay down any limits to the possibility of knowledge and will to be and become. The new conceptions of space and time, of energy and atomic constitution, as also many new advances in the knowledge of physical, chemical, biological and psychological facts and laws, have all conspired and plotted to blow up any such prison house. The present tendency is decidedly against any dogmatic assertion of the supremacy of matter and force, the absolutism of mechanistic determinism, the universal uniformity of natural occurrence and governance, the impossibility of the transcendental and improbability of the so-called mysterious and miraculous.

The tiny modern atom has proved powerful enough to upset many of the 'invulnerable' positions of nineteenth-century scientific dogmatism. The atom has shown that the seemingly smallest thing is only seemingly so—that it is great in its energy and great in the appointments of that energy, and yet that all this greatness has not made it something ultimate and indestructible, but only a bubble, with a longer lease of life than perhaps the suns and the stars, blown up into being, we know not how, and blown out of being, we know not also how, on the bosom of a Being which may be Ether, or Space-Time Continuum, or any other imperfectly understood thing, but certainly is not matter in the ordinary physical acceptation of the word.

The Quantum Theory of Energy, again, has profoundly affected the older ideas of the continuity of the dynamic entity, and also, as we shall presently see, of the causal operation. Our new space-time concept has proved a powerful solvent so far as the absolute character of the ordinary relations of space and time are concerned. Physics

has been emerging out of the mouldering heaps of old physical conceptions, and building itself on the gravestone of swaggering nineteenth-century materialism, empiricism and mechanistic determinism.

And yet there has never been a compelling reason for Philosophy having consented to sell her birthright for a mess of scientific pottage. It is true Science had persuaded herself, upon insufficient data as it subsequently appeared, that any condition of the universe as a whole is determined by the given antecedent assemblage of conditions which, as many orthodox physicists thought, are reducible to a given configuration of matter and a given distribution of motion; and that the realms of life and matter are either included in the universe of matter and motion as constituent and dependent parts—a more likely hypothesis—or island universes having commerce with the main continent but enjoying the status of a sovereign state—an unlikely hypothesis.

On a recent occasion, a scientist who has the authority to speak in the name of science thus contrasted the spirit of new science with that of the old:

When we oldsters were boys, Science meant knowledge. Science means no such thing now, because there is no such thing as knowledge: there is only a partial emergence from ignorance. Formerly, Science was bold and dogmatic and announced eternal truth. Now, Science is timid and apologetic and propounds momentary hypothesis....Formerly Science purported to observe facts and to explain them. The facts were positive and the explanations were final. Today, we have neither facts nor explanations, but only appearances and theories. Thus we no longer speak (scientifically) of matter and its properties as the sole reality; nor should we be grossly unscientific if we venture to speak of matter as the sole illusion. This may seem to

carry us back towards the ancient Hindu idea of Māyā (or mirage); but what then?....And as with matter, so with the properties of matter. The substantiality of a substance, the solidity of a solid, the fluidity of a fluid, the ponderability of a weight, the mobility of a moving body, all these are now seen to be mere mental pictures that may loosen thought, not finalities to enchain thought.

He further adds that, while Old Science rated only its latest results as true and all previous results which did not tally with these as false, New Science has now a more generous outlook inasmuch as it considers all results, earlier or later, as being only relatively true.

Tyranny of Science Gone

The gain of Philosophy and the stock of true human knowledge has been twofold. The chief gain has of course been that the tyranny of scientific absolutism is now gone. The human spirit of enquiry is now breathing free. Matter no longer is there with its noose round its neck. As to the other point that matter is an illusion, or for the matter of that, the sensed and perceived world is merely an appearance, it must be recognized that indications are there which suggest that all may be Māyā. But here again science should not be dogmatic and say something outside its brief. The question of the reality of the world must as yet be left an open question, and one upon which Science as science should not claim to have the final say. So long as Science was arrogant, it required Philosophy to play second fiddle to it. Now that Science is modest, it may feel that it had no right to demand of Philosophy its vassalage, and may now return the deed of its self-surrender which it had not rightfully in its possession.

That the world may be a Maya is not a new revelation in Natural Philosophy. Herbert Spencer was commonly looked upon as the best exponent of the philosophical creed of the older generation of physicists; and his philosophy certainly did not make matter and motion the first principles. The world is the transfigured projection of an unknowable Being, an inscrutable Power. If we but put the Brahman of the Indian Upanishads for this inscrutable Power, and the transfigured projection of that Power for Maya, then it does not appear to be a far cry from this sort of scientific agnosticism or 'realism' to the ancient doctrine of Maya. Brahman, however, is not the unknown and inscrutable Being or Power. It is certainly unmeasured and immeasurable, undefined and indefinable, undivided and alogical. But it is not merely the hidden but the patent Wonder: not merely the transcendent but also the immanent Being or Power. But let us not pause over this. Among physicists themselves there were some who possessed the 'X-ray vision' to penetrate the hard *ensemble* of scientific facts and laws, deductions and explanations and get at the kernel of truth, the foundations of the edifice of Science. They found not only that Science proceeded upon limitation of the given data, but upon not actually given but manipulated and prepared data—that the basic elements of scientific construction were largely, if not exclusively, conceptual moulds and convenient fictions only. Some cautious minds had even suspected that the Law of Causation, the Principles of the Uniformity of Nature, the Conservation of Matter and Force, and so forth might not after all be absolute and unquestionable.

Nevertheless the facts and principles of Science, the methods and results, the spirit and outlook of Science were, and still to some extent are, the models to which all facts, etc., must conform. New Science has ceased already to pitch its demands too high, and sundry orders of phenomena are already seceding from the empire of physical and mathe-

matical science and declaring their independence and domestic sovereignty. And Philosophy ought to take, if she has not taken already, the lead in this movement. She must declare that she has a subject-matter which is not covered by the Science Group, and that her method of doing her job has not been and cannot be assigned by science. It is now felt that Philosophy must be more scientific and Science must be more philosophical. Truth cannot be partitioned between Science and Philosophy; nor can the apprehension and appreciation of truth be cut in halves and each half reserved for each of the two disciplines.

The time has now arrived when it should clearly be recognized that there is an aspect of the universe of experience which is amenable to scientific treatment, to which the logical operations of definition, measurement, classification and deduction are applicable; and this aspect embraces not only the so-called realm of matter, but also those of life and mind. There is a great deal of truth in the assertion that the trend of modern philosophy is to find that mind is less mental and matter is less material than they were formerly supposed to be. There is now hardly any room for doubt that between matter and mind or between matter and life there is not only community of essence, but also community of natural governance. Science cannot be denied jurisdiction over these.

But it has further to be recognized that there is also an aspect of experience which is transcendental in the sense of being ultra-scientific, which is not capable of being defined, measured, classified and explained in the sense that scientific entities are. And these two aspects are not in regions isolated from each other. Every scientific entity, for example the orbital motion of an electron, or the excitability of a plant tissue, presents a measurable and therefore scientific aspect, and a non-measurable or ultra-scientific aspect. In every actual measurement of a given fact or event, a residuum of the unmeasured always remains. No solution is

absolutely without a precipitate which has not dissolved. The unmeasured and unexplained dislodged from one position is sure to reappear in a subtler and perhaps more complex form in another. It cannot be pretended that the modern physics of the constitution of the atom and quantum phenomena has laid the science of the universe on simpler and more understandable lines. The theory of hyper-spaces, of space-time, and so on has not presented a picture of simplicity at the background of the riddle of the universe.

Pictorial Thinking

To speak in terms of aspects is only pictorial thinking, but it does sometimes help us, when we may be thinking and talking analytically, to put our exhibits in a convenient way. It does not explain the whole or the parts and their correlation to say that the whole presents the aspects A, B, C, anymore than the classification of a number of things into certain groups explains the things or their affinities. But then classification serves a purpose. And so does analysis in terms of aspects. It has the advantage of riveting us to the indivisible unity of the whole.

Now, the universe presents four aspects. First, there is the aspect of what we may call the whole and the fact. The whole of experience is always beyond measure and logical appreciation. The measurable and understandable order is ever imbedded in an unmeasurable and un-understandable whole. The actual fact of an event, again, in its concreteness baffles every measure and attempt at analysis. It is amenable to scientific treatment only after the paring off of all the irrelevant details. Secondly, there is the aspect of the as yet unmeasured but measurable order in experience. It is this which makes it possible for science to possess an ever expanding frontier. Thus some of the frontiers of the

previous century have been pushed considerably back in the present. The twentieth century need not stop where the last century had to stop. There has been remarkable extension in the knowledge of great things and small. The universe in the atom as well as the island universes beyond our galactical system are now being scientifically surveyed and mapped. There has been extension in the fields of life and mind phenomena also. We now know more about the cell, its nucleus and fertilization; and more about subnormal and abnormal psychology relating to parapsychic phenomena. The subconscious mind, the potentialities of the mind hitherto unsuspected or disbelieved, the dynamism of the mind and its action and reaction on the dynamism of matter, all these are better exhibited, if not better understood, today than they were yesterday. The humility of new science is not due to the fact that it is better informed today in such matters than old science, but to the fact that it knows that it does not know in matters in which old science thought or pretended to think that it knew.

Thirdly, there is an aspect of facts or events, not merely biological and mental but also physical, which is open indeed to observation, and also to some extent to experiment, but not, at least to the same extent, to treatment by the methods of measurement and calculation. There may be an incalculable factor, an element of idiosyncrasy or choice or whatever else we call it, in the behaviour or phenomena. The jumping of an electron in its orbit may or may not in the final analysis present such a factor. But it remains as yet doubtful that any so-called physical event, outside the abstract and prepared treatment by the methods of Science, will ever be completely pressed into the moulds of any deterministic equations or formulae. It may after all possess a character of unaccountable indeterminateness. In the reign of law and order, it may bear at the centre of its being an ineffaceable right to be free and to choose in the face of all the tyranny of natural necessity. As regards life phenomena

and mind phenomena, a *prima facie* case has always existed that they involve an incalculable factor, a suggestion of something free and spontaneously choosing its line of action. And the burden of proof is on the determinist to show that freedom or spontaneity in these groups of facts is but Maya in the same way as the onus is on the scientific mechanist to show that the spontaneity in radioactive phenomena or the discontinuity in quantum phenomena is only seeming.

Fourthly, there is that growing body of the so-called facts and laws which have passed muster in Science. This does not mean that the cases are closed and cannot be reopened. They are always being reopened, and there is no prospect of finality ever being reached. And further it should be remembered that even the best attested facts and laws in Science are determined and determinable only with reference to some conventional frames of reference, making certain elements in the concrete situation relevant, and the rest, however important from other standpoints, irrelevant. For example, in dealing with the mutual attraction of the earth and the moon we may regard each as a perfectly rigid sphere with its mass concentrated at its centre. But the actual concrete situation is evidently vastly more complicated. Scientific statements are thus in the nature of approximations. Again, in making its deductions Science has to rely on certain principles of a comparatively fundamental character such as universal causation, uniformity of Nature, and so forth which are not self-evident propositions, but are only postulates requiring examination.

Probability and Fixity

Some of the front-rank scientists themselves are now perceiving that some of these principles may have their absolute dominion challenged. The very key-stone of the

scientific determinism of the last century and also of the present is universal causation. But this key-stone is now found to be neither granite nor ferro-concrete, but sandstone with holes and fissures in it. Not only what are called 'emergent' events are now pressing themselves more and more strongly into acceptance, but the fixity of the chain of causal concatenation itself (that A must be followed by B, B must be followed by C, and so on; that for a given effect there must be a given cause and no other, and so on) is now found to be loose as soon as we descend from that plane of totals and averages to that of the single bits of events such as the quantum phenomena. Whether the single pulse of event A will be followed by B or by C, is a question of probability; all that we can say in a given instance is perhaps this that A is more likely to be followed by B than by C. Under certain circumstances we can calculate the relative probability.

When however we come to deal with facts or events in groups and consequently with statistical averages, we come to the region of uniformity and fixity. Thus an average particle in a heated gas or liquid conforms to a determinate plan or law of conduct, which need not mean that any individual particle in the swarm also rigidly conforms to it. By taking averages even facts which are believed to be extra-physical may present a character of determinateness, enabling us to draw graphs of their behaviour and formulate laws pertaining to them.

With regard to the emergent phenomena and the 'personal factor' and eccentricity of every phenomenon, there has been and there will always be difference in outlook among scientific men and philosophers. According to some the domain of mechanistic determinism must remain unchallenged in so far as the physical order of facts at least is concerned. The spontaneity of radio-activity and the jumping of the electron in its orbit, for example, must have their adequate and sufficient physical reason which we

at present happen not to know, but which we may know tomorrow. The emergent variation in the germ-cell which results in the development of a new species of plant or animal may defy the scientific principle of sufficient reason today, but tomorrow even it may fall in with the body of facts that have been accounted for. On the other hand, there are others who would place not only the vital and psychical facts beyond the pale of absolute mechanistic determinism, but would claim even for the so-called physical phenomena some latitude of spontaneity and indeterminateness. And it has to be noted that the outlook of new science on such postulates as universal causation, together with some of its latest findings in the region of quantum and atomicity, radio-activity, and so on, have a clear tendency to favour the latter attitude of mind.

Interwoven

For my own part, I believe that the determinate and the indeterminate, the accountable and the unaccountable, the measurable and the unmeasurable are interwoven together in every bit of event, material, vital and mental; that these distinctions are themselves pragmatic and conventional. Matter is matter only in accordance with a certain frame of convention, only with respect to certain uses and habits of acting and reacting and experiencing centres such as we are. Apart from such frames of reference and possibly with respect to other appropriate frames of reference, a particle of sand, for example, may be a living and thinking centre. Scientific relativity should no longer preclude the possibility that it may be so. However that may be, we should now clearly recognize that the scientific explanation of any event, even in the so-called physical realm, on deterministic lines must be in the nature of asymptotic approximation. The net of scientific calculus

has an ever-widening spread and its meshes are becoming finer and finer; but the actual concrete fact, whether small or great, both exceeds its utmost spread and slips through its finest meshes. Neither the whole nor the point-event as such can be gripped by the pinchers, and any object can be so gripped only after it has been trimmed to convenient proportions by a pair of analytical scissors.

It has been said that modern science shows the world of experience to be an illusion. Some have even used the Hindu term Maya. But Maya fundamentally means 'what measures'. The unmeasured and unmeasurable Reality finitizes and measures itself in and as the things and events of the world, but it ceases not to be itself in the manifold of centres thus evolved and evolving. For this reason every object, great or small, presents one aspect in which it can be scientifically measured and logically appreciated, and another in which it exceeds the foot-rule and eludes the logical apparatus. Its determinate and necessary 'self' is imbedded in an essential background of indeterminateness and freedom. What is but an appearance is the Mayik aspect that it is finite only and not infinite, that it is deter-mined only and not free, that it is passing only and not enduring or independent of space-time reference, that it is dead and unconscious only and not in substance life and consciousness. It is veiled experience to know the measured and conditioned only apart from the unmeasured and unconditioned—to fail to realize that even a particle of dust is Sachchidananda Brahman as Power to variously posit itself in space-time and other relations. As the Veda says in mystical language: 'It has a thousand heads, a thousand eyes and a thousand feet; it unfailingly pervades all, and yet exceeds all by the measure of ten fingers.' The world is appearance as long as the veil is on. It is real when the veil is off. Then all is Real and All is Brahman. And this *All embraces the Appearance* also. For Reality as Power both is and appears.

Science thus covers not the Whole of Reality, but relates to certain aspects of it. It relates to the realm of Maya in the sense of what is measured. And it has its method of doing business. Philosophy must address itself to the Whole, and for this purpose must have a method of its own. Science with a truer appreciation of its limits and an ampler vision of its possibilities is coming to realize this. This has rendered a better understanding between the two possible. And with better understanding and co-operation the release of Philosophy from an unjust vassalage has now become possible. The release will mean the resurrection of the Spirit of freedom and joy—Lila and Ananda—buried in the heart of all things—even matter.

SPIRITUALITY AND ACTIVITY

Swami Yatiswarananda

For the speedy attainment of the summum bonum of our life, it is absolutely necessary for us not only to form a clear conception of the ultimate goal, but also to know definitely what particular course of action is calculated to lead us to its realization. An ideal becomes no better than a wild fancy unless we follow the proper path that is sure to help us to realize it sooner or later. Again, when we lose sight of the goal, our activities cannot but become aimless and even misdirected, and make us wander farther and farther from our life's destination. This is what is happening every day in our individual and communal life. Practice does not conform to the ideal. This is the root-cause of most of our troubles both in the East and in the West.

In spite of her terrible sufferings and trials, India is still the home of religion and spirituality. She is still the mother of prophets. Rightly does Mr. William Digby observe in his remarkable book, *Prosperous British India*:

Ram Mohan Roy, Keshab Chandra Sen, Ramakrishna, Bengalis to a man, to mention spiritual workers only who have passed away, are known everywhere and.... are honoured, as amongst humanity's noblest spiritual teachers....During the last century the first fruit of British intellectual eminence was, probably, to be found in Robert Browning and John Ruskin. Yet they are mere gropers in the dark compared with the uncultured and illiterate Ramakrishna of Bengal, who knowing naught of what we term 'learning', spoke as no other man of his age spoke, and revealed God to weary mortals.

All this is true. But it is in India again that in the name of religion millions of people are living a life of apathy and laziness. While aiming to live a life of other-worldliness, they are following the path of morbid inactivity, and are sinking lower and lower into appalling inertness and ignorance. This is far worse than a life of worldliness, which at least entails a certain amount of activity, and this sometimes of a strenuous nature.

When we turn our eyes to the Occident—the land of 'activity and progress'—there, too, we do not find a very encouraging state of affairs. The achieving West has no doubt produced many men of science and inventive genius, and their lifelong labours have tended to mitigate human sufferings, and have brought education, sanitation, health and comfort to the doors of millions. But it is also true at the same time that in the mad rush 'to squeeze the orange of the world dry in the shortest possible time', the Westerners are losing, and as a matter of fact have already lost, much of their life's leisureliness and peacefulness. And not only this. On the plea of spreading the light of civilization and culture and thereby making the world better, they have developed a form of militarism which threatens not only to destroy the peace of the non-European races, but also to exterminate the white nations themselves. Their religion has in most cases become only a pretence for gaining territorial expansion and material prosperity. In India the spiritual mood seems to lapse into indolence, weakness and slavishness. In the West the active temperament tends to lead to restlessness, militarism and aggression. The result is that the true spirit of religion—the one thing needful—seems to slip away in the midst of both the extremes—apathy and restlessness. What then is the remedy?

The morbid desire to reach the highest ideal all at once, whether one has got the necessary capacity and qualification or not, is responsible to no small extent for many of our troubles in the various spheres of life. It is true that we must never lose sight of the ideal. But we must know at the same

time that we are to pass through a number of preparatory
stages, through periods of strenuous physical and mental
training and discipline before we can hope to live the
highest ideal of inward stillness and meditation. Many of
the so-called religious men mar their career and also bring
discredit to the noble name of religion simply because they
unwisely violate this first law of spiritual life. The Hindu
scriptures are quite explicit on the point. Says the *Gita*:

> For the man of meditation wishing to attain purifica-
> tion of heart leading to concentration, work is said to
> be the means. For him when he has attained such
> concentration, *inaction* is said to be the way. He whose
> intellect is unattached everywhere—he who has sub-
> dued his heart—he whose desires have fled, attains to
> the supreme perfection, consisting of freedom of action
> by renunciation.

The authors of the ancient Hindu social system never
lost sight of this ideal, and that is why they inculcated the
Ashrama Dharma—the duties and responsibilities to be
fulfilled in the different stages of life. Owing to the changed
circumstances, it may now be necessary to change the non-
essentials to some extent, but the old principles hold good
in our present condition as strongly as ever.

Activity is inborn in every being. Swayed by his
tendencies, or drawn by the siren voices of the world, as
some would like to put it, man is engaging himself in
various kinds of work, good, bad or indifferent. He wants
to live what he thinks to be a brighter and fuller life, to
enjoy to his heart's content the gifts of Providence. And in
doing this he does not hesitate to tyrannize over the weaker
and less fortunate of his fellow-men. In the scrambling for
power and enjoyment that ensues, mutual hatred and
jealousy, aggression and exploitation, horrible machines for
the destruction of human life and property come to play
their ignoble part. Wars and massacres, starvation and

famine, and other forms of horror follow as a matter of course. This is the picture we find in most of the Western countries, and in other parts of the world dominated by the Western nations. Christianity is the religion of the members of the White race, but these people with some individual exceptions are little influenced in their life and thought by its tenets. Most of them have made, in the words of a Western writer, 'the pretence of the profession of ideals an acquittal to act even remotely in accordance with them.' 'The Kingdom of Heaven is within you'—says Christ. But his followers are mad after founding their kingdoms and empires in the material world, and this even by means of bloodshed and slaughter of the innocent. 'For what is a man profited, if he shall gain the whole world, and lose his own soul?'—declares Jesus. But the Christian nations are scrambling for world-hegemony, even at the risk of suffering the loss of their soul. 'Blessed are the meek, for they shall inherit the earth'—is one of the precepts of the Prophet of Nazareth. But the so-called Christian powers never care to practise it even in their dealings with one another, far less with the Oriental nations. They have proved by their action that to be meek and remain meek is the surest step to the 'disinheritance' of the earth!

The person who is absorbed in Samadhi, and has merged his individuality in the Absolute, may alone be said to have reached the true actionless and perfect state. Of others, 'verily none can rest even for an instant without performing action, for all are made to act helplessly, indeed, by the Gunas, born or Prakriti.' Activity, when understood in its comprehensive sense, is both physical and mental. There are thousands in India who have given up the active life of the world, and are sincerely living the life of strenuous spiritual practice. Against these inwardly active people none should have anything to say. For they are making the best possible use of their time, and are holding aloft before mankind the highest ideal of life—the realization of the Divine. There are others, again, who living in the world are

leading a life of intense activity, both external and internal, and are attempting to do the greatest good to others as well as to themselves in various spheres of life. Both the above mentioned types of men, whether they follow the path of meditation or work or both are the salt of the earth, and are really helping to make the world better than what it is now. They are following paths which will ultimately lead them to the state where 'all knots of the heart are cut asunder, all doubts are solved, and all Karmas cease to exist.'

But those who are trying to avoid work as the source of all evil, and 'restraining the organs of action sit, revolving in the mind thoughts regarding the objects of the senses,' are only forging fresh fetters for their soul. Such is also the case with those who are allowing their activities to be swayed by their passions, and are madly following the path of worldly enjoyment, regardless of the sufferings and miseries of others. To them the *Gita* preaches the Karma Yoga in the following terms—'Without performing work none reaches worklessness; by merely giving up action no one attains to perfection. Do thou always perform actions which are obligatory, without attachment; by performing action unattached one attains to the highest.' Action by itself is not evil. It becomes so when it is not performed in the right spirit, and is made a means to self-aggrandizement and sense-gratification. But when it is brought under the regulative influence of higher ideals as furnished by religion, it becomes a potent instrument for freeing man from the shackles of ignorance, and thereby bringing to him undying peace and blessedness.

The whole secret of Karma Yoga lies in the word 'non-attachment'. This Yoga aims to bring freedom to man through work done without any thought of self. According to it, the path to perfection lies through intense activity. But this activity must be selfless. Then only can it purify the mind, and when this is done the glory of the Atman shines forth in all its splendour. And the person who is blessed with the glorious vision realizes his true Self and reaches

perfect freedom even in this very life. Therefore does the *Gita* declare—'Being steadfast in Yoga, perform actions, abandoning attachment, remaining unconcerned as regards success and failure. This evenness of mind (in regard to success and failure) is known as Yoga.'

Whether in the East or in the West, the crying need of the times is to combine spirituality with activity, and so direct all human strivings that they may ultimately lead man to the destined goal. To bring about this much desired state of affairs, thus did Swami Vivekananda suggest:

In India, the quality of Rajas is almost absent; the same is the case with Sattva in the West. It is certain, therefore, that the real life of the Western world depends upon the influx, from India, of the current of Sattva or transcendentalism; and it is also certain that unless we overpower and submerge our Tamas by the opposite tide of Rajas, we shall never gain any worldly good or welfare in this life; and it is also equally certain that we shall meet many formidable obstacles in the path of realization of those noble aspirations and ideals connected with our after-life.

Only a few thoughtful men and women of different countries are now able to recognize the union and intermingling of the two forces of spirituality and activity. But the sooner the bulk of mankind come to realize this urgent need the better for the world and the human race.

ADVAITA VEDANTA: ACCORDING TO SCRIPTURE AND ACCORDING TO REASON

Dr. Harold Barry Phillips

The Scriptural Basis of Advaita Vedanta

The essence of Advaita Vedanta can be summed up in the following statements: (1) Brahman alone exists, (2) but due to ignorance, (3) each of us thinks he is a separate individual soul, and (4) sees Brahman as the external world; (5) could one but realize the Truth, (6) one would know oneself as identical with Brahman, and (7) the external world would be seen to be unreal.

1. Brahman Alone Exists

In the account of creation, we read: 'In the beginning, dear boy, this was Being alone, one only, without a second (*advitīya*)' (*Chāndogya*, VI.2.1.). From this last word, *advitīya*, comes the related form *advaita* (non-dual). To the same effect is *Aitareya*, 1.1: 'In the beginning, verily, all this was Atman alone. There was nothing else existing as a rival.' The reality behind the universe is called Brahman; the reality behind the individual is called Atman; it is the thesis of Vedanta that Brahman and Atman are the same. Hence the words are often used interchangeably, as here. Or, if it be objected that it is the present with which we are concerned, not the state of affairs some 6,000 million years ago, then we cite *Katha*, IV.10: 'Whatever is here, that is there; what is there, the same is here. He who sees here as different meets with death again and again.' That is, the

Real is one without a second, but those who are in the world see difference, which brings us to the next point.

2. Ignorance Is the Cause of the World

Why does one see manifoldness, as stated above? Because of ignorance, *avidyā*. Because it is rooted in ignorance, the world as perceived is often termed illusion, *māyā*. Thus, 'Know then that nature is *māyā*, and that the great God is the Lord of *māyā*' (*Śvetāśvatara*, IV.10). Again, 'On account of false notions (*māyābhiḥ*), the supreme Being is perceived as manifold' (*Bṛhadāraṇyaka*, II.5.19). These Upanishads are the only ones using the term '*māyā*' in this sense; but we have the analogous use of *avidyā* in the following places: 'Fools, dwelling in the very midst of ignorance, yet vainly fancying themselves to be wise and learned, go round and round' (*Kaṭha* II.5); 'He who knows this supreme immortal Being, as seated in the cavity of the heart, rends asunder the knot of ignorance even here in this life' (*Muṇḍaka*, II.1.10). But the same idea is conveyed by the use of metaphors, thus: 'Like a lid, Thy shining orb covers the entrance to the Truth in Thee' (*Īśā*, 15); 'Take me from darkness to light' (*Bṛhadāraṇyaka*, 1.3.28).

The notion of Brahman being falsely perceived as the manifold world also occurs in these passages: 'Just as, though people who do not know the field walk again and again over the treasure of gold hidden underground, but do not find it, even so all the creatures here, though they go daily into the Brahman world, yet do not find it, for they are carried away by the untrue' (*Chāndogya*, VIII.3.2); again, 'For when there is duality, as it were, then one sees another' (*Bṛhadāraṇyaka*, II.4.14); and finally, 'The self-existent God has rendered the senses so defective that they go outward, and hence man sees the external and not the internal self, (*Kaṭha*, IV.1). From these references, Shankara worked out the doctrine of superimposition (*adhyāsa*): that what we see

is not the Real, but is an illusory appearance which the mind superimposes on the Real: 'Just as blueness in the sky, water in the mirage, and a human figure in the post are but illusory, so is the universe in Atman' (*Aparokṣānubhūti*, 61).

3. The Jīva

If there is really nothing but Brahman, but in the state of ignorance we see a world, by the same token, 'we' are Brahman in the state of ignorance, having thereby become manifold. Hence there is a lot of evidence in the scriptures for the difference between Brahman and the individual soul or *jīva*, or more properly, between the real Self (Atman) and the *jīva*. So *Bṛhadāraṇyaka*, II.4.5: 'The Self, my dear Maitreyi, should verily be realized; should be heard of, reflected on, and meditated upon.' If the Self is to be realized, then the realizer or *jīva* must be different from the realized or Atman. Again, 'Two birds, bound to one another in close friendship, perch on the selfsame tree' (*Muṇḍaka*, III.1.1–2). Here the two birds represent the *jīva* and the Atman. Further, 'When this self that is associated with the intellect is thus asleep, it...lies in the supreme Self that is within the heart' (*Bṛhadāraṇyaka*,II.1.17), and to the same effect is *Chāndogya*, VI.8.1: 'When a man is said to be sleeping, then, dear boy, he has become united with being.' Here the *jīva* must be different and separate from the Atman, if in sleep it becomes united therewith. Indeed, in *Śvetāśvatara*, IV.10, we have the explicit statement that the *jīva* is a part of Brahman: 'The whole world is filled with beings who form His parts.'

4. Jagat

In *Kaṭha*, IV.10, quoted above, we saw a reference to Brahman as both here and there, that is, as both in the

subject and in the object, in the seer and in the seen. The same notion lies behind these famous lines from *Bṛhadāraṇyaka*, V.5.1: 'That Brahman is infinite, this universe too is infinite. The infinite universe emanates from the infinite Brahman. Assimilating the infinitude of the infinite universe, the infinite Brahman alone is left', which signifies that in meditation one should strive to realize the universe (*jagat*) as an embodiment of Brahman, as is stated in *Iśā*, I: 'Whatever there is changeful in this ephemeral world, all that should be seen as pervaded by the Lord.' Hence, there is an external world, which is, in fact, Brahman, but to our senses it appears as manifold—it is but the appearance of Brahman. Or rather, it is one of several different appearances, as is enigmatically stated in *Kaṭha*, VI.5: 'Brahman is seen in the self as one sees oneself in the mirror; in the world of manes, as one perceives oneself in dream; in the world of gandharvas, as one's reflection is seen in the water; in the world of Brahmā, as light and shade.'

5. *Knowledge or Samadhi*

In the last two quotations, it is implicit that in the state of superconsciousness (*samādhi*) we realize the universe as Brahman; by the same token, in that state we realize our true Self as Brahman. This is evidenced by many references, especially the following: 'The self-existent God has rendered the senses so defective that they go outward...Only perchance some wise man, desirous of immortality, turns his eyes in, and beholds the inner Atman' (*Kaṭha*, IV.1), where the process of attaining *samādhi* is referred to. So also, 'Being covered by *māyā*, which is mere sound, it does not through darkness know the *ākāśa* (i.e. Brahman). When ignorance is rent asunder, it being then itself only sees the unity' (*Amṛtabindu-Upaniṣad*, 15). Here knowledge (rending ignorance asunder) is described as seeing through or transcending *māyā*. Next, we have *Śvetāśvatara*, I.10: 'By

meditating on Him, by uniting with Him, and by becoming one with Him, there is a cessation of all illusion (*māyā*) in the end.' Finally, *Kaṭha*, III.14, is worth quoting because of the famous metaphor therein mentioned: 'Arise, awake, O man! Realize that Atman, having approached the excellent teachers. Like the sharp edge of a razor is that path, difficult to cross and hard to tread—so say the wise'; cf. *Muṇḍaka*, III.2.4. (Only very exceptional aspirants are able to attain the superconscious state by their own unaided efforts. A *guru* is needed.)

The philosophical basis of this state is the *turīya*, the superconsciousness that lies as the witness beyond the three states of waking, dreaming, and sleeping. The *locus classicus* for this is the *Māṇḍūkya-Upaniṣad*, but a shorter reference is the *Sarva-Upaniṣad*, 2: 'When the essence of consciousness, which manifests itself as the three states, is a witness of the states, but is itself devoid of states, positive or negative, and remains in the state of non-separation and oneness, then it is spoken of as the *turīya* or the fourth.' That is, the Atman, when it enjoys the states of waking, sleeping and dreaming, is the *jīva*, but it is to be realized in its true nature by transcending these three states, by getting behind them, so to speak. Just as we waken from sleep, so we must waken from the waking world, as it were, and enter into the world of Brahman.

6. Tat-tvam-asi

It is in this superconscious state that the *jīva* becomes identical with the Atman, as in the *Amṛtabindu-Upaniṣad*, 8: 'Realizing "I am that Brahman", one becomes the immutable Brahman.' To the same effect is *Bṛhadāraṇyaka*, IV.4.25: 'He who knows the Self as above indeed becomes the fearless Brahman'; also *Muṇḍaka*, III.2.9: 'Whoever knows the supreme Brahman becomes that very Brahman', where it is clear that the *jīva* is not Brahman in its normal (waking)

condition, but only when it realizes Brahman, or attains the state of *samādhi*. It might be mentioned here that this identity is expounded by means of four aphorisms: (i) 'That thou art' (*Tat-tvam-asi*) (*Chāndogya*, VI.10.3); (ii) 'This Atman is Brahman' (*Māṇḍūkya*, 2): (iii) 'Consciousness is Brahman' (*Aitareya*, V.3); and (iv) 'I am Brahman' (*Bṛhadāraṇyaka*, I.4.20).

7. The Unreality of the External World

In the state of *nirvikalpa samādhi*, the distinction between the subject and the object vanishes; there is no longer any external world, no personal body even. So says *Bṛhad-āraṇyaka*, IV.5.15: 'For when there is duality, as it were, then one sees another...But when all has become the very Self of the knower of Brahman, then what should one see and through what?' This clearly describes the real nature of the universe; it is a mode of that Consciousness which is Brahman. In the state of waking, the external universe is there; in the state of *samādhi*, it vanishes. The fact that Brahman is actually Consciousness, pure Intelligence, is witnessed by *Aitareya*, III.1: 'The whole world is founded on Consciousness (*prajñā*), and therefore Consciousness (*pra-jñāna*) is Brahman.' Compare Śvetāśvatara, VI.2; 'Him who is the master of the *guṇas* and the maker of time, who is omniscient, who is pure Consciousness itself (*jña*): also *Taittirīya*, II.1: 'Brahman is Existence, Intelligence (*jñāna*), Infinitude.' Also *Kaivalya*, 18 and 21: 'I, the witness, the pure Consciousness (*cinmātra*), the eternal Good' and 'I am always the Intelligence (*cit*)'.

Again, it is stated that the universe was created by this pure Intelligence by an act of 'thought', as in *Muṇḍaka*, I.1.8: 'From brooding thought (*tapasyā*), Brahman swells with the joy of creation', and *Chāndogya*, VI.2.3: 'That Being willed (*aikṣata*), "May I become many, may I grow forth."' Similar-ly, there are numerous other passages where Brahman or

the *turīya* is said to be the reality behind the states of sleep, dream, and waking, as in *Kaivalya*, 17: 'That which manifests the phenomena, such as the states of wakefulness, dream, and profound sleep, I am that Brahma.' And, again: 'The Puruṣa who remains awake shaping all sorts of objects of desires even while we sleep—verily that is the pure, the Brahman' (*Kaṭha*, V.8).

Hence the scriptures testify that Brahman is Consciousness, which has various. states, in at least one of which (*avidyā*) there is plurality of souls (*jīvas*) and a manifold world (*jagat*); and in another (*samādhi*), these vanish, and Brahman alone exists. Such is the conclusion of reason also, as will now be shown.

Advaita Vedanta According to Reason

1. Māyā

The table which I see is oval, shining, and four-legged; the table which you see is round, dull, and three-legged; the table which perhaps a third party sees has a flat top, and is two-legged. All this can be verified from experience. Thus we say that each person perceives a different world; that each person has his own private world. In philosophy, we term such private world 'the object'. Now the basic fact about such private worlds is that they are primarily constituted by colours of various shapes, patterns, and sizes; and as it is difficult to conceive how any colour can exist *as that colour* apart from an eye and a brain, we say that the brain constructs these colours, and therefore constructs the object entirely. That part of the brain concerned with this construction is termed the sensorium (*manas*, in Sanskrit), so that the object, the world as revealed to the senses, has no existence apart from the sensorium.

One of the strongest arguments for this position is the nature of dreams and hallucinations. The essence of a

dream or a hallucination is that the external object seems to be there, but there is no external stimulus. The stimulus, we say, comes from the sense-impressions buried in the *manas* itself. Now, if the external world appears as it does when the sensorium is stimulated from outside, and the dream or hallucination appears when it is stimulated from inside, it is surely obvious that the appearance is of the same nature in both the cases: it is the creation or construct of the sensorium. (We shall deal with the nature of the external stimulus below).

Or, take the case of the rising moon, especially the full moon. As it rises, the moon appears to be of a certain size; when it is up, it appears much smaller. But reason assures us that the size of the moon is constant. Thus, its differing size is evidence that the moon, as seen, is the construction of our minds.

If we saw objects directly, then when we look in a mirror at something behind us, we should see it behind us. But we see it in front of us, nay, as inside the mirror. But the mirror has no inside! That is where the sensorium constructs it, because it reacts in the same way irrespective of the provenance of the stimulus.

Finally, we know that when we see a rainbow, there is, in actual fact, nothing there of that kind at all, but only water vapour, with the sunlight playing on it. But we see a rainbow there. Such is the nature of the sensorium. It creates its own world of colour (and of sound, smell, taste, and feeling as well), and indeed perceives by reason of that very projection of the object. As reason must be based on perception, we are therefore imprisoned within our own minds: we can know nothing that is not the creation of our own minds. this is the doctrine of *māyā*: the world is my idea, and I can know only my own ideas. So thought Shankara also: 'In dreams, when there is no actual contact with the external world, the mind (*manas*) alone creates the whole universe consisting of the experiencer, etc. Similarly, in the waking state also; there is no difference. Therefore, all

this phenomenal universe is the projection of the mind' (*Vivekacūḍāmani*, 170).

2. *Avidyā*

It is this projection of the world of appearance that is meant by ignorance: 'Hence, sages who have fathomed its secret have designated the mind as *avidyā* or ignorance, by which alone the universe is moved to and fro, like masses of clouds by the wind' (ibid. 180). And, again, in *Viveka-cūḍāmani*, 252: 'As the objects...called up in dream are all unreal, so is also the world experienced here in the waking state, for it is all an effect of one's own ignorance.' Thus, by ignorance is meant that state of consciousness in which we are aware of the existence of the 'rainbow' world of colour, etc., and this is normally the waking state. This world vanishes in the states of sleep and *samādhi*, which latter is termed knowledge (*jñāna*); and *only because it thus vanishes* is the world termed unreal: 'If the universe be true, let it then be perceived in the state of deep sleep also. As it is not at all perceived, it must be unreal and false, like dreams' (ibid. 234).

3. *Jīva*

We have reached this point that the object is a construct. Now, 'object' entails a 'subject'; and the problem now is, who or what is the subject of which the object is a construct? The object is not *my* construct, for I cannot create the object by a mere act of will. Indeed, I cannot even will a hallucination to appear before me—otherwise, it would not be a hallucination at all! But such hallucinations can be made to appear in the state of hypnotic trance. And this is the key to the nature of the subject. For when we talk about 'I', we mean the self-conscious, thinking principle (*buddhi*),

which is termed 'ego' in philosophy. The hypnotic trance depends essentially on just this fact that the ego is suppressed. So it is not the ego, the 'I', that projects the object, that is responsible for hallucinations, that dreams, but it is that principle in man which is present both in the waking and in the dream or trance state. This persistent mind is termed 'transcendental Self', or simply, the Self, Atman. Therefore, we conclude that dreams, hallucinations, and the object itself are the creations or constructs of the Self. They seem to be given to the ego independent of its own activity, and hence they are termed real—real at least as long as they last. In a word, in the dream state, we are living in one world; in the waking state, we are living in a different world; indeed, in each case, it is a different 'we'. This 'I' or ego is, in Sanskrit, the *jīva*, and as we refer to it as 'I', we can state that, just as the object is the creation of the Self, so the ego, too, is the creation of that Self; and 'I-making', in Sanskrit, is *ahankāra*.

4. The External World

We said that what distinguishes the object from the dream or hallucination is that, in the former case, the sensorium projects the object in response to an external stimulus. But we can never directly know this external thing, for our idea, the object, always comes in between. We can know it indirectly by means of reason. Clothes hung near the seashore grow moist; hung in the sun, they become dry. A ring on the finger is worn thin; a ploughshare cutting through the soil wears away; dripping water hollows out a stone; wheels wear grooves through the cobble-stones of a street; and the hands of bronze statues are worn away by the kisses of devotees. Such are the arguments that led the ancients to the conclusion that the unknown and unknowable thing of the external world is made up of atoms.

We cannot suppose that the object is some sort of illusion, like the snake which may be seen when we are really looking at a rope, because we cannot then explain why we always see two eyes above a mouth, and not, say, three eyes, or two eyes below a mouth, or no eyes at all. Or, to keep to the Vedantist example, why we do not see sometimes a worm, sometimes a dragon, or even a stick. The answer to the former set of questions must surely be that we see two eyes above a mouth because there are analogues of two eyes and a mouth in the thing-in-itself. The object parallels the thing; that is, the laws of thought (which determine the object) parallel the laws of nature (which determine the thing). For this to be the case, there must be a pre-established harmony between the ideal world and the real or physical world. That is, the same activity, which is productive with consciousness in perception, is productive *without* consciousness in the formation of the world. In other words, we have the following choice (reason can go no further than this): either we must accept, as did the atomists, an ultimate pluralism of an infinite number of basic corpuscles and explain, as best we can, how mind can emerge from inanimate matter; or we must follow Plato : 'Can we be persuaded that the Completely Real does not share in motion and life and soul and thought, neither lives nor thinks, but remains motionless and without mind, solemn and holy?' Let us then seek for this Mind, the workings of whose laws run parallel to the workings of our own minds.

5. Atman

First, let us digress a moment. The simplest forms of life (germ-cells and amoeba) reproduce by total division. At one moment, there is one such cell; at the next moment, there are two; then four; and so on. Since consciousness is not a 'thing' that can be cut with a knife, we may say that,

at the germ-cell level, there is continuity of consciousness. Now, biology taches us that any particular human being arises in the first place from a germ-cell. There is a continuity of consciousness from Adam to myself—but only at the germ-cell level! Before 'I' attain to individuality, that germ-cell must divide and subdivide; and while there is one consciousness embracing the millions of cells that constitute 'me', this consciousness has become different from the consciousness that constitutes 'you'. We can see this individual consciousness at work in the lower forms of life. Pull off a crab's leg, and he grows another. Cut a worm in half; the one half will grow a head, and the other half will grow a tail. Is it any marvel then that, in the Ratieb, the subject can plunge a sword into his abdomen, or a skewer into his chest, and suffer no harm? This is because, at that level of consciousness, the body ceases to be real in the same way that it is real in the waking state; and this is the level of the Atman. But if one goes beyond this level, death ensues, because the Atman has returned to its source, or has betaken itself to heaven or some other place—it makes no difference.

6. *Brahman*

Let us, in conclusion, return to that Mind which works along the same lines as ours, but with infinitely greater power. A simple idea exists ideally in my mind, but it exists factually in the infinite Mind. A feeling in my mind is just a feeling, but a feeling in the infinite Mind is a living soul.

Now, if I visualize such an infinite Mind existing by itself alone, with no mental content at all, I could say that, at such a point of 'time' the infinite Mind exists and there is no second thing. This is Nirguna Brahman. This is the first level of consciousness. But a mind must 'think', and when this Brahman has simple thoughts, we have a mind with a mental content, which can be figured as Brahman

with a subtle body—Saguṇa Brahman. Modern science believes that this state, this second level, is symbolized as the state of the universe before creation (in *pralaya*?), when existence was confined to a whirling mass of protons, electrons, etc., prior to the formation of any molecules. The nearest approach to such a state might be visualized as the sun, our sole source of energy. An electron is the embodiment of a law of repulsion, and a proton is the embodiment of a law of attraction. Hence, science could, were it so inclined, regard this state of affairs as centres of energy existing as 'ideas' in an infinite Mind.

The third level is when these ultimate particles are combined by the infinite Mind into molecules, as complex ideas. (The ancients misconceived these as indivisible atoms.) This is the gross body of Brahman, the world as it must have existed before there was any life on it, or as conditions are on the moon. But into certain aggregations of molecules, termed cells, the infinite Mind infuses a 'feeling', and these cells normally develop into individual organisms, such that each is a 'finite mind'. This 'finite mind' corresponds roughly to the Puruṣa of the Sankhya Yoga system and to the Atman of Vedanta. At the lowest level (plant life), these 'finite minds' are chiefly concerned with bodily organization and the so-called vegetative functions in men and animals. At this level (the fourth), one enjoys deep sleep, or perhaps, we would say, the trance level of lethargy or suspended animation. However that may be, this 'finite mind' may develop, so that it can project the object (level five). This is the level of the animal part of our nature, and it characterizes the dream state, or, we should rather say, the state of medium hypnotic trance. It is due to the presence of this level of consciousness in us that we are bound by *māyā*, which is normally beyond our control, at any rate of our direct control, because the 'I' is at a still higher level of consciousness (the sixth). For the 'finite mind' may eject a feeling of personality, and this is the ego, the *jīva*. At this level, we enjoy self-consciousness and

reason; this is the waking state, the state of 'I-ness' or *ahaṅkāra*.

At the levels of Saguṇa and Nirguṇa Brahman, there is an identity of subject and object, but subject and object separate out, the one from the other, in the state of so-called deep sleep (the unconscious) in the vegetable state of life and in inanimate matter, respectively. This distinction between subject and object is maintained at the next higher level, where the sensorium acts as subject with the 'rainbow' world as object, characteristic of the subconscious. And, again, at the level of self-conscious thought or waking state, the ego is the subject, which contemplates percepts and concepts as its object. But there is a higher (seventh) level, at which subject and object again unite; this is the superconscious experience of *samādhi*, when the *jīva* becomes united with the Atman. Now, observe, at the level of the continuity of consciousness in the germ-cell, the individual is a *part* of Brahman; it is only at the other end of the scale, in *samādhi*, that the individual becomes *identical* with Brahman. So, 'It is the identity of the implied, not the literal, meaning which is sought to be inculcated...The wise man must give up the contradictory elements on both sides' (*Vivekacūḍāmaṇi*, 242, 248–49).

Thus the whole universe and all its contents are but 'thoughts' and 'feelings', as it were, of the infinite Mind or Brahman. But owing to the separation of subject from object, the 'finite minds' have an individuality of their own, which is ignorance. The aim of life, as conceived by *yoga*, is to reunite subject and object in mystical communion with God.

INDIAN HOLISTIC EXPERIENCE AND
ANALYTICAL RATIONALITY

Raja Ramanna

It is an old classification that divides the Universe into three sets: Things with consciousness, things without consciousness, and God: a classification which, after several centuries of development, including the amazing advances of science, continues to remain valid. The understanding of the relationships between them is a very complex problem and there has been hardly any progress as to whether they are disjoint, or whether there is an intersection between them, or whether they are merely sub-sets of each other. The problem has remained in this state, though it has engaged the best minds over several centuries.

Using a slightly mathematical terminology to avoid contradictions of language, the classifications can be defined as follows:

(1) Sets of all things which have no consciousness, referred to as the *A-Chit-set*, S(A), (*Chit* meaning Consciousness);

(2) Sets of all things which have consciousness, referred to as the *Chit-set*, S(C); and

(3) God, referred to as the Ishwara-set, S(I), and, for purposes of this limited discussion, defined as a set of all possible sets with the widest possible scope including things responsible for the origin of life. We assume for the time being that S(I) is not merely the union of S(A) and S(C). In Vedantic literature, God does not necessarily mean an all powerful anthropomorphic Entity.

As is known, the brain is capable of being programmed as in a computer and the lower animals. But the human brain and perhaps those of some higher animals have special

capabilities which can question their own actions and thoughts. Among these can be included will, conceptualization, etc. Wherever the word consciousness is used, it refers to the non-programmable part of our consciousness. As to the demonstration of its existence, we refer to daily experience.

We have defined the S(I) as God for making contact with the older literature, and we repeat—in Vedantic literature God does not necessarily mean an all powerful anthropomorphic being and a capricious law-giver. Another definition is given, hopefully without contradiction, so that the relationship between the modern physical view and the Vedantic view can be analysed in a fruitful manner. As seen later, the S(I) becomes very significant if an appropriate interpretation is given to it.

The significance of the relations between the various sets as seen by a mechanist scientist, a quantum scientist, and a follower of Vedanta as expounded by the great Indian philosopher Shankara and others who came after him will form the substance of this paper.

The Mechanistic View

This view is based on a model of the Universe as a system which works on purely mechanical principles. Such a view was strongly prevalent in Europe till the end of the nineteenth century. Its importance now is that it is an example of how immediate successes of a theory covering one branch of knowledge does not necessarily imply universal validity. It was further believed that there is no requirement for a separate S(I). Such views gained added strength from the work of Darwin, though it is not clear what is meant by 'survival of the fittest' and such other non-molecular statements. The strongly materialistic view of nature is not new and is well expressed in the Charvaka philosophy of early Hinduism. It was rejected by the savants of the time to give place later to Buddhistic thought.

In the mechanistic view, since the Universe is made up of physical entities whose laws of behaviour are supposed to be well understood, consciousness is said to arise from the physics or chemistry of the materials that constitute the body and nothing else. There is, of course, the question how life itself originated. Assuming that it did originate by some physico-chemical processes, it is conjectured that the creation of consciousness would have come about by some such similar process. The effect of drugs on consciousness, a fact known over a long period of time, adds strength to this view. The general belief was, and is, in some quarters, that it would perhaps take a few more years to understand the details of the physico-chemical processes that constitute life and consciousness.

We recall that physics and, therefore, the rest of science has been defined as the science of measurement (Kelvin). The supreme position Science holds in defining knowledge arises from the fact that it gives, in a consistent manner, a satisfactory explanation of the behaviour of inanimate matter. The word 'consistent' is used here to mean that it avoids problems of begging the question.

Measurement and quantification have led us to believe that the language of science is mathematics. This association has been extremely fruitful not only in explaining scientific facts but even in being able to unify a large body of information in such a way that it can be expressed in a very concise form, demonstrating that they do have a unified origin. All this has contributed to the spectacular success of the scientific method.

However, these very successes have sometimes fore-closed our analytical powers, and our reasoning seems to have become conditioned to search for problems whose solutions suit the assumptions of the theory and reject those problems which fall outside its scope, as though they are not problems at all. This is often done on the grounds that the problems do not fit into a scheme of quantification or measurability.

We note that, even when one moves from the field of numbers to a more general concept of sets, particularly an infinite number of them, pure logic can lead to inconsistencies of a very fundamental nature. The theorem of Godel demonstrates that mathematics, with all its rigour, is not all that complete as to be able to tackle all types of problems.

Since physics is defined as the science of measurement, it is interesting to ponder over the origin of this word from its root. The word comes from the root *mā*, meaning measurement, from which the Indo-Aryan words such as *metron* (Greek) and *mātrā*, (Sanskrit) are derived. But what is strange is that the Sanskrit word *māyā* also is derived from the same root. The word *māyā* is normally translated as 'illusion', but another translation could be 'immeasurable'.

To erase Western notions of the State of Science in ancient and medieval India, I quote the following verse from Sanskrit logic which defines the word 'measurement'. It runs as follows:[1]

> Paratvaṁ cāparatvaṁ ca
> dvividhaṁ parikīrtitam;
> Daiśikaṁ kālikaṁ cāpi
> mūrte eva tu daiśikam;
> Paratvaṁ mūrta-saṁyoga-
> bhūyastvajñānato bhavet;
> Aparatvaṁ tadalpatva-
> buddhitaḥ syāditīritam.

Distance and nearness are described as being of two kinds, viz. spatial and temporal. The spatial abides only in measurable things. Distance arises from a notion of preponderance of the intersection of measurable things, and nearness is said to arise from a notion of its meagreness.

The idea of 'measure', 'set' and 'intersection' is fully implied and yet, as we see later, the Vedantist would prefer

us to have it that it is Māyā (immeasurability) that represents Reality and not that which can only be measured.

The Quantum Mechanical View

The powerful new method of physics, that is, Quantum Mechanics, does allow for a greater flexibility of interpretation than the mechanistic view of the Universe. The theory has a right to claim to be a universal theory to explain 'all' phenomena. However, ever since it was proposed, it has been facing problems of consistency and incompleteness, some of it arising from pre-conditioned notions based on mechanistic thinking. It allows, at least to some physicists, for the mind or consciousness to play a part in the completion of a measurement. All descriptions in Quantum Mechanics are based on probability amplitudes, and its conversion to an actual measurement requires the mind to operate (collapse of the wave function). There has, of course, been a tremendous amount of effort to avoid the inclusion of the existence of a separate entity called 'mind'. Among these are, for example, the hidden variables theory, the many world theories, etc. The seriousness of the need to find an explanation of the collapse of the wave function in the measurement process, within the body of physics, is understandable, because if we accept the assistance of something outside that of physics, then science will no longer be an all comprehensive field of knowledge and its very foundations will be in question.

Strangely enough, all the efforts to resolve this problem have not succeeded and have led invariably to a null-type result, that is, to a solution which neither says 'yes' nor 'no'. They seem to require more assumptions than what one started with or they lead to inconsistencies which are more severe than the assumption of the existence of mind. At least, the mind is observable, if not measurable. The most recent of the attempts are based on the consideration that

Quantum Mechanics works best for isolated particles and, as one moves to conglomerates, a process of 'mixing' takes place, leading to classical descriptions, thus eliminating the need for the collapse of the wave function. The theory gives no prescriptions as to where one draws a line between a few particles and a conglomerate. Recent experiments indicate that Quantum Mechanics seems to be meaningful even in macro-systems, for example, superconductivity, etc.[2] The controversy is not a new one, as the very founders of Quantum Mechanics were aware of it right from the beginning.

The flexibility of Quantum Epistemology rests on the fact that an uncertainty principle operates in the process of measurement itself and the phenomena one is looking for may be disturbed by the very act of investigation. It has even been pointed out that the processes of life may be screened in this permanent way from physical investigation. However, to invoke 'uncertainty', one must show that the conditions that are required for this principle to operate are indeed fulfilled.[3]

We thus see it is, in principle, possible to decouple some aspects of physical existence from physics through the Uncertainty Principle, and also from the requirement of a 'mind' to complete the process of measurement. Another limitation comes from within mathematics, that is, from Godel's Theorem, though some scientists are inclined to believe that it has nothing to do with physical investigations. But the theorem clearly states that, within its own set of postulates, it is possible to show that there are an infinite number of propositions which are true but can never be proved within its own frame-work. Expressed in not too exact a language it says, 'Truth is greater than Proof.'

It is not the intention of the paper to discuss the epistemological problems of Quantum Mechanics, as there is already much literature on the subject. The objective is to point out the long way epistemological problems of Quantum Mechanics have travelled from the mechanistic conception of

physics and how the present philosophical approach leans more towards Vedantic thought. Unfortunately, the old literature in Sanskrit has been translated into English by people who have had no knowledge of Science, and even texts that are fairly simply and straightforward in their purport are made to look complicated and mystical.

For the purpose of showing the overlap between modern scientific philosophy and Sanskrit thought when it is properly translated and interpreted, some facts about Quantum Mechanics are summarized below:

(1) Quantum Mechanics is essentially an abstract theory. Non-observables are used and have to be properly interpreted to get useful information. Not all physical quantities associated with an atomic system can simultaneously be measured or given numbers. There are definite limitations on the amount of information that can be obtained about any atomic system. The theory itself gives only probabilities. The probabilities used here are different from that used in the tossing of a coin. It can apply even to single events.

(2) How far one has moved from the earlier concepts will become clear from quotations from the writings of Lord Kelvin, one of the great physicists of the last century, and from Dirac:

Kelvin: It seems to me that the test of 'Do we or do we not understand a particular point in Physics?' is 'Can we make a mechanical model of it?'

Dirac: The methods of progress in theoretical physics have undergone a vast change during the present century. The classical tradition has been to consider the world an association of observable objects (particles, fluids, fields, etc.) moving about according to definite laws of force, so that one could form a mental picture in space and time of the whole scheme. This led to a physics, whose aim was to make assumptions about the mechanism and forces connecting these observable objects, to account for their behaviour in the simplest possible way. It has become increasingly

evident in recent times, however, that nature works on a different plan. Her fundamental laws do not govern the world as it appears in our mental picture in any very direct way, but instead they control a substratum of which we cannot form a mental picture without introducing irrelevancies.

A typical example of irrelevancies is the beautiful experiment with neutrons:[4]

A beam of neutrons is made to go through two holes as in the case of Young's experiment on interference with light. The theory predicts that an interference pattern should appear on the screen. The intensity of neutrons is such that there is a large time difference between the arrivals of the neutrons at the holes, and yet an interference correlation appears on the screen. The question usually asked is: How do the neutrons communicate with each other to be able to stabilize the pattern? It seems that the very abstract nature of the theory by itself takes all this into account and makes the question irrelevant.

From all this, we can conclude that it is too drastic to assume that S(C) is a sub-set of S(A) and it is likely that the two sets have a disjoint portion.

(3) We are all aware of the existence of static symmetry, for example, geometric objects, etc. Expanding on this idea, we can define time-dependent symmetry (dynamic symmetry), where the invariance is not the shape of the objects but the physical laws themselves. It is thus possible to express all physical laws as abstract symmetries, either as those arising from symmetry considerations or due to departures from them. A law can arise out of symmetry or asymmetry, that is, break of symmetry. In this way, it is possible, in principle, to arrive at a situation where all physical laws can be unified by arriving at some sort of an all-supreme Symmetry and departures therefrom. Using this possibility, one can define the S(I) as giving rise to sets from the symmetric and asymmetric components of the Supreme Symmetry. The possible existence of a Supreme Symmetry

which forms an all-comprehensive set in idealized symmetry and contains all that we need to know, and from which the measurable world can be projected directly or through departures from it (Supreme Symmetry), leads us straight to Vedantic thought.

We note here that, since we are talking of physical laws, the Supreme Symmetry has not been given anything more than pure physical meaning. It remains aloof from that which it creates and is not particularly concerned with the welfare of what it creates. It is not clear that it is even responsible for the non-programmable part of our consciousness. The very idea of unity through Symmetry is an example of order coming out of order and, before we commence considering the implication of modern scientific thought on philosophy, we quote the following polemic from the *Chandogya-Upanishad* composed about 3000 years ago:

> ...though some hold that chaos alone was before a second, and order came of it, how can it ever be so? Order indeed was alone in the beginning....

The Vedantic View: (Shankara, Eighth Century)

A holistic appreciation of the Universe has not been fashionable in recent centuries. This is because of the great benefits that the scientific method has bestowed on mankind. In view of the successes of Science in explaining the S(A), it is not unreasonable to assume that every aspect of the Universe can be explained by its methods. It is, however, important to separate the material usefulness of theories and their universal validity in discussing philosophical matters. One must also avoid even deducing too much from symmetries covering smaller regions of knowledge. An example of the latter is the interpretation of the new discoveries in molecular biology. The biologists would have us believe that their results confirm the fact that the S(C) is

but a sub-set of the S(A) and that the DNA molecule would explain all aspects of life and consciousness in due course. Our comment is that the break between the two sets is a more fundamental one than what biology can offer us as solutions. The problems under consideration refer to the limitations of Quantum Mechanics, and no symmetries observed in bio-processes can bypass these fundamental questions.

We have seen in the last half century how new discoveries in the sciences have altered our thinking. It is now time to examine whether the altered path is turning us back into the past, even if it be only to have a new look at the older deductions in the hope that it could lead to new methods of investigations.

The criticism of the older methods has been on the grounds that they are (1) not based on measured data; (2) based on verbal testimony; and/or (3) mystical. As mentioned earlier, (1) may be the very restriction of science, restraining our understanding of all knowledge; (2) and (3) may be partly true, but such views have come about due to unsympathetic translations and other historic reasons.

Shankara was a logician, highly influenced by Buddhist thought. From Alexander's time, the Buddhists had been in close contact with Greek civilization, as many Buddhist areas came under the Greek rule, specially Bactria and Afghanistan. While they were deeply influenced by Greek sculpture, the Indians did not completely accept either their mathematics or philosophy. For example, the Hindus never accepted the supremacy of geometry and preferred analysis and number theory. In spite of Greek mathematical inputs, philosophy in India gave great, if not more, importance to things that were beyond measurement as possessing the ultimate truth. However, that Shankara had an objective approach to these matters is clear from the following verse:[5]

This universe does not exist apart from the sense of perception; and the perception of its separateness is

false like the quality of the blueness of the sky. Has a superimposed attribute any meaning apart from its substratum? It is the substratum that appears like that due to delusion.

The Vedantic view insists that it is the S(A) which is the sub-set of the S(C). It is consciousness that perceives the Universe to the extent it can be observed. If there was no consciousness in man, he would not be able to observe its existence or communicate with others to ask what is its structure or purpose. Search for reality is that which makes one see things that were not visible at first sight. Our consciousness appears in various states, and what we observe in the normal waking state may not be the reality.[6] Yoga (not as exercise) and meditation could improve one's perception.

This Vedantic interpretation of the Universe implies that there must be an unchanging Supreme Brahman. It is described as something having a symmetry of symmetries—remote and pure. Only from the departures from this symmetry do the laws of the observable Universe begin to exhibit themselves. The departures are said to arise from Māyā, the one that screens us from the Supreme Reality. Creation is thus considered as a fall from an otherwise perfection, which either 'was' or 'will be' but never 'is'.

Shankara has been criticized over the centuries, not for his logic as much as for the fact that his perception of Brahman is one that is remote, unresponsive and sterile. If we compare the Supreme Symmetry, Brahman, of Shankara with the 'Unification' proposals of modern physics, both show similarities. They both claim that it is the departure from symmetry that leads one to the laws of the measurable world. Given the necessary flexibility in interpreting an ancient exposition to compare with the modern technical language, the parallel is striking. Both refer to a Supreme Origin of Symmetry, which takes no moral responsibility for what it can create.

The comparison between Shankara and modern physics is made not because it is the intention to show that everything of modern science had been understood in the past by intuition, but just to indicate that there are other methods of thinking to arrive at generalities, in much the same way the works of the great Indian mathematician, Srinivasa Ramanujan, whose birth centenary was celebrated in 1988, demonstrates in the field of mathematics. He could arrive at theorems in the forefront of mathematics for which often he would give no proofs at all. Even to this day, proofs are being supplied by others, for which they have had to use developments in mathematics that just did not exist in Ramanujan's time. That this is possible in a field like mathematics suggests greater possibilities in the realm of philosophy.

The Vedantic View (Ramanuja, Twelfth Century)

The person who criticizes Shankara is another Indian philosopher, Ramanuja.[7] His criticisms are not so much on Shankara's logic as on the grounds on which he created S(I) which is absolute, remote, unchangeable and sterile—and, as has been observed, a sterile set can never create. It can only project and hence comes the concept of Māyā as illusion: A sterile unchangeable entity can project only by illusion. Further, the laws of the Universe come about on defects and departures from the Absolute Symmetry.

Ramanuja's contention is that the S(I), if it is to be responsible for the creation of the Universe, has to be by a process of achieving order from chaos—'The blossoming up of Reality from initial chaos'—in much the same sense that modern non-equilibrium thermodynamics would have it. Further, a study in systematic terms of chaos suggests that, even in systems having a few parameters, imperfect knowledge of the initial conditions can lead to elements of order in chaotic systems and phenomena. Can we say that this is an echo of 'beauty in the eye of the beholder?'

Ramanuja holds that since creation is derived order from disorder, it also implies that the ever-changing Supreme Brahman 'cares' for that which It has created. The use of humanitarian language may upset people who have been brought up only in the scheme of science, forgetting that humanitarian impulses are as much a part of the physical world as any of the laws of thermodynamics.

We have seen that the successes in explaining the S(A) is based on measurability. It has been so successful that one is tempted to believe that this is all that we have to know of the Universe. But from within measurability itself it speaks of its limitations, much as a scientist would not like it to be so. The Uncertainty Principle is a limit to the measuremental attitude towards all knowledge. Godel sets a limit to what can be done with the assistance of mathematics. The very null-type of resolutions to the problems of Quantum Mechanics would indicate that there is a break between knowledge based on measurement and things immeasurable, that is, life processes and consciousness. While we may never be able to demonstrate the Supreme Symmetry to which all knowledge leads us, departures from it can lead us to a branch of knowledge known as Science that is not inconsistent with scientific ideas.

There is perhaps also a break between the S(I) and the S(C), which represents a break between purely life processes and those leading to the unique feeling of concern for human welfare, in much the same way as there exists a break between the S(A) and S(C) through Uncertainty, etc. Ramanuja's criticism of Shankara may be the break between the S(C) and the S(I). He argued for this status nearly a thousand years ago. It is unlikely that methods other than holistic experience have the key to the understanding of this problem. Ramanuja's ideas have either not been studied or not known to the Western world. It is possible that revaluation of Shankara and Ramanuja may lead to new pathways in the study of all knowledge.

REFERENCES

1. Vishvanatha, 17th cent. A.D: *Bhāsā-Pariccheda* (verses 121–2), trans., Swami Madhavananda, Advaita Ashrama, Calcutta.

2. A.J. Leggat: *Reflections on the Quantum Measurement Paradox*, Foundations of Physics, David Bohm, Festschrift.

3. B.D. Josephson, Cambridge: *Limits to the Universality of Quantum Mechanics*, Foundation of Physics, Bohm Festschrift.

4. H.Rauch: *Quantum Measurements in Neutron Interferometry*, Proc. 2nd International Symposium Foundations of Quantum Mechanics, Tokyo, 1986.

5. Shankara, *Viveka-Cūdāmani* (verse 235): trans., Swami Madhavananda, Advaita Ashrama, Calcutta.

6. R. Ramanna: *Logic, Shankara & Subramanya Iyer*, Prof. Murty 60th Birthday Volume 1986, Motilal Banarasidass, Delhi.

7. K.S. Narayanachar: *The Concept of Relation in Viśiṣṭādvaita*; Quarterly Publication, 'God and the World', Pathway to God, Ranade Institute, Belgaum, India.

8. Gaudapada: The *Māṇdūkya-Kārikā*, trans., Swami Gabhirananda, 1987, Sri Ramakrishna Ashrama, Trichur, Kerala.

THE IDEA OF *PURUSHĀRTHA*

Prof. M. Hiriyanna

The idea of *purushārtha* has played a very important part in the history of Indian thought. All the *vidyās* or branches of learning assign to it the foremost place in their inquiries, though they differ from one another in various respects concerning it. We propose to consider here what this idea stands for in general without entering into details.

The term *purushārtha* literally signifies 'what is sought by men,' so that it may be taken as equivalent to a human end or purpose. The qualifying word 'human' here may suggest that the term is not applicable to ends which man seeks in common with the lower animals; but really it is not so, for we find it used with reference to several among such ends like food and rest. The qualification should therefore be explained in a different way. We know that man, like the other living beings, acts instinctively; but he can also do so deliberately. That is, he can consciously set before himself ends and work for them. It is this conscious pursuit that transforms them into *purushārtha*. Thus even the ends which man shares with other animals, like food and rest, may become *purushārtha*, provided they are sought knowingly. The significance of the first element (*purusha*) in the compound is not accordingly the restriction of the scope of the ends sought, but only of the manner of seeking them.

The implication of the other element (*artha*) in it is that the end is non-existent at the time it is cognized as worth pursuing, and is still to be accomplished. It is a 'to be' which is 'not yet', and therefore demands for its attainment effort on the part of the person seeking it. For this reason, it is described as *sādhya*, which in the terminology of modern philosophy may be expressed as 'a value to be realized'. Fame, for instance, or what comes to the same

thing, the feeling of gratification resulting from it, which
cannot be attained without much toil, is a value in this
sense. Now the pursuit of a value presupposes a knowledge
not only of what that value is but also of a suitable means
to its realization. Sometimes this means or *sādhana* also is
styled a *purushārtha*, giving rise to the distinction of 'instru-
mental' (*gauṇa*) and 'intrinsic' (*mukhya*) values, as they are
called. For instance, money, which is ordinarily acquired as
a means to an end, is an instrumental value while pleasure,
which is sought for its own sake, is an intrinsic one. We
may thus define a *purushārtha* as an end which is conscious-
ly sought to be accomplished either for its own sake or for
the sake of utilizing it as a means to the accomplishment of
a further end.

From what has been stated so far, it appears that a
purushārtha is something which does not already exist, but
is to be produced anew. Indeed, according to some Indian
thinkers, viz., the early Mīmāṁsakas, no existent object
(*siddha*) can by itself be an intrinsic value or a *purushārtha* in
the primary sense of the term (*na bhūtaṁ bhavyāya kalpate*).
It can, at best, be only of instrumental interest. But others
allow that the achievement of a value need not always be
understood in this positive sense. The end sought may be
already there, and yet we may not be able to get at it owing
to some obstacle or other as, for example, in the case of
buried treasure. Here achievement consists merely in
removing the obstacle. When that is done, the treasure, with
the accompanying joy, is attained at once.

This variety of value also requires the exercise of
activity before it is attained, though the activity is directed
solely towards the removal of hindrances which stand in
the way of its attainment. Hence such values also may be
described as *sādhya*, but only in a negative or an indirect
sense. Nor need this hindrance be always physical as in the
above example; it may be mental, being merely our failure
to realize that what we seek is already in our possession. To
give a trivial but typical example, a person may be so much

beside himself as to set about searching for his eye-glasses while he is actually wearing them. Here 'attainment' consists in the person in question overcoming the delusion into which he has fallen, either by being appraised of the fact by someone else or by himself coming somehow to discover it. This kind of *purushārtha*, again, may be classed as *sādhya*, provided we grant that knowledge also, like action, can be the means of achieving values. Here too, as in the previous case, nothing new comes into being. But both achievements alike involve a change in the existing state of things; only while the change brought about in the one case is in the realm of being, in the other it is in the realm of thought.

The *purushārthas* that have been recognized in India from very early times are four: *artha, kāma, dharma* and *moksha*; and the main aim of every *vidyā* is to deal with one or another of them. This shows, it may be stated by the way, that the Indian thinker was actuated by more than speculative interest in his investigations, and that he carried them on, having always in view their relation to human purposes. Not all these values, however, are of equal rank. They admit of being arranged in an ascending scale, and the determination of their relative status forms the chief problem of philosophy as conceived in India. We can refer here to only one aspect of it, viz., the distinction between secular and spiritual values. To contrast them generally, the former are what man is naturally inclined to seek while the latter are what he ought to seek but ordinarily does not. The notion of a higher or spiritual values is suggested to him as the lower or secular ones are not finally satisfying. A lower value may, when realized, bring immediate satisfaction; but sooner or later the satisfaction terminates. Other values of the same kind will thereafter make their appeal, but the result of pursuing them will be no less transient. It is in contemplating their invariably transitory character that man comes to think of enduring values and to yearn for them.

Of the four values mentioned above, the last two, viz., *dharma* and *moksha*, are spiritual; and the sole purpose of the Veda as it has for long been held is to elucidate their nature and to point out the proper way to realize them. But pursuing these higher values does not necessarily mean abandoning the lower ones of *artha* and *kāma*, for there is no necessary opposition between them—at least according to the majority of Indian thinkers. What is discountenanced by them is only their pursuit for their own sake and not as means to a higher value. When they are made to subserve the latter, they become totally transformed. There is a world of difference, for example, between wealth sought as a means to self-indulgence and as a means to some beneficent purpose.

Of the two spiritual values, there were schools of thought in India that upheld supremacy of *dharma*; and more than one old Sanskrit work speak only of three categories of values (*trivarga*), leaving out *moksha*. But gradually, *moksha* came to be regarded as the only ultimate or supreme value (*parama-purushārtha*), *dharma* being subordinated to it in one way or another. Thus what was once considered good enough to be the goal of life became later but a stepping-stone to the attainment of a higher end. The way of subordinating *dharma*, which has stood the test of time, is what we owe to the teaching of the *Gita*, viz., that when it is pursued with no desire for what is commonly recognized as its fruit, it qualifies for *moksha* through purifying the affections (*sattva-shuddhi*).

As regards the type of *sādhya* which *moksha* represents, we have pointed out that the word *sādhya* may be understood in a positive or a negative sense. *Moksha* being the realization of one's self in its true nature according to all schools, it is not to be effected in the former sense as *dharma* is. Its achievement can be only indirect, and we find that both possible views here are held by Indian philosophers. While the generality of them maintain that *moksha* involves an actual change in the condition of the self, some hold that

it means merely a change in the point of view towards it. It is in this latter way that Shankara, for instance, understands it. In his view, the self has been and will ever be what it always is, viz., Brahman. This truth, however, is lost sight of by man during *saṁsāra* owing to congenital ignorance. It thus lacks realization though eternally achieved. *Moksha* consists merely in getting rid of this ignorance; and, simultaneously with its riddance, the self reveals itself in all its spiritual splendour. Hence *jñāna* is regarded as the sole and sufficient means to *moksha* in Advaita, while in other doctrines, generally speaking, it is taken to stand in need of being associated with *karma* to serve that purpose.

In conclusion we may just refer to one more point. Is the highest value realizable by man or is it merely an idea? All Indian thinkers agree that it can be realized, some maintaining that the realization may take place even within the span of the present life. Nature, including the physical frame with which it has invested man, is not finally either hostile or indifferent to his spiritual aspirations; and he is bound to succeed in attaining them in the end, if not at once, provided only that his efforts in that direction are serious and sincere. One system, viz., the Sāṅkhya goes so far as to maintain that the kingdom of Nature is not merely favourable to man's realization of the highest ideal, but that it is designed precisely to bring about that consummation.

PERENNIAL PSYCHOLOGY AND
THE HINDU PARADIGM OF WELL-BEING

Prof. M. Sivaramkrishna

The aim of this paper is to examine the basic assumptions of 'perennial psychology' and their implications in terms of achieving total well-being. To give focus to the discussion of goals and values of this well-being, the fourfold value system of Hinduism (the *puruṣārthas*) is chosen as a helpful paradigm. Finally, an attempt is made to analyse how this well-being is both individual and transpersonal and how this is likely to concern us in futurist thinking.

I

As a preliminary, one can draw attention to a momentous change perceptible today in our 'cognitive maps' or what A.F.C. Wallace has called 'the mazeways' of human consciousness. A 'mazeway' is a map, or more precisely 'an image of space and time [and] it tells us who we are, where we come from and where we are going.' It 'charts a more personal path by which each of us can make his or her own way through space and time.'[1] In short, it is 'imaging of personal values and cultural forms.'

Contemporary thinking reflects at almost all levels a (sudden?) shift in the basic mazeways. There is today what Fritjof Capra has termed a definite 'turning point'[2] in man's quest for well-being. This is implicitly a 'paradigm shift' involving a movement away from the external to the interior, or more precisely an exciting exploration of inner space brought into being probably by man's perception of

7

the wonder and mystery of the outer. This is reflected in the countless guides for the perplexed exiles of a mis-directed techno-scientific odyssey desperately trying the difficult job of 'coming home'. These guides invariably involve the mapping of interior consciousness and ways of heightening it so that, to use William Irwin Thompson's suggestive words, 'time-falling bodies can take to light'.[3]

Whatever the path one advocates or whatever the map one uses, all the explorers who had traversed the path assume, with minor variations, certain grades or levels of human consciousness which are remarkably similar in almost all traditions. The 'forgotten truths of primordial traditions'[4]—as Huston Smith calls them—have given us a spectrum of consciousness which in its perennial psycholog-ical motifs is a kind of psychic counterpart to perennial philosophy. Well-being in terms of this basic spectrum of consciousness involves both awareness and transcendence.

Consciousness is unitive and therefore to talk about distinctions and levels is only for analytic convenience. Since human personality is 'a multi-levelled manifestation or expression of a single consciousness',[5] distinctions drawn for conceptualizing can never be regarded as or reduced to generic differences. Consciousness in its multiple manifesta-tion ranges, in this sense, from the supreme 'level' of cosmic consciousness to 'the drastically narrowed sense of identity associated with egoic consciousness'.[6] Levels vary therefore from the Pure Being of *Brahman* to the 'shadow level' of *ahaṁkāra*, the persistently egoic 'I'.

Underlying, as the Common Ground, all levels of con-sciousness is what Ken Wilbur calls simply *Mind*. This is consciousness without any differentiation, the pure *sat*, *cit* and *ānanda*. This is, as Wilbur says, 'what there is and all there is, spaceless and therefore infinite, timeless and therefore eternal, outside of which nothing exists. On this level man is identified with the universe, the All, or rather, he *is* the All.'[7] In effect, perennial psychology regards this as the only *real* level of consciousness, the great *Hiraṇya-*

garbha—or rather not a level as such but the substratum of all levels. Reflected in the state of *turīya*, which subsumes all other states of *jāgrat*, *svapna* and *suṣupti*, this Mind is the Cosmic Mind before the process of differentiation begins. It is, as Zen Master Seung Sahn has put it, 'the area [in which] a statue can cry; the ground is not dark or light; the tree has no roots; the valley has no echo.'[8] A striking analogy used by Sri Ramakrishna makes this more explicit. He uses the more familiar word, God, for consciousness:

Satchidānanda is like an infinite ocean. Intense cold freezes the water into ice, which floats on the ocean in blocks of various forms. Likewise, through the cooling influence of bhakti, one sees forms of God in the ocean of the Absolute. These forms are meant for the bhaktas, the lovers of God. But when the Sun of Knowledge rises, the ice melts; it becomes the same water it was before. Water above and water below, everywhere nothing but water.[9]

The process of differentiation within an enveloping unity is extraordinarily paradoxical: hence the extremely suggestive image used by Sri Ramakrishna: water, the most conformable of elements. In fact the comment by Huston Smith, using the same image, is interesting:

Spirit is the bedrock of our lifestream, but the waters that course over it are for the most part too soiled to allow the bed to be seen. Where the banks widen and the current slows, however, sediment settles and we glimpse our support. Always in this life some water intervenes to veil...Not only is the bed there throughout; it is truly the bed that we see even when we see it obscurely. Man is Spirit while not Spirit unalloyed.[10]

Another equally significant comment is made by Martin Lings. The image of ice and water

is all the truer in that the frozen crystallization appears to be far more substantial than unfrozen water; and yet when a large piece of ice melts, the result is a surprisingly small quantity of water. Analogously, the lower worlds [the terrestrial and intermediate planes], for all their seeming reality, depend for their existence upon a relatively unample Presence compared with that which confers on the Paradise [the celestial plane] their everlasting bliss; yet here again, everlastingness is not Eternity, nor are the joys of these Paradises more than shadows of the Absolute Beatitude of the Supreme Paradise [the Infinite].[11]

Intimations of this unity, however intermittent they are, conform to what Abraham Maslow called 'peak experiences'.[12] But the undifferentiated consciousness does not correspond to any hypothetical aggregate of these peak experiences. For to admit 'peak' at one level is to concede 'plateau' at another, while the consciousness we are discussing is beyond and before all categorizing begins. This state is what John Welwood, following Buddhist psychology (and echoing Upanishadic motifs), has described as 'the larger environment of mind that can never be grasped as an object of thought and at the same time is the basis of thought, that which makes thought possible.'[13] He illustrates the idea thus:

$$\bullet \quad \bullet \quad \bullet \quad \bullet \quad \bullet$$

'The gaps between the dots,' he says, 'are in one sense nothing; in another sense they act as the ground that allows the dots to stand out as separate entities.'[14] In other words, 'separate forms, spaces around them and the background environment in which form and emptiness occur'[15] are equally valid points of the mind. 'Can,' he asks rightly, 'any one aspect be separated and meaningfully held independent of the whole?'[16]

This consciousness, moreover, is not a metaphysical postulate but a directly experiential state of being. As Huston Smith puts it, 'a substratum linking insentience to sentience does exist; depending on the level of reality on which the question is raised, it is a form, existence, being, or the Infinite.'[17] But once we become aware of a personal identity, then the *levels* of consciousness 'emerge': in Sri Ramakrishna's suggestive image, in these levels the 'salt doll'[18] is still maintaining its separate identity from the ocean.

The first level we encounter here is what we call *kāraṇa śarīra* or the *transpersonal* level. The characteristic feature here is its ambivalence. While the consciousness is not *completely* aware of the unitive level, it is also not 'confined to the boundaries of the ordinary individual organism.'[19] Probably this is what Sri Ramakrishna used to designate as the state of *bhāvamukha*: the threshold of unitive consciousness, the All, is simultaneously aware of the pluralistic Many without exclusively focussing on either. 'The world' appears in this state 'as an immense mind in which innumerable waves of ideas' are 'rising, surging and merging'.[20] This is the 'direct experience and vision of the real nature of that universal consciousness and power as "One without a second", as living and wide awake and as the creator of all wills and actions.'[21]

This level is 'the persistent source of existential, rational, volitional awareness', 'the internalized matrix of cultural premises, familial relationships, and social glosses, as well as the all-pervading institutions of language, logic, ethics and law.'[22] It is from this ground that myths—the nearest mode through which the truths of unitive consciousness can be expressed—emerge. As such, this is the field of *bījas* or *vāsanās*, in short, of archetypes. The seeds of holistic well-being lie here, but the fructifying depends on the transcending or trapping of the psyche in the levels further down—bringing the consciousness to seed if it is trapped, or elevating it if it transcends.

What it transcends or is trapped in constitutes the next level of consciousness, the 'Ego-Level'. This is marked by the frontal attack of contingent reality on unitive consciousness. In the image of the Upanishads, the bird of consciousness is caught in bitter-sweet fruits of a basically dualistic character. Even the glimpse of the bird above—the level of unitive consciousness—is lost and consciousness gets enmeshed in what Sri Ramakrishna called, in his infinitely evocative images, 'lust and gold" or to stretch it in terms of another system, the Freudian and Marxian syndromes. Dichotomizing no longer remains a seed, Descartian dualism is no longer incipient. There is shift from the inclusive All to the divisive, pluralistic Many. The ego is, in short, 'split from and therefore trapped in the body'. This relays itself on all levels: epistemologically, between the seer; mythically, heaven and hell, the sacred and the profane; ontologically, between self and organism. This is, in effect, descent into history from myth, into life or (not *and*) death, for, as Norman O. Brown says, 'the consequence of the disruption of the unity of Life and Death in man is to make man, the historical animal.'[23]

Since this level is that of the ego, the most relevant dialectic which explains the corresponding predicament is that of 'Māyā'. In fact, the ego is only a layer of Māyā. As Sri Ramakrishna puts it, 'Māyā is nothing but the egotism of the embodied soul. This egotism has covered everything like a veil.'[24] The covering is explicable in terms of several *upādhis* or adjuncts with which the consciousness identifies itself. In fact, 'lust and gold' are frequent *upādhis* on this level. 'Normalcy' in terms of die-hard behavioural psychology is the identification of consciousness with the contents of the first three levels which Sri Ramakrishna described with unerring clarity as those associated with 'the organs of evacuation and generation, and at the navel.'[25] In these areas, 'the mind is immersed only in worldliness, attached to "lust and gold".'[26]

II

These levels of consciousness have analogues in Hindu conception of 'sheaths' or 'layers' (the Sanskrit word is *kośa*). 'The notion that man has several bodies or sheaths of different density or vibratory rate which interpenetrate one another' is quite familiar in Yoga and Tantra. These 'sheaths', which the *Taittirīya-Upanisad* expounds at length, are not separate or separable. Moreover, from the purely relativist perspective, these sheaths become subtler and subtler through progressive levels of transcendence. Therefore the more helpful way is to regard them as 'interpenetrating forms of energy'. As Lama Anagarika Govinda has pointed out:

> These sheaths are not separate layers...but rather in the nature of mutually penetrating forms of energy, from the finest 'all-radiating', all-pervading luminous consciousness down to the densest form...which appears before us as our visible, physical body. This correspondingly finer or subtler sheaths penetrate and thus contain the grosser ones.[27]

In terms of 'values' or desirable normative ends, these energies and their harmonization is suggested in the Hindu paradigm of the *purusārthas*. Well-being is obviously harmonizing of these values implicit in the integration of corresponding levels of consciousness.

In analysing these values and their realization, it is necessary to keep in mind the fact that fulfilment on any one level without awareness of the infinite, timeless consciousness which is the ground of all levels is not only futile but positively dangerous. This is the reason why therapy aimed at only one of the levels—for instance, the 'ego level'—can never be regarded as total therapy. This is only, as Aldoux Huxely put it, making the troubled individual adjust himself to the society of less troubled individuals.

Such therapy instead of bringing in holistic awareness succeeds only in truncating consciousness.

This is the reason why the Hindu paradigm of ultimate values draws a sharp distinction between the 'pleasant' and 'the good', the *'preyas'* and the *'śreyas'*, *'abhyudaya'* and *'niḥśreyasa'*, and exhorts the seeker after the Ultimate Awareness to choose the 'electable' in preference to the 'delectable' [28] Moreover, the *'niḥśreyasa'* that the Hindu paradigm postulates subsumes rather than rejects the values inhering in *'abhyudaya'*. This is clear from the way in which *artha* and *kāma* are placed centrally in the scheme. In their basic sense they are of course assumed to be sex and money. But as Karl H. Potter[29] has shown in his analysis, these are capable of wider interpretation and indicate the *attitude* which one has to take towards the contexts in which they cease to be constricting. For *artha* is surely concerned with material prosperity, but since this is fenced in with *dharma* on one side and *mokṣa* on the other, it does not indicate its relentless pursuit. Rather, from the point of view of ultimate level of total awareness, *artha* involves the attitude of *minimal concern* towards things material. The ego-level on which the values of *artha* and *kāma* operate cannot be rid of its constricting impact unless the higher levels, corresponding to *dharma* and *mokṣa*, are constantly cultivated.

It is also possible to relate the motif of *artha* to esoteric systems such as *alchemy* in which an actual one-to-one correspondence exists between the physical purification and psychic transformation. As analysed by Ralph Metzner, in the

new alchemy, current knowledge of biochemistry and psychopharmacology would be integrated into an experimentally verifiable understanding of psychophys-iological energy systems, rather than being, as now, a mass of separate, unsynthesized data. It will be found, as it was found by the old alchemists, that there are certain laws that are operative at every level of energy

organization and corresponding level of conscious-
ness.[30]

In this sense, probably by postulating *artha* as a basic
value, the Hindu paradigm suggests—apart from the
metaphor of base metal, the crude level, getting refined—an
actual physico-psychic process of achieving higher levels of
being. In every instance there is exquisite harmonization on
the *visual* (*yantra*), the *verbal* (*mantra*) and the *physico-gestural*
(*mudrā*).

Similarly, *kāma,* in its positive side an attitude of
passionate concern, can be effectively made use of in
awakening the egoic consciousness to higher levels of
awareness. Sexual relations as contexts in which this
attitude of passionate concern manifests itself can them-
selves be rid of their taints and made to manifest higher
levels. In other words, sexual energy, assumed as the most
vital of *prāna*, can be transformed in conjunction with the
ultimate impelling force in the paradigm: *moksa*. In fact, in
both *Tao* and *Tantra*, systems based on what Ralph Metzner
has called 'verifiable experience of definite states of con-
sciousness',[31] the attempt is unmistakable to make use of
subtle centres of sexual energy to yield a consciousness free
from polarized sex. Contemporary models of the psyche,
such as the Jungian one, reaffirm this when they suggest
that 'the male has an internalized female counterpart; the
anima; while the female has an internalized masculine
counterpart, the *animus.*'[32] In this use of sex as a powerful
propeller of unitive consciousness the yogi is 'the andro-
gyne of prehistory reachieved.'[33]

That these levels, those of *artha* and *kāma*, are essential-
ly energies or attitudes which can find, impelled by *moksa*,
a higher direction and orientation is suggested by Sri Rama-
krishna in his own inimitable images:

God reveals Himself to a devotee who feels drawn to
Him by the combined force of these three attractions:

the attractions of worldly possessions for the worldly
man, the child's attraction for its mother, and the
husband's attraction for the chaste wife. If one feels
drawn to Him by the combined force of these three
attractions, then through it one can attain Him.
The point is, to love God even as the mother loves her
child, the chaste wife her husband, and the worldly
man his wealth. Add together these three forces of
love, these three powers of attraction, and give it all to
God. Then you will certainly see Him.[34]

Ramakrishna's idiom is theological, but the *method* he
suggests is that of experimental psychology meant to
explore man, as Medard Boss has put it, 'as an essentially
luminating *atman*-being, belonging directly to Brahman, the
hidden matrix of all—appearing, being, vanishing and non-
being.'[35] Ramakrishna's method corresponds more or less to
what St. Teresa called 'interior senses', in the sense 'of a
seeing, hearing, touching and embracing that are different
from the seeing, hearing, touching and embracing that we
associate with external sensation.'[36] Understood in this way
sex becomes a liberating force, and indeed one can visualize
the possibility, as Teilhard de Chardin did, 'of a human race
evolving towards virginity which, far from being a denial of
love, will be a magnificent expression of love of another
kind.'[37]

III

So far we have seen how the different levels of con-
sciousness, including those that appear to be lower, can in
fact be integrated and given a sense of direction by con-
stantly keeping in view the transcendent one. This level of
all levels is *mokṣa*, the achieving of which depends on the
integration of *artha* and *kāma* understood as positive
energies. The principle of integration, it now remains to

add, is *dharma*. The relation of *artha* and *kāma* as effective only when linked to *dharma* is brought out by Nitya Chaitanya Yati thus: *dharma* is that condition when we know that there is nothing else to attain. Says Yati:

> The highest of all attainments is to know that there is nothing to attain, because one is with the Absolute, which lacks nothing. In that sense, *dharma* and *siddhi*, the ground and attainment, are not two. *Artha* is wealth only when wealth becomes meaningful in its instrumentality to make one happy. Happiness exists when one is entirely with oneself and there is not a second to tempt or threaten. One who has realized that one's Self cannot be differentiated from the Absolute finds the highest meaning in that state. The Absolute is adorably precious and there is nothing that can be equated with it. Hence *artha* and *sukham*, meaningful wealth and happiness, are seen in the attainment of one's original state.[38]

'The attainment of one's original state' is obviously *mokṣa* or what, in the initial section of this essay, has been designated, after Ken Wilbur, as the Mind or the ground of all levels of consciousness. If this level beyond all levels is lost sight of, then *artha* becomes *greed* and *kāma* becomes *blinding desire*. In other words *kāma* becomes a trap: while giving us a glimpse of a state in which the 'artificial division between existence, subsistence and value is sublated',[39] unawareness of its tentative unity and its implicit experience can only cut us off from the Mind or the Atman-consciousness. Therefore the crucial paradox: '*Kāma*', desire fulfilled at the unitive level, is 'identical' with liberation, or *mokṣa*, which is a state of unity that arises from a permanent negation of the tentative regress to a state of dualistic experience.

We are now able to draw the conclusion that *artha* and *kāma* are energies which either become emotional wastes or modes of liberation through their recycling, depending on

the contingent question: whether we are aware of consciousness as distinct from the contents of consciousness. In short, the Hindu paradigm of well-being, by thinking of man's basic levels of consciousness inhering in *artha* and *kāma* as reflectors of the higher unitive levels, has shown us the psychologically demonstrable bases for inner transformation.

REFERENCES

1. Quoted, William Irwin Thompson, *Darkness and Scattered Light* (Garden City, N.Y.: Doubleday, 1978), p. 13.
2. See Fritjof Capra, *The Turning Point.*
3. William Irwin Thompson, *The Time-Falling Bodies Take to Light* (London: Rider/Hutchinson, 1981).
4. Huston Smith, *Forgotten Truth, the Primordial Tradition* (New York: Harper & Row, Publishers, Inc., 1976).
5. Ken Wilbur, 'Psychologia Perennis: The Spectrum of Consciousness', *The Meeting of the Ways: Explorations in the East/West Psychology*, John Welwood, ed. (New York: Shocken Books, 1979), p. 8. Hereafter *The Meeting of the Ways.*
6. Ibid.
7. Ibid. p. 9.
8. Stephan Mitchell, ed. *The Teaching of Zen Master Seung Sahn* (New York: Grove Press, 1976), p. 7.
9. M., *The Gospel of Sri Ramakrishna*, Swami Nikhilananda, tr. (Madras: Sri Ramakrishna Math, 1981 edn.), p. 191. Hereafter *The Gospel.*
10. Huston Smith, *Forgotten Truth the Primordial Tradition*, p. 88.
11. Quoted, ibid. p. 91.
12. See Abraham Maslow, *Religion, Values and Peak Experience* (Viking Compass, USA; Penguin Reprint, 1976).
13. *The Meeting of Ways*, p. 38.
14. Ibid.
15. Ibid. p. 39.
16. Ibid.
17. Huston Smith, *Forgotten Truth, the Primordial Tradition*, p. 68.

18. *The Gospel*, p. 103.
19. Ken Wilbur, *The Meeting of the Ways*, p. 9.
20. Swami Saradananda, *Sri Ramakrishna, the Great Master*, Swami Jagadananda, tr. (Madras: Sri Ramakrishna Math, 1952), p. 390.
21. Ibid.
22. Ken Wilbur, *The Meeting of the Ways*, p. 10.
23. Quoted, ibid. p. 13.
24. *The Gospel*, p. 169.
25. Ibid.
26. Ibid.
27. Ralph Metzner, quoted, *Maps of Consciousness* (New York: Collier Books, 1971), p. 35.
28. See *Katha-Upanishad* for relevant discussion.
29. Karl H. Potter, *Presuppositions of India's Philosophies* (Englewood Cliffs, N.J.: Prentice Hall, Inc., Indian rpt. 1965), pp. 5–10.
30. Metzner, *Maps of Consciousness*, p. 103.
31. Ibid. p. 31.
32. William Irwin Thompson, *The Time-Falling Bodies Take to Light*, p. 31.
33. Ibid. p. 33.
34. *The Gospel*, p. 83.
35. *The Meetings of the Ways*, p. 183.
36. William Johnston, *Silent Music* (London: Collins, 1974), p. 149.
37. Ibid. p. 157.
38. Nitya Chaitanya Yati, tr., *The Bhagavad-Gita* (New Delhi: Vikas Publishing House Pvt. Ltd., 1981), p. 343.
39. Ibid.

YOGA AND PSYCHO-ANALYSIS

Kumar Pal

Man and His Mind

'Know thyself' is a universal exhortation true for all times and climes. Self-knowledge has forever been the problem of problems, the ultimate crux of all serious thought, philosophical and scientific. Though the self of everyone is the nearest of all things and its knowledge, apparently, the easiest task, it is all the same the farthest removed from human ken. As Freud tells us, the last thing man desires to know is himself.

> Mankind has ever been ready to discuss matters in the inverse ratio of their importance, so that the more closely a question is felt to touch the heart of all of us, the more incumbent it is considered upon prudent people to profess that it does not exist, to frown it down, to tell it to hold its tongue, to maintain that it has long been finally settled, so that there is now no question concerning it.[1]

Self-realization is a problem of utmost importance for both psycho-analysis and Yoga. Psycho-analysis, says Otto Rank, 'took "know thyself" seriously for the first time and found new paths to self-knowledge.'[2] But, as was remarked in some other connection, the self for psycho-analysis was identified with 'the unconsciously working primal libido.'[3] Freud came very near the threshold of truth when he realized that 'normally there is nothing we are more certain of than the feeling of our self, our own ego as sharply outlined against everything else.' This is the starting-point of the journey. It is from this feeling that the search, the

quest for the self begins. But he flies at a tangent on the wings of his pithy phrases and entangling terms, to the construction and use of which he has paid no attention. Proposing a highly speculative and philosophical enquiry, he takes up an attempt for a scientific and psychological discussion. Freud aspires to find a fruitful solution of the problems of philosophy, but despises the role of a philosopher. So he turns to the scientists' method, but finds it inadequate.

In fact psychologists in general have had a fright of metaphysics even though they are time and again faced with problems which demand metaphysical explanations. We need not bother our heads, here, about the numerous concepts of psychology and of mind held in the West. Briefly stated, some prominent views were the soul theory of the ancients, the 'atomic mind-stuff theory' of the associationists, 'the sum total of mental processes' theory of Wundt, Kulpe and Titchner, 'the flux or stream of consciousness theory' of William James, and 'the presentational continuum' of Ward and Stout.

Psycho-analysis started, as we have seen, as a system of medicine treating nervous disorders. These peculiar troubles were formerly regarded as connected with the organic structure. Freud and some of his predecessors discovered the reasons in the mind. The abnormal behaviour of the patients was found to be the expression of their abnormal personality and mental constitution. Hence they were driven or, as Freud writes, 'glided unawares out of the economic plane over into the psychological.'[4]

This was not like a complete conversion. Freud came to it as a necessary stage in a process of development. He carried his old scientific attitude into psychology and applied the dynamical principles of continuity and causality to psychological problems. This introduction of the dynamic conception into psychology led to a quickening of the moribund academic psychology. The total denial of consciousness by the Behaviourists had already given a rude

shock to all serious psychologists. Formerly mind and consciousness were thought to be co-extensive and unconscious mind was a contradiction in terms. But now mental phenomena came to be regarded not as static events taken out of the context of mental life, but as active living processes.

The content of consciousness gives no explanation for our sense of personal continuity; recognition of past experiences, revival of lost memories; unaccountable free-rising ideas, feelings and 'hunches,' peculiar emotional states and unconnected acts of everyday life; phenomena apparently involving intelligence as solution of problems in dreams, hallucinations and hypnosis; answers to questions in hypnosis; post-hypnotic phenomena, etc. Hence the scientific mind, which demands continuity and causal determination everywhere, was dissatisfied with the old hypothesis. These very gaps, as Hart argues, should be supplied with some theory of the subconscious, if one is to stay on his own side of the scientific fence and be consistent in thinking.

Various theories were propounded and several of them may well claim some adherents. Hugo, Ribot, Jastrow, Carpenter, and Munsterberg held the extreme negative view of unconscious cerebration, and regarded the notion of subconscious mental facts as 'self-contradictory', 'futile', 'fruitless', 'gratuitous', and 'unnecessary'. They confused the psychical with the physical, and their explanations ultimately foundered at the rock of memory and recognition.

Hudson postulated two minds, one conscious and the other unconscious, after the fashion of faculty psychology. But his 'Dual Mind Theory' found no favour with the scientists, as it could not vindicate the sense of unity and continuity of mind.

Hartsmann, Myers and Dr. Stanley Hall likewise explained the subconscious in terms of the subliminal. Their view is also known as 'the Limbo Conception'. The unconscious according to them is a sort of lumber room to which all mental processes are relegated when they are in a state

of inactivity. Myers regarded each man as 'at once profoundly unitary and almost infinitely composite, as inheriting from earthly ancestors a multiplex and colonial organism—polyzoic and perhaps polypsychic in an extreme degree.'[5] According to him our subliminal consciousness looked after the maintenance of our larger spiritual life during our confinement in the flesh.[6] Dr. Hall likened the mind to an iceberg of which only a small portion is visible above the surface of water.

William James, though in large part adhering to the above view, added his own ultramarginal conception to it. According to him the field of consciousness contains two clearly distinguished regions, a central or focal region of attention and a surrounding marginal or sub-attentive region below the threshold of consciousness. He has named them 'A region' and 'B region' also. The latter, he says, is obviously the larger part of each of us.[7] This subconscious is for him, in a way, the potentially conscious.

Ward and Stout, too, regard the unconscious impressions as potential presentations. 'The subconscious experiences are capable to entering the sphere of consciousness and constantly tend to do so.'[8] Further, 'they tell on conscious life as sunshine or mist tells on a landscape.'[9]

Apart from the wranglings and fulminations of these psychologists much more productive work was being carried on in medical clinics. Morton Prince, in his study of numerous cases of multiple personality, was confronted with peculiar mental phenomena on whose basis he constructed a theory about the structure of mind. Besides consciousness he admitted the co-existence of intelligent mental processes which were nevertheless dissociated from the personality. These, he consequently termed as 'Co-conscious'. To Prince is also attributed the view of the unconscious as a storehouse of neurograms in the brain. Every sensation leaves some impressions and produces dispositions in the neurones of the brain. Each experience, however, involves many neurones and thus comes to be

8

crowded by a number of organized residual or brain patterns which Prince calls neurograms.

Like several physiological theories previously mentioned, Prince's theory also violates the principle of independence and militates against the firmly grafted feeling of unity.

At present, the psycho-analytic theory of Freud is on the ascendant. But before embarking upon the tortuous path which it has traversed in its day-to-day modifications and revisions, it is wise to briefly refer to the derivative theories of Adler and Jung, who started as Freud's disciples but revolted in the end against his way of looking at things.

'It is indeed difficult,' says Crighton Miller, 'to gather Adler's views regarding the unconscious.' He was formerly a devout follower of Freud, and only lately, smarting under his sense of inferiority and unwilling to play second fiddle, he stuck out a new and simpler path for himself that could gain him cheap popularity. At times, like his divorced parentage, he seems to describe the unconscious as a repository of one's own evil and unacceptable, unnatural emotions, wishes, and inclinations for which people will not be responsible.[10] But what is really emphasized, time and again, by Adler is a continuity of the mind. He does not fully endorse the distinction between the conscious and the unconscious. For him the 'unconscious is much less unconscious.'[11] 'After all nothing in life is entirely known or nothing entirely unknown' is a characteristic saying of Adler. Elsewhere he says, 'The conscious and the unconscious are not separate and conflicting entities, but compensatory and co-operating parts of one and the same reality.'[12]

The unconscious for Adler is, at any rate, very vague. It is rather the 'unregarded'.

Jung, much concerned to incorporate the achievements of both Freud and Adler in important subjects, accepted the unconscious as a handmaid to the conscious. He remarks, 'The unconscious so far as we can now see has a compensatory function in respect to consciousness.'[13] But at the same time he very often refers to it also as an antithesis to

consciousness, as 'an opposing power, with which the individual has to come to terms'[14] and as an 'entity untouchable by personal experience.'[15] He even goes much further in his endeavour to reconcile the other views when he defines the unconscious as the totality of all psychic phenomena that lack the quality of consciousness. Instead of being called unconscious these phenomena might well be called 'subliminal'.[16]

The structure of the whole mind according to Jung may be graphically represented as follows:

Consciousness
Threshold of Consciousness

Un-Consciousness } Personal Unconscious
Racial Unconscious

The whole mind is divided into conscious and unconscious. The conscious psyche is an apparatus for adaptation and orientation, consisting of a number of functions. There is a threshold between the two. The unconscious is a deposit of all human experience, 'a totality of psychic contents in *status nascendi*'.[17] It is distinguished into the personal unconscious and the collective, racial or absolute unconscious. The personal unconscious includes the repressed material, other forgotten incidents, distasteful memories and other impressions acquired unconsciously. The collective unconscious is an inheritance of past animal ancestry, and it consists of 'methodological themes or images',[18] instincts and archetypes 'which are merely the forms which the instincts have assumed.'[19] 'From the collective unconscious as a timeless and universal mind we should expect reactions to the most universal and constant conditions, whether psychological or physical.'[20] But it is independent of the conscious mind and even of the surface layers of the unconscious. It is 'independent, and untouched, perhàps untouchable, by personal experience.'[21]

But Jung is most singular in agreeing with Freud in his conception of the evolution of the present structure of our psyche. And it appears to be a characteristically Indian view. In the chapter on 'Mind and the Earth' in his *Contributions to Analytical Psychology*, Jung discusses this problem at length and illustrates the structural evolution of our minds by the example of an ancient building, the upper storey of which was erected in the nineteenth century. 'The ground floor dates from the sixteenth century and a careful examination of the masonry discloses the fact it was reconstructed from a dwelling tower of the eleventh century. We live in the upper storey and are only dimly aware that our lower storey is somewhat old fashioned.'[22]

In the next paragraph he draws a comparison between the growth of the individual and of the race on phylogenetic lines. The consciousness of the primitive is likened to the sporadic and limited nature of a child. 'Our childhood,' he says, 'rehearses reminiscences of the prehistory of the race and of mankind in general.'

Freudian Theory of Mind

It was Freud whose investigations brought the theory of the dynamic unconscious mind into prominence. Though contested by many, his theory continues to play a dominant role in psychology at present, as the only scientific theory that can explain complicated mental mechanisms.

But the most perplexing difficulty in his theory is that not only did he reveal the dynamics of the mind, but he dexterously applied it to his own theory which has never been static and is still in liquid form. It has constantly been undergoing considerable changes with every new publication, mostly proposed by Freud himself. The result is a confusing conflict of opinions which have made Freud a farrago of incomprehensibility, with abundant contradictions.

As the theory was not a ready-made one based on logical considerations, it had to be modified several times when new facts began to accumulate. Freud did not begin his work with any preconceived notion about the nature of the mind. The theory of the unconscious was gradually evolved as a corollary of the attempt to explain pathological disorders which were and are still so baffling to medical men. Invented to account for the abnormal mental life, his theory was found equally applicable to some normal mental processes also. Thus it attained the status of a complete self-subsistent theory of the whole human mind.

Investigations of numerous cases of mental disorders indicated to Freud that, besides the field of consciousness which formed the subject-matter of academic psychology, there exists a huge lumber room of forgotten mental material. This had so far constituted the content of the subconscious of the psychologist. Out of this, Freud found, many ideas were at the beck and call of the individual. This region was termed the foreconscious or preconscious. One needs only turn one's attention upon these memories and they come to the focus of one's consciousness. Whatever is likely to be useful in future is thus stored up in the preconscious. But what was an original discovery of Freud is his postulation of the unconscious which consists of material, forgotten no doubt, but which is not easily recallable by ordinary means. Weighty evidence was found for the existence of such an unconscious level not only in the clinical records, but also in the dreams of normal people, slips of tongue and pen, peculiar mannerisms and modes of belief.

The earlier conception of the unconscious was very nebulous. When Freud started his work he had no idea of the sort of material he would obtain by digging into the unconscious. His initial analysis unearthed mental processes that were sexual in nature and had, therefore, been repressed. A little more examination brought home to the analysts that the hidden incidents—sexual traumas or

mental injuries—related to the early childhood period. In order to reconcile the sexuality and the infantile character of such contents Freud, as we have seen, had to extend the meaning of the word 'sex' and dub the innocent child a polymorphic perverse. The early cravings of the child were either not fulfilled or were pushed back as being annoying and disagreeable to those around him and hence even to himself, for he held them in esteem.

For the first few years of his therapeutic work, Freud exclusively confined himself to the study of pathological cases only. Their dreams and infantile memories were analysed as aids to his method of free association. Very soon the limits of abnormality widened and Freud turned his gaze to the psycho-pathology of everyday life. Further, when Freud observed that sometimes the neurotic patients got cured by various types of resort to some religious person, some hobby, or useful social work, he extended the field of psycho-analysis to include diverse subjects—religion, primitive customs, mythology, folklore, social custom, fashions, criminology, sociology, mysticism, anthropology, and what not. And curiously enough Freud explained their irrationality by presuming unconscious motives or drives behind each of them.

It would be an enormously engaging subject if one reads the lengthy interpretations by Freud to prove his hypothesis. For us, however, space does not warrant such wide diversions. What alone is relevant here to notice is that in the long run the unconscious came to be regarded as a tremendous reservoir of all that is sublime and evil, primitive and bestial, unsocial and abominable, infantile and acquired, barbarous and criminal; 'the lowest and the highest'[23] in short. This 'unconscious' is, again, subdivided into the primary and the secondary or Freudian unconscious. The former was inherited by way of the organism and is a sort of a representative relic of primitive times. It consists of those animal tendencies that have condensed in the form of the organism and never become conscious; it

also consists of those disagreeable experiences that have been pushed into it from consciousness and those unpleasant impressions that have been repressed before their appearance in consciousness. These are accessible to extraordinary methods of recall during hypnosis or free association.

A very meaningless obscurity is introduced into this conception of the unconscious when Freud postulates, besides these two, a third unconscious which is neither 'latent like the preconscious nor repressed'.[24] The property of unconsciousness thus loses all significance for practical purposes.

It is also held that in the beginning when life starts, there is no such division into levels. Only unconsciousness exists at birth. The unconscious is, in the words of Lipps, 'the general basis of the psychic life'. Consciousness and preconsciousness arise only when the organism meets with resistance from the reality and has to mould either the object or itself in order to effect a successful adjustment to ensure survival. Even the unconscious gains in content, as mentioned before, by the addition of the repressed uncongenial thoughts that are hurled down into the secondary unconscious.

Freud further inferred the existence of a peculiar entity which has been variously described as the censor, the endopsychic censorship, resistances, defences, or barriers. This is said to be lodged between the unconscious and the preconscious. It serves to keep down the mighty surges and the powerful currents that roar and rage beneath in the boundless, dark ocean of the unconscious. The foreconscious has to erect strong defences in order to resist any encroachment by the barbarians into the domain of reason and morality. The censors also serve as policemen on the frontier to guard against open foreign incursions. Aliens are allowed only when under a profound disguise or in company with some of the national domiciles. Despite strict vigilance, they do secure entry sometimes under the cover of darkness when

censorship is in abeyance, and are expelled during the daylight of waking consciousness. There is another line of such fortifications just on the outskirts of consciousness. But this is not so impregnable.

When, however, due to the weakness of the defences or the negligence of the guards or the superiority of the insurgents, most of whom are exiles from consciousness, these unconscious cravings, reinforced by a strong catharsis, succeed in breaking out, generally in complex groups, they assume the form of uncontrollable symptoms. Then they set up a state of tension in the mental kingdom or else divide the whole united realm into several dissociated co-ordinate parts.

This so-called topographical and dynamic description of the human mind is illustrated in different interesting metaphorical ways by various writers on psycho-analysis. I cannot here resist the temptation of quoting Joad. He compares consciousness and the unconscious to 'two families dwelling upon different floors of the same house with a policeman in the staircase to guard the approach from the lower to the upper.'[25]

A note of warning would here be very necessary, lest the above description, taken too literally, should mislead us. The talk of divisions and levels gives us an impression that mind is a spatial thing. Far from this, for Freud the stratification of mind is only a convenient way of comprehending it. The terms 'below', 'surface', etc. are mere metaphors.

Id, Ego, and Super-Ego

The above tripartite scheme of the various strata of our psyche is commonly confused with another triadic division of our so-called 'personality'. The terms Ego, Super-Ego, and Id are displacing the older concepts of conscious, preconscious and unconscious. This does not warrant us, nevertheless, to say that the old classification has been

totally dispensed with. What is really meant is that a thorough revision is taking place, and sharp lines of demarcation are no longer drawn. A sort of continuity is recognized in the mind from consciousness to the unconscious, through the middle ranges of the preconscious. The difference now appears to be only in degrees. All talk of a censor is fast disappearing. But yet all the previous terms are retained notwithstanding the complete abandonment of their old meaning. Moreover, Freud himself has failed to accurately define the relation between the two triplets.

In the early stages of psycho-analysis, corresponding to the antithesis between the unconscious and consciousness, Freud advocates a similar polarity between the Id and the Ego. The Id was identified with the unconscious, and the Ego was regarded as synonymous with consciousness. The Super-Ego performed the function of the censor.

The Id (English It) was an expression adopted from George Groddeck to designate the portion of our mind that is beyond all grip of the conscious individual and that provides the motive force for our instinctive urges. The term 'It' denotes its impersonal nature and therefore may very well be compared to the racial unconscious of Jung. 'It designates,' says Conklin, 'all those cravings of the body which are on an inorganic level.'[26] According to Freud, 'we are lived by unknown and uncontrollable forces.'[27]

But generally, psycho-analysts glibly employed the word 'Id' for long as convertible with the unconscious. Both these terms have now enormously changed their connotations. They in fact mean quite different things. Sometimes even conflicting contents are ascribed to the two. The unconscious, we have seen, is losing all sensible significance even for Freud. Id also enjoyed a varying fortune. It is sometimes declared to be the 'animal in man', 'the enemy within', 'the antithesis of Ego' and also of the Super-Ego. Secondly, Freud presents it extending its boundaries, affecting the Ego and overlapping with it, leaving a little part of it to cope with external reality. In the third place, Freud in his later writings

began to depict the 'Id' as the primal, undifferentiated and unconscious form of the mind, from which were gradually evolved all the institutions of the mind in the course of adaptation to the environmental vicissitudes. The Ego and the Super-Ego both merge in the Id.

The Ego of Freud must not be in any case confounded with the ego of the philosopher or even of the layman. It is a much narrower concept. Freud's Ego is strictly empirical, though several times he talks of it in the vein of a philosopher. A greater part of the mind is out of its access. Formerly regarded as co-terminous with consciousness, it was found that the Ego had an unconscious component. Freud says, 'We land in endless confusion and difficulty if we cling to our former way of expressing ourselves and try, for instance, to derive neuroses from a conflict between the conscious and the unconscious. We shall have to substitute for this the anti-thesis between the organized Ego and what is repressed and dissociated from it.'[28]

Yet the status of the Ego is even now quite anomalous. It is represented, on the one hand, as extending to and arising out of the unconscious 'Id' and, on the other, as in actual contact with the outer world. As Dr. G. Bose writes, 'The Ego has been evolved from the Id as an adaptation to the environment...It is not sharply differentiated from the Id but merges in it.'[29] The perceptual system forms its nucleus. It receives perceptions from within as well as from without.

In its earlier stages of development 'the ego-desires' are but slightly different from those of the Id. Gradually a partial opposition is set up between the two, because the Ego incorporates by way of introspection the ethical standards of reasoning, right and wrong, propriety and decency from outside authority, parental or preceptorial, which are out and out opposed to the irrational, impulsive, selfish, passionate demands of the Id. The Ego, with a view to future welfare and social approbation learns to postpone gratification, control certain passions and direct the impulses in different directions. 'The Ego represents what we call reason and

sanity in contrast to the Id which contains passions.' Born in and floating on the surface of the unconscious Id, the Ego begins to exercise a directive influence upon the currents and waves of the mighty ocean. Glover, however, only exaggerated the contrast when he said that 'the ego in relation to the Id is like a baby riding on an elephant.'[30]

The Super-Ego is a still newer concept in psychoanalysis and is enshrouded in a mist of vagueness and inaccuracy. Freud was led to coin this word after the liquidation of the concept of censorship. Instead of the services of the policeman, the ego now frequently derives assistance from the Super-Ego in opposing the undesirable impulses of the Id.

Many cases of paraphrenia and hypochondria revealed to Freud the working of a strange mental mechanism whereby the patient incorporated an external object into the ego and the object libido was transformed into the narcissistic libido. External authorities were internalized and a sort of censoring, guiding, checking and supervising Super-Ego was formed in the mind. It acts as a prototype of the social institutions and conventions. It manifests in our daily life as conscience. The internal authority is thus invested with the powers of the master, the parliament, police, courts and jails at the same time. It is also generally spoken of by Freud as the Ego-Ideal. As such it is compared to the higher nature of man.

Freud makes this conception ambiguous when he insists that the Super-Ego, which is an unconscious component of the Ego, is developed out the Id in the course of its struggle with the external world and is 'a representative of the inner world of the Id.'[31] This stands in a glaring contrast to all previous statements. The Super-Ego has an anomalous character inasmuch as it is derived from the Id and still fights against it. Why the Super-Ego should sometimes act as an ally of the Ego and sometimes as its enemy is not at all understood. No explanation is given for the active drive of the Super-Ego acting in executive capacity.

The whole structure of Freudian psychology is thus seen to bristle with anomalies and contradictions. There are sharply defined concepts to give the system at least an apparent stability. But all this does not cause an iota of embarrassment to Freud. He is rather encouraged to revel in his daily revolutions, by the analogous character of the physical sciences of the West. In his paper on 'Narcissism', Freud remarks that science as contradistinguished from a speculative theory is 'founded upon constructions arrived at empirically. Science will not begrudge to speculation its privileges of a smooth, logically unassailable character, but will itself be gladly content with nebulous, scarcely imaginable conceptions, which it hopes to apprehend more clearly in the course of its development.'[32]

However cogent the argument may seem to a Westerner, for whom philosophy and science are but mere tentative hypotheses leading ultimately to a revelation of the absolute truth, such an irrational attitude cannot commend to an Indian, for whom there is nothing new under the sun which may warrant any alteration in the fundamentals of sound theory advocated after needed deliberation. In fact, such frequent and divergent 'developments' have only added to the prevailing confusion and indecision, without in the least contributing to the clarity of the real issue. Truth flies further away before such inconsistent thinking. It eludes all such methods of study. Freud evinces a want of clear comprehension of the different standpoints from which he has grappled with the problem at different times.

> What hast thou to do with riches?
> What hast thou to do with kin?
> How shall wife bestand thee?
> And son! thou shalt surely die?
> Fathers and grandfathers, gone are they,
> Seek thine own self within thy bosom.
>
> —*Mahabharata*

Indian Theories

What am I? and whence? and whither bound? and why? This is the great question which is set to all serious thinkers of whatever age or area. The Indian seers answered it in countless ways. Howsoever perplexing the arid logomachy of each school of thought, the Indian philosophical systems, one and all, excepting the crude nihilism of Charvaka and the abstruse absolutistic nihilism of Buddhism, gave an unequivocal reply to this quest, assuring that 'man is a complex of consciousness (or Self), mind, and body.'[33]

Buddhists in India, and Hume and James in the West, rendered a great service to the problem of the Self in rightly repudiating the current notion of the Self and establishing without an inkling of doubt that the search for the Self in the changing states of the mind never gives us the Self. The Atman though undefinable and unknowable is of the nature of 'pure consciousness, which is the supposition of even the consciousness of objects'[34]; it is Chit, the 'subject par excellence'[35]; it is Aham, 'the source of all categories'[36]; it is 'the ultimate subject',[37] the 'pure consciousness divested of all objective factors',[38] 'the vacuum plenum'.[39] But as regards their total rejection of the Self it would be wise to follow the sound advice tendered by Sir Oliver Lodge: 'The assertions of men of genius are often of value: their denials seldom or never.'[40]

Having full self-realization as its main subject of study, Indian philosophy deals with the mind also as distinct from the Self, but related to it by close bounds. It should be clearly borne in mind that in India the anti-thesis is not between matter and mind, or body and mind, as in the West, but between matter and spirit, not-Self and Self. The Ego is sharply outlined against everything else, mind included.

Before enquiring into the different concepts of Self, we must, however, briefly dispose of the chief contentions of

the two 'Self-less' schools of philosophy. The Charvaka view can hardly be regarded as a system of philosophy in the form in which it is now known. Yet, we are here more specially interested in this view, because, as it is sometimes put forth, it borders upon modern behaviourism. According to Shalinath's summary, the Charvaka regards feeling as directly characterizing the physical body and describes it in terms of bodily expression.[41] All the same, the Charvaka does not deny consciousness or spiritual principle. He only denies the survival or independence of the Atman, and believes that it comes into being with that particular concatenation of the elements which we call the living body. Consciousness is only a by-product of matter, an epiphenomenon, or in the words of Hodgson, a sort of foam, aura, or melody.

The early Buddhistic nihilism was much more audacious and radical than the position of Hume and James in Western psychology, in so far as they postulated no neutral events like them. For the Buddhists the Self is not an independent entity in itself, as can be readily understood from the *Questions of King Milinda*, when the sage Nagasena declares after the illustration of a chariot and its parts that the word 'Self' is only a label for the aggregate of certain physical and psychical factors, a samghata of sensations, thoughts and body. This combination is sometimes described as nama-rupa or mind-body complex, or the 'psycho-physical organism' as understood by Hiriyanna. A closer examination revealed further division, and the Self came to be conceived as fivefold, consisting of five skandhas or classes: rupa, vedana, sanjna, samskara, and vijnana.

But this need not be interpreted in a static manner. These factors themselves are constantly changing (kshanika) and there is no such thing as a permanent Self. It is only a flux of perceptions (vijnana-santana), a stream of consciousness (samvit-santati). The present thought is the only thinker. As is beautifully put by Mrs. Rhys Davids, there is, according to Buddha, 'No king Ego holding a level of

presentation.'[42] The most remarkable fact is that, according to Buddhism, 'the mental is to be regarded as more shadowy than the physical aspect'[43] of the samghata.

This is, however, only one interpretation of Buddhism. There are many exponents who are of the opinion, on the contrary, that Buddha did not positively deny the Self. Radhakrishnan writes, for example, 'It is wrong to think that there is no Self at all according to Buddha. He neither affirms nor denies it.'[44] And this seems very odd, to admit transmigration and deny a soul on which actions inhere and occasion birth. This is still a moot point in Buddhism and there is none to decide. Buddha himself wrote no books and therefore there is vagueness about his tenets.

There is, however, no denying the fact that, while some of the later developments of Buddhism have deliberately taken cudgels against the theory of Self, there are several important schools, especially in Mahayanism, that share some Hindu ideas and accept Self. This school regarded the spirit as 'imprisoned in the shackles of flesh and enjoined retirement from the bodily pleasures of the world.'[45] The truth seems to me to be that Buddha, aware of the sterile nature of philosophical discussions, tried to avoid all metaphysics, and in keeping with his practical attitude merely eliminated the conceptions of Self altogether.

The Jaina doctrine of jiva, as Sinclair Stevenson points out, is very confused. The word has been varyingly used to connote 'life, vitality, soul, or consciousness'.[46] The jiva is taken to be bhokta and karta, actor and acted upon.[47] In general, it corresponds to the notion of the Self in other schools. Very queerly, the Jains believe that the size of the jiva varies with the size of the body. It is a growing and changing entity, which should hardly merit the characterization of Self.

The Nyaya-Vaisheshika school agrees with the Jains in attributing all actions, feelings, desires and knowledge to the Self. The Self is jnata, karta and bhokta. But it is not like their life principle. The Atman is omnipresent and all-

pervading. Souls are infinite in number. Thought, feelings and volitions are attributes or qualities of the Atman.

The Sankhya and Yoga schools differ radically from Jainism, and go further than even Nyaya-Vaisheshika to deny to the Self or Purusha all attributes of jnana, darshana, sukha and virya which the Jaina school proposes. These qualities inhere in Prakriti—a complex of mind and matter. The Self is absolute pure consciousness (kutastha sakshi). It is mere sentience, changeless, eternal, and omnipresent. But like the Nyaya-Vaisheshika doctrine, the Sankhya and Yoga schools also harbour a plurality of Selves, all of identical nature.

The Mimamsa school is split into two—Prabhakara and Bhatta. Both differ slightly in their conception of the Self also. For both, Self is a necessary postulate to account for the Vedic texts and pronouncements. They also agree regarding its plurality. The Bhatta school of Kumarila, like the Nyaya school, conceives the Self as an agent (karta) and enjoyer (bhokta), but recognizes the possibility of modal change in the Self while it remains eternal. Prabhakara disagrees with Kumarila in this respect and is opposed to all change in the Self. What is most surprising in his theory is that he regards the Self as wholly non-sentient (jada) and assumes a third element, a self-luminous samvit, which reveals both the object and the subject simultaneously with itself.

The Vedantists, however, level their crusade against all. They agree with the Buddhists in the denial of Self in the states of mind. But they denounce their notion of 'continuity in flux' as inconsistent and unintelligible without an ultimate subjective principles which while itself unchanging unifies and apperceives all changing states and can never be made an object. The idea of a spiritual substance underlying thought, feeling and action, to which Jaina, Nyaya and Mimamsa schools subscribe in different ways, is also repudiated. The 'multiplicity of Selves' without distinction is declared impossible. In the opinion of the Vedantins, all

distinctions within Selves and within subject and object necessarily imply a universal foundational unity of Consciousness, as the deepest reality. 'This absolute is the ultimate Self of all,' says Vasishtha, 'from which all spring up, in which all live, and to which all return.'[48] This is the sole Reality, the one supreme Consciousness as well as the infinite Bliss, (Sat, Chit and Ananda). In Taylor's words, the Absolute is a 'Union not only of Thought and Will' but of 'aesthetic feeling and judgement' as well.[49]

Conscience

Before studying the theories of mind, we must be clear first of all about the often misunderstood Indian notion of the Atman as a faculty of conscience. Common people ascribe the checking, guiding and supervising functions to the Atman. But this, however, is not philosophical.

The Indians, in fact, long ago realized the existence of some such entity within the Self which sounds notes of warning and also prompts one to indulge in some pursuit. Some explain it away by vague descriptions and call it some mysterious God or Power.

By close scrutiny two sides were distinguished in this inner controlling Deity (Antaryami Deva). The *Gita* tells us that it is lust and passion, on the one hand, which as constituents of man's nature impel him to undertake misdeeds against his will, and on the other hand, it is the Lord (Ishvara) himself who residing in the hearts of all is controlling them, as if they are mounted on a machine and He is turning it round and round.

The Upanishads and the Puranas relate the whole struggle between the lower and the higher, the animal in man and the God in man, by the allegory of the Devasura-Samgrama, which is going on eternally in everyone's mind.[50] In psycho-analytic terminology we shall have to express this as the conflict between the Super-Ego and the

Id, which have been compared by Freud himself to 'the higher nature in man,' and 'the animal in man' [51] Goethe gives a beautiful picture of this internal war within the Self.[52]

The Doctrine of the Bodies and Their Evolution

It is held generally that, if there is any common feature of Hinduism which is accepted both in theory and practice by all shades of opinion, it is the doctrine of transmigration according to the law of Karma. The Self, whatever be its character, according to all schools of Indian philosophy, except Charvaka, incarnates itself into matter and then tries to get out of it, time and again.

We are given a clear and detailed description of the gradual process of descending into matter. The original cause of the descent, as we have already seen, remains an enigma to us. But somehow, when the limitless, infinite, indeterminate supreme Self got into limitations (Maya Upadhi) and forgot its true nature, the first determination to begin with was the undifferentiated state called Avyakta. It was a state of all potentialities and no actualization yet. The primal Maya became surcharged with the possibilities of pluralization. Yet there were, then, no distinct individuals, no sense of differences, or egoism. But it was the origin, the basis of all later distinctions. A sort of tension had been started.

The dormant seeds of later differences soon acquired distinctions and a sense of individuality (Ahamkara) was born. The not-Self gave rise, while in compact with the Self, to the feeling of self-hood or egoism. Out of the 'indistinct vague waters of the unconscious, non-ego, or Id,' in the words of Freud, 'the ego began to float upon the surface. Gradually, just as the unconscious evolves into the conscious in mankind, so does the mind essence evolve into the soiled mind consciousness.'[53] Now the embodied or empirical ego required an organ, a medium to communicate with

and receive impressions from the outside. Hence there arose manas, the inner organ of the soul, to meet with the situation. This may be likened to the perceptual system of Freud, though he fails to state clearly the relation between it and the ego. This was a transformation of the sattva aspect of Maya or Prakriti.

A further change brought forth the subtle seeds of five sense organs from the sattva aspect, five motor organs and five vital pranas from the rajas aspect. The two sets of five organs have corresponding to them five gross elements, which in themselves were the result of a similar transformation of the five seeds or Bhutas from the tamas aspect of Prakriti.

Such is the broad explanation of the whole world process. The spirit thus becomes fully embodied in several material sheaths or bodies.

The original causal undifferentiated state, which we have called Avyakta, constituted, from the individual point of view, its causal body (karana sharira). The individual was then in a nascent state, devoid of the afflictions and strains which accompany the mind and the body. Though veiled in ignorance or Maya, he was yet enjoying bliss. There was no sense of time limitations. Rational processes were conspicuous by their absence. There were no moral or logical standards. Opposites could exist together without marring the sense of rest. It was the super-individual state. In fact, being the first formulation of the eternal wish of Brahman, it was still only a wish, an impulse incarnated, with specific directions and tendencies. It contained the potent seeds of future fruits. It was nothing but crude primal tendencies and primitive instincts, in Freudian terminology.

The sense of individuality (ahamkara) and the necessary sense organs, inner and outer, combined with the five pranas go to make up the sukshma sharira, subtle vesture, or the astral body in theosophical words. It has been subdivided variously into several subtle bodies by different

schools, particularly by Tantrics. It accompanies the soul in its wanderings into the world for one kalpa (world-period) and survives the death of the physical body. It is the repository of all past mental impressions (samskaras) and experiences which have been forgotten or pushed out of memory. It is also a storehouse of the libidinal energy in a subtle form. All desires (vasanas) are deposited herein. In fact, as the Buddhists say, it is the sambhoga-kaya, whose function is bhoktritva, enjoying the fruits of evil and good actions.

This subtle body is periodically joined with a body of flesh (sthula deha). This serves as the agent for action, and enables man to react to the stimuli coming from the gross physical world, which at its basis is constituted of the same stuff and thus has a common ground of interaction. It is in this sthula sharira that man directly experiences pleasure or pain.

According to Vedanta, each of the three individual bodies has a corresponding macro-cosmic body. There resides in each of the six bodies a particular kind of consciousness or intelligence (chaitanya). The microcosm is the macrocosm. The infinitesimal is also the infinite.

The chaitanya in the individual is called Vishva, Taijasa and Prajna, and in the macrocosm it is named Vaishvanara, Hiranyagarbha and Ishvara, respectively.

The Buddhists too have a conception of such consciousness, which they call vijnana. They admit three modifications of vijnana: alaya vijnana, mano vijnana, and pravritti vijnana. The alaya vijnana resembles the unconscious of Freud to a large extent. It is described as constantly active and flowing. The pravritti vijnana, like the consciousness of Freud, takes its birth from this and deals with the actual world. The mano vijnana is, however, only the act of actualization, the categorizing activity between the two.

The words used for the body in the Indian philosophy convey by themselves a characteristic contingent quality of body as the embodiment of a spirit residing within. The

word 'purusha' is literally derived as that into and out of which the spirit comes and goes. Sharira, derived from shri, to crumble, means that which is incessantly crumbling. *Manu-Smriti* (I.17) says that sharira is so named because it is made up of shat, six things, as chief components. It is the sheath or locus of the mind and the five sense organs.

The Doctrine of Koshas

The Vedanta has, however, tackled the problem of evolution very brilliantly from a standpoint which quite precisely resembles the holistic conception of General Smuts and rather goes further in completeness and exactitude.

In its descent into matter the spirit is here related as passing through five stages, taking on one sheath at every stage. Each successive step removes man farther from its source. There are numerous stages of this emanation or enveloping, which if looked at from the side of the spirit appear as a descent but from the side of man as a re-ascent. If man has to discover and regain his lost status or the supreme Consciousness, he must traverse the full course again in a reverse manner. So then, what was last for the Infinite comes foremost for the individual.

There is an interesting anecdote in the *Taittiriya-Upanishad* about this search. Bhrigu approaches his father Varuna, entreating him for instruction about the nature of reality. During his long enquiry the son passes from the lowest to the highest truth. The stages are five: Anna, Prana, Manas, Vijnana, and Ananda. The first four exactly correspond to the different wholes of Smuts: matter, cell, mind, personality. The social and ideal wholes of the values of Truth, Goodness and Beauty do not exactly represent the Ananda of the Upanishads.

From the evolutionary standpoint, further progress beyond the human personality is at present unpredictable on scientific lines. But there are indications looming large on

the present horizon which unambiguously contain the outline of the next stage of super-human evolution. In the absence of data, only philosophers can guess or only mystics can visualize the future 'Kingdom of Heaven' and 'its descending on the earth'. The character of the Ananda as the last and final reality is more clearly brought out by Alexander's conception of 'Deity', which according to him is all bliss and the next stage of evolution after the human personal organization.

The idea of temporal order of succession or of emergent evolution in these wholes as held by Lloyd Morgan and Smuts, or even of creative durational evolution of Bergson seems quite hypothetical and too conceptual. Their belief that out of unorganized inorganic matter emerged organic life and out of the cell arose mind and the mind gave birth to personality, so on and so forth—is quite unwarranted by their study. No doubt, as enquirers and students of the present constitution of the universe we come across these five big classes and the preceding is simpler than the following ones. But to presume that the more complex came out of the simpler and that evolved out of the simplest flies in the face of obvious facts. It jars even common sense to hear that life emerged out of lifeless matter and mind from an unconscious organism, etc.

How could life arise or come out from something where it was not contained? Either we must say it is incomprehensible, or else, if we contend that 'matter' has the potential possibility of all later developments, the concept of matter as inanimate, unconscious, irrational and inert mass has to be totally abandoned. Call it 'matter' or 'It' or by any term, the primal stuff of the universe must have all the characteristics of its evolutes. Only then shall we be entitled to call it evolution and then alone shall we understand the whole world.

The only sound explanation of the process is that which has been given by Yoga and Vedanta. Or else the problem must be declared insoluble.

At any rate we must now revert to the individual himself. What interests us here is only the fact accepted by all evolutionists, that man, as the last of the series, subsumes and transcends all the previous stages. In his physical growth in the womb and then outside in the world from the moment of birth, he repeats the whole cycle of evolution in outlines. At first lying in the bed at one place, no better than a lump of flesh; moving his limbs while lying still he merely imitates plant life; rolling right and left he acts as an amoeba or insect does; creeping on the stomach to and fro the baby behaves like the reptiles; crawling on all fours he is like a quadruped animal. Only when he begins to walk on two legs does he become a full man in the evolutionary sense.

In his mental development too man recapitulates the whole evolution in a brief period. Bereft of all consciousness in the embryo, the child remains unconscious for some time even after birth, with his eyes closed and insensitive to all stimuli. The behaviour is like that of the lower animals. A little degree of perceptual consciousness dawns upon the infant very soon, but there is no central control or synthesis. It is only after a good deal of learning and training that he acquires rational standards and becomes a man. And then the previous stages remain ingrained in the lower levels of his mind. The *Yoga-Vasishtha* gives us an elaborate discussion of the seven levels in the unconscious mind, which are called ajnanabhumayah, besides seven levels of consciousness (jnanabhumayah).

According to Vedanta, there are five shells corresponding to the five strata in the macrocosm which envelop the individual ego. They are, therefore, called koshas. Man is, in the words of Smuts, matter, organism, mind, personality and the absolute values—all rolled into one. There is first of all the annamaya kosha, literally the gross material sheath, made of food, corruptible by food[54] and 'for the purpose of being used up by life'[55] like food. The pranamaya kosha, consisting of the five pranas (life forces) and the motor-muscular organic powers, is responsible for circulation,

assimilation and motor discharge. Above the 'sensitive and appetitive me', in the words of Woods, we experience the 'thinking and willing me'[56] or the manomaya kosha. Constituted by manas and five senses, it lacks self-conscious direction and synthesis of activities. This is in nature instinctive (vasanatmaka)[57] and is characterized by desire (ichhashaktiman).[58] The vijnanamaya kosha is another organization of the senses under the guidance of buddhi and ahamkara. It is the knower and the agent who is responsible for all acts, and regulates and supervises them from a centre, like the personal whole of Smuts. The anandamaya kosha is a very subtle super-personal locus of the self, individualized in the jiva, the region of aesthetic feelings and artistic intentions, a mystical, super-conscious and super-psychological entity. That state of bliss is only occasionally experienced in the philosopher's contemplation, and mystic devotion, or artistic insight.

The concept of the evolution of mind as a whole has come to stay. Even the static psychologists now dare not raise their finger against the evolutionary hypothesis. In modern psychology it was Freud who first of all adumbrated this theory of the dynamic unconscious. He discovered the real continuity of our psychic life from the conscious state to the foreconscious level and ultimately to the great unconscious ground. But he stopped at that and did not extend the application of the dynamic principle to the region of consciousness. Consciousness to him remained a static mental level in which mental processes may come before the limelight and retire. In Yoga we can read about the several grades and levels or bhumis within consciousness itself.

The Structure of the Mind

The problem of the mind has been studied from another standpoint also in almost all schools of Indian philosophy. For Indians, besides the five sense organs there

is an additional inner sense which is called the antahkarana. It is unanimously considered as material. It obeys all fixed laws of causation as matter does. Though it cannot be correctly translated as mind, we have used the two words as convertible all through. The mind from the point of view of evolution is a modification of the sattva guna, but as a substance it is made up of three gunas and is characterized by the triple function of cognition, desire and action.

Mind is material substance. It is intangible and subtle (Nyaya-Manjari, I.14). The mind is subtle or atomic (Vaisheshika-Darshana, VII.i.23). The eleventh (sense) is sattvic (Sankhya-Karika, 25).

This conception of mind as a subtle substance having spatial existence and capable of taking on shape is so basic in Eastern psychology and so foreign to the West that it constitutes a real barrier to mutual understanding. Even in the various schools of Indian philosophy, beyond the agreement upon the above, we meet with a conflicting mass of statements and counter-statements, regarding the nature, divisions and modifications of this internal organ. The mind in Buddhistic psychology is a samghata, aggregate of vedana, sanjna, samskara and vijnana.

The Nyaya mentions buddhi and manas separately[59] and makes jnana or cognition a mark of the Atman[60], and then also identifies jnana with buddhi.[61] The Nyaya-Vartika Tatparya-Tika makes the confusion more confounded by equating buddhi with manas.[62]

The Sankhya speaks of a triplicity in unity. The same antahkarana becomes threefold by dint of its three modifications: mahat (buddhi), ahamkara and manas.[63] Sankhya-Pravachana-Bhashya substitutes chitta for ahamkara and subsumes ahamkara under buddhi.[64]

The Yoga is generally depicted as if it accepts the whole Sankhya psychology. But, in fact, if one sees carefully enough, one will notice that it takes no notice of the above division. It indiscriminately uses manas and chitta as equivalent but performing all the three functions of the

antahkarana,[65] while buddhi is made to stand for any cognition or knowledge[66] at some places and for the whole mind generally.[67] Ahamkara is used in the sense of conceit or egoism.[68]

The Vedanta believes in the tetrad of the antahkarana which consequently is described as antahkarana chatu-shtaya. The *Shabda-Kalpa-Druma* and *Devi-Bhagavata* also support the fourfold classification. The four names given to them are manas, buddhi, ahamkara and chitta.[69] The chitta of Vedanta should not be confused with that of Yoga. While the chitta in Yoga stands for the whole mind, in Vedanta it merely means a faculty of memory (from chi, to collect). But in Vedanta also some later writers admitted only a twofold classification into manas and buddhi.[70]

The *Mahabharata* lends a partial support to this dual distinction.[71] But in the *Shanti-Parva* (chapter 287) we are given an elaborate discussion of the whole process of perception, and there it mentions a peculiar triad of chitta, manas and buddhi.[72] The Tantras assign different designations to the Sankhya triplet as klripti, mati and syati.[73]

The Freudian Unconscious and the Samskara-Vasana Complex

While the Yogic concept of three bodies and five sheaths may be interpreted as circles within circles or wholes within wholes, the description of the different types of mental modes (three vrittis or antahkarana) is more or less a vertical classification. But we come across in the Yoga system with another analysis of mind from a horizontal view point, which very closely resembles the ideas of Freud and may be rather understood as a possible alternative theory in Indian psychology without the faults of Freudian analysis. It has already been remarked that Freud's dynamical, economic and topographical view of the psychological forces combined with his theory of censor presents a

disjointed view of psychology. Freud himself felt the inadequacy and introduced the other tripartite division with the Super-Ego; yet he is too fond of the policeman.

According to Yoga theory, we may dispense with the censoring activities and at the same time accept the double distinction between conscious and unconscious. As with psycho-analysis so with Yoga, the problem arose in relation to the question of motivation or causation of our conduct. According to the Yoga notion of causality, known as sat-karyavada, the effects are mere explications of the potentialities that lie embedded in the cause in a *status nascendi*. The whole process of change is a mere transformation from the unmanifest (avyakta) to a manifest (vyakta) state. Nothing is ever destroyed and nothing comes out of nothing.

The chitta or mind in Yoga is compared to a stream of which only the modifications of the surface at a particular place are exposed to consciousness. These are called the vrittis. The unconscious ideas come to the focus of consciousness, and again pass into the dark unmanifest condition. Any particular conscious experience, or vritti, in the potential state is called tendency, or vasana, and in the later spent-up condition is called a disposition, samskara.

This samskara-vasana complex may be well compared with Freud's modified views in his later years about the whole subconscious. In psycho-analysis too the unconscious has lost its earlier significance of an inaccessible dark region of the mind. The samskara-vasana vyuha, in fact, covers the whole range of the subconscious which has been split by Freud, Jung and others into many divisions. Like the primitive instinctive unconscious, called 'primary' by Freud and 'racial' by Jung, the samskaras are transmitted to us along with the psychophysical organism, by way of the karmashaya in the linga deha, or subtle body.

The conception of the karmashaya is very elaborate and does not warrant a detailed consideration in this limited space. The only thing that we have to note is that it is a sleeping place of the seed germs of desires, wherein desires

lie latent. It is a repository of potential passions. The commentator Vyasa explains it as the conglomerate of the tendencies to sin and sacrifice, vice and virtue, and merits and demerits, etc., and these dormant seeds of both good and evil give rise to virtuous and vicious deeds, in due course, when the seeds come to fructify. Vachaspati Mishra in his *Tattva-Visharadika* gives the following explanation of ashaya: 'ashayas are so-called because the transmigratory jivas rest in them.'

Maniprabha confirms the same. Ashaya is that in which the transmigrating, evolving individuals sleep. It is the bed in which we lie, but it is also a bed of our own making. Just as the future oak sleeps in the acorn, even so does the future individual sleep in the samskaras. They shape our character. What we shall be depends upon what we think, feel and do.

Thus the karmashaya gathers within itself both the Id and the Super-Ego with the unconscious component of the Ego, in the Freudian way of speaking. As a storehouse of memories and dipositions, whether easily recallable or not, the karmashaya contains the foreconscious as well. The points of agreement between the unconscious and karmashaya may thus be summarized. Both are primitive, non-conscious (avyakta), instinctive (vasanarupa),[74] dynamic or causal (shaktirupa),[75] non-moral, and contain both good and evil, dharma and adharma. A certain part of the karmashaya, called drishta-janma-vedaniya-niyata-vipaka is recallable. But a major and more important part consisting of adrishta-janma-vedaniya and drishta-janma-vedaniya-aniyata-vipaka remains entirely shut up to ordinary means of recall. Only by a strong concentration on the part of the Yogi can the latter samskaras be revealed in his state of Samadhi, which is a sort of superconscious trance.[76] This part again is not open to outside influence ordinarily. In that part the past, present and future are simultaneously present. The deepest layers of karmashaya are beyond the temporal categories.

But besides these general agreements there are some significant differences also, mostly due to the inadequacy of the psycho-analytic methods of study and the deliberately restricted nature of its subject matter. Psycho-analysis is based exclusively upon abnormal data and bears an ungenerous attitude towards the entire range of super-normal phenomena.

While the whole fabric of the Yoga system rests upon the presumption of previous births and life after death, psycho-analysis, though occasionally making reference to the influence of the whole past of the race as transmitted through the parents' germ plasm and as represented in the primary unconscious, leaves the future completely out of account. Consequently, while the determining factors of our character, health and experiences, according to the Yoga theory may extend to past lives, psycho-analysts have to huddle up all the causal influences of many inexplicable incidents and character traits either into the infancy or into the parental period. Even the adherents of Pavlov acknowledge that the child is born not a *tabula rasa*, but with specific trends, abilities, capacities and broad interests of its own. The relegation of all unknown conditioning factors into 'the intrauterine, embryonic environment'[77] draws too much upon credulity.

REFERENCES

1. Samuel Butler: *God the Known and God the Unknown*, p. 9.
2. Otto Rank: *Trauma of Birth*, p. 178.
3. Ibid. p. 178.
4. Freud: *The Future of an Illusion*, p. 16.
5. Myers: *Human Personality and Its Survival After Death*, p. 20.
6. Ibid. p. 48.
7. William James: *Varieties of Religious Experiences*, p. 483.
8. Stout: *Manual of Psychology*.
9. Ward: *Encyclopaedia Britannica*.

10. Drickures: *An Introduction to Individual Psychology*, p. 71.
11. Philippe Mairet: *A.B.C. of Adler's Psychology*, Foreword.
12. Adler: *Problems of Neuroses*, pp. 29, 163.
13. Jung: *Contributions to Analytical Psychology*, p. 307.
14. Ibid. p. 117.
15. Ibid. p. 106.
16. Ibid. p. 275.
17. Ibid. p. 148
18. Ibid. p. 110.
19. Ibid. p. 117.
20. Jung: *Contributions to Analytical Psychology*, p. 111.
21. Ibid. p. 106.
22. Ibid. p. 119.
23. Freud: *The Ego and the Id*, p. 33.
24. Ibid. pp. 17–18.
25. Joad, C.E.M.: *Guide to Modern Thought*, p. 104.
26. Conklin: *Abnormal Psychology*, p. 17.
27. Freud: *The Ego and the Id*, p. 27.
28. Ibid., p. 17.
29. *Indian Journal of Psychology*, Jan. 1933, p. 72.
30. Clifford Allen: *Modern Discoveries in Medical Psychology*, p. 134.
31. Freud: *The Ego and the Id*, p. 48.
32. *Collected Papers by Freud*, vol. iv. p. 34.
33. P.T.S. Iyengar: *Outlines of Indian Philosophy*, p. 6.
34. A.C. Mukherjee: *Nature of Self*, p. 317.
35. Freud: *New Introductory Lectures*, p. 80.
36. A.C. Mukherjee: *op. cit.*
37. Malkani: *Philosophy of the Self*, p. 182.
38. B.L. Atreya: *Yoga-Vasishtha and Its Philosophy*, p. 84.
39. Dr. Bhagavan Das: *Science of the Self*, p. 84.
40. Sir Oliver Lodge: *Making of Man*, p. 24.
41. *Prakarana-Panchika*.
42. Mrs. Rhys Davids: *Buddhistic Psychology*, p. 139.
43. Mrs. Rhys Davids: *Buddhism*, p. 133.
44. Radhakrishnan: *Indian Philosophy*, I. p. 386.
45. McGovern: *Introduction to Mahayana Buddhism*, p. 203.
46. Sinclair Stevenson: *Heart of Jainism*, chap. VII.
47. *Siddhanta-Muktavali*, p. 207.
48. B.L. Atreya: *Yoga-Vasishtha and Its Philosophy*, p. 248.
49. Taylor: *Elements of Metaphysics*, p. 409.

50. Shankara's Bhashya on *Chandogya-Upanishad*, I.ii.2.
51. Freud: *The Ego and the Id*, p. 47.
52. Goethe: *Faust*, p. 55.
53. Freud: *The Ego and the Id*, p. 47.
54. *Vedantasara*, Khanda 17.
55. Radhakrishnan: *Reign of Religion in Contemporary Philosophy*, p. 417.
56. Woods: *The Self and Its Problems*, p. 136.
57. *Yoga-Vasishtha*: Chindala Upakhyanam.
58. *Vedantasara*, Khanda 13.
59. *Nyaya-Sutra*, I.i.9.
60. Ibid. I.i.10.
61. Ibid. I.i.15.
62. Ibid. I.i.16.
63. *Sankhya-Karika*, 33, 35.
64. *Sankhya-Pravachana-Bhashya*, I.64.
65. *Yoga-Sutra*, I.10.
66. Ibid. I.11.
67. Ibid. II.18, 24, 25, etc.
68. Ibid. I.45, II.15, III.47.
69. *Prashna-Upanishad*, IV.8.
70. *Panchadashi*, I.20.
71. Dr. Bhagavan Das: *Science of Peace*, pp. 213–14.
72. Ibid. p. 208.
73. *Shiva-Sutra-Vimarshini*, III.I, *Spanda-Karika-Vivriti*, iv.20, *Tantra-Aloka*, ix.
74. *Yoga-Sutra*, iv.9, Bhojavritti.
75. Ibid.
76. Ibid. III.18.
77. Otto Rank: *Trauma of Birth*, p. 80, footnotes.

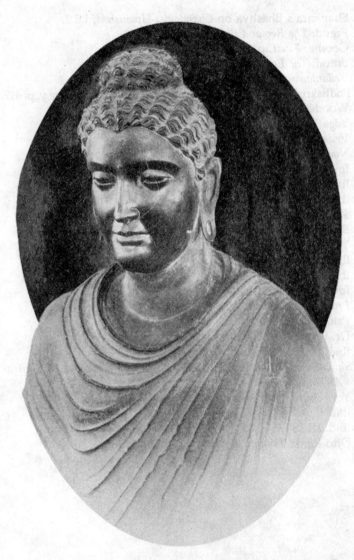

Buddha (Hotimardan)

BUDDHIST PSYCHOLOGY

Dr. Herbert Guenther

The interest in Eastern spiritual life is increasing steadily in the Western world and already many people are fascinated by the teachings of the Eastern sages. The reason is obvious: the Western philosophies are no longer able to meet the needs of the human soul. At the same time, this interest appears like a counter-attack by the East. It would have been astonishing, indeed, if the East had not reacted in some way or other after the West had brought or, to state it more exactly, forced its material civilization upon the East and in so doing brutally interfered with the Eastern organism. The counter-attack has been launched from whence no one would have expected it: the Western world has been attacked by the spirit of the East and is taken hold of by it.

Nevertheless, the Eastern spirit, so different from the Western one that busies itself with external things almost exclusively, is a most precious gift which we must strive to gain before we may say that we own it. It will be gained and owned only when we earnestly try to understand it. The mere belief in words or a simple imitation will not do. That would only be a pitiable misunderstanding and the shortest way to bedlam. In view of what has been said about the Eastern discernments it must, however, be admitted that we are still very far from a true understanding. We have blocked and even made impossible the way to an understanding by a mere word—and this word is called philosophy. Works dealing with Indian philosophy have flooded the book market, but all of them bear traces of the fact that the authors did not get on quite well with the subject-matter. This rests upon the fact that they use the term philosophy in a way which proves that they do not see the difference between Eastern and Western philosophies.

It is true that a definition of philosophy is hardly possible, because every philosopher defines it in his own peculiar way. In one respect, however, philosophers are all of one mind: the aim of all philosophies is to understand the world, especially the outer world, in a better way; to search out the most general causes and principles of things; and, in so doing, to secure a happier world for man. Such a striving for knowledge, characteristic of the extrovert attitude of the West, has been foreign to the Indians throughout the ages. They too strove for knowledge but the direction of their thoughts was different. They were not interested in the Without but in the Within. They wanted to find out what were the hidden forces working within man. This was the reason that the Indian philosophies never departed from religious thinking to such a degree as happened in the West and that Indian thinking always remained a striving and a search for knowledge in a religious sense.

The aim of all the Indian philosophies and sciences which branched off in course of time was Liberation, Illumination. It is, indeed, an indubitable fact that every discernment of the depths of the human soul inevitably takes on the tinge of an awe-inspiring religious experience when a certain stage has been reached. On account of this fact that Indian thinking was differently related to knowledge, what up till now has been termed philosophy is much better called *psychology* or *psycho-technique*, or even *psycho-synthesis*. Since it was Buddhism that deliberately cultivated introspection and made full use of the discernments won by this procedure to an almost unimaginable degree, I prefer to speak of *Buddhist Psychology*.

In the same way as the Western world has been occupied with the Without, has endeavoured to subjugate and master nature, the Eastern world has looked at the possibilities of the development of man's inner nature. The development and actualization of the hidden potentialities of man's nature, that is, to live one's very own life, has

always an *esoteric* character. The term esoteric does not mean something that is concealed from a larger public; every judicious person knows too well that the secret of spiritual development cannot be disclosed, because this development depends upon the faculty of the individual. Nor does the term esoteric mean that spiritual development has been reserved by nature for a few distinguished persons.

Spiritual development, which may also be called a development of personality as the sum total of the individual in a well-integrated fashion or as an adjustment to the higher demands of life, is but the fulfilment of the law of life. It has nothing to do with intelligence; which is not a quality but a modality; it may be achieved even if intelligence is lacking, in which case other factors will be helpful. Nor has the development of personality to do with the intellect. The intellect is not interested in the quality of the discerning and cognizing subject, inasmuch as it thinks only logically. But life is not made up of logic exclusively; much exists which may appear illogical to the intellect. Therefore the development of personality is incommensurable with the intellect which has never been a creator of spiritual worlds.

The existence of the esoteric means only that very few individuals have felt the necessity for developing a personality and for adjusting themselves to the higher demands of life. In so doing they were instantaneously separated from the undifferentiatedness and dullness of the masses. Esotericism means that the individual has become lonely, because he has become a stranger to the conventional ideas by which the masses live. But let no one confound personality with the many unfit who imitate those who under most difficult conditions have worked themselves up to the climax of human destiny! These imitators are despicable and their assumed 'personality' is not convincing.

Esotericism means that the development of personality and the discernment of what lies hidden in the depths of

soul have always been fit only for contemplative people who wanted to know *what* they were living and who wanted to see how the world is born out of the soul. Contemplativeness is not identical with brooding. Brooding is no work but is a vice, it leads to nothing, it is sterile in itself.

The development of personality, however, is a creative process; it is also like entering the realm of the Beyond and, therefore, is inseparably connected with religion. True religion, unlike its ersatz or confession, aims at the Beyond, which is not a state beyond death primarily but a psychological Beyond, freedom from all debasing entanglements, the birth of light in a world of darkness and ignorance. What the world thinks of such a religious experience as the attainment of personality is insignificant. Those who have had this experience have found the inexhaustible treasure that became a source of life, meaning and beauty to them. Because it helps man to live, is there really any other treasure that deserves this name?

The rationalist, stuck in his conventions, cannot understand all this; he is inclined to denounce all that is beyond his faculty of understanding as 'nonsense'. But when is one entitled to declare something as sense and something as nonsense? History has proved that what once was believed to be nonsense has become sense and what once was sense has proved to be nonsense. Furthermore, it has never to be forgotten that between the secret of being and human reason creating limited categories of reality, there is some discrepancy. The human mind with its tool called intellect has achieved much that is extraordinary, but whenever the question of life was involved it has failed to find out the paths that lead to this greatest mystery.

The *psyche* is the object of psychology and unfortunately also its *subject*. This is a deplorable fact that cannot be altered. The necessary conclusion is that mere objectivity written by all sciences in capital letters is absolutely impossible; there is always a subject that makes the statements as

regards an object. In order to comprehend an object totally, man ought to be omniscient, but since man does not know all and everything, every fact, every object still possesses something unknown. If we speak of the totality of an experience, it is restricted to the conscious part of experience. The nature of an object can only be determined as far as the human organism allows it, that is, we are only able to see to the best of our own ability.

Since it is impossible to see merely objectively, it is sufficient if the individual does not see too subjectively and does not conceive the subjective disposition to be a universally valid and fundamental truth. This would be no longer science but belief engendering intolerance and fanaticism. The one subjective disposition has the same range of validity as has the other one, and though it would be very convenient if only one truth prevailed, we have to acquiesce in antinomies and guard ourselves against the mistake of considering the one as a pitiable misunderstanding of the other. Of course, I do not mean that the subjective disposition is a unique phenomenon—in this case it could not be understood at all. On the contrary, it is a well known fact that the opinions of a scientist are shared by many other people, not only because they repeat them mechanically without thinking—this may be so, of course, depending upon human laziness and inclination to indolence—but much more so because they have understood them thoroughly and approved of them.

No science can get rid of the subjective condition of cognizance, least of all psychology, because, as I have said above, in this branch of science subject and object are identical, the one psychic process has to explain the other process. Psychology is only applicable if the scientist is up to the object he wants to explain, that is, he must be able to understand the various points of view, and therefore preconceived theories are fatal; they will assuredly lead him astray. All this implies that science cannot be concerned with dogmatism; only opinions standing on tottering feet

take refuge behind dogmas, while scientific theories are but suggestions as to how a phenomenon may be regarded and have only a heuristic value. It is, furthermore, commonly known that man does not learn by truths exclusively; on the contrary, in practical life he will learn much more by errors. These are not an obstacle to the progress of science. Only conservatism, clinging to discernments once made, and the fear of making mistakes, obstructs the development of sciences. When, having followed up the wrong track, one candidly admits to having gone astray, this confession will be helpful to other researchers.

Science is not made up by a single individual but by many men, and every one is under an obligation to say what he has found on his way; perhaps it will be a fertile soil, perhaps it is but a barren desert. Time will teach what has been useful and what not, but never the personal opinion of one individual. Everything is undergoing probation. Since all sciences are dependent upon the subjective constellation, their aim can only be to formulate laws that are the concise expression for processes which, though they be diverse, yet have been experienced in a uniform way. True science must be like a servant, not like a master; it must be a tool for a wider and better understanding. Strictly speaking, science, this most powerful tool of the occidental mind, has no boundaries at all; wherever one branch of science comes to an end another branch of science must assist in procuring a wider and deeper understanding. This is, above all, necessary for the Buddhist texts which over and again unfold a vast field of spiritual matter before our eyes, and it will certainly not do to reserve those texts for one branch of science and to withhold them from all others, for the simple reason that every science is insufficient in itself and needs the other sciences, equally insufficient in themselves, in order to achieve that practical importance which is needed in life.

Moreover, what has been laid down in the Buddhist texts is of human concern and may become an experience

that is to be taken seriously, although generally the Western mind tends to reject with horror a real sympathy for unfamiliar matters and prefers to classify Eastern spiritual discernments, which have been born out of a thoroughly genuine life, as ethnological or philosophical oddities, out of the reasonable fear that by treating these discernments seriously its own air-tight world, so cautiously built up, might go to pieces. It is, indeed, psychology that assists in understanding the Eastern spirit in a better way, because the human psyche is the central point from whence all and everything has started. The psyche underlies all kinds of thinking, be it philosophical thinking or be it the thinking of a lunatic; and furthermore, the world is not *per se*; on the contrary, it is much more 'as I see it', which again implies psychic activity.

What then is the psyche? The psyche presents such a variety of aspects that it may be viewed from innumerable angles. It presents so many puzzles that it is simply impossible to reduce it to a definite system, and every attempt to do so is not only ridiculous but also the most conspicuous sign of incapacity and inadequacy. The psyche is not limited as are all theories; it is not static but is inseparably connected with the continuity of life, so that, on the one hand, it appears as something created but, on the other, it also appears as something creative. Every psychological moment is but a passing through from the past to the future. It is the one and only immediate reality, and since it is manifesting itself in ever-changing forms it inevitably destroys one-sidedness. Although one-sidedness is very effective in achieving a desired end, it always stresses one aspect only, which may be sufficient for the time being; but whenever the whole is demanded it will fail and it must never be forgotten that one-sidedness overdone will lead to barrenness and torpidity, but not to life.

Here lies the immense difference between Eastern and Western modes of thinking; the Western way of thinking is

analytic, it wants isolated facts; the Eastern way, however, is synthetic, it is not so much concerned with the minutest details but endeavours to comprehend the whole, especially by way of intuition. This attitude, so very different from the Western way of thinking, often creates the impression that the Eastern mind is vague or confused or even unintelligible. It is so only for him who does not or cannot understand that the whole defies all attempts to stretch it on the dissecting-table of the intellect which is but a part of the whole, but one psychic function among many others, and is unable to create a picture of the whole because of its inherent limitations. The comprehension of the whole is beyond all dualistic modes of thinking and reasoning, and cannot be enslaved by formulas set up by the intellect. The Western mind tends to reduce all and everything to some well-known banality or other, the Eastern mind uses symbols which are expressions for dynamic processes and hint at the future.

A psychology that actually deserves the name 'psychology' cannot afford to cling to theories which in advance determine what qualities the psyche must possess. Just as physiology does not consider the human body as figurative only but is convinced of its reality, so also psychology must consider the psyche as a factor *sui generis*. It certainly cannot work on the hypothesis that the psyche is but an epiphenomenon that in some way or other can be reduced to physical or chemical processes. It must take for granted the reality of the psyche which, indeed, is so obvious that only a blind person fails to see it. It is true that actual psychic phenomena cannot be seen through a microscope, and for this reason the rationalist is inclined to deny their reality. Since he is concerned with the outer tangible reality alone, he is unaware of the deep and secret source of all being. His concept of reality is so narrow that for him only what can be produced in a retort may claim the predicate 'real', and consequently he is always eager to derive the within from the without.

But there is absolutely no reason for considering the psyche as a paltry appendage to the material world. Nor are all our activities mere reactions to certain stimuli; on the contrary, they are influenced and directed by most complicated psychic conditions; everybody responds to a stimulus in a different way. The logical 'fact-considering' thinking of the rationalist is often called 'reality thinking' and contrasted with 'fantasy thinking', which is said to be a leftover from childhood; the consequence of a fixation or a recrudescence of childish modes of thought in maturity as a consequence of the blocking by complexes or by the tendency to regression. It is true, 'fantasy thinking' not infrequently presents a morbid character, especially when the individual is unable to assimilate the pictures created by the soul, but the fact should not be overlooked that fantasy is much more often the expression of the highest and most valuable psychic activity. What we call fantasy is perhaps reality for the psyche and may be of overwhelming importance. Has not everything that we call 'real' nowadays existed in fantasy beforehand?

All this only shows that the reality categories set up by the intellect do not hold good for the psyche. 'Everything is outside, in the material objects'—such are the words of the rationalist; 'nothing is outside, nothing is inside'—thus speaks the Buddhist, because he knows that within and without are but the contraries by which the psyche manifests itself, without, however, being emptied into any of its forms. While for the rationalist no value at all attaches to the psyche, because he cannot localize it in any outer object, for the Buddhist the psyche is of immense value—for him it is the vessel of all that is sublime and lowly, it is the awe-inspiring mystery that is beyond words. Therefore the Buddha is said to have uttered the following words:

> The psyche, O Kashyapa, is perceived neither within nor without nor in the midst of these two extremes; the psyche, O Kashyapa, is immaterial, it cannot be seen, it

cannot be run against, it is not an object, it defies all notions, it is not localized anywhere, it has no fixed abode; the psyche, O Kashyapa, has not, is not, and will not be seen by all the Buddhas; how can one say of what has not, is not, and will not be seen by all the Buddhas, that such is its moving about, unless one suffers from illusions!

Or in one of the Tantric works, which are the greatest contribution of Buddhist wisdom to the world, the sublime greatness of the psyche has been spoken of in the following words:

The psyche alone is the germ-cell of all and everything; out of it both the continuation of the world (*saṁsāra*) and the Nirvāna come to light. Worship what is like the wish-fulfilling gem! It grants all boons.

And,

Friends, do know that the variety of the world is but a manifestation of the psyche.

But best of all, the grandeur of the creative power of the psyche is expressed by Anangavajra, who states that:

The possessor of the adamantine nature calls the world of woe a manifestation of the psyche when it is overwhelmed with the darkness of manifold false thought-constructions, as fickle as a flash of lightening in a storm and besmeared with the dirt of craving and the like not easily to be removed.
But he also calls it the excellent Nirvana when it is radiant and free from thought-constructions, when it is devoid of the ointment of the dirt of craving and the like; which cannot be known and does not know and is the highest reality.

Therefore there is nothing more sublime than the psyche. It is the foundation of multiple woes; it is the cause of the rise of infinite bliss. You who strive for liberation must know that there is nothing more sublime than the psyche.

With these words he continues an old tradition, for the Buddhists knew and were convinced that out of the psyche something useful may come, in opposition to a widespread notion in the Western world that out of the soul, which is called divine and immortal, only the most vile things can spring up. Being for ever at work, the psyche is like an artist creating manifold works (karman), but these works become snares and traps that cause man's downfall so that he gets entangled in everyday life, attaches himself to the objects of the world and finally is engulfed by them. Then the psyche acts like a terrible demon preying on its victims and devouring them; for, destruction is the inevitable companion of creative play. Therefore the Kāshyapaparivarta exclaims: 'The psyche, O Kashyapa, is like an artist, because it creates works of many kinds', and 'The psyche, O Kashyapa, is like a life-sucking ogre, because it always goes out marauding.'

Since the psyche is of such an overwhelming import for the life of man, it is absolutely impossible to derive it from simple formulas, or even to outline with certainty the range of what may be experienced. Although it is thought to be 'scientific' when the psyche is derived from physical processes, when, in a sense, the psyche is thought of as a secretion of the brain, because sound psychic functions are connected with an unimpaired brain, and although this materialistic nonsense is fervently believed, it is no less nonsensical to consider the psyche as a mere reflex phenomenon that has not the slightest autonomy in its working. The psyche copies our empirical world only partly, while for the grater part it moulds those pictures according to the psychic disposition and in so doing describes in which way

the physical process together with all its accompanying circumstances is experienced by the psyche. Sometimes it acts in such a sovereign way that the tangible reality is simply ignored or cannot be recognized. Only partly does every comprehension of an object start from the objective mode of the object; much more does it start from intro-psychic facts, especially when consciousness has not yet attained a very high degree of brightness, as is the case with all primitive people, so that what is subjective and what is objective penetrate each other indiscriminately.

The psyche is, furthermore, not identical with con-sciousness or ego, which is but a segment out of the whole of the psyche and for ever exposed to perturbations that come out of the invisible, yet real and effective, field called the unconscious. Although the concept of the unconscious has been much contested, it will be reorgarized at once that there are many instances of conscious processes appearing in the stream of consciousness which are totally inexplicable in terms of any of the preceding conscious processes. Inspirations, sudden notions and the spontaneous occur-rence of ideas are good examples of such apparently uncaused processes. The course of consciousness is always too seriously interrupted to be thought of as a continuum, and it is these very gaps that are filled by the unconscious.

It is a peculiarity of consciousness that it believes itself to be free and independent, to be its own master; and, indeed, without this feeling of independence and freedom there could be no ego-consciousness. In reality, however, this freedom is illusory, because everybody has his own psychic disposition out of which everything arises and which limits freedom considerably. Since consciousness is always ego-centric—without an ego there is no conscious-ness—it has the tendency to claim proprietorship and authorship of its contents and tries to suppress or repress whatever it considers to be unsuitable. There is, however, no idea or opinion that has not historical antecedents dating back to times where consciousness was not yet of a thinking

nature but merely of a perceiving order. Thus ideas were objects of intropsychic perception, they were not thought but perceived like an apparition. And since they were forced upon the subject and had the character of an immediate fact, they were instantaneously convincing. To the primitive men as well as to many modern men thinking is pre-existent to consciousness, and consciousness is much more the speaking-tube than anything else, so that the subject is more or less the exponent of the ideas but not their creator.

Nevertheless, in course of time consciousness has succeeded in forming abstract notions, and in the form of knowledge (not wisdom!) it has attained an extension that seems to be immense. Together with this development the ego has won greater confidence in itself and established its position more safely; but since it is a late product of differentiation out of the whole of the psyche, its fortress is liable to be besieged and taken by storm, as can most easily be seen from the effects of the emotions which carry the ego away with them, let alone obsessions, compulsive acts, motor agitations and other seizures, which formerly were thought of as a manifestation of demoniac possession or looked upon as a manifestation of divine presence.

In the psyche, therefore, there is always something that takes possession of the ego. And in order to conceal this painful fact and in order to inspire ourselves with courage we have become accustomed to say, 'I have the inclination or the habit of doing so', instead of stating truthfully, 'The inclination or the habit has taken possession of me and compels me to do so.' The more consciousness gains in strength, its feeling of autonomy considerably increased thereby, the more it tends to repress and shut off what has been its source and what has kept it under control. In so doing, however, it forces all that which has been suppressed and not acknowledged by it to revolt, and consequently it will pay for its *hubris* with catastrophes of the worst and most disastrous kind, as everybody knows who has had occasion to observe the growth and development of a serious neurosis.

At different times the freedom and dependence of consciousness has been stressed differently, because in actual life both these factors are co-existent. Buddhism has stressed the dependence of consciousness on its source, the unconscious, most explicitly and has been concerned more with the genetic aspect of consciousness than with actual consciousness. The Buddhists saw and knew that consciousness is not created by itself but springs up out of unknown depths which influence it greatly, and this influence is the stronger the less the individual is aware of these powers. It would, however, be erroneous to assume that the Buddhists were obliged to adopt such a point of view because of an extraordinary need for 'causal explanations'. The causal method of explanation, accepted as universally valid and permitting no exceptions, is but an infringement of an unrestricted rationalism. There is absolutely nothing that might be explained by causality exclusively. Such a view is narrow and prejudiced, and overlooks the dynamic forces working in every phenomenon which needs a final mode of explanation as well. If causality alone were sufficient, life would be superfluous and the living individual would be irrelevant, he might as well be dead; but since he is very much alive—and so is every psychic phenomenon—it is simply impossible to 'explain' a fact by reducing it to some well-known banality.

Everything stands between the past and the future, and the future is sometimes much more important than the past. By applying a final or teleological mode of explanation the 'causae' are by no means denied; on the contrary, they are only put in their proper place. The facts are the same but a different standard has been applied to them, a standard that is more appropriate to their nature. The causal explanation is valuable to some degree, but it needs the final mode of explanation for completion and correction. The stress is laid upon causality, and explanation by causality alone, adopted by the rationalist, seems to be but the expression of his anxiety to face the future. He is behind the times in the true sense of the word.

That form which consciousness has developed in course of time through the greatest struggles in the unconscious possesses a certain kind of autonomy, being at the same time highly creative and not subject to the arbitrary rule of consciousness. It is certainly no mere absence of consciousness, in which case it would be unable to produce certain effects. Although it is not ratiocinative like consciousness, its subtle processes are most effective for the whole of the individual, as is everything that participates in the secret powers of nature. In it there lie latent potentialities (*bījas*) which assign the clearly defined way to every psychic process. Out of these potentialities there result the specific modes of selection and formation of apperception. They are, as the name implies, functional patterns without any specific content; the specific content will be met with in individual life only when the personal experiences are received by these very patterns. The functional patterns, however, are nothing rigid but something very much alive, always assuming a new shape, ever entering new constellations embedded in the incessant stream of life. Therefore the unconscious has been aptly compared with an ocean, its waves being the sensory (actual) consciousnesses which have taken on their peculiar shape (content) under the influence of the objects acting like a storm lashing these very waves.

'Just as the waves of the ocean stirred up by the wind continue to dance, no interruption being known, so also the unconscious (*ālayavijñāna*) always agitated by the storm-like objects continues to dance with the various wavelike consciousnesses.'

'The transformation of the ocean is the manifold shapes of the waves. In the same manner the unconscious continues (to be active in the form of the) various consciousness.'

'In the same way as there is no (essential) difference between the ocean and its waves, so also an (essentially different) transformation into the (sensory) consciousnesses does not obtain within the psyche.'

As long as consciousness is dependent upon and, in a sense, still contained in the infinite reservoir of the unconscious, problems as to why and how something should be done do not exist, and the individual feels safe and secure. This feeling of security will last until something disturbs this heavenly peace, until circumstances crop up which demand higher attainments, and if formerly, in a world of relatively unchanging conditions, instinctivity was quite sufficient, now troubles arise which are basically attributable to maladjustment, to the appearance of conflicting and unsuitable responses, and especially to the course of cognitive and emotional experiences.

The remarkable fact that consciousness has developed and does exist is of far-reaching consequence. Every step taken by consciousness, even the smallest one, creates and changes the world, it creates the contraries, for there is no conscious state where contraries do not exist and are not discriminated. And as soon as the contraries have come into existence the former feeling of security is shattered. New possibilities have arisen and the individual is forced to select the one way or the other. At this very moment the individual is alone, nobody can help him and he must choose for himself and venture the step that will lead him either through darkness to light or to fatal ruin. In order that he may take this step he must be aware of the fundamental facts that consciousness is not the only master and that, when he adopts the one position regardless of what the other side has to say, this other side will revolt and finally devour its adversary.

What then has the individual to do in order to achieve that unity which is considered the best expression of his individual personality and where the conflict has ceased to rage within him? In order to answer this question we must first consider these individual differences which have been termed extroversion and introversion and are characteristic of persons who in these respects fall within the extremes of a normal distribution, mostly in the upper and lower

quartiles. Of course, there are many gradations in between, but the distinct character of these two extreme features assist greatly in understanding not only Buddhist psychology but also what has to be done by the individual in order to avoid the extremes and find the Middle Path.

Extroversion designates a habitual or predominant interest in that which is commonly classified as external, in external objects and events. The extrovert lives all the time in a way that corresponds to objective conditions and their demands. His subjective opinions rank lower than the objects. His consciousness is focussed upon the without, because everything that is decisive for him comes from the external objects and events, and because he expects the decisive factor to come from without. But he runs the risk that he will be attracted by the external objects or events to such a degree as to get lost in them. Becoming absorbed in a thing seems to him to be the proper and most ideal adjustment. This is, however, by no means true, for an external object or event need not necessarily be normal; even in the best possible case it is only valid for the time being. And although he seems to be normal when absorbed by the objects, he is nevertheless abnormal as regards the laws of life, he has no foothold whatever as far as his personality is concerned. Therefore he is not adjusted at all, because adjustment does not mean to be carried away by or to partake in a temporarily valid fashion without reserve.

While extroversion thus denotes the getting absorbed in external events, the being preoccupied with what is without, introversion designates a habitual or predominant interest in the things within. The introvert acts by starting from the psychic structure that is inherent to the individual but never identical with the ego of the subject; on the contrary, this structure exists before an ego has developed at all. He will always superimpose the subjective psychic factor on the objective one. And in the same way as the extrovert runs the risk of identifying himself with external

objects or events and of becoming absorbed in a thing, in his business for instance, so also the introvert always tends to press the pre-existent psychic structure into his ego and make his ego the subject of the psychic processes, in this way subjectivating his consciousness to such a morbid degree as to become alienated from the objects. Therefore he also has no foothold whatever.

The result is the same in both the cases: consciousness has become inflated to such a degree as to be unable to learn from the past, to comprehend what is taking place at present, and to draw the necessary conclusions for the future. Oblivious of their true nature, both the extrovert and the introvert get wrong notions as to their real nature, believing that their true nature is either the absorption into the external events or objects, or the absorption into the internal psychic structure, and out of this there results the peculiar concept of man's true nature which I have called the Atman complex.

The two extremes, extroversion and introversion, are easily recognizable in Sthiramati's discussion of the Atman problem. He observes as follows:

> The view that the groups to which one supposes oneself to belong (upādānaskandha) are the Atman is called the Atman view (Atman complex); it is identical with the view that the human body is one's true nature. Infatuation means not having true knowledge, therefore not having true knowledge of the Atman is called infatuation as to the nature of the Atman. Delusion persisting in spite of normally convincing contradictory presentations as to the object deemed to be Atman (i.e. the identification with or absorption in an object) is called delusion as to the nature of the Atman; it is identical with the (illusory statement) 'I am' (that is, the individual takes an enormous pride in magnifying its speciality and loudly proclaims to the world that it is for ever fixed in its uniqueness). Attach-

ment to the Atman is being attached to the Atman devotedly, and is identical with love for the Atman.

Having wrong notions as to the intrinsic nature of the psychic structure (*ālayavijñāna-svarūpa*), the individual adopts the view that this structure is the Atman. The inflation of consciousness starting with the Atman view (Atman complex) is called the illusory statement, 'I am'.

Since man's nature cannot be found either in the absorption into the external objects or in the identification with the pre-existent psychic structure, and since both these alternatives lead the individual away from himself and are, consequently, to be rejected as a means of attaining one's true nature, the individual is forced to seek a way out of this dilemma by other means. But to do so is the most difficult task, it demands everything from him, if what is to be achieved shall not be but a patched-up solution or a shoddy compromise. Every step forward and every acquisition on this way is made under the greatest difficulties and infinite pains. Torturing uncertainty precedes every step and dangers are lurking everywhere. But at the same time, this very uncertainty means the possibility of an enlargement of consciousness, the possibility of piercing the dark veil of ignorance or state of insufficient consciousness (*avidyā*), and of approaching light.

In order to get out of this uncertainty the individual cannot do otherwise but replace what has formerly been done by nature or mere instinctivity by conscious decisions. And in order to come to conscious decisions and to a suitable solution of the problem the individual must have recourse to reflection and thereby come to an understanding with what he has seen and discerned. For it is only by understanding the forces working in man that he escapes from the danger of succumbing to them. But as soon as he begins to reflect on what is taking place, he becomes aware of the fundamental facts of his soul, and then he is no longer the shuttlecock of

the dark powers, but by being able to choose and to decide he goes his way consciously and is aware of what he does. Therefore, when the Buddhists stressed the dependence of consciousness upon the unconscious, they took care that the contraries never lost sight of each other and that actual psychic catastrophes were avoided.

This constant neighbourhood of the contraries corresponds to the primitive mentality from which Indian reasoning has developed uninterruptedly and, therefore, the malformation of whatever there may be of instincts has been absent. But since they felt the conflicting tendencies which have ever dragged man into extreme attitudes, have entangled him in the world, be it the spiritual one or be it the material one, and which in so doing have set him wavering and departing from his true nature, they went out to seek that way which would lead them out of this conflict, and developed a method to this end, which when applied in the right way by the right man was destined to guarantee true life.

By seeing and by becoming aware of the contraries, man is enabled to grasp the value of what he formerly believed to be worthless, to perceive the error of his former one-sided attitude, and to choose for himself. It would, however, be erroneous to assume that this value is absolutely extinct in the moment that the individual has succeeded in discovering that no value is absolute but that in it there is also something worthless, so that he is constrained to cast it away and plunge head over heels into its contrary. If the individual does so, he will inevitably pay for his folly.

What is meant by pointing out and seeing that everything that exists is not only valuable but at the same time also worthless is that all that exists is but relative. And by comprehending the relativity of all existing factors and by living up to such a standard whereby what formerly has been of value to the individual is preserved as well as what is formerly thought to be worthless is acknowledged as

having some value also, in this way gaining a wider experience and a deeper knowledge—perhaps I should say wisdom—,a more comprehensive consciousness that sees things in a different light springs up, and the individual's centre of gravity is shifted from the extremes to the middle and the former unbalanced state is done away with. The egocentric attitude has been given up in favour of one that indeed comprises the ego but at the same time leaves nothing out. Finding this centre designates the creation and development of the primordial totality. It is, as it were, an omnipresence of consciousness, Nirvana, the cessation of all conflicts, a state beyond and above the contraries. It is, indeed, man's true nature and final goal, it is the right adjustment both to the within and the without. It is the most individual fact and the most universal fulfilment of whatever sense there is in life for a human being.

The development of man towards this goal is the most difficult task. Everything depends upon the individual himself in this case. He alone must strive assiduously that he may win the distant goal which can never be imparted to him by education, because this goal is beyond and even opposed to all conventions to which the individual is trained by ordinary education and society. Of course, I do not intend to disparage education, but what is the use of an education that ignores the needs of the human soul! A vast amount of knowledge has been imparted to the Western mind, but unfortunately not wisdom, and this burden the Western mind has not been able to utilize for spiritual progress. On the contrary, it has led the Western mind into utter devastation. The goal for the attainment of which the Buddhist sages spent the best years of their lives cannot be copied and distributed like a mass article at a cheap price, because it is something that will grow within and only be experienced by the individual who lives up to it. This goal is perhaps the only truth that deserves this name and it certainly is no topic which can be discussed at a tea-party or at an intellectual meeting.

The problem concerning this goal does not consist in finding an intellectual answer but in finding the way which will lead to an experience of what cannot be expressed by words. Because words will either limit or exclude. But such experiences as cannot be compressed in a rationalistic formula are in most cases the very best ones. The fundamental error is that most people believe in definite statements which will shed the necessary light and which will except them from the painful necessity of working hard for themselves and giving up their paramount virtue—laziness. Only what has become the inmost experience is worthwhile, everything else does not count, is but a burden, and useless to the utmost degree. The experience of totality, inaccessible to discerning reason, is the most precious one and, since it cannot be 'made' like an article, it cannot be labelled or be found outside in external objects. Therefore Anangavajra, speaking of man's final goal, is right in stating:

> Even the Buddhas cannot say, 'Such is this.' It is not found in the outer objects, because it is to be experienced within one's inmost self.

Buddhist psychology has always had a teleological character, and since the Buddhists have always endeavoured to find this unspeakable experience of totality, which is the *summum bonum*, bliss, they have viewed everything in the light of this most wondrous and mysterious goal. And since their attitude and course of thinking has been synthetic and not reductive, they have never made the mistake of overestimating or exaggerating a single psychic function, for every sort of onesidedness leads away from totality. Psychology was not an end in itself for them but was a means for approaching the final goal. Although this goal cannot be proved or demonstrated scientifically by experiments, yet it has for ever been effective in the human soul, and it seems as if psychic life in the end makes for this goal, for life is a stream into the future and not a stagnant backwater,

What has been described in the Buddhist texts are undoubtedly psychic processes that have been and are to be experienced. Since that sort of modern psychology which has to do with the actual human soul and not with preconceived theories about the psyche opens up the possibility of understanding what takes place in the psyche, I have approached the Buddhist problems from a psychological point of view. I must expressly state that I have no theories at all about these psychic processes and I do not know into what isms the practical discernments of the Buddhists may be pressed; nor am I interested in them, because everything that is alive and effective cannot be pressed into dead formulas.

And since these discernments have a thoroughly dynamic character, my only aim was, and can but be, to build a bridge of understanding, not only because understanding the Eastern spirit is more important and more valuable than we may think at the moment, but also because by understanding what took place in the psyche of the Buddhists I may be enabled to gain similar experiences, which will enrich and enlarge my outlook on life. This could never be the case if I had a fixed theory about these discernments which, since they lie beyond the limit of the experimental, can only be 'explained' approximately, even if such an explanation be a very acceptable approximation. For, every preconceived theory, especially if it operates with notorious isms, is the best trade-mark for ignorance and insufficient experience. The results are narrow-mindedness, superficiality and barrenness.

Since, as I have pointed out, everything that is alive and concerned with the future cannot be reduced to formulas or terms devised by the intellect, I have refrained from translating the Buddhist terms by a single word, because any fixed translation would be absolutely misleading. The Buddhists have described complex processes of the psyche for which we have no adequate terms, for the simple reason that we have not in general had corresponding

experiences, although they are accessible to him who has to do with the actual psyche of the individual. The meaning of every psychological term in the Buddhist text can only be inferred from a careful reading of the context, and for this reason I have restricted myself to describing those phenomena of which the Buddhists are speaking. Such a procedure is more scientific than starting from some preconceived theory or other and, when something does not fit into it, declaring that the reasoning of the other party is open to doubt. The psychological discernments of the Buddhist sages are not a heap of absurdities; on closer inspection they prove to be downright consequential.

Section II

ART, CULTURE, RELIGION

NEW FORMS OF IDOLATRY

Aldous Huxley

Educated persons do not run much risk of succumbing to the more primitive forms of idolatry. They find it fairly easy to resist the temptation to believe that lumps of matter are charged with magical power, or that certain symbols and images are the very forms of spiritual entities and, as such, must be worshipped or propitiated. True, a great deal of fetishistic superstition survives even in these days of universal compulsory education. But though it survives, it is not regarded as respectable; it is not accorded any kind of official recognition or philosophical sanction. Like alcohol and prostitution, the primitive forms of idolatry are tolerated, but not approved. Their place in the accredited hierarchy of spiritual values is extremely low.

Very different is the case with the developed and civilized forms of idolatry. These have achieved, not merely survival, but the highest respectability. The pastors and masters of the contemporary world are never tired of recommending these forms of idolatry. And not content with recommending the higher idolatry, many philosophers and many even of the modern world's religious leaders go out of their way to identify it with true belief and the worship of God.

This is a deplorable state of affairs, but not at all a surprising one. For, while it diminishes the risk of succumbing to primitive idolatry, education (at any rate of the kind now generally current) has a tendency to make the higher idolatry seem more attractive. The higher idolatry may be defined as the belief in, and worship of, human creation as though it were God. On its moral no less than on its intellectual side, current education is strictly humanistic and anti-transcendental. It discourages fetishism and primitive

idolatry; but equally it discourages any preoccupation with spiritual Reality. Consequently, it is only to be expected that those who have been most thoroughly subjected to the educational process should be the most ardent exponents of the theory and practice of the higher idolatry. In academic circles, mystics are almost as rare as fetishists; but the enthusiastic devotees of some form of political or social idealism are as common as blackberries. Significantly enough, I have observed, when making use of university libraries, that books on spiritual religion were taken out much less frequently than in public libraries frequented by persons who had not had the advantages, and the disadvantages, of advanced education.

The many kinds of higher idolatry may be classified under three main headings: technological, political and moral. Technological idolatry is the most ingenuous and primitive of the three; for its devotees, like those of the lower idolatry, believe that their redemption and liberation depend upon material objects, namely, machines and gadgets. Technological idolatry is the religion whose doctrines are explicitly or implicitly promulgated in the advertising pages of newspapers and magazines—the source from which millions of men, women and children in the capitalist countries now derive their philosophy of life. In Soviet Russia, during the years of its industrialization, technological idolatry was promoted almost to the rank of a state religion. More recently, the coming of war has greatly stimulated the cult in all the belligerent countries. Military success depends very largely on machines. Because this is so, machines tend to be credited with the power of bringing success in every sphere of activity, of solving all problems, social and personal as well as military and technical.

So whole-hearted is the faith in technological idols that it is very hard to discover, in the popular thoughts of our time, any trace of the ancient and profoundly realistic doctrine of Hubris and Nemesis. To the Greeks, Hubris

meant any kind of over-weening and excess. When men or societies went too far, either in dominating other men and societies, or in exploiting the resources of nature to their own advantage, this over-weening exhibition of pride had to be paid for. In a word, Hubris invited Nemesis. The idea is expressed very clearly and beautifully in 'The Persians' of Aeschylus. Xerxes is represented as displaying inordinate Hubris, not only by trying to conquer his neighbours by force of arms, but also by trying to bend nature to his will more than it is right for mortal man to do. For Aeschylus, Xerxes's bridging of the Hellespont is an act as full of Hubris as the invasion of Greece, and no less deserving of punishment at the hand of Nemesis. Today, our simple-hearted technological idolaters seem to imagine that they can have all the advantages of an immensely elaborate industrial civilization without having to pay for them.

Only a little less ingenuous are the political idolaters. For the worship of tangible material objects, these have substituted the worship of social and economic organiza-tions. Impose the right kind of organizations on human beings, and all their problems, from sin and unhappiness to sewage disposal and war, will be automatically solved. Once more we look almost in vain for a trace of that ancient wisdom which finds so memorable an expression in the 'Tao Te Ching'—the wisdom which recognizes (how realistically!) that organizations and laws are likely to do very little good where the organizers and law makers on the one hand and the organized and law-obeyers on the other are personally out of touch with Tao, the Way, the ultimate Reality behind phenomena.

It is the great merit of the moral idolaters that they clearly recognize the need of individual reformation as a necessary pre-requisite and condition of social reformation. They know that machines and organizations are instruments which may be used well or badly according as the users are personally better or worse. For the technological and political idolaters, the question of personal morality is

secondary. In some not too distant future—so runs their creed—machines and organizations will be so perfect that human beings will also be perfect, because it will be impossible for them to be otherwise. Meanwhile, it is not necessary to bother too much about personal morality. All that is required is enough industry, patience and ingenuity to go on producing more and better gadgets, and enough of these same virtues, along with a sufficiency of courage and ruthlessness, to work out suitable social and economic organizations and to impose them, by means of war or revolution, on the rest of the human race—entirely, of course, for the human race's benefit. The moral idolaters know very well that things are not quite so simple as this, and that, among the conditions of social reform, personal reform must take one of the first places. Their mistake is to worship their own ethical ideals instead of worshipping God, to treat the acquisition of virtue as an end in itself and not as a means—the necessary and indispensable condition of the unitive knowledge of God.

'Fanaticism is idolatry.' (I am quoting from a most remarkable letter written by Thomas Arnold in 1836 to his old pupil and biographer-to-be, A.P. Stanley).

> Fanaticism is idolatry; and it has the moral evil of idolatry in it; that is, a fanatic worships something which is the creation of his own desires, and thus even his self-devotion in support of it is only an apparent self-devotion; for in fact it is making the parts of his nature or his mind, which he least values, offer sacrifice to that which he most values. The moral fault, as it appears to me, is the idolatry—the setting up of some idea which is most kindred to our own minds, and the putting it in the place of Christ, who alone cannot be made an idol and inspire idolatry, because He combines all ideas of perfection, and exhibits them in their just harmony and combination. Now, in my own mind, by its natural tendency—that is, taking my mind at its

best—truth and justice would be the idols I should follow; and they would be idols, for they would not supply *all* the food which the mind wants, and whilst worshipping them, reverence and humility and tenderness might very likely be forgotten. But Christ Himself includes at once truth and justice and all these other qualities too...Narrow-mindedness tends to wickedness, because it does not extend its watchfulness to every part of our moral nature, and the neglect fosters the growth of wickedness in the parts so neglected.'

As a piece of psychological analysis this is admirable, so far as it goes. But it does not go quite far enough; for it omits all consideration of what has been called grace. Grace is that which is given when, and to the extent to which, a human being gives up his own self-will and abandons himself, moment by moment, to the will of God. By grace our emptiness is fulfilled, our weakness reinforced, our depravity transformed. There are, of course, pseudo-graces as well as real graces—the accessions of strength, for example, that follow self-devotion to some form of political or moral idolatry.

To distinguish between the true grace and the false is often difficult; but as time and circumstances reveal the full extent of their consequences on the personality as a whole, discrimination becomes possible even to observers having no special gifts of insight. Where the grace is genuinely 'supernatural', an amelioration in one aspect of personality is not paid for by atrophy or deterioration in another. Virtue is achieved without having to be paid for by the hardness, fanaticism, uncharitableness and spiritual pride, which are the ordinary consequences of a course of stoical self-improvement by means of personal effort, either unassisted or reinforced by the pseudo-graces which are given when the individual devotes himself to a cause, which is not God, but only a projection of one of his own favourite ideas. The idolatrous worship of ethical values in and for themselves

defeats its own object—and defeats it not only because, as Arnold rightly insists, there is a lack of all-round watchfulness, but also and above all because even the highest form of moral idolatry is God-eclipsing, a positive guarantee that the idolater shall fail to achieve unitive knowledge of Reality.

TWO GREAT SOCIAL CHANGES
OF OUR TIME

Dr. Pitirim A. Sorokin

A successful growth of Sri Ramakrishna and of the Vedanta movements in the West is one of many symptoms of two basic processes which are going on at the present time in the human universe. One of the these changes is the epochal shift of the creative centre of mankind from Europe to the larger area of the Pacific-Atlantic, while the other consists in a double process of continued decay of sensate culture and society and of the emergence and growth of the new—Integral or Ideational—socio-cultural order.

We all know that up to roughly the fourteenth century the creative leadership of mankind was carried on by the peoples and nations of Asia and Africa. While our forefathers in the West were still in the stage of the most primitive way of life and culture, in Africa and Asia the great civilizations—the Egyptian, the Babylonic, the Iranic, the Summerian, the Hittite, the Hindu, the Chinese, the Mediterranean (the Creto-Mycenaean, the Greeco-Roman, the Arabic) and others—emerged, grew, and fluctuated in their repeated blossoming and decay for millennia. The Western, Euro-American, peoples were the latest in entering and then carrying on the creative leadership of mankind. They became such a leader only in the fourteenth or even the fifteenth century; and so far, they carried this torch only during the last five or six centuries. During this short period of the Western leadership, they discharged their creative mission brilliantly, especially in the fields of science, technology, sensate fine arts, politics, and economics.

At the present time, however, the European leadership shows the unmistakable signs of fatigue and exhaustion of

its creative forces for the present and the near future. As a matter of fact, European monopolistic leadership can be considered as definitely ended: the creative centre of human history is already shifting to a different and much larger area of the Pacific-Atlantic. The present and the future history of mankind is not going to be centred in and around Europe, as it has been for the last few centuries, but will be staged on a much larger scenery of Asiatic-African-American-European cosmopolitan theatre. And the stars of the next acts of the great historical drama are going to be: the Americas, the renascent great cultures of India, China, Japan, the Arabic world, Russia, and Europe, if it would be able to unite itself into one peaceful union.

This epochal shift is already under way and is rapidly moving from day to day. It has manifested itself in the dissolution of the great European empires like the British and the French, in the decreasing political and cultural influence of Europe in the international relationships, in the shift of creativity of several European nations to other continents: the Anglo-Saxon to the United States, Canada, Australia; the Spanish and Portuguese to the Latin America; in the creative growth of the Asiatic Russia in comparison with its European part, and so on. A still stronger manifestation of this shift is the unquestionable renaissance of the great cultures of Asia and Africa: the Indian, the Chinese, the Japanese, the Indonesian, the Arabic, and others. This renaissance lies at the basis of a successful liberation of these nations from Colonial servitude. It has shown itself in a rapid growth of their political and social independence and of their influence in international affairs; in a successful diffusion of their religious, philosophical, ethical, artistic, and cultural values (including the diffusion of Sri Ramakrishna and the Vedanta movements) in the Western world; and of many other phenomena.

All these and a legion of other evidence make the fact of the great shift of the creative leadership of mankind from Europe to Americas, Asia, and Africa fairly certain. Though

in Russia and China the shift has temporarily assumed a somewhat ugly form of Communistic Totalitarianism, this form, however, is to be viewed as a kind of 'the socio-cultural measles' of their renaissance process. The 'measles' are bound to be quite temporary and will pass, as they pass in a growing child; but the basic renaissance process will continue with all its epochal consequences for the whole humanity. Such is the first basic process of which the Sri Ramakrishna movement is one of the symptoms.

The other process is possibly still more significant for the present and the future of mankind. It consists in a double process of (a) continued decay of the sensate culture of the West, and (b) emergence and slow growth of a new socio-cultural order—Ideational or Integral—as the dominant order of the future.

Some thirty years have now passed since the time when I ventured to diagnose the present state of the Western culture, and then to make several forecastings of its future trends. The diagnosis, made at the end of the nineteen-twentieths, stated that the sensate form of the Western culture and society, dominant during the last five or six hundred years, was disintegrating; that the Western world was in the state of the total crisis in which all compartments of its culture, all its main values, the very bases of its social organization, the dominant type of the Western personality and of the way of life, were crumbling; and that, as a result of this greatest total crisis, we should expect an extraordinary explosion of wars, bloody revolutions, destruction, misery, liberation in man of the 'worst of beasts', and many other pregnant consequences. In considerable detail, I ventured to predict many specific trends (later on fully published in four volumes of my *Social and Cultural Dynamics and Crisis of Our Age*) of this epochal decay of sensate dominant order and of a probable new order that had to replace it.

In the gaudily-optimistic atmosphere of the nineteen-twentieths, this sort of diagnosis and predictions were

naturally 'a voice crying in the wilderness' and appeared to many as 'loony', 'crazy', 'impossible', 'improbable', and entirely 'wrong'. Despite this inimical reception of my diagnosis and predictions on the part of the prevalent opinion of that time, the diagnosis and the predictions have come to pass even earlier than I expected myself. At the present time everyone knows that mankind is in the state of a greatest crisis, though most of the people still do not know exactly its real nature, and its how and why.

In accordance with my diagnosis and prognosis of the Crisis, the central process for the last few decades has consisted in (a) a progressive decay of sensate culture, society, and man, and (b) in an emergence and slow growth of the first components of the new—ideational or idealistic—socio-cultural order.

In science this double process has manifested itself in (a) the increasing destructiveness of the morally irresponsible, sensate scientific achievements, of invention of nuclear, bacteriological, and other Satanic means of destruction of man of all main values; and (b) in a transformation of the basic theories of science in a morally responsible, ideational or idealistic direction. This change has already made today's science less materialistic, mechanistic and deterministic—or less sensate—than it was during the preceding two centuries.

For this modern science, matter has become but a condensed form of energy which dematerializes into radiation. The material atom is already dissolved into more than thirty non-material, 'cryptic, arcane, perplexing, enigmatic, and inscrutable' elementary particles: the electrons and anti-electron, the proton and the anti-proton, the photon, the mesons, etc., or into 'the image of waves which turn out into the waves of probability, waves of consciousness which our thought projects afar...These waves, like those associated with the propagation of light quanta, need no substratum in order to propagate in space-time; they undulate neither in fluid, nor in solid, nor

yet in a gas.' Around a bend of quantum mechanics and at the foot of the electronic ladder the basic notions of 'materialistic and mechanistic science' such as matter, objective reality, time, space and causality are no longer applicable, and the testimony of our senses largely loses its significance. As to the deterministic causality, it is already replaced in the modern science by Heisenberg's principle of uncertainty, by fanciful 'quanta jumps', by a mere chance relationship or—in psycho-social phenomena—by 'voluntaristic', 'free-willing law of direction' exempt from causality and chance.

Similar transformations have taken place in the new, leading theories of biological, psychological and social sciences. In contrast to the superannuated, though still intoned, cliches of mechanistic, materialistic and deterministic biology, psychology and sociology, the rising, significant theories in these disciplines clearly show that the phenomena of life, organism, personality, mind and socio-cultural processes are irreducible to, and cannot be understood as, purely materialistic, mechanistic and sensory realities. According to these theories, they have, besides their empirical aspect, the far more important—mindfully-rational and even supersensory and superrational— aspects. In these and other forms the most modern science has already become notably ideational or idealistic in comparison with what it was in the nineteenth century. This means an increasing replacement of the dying sensate elements of science by the new—idealistic or ideational—ones.

In the field of philosophy this double process has manifested itself in increasing sterility and decline of recent materialistic, mechanistic, 'positivistic' and other sensate philosophies, and in the emergence and growth of 'the Existential', 'the Integral', 'the Neo-Mystical', 'the Neo-Vedantist', and other philosophies congenial to the basic principles of Ideationalism or Idealism.

A similar double process has been going on in all fields of fine arts.

In the realm of religion it has shown itself in the simultaneous growth of (a) militant atheism, and (b) religious revival.

In ethics it has called forth (a) utter bestiality and horrible demoralization shown in the second World War, bloody revolutions, and increasing criminality, and (b) growth of moral heroism, sublime altruism, and organized movements for abolition of war, of bloody strife, and of injustice.

In politics the double process has resulted in (a) proliferation of all kinds of tyrannical dictatorships, and (b) the slowly swelling grassroots movement for establishment of a competent, honest and morally responsible government of the people, by the people, and for the people.

This struggle between the forces of the previously creative but now largely outworn sensate order and the emerging, creative forces of a new—ideational or idealistic—order is proceeding relentlessly in all fields of social and cultural life. The final outcome of this epochal struggle will largely depend upon whether mankind can avoid a new world war. If the forces of the decaying sensate order start such a war, then, dissipating their remaining energy, these forces can end or greatly impede the creative progress of mankind. If this Apocalyptic catastrophe can be avoided, then the emerging creative forces will usher humanity into a new magnificent era of its history. Which of these alternative courses is going to take place depends tangibly upon every one of us.

THREE KEY ANSWERS TO
THREE KEY QUESTIONS

Gerald Heard

There is no more striking way in which the teaching of the saints reaches our hearts than in their sudden answers to really searching questions. Three of such answers are given in the following lines. It should be possible to make a collection of such pointers as might be of great value to souls who happen to have reached some turning point in their lives. The three authorities here quoted are very different, yet their replies all give the sense of authenticity and applicability—they are wide and at the same time instant.

The first to be quoted is Thomas Acquinas. He is thought of as the supreme schoolman—the strange medieval brain that could best play that odd form of verbal chess whereby you mated each other with syllogisms and gave much display of allowing your opponent to be answered but in matter of fact never yielded him the slightest concession on any of the issues debated. The whole thing was a foregone conclusion. But Thomas was, in spite of his occupation—which included that of a diplomat—a saint—one who was always breathless spiritually because he never could breathe in deeply enough of that Atmosphere of the Soul for lack of which we are always suffocating and most of us are in coma. Thomas, at the end of the mass in St. Nicholas Church in Naples on St. Nicholas day, as he celebrated, saw; and after a silence of days was at last willing to say why he had ceased to write—his *Summa*—'because what I have seen makes all that I have written mere chaff.' And when he had said that, he was silent again, and after a few weeks he was released. The veil, the

membrane of the mind-body through which the soul can at best but breathe pain, was at last removed.

We are told that once he was asked, 'How can I love God?' He replied, 'Will to love Him.' The answer is as searching as it is simple. The problem of loving God is very real. The soul knows that it must do so, if ever it is to escape its deadly captivity to the self. But the love of God is different from any other love. The two loves we know are of persons and things. Things we love by interest—which means by so penetrating their nature that we understand them. We cannot take that kind of interest in God for we can never hope to understand Him. There is the intellectual love of God, but that has nothing to do with the analytic method that has yielded such remarkable results in our handling of inanimate nature and such ludicrous result in theology—the sad pretence at a science, which produces only greater confusion of the mind and enmity in the heart. We cannot then love God as we love things.

Our only other method of human love is our love for persons. Again, we love very largely because we think we understand our friend. Most affection is little lasting because we find that our knowledge was inaccurate. But we have, if we are patient and have a real need for affection—and not merely wish to have someone to listen to us—quite extensive opportunities of understanding one another. We are very much the same—much more than our egotism lets us allow. And being gregarious creatures we have to depend largely on each other. Though affection is always snapping, it is always being spun again—we are like spiders in that respect. And of course in all human affection there is some wish for return. Mother-love, which used to be thought so selfless, has now won and worn for some time the explanatory of working title—Smother love.

Of course, because the above are our only two ways of human loving, we cannot begin by loving God except from motives in which these two urges are paramount—we hope to gain a return, we hope to understand. Yet everyone

realizes the hard truth in Spinoza's famous saying—'He who would love God must not expect God to love him.'

There is, however, a third faculty in man besides the two others of interest and affection—there is the will. True, you cannot ever wholly separate the three basic faculties. But it is possible to recognize that one or the other does take the lead in any enterprise or behaviour. As we may be first touched by a person and then become interested in him, and contrariwise we may be interested in a thing—an art or science, and then become devoted to it—so the will may be the starter. True, the will very seldom is the initiator of anything that has to do with our life in this world. It comes in afterwards to give us persistence. We start because, as we say, our interest was caught or we were touched—in fact we were passive at the beginning; only after, and to keep us going, did the will take over. But as God is not to be understood—as our minds can understand—or to be loved in the possessive way that our hearts naturally like to love, there is then only one way to love Him truly, and that is as, Thomas says, through the will, by willing it.

That is of course not an irrational act. As the Christian Church has held, the existence of God can be deduced. By the balance of probabilities—which is the basis of all our rational acts—it is more likely than not that the Supreme Being does exist. But it is to love a deduction or indeed to have any devotion toward a plus balance of probability. But that again does not mean that one ought not. One may feel rightly some guilt because of one's inability to feel either affection or vivid interest in the Being who though He be incomprehensible and is not for our convenience can nevertheless be argued to be worthy of adoration. We may know we ought to love Bach's B minor Mass, but because our musical taste is very poor we may only feel boredom, yet not ashamedly. Therefore, after we have discovered first about God that His existence can be deduced and next about ourselves that we cannot love in any human way a

deduction, we find out, thirdly, that we have a faculty that just fits our very awkward need—we have the will.

We don't like using the will for two reasons—in the first place it is tiring and, in the second, when we use it we don't seem—at least for a long while—to get any results—either outward or inward. The will is, always, for us (not for God and that is another grave difference between us) in the future tense. While inwardly we use the will, we don't get that warm sensation (which actually can make failure melodramatic) that rises from the movement of the feelings. We have little or no sensation when the will works, and often when we do have a sensation it is far from pleasant—we feel we are committed, that we have foolishly trapped ourselves. Nevertheless we know that acts of the will are our supreme human endowment—the one way we ever get control over ourselves or our environment. In a piece of doggerel which shows better than worthy verse a great Victorian poet's real conviction and probably acute regret, Tennyson wrote:

> O well for him whose will is strong
> He will not have to suffer long.

The way to enlightenment and liberation is through acts of the will—there is no other. We find ourselves a mass of fantasy and wishful thinking—and so we shall end in the anecdotage of senescence unless we have painfully compacted that mush, by acts of will, into a firm one-pointed consciousness by the time we are old. For whether there is a God or not, or whether we can love Him or not, there is no escaping the fact that this world is so made that we can will and out of our will a consistent consciousness can be made, but if we try to get our wish we shall end at best disillusioned—at worst in incomplete fantasy. The Bardo of the *Mahayana* seems a terribly convincing attempt to show people into what headlong delirium the soul must be plunged which leaves the anchorage of the body before it

has transmuted all the pandemonic force of fantasy which
should by acts of the will have been shaped into the one-
pointed devotion to the Supreme Will.

The human will is then the specific faculty whereby
man gets in touch with the Supreme Being. 'Thy will be
done', as Eckhart says, is the one complete and all powerful
prayer. 'But I can't go on saying that'—is the usual answer
and a fair one. If we think that we are simply saying encore
to the Infinite, our part becomes a little otiose. He does not
need our aid, still less our applause to encourage Him to do
what He always intended and can never be turned form.

It is here that faith comes in—the naked faith of which
the masters of prayer so often speak. We make an act of
faith that when we exercise our will and intend that we
shall will only what God wills, something actually does
happen. We will, and thereafter don't feel or speak or
behave a whit the better. 'Nothing has happened,' says the
ordinary consciousness; 'Had anything taken place I should
have felt the effect.' Yet we know that when the high non-
sensuous consciousness works, our everyday consciousness
is utterly unaware of it. That has been proved in all work
on Extra-Sensory Perception. The cards used for the scoring
will show after, that you have been exercising this power.
But while you are actually doing it, you will have no feeling
of any sort to guide you when you have 'hit' right and
when you have missed. We know then that God is regard-
ing us and that we can regard Him. When then we bring
ourselves into an act of relationship with Him by willing
that His Will be ours, we are like a patient who puts
himself into the focus of an X-ray. He will feel nothing or
see nothing while the operation is on. And not for some
days, perhaps for many, will he experience any improve-
ment. He might say, even when the improvement comes,
'As I saw nothing to account for it when being given the so-
called treatment, what beneficial effect I now experience
may just as likely be due to some natural improvement and
have nothing to do with this theory of invisible radiation.'

But this illustration makes the relationship easier than it actually is. We know that God is confronting us, we know by deduction that as He exists we do come into relationship with Him whenever we make an act of the will to do so. But that is all. As to how He will act when and where, we are of course always in the dark—the dark of blind faith. T.H.Huxley used to speak of life being played by each of us being confronted by a 'veiled antagonist' the other side of the board. The simile is a telling one—one that none with even the slightest experience of prayer but knows to be descriptive of much of the time spent in prayer. In chess the greater the master with which one is confronted the more certain one may be that his moves will leave one in the dark. One may be sure only of two things—that every time I move, without exception a move of reply will be made and, secondly, every one of those moves is directed to take away all my freedom to move.

Yet even here the analogy is far too feeble. For the best chess master has a finite mind and must play a game confined within the simple rules of the game, a game which is to end with one of the antagonists unable to move. The game the soul plays with its Maker is not only played with an infinite opponent, whose resources are inexhaustible, but also the aim of His 'play' is not to take away the soul's freedom but to restore that freedom to it and to keep on so doing until at length the soul has won the power to retain it. Even if we were allowed to view the 'board' entire—instead of through the slit aperture of what we call the present moment—how could we hope to understand at each move, or a whole lifetime of moves, the strategy of the Master?

We are, therefore, confined to the one exercise which is germane to our attempt—our intention to love God if we only knew how. We can and must keep on making these 'blind acts of the will', knowing that to each of these 'openings of the soul by the soul' God responds by a reply of infinite inscrutable aptitude. Of course it is not

easy—perhaps it is the hardest thing in the whole of our lives. For it means that we must never complain—which is with us even a stronger passion than our appetite to enjoy. It means in the end we shall know that there is no chance or accident, because we can now practise the constant Presence of God. And that end is far off not because it is not rationally obvious but because the nearer we get to really willing to do God's will, the purer the opportunities He can and will give us of so doing.

At the beginning He mixes the satisfaction of our desires with the performance of His intention. So people feel we are something of a success—of course a very nice one, but we *are* lucky and religion is something that the ordinary man might well invest in—it pays. Then that goes and we fall back on a less obvious aim—we have to comfort ourselves that at least we are resigned and are growing in virtue through the way we accept our failure. And then that goes, too. Like Job, the soul has to yield its last desperate cry, 'I will not let mine integrity go from me', and can only mutter, 'Yea, though He slay me, yet will I trust in Him.' For at the worst in the deepest darkness the polar facts remain. God is and nothing that can happen to my fortunes alters the facts which show deductively that the Supreme Being exists. And the other fact is that I have a will. Though that will may produce no results, I can keep on making acts with it. My holding on to my intention or my surrender of my intention, those two facts have really no more to do with whether I succeed in carrying out my will than has the existence of God to do with whether He comes to my aid at the time and in the way that would soothe my feelings. It seems clear, then, that Thomas Aquinas' saying is true and apt. It is hard, but it is the precise answer to the pressing question, the most pressing question in the whole of life, 'How shall I love God?'

THE YOGA OF ART

James H. Cousins

Underlying the apparently numerous phases of activity in the life of nature and humanity, there are two main directions of movement. In the great world of nature they are seen as disintegration and integration; in one of its special phases as motion centrifugal and centripetal; in man's particular world of conscious activity as analysis and synthesis.

Through whatever phases of life these two main movements operate, their characteristics are the same: on the one hand, separating, elaborating, scattering; on the other, gathering, co-ordinating, simplifying, unifying. Going to extremes, either movement would, theoretically, nullify itself, the one in annihilation, the other in inertia, the equal bankruptcy of poverty and plethora. This, however, is apparently not the intention of life.

Between expansive energy and contractive substance as we find them in life (and leaving aside recent scientific formulae which make energy a mode of substance, and substance a phase of energy), there is a perpetual interplay for the purposes of life's necessity of continuity, and a perpetual shifting of the point of balance on either side of the centre of poise for the purposes of life's pleasure in variety and interest. Radha and Krishna, as Vedic thought and art have personalized these processes (which is not denying, but fulfilling, the declaration of Hermetic vision that in the cosmos all things are persons), dance the dance which keeps life alive: but sometimes Krishna, who is embodied energy, strays away from home (which is round about but not exactly on the pole of life); and sometimes Radha, who is embodied substance, remains too sedulously at home; and out of these defections from the perfect have

arisen the stories that life loves to tell itself for self-edification and entertainment, stories of the limitations wherewith substance and form must shackle and manacle energy in order to provoke it into dynamic definition, and of the struggle and adventure of energy towards liberation from its limitations.

The history of humanity is the record of this interplay of resistance and release; of the process of disintegration whose end is death in one or other of its many forms, and the circumventing of this process by expedients of integration for the preservation of identity. In group life this integrative necessity shows itself, and never so urgently and largely as today, in alliances in trade, in politics, and otherwise. The balance of activity has oscillated too near the danger-point of group-disintegration, and the pull in the opposite direction is correspondingly emphatic.

In individual life the preservation of identity has, generally speaking, evolved no more intelligent technique than that of self-assertion and acquisitiveness, both of which tend to defeat their own purposes, since they relate the individual to the others on terms of separateness and antagonism, which reduce the nourishing and continuing properties of ideal human association as regards both the body and the psyche.

The medieval monastic disciplines of the Occident sought to establish individual identity, and to carry it on to kingdom-come; but their method, while it was deep, was narrow. It responded to a realization of the possibility that, if we do not consciously align the individual will and action with those of the 'divinity that shapes our ends', that divinity, which is the law behind and within life, will eventually end our shapes. But it touched life through an expansive emotion cramped by a creed. It mistook theological formulae, which were means to ends, as origins, because they proved effective, not seeing that life has an amazing knack of utilizing and surviving the most peculiar prescriptions from the spiritual pharmacopoeia.

The oriental genius got nearer the discovery of a complete technique of individual integration. It recognized the possibility of emotional disintegration; but it did not meet it by *mental* constriction. Neither did it meet the trend towards mental disintegration by setting up a counter-trend in the *emotional* nature of the individual. The wheels of life must evolve in mutual reaction for a unifying purpose beyond their individual service; but each must revolve on its own centre. It is good advice to 'feel intelligently': it is equally good advice to 'think sensitively': but, for the good performance of these acts of synthesis (not merely the simultaneous exercise of two different functions), both feeling and thinking must be cultivated to their finest flowering, each from its own root and according to its own necessities.

Out of such realizations of psychological law arose the Yogas of India: means to the discarding of non-essentials to the work in hand; and to the attainment of enlargement and intensity through which the individual achieves integration, first within his own nature, and last between himself and his universe. This is the *union* which is the etymology and purpose of Yoga.

India evolved numerous systems of individual integration (Yoga). But, for the purpose of this study we shall generalize them as the integration (1) of action (Karma-Yoga), (2) of cognition (Jnana-Yoga), (3) of emotion (Bhakti-Yoga), (4) of volition (Raja-Yoga). In familiar speech these are the discip-

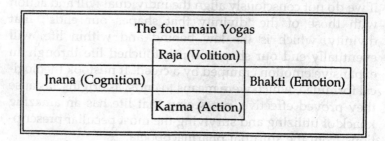

The four main Yogas

	Raja (Volition)	
Jnana (Cognition)		Bhakti (Emotion)
	Karma (Action)	

lines of the body, mind, heart and will, each turned in upon itself, yet affecting the others, not in the time of the specific exercise of the Yogic-discipline, but in the spontaneous sharing of increased capacity in the activities of ordinary life.

It is not within the purpose of this study to set out the technique of these means towards individual integration. This has been done in many books, original and complied or translated. The Yogas are summarized here as the psychological ground-plan of our thesis that, in the exercise of the creative function in the arts, there is available to humanity a most effective Yogic agent which, though recognized in the Orient, has not yet been fully exercised, and in the Occident has hardly been recognized at all.

The Yogas thus summarized serve the four basic functions of the human entity. But they do not serve them completely. Their intention is, as integrating expedients, naturally from without to within, and they have been drawn behind the out-turned aspects of cognition and emotion. Jnana-Yoga is contemplative, and only incidentally uses the out-turned function of the mind. Bhakti-Yoga is devotional, and only incidentally uses the out-turned emotional function. Yet the mind turned outwards in the exercise of observation (which is the function of science) serves the purpose of the inner light which lightens the path of the Will; and the emotions turned outwards in creative expression (which is the function of the arts) serve the inspiration to action which sometimes calls, sometimes drives, and always accompanies the Will on its explorations in life for further illumination to still finer inspiration.

Karma-Yoga is concerned with the inner aspect of action; that is, with action between entities realized as interacting constituents of a more inclusive and therefore higher entity than the external individual. Out of the tendency to disintegration in external action the Occident evolved the partial Yogas of ethics, which seek to control conduct intellectually, and of moral, which seeks to control

the emotional aspects of conduct. But these expedients can never be effective, because they seek to control individual action from without instead of from within, and take their authorizations from effects instead of from causes. The Oriental genius, however, realized also that 'there is no Yoga without health', and evolved the preliminary discipline of breath-control (Pranayama) as a way to making the physical and neural phases of individual endowment more capable of responding beneficently to the intention of the higher discipline of group activity (Karma-Yoga). Without such health, which systematic rhythmical breathing brings about, the intensification of life which follows any Yogic discipline may, by frustration or distortion, lead to disaster. On the other hand, the accession of personal power which may come from Pranayama is preserved, by the restraints of the collective activity of Karma-Yoga, from the disintegration that would follow the exercise of such power for selfish and therefore separative purposes.

Now it is precisely because the out-turned movement of the cognitive function, which is science, has in the Occident been denied the natural restraints of its own in-turned movement of contemplation, whose historical expressions are philosophies, that science, for all its gifts to external life, threatens the destruction of human achievement if some unforeseen and probably trivial impulse suddenly translated present international suspicions, jealousies and fears into overt action that would bring into play the demoniacal agents of mutual destruction that science has within the last generation conjured out of its witches' cauldron of hellish invention. It is also precisely because the out-turned movement of emotion, which is creative expression, has been denied the restraint of its own in-turned movement of aspiration, whose expressions are the religions, that the Occidental arts, in some of their more reprehensible and popular phases, have threatened the spiritual destruction of humanity by the disintegration of its aesthetical consciousness and the degradation of its capacities

for sensitive reaction to the level of self-destructive forces of sensuality. To meet this double threat there is need for a Yoga of Science and a Yoga of Art.

SUMMARY OF THE FUNDAMENTAL YOGAS Including the Yoga of Science and the Yoga of Art		
	VOLITION Illumination Inspiration (Raja-Yoga)	
COGNITION Contemplation (Jnana-Yoga) Observation (Yoga of Science)		EMOTION Aspiration (Bhakti-Yoga) Creation (Yoga of Art)
	ACTION Group (Karma-Yoga) Individual (Pranayama)	
The dotted lines differentiate the in-turned (upper) and out-turned (lower) directions of the four human functions.		

We leave the matter of the Yoga of science to others. The necessity for circumventing the disintegrating threat of

modern science is being felt not only by the threatened general public but by scientists themselves who share in the common danger. The movement of 1932 in the British Association towards co-ordinating science and life by developing scientific control of scientific destructiveness is a sign of awakening awareness of the inaptitude of letting the part threaten the overthrow of the whole. The success of the movement, if scientific orthodoxy permits it to develop, will depend on its allegiance to the law of integration, which is union or Yoga; and this strikes shrewdly at such aspects of science as the anti-Yogic exploitation of the animal kingdom for the acquisition of knowledge which in many cases is useless, and in any case has obstructed the true advance of life by interposing spurious alleviations of false habits of conduct between humanity and the infallible therapeutic and prophylactic power of natural living.

Sixty years ago Nietzsche ('The Birth of Tragedy', 1872) observed that the whole modern world (by which he meant the Occidental world) was 'entangled in the meshes of Alexandrine culture', that is, 'the Socratic love of knowledge', and recognized as its ideal the theorist equipped with the most potent means of knowledge, and labouring in the service of science. The central doctrine of modern Socratism, according to Nietzsche, was 'the redemption of the individual'—not, unhappily, in the Yogic sense of finding individual salvation through union with society and the cosmos, but in an individual exploitation of the universe for the purpose of the individual, which made such redemption the 'annihilating germ of society'. He saw, however, in the philosophy of Kant and Schopenhauer what he took to be signs of the inauguration in Germany of a new culture, similar to that which produced the Greek tragedies, a culture 'uninfluenced by the seductive distractions of the sciences', a culture which would take a 'comprehensive view of the world', and produce a generation having the will 'to live resolutely' and demanding the 'metaphysical comfort' of a new art of tragedy. Nietzsche was only half a

prophet, for what he foresaw as an art of tragedy became a life of tragedy for the children of the generation which he addressed.

Nietzsche's prescription of art as a reaction from science was healthy psychology. In the round, science and art are expressions of the two interacting inter-dependent functions of humanity: science in its phase of application becoming an art, but using cognitive instead of aesthetical materials; art fulfilling itself in expression governed by the science of its own nature. On the flat they appear as nominally separate phenomena, one being mainly mental, the other mainly emotional, but having a common out-turned direction.

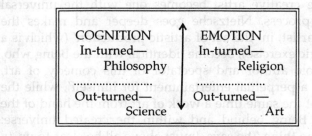

COGNITION EMOTION
In-turned— In-turned—
 Philosophy Religion

Out-turned— Out-turned—
 Science Art

Hegel had already (in 'Philosophy of the Fine Arts') asserted the integrating power of the arts, and supremely of the inclusive art of drama. Means to polarization, he called them, which was the same as calling them Yogic agents, that is, means for focussing attention on essentials, and through these bringing the individual into contact with the most worthy and least transient elements of life. In this he saw deeply into reality, for he saw the arts not simply as products or alleviations of a national psychosis, but as powers capable of being applied to the elucidation of the truth of life and therefore to the true solution of its problems. To know is good, provided knowledge be obtained and applied in the Yogic spirit, the spirit of union; to understand is better, for it unifies and can anticipate knowledge

and so reduce its tendency towards disintegration in details; to create is best, because it puts the creator in art *en rapport* with the creative process in the universe and, by participation of like spirit, rather than by impartation of understanding or presentation of knowledge, makes the creative artist a sharer in the main process of life, which is creation, and therefore in the highest sense an understander of its operation and a knower of its intention—hence the seership and prophecy in the great artists.

Knowledge and understanding exist through the metaphysical sundering of the knower and that which is known or understood. But creation can only be fulfilled through what Rabindranath Tagore has called 'creative unity' in the volume bearing the same title. In the Hegelian sense the creative artist becomes one with the universal creative process. Nietzsche goes deeper and makes the creative artist, in 'the act of artistic production' (which is a pure Yogic exercise), become 'identical with the Being who, as the sole author and spectator of this comedy of art, prepares a perpetual entertainment for himself', while the artist is at the same time a work of art from the hand of the Creative Being behind and within the created universe: '...this one thing,' he says, 'must above all be clear to us, to our humiliation *and* exaltation, that the entire comedy of art is not at all performed, say, for our betterment and culture, and that we are just as little the true authors of this art-world: rather we may assume, with regard to ourselves, that its true author uses us as pictures and artistic projections, and that we have our highest dignity in our significance as works of art—for only as an *aesthetic phenomenon* is existence and the world eternally *justified*' ('Birth of Tragedy'; italics Nietzsche's).

In placing the source and purpose of creative art beyond the artist and the specific art, Nietzsche repeated the ancient vision of the seers of India who in various stories attribute the origination of the arts to Brahma the Lord of Creation. Thus they personified the experience of the artist

that he, the Brahma of his cosmos, can produce, within his cosmos, world after world which expresses yet does not exhaust, singly or in their totality, the energy and substance of his own life; and if any of his creatures complain at being no better than they are, he, their creator, can sympathize with them, being himself pulled between his own perfection and the inescapable imperfections of his expression.

The creative artist knows, not by scholarship but by experience, the secret of the struggle towards the expression of his own perfection and its perpetual frustration; and he does not, as so often does the thinker as well as the thoughtless, charge God (whatever that term may mean to them) with the blemish of suffering or the inconsistency of ugliness. To ask an assumed perfect Being to produce perfection is to ask it to reproduce itself, which logically is impossible. By his own analogical experience the creative artist knows that a perfect Being, producing within the area of its own perfection, can only produce that which is less than perfect, that is to say, imperfect; yet these imperfections exist by virtue of their relationship to a perfection that forever allures and forever eludes them. 'To attain perfection would be to lose the greatest stimulus in life, the stimulus of struggle', said Paderewski to the writer of this article.

Whatever be the code by which the lips of the creative artist relate him to his fellows along the surface of life, his true utterance is his art, the synthetical and therefore symbolical mother-tongue of his and every other soul, which, like the calligraphy of China and Japan, is read from above downwards, sometimes from below upwards and, in rare incursions of vision into expression, simultaneously both ways. The upper end of the artist's Jacob's ladder of aesthetical revelation may be hidden in clouds or 'pinnacled dim in the intense inane', but its foot must allow the angels whose one wing is truth and the other beauty, and whose feet are swift in goodness, to step communicably to earth. To the artist his ladder of expression may be let down form

the dim bastions that guard the secret of things from those who are timid enough to be afraid of them, and so not bold enough to bear the responsibility of the secret. To the spectator the ladder of art appears to rise from the solid ground towards the stars: that is to say, true art, great art, must of necessity present a tangible, visible, audible outer semblance to the perception of the spectator; but it has failed in the highest purpose of art if it has not signalled mysteriously beyond itself from spirit to spirit. The subject of art must be objective, but its object must be subjective.

It will have become evident to those who have brooded over the nature of art and the artist, that much of what has been said above belongs not only to the artist but to the mystic, since they both are sensitive and receptive to some more complete and unified communication from Life than ordinary individuals. This relationship between them is not casual. It is fundamental, and rises out of the relationship, in humanity's psychological endowment, of aspiration and creation as the in-turned and out-turned directions of the emotional function which they both exercise in a special degree. These directions are not away from a common base, but overlap and intertwine. 'There can be no inspiration without aspiration', was one of the aesthetical instructions of AE to the writer as an apprentice in poetry thirty years ago. His reiteration of the formula ('Song and its Fountains', 1932) indicates the depth of his conviction as to this psychological law.

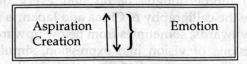

But besides this interaction of opposite movements over the whole emotional area, there is a further interaction within the two nominally separate areas of aspiration and creation that are identified as religion (which is emotion aspiring towards union of the individual life with the

cosmic life) and art (which is emotion endeavouring to express its glimpses and touches of reality in forms less transitory than the flux of daily life); religion and art have themselves each an in-turned and out-turned direction. In religion these movements show themselves in the simplicities of mystical experience and the elaborations of ceremonial observance; in art as idealism and realism.

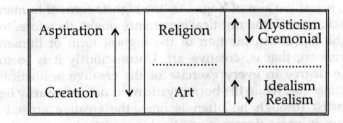

Aspiration ↑	Religion	↑↓ Mysticism / Cremonial
Creation ↓	Art	↑↓ Idealism / Realism

The mystic and the artist are therefore sharers in a common inner experience of reality, but differ in their code of communication. Both receive the accolade of the spirit, and express their spiritual ennoblement in their temperamental vernacular, the mystic in the theological terminology of his or her upbringing, the artist in the aesthetical symbolism of his or her chosen art.

In an effort to relieve the term mysticism from the overgrowths of misunderstanding, a writer (William Kingsland, 'Rational Mysticism', 1924) has said, 'Mysticism is essentially *union*, that is to say, *wholeness*...to realize...that each moment contains all eternity, and is fulfilled with immeasurable Beauty and Perfection—this would be to be a mystic indeed.' William Blake, the mystic poet and craftsman, made the same realization one of the signs of the achievement of innocence. Miss Evelyn Underhill, in her invaluable work, 'Mysticism', essayed the same task and made much the same definition. She expressed the hope that the term mysticism might be 'restored sooner or later to its old meaning as the science or art of the spiritual life' (a phrase 'in the round' containing temptation to further

synthetical disquisition to which, however, we must not yield), and added: 'Broadly speaking, I understand it to be the expression of the innate tendency of the human spirit towards complete harmony with the transcendental order...the true line of development of the highest form of human consciousness.'

Now, the movement towards 'union', 'wholeness', 'harmony', which these students of mysticism declare to be its aim, is just the aim of Yoga. As 'the highest form of human consciousness', the mystical experience ought, therefore, to be the highest inspiration of the highest form of human expression, that is, creative art. Unconsciously it is so to some degree in every exercise of the creative aesthetical function; for, while the born mystic need not necessarily be an artist (though he often is one), the creative artist is always in some degree a mystic, his reception and revelation of the inner life in which, willy-nilly, he participates being conditioned by temperament and environment. When he is consciously so, and when those who have had conferred on them the responsibility of aesthetical creation realize the majestic and sacred sources of their inspiration, and the redemptive potentialities of its expression in an unspeakably inartistic world, there will come once more into art the spirit of consecration, which is the essence of Yoga, that brooded over the great eras of the past, that still animates the art of India, and that will, by integration towards the ideal, recall the Occidental art of today from the path towards disintegration.

Not all the arts are equally capable of fulfilling the service which the artist owes to his world of making a fully intelligible communication of inner experience. A mystical tincture may be given to painting, a mystical gesture to sculpture, a mystical tone to music. But their codes are not (at any rate at the present stage of their articulation and of human capacity to use them) capable of transferring more than a hint of inner experience from consciousness to consciousness. For intelligible communication there is

needed the fuller code of language. This itself is not wholly adequate; but its communicative capacity can be expanded; it can be made memorable by design, significant by symbol, impressive by rhythm, exalted by verbal music. Poetry, which combines these qualities, is therefore the nearest to being a complete medium for the expression of the highest experiences of the individual soul. The other arts have their own special services to render in the preliminary stages of the approach to the Yoga of art, and we are helped to a realization of this distinction in the Yogic potential of the various arts in the striking presenta-tion of their two main characteristics given by Nietzsche ('The Birth of Tragedy') under the personifications of Apollo and Dionysius.

To Nietzsche, Apollo stood as the type of the individu-ating principle in life whose tendency is to fulfil itself in separateness; 'while by the mystical cheer of Dionysius the spell of individuation is broken, and the way lies open to the...innermost heart of things.' The fulfilment of the Dionysian principle of union was achieved by what Miss Underhill terms 'transcending the limitations of the personal standpoint' and 'surrendering to reality'. Nietzsche definite-ly calls the Dionysian practice of ecstatic commingling (so contrasted with Apollonian egotism, which sets up separat-iveness) a mystical agent, that is, an expedient towards union or Yoga. It was used in the Dionysian orgies; it was and still is used, but with a difference, in the Chaitanya festivals in India.

Nietzsche is quite clear as to what is mystical (Yogic) art and what is not. The arts of painting, sculpture and epic poetry are Apollonian, separative, non-mystical, because the artist is 'sunk in the pure contemplation of pictures', his art being therefore static, without the intermingling flux that unifies. The musician stands on the side of the Dionysians, 'himself just primordial pain, and the primordial re-echoing thereof', but lacking the power of intelligible communica-tion of subjective experience.

But the 'lyric genius' is completely Dionysian, communicating, intermingling, liberating, and therefore mystical, Yogic. 'The lyric genius,' says Nietzsche,

is conscious of a world of pictures and symbols—growing out of the state of *mystical* (italics ours) self-abnegation and oneness—which has a colouring causality and velocity quite different from that of the plastic artist and epic poet. While the latter lives in these pictures, and only in them, with joyful satisfaction...the pictures of the lyrist...are nothing but his very self and, as it were, only different projections of himself, on account of which he, as the moving centre of this world, is entitled to say 'I'; only, of course, this self is not the same as that of the waking, empirically real man, but the only verily existent and eternal self resting at the basis of things, by means of the images whereof the lyric genius sees through even to this basis of things.'

It is the function of the 'lyric genius', the poet as mystic, to utter the felt Absolute in the language of the known relative: it is also his function, as creative artist, to interpret the relative in terms of the Absolute.

ART	
APOLLONIAN	DIONYSIAN
Separative	Unitive
Epic Poetry Plastic art	Lyrical art Music

Nietzsche did not leave Apollonian and Dionysian principles, as they developed through Greek culture, in

perpetual opposition. He saw them reconciled in the subsequent tragic drama whose mystery-doctrine was the 'fundamental knowledge of the oneness of all existing things, the consideration of individuation as the primal cause of evil, and art as the joyous hope that the spell of individuation may be broken, as the augury of a resorted oneness'. An excellent doctrine, at points corresponding with the thought of the Orient; but its hope was not satisfied, its augury not fulfilled, partly, perhaps wholly, because Greece did not live up to the 'fundamental knowledge of the oneness of all things', that is, did not realize the Yogic or unifying power of art, and set that power to work in her general life. It is not sufficient for a nation to produce, through a few individuals, outstanding works of art: its justification for being granted the boon of existence, and for enjoying that boon to its fullness, rests on its being itself, as Nietzsche has said, a work of art: he synthesized expression, in individual capacity and quality and in organized social relationships, of the finest intimations of reality; a complete embodiment of the Yogic principle and practice of 'the oneness of all things'. The Yoga of art is essential as an integrating power in national as well as in individual life.

But before art can efficiently fulfil the Yogic service of recalling life from the path towards disintegration, it must itself be redeemed by integration, and released into the fullest exercise of its Yogic potentialities, not only for art's sake, or for the sake of the artist, but as Vedic scripture has it, 'for the sake of the self', that is, of the commonly shared, though differentially realized and expressed, inner life on which 'hang the law and the prophets', art and the artists, and that shadow-dance in time and space which is called life.

This redemption of the world through art does not apply only to the Dionysian 'lyric genius' who deals in communicable experience: it applies also, though not in the same way, to the Apollonian plastic and the epic artist. Nietzsche's division of them must not be applied too

radically. The painting art of India has always been lyrical and expressive of spiritual experience: the sculpture of George Grey Barnard of New York nobly incarnates the vision and experience of a veritable seer. Moreover, while it is true that the Apollonian artist fixes his attention on static objects which, theoretically in Nietzsche's sense, are agents of individuation, it is also true that their service to the artist himself is Yogic in nature. It calls for concentration and integration on his executive consciousness and activity; every stroke of his mallet not only moves outwards to the object but inwards towards eternal laws and their reflections in the tradition of art, and so puts him subjectively in a posture receptive to intimations of reality. This integrating concentration is the basic exercise of Yogic discipline. In the Yoga of art it will be directed towards aesthetical creation; in Raja-Yoga it is directed towards pure volition, in Bhakti-Yoga towards aspiration, in Jnana-Yoga towards contemplation, in Karma-Yoga towards action in daily life.

We may therefore take poetry, and after it music (and we shall add aesthetical interpretative dance), to be the most intimate means of making comprehensible to himself the inner experience of the born artist, and of communicating such experience intelligibly in verbal expression, or infectiously in musical sound or rhythmical motion, to others, drama being the large-scale inclusive Yogic art; and the plastic arts as means for the preparation of humanity in general for the ultimate Yogic experience through the exercise of the Yogic potential that is inherent in such arts.

This distinction has the assent of recent experiments in the education of individuals farthest removed from Yogic possibility, that is, delinquent children whose tendencies are almost completely disintegrative in their impulses towards the satisfaction of their merely physical desires. It has been found that the arts which call not only for integrative concentration, but for the objective exercise of physical capacity (the more energetically the better in some cases), that is to say, the art-crafts and manual-arts, are most

effective in their curative capacities. This being so in pathological cases, it is obvious that the use of the Yogic potential of these arts as a constant obligatory item in ordinary school life (which indeed, and alas! is almost universally pathological in some degree) would help the rising generation towards the attainment of that health without which the Vedic seers regarded Yoga (union of the outer and inner natures) as unattainable, and for which they instituted the Yogic hygiene of controlled breathing (Prana-yama).

The aesthetical hygiene of art-crafts would materially reduce the physical creative impulse in male youth by providing the elevating and keen satisfactions of creative achievement in beautiful and useful forms that do not enslave but liberate. The universal creative impulse presses upon all the capacities of the individual, as the Breath of the Infinite Being passes through the Flute of Krishna (a symbol of the cerebro-spinal system of humanity) pressing for expression equally at each aperture, and finding its perfect music in the melody of a balanced life. But because neither education nor social organization provides humanity fully with the aesthetical means of creative release, the creative impulse presses unduly on the neurotic and erotic elements in human equipment, and brings about the exaggeration and distortion of the sex-function which today, through the disintegrating tendencies of self-indulgence exploited and made glamorous by the profiteers of spurious and debased forms of art, makes its sinister threat against the health and morale of the future.

The inclusion of art-crafts in education on the same level of importance as the 'three R's' (not for the develop-ment of specialists in any art, any more than the common instruction in language is to develop literary specialists, but because it is essential to human health and happiness) would in three generations, perhaps in one, revolutionize humanity and its institutions by developing pure, sensitive, intense, controlled, intelligent and powerful embodiments

of the at present obscured and thwarted human ideal, and a universal and sagacious audience for the geniuses in art who will incarnate for the further helping of the race.

The Yoga of art, therefore (to summarize and conclude the matter), has two modes of operation. First, a general mode, by which, through universal participation in art-activities, humanity as a whole may develop its higher powers, and in their exercise become better members of a better society, and find freedom from the lower tendencies of their nature—in the terminology of an oriental scripture ('*Vishnudharmottaram*', translated by Stella Kramrisch), be helped by art to fulfil their Dharma or life-purpose and to find Moksha or spiritual liberation. Second, a particular mode, through which, by the understanding of the real nature of the creative artist and art-creation, and by conse-crated devotion to the purest reception of the inner intima-tions of reality and their truest and most beautiful expres-sion, the born artists may become conscious co-operators with the Creative Power in the universe, projectors of illumination upon and through the problems of life, and inspirers of humanity to individual and organized action that will establish on earth the 'aesthetical phenomenon' of a true civilization.

TRADITION IN INDIAN ART

Ajit Mookerjee

The universal adoption of an elementary formal idiom from time immemorial seems to be in conformity with India's abandonment of external reality for inner searching. In this spiritual process, a new sign language, symbolical of man's relation with the universe, was discovered and used throughout.

Indian artists, to be precise, *śilpi-yogins*, have conceived this realization in terms of dimensions—*śabda*, the primordial sound substratum, as a form of monosyllabic mantra, the *Om*; and *brahmāṇḍa*, the cosmic Egg, as the vital key-form of a supersensuous world. *Om* aims at the total elimination of 'sub-object' by expression of sound-rhythms, while *brahmāṇḍa* epitomizes the eternal reality in an absolute form.

Śiva stands for *Aśabda* Brahman, the unqualified one, and Śakti for *Śabda* Brahman, the creative impulse in the cosmic process. *Liṅga*, according to *Skanda-Purāṇa*, is the name for the space in which the whole universe is in the process of formation and dissolution. *Śiva-liṅga*, the all-pervading space, thus symbolizes a cosmic form, serenely detached and self-sufficient.

To enclose space is to create volume. The total effect is an overall compression that produces intensity. *Gaurī-paṭṭa* represents *ādyā-śakti*, the energy quanta; *mahāmāyā*, the power of manifestation; *yoni*, the primal root or source of objectivation. Hence *śivaliṅga* with *gaurīpaṭṭa* is the embodiment of both inaction and action, matter and energy.

In the hands of the artist, this manifestation is expressed in the form of *liṅga-yoni* or vermilion daubs. The formless gets a time element, a dimension, a permanent shape, the abstraction of which is aimed at incorporating spatial values conditioned by sound and light.

14

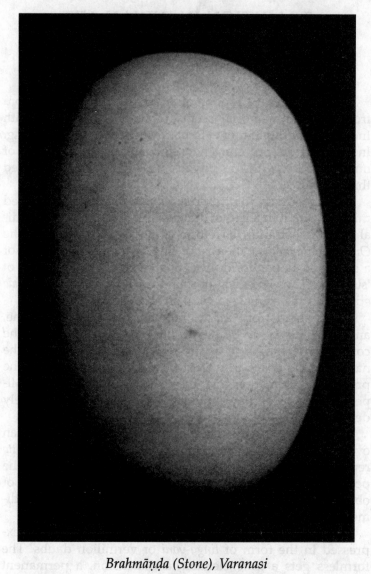

Brahmāṇḍa (Stone), Varanasi

In the egg-shaped *brahmāṇḍa*, in the globe-shaped *śālagrāma*, or in the *śivaliṅga*, the artist tries to release the symbols imprisoned in stone by a reduction of the material to its absolute essence. Matter is made to yield its intrinsic nature, the inert becomes active.

Hence there is no flamboyance or associative corruption. Broad universality of impersonal form and content, and close relation to nature predestine this art to mass recognition and general acceptance. To give these figures depth and significance, they are still placed under the open sky, below the banian-tree, that serene godlike perspective.

In its search for fundamentals, Indian art has always tried to integrate forms into geometrical and architectural patterns, the archetypes. The *Bhāgavata-Purāṇa* says: 'He perceives through the geometrical lines the form he is to sculpture.' A modern critic notes the same thing: 'Geometry thus provides a plane of refraction, as it were, between the world of essential being and the world of formal manifestation.' A wide variety of geometrical shapes dominates the whole range of Indian symbolism, particularly in Vedic and Tantric diagrams and formulae, in which the motifs have reached the goal of absolute 'geometrical purity'.

The mathematical zero, discovered in the yogic process, was born out of reduction, and it is with this number that duality comes into existence. Even the conception of the sound *Om*, which is the combination of the three *mātrās*, *a*, *u*, and *m*, presupposes geometrical patterns corresponding to a straight line, a semi-circle, and a point. Similarly, in the Vedic diagrams and Tantric *yantras*, or in the Jain astral signs, geometrical forms and patterns are registered and are aesthetically vivid, while mantras lead the spirit lost in the objectivation back to pure essence. 'An image or a *yantra*,' according to the *Divyāvadāna*, 'is a piece of psychological apparatus to call up one or the other aspect of divinity.'

Sanskrit texts emphasize the necessity of inner visualization and the hidden meaning of things. The vision that

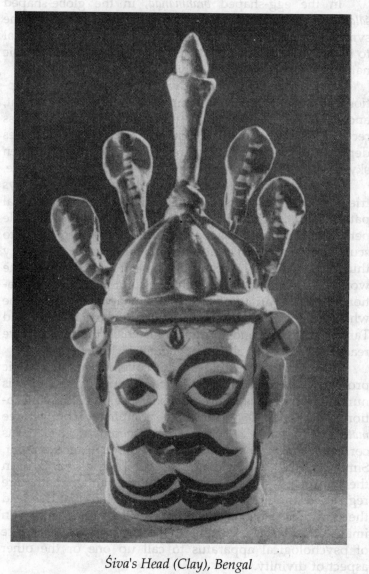

Śiva's Head (Clay), Bengal

enables the artist to so visualize reality is a supreme form of concentration. Śukrācārya insists: 'There exists no form or concentration more absolute than that by which images are created. Direct seeing of a tangible object never allows of such an intensity.'

It is here that the methods of *yoga* assume a great importance in art; art itself can be considered one of the essential forms of yoga. To penetrate the enigmatic silence, the mystery of the universe, the *śilpi-yogi* employs his mental faculty—*manas*—though he sometimes gets through to the latent meaning by intuition.

Both the *śilpi-yogi* and the surrealist strive towards the same thing—to unfold the secret world. The Tantric symbols and patterns, the storehouse of which is yet little known, achieve a unique illumination of form and colour, because what the *śilpi-yogi* arrives at is related to his inner spiritual growth. But the dream world of the surrealist, its forms and fantasies, creates a sense of frustration and flux, because it is contingent on the passing, shifting moment.

The underlying character in folk and primitive art traditions upsets the norm, because it throws up realities and symbols that are far removed from the commonplace and the conventional. It charges the apparent, the insignificant, with strangely evocative ideas and associations. It is drawn from a life that has retained its ancient simplicity, despite time variations, like the mind of a child which simultaneously lives in both the present and the primordial. And every artist who makes a real contribution to living art invariably shares this quality.

An artist is not an innovator in the crude sense of the term. He expresses something that already exists—*sarvam*—of which he is a part, and which he feels impelled to give back to the world. In this giving back, the process through which he realizes himself and the world is much more important than individual specimens. This process becomes a way of life that creates concepts and forms in which a particular age seems to crystallize and find itself.

Mother (Terracotta), *Assam*

Śivaliṅga, Brahmāṇḍa, Śālagrāma, Viṣṇu, Buddha, Naṭa-
rāja, Kālī, each is such a concept, and the culmination.
Śivaliṅga is an absolute form, whereas Naṭarāja is a total
expression, and both dissolve in the primeval concept of Kālī.

Kālī, the black One, is *cit-śakti*, pervading the whole
universe as pure consciousness. By her *māyā*, she is mani-
festing herself, renewing the cycles of inception and annihi-
lation through never-ending aeons of time. Her form
embodies the frozen darkness of the void, *mahāśūnya*. She is
digambarī, space-clad, full-breasted; her motherhood is a
ceaseless creation, rather, a state of continuous 'birthing',
ananata-prasava. But in her womb are both creation and
doom. With the sword of physical extermination, she cuts
the thread of the life of bondage, and is relentless only to be
benevolent, *karuṇāmayī*. Her white teeth, symbolic of *sattva*,
the translucent intelligence-stuff, suppress the lolling tongue
which is red, indicative of *rajas*, a determinate level of
existence leading downwards to *tamas*, inertia. Her right
hands dispel fear and exhort to spiritual strength. Her third
eye looks beyond space and time. She is the changeless,
unlimited, primordial power acting in the great drama,
awakening the pent-up force of Śiva, while Mahākāla lies
inert, a passive onlooker, destined to be dissolved in the
great dissolution, *mahāpralaya*.

This tremendous conception of Kālī was again resolved
by the *śilpi-yogi* into a simple geometrical pattern—a
triangle within a circle. 'Hrīm', the *bīja-mantra*, almost an
equation for this, was a further simplification in which the
essence of the concept is latent.

It was this belief in a cosmic order, whose principles art
tried to capture and communicate, that enabled the *śilpi-yogi*
to make himself a part of the mystery, to live in it as well
as with it. He knew that, without this complete identifica-
tion of his being, there could be no revelation of the great
secret.

Coomaraswamy notes: 'The practice of visualization,
referred to by Śukrācārya, is identical in worship and in art.

Hari-Hara (Temple Banner), *Nepal*

The worshipper recites the *dhyāna-mantra* describing the deity, and forms a corresponding mental picture, and it is then, to this imagined form, that his prayers are addressed and the offerings made. The artist follows identical prescriptions, but proceeds to represent the mental picture in a visible and objective form, by drawing or modelling. Thus, to take an example from Buddhist sources:

> The artist (*sādhaka, mantrin,* or *yogin,* as he is variously and significantly called), after ceremonial purification, is to proceed to a solitary place. There he is to perform the 'Sevenfold Office', beginning with the invocation of the hosts of Buddhas and Bodhisattvas, and the offering to them of real or imaginary flowers. Then he must realize in thought the four infinite moods of friendliness, compassion, sympathy and impartiality. Then he must meditate upon the emptiness (*śūnyatā*) or nonexistence of all things, for 'by the fire of the idea of the abyss, it is said, are destroyed beyond recovery the five factors' of ego-consciousness. Then only should he invoke the desired divinity by the utterance of the appropriate seed-word (*bīja*), and should identify himself completely with the divinity to be represented. Then, finally, on pronouncing the *dhyāna-mantra,* in which the attributes are defined, the divinity appears visibly, 'like a reflection', or 'as in a dream', and this brilliant image is the artist's model.
>
> This ritual is perhaps unduly elaborated, but in essentials it shows a clear understanding of the psychology of the imagination. These essentials are the setting aside the transformation of the thinking principle; self-identification with the object of the work; and vividness of the final image.

The *Mānasāra* also emphasizes that 'the features of the image are determined by the relation between the worshipper and the object of his worship.' When, at the Viśvanātha

temple in Varanasi, the great *ḍamaru* begins to sound in the evening, it evokes a primal tone, a sound-image, in which that pristine form almost becomes a living entity, and the communication of the worshipper and the worshipped becomes complete.

The temple *āratī*-dance was, perhaps, the supreme means to such communication with divinity. The abandon and identification of the *devadāsīs* was to be seen to be believed. In the trance-like silence of night, flickering lamps lit the dense darkness of the innermost chamber of the temple. And there, even a few years ago, the *devadāsī* danced nude before the Lord of the Universe, Jagannātha. Step after step, she became a symbol of surrender and fulfilment, a link between the past and the present, the visible and the invisible. No artifice, no conventionality, no histrionics; she was naked, truthful, sincere. Annihilating all traces of self, she found her Self in the image and also something more, for which the right word can never be found.

THE SPIRITUAL ASPECT OF MYTHOLOGY

Dr. Leta Jane Lewis

India's beautiful spiritual mythology can constitute a serious obstacle to the Westerner who is developing an interest in Vedanta. If he takes this mythology too literally, as many people do, he can be so shocked that he will lose interest in India's great spiritual tradition before he has investigated it. Demanding what he believes to be absolute truth and absolute reality from religion, the average Westerner sees no excuse for worshipping anyone or anything that cannot be verified historically. So he draws back in amazed disbelief when he discovers that there is no good evidence for the historicity of India's favourite divine incarnations, Rama and Krishna, whose inspiring stories are told in the mythological epics, the *Ramayana* and the *Mahabhabharata*. He is saddened to read that one of the most competent authorities on Indian philosophy and religion, Sir Sarvepalli Radhakrishnan, actually states that Krishna is a composite of three legendary figures rather than one historical person.[1]

He is further taken aback when he encounters India's many gods, some of whom impress him as being very beautiful and some of whom seem very strange to him with their many heads and arms. Some grotesque gods have such deformities that he cannot imagine how a child born with them could hope to survive. Although he thinks that the elephant-headed Ganesha is more humorous than repulsive, he cannot take him seriously. He wonders how this funny little fellow, with an elephant's head on a human body, could manage to function. He abhors the worship of the Shiva lingam, a phallic symbol which is meaningless to him. And, finally, he is horrified that these unreal gods and goddess are worshipped and reverently housed in temple shrines.

The Westerner with a superficial knowledge of Indian mythology may conclude that it is only folklore, which everyone knows is fictitious, rather than religion, which is the Lord's own truth. He may think that the worship of mythological figures conforms to Webster's definition of superstition as 'an irrational abject attitude of mind toward the supernatural, nature, or God, proceeding from ignorance, unreasoning fear of the unknown or mysterious, morbid scrupulosity, a belief in magic, or chance, or the like.'[2]

If, however, the occidental inquirer consults scholarly sources, he is sure to find statements suggesting that this point-of-view is too narrow. Expert mythologists are now setting forth the theory that many myths express hidden truths about man's relationship to the cosmos. For instance, Mircea Eliade writes, '...in reciting or listening to a myth, one resumes contact with the sacred and with reality, and in so doing one transcends the profane tradition, the "historical situation".'[3] Thus Eliade believes that in reaching reality, one must transcend the historical situation, which some Westerners take to be the chief criterion of reality. Heinrich Zimmer, a foremost authority on Hindu mythology, specifically warns that 'it would not do to seek to constrain the Oriental conceptions into the delimiting frames familiar to the West. Their profound strangeness must be permitted to expose to us the unconscious limitations of our own approach to the enigmas of existence and of man.'[4] In other words, scholarly research suggests that the problem with Indian mythology must be in the inquirer rather than in the mythology itself.

The respectful study which Indian mythology deserves should probably begin with India's ancient scriptures, the Vedas, which are dated approximately between 2500 B.C and 600 B.C. and which contain the earliest references to the Indian gods and goddesses. Careful analysis of the Vedas makes it clear that, in spite of the proliferation of gods and goddesses, there was no real polytheism in India even in

ancient times. One Sanskrit scholar, Swami Prabhavananda, explains:

> Casual visitors to this ancient land carry away with them the impression of an elaborate polytheism. True it is that India has always had many gods—but in appearance only. In reality she has had but one god, though with prodigal inventiveness she has called him by 'various names'.[5]

With reference to the sections of the Vedas called the Samhitas, the Swami writes:

> The Samhitas are collections of mantras, or hymns, most of which sing the praises of one or another personal god. Sometimes the god is conceived as little more than a magnified man. In one hymn, for example, Indra, the god of rain, has a body clad in golden armour, is very strong, and descends to earth, where he lives and eats with his votaries, fights and overcomes their enemies the demons, and establishes his dominion. Similarly, Varuna, in another hymn is described as a mere nature god, presiding in anthropomorphic form over air and water. But, again, the god—even at times the same god that was just now so much a man—becomes nothing less than the Supreme Being, omniscient, omnipresent, omnipotent—and that within which the visible world is contained.[6]

Max Müller, coined the word 'henotheism' for this elevation of one god after another to become the one supreme God who creates and sustains the universe. According to the Vedas, however, even this one God is not the ultimate divine reality. In the words of Swami Satprakashananda:

> ...the deities mentioned in the Vedas...were neither supernatural beings nor deified forces and phenomena

of nature, but different manifestations of Nondual Brahman, 'the One without a second'. Indeed, the prevailing note of the Samhita part is not polytheism, henotheism, or even monotheism, but absolute monism or nondualism.[7]

The mythology of the Samhitas embodies the concepts presented in the philosophical portion of the Vedas, the Upanishads. The highest, most comprehensive, truth set forth in the Upanishads is nondual. But Vedantic sages recognize that gradations of philosophical truth are inevitable because Brahman, the absolute, nondual Reality is only partially revealed to the vast majority of us. In Swami Prabhavananda's eloquent words, the experience of Brahman is 'so utterly impersonal, so devoid of anything describable in human terms, as to be suited only to the greatest saints, and to those only in their most strenuous moments.'[8] We see Brahman through a sort of spiritual fog. At first our perception is very vague, but our vision gradually becomes clearer as the fog dissipates. Brahman is always the same; it is our perception that varies. Since this nondual ultimate Reality, of course, admits no other, all that we experience in the apparently finite universe must be Brahman imperfectly understood. We first see Brahman, the all-inclusive reality, not as spirit but as matter. When our vision clears a little, we see Brahman as an external personal deity; then, with greater clarity, as the all-pervasive personal God in whom we live, move, and have our being; and, finally, we know Brahman as undifferentiated divine existence, consciousness, and bliss. We then know that the true Self, the Atman, is one with this absolute spirit, Brahman. Brahman is divine, so we are divine.

In worship, as in nondual absorption, the divine is experienced as blissful consciousness, which is much fuller and more intense than our ordinary consciousness. On the spiritual level of mythology, characters such as Rama and

Sita embody this consciousness in exemplary lives to give us an idea of our own unrealized divinity.

Humanity has projected its own nature, both human and divine, into myths. When the gods are conceived of as having ordinary human weaknesses, it is because we have attributed our weaknesses to them. And when the gods display saintliness and wisdom, it is because these qualities also are part of our nature. The myth of the great god Shiva is an example of both human and divine projection. In the *Atharva-Veda*, Shiva (there known as Rudra) is 'dark, black, destroying, terrible'; he is the fierce god who is implored 'not to assail mankind with consumption, poison or celestial fire'.[9] But in the Upanishads, Shiva proclaims his own divinity as follows: 'I alone was before (all things), and I exist and I shall be. No other transcends me. I am eternal and not eternal, discernible, and undiscernible, I am Brahma and I am not Brahma.'[10] To the advanced saint, Shiva even personifies the absolute Brahman. He is also the compassionate one who drank the poison which threatened to destroy the world and who broke the fall of the Ganges on his matted locks so that it would not devastate the land with its raging current.

We make our own gods. When they are divine, it is because there is divinity within us, their creators. In an exquisite passage, George Santayana says that our personal conceptions of Jesus and Virgin Mary come from within us, not from history, although it is perfectly possible that the historical Jesus and the historical Mary were as we imagine them.

> The Christ men have loved and adored is an ideal of their own hearts, the construction of an ever-present personality, living and intimately understood, out of the fragments of story and doctrine connected with a name. This subjective image has inspired all the prayers, all the conversions, all the penances, charities, and sacrifices, as well as half the art of the Christian world.[11]

A Vedantist would say that the Christ spirit within countless Christians has been projected into the Christ men have loved and adored. Santayana continues:

> The Virgin Mary, whose legend is so meagre, but whose power over the Catholic imagination is so great, is an even clearer illustration of this inward building up of an ideal form. Everything is here spontaneous sympathetic expansion of two given events: the incarnation and the crucifixion. The figure of the Virgin, found in these mighty scenes, is gradually clarified and developed, until we come to the thought on the one hand of her freedom from original sin, and on the other to that of her universal maternity. We thus attain the conception of one the noblest of conceivable roles and of one of the most beautiful of characters.[12]

Myths are not confined to completely fictitious characters. They also grow up around actual historical persons like Jesus, the Virgin Mary, and the Buddha, making it difficult to distinguish fact from fiction. Was Jesus really born in a manger? Did angels sing and the star of Bethlehem appear in the sky on the night of his birth? Was Mary actually a virgin then? She may indeed have been, but, like Jesus, Krishna and the Buddha are said to have been conceived without human fathers. Their mothers, too, are supposed to have learned of the coming divine births through supernatural annunciations. Several centuries before Jesus' birth, Krishna was taken away and hidden from a wicked king, who sought to kill him for fear of losing his life and his throne. In Krishna's case, as in Jesus', the cruel king is reported to have slain many innocent children in the hope that the divine child would be among the victims. Can it be that the same myths and fragments of myths became attached to Jesus, Krishna, and the Buddha?

Although, as far as we know, the Krishna of the *Bhagavad-Gita* was not a historical personality, he had all the

characteristics usually attributed to divine incarnations. Perfect from birth, he came into the world not to satisfy personal cravings but for the good of humanity. He wanted to help mankind end its suffering and attain pure bliss in the Atman. Unlike ordinary people, he was always fully aware of his divine identity; he even appeared in his cosmic form to the frightened Arjuna. Such a figure is too great spiritually, too transcendent, to be the product of even our finest projections. It would be impossible to imagine a Krishna without knowing a Krishna. Only a divine incarnation could have furnished the model for the Krishna of the *Gita*, so one must have existed approximately when the *Gita* was composed. The incarnation's name and exact dates are, therefore, not needed to prove his historicity. And who knows? Perhaps the historical divine incarnation's personal identity actually was that of the Krishna of the *Gita*.

The other Krishnas: Krishna the king, the darling baby Krishna, and Krishna the enchanting cowherd boy, may all have been figures in legends which attached themselves to the divine incarnation of the *Bhagavad-Gita*. Krishna, the cowherd boy who steals the hearts of his devotees with his captivating smile and flute, may not have danced in the meadows of Vrindaban. But that does not matter to his devotees. They say that Krishna did not need to dance in Vrindaban, for he will always dance in their hearts.

Mythological characters like Krishna, Rama, and Shiva have brought multitudes of Indian devotees closer to God. Because it is impossible to imagine spirit in the abstract, personifications like these are important aids in people's spiritual lives, as are images and symbols of various sorts. As Swami Vivekananda says:

> All of you have been taught to think of an omnipresent God. Try to think of it. How few of you can have any idea of what omnipresence means! If you struggle hard, you will get something like the idea of the ocean, or of the sky, or of a vast stretch of green earth, or of a

desert. All these are material images, and so long as you cannot conceive of the abstract *as* abstract, of the ideal *as* the ideal, you will have to resort to these forms, to these material images.[13]

Devotees throughout the world create images of the historical and mythological divine incarnations, saints, and deities in whom they feel a holy presence. They do this for much the same reason that a lover keeps his sweetheart's photograph on the desk before him. The picture . is a reminder of the beloved person, not, of course, the actual person. Indian devotees neither think of stone images as the actual personalities whom the images represent, nor do they worship the images as stone. As Swami Vivekananda explains, such worship would be contrary to human nature:

Is there any God? Is there anyone to be loved, any such one capable of being loved? Loving the stone would not do much good. We only love that which understands love, that which draws our love. So with worship. Never say...there is a man in this world of ours who worshipped a piece of stone....[14]

The Swami further explains the use of the images in India:

The man is before the idol, and he shuts his eyes and tries to think, 'I am He; I have neither life nor death; I have neither father nor mother; I am not bound by time or space; I am Existence infinite, Bliss infinite and Knowledge infinite; I am He, I am He...I am Existence Absolute, Bliss Absolute; I am He, I am He.' This he repeats and then says, 'O Lord, I cannot conceive Thee in myself; I am poor Man.'...This poor Hindu sits before that idol and tries to think that he is That, and then says, 'O Lord, I cannot conceive Thee as spirit, so let me conceive Thee in this form, and then he opens

his eyes and sees this form and prostrating he repeats his prayers. And when his prayer is ended, he says, 'O Lord, forgive me for this imperfect worship of Thee.'[15] A curious round stone is the emblem of Vishnu, the omnipresent. Each morning a priest comes in, offers sacrifices to the idol, waves incense before it, then puts it to bed and apologizes to God for worshipping Him in that way, because he can only conceive of Him through an image or by means of some material object. He bathes the idol, clothes it, and puts his divine self into the idol 'to make it alive'.[16]

Those who officiate at the dedication of an image in a temple pray that the Lord may come and live in it. Then the devotees who worship there feel that the Lord is present in the image in much the same way that the spirit is present in the body.

Like true devotees all over the world, the Hindu who kneels before the image is worshipping the one God in spirit and in truth.

When the devotee kneels before the image ardently praying, 'Lord, Lord, reveal thyself to me', he may feel a holy presence. The one to whom he prays, perhaps Krishna, Shiva, or Kali, may appear to him in a vision and even speak to him. Are such visions the hallucinations of schizophrenics? People who insist that Jesus came and spoke to them frequently end up in mental institutions. Some of the mentally deranged even believe that Jesus commanded them to commit murder. But Jesus would do no such thing, and no true devotee would carry out such an order.

The distinguishing feature of a genuine vision is the elevation of consciousness which accompanies it. Those who have felt a divine presence in legitimate visions manifest it spontaneously in their lives. They are saner and more compassionate after the experience than they were before. The touch of God has a softening effect, and it purifies the heart.

Some sages say that God in His infinite compassion takes the form the devotees loves, that He assumes the form of a Krishna, a Kali, or a Jesus Christ much as water freezes into the different shapes of ice, snow and hail. Sri Ramakrishna taught that divine incarnations, like blocks of ice floating on the ocean, retain their personal identities for the sake of their devotees instead of disappearing in the undifferentiated Brahman. Perhaps these holy ones as well as living and departed saints can appear to us through some subtle faculty. Our five senses and even our best scientific instruments tell us little of the finer workings of our psyches and of the universe in general. It may be that when the devotee's consciousness rises through prayer and meditation he can experience the presence of the saints and other divine personalities who are always on that level of consciousness. If we climb (or take the elevator) to the penthouse on the roof, we will meet the people who live there.

The essential feature of a vision, however, is not the personality of the holy man or woman who appears to the worshipper. The essential feature is the divine consciousness—the grace—which communicates itself to him.

Visions and related experiences can have various logical interpretations, none of which contradicts the others. We are the Atman, Brahman-within-the-Creature, but we are not aware of it. The Atman is much more intense consciousness than our ordinary consciousness, which is a little ray of the Atman. In other words, we have a spiritual superconsciousness which the little limited ego does not usually experience. But when prayer and meditation become deep and sincere, the devotee's level of consciousness can rise. Then intense spiritual consciousness can penetrate the surface consciousness, bringing ecstasy and bliss. A divine presence is felt; a vision is seen or a voice heard. It may be that the devotee's own mind interprets this spiritual presence as that of Jesus, Shiva, the Buddha or any holy person he especially loves. The vision is seen because the

area of the mind which is the source of all symbols has been stimulated. Thus, spiritual visions can come from the devotee's higher consciousness. Or they can be produced externally because God in His grace takes the form the devotee loves.

Perhaps different visions have different causes. But in a certain sense there is only one cause. There is only one spiritual consciousness, Sacchidānanda, absolute Existence, absolute Consciousness, and absolute Bliss. Since there is no spiritual consciousness outside of Brahman, Brahman is the ultimate source of all true visions whatever their immediate cause. The air in our lungs, which becomes part of us, is not different from the air outside. Similarly, the divine within (Brahman-within-the-Creature) is identical with the divine outside. Since there is only one divine existence, no valid distinction can be made between the divine within and the divine without.

A legitimate vision or other spiritual experience derives its reality from the living spirit which animates it. The vision is real even when the historicity of the divine incarnation, saint, or god who appears in the vision cannot be definitely established. The divine presence experienced by the devotee worshipping before the image of Krishna, Shiva, or Rama is the same divine consciousness, the same holy spirit, which lived in the historical Jesus and Buddha.

Spiritual life deteriorates when we place such emphasis on the body that we forget that the spirit is only temporarily associated with it. In the West we commonly say that we have souls, implying that we are bodies which possess souls. Vedanta puts it the other way, saying that we are spirits inhabiting bodies. The spirit animating Jesus' body gave it worth; even *his* body would have been nothing without the spirit. We burn or bury bodies from which the spirit is gone. When Jesus said, 'I am the way, the truth and the life: no man cometh unto the Father, but by me',[17] the 'I' of which he was speaking was the 'I' to which he referred when he said, 'I and my Father are one.'[18]

This 'I', the one divine Existence, also spoke through the Buddha and through Krishna. It speaks through Kali, Shiva, or Rama to the devotee kneeling before the image. The one infinite spirit, which is the way, the truth and the life, mercifully appears in many forms for the sake of spiritual aspirants with different spiritual ideas. It is not restricted to any one individuality. When Sri Ramakrishna had a vision of Jesus, Jesus walked up to him, entered his body, and disappeared. Although these two supremely great souls may seem to have been separate individuals, they were—and are—identical on the only level that really matters, that of the spirit. The poet who wrote the following lines knew his Krishna to be pure radiant spirit:

> Meditate, O my mind, on the Lord Hari,
> The Stainless One, Pure Spirit through and through.
> How peerless is the light that in Him shines![19]

Although the Lord can appear in many forms, He is not restricted to any of them. He always remains the same.

Idolatry is worshipping the physical, whether it is clay or flesh and blood, instead of the spiritual. It does not necessarily involve image worship or any other specific kind of worship. Even Jesus and the Buddha can become idols if too much emphasis is placed on the bodies associated with them. We make idols of our friends and relations when we love them for personal rather than spiritual reasons.

The complete independence of the divine existence from anything physical is demonstrated by Sri Ramakrishna's experience of the nondual absorption, *nirvikalpa samadhi*. Sri Ramakrishna began worshipping the mother goddess Kali in her image in the Dakshineswar temple when he went there as a young priest. As time went on, he developed profound love for Kali, came to feel her presence wherever he was, and saw her in many gracious feminine forms. At the height of this spiritual relationship, he became

infused with her blissful consciousness. Although his consciousness was then pervaded with divine conscious-ness, he retained a slight sense of ego which prevented total absorption. At this critical point in Sri Ramakrishna's spiritual life, the austere nondualistic monk Totapuri (Nangta) appeared to help him. Describing the events that followed Totapuri's arrival, Sri Ramakrishna himself said:

> Nangta began to teach me the various conclusions of the Advaita Vedanta and asked me to withdraw the mind completely from all objects and dive deep into the Atman. But in spite of all my attempts I could not altogether cross the realm of name and form and bring my mind to the unconditioned state. I had no difficulty in taking the mind from the objects of the world. But the radiant and too familiar figure of the Blissful Mother, the Embodiment of the essence of the Pure Consciousness, appeared before me as a living reality. Her bewitching smile prevented me from passing into the Great Beyond. Again and again I tried, but She stood in my way every time. In despair I said to Nangta: 'It is hopeless. I cannot raise my mind to the unconditioned state and come face to face with Atman.' He grew excited and sharply said: 'What? You can't do it? But you have to.' He cast his eyes around. Finding a piece of glass he took it up and struck it between my eyebrows. 'Concentrate the mind on this point!' he thundered. Then with stern determination I again sat to meditate. As soon as the gracious from of the Divine Mother appeared before me, I used my discrimination as a sword and with it clove Her into two. The last barrier fell. My spirit at once soared beyond the relative plane and I lost myself in *samadhi*.[20]

Sri Ramakrishna had experienced the divine conscious-ness in the form of Kali. But when he severed Kali with the sword of discrimination, the non-essential form vanished

leaving only the spirit, the divine consciousness in which his ego and plurality disappeared.

Without the image of Kali, Sri Ramakrishna would probably have progressed more slowly toward this ultimate realization. The worship of Kali in her image concentrated his mind on the divine, making it relatively simple for him to go beyond the goddess herself to the spirit she embodied for him.

The initial experience of nondual absorption was often repeated and became interspersed with visions of Kali, Krishna, and other holy figures. Knowing from experience that the divine assumes forms, Sri Ramakrishna did not deprive himself of the joy of dualistic worship even after *nirvikalpa samadhi*. In teaching his disciples, he emphasized the fact that God can be worshipped either with form or without form. But since the nondualistic vision is very difficult to attain, he taught that almost everyone should worship God with form. And because he knew that one divine spirit, one God, is worshipped by the devotees of all religions, he effortlessly extended his devotion beyond Hinduism to Islam and Christianity. One day at a friend's house he caught sight of a lovely painting of the Virgin Mary holding baby Jesus on her lap. Overwhelmed with love for the Christ child, he spontaneously entered into deep meditation and had an ecstatic vision of the divine child's luminous form.

Sri Ramakrishna knew how easily a devotee could be tempted to think that his own spiritual ideal, his Krishna, Buddha, or Jesus Christ, is beyond all comparison, and how easily he could then conclude that this ideal is the one source of salvation for all mankind. Such an attitude would naturally lead to bigotry and intolerance of other faiths. But if he were to grow sufficiently in understanding to realize that the followers of other religions also worship the divine spirit he worships, the devotee would be able to appreciate their ideals and forms of worship. Using a little effort, he would be able to transfer his own religious experience to

other situations. For instance, the Hindu, in his creative imagination, could transfer his love for the baby Krishna to the baby Jesus, not permanently, but long enough to feel kinship with Christians who adore the Christ child.

Because they know that the spirit alone gives life, the Vedantic sages do not try to convert anyone. And because they realize that conceptions of the divine vary with spiritual aspirants's backgrounds, they hope there will never be a universal religion with a universal mythology. Sri Ramakrishna, for example, recommended different spiritual practices to aspirants with different personality types and degrees of development. In defence of this undogmatic approach he told the following parable:

> God Himself has provided different forms of worship. He who is the Lord of the Universe has arranged all these forms to suit different men in different stages of knowledge. The mother cooks different dishes to suit the stomachs of her different children. Suppose she has five children. If there is fish to cook, she prepares various dishes from it—pilau, pickled fish, fried fish, and so on—to suit their different tastes and powers of digestion.[21]

Because many stomachs are too weak to digest the pickled fish of abstract thought, myths are used to present Indian cosmology. These myths are projections of actual human experience in spite of the fact that no one could possibly remember the creation. In *nirvikalpa samadhi*, the greatest sages experienced the undifferentiated divine Essence, Brahman, as the ultimate Existence. They then realized that all creation has it being within Brahman. So India's great creation myths teach that Brahman is the source, the so-called 'clay', which gives substance to all things. One Upanishad compares the universe emanating from Brahman to a spider's web issuing from a spider. According to these myths, periods of involution, in which

there is no finite universe, alternate with periods of evolution, in which universes appear, evolve through countless ages, and finally disappear. This alternation of periods of evolution with periods of involution is beginningless and endless.

In one of the favourite Indian creation myths, the spirit of God hovers over the waters prior to creation much as it does in Genesis. At the end of the period of involution, when all is still in the undifferentiated state, Vishnu (the spirit of God) is asleep upon the cosmic ocean. That is, he reclines on one of his mounts, the enormous serpent Ananta, who rests upon the cosmic ocean, which it also represents. In spite of the apparent individual differences, Vishnu, the snake Ananta, and the cosmic ocean are not separate entities. They are Vishnu, who personifies the absolute Existence, in which there are no differences. When creation is about to begin, Vishnu puts forth from his navel a lotus of a thousand pure gold petals, stainless and effulgent. Upon this lotus sits Brahmā, the Creator God, who is an emanation from Vishnu. Then with Vishnu's energy working through him, Brahmā proceeds to create the universe. When creation is finished, Vishnu pervades and sustains the universe which evolved from him.

Brahmā, the creator, is one of the strange gods with several heads and arms, which some Western novices in Indian mythology have difficulty understanding. Brahmā has four heads, one facing north, one facing south, one facing east, and one facing west, so that he can watch all points of the compass while creating the universe. In his hands he holds his sceptre, or a spoon, or a string of beads, or his bow, or a water jug, and the Veda. He uses these four arms (which symbolizes his power) and his several instruments for his various characteristic activities, which he can carry on simultaneously.

The Shiva lingam belongs to a different creation myth. Like Vishnu's votaries, Shiva's votaries think of him as the one supreme God. They think of the lingam as representing

the power by which Shiva creates, preserves, and destroys the universe. They do not think of the lingam in terms of the phallic symbol. To Shiva's devotees, it represents the great God in his many aspects, of which creation is only one.

The conscientious study of Indian mythology thus makes clear the error in the snap judgement that the worship of mythological figures conforms to Webster's definition of superstition as 'an irrational abject attitude of mind toward the supernatural, nature or God, proceeding from ignorance, unreasoning fear of the unknown or mysterious, morbid scrupulosity, a belief in magic, or chance, or the like.' Far from being irrational, this worship proceeds with the clearest reasoning. It is not abject. It is inspired by knowledge, not ignorance, and there is absolutely no fear involved in it.

REFERENCES

1. Sir Sarvepalli Radhakrishnan, *Indian Philosophy*, vol. 2 (New York: Macmillan Co., 1958), pp. 493–4.
2. *Webster's Collegiate Dictionary*, fifth edition.
3. Mircea Eliade, *Images and Symbols*, trans. Philip Mairet (New York: Sheed and Hard, 1952), p. 59.
4. Heinrich Zimmer, *Myths and Symbols in Indian Art and Civilization* (Princeton: Princeton University Press, 1974), p. 12.
5. Swami Prabhavananda, *The Spiritual Heritage of India* (London: George Allen and Unwin, 1962), pp. 34–5.
6. Ibid. p. 31.
7. Swami Satprakashananda, *Swami Vivekananda's Contribution to the Present Age* (St. Louis: The Vedanta Society, 1978), p. 212.
8. *Spiritual Heritage*, p. 35.
9. John Dowson, *A Classical Dictionary of Hindu Mythology* (London: Routledge and Kegan Paul, 1972), p. 296.
10. Ibid. pp. 296–7.
11. George Santayana, *The Sense of Beauty* (New York: Dover

Publications, 1955), p. 116.
12. Ibid. pp. 116–7.
13. *The Complete Works of Swami Vivekananda* (Calcutta: Advaita Ashrama, 1968), vol. 2, p. 40.
14. Ibid. vol. 6 (1969), p. 51.
15. Ibid. vol. 8 (1964), pp. 210–1.
16. Ibid. vol. 6, p. 25.
17. John 14.6.
18. John 10.30.
19. *The Gospel of Sri Ramakrishna*, trans. Swami Nikhilananda (New York: Ramakrishna-Vivekananda Center, 1973), p. 924.
20. Ibid. p. 29.
21. Ibid. p. 81.

SPIRITUAL PREPARATION OF THE TEACHER

Dr. Maria Montessori

The teacher must not deceive himself by thinking he can prepare himself for teaching by the study of anything, by the building up of his own culture. What he must do above all is to prepare within himself a certain moral attitude.

There is a central point in this question: *the way in which we are to consider the child*. This point cannot be faced only from without, as if we had here to do with theoretic knowledge or general ideas of nature or with the right way of instructing or correcting.

I wish to stress, on the contrary, the need of the educator's undergoing an inner training; he must methodically enter into his own heart that he may discover certain clearly defined faults within himself that might be obstacles in his dealing with the child. If we are to discover faults already deeply rooted in our consciousness, we must have an aid, a 'teaching'. Thus, for example, if one wants to know what has got into one's eye, one must be aided by another person looking into it for us and telling us what is there.

In this sense the teacher must be 'initiated' as to her inner preparation. She is too greatly concerned with the 'bad instincts of the child', too anxious to 'correct his naughtiness', too much preoccupied about 'the dangerous effects left in the child by the traces of original sin', etc.

Instead of all this, she must begin to search for flaws and faulty tendencies, within herself.

'First remove the beam from thine own eye, then seek for the mote that is in the eye of the child.' This inner preparation is not *generic*; we are not dealing, that is, with

the search after self-perfecting, the search of those leading a religious life.

It is not necessary to become perfect, free from every form of weakness in order to be educators. A person who is continually preoccupied about his own inner life, so that he may raise himself spiritually, might be quite unconscious of those of his faults which stand between him and a perfect comprehension of the child. That is why it is necessary to *learn*—to be directed—to be prepared for becoming teachers of little children.

Within us we have certain tendencies which are not good; these are capable of growing like the weeds in a field (original sin).

These tendencies are many: They fall into seven groups; these groups we call the seven *peccati mortali.*

All of these set a distance between us and the child, since the child as compared with ourselves is not only a purer being but one possessing mysterious hidden qualities unseen by grown up people—qualities, however, which we must believe and have faith in, for Jesus spoke of them clearly and emphatically, so much so that all the Gospels record it: Unless ye are converted and become as little children, ye shall not enter into the Kingdom of Heaven.

The essential thing for the teacher is that he should be able 'to see the child as Jesus saw him'. The effort to achieve this—a clearly defined, strictly limited effort—is what concerns us here. The teacher is not merely one who seeks to make himself better and better; he is one who frees his own soul from those obstacles which hinder him from understanding the child. Our instruction of teachers consists in pointing out to them which are the states of mind they should correct: as a doctor would point out which particular and determinate illness is weakening and endangering a physical organ.

Here, then, we have the positive aid: '*The sin which arises within us and prevents us from understanding the child is anger.*'

But no sin can act singly—it is always linked and blended with the others. Just as Eve, when sin first entered into human life, sought and joined Adam, so anger calls forth and blends with another sin, of more noble and elevated aspect—and thereby more diabolic: This other sin is pride.

Our evil tendencies—*peccati mortali*, can be corrected in two ways. Correction may come from within; the individual who has seen his own faults in the clearest possible light his intelligence can offer, may himself take up arms against them and voluntarily, that is, with an effort of his whole being, may seek to combat them and by God's grace purge his own soul of sin.

The other way is from without; it is a social corrective. One might point to it as resistance coming from the environment opposing the expression of our evil tendencies, so as to put a check upon their development.

This external influence has much power over us. It is, we may say, the principal warning we get of the existence in us of moral defect; it is in some cases this warning which leads us to reflect upon ourselves, and thus to set vigorously to work on an inner purification earnestly and voluntarily undertaken.

Let us take these sins: Our pride is kept in check by what people think of us; our avarice finds itself limited by the material circumstances of life; our anger is arrested when we meet with those who are stronger than ourselves; sloth has to give in to the necessity of working in order to live; sensuality is modified by the standard society sets; gluttony limited by the greater or less possibility of getting possession of superfluities; envy is checked by the need of keeping up appearances. There is no doubt whatever that, apart form these corrective and modifying circumstances, there may exist the individual voluntarily battling with his own defects. Still, our social surroundings do provide a positive and continuous warning of a salutary nature.

This social control has great importance as a basic support ensuring the moral balance of the individual.

But for all that, our attitude towards God is a purer one than our relation to social checks. Our soul yields readily to the need of self-correction when we have freely acknowledged that we are in error; but it is slow to yield to the humiliating control of others. We actually feel more humiliated by having to yield to them than we feel humbled by the fault we have committed. When it is *necessary* to check ourselves—when it is unavoidable that we should yield—, an instinct of protecting our dignity in the eyes of the world makes us seek to make it appear that we have freely chosen what was really inevitable. It is one of the most widely diffused customs in social life to fib by saying that the grapes are sour.

We offer resistance to what resisted us, by fibbing about it; we are warring, but not for our own perfecting.

And, as in every contest, there soon comes the need of organizing the combat; the individual activity becomes stronger by collective action.

Those who have some fault in common, before they will yield in respect of that fault, tend instinctively to join together, that their union may be its defence. A kind of little fortress is thus built up to oppose those who war against the expansion of our capital sins.

No one will dare to say, for example, that the equal division of their possessions is distasteful to the rich because they are avaricious and slothful. But one will say that such distribution of riches would be a good thing for everybody, and necessary for social progress, and one may even hear it said by many rich people that they resign themselves to it for the good of all; there is an instinctive leaning towards the covering away of our sins under the pretext of a lofty and necessary duty to be performed. Just so in war may deadly explosives be hidden away beneath what meets the eyes as a field full of flowers, acting as *camouflage*, to deceive the foe.

The less resistance is offered to our defects by our surroundings, the more convenience and time are afforded us

for forming our *camouflage*, for building up our fortified towers.

As we go a little deeper into these reflections, we end by realizing that we are actually more attached than we think to our bad habits; and that the devil easily slips into our subconscious with the suggestion that we should mask ourselves to ourselves.

Such is the mask—a defence not of our life but of our faults—which we like to assume, and to which we give the name of 'necessity', 'duty', 'good of all', etc., and which therefore becomes day by day more difficult for us to lay aside and be free.

This state of confusion has arisen from our becoming convinced of a truth which had once been voiced in the dull, unechoing depths of our conscience and which we had dealt with as if it were false instead of true.

Now the teacher, or the educator as such, must purge himself of that condition of error which places him in a false position as regards the child. We must clearly define the most prevalent of his faults; and here it is not just a single sin but a blend of sins, closely akin to each other: pride and anger.

It is really anger which is here the sin; pride has joined herself to anger, lending her an agreeable disguise; veiling the personality of the adult so as to make it appear attractive and even deserving of veneration.

Anger is one of those sins which are held in check by the forcible resistance of other people's wills; man will not lightly undergo the effects of anger at the hands of his fellowman. So anger is powerless, is a prisoner, when she meets with resistance from the strong. Man is ashamed of showing anger in the presence of another, since humiliation awaits him when he is obliged to beat a retreat.

An outlet for his anger is afforded when he meets with a person who can neither understand nor defend himself, one who believes all—the child. Children not only forget immediately when we do them wrong; they also feel that

they are guilty of everything we accuse them of. That Saint, a disciple of Saint Francis of Assisi, who wept because he thought he was a hypocrite, was like this; a priest had accused him of hypocrisy.

The educator is here invited to consider a very grave matter: the result such conditions have in the life of the child. It is only the child's reason which does not grasp the misunderstanding; his soul feels it however, is oppressed by it, often so oppressed as to become deformed. Then there emerge those reactions on the part of the child by which, though he is unaware of the fact, he is defending himself. Timidity, lying, mischief, weeping without any apparent cause, restlessness at night, all kinds of exaggerated fears and similar obscure symptoms correspond to unconscious states of self-defence on the part of the little child who is not yet able by the light of reason to discern the real state of his relations with the adult.

On the other hand, anger is not always material violence.

From that unveiled, primitive impulse which we generally mean when we speak of anger may spring various complex manifestations. Man, whose nature is psychologically elaborate, masks and complicates his inner states of sin.

Anger in its simple form manifests itself merely as a reaction to open resistance on the part of the child. But when faced with those obscure expressions of the childish soul which we have mentioned, anger and pride mingle and blend, and a complex state results: This state assumes the well-defined, calm and respectable form which is known as *tyranny.*

A form of manifestation about which no discussion is possible places the tyrannous adult in an impregnable fortress of recognized rights and admitted power; his power over the child belongs to him from the fact that he is an adult. Discussion about this would be *lex majesty.* In the world of adults this tyrant has been recognized as God's

elect. But with children he stands for God Himself. No discussion is possible: in fact, the only being who might discuss the matter is the child, and he is silent. He yields to all, believes all, and he forgives all. When he is smitten he does not revenge himself; he readily asks forgiveness of the angry adult, omitting to ask in what respect he was offended.

At times the child does give vent to acts of self-defence, but these are not in direct and voluntary response to the actions of the adult. They constitute a vital defence of his own psychic integrity, they are the reactions of a soul repressed.

It is only when the child grows bigger that he begins to direct reactions in self-defence against the tyranny that oppresses him. But the adult then finds causes to which he may attribute, and by which he may justify, his own actions; and these he uses in order to entrench himself, more safely behind his frontier of false excuses so that he sometimes succeeds in convincing even the child himself that the adult *must* be a tyrant—for the child's own good!

Respect exists on one side only; respect of the weak for the strong.

That *offence* should be inflicted by the adult is legitimate; he is allowed to judge the child, to say ill of him, and this he does; even to the pitch of inflicting blows.

The adult directs or suppresses the needs of the child as he chooses. A protest from the child is an act of insubordination which it would be dangerous to tolerate.

All this has been built up as it were into an age-old form of government of a land whose subjects never had their Duma. As some people have managed to believe that they owed all to the benevolence of their King, so this people, these subject children have thought they owed everything to the kindness of the adult. Or rather it is the adult who believes it. His *camouflage* as creator has been organized. It is he who in his pride is convinced that he has created in the child all that the child possesses: intelligence,

instruction, virtue, religion; it is he who creates for the child the possibility of communicating with the world without, with men, and with God Himself. This mission is a fatiguing one; the self-sacrifice of the tyrant completes the picture! What tyrant would confess that it is his subjects that are being sacrificed?

*

What our Method asks of the teacher as a preparation is that she should enter into herself and free her own soul from the sin of tyranny, tearing from that soul the matted growth of pride and anger that for ages unknown to themselves has choked the hearts of adults. Pride and anger must go, humility must take their place, charity as a mantle must cover all. This is the attitude they must take up, and here is the central point on which balance depends, and progress. Such is the preparation which is needed: an inner training from which all starts, to which all tends.

Not that every act of the child is to be treated with approval; not that we are to abstain from judging him; not that we have nothing to do in helping the development of his heart and mind. Oh no! We must not forget that we are dealing with education, that we have positively to become the teachers of the child.

But what is needed is an act of humility, the casting away of a preconceived idea that was ingrained in our hearts, just as the priest before he ascends the altar steps must recite his Confiteor.

Thus, and not otherwise!

It is not the abolition of educative help to the child that we aim at: it is the change of a state within us which prevents adults from comprehending the child.

SOLITUDE

Lizelle Reymond

In the period of upheaval in which we now live, when everything jars and disappointment grows upon us, we readily build up an illusion for ourselves. 'If only I could get away, I would find joy....Yes, but where shall I go?' Wearied with the noise and the crowds, you let desire invade you to be alone and to taste the joy of solitude. Solitude lures you like an oasis. In sheer opposition to all that you leave behind, you imagine a solitude that would be pure delight. We forget, however, that the chaos we are leaving remains within us in our most secret life. In these conditions, how can the two words, solitude and joy, be taken together? Those who have forsaken the world assure us it is possible. They know, they tell us, of a solitude inhabited, visited by God, and which is actually a withdrawal from life in order to converse with God and to live by His spirit. This is perhaps the archetype of joy which the painters of the quattrocento showed reflected in the faces adorning their triptychs. Perhaps joy existed in those days, I do not know—I did not taste it then. What I can say is that around me, amongst millions and millions of people who live 'outside of God', I have never encountered it except in very young children. Nevertheless, pure joy does exist. It was the food of my life in India and I have brought back a warm and everlasting remembrance that to me has become very real.

As for this joy, I do not think solitude should be asked to reveal its secret. Joy is beyond solitude. Solitude is a crucible, and he who has been through it is no longer the same as before. When joy springs forth, there is no longer solitude. The word 'solitude' leaves no room for anything but the one who is 'alone'. There can be no question and no answer. God himself is silent.

But this solitude is great adventure.

It should be approached with infinite gentleness, I would almost say, with a shade of tenderness. It is always frightening, although it is desired 'intellectually' by all who like agitation and complications. 'Ah! if only I were in your place!' But when they happen to give it a trial and realize that solitude is that consciously desired state in which there is no one we can share our thoughts with, no one to listen to us and admire our smallest actions, they soon hurry back. Having no spectator of any sort, the soul wrestles with time and is tossed like a ball between causes and effects until all the rough edges are smoothed. It is a stern and direct discipline: When living 'in the world', one very rarely has an opportunity of putting solitude to the test. Here is the one that I tried: a little house in the in the heart of the forest, three miles from the village. No neighbours. No road but a rugged footpath; no gate, no closed door at night. The postman, as he brought the mail, left the loaf of bread on the table. The rest of my food was supplied by the goat and the hens and the garden. I often spent as much as three weeks without going to the village or talking to anyone.

How did I enter into this solitude?

By a very narrow and stony path. I had a hard struggle. Solitude nearly defeated me. Then I looked it squarely in the face and a real duel began. I made it my task to conquer it and I was prepared to pay whatever it might cost.

There are of course several ways to venture into solitude. The Golden Legend tells us of cohorts of men and women saints who have tried it; the white enclosures of convents hold the secret of detailed and subtle experimentings. In life in the world, there are unfortunately very few cases of a personal experience which can serve as an example. (I might quote that of Byrd at the South Pole; his book *Alone* extols man's struggle with himself.) Once again I appealed to India, where usually everyone at some time or other in his life goes in for solitude, following the theoretical teaching and practical instructions of some wise man. I

humbly set my problem before me and let the skein unwind itself. Each stage to be cleared was plainly marked off. I will only deal with a few of them here.

I

Why are people so afraid of being alone, particularly at the approach of night, the most favourable time of all when, as the Hindus say, the air itself quivers with piety? The world of day sinks into the world of night. The great astral influence changes, bringing another rhythm. Man does the same. At that hour, children climb unto their mother's lap and want to be fondled; young animals seek their mother to be fed and to nestle between her paws. In India, this moment is called the 'hour of grace', and the sacred lights are lighted everywhere with a moving ritual, even in the booths amid the hubbub of the bazaars. Here at home, the Angelus rings, but only a handful of believers respond to it in a moment of solitude born of prayer. The teeming multitudes, the numerous Christian nations all through the West, the toiling populations are no longer aware of this moment, no longer desire or feel the need of it. However distressing that may be, we must dare to recognize that we have completely dissociated the soul from the body just as we chased solitude out of our active life. The resultant callousness is the just price which we must pay.

The intellectual explains everything he does not understand by using more or less correct mental images, depending upon his power of expression. The countryman remains much more simple-minded, and the sensations he scarcely knows how to control are the only screen between him and his soul. That is why he acknowledges his 'fear' of the twilight and materializes it to the extent of seeing in it moving forms and of hearing voices; a shadow then assumes a density equal to that of a man. And this fear remains until the morning breaks. He bars and bolts his

house. He lights the fire. He dreads the screeching of owls as much as the wind in the foliage. It is the fear of solitude—the least of all the solitudes—that which is met at the first gate.

Nevertheless, one must plunge into it as the baker plunges his arms into the dough, turning it over, spreading it out and kneading it. A man must measure the night as he measures the day. He then discovers that darkness is not the opposite of the life he loves in the sun and that the absence of manifestations is not death. The earth basking in sunshine and the earth plunged in night are both steeped in the same solitude just as his soul within him that magnifies the Lord and his instincts that grovel in the mire are the same clay which he will work with his hands.

Lord, is not the solitude of twilight the courageous look on the workshop? The audacity to fathom the depth of the shadows to read the richness of the colours? The Hindu says: Meditate in this Holy Hour. Cast away all that you possess as so many garments that hinder you. Strip yourself. Lay aside your ornaments, your clothes, and your dirty linen. Strip yourself of everything. Give to your Lord all that you are in the whole of yourself, in good and in evil. Is it for you to choose your humble offering? Give to your Creator what He Himself has given you, without pride and without humility. Say to Him: 'Divine potter, fashion me': Does the forest itself elect the tree with the straight trunk or the tree with the gnarled trunk? Do likewise, give of yourself with love. When you take up your garments again, you will easily know which of them you must wash in the river and beat on the stones in the living water....

II

There is another solitude which is pursued by making noise, no matter what noise, provided a voice answers the voice that speaks within the heart, and that is never silent,

whether in daytime activity or in the dreams of sleep. One wishes both to hear it and not to hear it. It drives you from solitude and plunges you into it by a see-saw game which begins every time you are convinced you have found tranquillity.

Almost all monks have among their rules the following recommendation: 'From such and such an hour, keep the great silence within thyself.' They are helped in this by their director or their elders. Nevertheless, many of them admit that 'it is a moment of terrible struggle.'

Have you noticed the complicated path taken by thought when it is out of control? It never stops. You may have calm gestures and be actively at work, and thought throbs in your skull like water enclosed in a sluice. You feel imbued with an energy that is destroying you, and you know quite well that a mere trifle might turn it into the constructive energy that would carry you forward. But how is one to go about it? I remember lying down heart-broken in a furrow in a field one day and crying out to heaven in my suffering. A few days previously, I had felt a profound joy on the same spot. Neither the sky nor my forest had changed, nor the powerful, majestic song of the earth. There was only myself, a poor human creature, who had carefully fenced myself off from the Creator—with a barrier of desires and intolerances hindering the flow of life—instead of singing the divine Name of God.

The Hindu says: 'Repeat the Name of God ten thousand times, twenty thousand times a day, one forgets the Lord so easily....' (A word from Sri Sarada Devi.)

The pious counsel makes us smile,...as well buy a prayer-wheel! So proud of our intelligence are we! It would irk us to put God between us and the world every moment, to let his Name hover upon our lips as naturally as the blood throbs in our veins without being noticed and without anyone thinking of it. Yet the Gospel says: 'Pray without ceasing.' (Th. v.17.) The Hindu teaches a technique which seems childish to us. It consists in repeating the name

of God till it becomes like the breath which actuates life itself, an imperceptible beating of wings mingled with the breathing—the Name of God always present. Then, is it we who seek God or God who seeks us? In the relation that is set up, an infinitely secret relation like prayer that no longer has any words, a new solitude is born in which every voice is silent—even the voice of God. The creature is now only a sensitive lyre that resounds in unison with the divine vibration.

III

No doubt, what one tries to do in solitude is to bring God to oneself. What ambition! But everything invites us to it. The Christian Church has permitted the portrayal of God the Father as a venerable ancient-of-days, thereby affirming that any form is proper for reflecting the immutable Light. Only one thing matters—to possess a particle of it, to have it for oneself. And to achieve this, one must tempt God. All means are good. Moreover, God willingly lets himself be tempted! He is like a mother watching her baby offer her the sweetmeat that had been sucked and dropped on the ground time after time. Is the work of the grass that lifts itself up to cry out, 'I draw near unto Thee', or the work of the ant close-bound to the earth of the same value as that of man? Man says, 'It is mine that counts because I was created in Thine image', but God may have quite a different opinion in this world of Nature in which He has manifested Himself in His power and according to His pleasure.

That is why in solitude, alone with himself, man has the daring to wish to reflect God in his soul, as the infinitely small can reflect the infinitely great. The child's blood responds to that of its mother, saps of like boles can mix. Why does not the human soul find spontaneously the divine soul? Because man puts between God and himself his thought, his reason, these precious instruments of

separation before they also become for him instruments of reconciliation.

'Long after he has recognized his God and has offered himself as a holocaust to God', says the Hindu, 'the worshipper must make a submission even more detailed and much more minute; the submission of all the parts of his being until, in the remotest corner, nothing more stands in the way of the divine grace....' A slow submission in detail begins, and it is an arduous and delicate task. One gains ground one day and loses it the next. There is nothing so wily as the spirit that trumpets 'I believe.' Subterfuges abound like cough-grass in an abandoned vineyard. We must toil and labour, let the birds and the worms feed on our flesh and continue the painful process to the end!

Blessed is the solitude in which this regenerating work is carried on. All the obstacles encountered are so many opportunities for discipline. Sleep itself is no more than a means of plunging into the unconscious in order to master it.

To bring God to himself, man models and raises himself up to God. Man watches out for Him as a lover for his beloved; he is thirsty, he is hungry, he lives in delirium. Sri Ramakrishna felt God's breath on his hand, he saw His gaze. Why should not God manifest Himself to one who loves Him? The slow work that builds in solitude is a constant labour of love in which nothing is ever abandoned, in which no sacrifice is ever made that is not rewarded a hundredfold.

IV

This reaching up of man towards God, the descent of God towards man, can only be achieved in solitude, the 'mould' of the sublime ravings in which exaltation and anguish, the vision of the lights of heaven and the shades of hell are close to one another. It is the years of life spent in

a cave or in the forest by the many wise men of India, it is also Saint Antony wandering in the desert, a prey to manifold temptations, the steep and painful ascent of Christian saints. On the rock of his faith, with no other weapon than his feeble ego which he believes to be strong, man becomes a giant in order to conquer himself. It is a struggle which cannot have any witness, and in which, at a certain moment, the struggler becomes the spectator of himself, and in which he suddenly perceives quite clearly the dualities that hold him in their grasp: on the one hand, personal God (as understood by the Hindu —*Ishvara*, Krishna) whom he has created for himself in order to adore Him, and on the other, Satan whom he likewise needs in order to disown him. Then, before the immensity that he discovers—an immensity without end or beginning—he has no other support than the very solitude which he feared. It becomes his ally. It becomes the closed field of his labour where all the roots of the human sentiments that were still vibrating are broken. It is also the divine compassion in which the worn-out wrestler eagerly slakes his thirst.

On the human plane, the whole cosmos becomes the 'centre' of his security. Has man utterly forgotten that his life, that is to say, that which differentiates him from the state of death, is the very thing which links him with the perceptible mode of God, with God himself in His essence of manifestation? If he knows that 'all is That', he knows also, by entering into himself, that 'he is also That' in the lower universe where he too can play a creative role, at his will, reflecting in his tiny understanding a particle of the sublime understanding of the Creator. If he can watch young puppies play and laugh at their fight for the same bone, will he be able to understand that God watches His creatures besmirch the precious goods He has entrusted to them with the same unconcern as that which we have for the puppies? We, in our egotism, say, 'Will God permit another war?' and at the same time, with the greatest sang-froid, we sow discord and death around us even in the

details of daily life without troubling to remember that every gesture we make invites the same gesture in return.

If, in the narrow sphere of my life in the country, I bring in a cat to keep away the rats, if I expect the hens to eat the grasshoppers, and the cockerel to fight against the sparrow-hawk, can I expect, above myself, the law of struggle to cease, because that is what I would like? Does not the cockerel with his jutting spur also think, 'Will God again permit other sparrow-hawks to attack me?' One must be a good loser when it is one's fate to lose. An act is the arrow shot by the bow. It cannot halt in its consequences and will reach its target with the precision desired by the archer. Why not recognize our responsibility in the great game of God in which we like to create constantly, as He does, because we are the life itself which He has breathed into us?

But God creates by love. His sacrifice is to manifest Himself without end in form, to protect Himself, to give Himself,while in his own creation man, on the contrary, aims above all at separating himself from the divine work and establishing his power of death in full liberty. By competition, by appetite, he sets up his limited sovereignty over everything he sees weaker than himself, and in so doing builds even higher barriers between God and himself. Separated from God, man is essentially a creator of death. In ten thousand men, how many are there who, in life, have not pushed aside their neighbour in order to take his place? In ten thousand women, how many are there who have not killed their unborn child in order not to be bothered with it?

Man demands of God a law of love and claims for himself the exercise of the law of death. If the din of the world drives the remembrance of this law from his mind, solitude gives him a tremendous vigour. It forbids the hypocrisy which expediency teaches us and which a complacent moral code has ended by accepting. Between the two movements constantly in action—that of man towards God and that of God towards man—the seeker

knows there is no other solution than to retire from the battlefield where he moves and to withdraw into the 'immobility' that is beyond dualities. This immobility is the perfect solitude in which there are no more struggles and no more joys, no more obstacles and no more rewards. The human soul immerses in the divine soul as a drop of water given back to the ocean—there is now only passivity for action fallen back into itself, or, better still, form returned to the undifferentiated.

The divine solitude in which That irradiates is pure joy, the *ananda* of the Hindu. Words fail to describe this state which surpasses all that the intelligence can try to express.

V

Before attaining this perfect solitude, there are jungles and deserts to be traversed one after the other. All solitaries know this. The white walls of cells are the scene of weird phantasmagorias, which the forcibly detained prisoner also sees behind his bolted door. For the one, they are degradation, and for the other, exaltation. The Hindu does not drive them away. He is without the possibility of casting his burden on to the shoulders of the Son of man who walks before him. As a beggar drags his pouch after him, he will take stock of it, and with his sole strength will neutralize every element without destroying it. His supplication goes to Shiva, the Lord whose throat is blue because he drinks the poison of the world: 'Lord, grant me discrimination.... There is no fear in this appeal; there is the intrepidity that conquers illusions, the love of liberty that plunges into the subconscious.

In order to get there, the solitary chooses a sharp and imperative discipline in which he will not fail. The greater the solitude, the more rigid will be the discipline, because the slightest element of disorder leads to the destructive intrusion of unsatisfied desires, repressed demands. What

a formidable procession! Evil rises up with such acuity that monks have seen it take shape and overwhelm them. The Hindu knows that this evil is as much his own as his passion for renunciation; both are the same energy demanding its right. What he has to do is to seize it, to master it and to direct it without depriving it of its virulence. The *yoga* is a path towards the goal and a means of bringing balance into the spiritual life; it is in no way a maceration of the body or the death of the elements of storm.

The price of solitude is that the dregs of the obscurities of the ego rise to the surface. But any depression which would impede the transformation of the being is a sin in the proper sense of the word—a rejection of association with God's work toiling within His worshipper.

On the contrary, we must open the eyes of our intelligence in order to regulate the body, and interrogate the passions of the body in order to compensate the pride of reason. All is proportion. The chaos let loose in man's ego is no different from that of God's great world of Nature with its storms that uproot trees and cause springs to burst forth. In solitude, the soul, alone with itself, has the unique chance of returning to the life involuted in itself and of feeling the throb of the rhythm of divine Harmony.

In this very last submission, the being emerges from the beating down of the ego with a cry of victory—it is the whiteness of almond tree blossoming when winter is over. The solitude which clothed the struggle disappears little by little. In the silence which was its sphere, it becomes melody. In the isolation which was the forest or cell, it becomes joy of union with God. Hallelujah! The solitary has emerged from solitude. He has surpassed himself so as to become all hearts that beat, all intelligences that think, and all hands that work. He is also the sap in every plant and the rain from every cloud.

The throb of his heart is the pulse of Life.

WOMAN'S PLACE IN HINDU RELIGION

Dr. A.S. Altekar

Woman's position in a religion is a subject of fascinating interest. In the present age religion is losing its hold on the popular mind, and the subject may therefore appear to some persons as of no great importance. Such, however, was not the case in the past. Religious rights and privileges were valued most highly; even political and proprietary rights faded before them in importance. The social status also of an individual was vitally connected with the place which religion accorded to him in its rites and rituals.

To the student of sociology, the place which was accorded to women in Hinduism is a topic of great concern. How far Hinduism stood for justice and fairplay, and how far it had succeeded in exploding prejudices and shibboleths of a primitive age can be fairly ascertained from the position it had accorded to women. Luckily for us, we have ample data to throw light on the subject, and it will be possible for us to survey the position from the earliest times to the modern days.

In early societies there was a general tendency to exclude women from religious rites and rituals because they were regarded as unclean, mainly on account of their monthly course. The Aryans also held women as impure during this period, but did not come to the conclusion that they should be therefore for ever excluded from religious privileges and functions. The impurity was regarded as only of a temporary duration, and women were regarded as perfectly fit to participate in religious rites and rituals after it was over. It is true that a ceremony to purify the wife before her participation in sacrifice has been enjoined. (S.Br., V.2.1.8–10). We cannot however attach much importance to it, because a similar purification has been prescribed for

men as well (*T.Br.*, 1.3.7). In the Vedic age women enjoyed all the religious rights and privileges that men possessed. They used to receive Vedic education. Many of them were even the authors of Vedic hymns. Women therefore could recite Vedic hymns as a matter of course.

Some women, especially unmarried ones, are seen offering Vedic sacrifices all by themselves. In one place we find a maiden finding a shoot of the Soma shrub while returning from her bath, and straightway offering it in sacrifice to Indra when she returned home.[1] In another place we find a lady, named Viśvavārā, getting up early in the morning and starting the sacrifice all by herself.[2] In the Vedic age there were no images to be worshipped and temples to be visited. The Bhakti school, advocating simple prayer to God by songs of devotion, was yet to come into prominence; so also the Jnana school emphasizing the contemplation either of Atman or of Brahman. So the offering of sacrifice was the only popular and well-established mode of worship. It could not therefore be interdicted to unmarried women or ladies whose husbands were away, especially in view of the Vedic initiation being then quite common among girls as well.

Marriage was the normal ideal recommended to society by Vedic religion. The woman was not an impediment in the path of religion: her presence and co-operation were absolutely necessary in all religious rites and ceremonies. This naturally increased her religious value. Man could not become a spiritual whole unless he was accompanied by his wife: gods do not accept the oblations offered by a bachelor. The husband alone cannot go to heaven; in the symbological ascent to heaven in the sacrifice he has to call his wife to accompany him on the occasion (*Ś.Br.*, V.2.1.8). A son was indispensable for spiritual well-being in the life to come and he could be had only through the wife. The wife was thus indispensable from the spiritual and religious points of view. This circumstance was responsible for ensuring her a status as high as that of her husband.

17

Normally religious prayers and sacrifices were offered jointly by the husband and the wife. There are several references to couples waxing old in their joint worship of gods (*R.V.*, V.53.15; I.133.3, etc.). The wife used to take an active and genuine part in family sacrifices. Like the husband she too had to perform a special *upanayana* on the occasion of special sacrifices. She had her own hut in the sacrificial compound, and also her own cow to provide her with sacred milk during the sacrifice (*Ś.Br.*, *Ś.* X. 2.3.1; XIV.3.1.35).

In the early Vedic period, the duty of reciting musically the Sāma songs was usually performed by her;[3] later on it came to be entrusted to a special class of male priests, viz. *udgātṛs*. The wife had to pound the sacrificial rice, give bath to the animal that was to be immolated and lay in bricks when the altar was to be built (*Ś.Br.*, VI.5.3.1; III.8.2.1–6). She participated with her husband in the preparation of the offering, the consecration of the fire, the offering of the oblations and the concluding ceremonies. She herself had to recite some mantras. It is true that sometimes these had to be dictated to her;[4] but the case was probably the same with the husband with reference to the mantras in many of the sacrifices. The wife's participation in the Vedic sacrifice was thus a real and not a formal one; she enjoyed the same religious privileges as her husband.

If the husband was away on a journey, the wife alone performed the various sacrifices, which the couple had to offer jointly. This was the case in the Indo-Iranian period as well (Erpatistan, Fargard 1). This practice continued down to the Sūtra period (*c.* 500 B.C).

Indrāṇi in one place proudly claims that she is the inventor of some rites and rituals.[5] We may then well infer that some lady theologians may have made some important contributions to the development of the Vedic ritual. Gods and goddesses are usually fashioned after the human model. What Indrāṇi did may well have been possible for other the cultured ladies of the Vedic age, too, some of

whose songs have been honoured by being included in the Vedic Samhitā. We have, however, no direct evidence on the point.

There were some sacrifices which could be performed by women alone down to *c.* 500 B.C. Sita-sacrifice, intended to promote a rich harvest, was one of them. Rudrabali was another; it was intended to ensure prosperity and fertility among the cattle (*P.G.S.*, II.17; III.8.10). Rudrayāga, intended to secure good luck to maidens in marriage, was the third one. The last mentioned sacrifice could of course be performed by women alone; in the case of the earlier two, it is possible that the exclusive association of women with them was due to the theory that since they are intended to promote rich harvest and fertility, they should be performed by women alone, who are their visible symbols.

If the husband was out on journey, or if his co-operation was unavailable for any other reasons, then the wife could perform the sacrifices alone. On the morning of Rāma's installation as the crown prince, Kausalyā is seen performing by herself the Svastiyāga to ensure felicity to her son; she was the neglected wife, and probably felt that it would be futile to expect Daśaratha to come to participate in the sacrifice. At that time Daśaratha was as a matter of fact engaged in assuaging the wrath of his favourite wife Kaikeyi. Similarly Tārā is represented as performing alone the Svasti-sacrifice, when her husband Vāli was about to issue out to fight with Sugrīva. This was probably because Vāli was then too busily engaged in equipping himself to find time to participate in his wife's sacrifice. These instances show that in the early period women's participation in the sacrifices was a real one; nay, very often husbands used to leave the whole affair to the exclusive charge of their wives when they were themselves otherwise busy. The usual practice, however, was that the couple should jointly perform the sacrifices.

Intercaste *anuloma* marriages were permitted during this period. What then was the religious status of the wife if she

belonged to a lower caste? Could she participate in the sacrifice? Later writers like Manu no doubt ordain that only the wife of the same caste could be associated with the husband in the sacrifices. The view of the earlier age was different; it allowed the wife of the lower caster full religious privileges, if she were the only wife of the husband (*B.G.S.*, II.9.11). A Shudra wife, or a wife for whom a bride price had not been paid, was, however, not entitled to any religious rights and privileges (*Manu*, IX, 86; *V.D.S.*, XVIII.17).

The participation in sacrifices presupposed Vedic study, and we have shown already how girls used to devote themselves to it during their maidenhood. The sacred initiation ceremony (*upanayana*) of girls used to take place at the usual age as regularly as that for boys. This was the case as early as the Indo-Iranian age. The custom is still observed by the modern Parsis. In India the initiation of girls used to take place regularly down to the beginning of the Christian era. The Vedic age held that Brhamacharya and Vedic study were as much necessary for girls as they were for boys. It was apprehended that if this most important religious *saṁskāra* was not performed in the case of girls, women would be automatically reduced to the status of Shudras; how then could Brahmins, Kshatriyas and Vaishyas be born of them? *Upanayana* of women was indispensable, if the cultural continuity of the different Aryan classes was to be preserved.

After their *upanayana* girls used to follow a discipline more or less similar to that of the boys. They were, however, shown certain concessions. They were not to grow matted hair. They were to go out to beg their daily food. As far as possible they were to be taught by their near relations like the father, the uncle or the brother.[6] They were permitted to discontinue their Vedic studies when their marriages were settled at about the age of 16 or 17. A few, however, continued their studies for a much longer time and were known as Brahmavādinis.[7] It is a great pity that most of the above rules about the *upanayana* of girls should have to be

gathered from works written at a time when the custom was rapidly going out of vogue or had already ceased to be followed. We therefore get only very scrappy information on the subject.

We have already seen how after their *upanayana* ladies used to specialize in Vedic studies, theology and philosophy. Nay, some of the ladies figure among the authors of the Vedas, whom a later age was to pronounce as ineligible to read! Ladies held that they were inherently entitled to study the Vedas: we find a maiden flatly declining to marry her lover, when she suspected that he was disinclined to reveal to her some of his Vedic doctrines and theories (*T.Br.*, 11.3.10). When *upanayana* of girls was common, it is needless to add that some used to offer morning and evening prayers as regularly as men; the *Rāmāyaṇa* twice discloses Sita discharging this religious duty (II.88.18–19; V.15.48).

In the age of the *Brāhmaṇas* (*c.* 1000 B.C.) the volume of Vedic studies became very extensive as a number of subsidiary sciences were developed and extensive commentaries were written on Vedic texts. The spoken dialect of the age had begun to differ considerably from that of the Vedic mantras, and the theory had found universal acceptance that to commit a single minor mistake in the recitation of a Vedic mantra would produce most fatal consequences to the reciter.[8] As a natural consequence society began to insist that those who wanted to undertake Vedic studies must be prepared to devote a very long period, say 12 to 16 years at least, to the task. Women used to be married at about the age of 16 or 18 and could devote only about 7 or 8 years to their Vedic studies. So short a period was quite insufficient for an efficient grounding in the Vedic lore in the age of the *Brāhmaṇas*. Society was not prepared to tolerate dilettante Vedic studies, and as a consequence women Vedic scholars began to become rarer and rarer.

Vedic sacrifices also became very complicated at this time; they could be properly performed only by those who had studied their minute intricacies very carefully. As a

consequence, the participation of women in sacrifices gradually became a matter of mere formality. Wives continued to perform for some time the duties that were once allotted to them in sacrifices, but gradually a tendency arose to assign most of the sacrificial work to males. Many duties in the sacrifice, which could be once done by the wife alone, came to be assigned to male substitutes in the age of the *Brāhmaṇas*.[9] In some rituals like the Srastarārohaṇa, women continued to take a prominent part and recite the Vedic mantras down to *c.* 500 B.C. (*P.G.S.*, I.4), but the practice was becoming gradually unpopular. Wife was originally entitled to offer oblations in the Gṛhya fire in the absence of the husband; now a son or a brother-in-law began to act in her place (*S.G.S.*, II.17.13). She continued to perform the evening sacrifice down to the beginning of the Christian era, but the recitation of the Vedic mantras was prohibited on the occasion.[10]

As amateurish studies of the Vedas could not be encouraged, and as women had now to take a more or less formal part in sacrifices, the *upanayana* of girls began to become a mere formality in course of time. At *c.* 500 B.C. we learn from Hārīta that only a few Brahmavādinis used to devote themselves seriously to Vedic studies after their *upanayana*; in the case of the vast majority of girls the formality of the ceremony was somehow gone through just before their marriage.

A few centuries rolled on in this way and then writers like Manu began to advocate that girls' *upanayana* may be performed, but no Vedic mantras should be recited on the occasion.[11] This development may be placed at about the beginning of the Christian era. *Upanayana* without Vedic mantras was a contradiction in terms, and so later writers like Yājñavalkya (*c.* A.D. 200) began to advocate the most honest and straightforward course of prohibiting the ceremony altogether in the case of girls. A theory was started that the marriage ritual in the case of girls really served the entire purpose of *upanayana*: service to the

husband corresponded to the service of the preceptor, and household duties were a nice substitute for the service of the sacrificial fire.[12] *Upanayana* therefore was unnecessary for girls. It may have been prescribed for them in a former age, but that rule was a dead letter in the present one. It is interesting to see how medieval writers like Medhātithi proceeded to explain away clear passages in earlier writers permitting women's *upanayana* (*Manu*, V.155). Eventually medieval Nibandha writers like Mitramiśra made wonderful discoveries of otherwise unknown Puranas which boldly declared that women are of the status of Shudras and so altogether ineligible for *upanayana*.

Minor religious rituals like the *Jāta-karma, Nāmakaraṇa, Chūḍā*, etc., were originally performed just as regularly in the case of girls as they were in the case of boys. When *upanayana* was discontinued in the case of girls, it began to be advocated that the other rituals also should be permitted in their case, only if they were performed without the recitation of the Vedic mantras. This position has been taken up by almost all the Smṛti writers.

Discontinuance of *upanayana* amounted to spiritual disenfranchisement of women and produced a disastrous effect upon their general position in society. It reduced them to the status of Shudras. We have seen how in the earlier age, women could, if necessary, perform sacrifices even by themselves. But now Manu came forward to declare that a pious Brahmin should not attend a sacrifice performed by women (IV.105). There were many Vedic texts which clearly declared that the husband and the wife were to perform the Vedic sacrifices together. When the *upanayana* of women became a mere formality at about 200 B.C., there arose a school which advocated that wives should not be associated with their husbands even formally in the performance of Vedic sacrifices. It argued quite seriously that the references in the sacred texts to the sacrificers in the dual number did not refer to the husband and the wife but to the sacrificer and the priest (*P.M.*, VI.1.2).

This new theory was opposed by the orthodox tradition as it was all along accustomed to see the sacrifices being jointly performed by the husband and the wife. The wife's participation had no doubt become a formal one, but society was not prepared to eschew it altogether. Jaimini was the spokesman of the orthodox school, and he has explained very clearly how the references to the sacrificers in the dual number can denote only the husband and the wife. While doing so, however, he emphatically declares that a woman alone is quite ineligible to perform any sacrifice. 'The woman can stand no comparison with man. The sacrificer is learned, his wife is ignorant.'[13] The new theory took some time to be popularized. In Jaimini's own time Queen Nayanika of the Deccan performed a number of Vedic sacrifices during her widowhood, and there was no dearth of learned Brahmins to accept her handsome gifts on the occasion (A.S.W.I., V. p. 88). The practice of women performing sacrifices by themselves, however, died down by the beginning of the Christian era. As pointed out already, Manu is seen condemning it sternly in his code.

It is interesting to note that the Smṛti school on the whole was more hostile to the recognition of the religious privileges of women than the Vedic school. The former had reduced them to the status of Shudras by about A.D 800. The latter, however, was not prepared to exclude them from formal association in sacrifices even in the fourteenth century A.D. Thus Sāyaṇa admits that a difficulty will arise in the sacrifice on account of the wife not being able to recite the Vedic mantras, she not having studied them before. He tries to get over the difficulty by suggesting that she should be given a manuscript and be asked to read from it.[14]

Sāyaṇa, however, forgets that in his days not even 5% women were able to read the mantras even from the manuscript. It is interesting to note that the passage in the Āśvalāyana-Śrauta-Sūtra on which Sāyaṇa relies does not support the procedure at all. It lays down that veda, that is,

darbha grass, should be given to the wife before mantras are dictated to her for recital. In order to support their theory of the wife's association in sacrifices, the followers of the old Vedic tradition were thus straining even the interpretation of the old Vedic texts. We have referred to this passage of Sāyaṇa and his wrong interpretation of the Sūtra text in order to illustrate how the Śruti school was more sympathetic to women than the Smṛti school. Medieval Hindu society was, however, influenced more by the latter than by the former. So nothing could save women from being reduced religiously to the status of Shudras from about A.D. 800.

In actual practice the prohibition of Vedic sacrifices to women did not produce any hardship; for, these sacrifices themselves soon went out of vogue. Neither men nor women paid much attention to them from about the beginning of the Christian era. What, however, did infinite harm to women was the theory that they were ineligible for them because they were of the status of the Shudras. Henceforward they began to be classed together along with the Shudras and other backward classes in society. This we find to be the case even in the *Bhagavad-Gītā* (IX.32).

It must be pointed out that the exclusion of women from Vedic studies and sacrifices was not due to any deliberate plot to lower their status. Custodians of the Vedic lore honestly believed that no one should be allowed to recite the Vedic mantras who had not studied them properly. Women found it impossible to devote the necessary time for this purpose on account of their early marriage. It was therefore but fair that they should not be allowed to invite themselves and their relations those dreadful calamities that were honestly believed to result from an incorrect recitation of the Vedic mantras. The desire was not to humiliate women, but rather to save them from dire consequences.

When the Vedic Karmamārga rapidly went into background, its place was taken by the new Bhakti and Purāṇa schools which rose into prominence at *c.* A.D. 500. The leaders of these movements were catholic in their outlook

and threw open their doors to all, irrespective of sex and caste. This was a welcome development for women. Their religious disenfranchisement by the Śruti school had created a vacuum; it was filled by the Bhakti-Purāṇa religion. In fact they became its *de facto* custodians.

Women are by nature more religious and sentimental than men. They can visit temples with greater regularity, perform religious rites with higher devotion, and submit to religious fasts with more alacrity than men. The Purāṇa religion, which came into prominence by c. A.D. 500, made ample provisions for the religious requirements of women. As early as the third century B.C., women were already accustomed to undergo a number of vows and fasts (*vratas*), which were unknown in the Śrutis and Smṛtis. They are referred to by Asoka in his Rock Edict No. IX, and the *Vivādavatthukathā* refers to a lady, who being anxious to devote herself to some *vrata* without being disturbed by her gay husband, paid him some money from her own *strīdhana* (dowry), so that he might get his pleasure elsewhere (I.15). *Vratas* thus were quite common even before the beginning of the Christian era. The reorganizers of the Purāṇa religion increased their number, spread them evenly over the whole year and invested them with moral fervour by associating a number of ethical and edifying stories with them. Hinduism, as it is known to and practised by the masses, is not the Hinduism of the Śrutis or Smṛtis, but the Hinduism of the Purāṇas, and women have been its most devoted followers and patrons.

Most of the women in society at this time were uneducated and therefore incapable of understanding or appreciating subtle intellectual arguments like those advanced by the Vedanta school. The new religion also mostly relied on an appeal to faith and devotion. It therefore appealed to women immensely. Being certain that those sections of society which were its devoted followers had an inexhaustible fund of credulity, the Purāṇa writers did not take much care to offer a reasonable or rational explanation in every

case. Very often virtues were so much exaggerated that they assumed the garb of vice. Vices were sometimes condoned because they were associated with some heroes or demi-gods. Hindu women, who went on performing the *vratas* and listening to the stories contained in the Purānas, became by temper and training very credulous and devotional. Most of them became strangers to rationalism based upon discriminative reason under the influence of the new religion. The same, interestingly, was the case with men at this time, if perhaps to a slightly less extent. It, however, cannot be denied that the continuance of the old religious vein, more fervour, and spiritual tradition is largely due to the zeal, sincerity and devotion of women. Those very women whom religion had once regarded as outcastes eventually enabled it to tide over most difficult times.

In the modern feminist movement in India, we hardly notice any tendency to get the religious disabilities of women redressed. This is natural. When men themselves have given up Vedic sacrifices, women feel no inclination to agitate for the right to perform them. The Arya Samaj, which has revived the sacrifices, has extended the right to perform them to women as well. In the modern materialistic world, the average woman feels no grievance, because she has been deprived of the right to become a nun. She looks with a smile on a dogma which would declare that she is ineligible for spiritual salvation. *Upanayana* has become a meaningless formality even in the case of boys; women naturally feel that they have nothing to gain by becoming re-eligible for it. It is true that the religious disenfranchise-ment that resulted from the ineligibility for *upanayana* produced a disastrous consequence upon the general status of women in society; but women have realized that im-provement in this direction in modern days depends mainly upon spread of education and acquisition of economic rights and independence. They therefore naturally feel no inclination for initiating an agitation for the restoration of their old religious rights and privileges.

It would be, however, in the interest of Hindu society if it remains constantly alive to the full implications of the Vedic viewpoint that the husband and the wife are equal and necessary partners in divine worship. The principle implies that men and women have equal rights and responsibilities in matters temporal as well. Since the spiritual disenfranchisement of women, men have become accustomed to regard women as their inferiors in all the spheres of life. This outlook must disappear. We must remember that women have done greater service to religion than men by preserving the old religious tradition, moral fervour and spiritual vein in Hindu society. These constitute a priceless heritage and men ought to be grateful to women for preserving it. If an effort is made to spread a rational knowledge of the fundamental principles of Hinduism among women, they would undoubtedly become much better representatives of our culture and religion than men are today.

ABBREVIATIONS

B.G.S.: Bodhāyana-Grhya-Sūtras
Manu: Manu-Smrti
P.G.S.: Parāśara-Grhya-Sūtras
R.V.: Rg-Veda
Ś.Br.: Śatapatha-Brāhmana
T.Br.: Taittirīya-Brāhmana
V.D.S.: Vātsyāyana-Dharma-Sūtras

REFERENCES

1. R.V., VIII.91.1.
2. R.V., V.28.1.
3. Ś.Br., XIV.3.1.35.
4. Ś.Br., III.8.2.4.
5. R.V., X.86.10.

6. *Hārīta Smṛti*.
7. Ibid.
8. *Pāṇini Śikṣā*, 5.
9. *Ś.Br.*, I.1.4.13.
10. *Manu*, III.121.
11. *Manu*, II.66. This verse occurs after the description of *upanayana*.
12. Ibid. II.67.
13. *P.M.*, VI.1.24.
14. Sāyana on *R.V.*, I.131.3.

THREE KINDS OF DHARMA

Swami Shuddhananda

A certain pandit in the course of his lecture once described Dharma to be of three kinds. One he termed as ceremonial Dharma, the second he termed as moral Dharma, and the third as transcendental Dharma. And he explained that all these three kinds of Dharma are necessary for man's growth towards spirituality and ultimate realization, according to the stage in which he is.

In ordinary conversation we hear such talks as, that person must be a religious man—for he regularly bathes in the Ganges, wears certain marks on his forehead, eats a particular sort of food, puts on a particular kind of cloth, and has made pilgrimages to Benares, Gaya, Hardwar, Vrindaban, etc. If, however, we closely watch him, we perhaps find that he does not scruple to tell a falsehood occasionally, or perhaps cheat a widow if occasion arises: in one word, he is not very particular in practising what is called morality. So we hear also of a certain class of people denouncing such kind of religious men and preaching that religion consists in truth, honesty, charity and so forth, and not in the observance of certain external forms. Many of these moral men will not perhaps make obeisance to an image of god or goddess, will not adopt any particular form of diet or dress; some of them may even doubt the very existence of God.

Our pandit, after describing these two types of religious men, explained that though the ceremonial and moral Dharmas may not always co-exist, still, it is true that both of them are necessary for man's spiritual growth, and it is possible to combine them in one and the same person, may be in varying proportions. So one type need not condemn or comment upon the other's conduct. These two forms of

Dharma at last culminate in what he termed as transcendental Dharma, as one finds in Manu—

Ayameava paro dharmo yad-yogenātma-darśanam.

'The transcendental Dharma consists in seeing the Atman with the help of Yoga.'

As on the one hand the advocate of mere morality condemns the believer in ceremonials, so on the other hand we find in certain religious books an actual advocacy of immorality in the name of religion. One line of a stanza occurs to our mind which bears out the above idea—

Man-nimitte kṛtaṁ pāpaṁ taddhi dharmāya kalpate.

The Lord says, 'Even a sin committed for My sake is transformed into virtue.'

In those religions which advocate faith and devotion as the principal aids to spirituality, we often find this disregard of morality, though an open advocacy of immorality may not occur.

Now, let us see how we can reconcile these two opposite stand-points, and whether we can be at one with our pandit's view that both of them are necessary.

Observation tells us that throughout the world in all periods of history, in all religions—even the most iconoclastic—the value of ceremonials as aids to man's spiritual growth has been admitted in a greater or lesser degree. The Mohammedan, who will not tolerate a picture in his mosque, turns towards the west when he prays, because in Mecca there is a stone called Kabala which is considered very sacred in his religion. Sometimes the so-called anti-ceremonial party will upon proper scrutiny be found to believe in its own particular form of ceremony, while condemning the ceremonials and forms of all other parties.

We knew of a religious teacher preaching the worship of the sun which he tried his utmost to prove was not material, while condemning the worship of all Incarnations of God.

In the same fashion, morality in some form or the other will be found to be an integral part of all religions, only the word morality must be understood in a broad sense, and different grades of morality must be recognized. It must be admitted that what under certain circumstances and with particular individuals is considered immorality, may be morality in other circumstances and with other individuals. Truth-speaking and non-killing, in their strict literal sense, may not be justifiable under all circumstances, although they are very necessary in many cases. A highly evolved soul also may not require the safeguards of injunctions and prohibitions though they are absolutely necessary for an average man.

Through reason also the efficacy of external forms and ceremonials in certain stages of religious growth can be proved. Man consists of a spiritual as well as a material part, and these two have intimate connection. If the body is diseased or dull the mind is also affected. We see also that certain kinds of food make our body and mind agitated. Again, if we try to think of very abstract conceptions we find that our mind cannot easily grasp them, but always reverts to familiar material conceptions and images. So what harm is there in taking these external aids for higher religious realization? We do not argue that they are necessary for all without exception, nor do we say that one coat should fit everyone. Neither are we for practising all sorts of ceremonials as a matter of custom, without reasoning—not understanding their real significance. Argue we always must, but neither should we discard anything, however trivial it may seem, without giving it a fair trial.

That morality also is never antagonistic to real religion can be easily proved. If an immoral man sincerely worships God, he must dwell on higher thoughts, and these noble thoughts will gradually drive out his evil propensities

which are the real springs of his evil actions, and so he cannot but turn to be a strictly moral man very soon. This truth has been forcibly preached by Bhagavan Sri Krishna in the *Gita*—

Api cet sudurācāro bhajate māmananyabhāk;
Sādhureva sa mantavyaḥ samyag-vyavasito hi saḥ.

Even if a dreadfully immoral man serves Me with his whole mind, he is surely to be considered a pious man, for verily his resolution is in the right direction.

The highest religion consists in pure bliss, and how can a man who continues to perform immoral acts rise to that exalted state without discarding his old evil propensities altogether? It is said in a celebrated Hindi verse: 'Where Rama is, there is no desire; and conversely, where desire reigns, there Rama is not. The two cannot co-exist, like the sun and night.' Aye, where there is desire, the Lord cannot be there, and is not desire the root of all immoral acts? The highest realization is possible only through renunciation and not through enjoyment, and what is renunciation but perfect morality? If some religions do not always insist on strict morality in its external sense, their underlying idea seems to be this—the sages understood that if a person could be made to taste the bliss arising from a glimpse of the Divine even for a moment, his conscience must be awakened and he must be a changed man in no time. So is it not always necessary to lecture him on what may be termed as 'school morality', and put before him a lengthy catalogue or moral virtues which, as the sages understand, are nothing but different aspects of one and the same thing, viz. the impulse towards the Divine.

If we study the life of Sri Ramakrishna we shall find ample justification for our pandit's view of Dharma. Who does not know that he strictly observed the particular ceremonials of all the religions he practised? On the other

hand, every reader of his wonderful life knows his strict regard for truth as well as his absolute conquest of lust and greed. In his life the moral and the ceremonial elements of religion were wonderfully blended, and at last they culminated in that transcendental insight which has been so beautifully described by Rev. Pratap Chandra Mazumdar—

His religion means ecstacy, his worship means transcendental insight, his whole nature burns day and night with the permanent fire and fever of a strange faith and feeling.

Many are for banishing all ceremonies from religion. To such people Sri Ramakrishna used to say:

In a grain of paddy, its kernel, that is, the rice, is what is most important, and you eat the rice, not its husk. Still, you must pause to consider that if you put a grain of rice underground, you will not get a plant from which you can get rice—for this you must put the paddy into the ground. So, however unimportant the ceremonials may seem, they are absolutely necessary for many in certain stages of their religious growth, though it must be definitely understood that the highest transcendental insight or Samadhi is the goal which one must always keep in view.

Those also who do not like to put emphasis on morality, as we understand it now, in higher religious growth, must bear in mind that true transcendental insight is the culmination of morality. The highest stage of religion may be non-moral, but it is never immoral, and in all stages of religious development we must practise morality according to our conscience, according to our inner light and should never raise false issues. Many a religious man practises, according to his stage of growth, either the first or the second form of Dharma, but for ultimate realization everyone must

combine the two in different proportions, and if one is sufficiently persevering, one will at last reach the third or transcendental Dharma, which is nothing but the highest Jnana and the highest Bhakti in one.

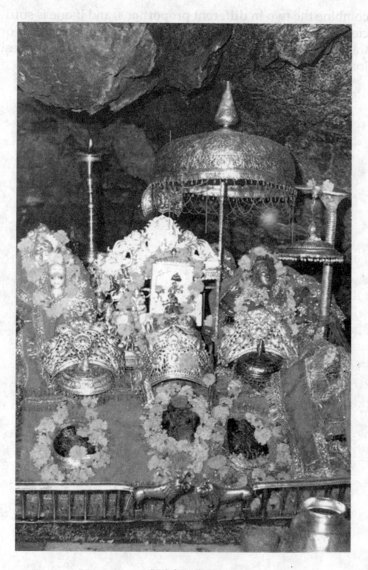

Vaishnodevi

VAISHNODEVI—
THE MYSTIC EXPERIENCE

Dr. Sumita Roy

Communion with the divine in an atmosphere of sanctity, silence and serenity, is probably the most enlightening experience of life. It sears the mind with a fire of inspiration. Pilgrimage to Vaishnodevi, the abode of Divine Mother, certainly falls in this category. Before we made the trip the sceptic in me cautioned, 'A trip to a cave in some obscure mountain to worship some stones! Not enough to warrant a journey of more than a hundred kilometers.' But once amidst the giant purple mountains with their steep slopes and proudly rising lofty heads embracing the clouds, there was no place for doubt or disbelief in the mind. Just a glimpse of the three-forked peak was enough to lift the mind into the realm of the spiritual, far away from the demands and doubts of this world.

The scenic beauty of the surrounding Himalayas—a tabernacle of gods and goddess—brings poetry even to the most hardened heart. Any place of pilgrimage in this holy mountain has indeed an unusual beauty of its own. Here everyone is seen silently conversing with nature. The entire area is charged with a tradition of piety and purity, which slowly sinks deep into the soul of all pilgrims. Even the most causal traveller feels uplifted with a feeling of well-being, contentment and bliss. To us who came to Vaishnodevi with a hunger of the soul, it was like a home-coming after years of aimless wanderings. At once we could perceive the Mother's welcome, a loving smile and a warm embrace, whose presence even the Mughal emperors had once felt in this holy spot.

The first thing one noticed was the lush greenery of the fertile land. It was as though mother earth had bestowed her entire treasure on this thrice-blessed spot. At times the whole panorama was dressed in clouds, and at other times washed with rains or brightened up by golden sunlight. Life takes on a new meaning as one encounters the fascination of this lovely landscape of the Himalayas. The brisk, invigorating mountain air gives strength to the tired body and the spent-up mind.

One of the wonderful experiences of this holy spot was the sunset. The sheer breathtaking beauty of it filled every one of us with awe and amazement. None could remain impervious to such a supreme splendour. Everyone looked on, unblinking, as though the sun was setting for the first time in the history of the earth.

As darkness descended, all of us felt a hush of eager anticipation. The long stretch of the serpentine trekking path up the mountain was now lighted up with hundreds of bulbs, and from a distance the whole scene was reminiscent of Deepavali, the festival of lights. It was indeed a journey through the path of light to the abode of Godhead. Anywhere else this fourteen kilometer trek would have exhausted a person. But here, with each step a new eagerness, energy and enthusiasm filled us. The thought of the Divine Mother waiting for all of us held us spellbound. Probably such a mood of eager expectation for Mother inspired the lines of the *Devī Māhātmyam*: 'Salutations to that Devi, salutations to her again and again, who is known as Vishnu-Maya present in all beings. Salutations to that Devi, salutations to her again and again, who is present in all beings as Mother.'

As we ascended the mountain path our thoughts were now centred on Mother only, the Mother who creates, sustains and destroys the universe, the Mother who never refuses to give shelter to those who come all the way to seek Her grace and to ensure Her eternal protection in life. The radiance of Mother's beauty and glory was reflected, as if, in every direction. Some invoked Mother's power with

their *bhajans*. The songs transmitted strength to the needy, who were struggling to take the next higher step. The youngsters enthused the older people with their zeal. The whole mountain path reverberated with the mystic chanting—repeated over and over again—*sare bolo jai Mata ki, milkar bolo jai Mata ki*. The difficult climbing up turned, as it were, into a great spiritual experience. Every step was a sacrifice for God. And the repeated chantings brought a slow and steady heightening of our consciousness. The everyday world was left far behind as we rose higher and higher on the way to the Divine Mother.

At last we reached the cave. The mouth of the cave appeared quite ordinary and unostentatious, but it brought to our mind a feeling of great expectations. It was the moment of culmination of the hopes and aspirations of many long years of our life. For how many days did we dream of this very moment! One had to bend down and slide in through a very small opening, and lower one's feet into icy water. We too entered. Ah, what a feeling! The cool water cleansed both the body and the spirit as we waded through it. Each step in the cave generated a new power of unimaginable magnitude. It is impossible to put into words the mood of our divine experience during those few moments. But how true it was to one who experienced it! In that epiphanic moment, one communed with Mother in the form of rock. The ice, the tingling fresh water and the people who chanted in one voice—all melted into one miraculous tranquillity. The congregation chanted again: *Prem se bolo jai Mata ki, phir se bolo jai Mata ki*. Not only the three-stoned spots of Mahalakshmi, Mahakali and Mahasaraswati in the temple complex, but every element of nature seemed to be suddenly vibrating with a tangible manifestations of the Divine Mother. It was a moment of harmonious integration between one soul and the other, between man and nature. It was indeed a moment of fulfilment and unalloyed bliss. And everyone shared it, rich or poor, young or old, sinner or saint.

The chantings continued. And with every repetition it brought a trance-like state of acute concentration, when each soul emanated strong and potent signals of innate spirituality. A vibrant divinity filled the cave, and every person present was engulfed in its waves. With each breath the lungs, nay, the entire being was filled with the pure and holy atmosphere of the cave. The spirit in us was rejuvenated for all times to come. A biting cold wind was blowing outside. Inside, the warmth of the cave made us feel as though the child had found a new and perfect solace, having sucked the peace from the Mother's body, the cave. This was the Mother's gift to her devotees, a great spiritual rebirth, a life of heightened consciousness, and divine assurance. Who would like to leave this tangible presence of the eternal mother?

As we journeyed back the heart cried out, 'Mother, O Mother! we do not want to go back. We want to remain here, near you, always, forever!' But the Mother's reply dispelled all gloom. 'You are not going away from me, my children. From now onwards, wherever you go, I go with you. Can you not feel my presence within you, around you, and beside you? Do you not see that I have been awakened in you? Do you not feel that I am protecting and guiding you?

'Yes, yes, beloved Mother, we can sense it. We now know that you *are* enshrined in our hearts and minds. In the monotony of our everyday existence, whenever we will feel tired, sad or frightened, we will never forget to take refuge in you. And in that moment of time, we will be mentally transported to your eternal Bhavan, this holy cave, which, though thousands of kilometers away from where we are, will yet be so near.'

Section III

COMPARATIVE PERSPECTIVES

Section III

COMPARATIVE PERSPECTIVES

THE SPIRITUAL ENCOUNTER OF
EAST AND WEST

Dr. Jacques Albert Cuttat

Introduction

For a diplomat, to speak in public about spirituality is unorthodox, at least according to a modern prejudice. A deplorable prejudice! Spirituality, that is, a discipline leading to a growing awareness of ultimate values by the whole human being, draws man into his ultimate depth. Politics transforms the world from without; spirituality transforms man from within. International contacts are the playground of diplomacy. Why should they not take place at the level of spiritual depth? Mircea Eliade, a Greek-Orthodox Christian and leading Orientalist, writes in this connection: 'Sooner or later, our dialogue with "others"— the representatives of traditional, Asiatic, and "primitive" cultures—must begin to take place not in today's empirical and utilitarian language,...but in a cultural language capable of expressing human realities and spiritual values.'[1]

Now, in concrete historical fact, spirituality is always associated with one of the various religions of the world. One could define it as the essence of the religion in so far as it is not only accepted, but lived and experienced. Thus, before we approach spirituality in general, we have first to distinguish between at least two groups of spiritualities— those shaped by the so-called Western religions and those shaped by the Eastern religions.

From the point of view of the number of their respective adepts, they form also two hemispheres, two halves of mankind. Hinduism, Buddhism, Confucianism, Taoism and Shintoism prevail in Asia; and among them, Hinduism and

Buddhism are leading numerically, in extension and in spiritual quality. Approximately, fifty per cent of the world's population belong to these five main Eastern religions or spiritualities. Their main common feature is to conceive the Divine, the Absolute, as being ultimately impersonal or 'supra-personal'. Let me call them the Eastern or Asiatic spiritual hemisphere. The other half of mankind belongs to the three religions which are predominantly (not exclusively) Western: Judaism, Christianity, and Islam; they have a common root, the Bible, and share the biblical concept of God as the Absolute in Person, as ultimately personal and even inter-personal. Let me call them the biblical or monotheistic hemisphere. The exemplary expressions of the Eastern spiritualities are the *wise* and the *yogin*, those of the biblical spiritualities the *prophet* and the *saint*.

One might object to the division of mankind in religious hemispheres that it does not apply to modern humanity, because, in fact, secularization makes the majority of mankind increasingly agnostic and indifferent to religion and to the corresponding spiritualities. My reply to this is not only that all cultures and civilizations, as profane and secular as they may claim to be, are still rooted in their religious past—every culture is originally religious and spiritual—but also that there is no modern atheist or agnostic who is not still, in fact, psychically shaped and spiritually stamped by his religious tradition, as much as he may call it superstitious or antiquated. Religious imprint on cultures and souls survives religious conviction and practice, privately, socially, and politically.

'Wise' and 'yogin', 'prophet' and 'saint' are still in some way or other, consciously or not, the respective archetypes of East and West.[2] I remember an agnostic Jewish friend of mine, an eminent physician, who said that for him ethical imperatives were but arbitrary human inventions from which he was fully emancipated, and who, shortly after this profession of unbelief, spoke of a medical colleague as of a revolting charlatan, devoid of moral sense in his profession.

Awakening to his spiritual depth in front of a concrete and serious situation, his unconscious ethical—in this case biblical—conscience spontaneously reappeared at the amoral, unbiblical surface of his consciousness. Similarly, an agnostic Indian who believes in non-violence adheres, in fact, to an essentially religious category for *ahimsa* is a specifically Hindu and Buddhist value.[3] Christian spiritual imperatives—the first to be universal after those of Buddhism—are the unacknowledged inspiration of the ardent sense for social solidarity of Western atheists.

'*Religio*', etymologically, means what 'draws men together' as well as what 'ties up' or 'unites' their personal centre by 'referring them back' to their common divine transcendental source; *dharma* means 'directing spiritual principle' and 'eternal inner law' relating all *jivatmans* (individual souls) from within to their Atman (spiritual Self), this Atman being Brahman, the 'non-dual' timeless origin and goal of the Hindu way of life. Thus, our concern should be the dimension in which the wise becomes able to speak to the prophet, the yogin to the saint, and *vice versa*. With a view to catching the nature of their spiritual space relating East and West, let us now turn to the central point of the title of this address, to the word 'encounter'.

I. THE INTERRELIGIOUS SPACE OF THE ENCOUNTER

1. '*As Many Summits Rising From a Common Basis*'

By spiritual encounter of East and West, I mean a dialogue between the biblical and the Asiatic spiritual hemispheres. A dialogue implies two irreductibly different subjects who share something fundamental. The greater the difference and even the contrast between the two partners, the deeper and higher is the only level on which they can really meet, the more genuinely uniting too. Such a spiritual contrast distinguishes the two hemispheres, as we shall

explain later on, and also unites them, provided that the differences are not explained away, not abolished or fused, but more clearly perceived, confronted in order to enrich each other, to speak to each other, to meet. Their inner relation is, *mutatis mutandis*, analogous to the relation of love between man and woman: in a sexless third dimension, love would be less, not more, uniting. In fact, confusion of sexes separates; so does confusion of cultures, religions, and spiritualities. The higher the value, the more does uniformity separate, and distinction unite.

As to the common ground or common spiritual basis of biblical and Asiatic religions, I would call it the *consciousness of the sacred*, and the sacred, as R. Otto has convincingly shown, is a *mysterium tremendum et fascinans*; it is the invisible presence of a higher Reality, which paradoxically attracts and repels, lifts up and throws back, fascinates and terrifies at the same time. Whenever two representatives of our two spiritual hemispheres, for example, a Hindu and a Christian, a Buddhist and a Muslim, etc., meet in this state of soul, both inwardly open to their respective mode of awareness of the sacred, then—and then only—there exists between them what I would call an interreligious space, the indispensable condition of a spiritual encounter of East and West. This space is a basis, not a summit.

There is no such thing as a supra-religious approach to the various religions and spiritualities, except if one reduces religion to mere social manners and customs, an attitude which amounts to a denial of religion and therefore misses its very object. Some agnostic scholars claim that a non-religious approach to the study of comparative culture and religion is the only objective one; this amounts to claiming that only those who are sceptic or ignorant about the medicine have the necessary competence and objectivity to participate in an international medical congress. In other terms, the interreligious space has to be a spiritual and therefore in some way a religious space, not a religious and spiritual vacuum.

2. *The Requisite of a World-wide Spiritual dialogue*

Now, a real dialogue supposes the readiness to listen to the other as other; and to listen means to make silence in oneself in order to let the other speak to us. On the inter-spiritual plane, such listening mental silence means not less than what Husserl, the father of phenomenology and restorer of modern philosophy, calls the phenomenological *epokhê*, the 'suspension of judgement', the difficult art of 'placing into brackets' all one's prejudices, vague evidences, traditional assumptions, including one's religious convictions, to forget and suspend them with a view to 'let the object speak', as Husserl says, that is, to let it disclose its real essence (its *eidos*). This object, in our interreligious dialogue, is the specific essence of the Eastern spiritualities approached by the Westerner, and the specific essence of the biblical spiritualities approached by an Oriental. This 'suspension of judgement' or 'placing in brackets' by no means implies the abandonment of one's convictions, but only that one abstains, for a certain time, from performing the act of faith in them, with the intention to reopen the parenthesis once the other has spoken, and then to give one's full answer to a fully understood partner, that is, to confront both hemispheres.

Two extremes have to be avoided if an interreligious dialogue has to make the spiritual essence of East and West visible to each other: the religious *exclusivism* (or fanaticism), which refuses to listen, to acknowledge other spiritual values, and the religious *syncretism*, which listens superficially and fails to grasp the uniqueness of the other as other. The West inclines to exclusivism, the East to syncretism. The view that salvation is only possible within the visible Church—a view expressly rejected by the Catholic Church—has been sustained by missionaries and eminent Christian theologians, even today. Such blindness for the spiritual riches of the East, for its mystical depth and intuition of the transparence of the cosmos to higher realities—such blindness always implies a

blindness for some basic aspects of Christianity itself, namely, for those aspects which it shares with all religions, for example, the awareness of the sacred, the value of contemplation; it supposes a value-blindness for the fact that man as such is an image of God. Thus, the well-known examples of violent conversions illustrate, not Christianity, but a very unchristian aspect of Western history.

The East is tempted by the opposite extreme, syncretism. It consists in wrongly equating biblical values with Eastern religious categories, for example, in mistaking monotheistic creation (*ex nihilo*) with the Asiatic concepts of emanation or manifestation, or in calling Christ an *avatāra* or a great *yogin*, or in identifying hastily Christian love with Buddhist *maitrī* or Hindu *bhakti*, overlooking their specific and irreductible differences.

The result of such premature jumping to identity is that many Eastern scholars and sages, instead of studying Judaism, Christianity, and even Islam from within and taking them phenomenologically as they are in themselves, reduce them to those aspects which are similar to the Eastern approach, isolate those aspects from their context, and thus force monotheism into a sort of Eastern Procrustean bed. In the Gospel, for instance, they read only some sayings of Jesus like: 'My Father and I are one', ignoring all those where Christ stresses his being irreductibly distinct from the Father, a distinction thanks to which they are not fused, nor merely identical, but each *within* the other, in a union which is an inter-personal communion, not a coincidence. Many Hindu or Buddhist scholars seem to know only Meister Eckhart and other more or less 'monistic' mystics; they consider them as the truest expressions of the Christian message without taking the trouble to enquire why the Church warned against their identification of man and God.

Such universalism is undoubtedly more tolerant, and less 'violent', than Western exclusivism, but equally blind to the specific inner visage of Christianity and the other biblical spiritualities. It shares with its opposite extreme the

fact that it reduces the dialogue to an apparently all-embrac-
ing monologue. The integration or 'homologation' of
different spiritual perspectives seems to me valid only
within the realm of *one* hemisphere. It is correct, for in-
stance, to equate the Vedic ritual sacrifice and yoga by
interpreting yoga as an inner sacrifice; Buddhism may be
correctly identified with a yoga transformed into a world-
religion. The reason why the reduction of Eastern structural
analogies to a common identity becomes invalid when
extended to the biblical categories lies in the fact that the
two hemispheres form two religious families, which differ
not only in degree, but in nature, so much so that the
difference between these hemispheres is a spiritual *contrast*.

To get a first glimpse of this still unexplored contrast,
let us try to look, phenomenologically, at the most typical
expression of each spiritual hemisphere, the saint and the
yogin. Considered in the above-mentioned and radically
unbiased way, the yogin and the saint are two *antinomical*
'phenomena'—phenomena not in the current sense of an
outward and transitory appearance, but in its etymological
(and phenomenological) sense of the manifestation (*phainom-
enon*) of the permanent essence (*eidos*) of an object when we
perceive it from within and 'antinomical' in the following
sense: between a yogin and a saint, the difference is in a
way much greater than that between an ordinary Hindu
and an ordinary Christian, greater and yet much lesser,
because, whereas the spiritually mediocre Indian and
Westerner share their lukewarmness (and the whole scale of
human passions) and yet differ in such a way that they
mutually exclude and possibly exterminate each other, as in
religious wars, the extreme distinction between a yogin and
a saint, their respective uniqueness, is not of an exclusive
and incompatible character, but of *complementary* nature.

The yogin is utterly absorbed and extinguished in an
impersonal Divinity; the saint is utterly confronted with the
Absolute in Person. The yogin is a pure Self without any
Thou; the saint is open to the divine Thou from the very

depth of his self. The yogin is liberated from the ego and the world; the saint is only liberated from evil. The yogin lives in 'non-duality' (*advaita*), without a second, beyond relation; the saint lives face to face with God, in inter-personal communion, in extreme reciprocity. The antithesis 'sage-prophet' is of a similar structure. Eastern and Western cultures have been decisively stamped by these antinomies. They are rooted in two contrasting metaphysical and anthropological backgrounds.

II. THE METAPHYSICAL BACKGROUND OF THE CONTRAST

A phenomenological approach to this background will not shade off the contrast, but sharpen it, bring it into full relief, and thus intensify the 'dialogical tension'. The above-mentioned 'awareness of the sacred' is the common spiritual ground of East and West, the basis for the dialogue; yet a basis is not a summit. The respective summits will only appear gradually in the course of the dialogue. The eight main religions of the world should first be compared, phenomenologically, to as many different peaks rising from this common basis, long before we are entitled to speak of them, metaphysically, as of many ways leading to the same summit; such may be the final result, never the initial assumption of a serious and valid confrontation. The phenomenological approach discloses the reason why some religions and cultures differ from each other in *degree* only, others in *nature*. Hinduism, Buddhism, Taoism, Confucian-ism and Shintoism, in spite of their specific features, differ ultimately from each other in degree only; yet each of the five Eastern religions differs in nature from Judaism as well as from Christianity and from their common offshoot— Islam. The members of each group or religious family share an outlook on world, man, and God, which is not only different from that which the other group has in common, but symmetrically *divergent*.

1. Emanation—Creation, Enstasis—Ekstasis: Two Divergent Spiritual Dimensions

The divergence is conspicuous in the respective outlook at the origin and development of the universe, and, consequently, in their respective outlook at the disciplines leading to God. Practically, all Asiatic cosmogonies consider the evolution of the objective cosmos not as a progress or an ascension, but, on the contrary, as a *descent*. Whether it is conceived as production, emanation, or manifestation, the world-process, as such, is a perpetual departure from its divine origin towards worldly periphery; becoming is a centrifugal movement from Reality to unreality; pre-cosmic plentitude unfolds itself towards periodic dissolution (*pralaya*). Therefore, the Taoist 'wheel of things', the Buddhist 'round of existence', the Hindu 'days and nights of Brhamā', are all not only centrifugal, but ultimately *māyā*, that is, a dreamlike manifestation of the unmanifested, yet omnipresent, uniquely Real. Correspondingly, all Eastern ways leading to the Divine—the Eastern spiritualities, strictly speaking—consist in an inner counteraction which neutralizes this centrifugal evolution by a symmetrically inverse *involution*. *Yoga*, Buddhist *jhāna*, Zen and Taoist meditation are all a movement backward, an inner return to the pre-cosmic, pre-temporal Reality. This implies a radical detachment from the world as such, not only from evil, as from peripherical illusion including the empirical ego. The first and last word of Eastern spirituality is *concentration* in the etymological sense of a 'concentric retreat' towards the divine centre abiding in oneself; no, coinciding with one's Self. Asiatic spiritualities aim at total *interiorization*. This spiritual orientation impresses to some extent all Eastern inner relations to values, particularly to finite values.

In Judaism, Christianity, and Islam, both these movements have an exactly opposite orientation. Their common holy scripture, the Bible, describes the world-evolution not as centrifugal, but as theo-centric, centripetal, not as

descending from God, but as ascending towards God according to the scheme (or divine plan) prefigured by the 'six days of the Genesis'. During these six world-periods, universal existence emerges first from non-being ('nothing') to inanimate (mineral) existence, then progresses to vegetal and animal life, and finally culminates in man as in an epitome of the cosmos as well as a free image of God, so that through man the whole cosmos can and should culminate in God. Thus, biblical becoming, even of the outer world, is not essentially a production, an emanation, a manifestation in the Eastern sense; not a production out of some pre-existing matter, but a total invention—including matter—out of nothing; not an emanation, a flowing *out* of an impersonal Divinity towards illusion, but a progress, a growth proceeding, not down from God, but *up* from nothing to God, rising through impersonal life towards an increasingly personal Reality; nor even a manifestation, a necessary unfolding of the 'possibilities' of a unique Reality, but the result of a free act of the absolute Person; in one word, a real *creation*. Creation places an intrinsically real world and free creatures *in front* of an ultimately personal Creator. Therefore, Judiac, Christian, and Islamic salvation or sanctification—that is, monotheistic way of union with God—is, accordingly, not an inner ascending recession *from* world and ego, but an ascending inner progression *with* world and ego, a spiritual movement forward towards a divine Thou, not a spiritual retreat into a pure Self; a fulfilment of creation by achieving its growth inaugurated by God, not a neutralization of the world-process. The basic inner gesture here is recollection *before* God, *confrontation*, not pure concentration within; full *response* to all values whether infinite or finite, not an interiorization of the finite.

The Eastern spiritual gesture of radical interiorization is at once physically symbolized—and inwardly induced—by the main *yoga* postures, by the suspension of breath, by the withdrawal of the senses from their objects (*pratyāhāra*); it is

unsurpassably expressed by the statues of Lord Buddha. So do similarly the Jewish, Christian, and Islamic liturgy and prayers outwardly transcribe as well as impress on the soul the monotheistic, complementary 'protreptic' (forward-leading) inner orientation. Both are *mudrās* (sacred gestures) suggesting self-transcendence—there a self-transcending assimilation of cosmic rhythms by re-absorbing them into one's pre-cosmic Self; here a self-transcendence leading from within towards the supra-cosmic interiority of God or of one's neighbour loved as God's image. Both convey the experience of a paradoxical omnipresence—there the paradox of an omnipresent 'blissful solitude' (*kaivalya*); here the paradox of faith and hope in an omnipresent, providential, yet increasingly unpredictable 'divinizing love'.

The ultimate goal of all Asiatic sacred gestures, symbols, myths, ascetic scriptures, and disciplines is summed up in Shankaracharya's famous sentence: 'The liberated sage contemplates everything (including God as Person) as remaining within himself.' The ultimate trend of monotheistic social achievements, art, poetry, liturgy, mysticism, and holiness is summarized, as it were, in Christ's injunction: 'He who loses his soul (that is, himself) unto Me, will find it.' The essence of Asiatic spiritualities is *en-stasis*, that of the biblical hemisphere is *ek-stasis*. Now *en-stasis*, a word coined to translate *samādhi*, means literally 'abiding within', to wit, within one's non-dual, thou-less, trans-personal Self. *Ek-stasis*, literally 'abiding outside', means in its classical sense, to have transferred one's innermost abode into the depth of the Absolute in Person, into God as an ultimate, unsurpassable Thou. The I-Thou relation is experienced in *enstasis* as a limiting duality surmounted by the knowledge of boundless Non-duality; in *ekstasis* as a deep polarity endlessly deepened and transfigured by infinite Love. *Enstasis* is transcendent pure interiority, impersonal self-transcendence, supreme identity; *ekstasis* is transcendent reciprocal interiority, inter-personal self-transcendence, supreme communion.

2. *Supreme Identity—Supreme Communion: an Antinomical Polarity*

I consider these two spiritual dimensions of mankind as ultimate and as the only two ultimately authentic; any attempt to reduce them to a third common denominator is vain spiritual obscurantism. If, on the contrary, I endeavoured to press the contrast, it is because, at the very moment in which the two extremes—pure and reciprocal interiority, identity and communion, Eastern Self and biblical Thou—reach the climax of their divergence, one discovers that they call for each other. Obviously, reciprocal interiority, far from excluding pure interiority, implies it; obviously, supreme identity can and should remain open to supreme communion, *enstasis* to *ekstasis*. Their deepest inner relation is not that of an alternative, but that of a transcendent spiritual tension, somehow comparable to the complementary tension relating the two poles of a magnetic field. The apparent contradiction culminates in an *antinomy*, that is, in a paradox meant to remain insoluble as an intellectual problem—and to be solved only when approached as suprarational mystery, an approach which transforms and unifies mind and heart by keeping them indefinitely open to the Infinite. Such a supreme interreligious tension can only develop its latent spiritual energies when it is not suppressed or ignored, as exclusivists think, nor reduced, as syncretists and exclusivists think alike.

If that is so, two questions arise, perhaps the two crucial questions of the spiritual encounter of East and West, namely:

1. Is our meeting with Eastern spiritualities, religions, and civilizations not a providential challenge for the extrovert of modern West to place at a deeper level of his consciousness the starting point of his relation to God, to the universe, and to man? And, as both hemispheres have a common sacred ground, does that challenge not at the same time remind the West of a forgotten or neglected dimension of its own tradition?

2. Is not, conversely, this growing spiritual and cultural interpenetration of the two hemispheres a providential challenge for Asia to revive in its turn undeveloped traditional energies, and thus to discover new or disregarded spiritual horizons, particularly those referring to inter-personal communion at the highest level, a level where the *yogin*, in spite of the universal dimensions of his consciousness, remains ultimately solitary?

A tentative answer to these two questions requires a glimpse at the history of the encounter, first of the West with spiritual Asia, then of the East with the biblical West.

III. THE WEST-EASTERN DIALOGUE

As surprising as it may sound, such an authentic dialogue has already taken place long ago in the West. Prepared since the fourth century B.C. by social, cultural, and even spiritual contacts between India and the pre-Christian Western Antiquity, these still largely unexplored initial relations of the West with Asia came to a spiritual culmination during the first five or six centuries of Christianity, namely, in the *patristic period*, the period of the 'Fathers of the Church', some of whom were spiritual giants. In their quality as inspired interpreters of Judeo-Christian Revelation, they elaborated the huge edifice of Christian doctrine on the threefold foundation of Greek beauty and philosophy, of Roman sense for justice and political order, and—last but not least—of Hellenistic mysteries, gnostic speculations, and other Near-Eastern religious institutions.

Since the secularizing Renaissance, the Greek and Roman elements of Christian doctrine and Western civilization have been overstressed at the cost of the Hellenistic, specifically mystical, element. In fact, this Hellenistic background has also contributed to shape decisively the basic categories and inner unity of the Occident. And what has been even more and is still widely ignored under the

narrowing influence of a certain Western spiritual provincialism is the fact that this Hellenistic building-stone of Christian culture, specially the neo-Platonist metaphysics of Alexandria, is, in reality, an Asiatic spiritual dimension of the patristic thought and therefore of the West.

1. The Augustinian Synthesis

Let me illustrate this by the spiritual evolution of the greatest thinker of Christian Antiquity, Saint Augustine, the most powerful architect of Western spirituality, culture, and civilization after Saint John and Saint Paul. His famous conversion (in Milano in 386) is too often described as a sudden leap from Manicheism, a rather materialistic form of gnosticism, to pure Christianity. One has not given due consideration to the fact that, at the end of his Manichean period and shortly before his dramatic conversion, Augustine had discovered Plotinus, the summit of neo-Platonism, whose influence is crucial on Christian and Islamic spirituality (Meister Eckhart and Ibn Arabi, for instance, are deeply Plotinian), an influence of which Augustine was one of the main channels. Indeed, Augustine did not only read some books of Plotinus; he confesses that through them he awakened for the first time to the knowledge of an immutable and absolutely spiritual God.

Now, modern scholars of Plotinus agree that his philosophy and cosmology is surprisingly close to Vedanta, closer than to Aristotle and even Plato. The Plotinian world-process is an emanation and manifestation of the divine Unity, unfolding itself simultaneously as macrocosm or 'great (outer) universe' and microcosm or 'small (inner) universe', strictly related to each other in such a way that the human body corresponds analogically to the whole physical universe, that the individual soul is a counterpart of the 'cosmic soul', and that the human spirit is a counterpart of the universal Intellect (Nous). These two parallel,

horizontally connected hierarchies are, in their turn, vertically related to the transcendent 'One' by an inner ontological continuity deriving from their ultimate identity. Like in Vedanta, the way leading to this supreme Identity of all subjects and objects in their thou-less precosmic Reality is an ascending concentric retreat, a contemplative withdrawal from all objects, including the empirical ego. Plotinian spirituality is a way back to the primordial coincidence of the divine Centre of the universe with one's own innermost divine centre. This blissful coincidence, often wrongly described as *ekstasis*, is, in fact, a radical *enstasis*, a pure interiorization, a *samādhi*, which Plotinus has known four times. According to recent researches, Augustine practised this Plotinian *enstasis* several times, and his conversion took place *after* those mystical experiences.

Now, his conversion was nothing but an overwhelming encounter with the personal God of the Bible, with the Absolute in Person, experienced in faith as transcending even metaphysical unity and ultimate interiority. He describes this absolute transcendence in his Confessions (written in 399), the only metaphysical and theological treatise written throughout, not about God, but *to* God. In other terms, Augustine, even after having reached a pure inwardness of the Eastern type, remained confronted with God as absolute Thou, because, as he says in a sentence which became classical for Christian spirituality: 'Thou, Lord, was more interior to my innermost and superior to my summit.' His Plotinian 'pure interiority' blossomed out in 'mutual interiority'; his union with God culminated, not in fusion, but in communion. Such ultimate 'transcending of one's self', as Augustine says, this self-transcending towards the other, became decisive for the Western concept of the human person as basically inter-personal. As Gabriel Marcel says: 'To exist as a person means to make oneself by surpassing oneself towards another person.' The example of Augustine's conversion shows, among many others of the patristic period,that Christian spirituality, far from exclud-

ing or rejecting Eastern spirituality, has, in fact, been deepened and enriched by it. But it also shows that this is only true when this East-'West' dialogue takes place at the spiritual summit of both hemispheres.

2. *The Modern Resumption of the Encounter*

After the patristic period, the Christian dialogue with spiritual Asia came to an end for more than a thousand years; from about the seventh to the eighteenth century, Europe remained culturally and spiritually isolated from Asia. Not that Asia was absent, but its presence to European thought remained 'incognito'. Spiritual Asia, as it were, went underground. Its presence took many disguised forms—for instance, the Plotinian influence on Christian mystics and philosophers (Eckhart, Tauler, Suso,[4] Spinoza, Boehme), or occult movements like the Cathars, the Patarins, the Illuminados, the Brothers of the Free Spirit, the hermetists and alchemists of the Renaissance, and other occultists. Its most important incognito was the Eastern interiority as a dimension integrated in European thought itself. In spite of numerous geographic, economic, and even religious contacts and exchanges since the sixteenth century, it was not before the end of the eighteenth century that European intelligentsia began to know Asia from within. Then only Asia's spiritual incognito was suddenly unveiled by the publication of the first translations of its sacred books—of the Upanishads, of the *Bhagavad-Gita*, and later of Buddhist and Taoist scriptures.

The impact on European mind of this huge discovery was tremendous. Nothing describes it better than the expression 'Oriental Renaissance' (borrowed from Schopenhauer by R. Schwab), for, like the Renaissance of pre-Christian Antiquity in the sixteenth century, this discovery was a rediscovery; it was the rediscovery, but this time far beyond the seas, of the same Asia which had lived unper-

ceived in Western souls for twelve hundred years. A sort of collective psychological shock resulted from the disclosure, not of a bygone antiquity, but of a living world of deep religiosity, high mystical insights, ascetic heroism, immemorial myths and symbols entirely new and yet strangely familiar to us. Asia emerged before our eyes like a distant mirror reflecting in magnified proportion our own forgotten past. Europe realized abruptly how much spiritually is inherent to all men and to all cultures of all times. Our dialogue with the Eastern spiritual hemisphere started anew on a much broader scale.

From the point of view of our inter-religious encounter, the nineteenth and twentieth centuries are closer to the patristic period than the twelve centuries lying between them. The first leader of the new dialogue was the founder of the German Romantic School, the Sanskritist Friedrich von Schlegel, soon joined by Herder, Goethe, Novalis, Schelling, Fichte, Hegel, Schopenhauer, and later by Wagner and Nietzsche. The revival of idealism in philosophy and the rise of romanticism in Western literature and art are unthinkable without this encounter with the sacred East. Baron Eckstein—whom Heine surnamed 'Baron Buddha'—shifted this wave of enthusiasm from Germany to France. Victor Hugo, Michelet, Lamartine, Vigny, and the symbolist poets were—at least temporarily—overwhelmed by the Oriental Renaissance.

However, our second dialogue with Asia started in a rather chaotic way. The brilliant and passionate French philosopher, Priest Lamennais, had to be condemned by Rome for threatening to dissolve Christianity in a boundless and timeless ocean of vaguely known Oriental religions. Most of the leading Western thinkers, largely dechristianized, had lost the pearl of Greco-Christian heritage—the truly spiritual approach to rationally unsoluble paradoxes and antinomies by 'thinking in tension', the intellectual faculty 'to distinguish without separating' in order 'to unite without merging.'[5]

Thus, no mutual understanding, no real encounter was possible between the 'pro-Western' and the 'pro-Eastern' European partners of the new East-West dialogue, both being incapable to disclose the viewpoint of the other by 'suspending' its own. In the pro-Western camp, the spiritual horizon was narrowed by self-righteousness and the wrong identification of the universality of the Bible with that of Western culture; in the pro-Eastern camp, composed mainly by agnostic philosophers (Schopenhauer, Nietzsche and Hegel), occultists and theosophists, the outlook was restricted by resentments against Western civilization and against the Church, as well as by a more or less conscious desire to elude the burden of the *ego* and of biblical ethics by escaping into a supra-moral and supra-biblical, allegedly Eastern, mostly self-fabricated gnosticism 'beyond good and evil', 'beyond all religions'. Our new encounter with spiritual Asia started as a dialogue of deaf persons.

A great deal of order came into the matter thanks to Frazer's *Golden Bough* and to the publication in Oxford (from 1859 onward), by the great Max Müller, of the *Sacred Books of the East*. This monumental collection of forty-nine volumes, together with the works of the French Sanskritists, provided at last the scientific basis for an impartial comparison between the main religions of the world, a field in which great scholars among missionaries (like Abbé Dubois) had been the first patient pioneers. The first university chair of history of religions was founded in Geneva in 1873, an example soon followed by other universities of Switzerland and by those of the Netherlands, France, and Germany, then of England and America. Among the Pleiad of brilliant authors who brought comparative religion into the realm of science in the twentieth century, I mention here only Dr. Radhakrishnan, because his 'Spalding Lectures' at Oxford—published in 1939 under the title *Eastern Religions and Western Thought*—are the work of the first Asiatic appointed to a Western university chair. The rapidly growing interpenetration of Eastern and Western cultures made an

authentic dialogue more and more urgent and unavoidable. The scientific approach is a necessary condition for it, but not a sufficient one, for objective information is one thing, and objective confrontation and judgement is quite another thing. It requires an approach from within, that is, a minimum of spiritual life. Such approach has followed in this century three very different lines, corresponding, again, to the two already analysed extremes and to a more difficult middle path.

3. Three Western Attitudes Today: Defensive (Exclusivistic), Surrendering (Syncretistic), and 'Dialogical' (Receiving)

Brilliant authors like H. Masis and A. Koestler (in his recent *The Lotus and the Robot*), 'conservative' writers, and many theologians and missionaries treat Eastern spirituality as inferior or pagan in a scornful sense; their exclusivism is less aggressive, proselytic, and self-assured than the old one, more defensive and somewhat depressed, but equally isolating. Concern for the threatened humanistic culture, rather than for the Christian spiritual universality from which it sprang, an often high but one-sighted religiosity, and a certain lack of intellectual charity make them feel uncomfortable in front of the truth expressed by Augustine as follows: 'The very thing which is now called the Christian religion...never failed from the beginning of human race up to the coming of Christ in flesh. Then the true religion, which already existed, began to be called Christianity.'

In the second, syncretistic line, the defence of Western values has capitulated, as it were, in favour of the opposite extreme—that of surrender to Eastern values. It is the approach of universally minded and highly gifted thinkers like A. Huxley, R. Guénon, and to a certain extent A. Toynbee. There, the common sacred ground, the *basic* unity of Eastern and biblical spiritualities, is sweepingly transformed into a coincidence, identity, or fusion of their respective *summits*;

universality is mistaken for absence of determination, because the approach is unilaterally intellectual, inhumanly metaphysical, and therefore also spiritually incomplete.[6] They forget that 'the dignity of man consists,' as Pascal says, 'not in surmounting his limits, but in becoming conscious of them.' In their anti-Western eagerness to reconstruct intellectuality with Eastern elements an esoteric Christianity (or Judaism, or Islam), they indulge in an unconsciously 'magic' play of inter-religious equivalences and often artificial equations, overlooking that, as Aristotle wrote, 'true equality consists in treating unequally unequal things'.

I call the third approach 'dialogical', because, by avoiding either of the first two extremes, its aim is a mutual encounter, a real dialogue. It has been undertaken—with unequal success—by men whose biblical faith did not close, as in the first case, but open their eyes to all spiritual values of the Orient, and whose loving knowledge of the East did not weaken as in the second case, but deepen their biblical spirituality, and who remained genuine Christians as well as genuine scholars, like R. Otto, H. Kraemer, Tillich, A. Schweitzer, de la Vallée Poussin, O. Lacombe, H. de Lubac, M. Eliade, R.C. Zaehner (the successor of Dr. Radhakrishnan at Oxford)—in India itself, the Fathers Dandoy and Johanns, S.J., the late *sannyasi*-abbot Mouchanin, and his followers today.[7] They all endeavour, in various degrees, to look at Brahman and Buddha through Christian eyes, as well as at Christ through Hindu or Buddhist eyes.

They respond to the Eastern challenge by an inner gesture, which is neither a defence nor a surrender of their own spiritual heritage, but a real answer, arising out of more, not of less, faith and love, a full monotheistic reply. As our Eastern spiritual brothers are first of all created in the image of the same God, some of these writers think that we should first of all listen to them and to their scriptures as to possible messengers of a challenge addressed *to ourselves* by the very God of the Bible. Consequently, our first question should be: What message is conveyed to us through

the East?' and not: 'What is our message to the East?'—a question which comes only after the first, if the spiritual dialogue has to be genuinely spiritual and a genuine dialogue. Then only does the encounter find its inter-religious 'sacred space', in which the highest values of both hemispheres can freely circulate. How much Western spirituality can be and has been enriched by this inner attitude is clearly shown by the already mentioned example of Augustine, whose eminently biblical union with God was deepened by 'assuming' the eminently Eastern dimension of interiority.

There are other Eastern spiritual riches of providential significance for the monotheistic hemisphere. I would centre them around an intuition largely forgotten in the West, the intuition of *symbolism* in its full and genuine meaning, the sense of the symbolic *essence* of all things.

4. Biblical Realism Enhanced by Eastern Symbolism

A symbol, in its true sense (still alive in the traditional East), is not a conventional sign; it is the finite expression of the infinite, the only means to evoke and convey realities which cannot be expressed directly. In this perspective, the world around us—things, plants, landscapes, animals, men, and the sky, are not only what they are in themselves or in relation to us, but also what they *signify*, what they are in relation to their ultimate eternal source. Modern science and technology have their root in the biblical conception of man called to rule over nature, to be the free king of a world created as real in itself, not as illusion. If the conquest of nature is divorced from its spiritual finality, if man's transforming power, ceasing to be his act as a free image of divine Freedom, becomes an end instead of a means to glorify God by freely conforming to the world, to God's creative call, as it happened in the post-medieval West, then the human domination of things, because merely human, becomes Promethean, that is, ungodly, and therefore also

inhuman. In such a de-spiritualized technocratic civilization, man, confronted only with products of human skill, lives in a world which refers him no more to its spiritual dimensions, but only to himself: a spiritually opaque world of egocentric structure.

Eastern landscapes, villages, and small towns, not to speak of Hindu and Buddhist sacred places, on the contrary, still seem to point to a reality beyond them and beyond the empirical ego; nature, customs, and dresses are, as it were, more *transparent* to the sacred than ours, a fact which explains the tremendous appeal to modern Westerners of books and exhibitions on Asiatic art, traditions, and landscapes. They fill a gap; they satisfy the same spiritual nostalgia as do in the West the monuments of medieval sacred art. Profane Western music, poetry, and art are a vicarious refuge of this ontological longing, which, in the West, is only fully appeased in liturgy. These two Western parallels to Eastern symbolism—medieval art and liturgy—clearly show that the true lesson of the Eastern world of myths and symbols to the spiritually starved Westerners is not to escape from the allegedly sinking ship of traditional Occident into a mysterious Oriental paradise, but to restore and integrate into modern perspective our own traditional symbols enriched by Asiatic dimensions, to revive the biblical transparency of the universe to the Divine. More precisely: to arouse from the subconscious and to re-integrate the biblical vision of creation as a 'cosmic liturgy', that is, as a universal *symbol*, which is *also* and ultimately an *inter-personal message*, because its divine model is an absolute Person.

Eastern symbolism is a challenge to renew, at the magnified scale of modern science and technique, Saint Paul's awareness of man's responsibilities for the destiny of the universe, of man's mandate to fulfil the world's culmination in God as in its creative and attracting Pole. Should we not respond by striving to remake, at this enlarged scale, the old Franciscan, remarkably cosmical, experience of the

sun, the moon, and the elements as our real brothers and sister, that is, as omnipresent manifestations of an inacessibly transcendent and yet eminently paternal creative power?

If the absolute distance between creation and Creator is an inter-personal distance, an absolute relation, a supra-cosmic infinite in which God posits in front of Him free creatures and a real world made out of nothing, as in the metaphysics of the Bible, then the world can become transparent to the Divine without being reduced to an unreal mirage; it remains fully real, a real symbol which, by its very subsisting finite reality, far from relativizing the absolute reality of the infinite Model, suggests and enhances its inconceivably greater reality.

5. *Christian Experience of Incarnation Enriched by Hindu Approach to Avatāras*

In the Christian view, this 'symbolic' transparency of the finite reality to its infinitely more real Model reaches its climax in Christ, the God-Man, the supreme Paradox in whom all relative and temporal relations of symbols to the Absolute become themselves absolute and eternal. Totally divine and totally human in one and the same infinite person, Christ, in Christian experience, is in person, word and deeds the absolute symbol of the Absolute, the Face of God, the objectively incarnated mirror of the 'Abyss of the Father', that is, of the trans-objective depths of God. Krishna and Rama are *avatāras* of Vishnu, that is, 'descents ' or 'manifestations' of the Divine; they are not, in Hindu view, real incarnations. The commonly accepted translation of *avatāra* by 'incarnation' is superficial and utterly misleading, because Krishna and Rama are not described as having really suffered and died. In the *avatāra*, God does not, as for Christians in Christ, become really man; He only appears in human form and remains, behind and beyond this earthly appearance, purely divine and unaffected by human

vicissitudes. The concept of incarnation, whatever the syncretists may think, has to be sharply distinguished from the concept of *avatāra*, yet only distinguished in order to unite both at a deeper level, like all true values, and not to separate or isolate them from each other, whatever the Christian exclusivists may think. To understand this, the Christian should have the intellectual charity to look at an *avatāra* with Hindu eyes, an effort rewarded by a richer experience of the very Christian contemplation itself, which always consists in looking at Christ.

Now, the great Ramakrishna helps us immensely in such effort, because, right or wrong, he considered Christ as an *avatāra*, as much as Kali, Rama, Krishna, and Mohammed. This peak of Hindu mysticism, who was an open book, clearly tells us how a Hindu contemplates inwardly an *avatāra*. After having meditated for three days on the life of Jesus, a human form appeared to him, drew nearer to him, and he heard an inner voice addressing his vision: 'Redeemer', 'Incarnate Love', and 'Master Yogin'. Now, the decisive point is that this figure became gradually absorbed in Ramakrishna, disappeared as an 'object', and, once fully interiorized, gave him the experience of samadhi, that is, the mystical awareness of the ultimate identity of his own innermost self with the divine self of the *avatāra*.

In other words, the *avatāra* is not an objective Thou, as Christ is, but a symbol in the highest sense which Asia gives to this word, namely, a sacred, but mythical, that is, ultimately unreal, dream-like, support of radical interiorization, an evanescent sacred mirror of *one's own* divine self. This shows at once the difference, the analogy, and the complementariness between an *avatāra* and Christ. No Christian looks at Christ with a view to absorbing him even in his highest self, nor does he intend to merge in Christ, nor even to merge with him in God. Obviously, two historically individualized persons cannot fuse or merge, nor can two real spiritual persons, whether human or divine; and this is precisely what the historicity of Christ, the unique 'individ-

uality' of the God-Man, suggests and makes obvious. This, by the way, points at the basic difference between Christian love and Hindu *bhakti*, for *bhakti* aims at a final fusion with God, whereas Christian *agapê* does not wish to abolish the distance from man to God or Christ. It intends, on the contrary, to deepen this infinite inter-personal distance, because it is the very breathing-space of a more infinite Love.[8]

However, the fact of Christ's unique historicity prevents his reduction to a timeless myth, and obliges the serious Christian to consider him as being either a charlatan or a historical, that is, irreductibly objective, manifestation of God as the absolute Thou. The fact, in other terms, that Christ is a symbol, and more than a symbol, shows that he is *also* and *a fortiori* a symbol in the full Eastern sense of the word, for the more implies the less. Thus, when we look with Hindu eyes at the incarnation in its full Christian sense, Eastern spirituality helps us to remember, to actualize, and to understand better certain neglected or wrongly understood Christian truths like Paul's exclamation: 'It is not I who lives, but Christ within me', or of Christ himself, when he says: 'The kingdom of heaven lies within you.' It discloses Christ as being *also* a perfect symbol in the Eastern sense of a holy mirror, which, by reflecting objectively, by making paradoxically visible preconscious regions of the soul, refers us back to dimensions of interiority otherwise inexorably hidden to ourselves, but always confronted, and thus awakens us to the incommunicable mystery of the person in the Christian sense of the word.

This ultimate personal centre to which Christian contemplation arouses, because it is incommunicable and therefore incapable of fusion or mergence, has a degree of interiority higher than that of the *bhakta* and closer to that of the Advaitin. The Advaitic way towards 'non-dual' identity of the Self (Atman) and Brahman by pure 'knowledge' (*jñāna*) discloses an inwardness which is also incommunicable and beyond 'bhaktic' fusion, and in this sense more truly personal. But it remains unconfronted, totally Thou-less, whereas Christian

contemplation, at this very point, becomes utterly inter-personal by opening totally to the inwardness of God's infinite Thou.[9] This shows the deep polarity by which the two hemispheres are distinguished and united.

In brief, the main spiritual gift of Asia to the monotheistic hemisphere consists in compelling us, as it were, not at all to abandon or to reduce our ultimately inter-personal approach to God, but to place its starting-point at a more and more interior sphere of the soul—a providential lesson, indeed, to so many modern monotheists who dare to approach the absolute Person from a peripheral, mundane, superficial, and 'mediocre' sphere of their consciousness, and tend to conform God to the image of man, instead of conforming man to the image of and resemblance of God.

IV. THE EAST-WESTERN DIALOGUE

If that is true, I can turn my attention now—in spite of my lack of competence—to examine our encounter from the opposite side, from the Eastern point of view, at least in principle. In principle, I fail to see any reason why the spiritual East should not, in its turn, open itself from within to the biblical hemisphere, why it should not also reach out for its complementary values and accept to be enriched by them, especially by those enhancing the inter-personal sphere and the objective side of reality.

1. No Full Encounter up to the End of the Nineteenth Century

To this, Hindus and Buddhists often object that all these biblical values and approaches are already included in their tradition and scriptures and even surpassed by them. This attitude reminds one of the defensive reaction of Christian exclusivists in the opposite sense. The irresistibly

growing presence of the West in Asia should rather induce them not to stop at the aforesaid assumption, but to check it. Even if it is true, Hindus, Buddhists and other Asiatics have nothing to lose, but only to gain by reacting to the spiritual West as to a providential challenge to revive some of their own traditional dimensions, which Asia—also spiritual Asia—may have forgotten or neglected in the long course of its immemorial history, those dimensions, namely, which the·West, otherwise also forgetful of its tradition, has kept alive and developed. Why should Asia refuse a dialogue in which the only thing which both spiritual hemispheres are asked to give up is their ignorance about each other?

If we now turn to concrete facts, that is, to Indian history, we see that India's real dialogue with the spiritual West is not older than about eighty years, and that this interreligious encounter is intimately related with India's political rise to national independence, with India's awakening to the full awareness of its indivisible cultural and political personality, that is, of its international vocation. India's first confrontation with the spiritual West as a whole increased her national self-consciousness, which, in its turn, inclined India to join the spiritual dialogue. Up to the end of the nineteenth century, the monotheistic—Jewish, Christian and Moslem—communities of India lived side by side with Hindus and Buddhists, tolerated by them, but also spiritually unrelated to them. In tolerant India, there is no such thing as the thirteen centuries of old Chinese anti-Christian tradition. Whether the Jewish, Christian, and Moslem communities originated in India by immigration, conversion, or invasion, the relation in India of monotheism with the Asiatic spiritual hemisphere was mainly that of two or more coexisting monologues. In the sixteenth century, Emperor Akbar, who, according to Max Müller, was 'the first who ventured a comparative study of the religions of the world',[10] organized inter-religious debates, which were not continued by his successors, and had no

lasting impact. In the seventeenth century, the bold attempt of the Jesuit Father De Nobili to start a full Hindu-Christian dialogue was turned down in Rome by his Dominican opponents. Indian Sufism is not a mutual Hindu-monotheistic encounter, but rather an absorption of the Moslem concept of a personal God by the Hindu ways towards an impersonal Divinity; a sort of conversion of Islam to Hindu spirituality; and a conversion, as such, is not the beginning of a dialogue, but rather the end of it, especially in old India.

2. *Vivekananda's Opening of the Dialogue*

The real encounter of Hindu spirituality with Christianity, prepared by Ramakrishna in the way described above, started with his ardent disciple Vivekananda. Received as a spiritual hero by the World Parliament of Religions held in Chicago in 1893, Vivekananda conveyed to the West the message of the universality of Hinduism, in which all religions seemed to him to converge as into a supra-religious spiritual synthesis. At the same time, however, he absorbed in the West, more and more consciously, some true biblical values which were new to him and less easy to integrate into his synthesis than he had first assumed. He had inherited from his Master a spiritual plasticity, which enabled him to be impressed by the specifically biblical stress on the highly spiritualizing nature of a relation to God—and through God to the neighbour—conceived not as ultimately impersonal, but as ultimately inter-personal. He seems to have growingly realized that this concept implies, in apparent contradiction to Hinduism, that the objective side of the universe corresponds to something ultimately real, not reducible to a dream.

It was the biblical hemisphere which made Vivekananda increasingly, albeit reluctantly, aware that the world of concrete things and concrete persons which confronts us is a place for spiritualizing action, not only of spiritualizing

detachment, a place made for a spirituality of response to finite positive values, not only of global retreat from the finite as a bulk of disvalues. He never forgot his first glimpse at a world approached as real creation to be fulfilled by man's co-creative co-operation with its Creator, where space and time, where God-intended dimensions in which and by which finite things have to be done, not merely to be undone and dissolved in a spaceless and timeless Beyond.

He also saw that all these values and perspectives, in spite of being contained in some way or other in the Vedas, the *Bhagavad-Gita*, and the Puranas, had been treated as belonging to a lower level and thus remained basically foreign to Hindu and Buddhist social consciousness. In an excessively severe judgement, he writes: 'No religion on earth preaches the dignity of humanity in such lofty strains as Hinduism, and no religion on earth treads upon the neck of the poor and the low in such a fashion as Hinduism.'[11]

His familiarity with the West induced him to attempt the revival of those neglected inter-personal values by developing the Hindu 'way of love' (*bhakti-mārga*) on partially Christian lines and by laying unprecedented stress on the social aspect of the Hindu spiritual 'way of action' (*karma-mārga*), described by the *Gītā* as action done with an inner detachment or renunciation of its fruits and as work dedicated to Krishna. Vivekananda's untiring exhortations to his people all over India started a movement conversely similar to the above-mentioned 'Oriental Renaissance' in Europe, and which might be called a 'Monotheistic Renaissance' in Asia. He met strong resistance provoked by the inveterate Indian tendency consisting in either loving the world too much, too egoistically, when they are profane or in the first two stages of the Hindu way of life, or, once they awaken to spirituality or enter the last stages, making an abrupt inner *volte-face* by which they turn entirely away from the world, from social responsibilities—work and fellow-beings being considered as *māyā*, devoid of spiritual value.

Leading Indians today, desirous to see India achieve industrialization and material and social progress without abandoning its spirituality, see no way out of the following dilemma: should India keep its traditional virtue of contentment at the price of backwardness and starvation, or accept and even foster discontentment as a necessary incitement to material progress, even at the price of materialism and gradual extermination of India's spiritual personality?

3. Progress and Spirituality: Nehru, Aurobindo, Tagore, Radhakrishnan, Gandhi

This seems to me a wrong alternative. The problem is not one of contentment or discontentment, but one of a new *spiritual* approach to the outer world, of a new inner relation to objects, breeding contentment without indifference, and productive activity without discontentment or restless activism. To achieve this aim, India should perhaps boldly proceed on the way paved by Ramakrishna and Vivekananda, by endeavouring to integrate more and more into *yoga* and *sādhana* all human relations to concrete objects and to the inter-personal, eminently ethical sphere. This realm of objective values, material or personal, which tend to be ignored or underestimated by the Hindu and Buddhist sweeping ways of liberation based on the equation of existence and suffering, this realm of finite yet true spiritual values fully disclosed by the biblical concepts of creation, incarnation and redemption, should only be transcended after having been fully acknowledged as such and inwardly assimilated. For, all true values belong to God, all are spiritualizing, all have to be taken seriously. To ignore them by a premature leap to pure interiority may deliver from the world, but might also make blind for God's infinite richness; it might impoverish spiritually, not only materially.

This shows that India's technical and social progress, by developing instinctively a more positive, more spiritually

integrating relation to matter and neighbour, could indirect-
ly open Indian eyes and hearts to many hitherto unper-
ceived theocentric dimensions of daily life. However, the
result will only be spiritual and not materialistic, if pundits
and *gurus* rethink and deepen all moral implications of
bhakti- and *karma-mārgas*.[12] Would they ask the West and
obtain from it to perform its technical assistance with a
minimum of awareness of the providential spiritual comple-
mentarity between both hemispheres, our economic co-
operation would become a part of the East-Western spiritual
dialogue and receive its full significance. I like to think that
this is what Pandit Nehru has more and more in mind in
his repeated recent statements, by which, quoting Vinoba
Bhave, he declares science without spirituality as amoral
and exhorts to unite them.

A spiritual Master of India, whose long stay in the
West enriched him precisely in this direction, is the late Sri
Aurobindo. Once retired from his political career after an
overwhelming mystical experience in prison, he undertook
to combine the Hindu cosmogony of descending emanation
with the eminently biblical concept of the world process as
a basically ascending evolution. This also was the result, not
of a mere importation of Western perspectives, as some
have thought, but of a revival and expansion of the old
Puranic doctrine of the ten successive *avatāras* of Vishnu.
These periodical multiform descents of the compassionate
Vishnu, the cyclical saviour of this world periodically
threatened with decadence and destruction, follow a move-
ment upward from Fish and Tortoise to higher animals, and
from those to Dwarf and to full human forms. As far as I
know, never before the recently started dialogue of India
with the West had the attempt been made to extend this
ascending movement of the whole cosmos.

Rabindranath Tagore, this mighty Bengali tree opening
freely its branches upwards, eastward, and westward as all
trees deeply rooted in their native soil, depicts a *sannyasi*
who, brought back by a little girl from pure inwardness into

the play of life, discovers that 'the great is to be found in the small, the infinite within the bounds of form, and the eternal freedom of the soul in love.'[13] Tagore, writes Jawaharlal Nehru, 'has been India's internationalist *par excellence*,...taking India's message to other countries and bringing their messages back to his own people.'[14] His revolutionary insistence on life as a great gift, his vision of love as the essence of inter-personal communion, sound more biblical than Hindu to Western ears; yet Tagore untiringly disclosed them as the main intention of Hindu scriptures.

All the recent spiritual tendencies and achievements, all these new outlooks and new remembrances, born of India's talking and listening to the West, converge in the philosophical works of Radhakrishnan. His brilliant writings seem to me to prepare the ground for a synthesis which has yet to be achieved within Hinduism itself, and which would greatly help the dialogue to become full and reciprocal encounter of the hemispheres at their spiritual summits: the synthesis of Vaishnavism and Shaivism, that is, of the Hindu way of love (*bhakti-mārga*) and of the Hindu way of knowledge (*jñāna-mārga*). In other words: the synthesis of God approached as the Absolute in Person and of God conceived as the impersonal Absolute. These two antithetic Hindu spiritualities appear to me to be still somewhat unrelated, perhaps because they are not sharply enough distinguished.

Mahatma Gandhi, a great admirer of Ramakrishna, is sometimes said to have 'received from the Sermon on the Mount his doctrine of non-violence'.[15] This view is contradicted by the fact that Gandhi, when asked in 1909 by Reverend Doke about the origin of his concept of *ahimsā*, quoted the following old Hindu verses which he had learned at home in Gujarati: 'For a drink, give back a full meal, for a greeting, honours without number. ..The truly noble knows only brothers, he retaliates evil with goodness.' However, equally wrong seems the opposite view (defend-

ed by O. Wolff, *loc. cit.*) declaring Gandhiji's concept of non-violence entirely devoid of Christian influence.

Pro-Western exclusivists share with their pro-Eastern syncretistic antagonists the same simplifying tendency to make of 'Christian influence' and of 'Hindu influence' one of these false alternatives on which the world lives and which obscures the higher polarity between them. Gandhiji also wrote: 'I can say that Jesus occupies in my heart the place of one of the great teachers who have made a considerable influence on my life.'[16] This tends to prove that Christ, this unique Pole of the monotheistic hemisphere, has at least helped the architect of independent India to actualize and to bring, for the first time in history, to concrete political life an age-old dimension of Hinduism, this homeland of the highest spiritualities of Asia. No wonder that Gandhiji's concept of non-violence has, in its turn, profoundly influenced contemporary Christian thinkers.[17]

The Carolingian Christian Empire has been shaped according to the *City of God* of Saint Augustine, who brought the biblico-Asian spiritual dialogue to its first climax fifteen centuries ago. In Gandhiji and his above-mentioned disciples, this same dialogue shapes the political structure of modern India.

A genuine 'dialogical' encounter reveals increasingly the two spiritual hemispheres as being, in reality, spiritual dimensions of man as man, whether Eastern or Western, and the tension between *enstasis* and *ekstasis* as a tension between two poles inseparably present in every human being. Reflecting in men a mysterious divine antinomy, these spiritual poles constitute the human person as a full person, that is, as self-transcending interiority polarized by another interiority. They have to remain always in tension, yet in a non-violent, inwardly transforming tension which unifies the whole person and enables man, brought to real peace with himself, to bring real peace to others. 'Non-violence is more than peace', Pundit Nehru once told me; it is more than absence of war. So is biblical Love.

East and West should meet like two spiritual persons. Persons are not 'problems' to be solved, but inexhaustible 'mysteries' to be explored. The point is not to come to a final agreement; the point is to understand the other as other, more and more, which is love. East and West are like two persons who, having lived long together like strangers, begin to discover that they love each other.[18] The dialogue will never end. Lovers are never tired to meet, to listen, and to talk.

REFERENCES

1. *Encounter at Ascona*, in *Spiritual Disciplines*, Papers from the Eranos Yearbooks, London, Routledge, 1960, p. XXI.

2. At least, as much as the more apparent archetypes 'genius' and 'hero' of each continent or country.

3. An interesting study could be made of the possible inner relation between political non-alignment and another eminently Indian summit of spirituality, *advaita* or 'non-duality'. Of the Divine in itself, says *advaita*, man can neither affirm nor deny anything; therefore, the unqualifiable divine Oneness can only be realized by refusing to opt for any of the complementary aspects of any pair of opposites, including—ultimately—good and evil.

4. The *Tercer Abecedario* of the Franciscan Ossuna, whose influence was decisive for St. Theresa's (of Avila) first mystical experience, is a method of recollection through pure interiorization.

5. This is the formula by which the Fourth Oecumenical Council, held at Chalcedan in 451, distinguishes the two mutually irreducible natures of Christ (the human and the divine) with a view to stressing their supernatural inner unity (in Christ as indivisible Person). The recently rediscovered impact of this formula on the faculty to 'think in tension', which has stamped Western thought, including modern scientific thought, has been analysed by Denys de Rougement in the brilliant chapter, 'From Nicea to the Atomic Age', of his book *Adventure occiden-*

tale de l'homme (Paris, Albin Michel, 1957). See also my *Encounter of Religions* (Desclée, New York, 1960), pp. 75–79 (on 'antinomic knowledge').

6. This 'metaphysical' or 'traditionalist' school seems to know only of a universality conceived in analogy to the reversible world of space and things, and of a basically 'extensive' infinity (infinite=unconditioned, unlimited, unqualified); it passes in silence over the infinity of 'comprehension' abiding in the intrinsic *quality of values* (infinite=perfect, supremely qualified, unique); there, universality is conceived in analogy to the irreversible world of time and persons.

7. Francis Mahieu and Bede Griffiths, the founders of the *sannyasi*-monastery of Kurishumala (Kerala), among many others.

8. A similar contrast distinguishes Christian charity from Buddhist *maitri* or 'universal benevolence'; as the respective subjects of evanescent elements, the 'love'-relations must themselves be non-subsistent and evanescent, whereas charity is an ultimately real relation between ultimately real persons.

9. On the antinomy according to which 'spiritual beings can only commune' by that which is 'most personal, most incommunicable,' and on the fact that the absolute Person 'is the pole, not the antipode, of the (human) person'; see H. de Lubac's *Catholicisme* (Cerf. Paris), pp. 301, 287.

10. Quoted by S. Radhakrishnan in *East and West in Religion* (London, Fourth Edition, 1958), p. 32.

11. Quoted by A.K. Brohi, formerly High Commissioner of Pakistan in India, in his address delivered on the 1st January 1961 at the opening of the Ramakrishna Cultural and Educational Exhibition at the Ramakrishna Mission Vidyalaya, Coimbatore, Tamil Nadu.

12. cf. This surprisingly 'biblical' exclamation of Tukārāma, a pure Hindu: 'Cursed by that knowledge which makes me coincide with Thee, I love to have precepts from Thee and prohibitions.' (Quoted by J. Correia-Afonso in *The Soul of Modern India* [Bombay, 1960], p. 7G.)

13. Quoted by S. Radhakrishnan, op.cit. p. 140.

14. *The Discovery of India.*

15. For instance, by the syncretist philosopher of religion Friedrich Heiler; quoted by Otto Wolff in *Indiens Beitrag zum*

neuen Menschenbild (Rowohlt, Hamburg, 1957), p. 68.

16. Quoted by N.B. Sen in *Wit and Wisdom of Mahatma Gandhi* (New Delhi, 1960), p. 52. Spiritual influences always imply a free response to values. Some sociologists miss the point by treating them in analogy to the instinctive growth of habits, to the impact of the climate, or to 'contagion'.

17. For instance, Pie Régamey O.P., *Non-violence et Conscience chrétienne* (Cerf, Paris 1958).

18. As Gaston Fessard explains in a penetrating work on Hegel, Marx, and Christian spirituality, all human relations—individual, social, and political—are shaped by the 'dialectics of Man and Woman' (analysed by Marx himself) as much and in a deeper way as by the Hegelian 'dialectics of Master and Slave'. See *De l'Actualité historique* (Desclée de Brouwer, 1960), vol. I. pp. 163 ff.

THE THIRD ORDER OF VEDANTA

Gargi

The Western Vedanta movement is very young as religious movements go. One can say, I think, that it has been active for about one hundred years, and one hundred years is a short time for an ancient religion to find the right forms of expression in relation to the deep-flowing traditions and needs of an adopted culture. Yet nowadays nothing moves or develops slowly, and a century or so today is equivalent to many centuries in an earlier age; so there has been ample time for the Vedanta movement to have developed certain distinctive patterns and modes. I would not say that these patterns have become set or crystallized. Most of them are, perhaps, trends rather than patterns, but though they are still fluid, some of them seem destined for permanence. This paper is concerned with one of these more stable and definite trends—one which is, I believe, bound to become a vital, indeed, an essential, characteristic of modern Vedanta. (I should say here that I do not think this trend is peculiar to the West; it will, I believe, become exceedingly important in India also. But in this article I shall concern myself only, or primarily, with its Western—and particularly its American aspect.)

What I have in mind is the emergence of a new type of spiritual aspirant—a type or class that constitutes what I would like to call the Third Order of Vedanta. Let me explain my use of this term. I have borrowed it from the Third Order that was established by Saint Francis of Assisi in the early part of the thirteenth century. In founding this Order, the great saint was responding to the pleas of a large group of men and women who longed to join one or the other of his monastic orders, either the First Order, that of monks (Friars), or the Second Order, that of the nuns (Poor

Clares). But it so happened that these people had work to do in the world—duties which, as St. Francis would have said, were God's will for them, or, as a Hindu might say, were their *svadharma* their true metier or calling in life, not easily, or properly, laid aside. He could not, on the one hand, allow them to abandon their genuine responsibilities; and, on the other hand, he could not, or would not, discourage their equally genuine spiritual fervour and desire to embrace a disciplined monastic life. The problem was real and perplexing. Saint Francis told his supplicants that he would give the matter thought. This he did, and out of that thought, which was prayerful and characteristically compassionate, was born the Third Order.

A Rule was drawn up, according to which the members of this order took vows to lead an ascetic and holy life, dedicated to religious pursuits and to helping the poor. They lived both in spirit and in fact like monks and nuns, with the exception that they continued to fulfil their obligations in the world and to work at their chosen trade or profession, giving in charity whatever money they did not use for their simple needs. It was these people—these holy men and women—whose lives inspired and gave meaning to the phrase 'in the world but not of it'.

If we think of such a way of life in connection with Vedanta, we find that the Third Order of Vedanta is actually, though not officially, existing. The Vedanta societies in America have many members who, though nominally in the world, live a life bordering on monasticism. Indeed this rapidly growing group of men and women seem to be not only members of a Third Order but—and this may be the same thing—examples of the 'new type' of spiritual aspirant that was mentioned by Swami Vivekananda. One day one of Swamiji's non-monastic disciples, Sharatchandra Chakravarty, had begged of him, 'Bless me, sir, that I may attain to the knowledge of Brahman in this very life', and Swamiji, placing his hand on the disciple's head, replied, 'Have no fear my son, you are not

like ordinary worldly men—neither householders nor exactly Sannyasins—but quite a new type.'[1] I may add here, rather parenthetically, that when he was in America Swamiji gave the vows of brahmacharya to a number of men and women without expecting them to live in monastic communities, but, rather, to support themselves or, as in the case of Miss Sarah Ellen Waldo—Sister Yatimata—to live on a private income. Were not these free lance brahmacharins also a 'new type'? And can we not say they were, in a sense, members of a Third Order?

At one time, and for a lack of better term, I thought one could call the intermediate class of spiritual aspirants who abound in Western Vedanta societies 'semimonastics'. But many people, including myself, disliked that term, as the prefix 'semi' has an implication of inferiority about it, a comparative tone. And that will never do: the very last thing semimonasticism is is a class better or worse than some other class. It is a class in itself, with its own standards and its own greatness, and it should not be compared to either monasticism or householderism. So the 'semimonastic' needs a name of his own. After considerable thinking and consultation, the word *mahāvīr* was hit upon. As you know, Mahavir was one of Hanuman's names, and it means 'great hero'. I thought that it was a fine appellation for the type we are considering, and so for the purpose of this paper, at least, I shall use it interchangeably with 'semimonastic' and thereby hope to counteract that offensive 'semi'.

Now, who is a *mahāvīr*? A Vedantic *mahāvīr* is a man or a woman who is unmarried, lives a life of strict brahmacharya, is an initiated disciple of a swami of the Ramakrishna Order, has renounced all worldly pursuits as such, cares nothing for worldly enjoyments or honours, lives simply, and has dedicated his energy, his time, and his heart to the realization of a spiritual ideal, and, as well, to the welfare of his fellowmen.

In what respect, then, is the *mahavir* not a monastic? In what respect is he (I shall often use the pronoun 'he'

throughout this paper, with the understanding that it means both 'he' and 'she')—in what respect is he a new type? In two respects: first, he does not live in a monastery, and second, he earns his own living, plans his own day. He is not, in other words, a cenobite—one who belongs to a monastic community and follow its routine.

To avoid confusion, I should perhaps point out here the fairly obvious fact that it is not possible in the West to live as do the wandering monks in India. The Western monastic must either live in a monastic community, earn his own living, or be arrested for vagrancy. There are no other practical choices. Further, in the Western Vedanta societies that are affiliated with the Ramakrishna Order, monastics are as a rule required to live in recognized monasteries or convents. Thus in these societies—and it is these societies that concern us here—the free lance, informal renunciate is not officially recognized as a bona fide monastic.

In India the *mahavir* (though not so called) is, I understand, becoming a recognized, though perhaps not common, type. In an article that appeared in 1973 issue of the *Prabuddha Bharata*, Swami Budhananda wrote:

> Hinduism does not look with much favour on *anāshra-mis*, those who neither enter the responsible house-holder's life through sacramental marriage nor re-nounce the world formally and become monks and nuns. But Hinduism sanctions what is known as *naishthika-brahmacharya*, or avowed celibacy while living in the world, for both men and women. On all hands it is acknowledged that their lives are even of a more difficult type than those of monks and nuns.[2]

As I say—such people are 'great heroes'; and their lives are difficult indeed—and this the world over. Let us consider how, generally speaking, the American *mahavir* lives. As I have already mentioned, he will lead a life of total chastity—in thought, word and deed. Yet, unlike the

cenobitic monk, he is unshielded from temptation; his mind alone is his armour and his fortress. His work—in office, school, hospital, or wherever—throws him into unavoidable contact with the opposite sex. His protection is not ready-made for him; he must build his own walls and keep them in good repair and free of chinks. In this respect, he must be exceptionally vigilant and strong; he must have the strength to resist, the strength to stand on his own feet against the powerful current of the world, which includes, of course, the current of his own worldly tendencies, all ready at a moment's notice to take torrential form.

On his own and exposed to danger, the young semi-monastic must live a sort of island life in the midst of a raging sea. He will avoid worldly lures and worldly distractions, 'innocent' though these may appear. Further, while he won't let himself be trampled on in his job or profession, he himself will trample on no one; he will have no worldly ambition whatsoever. The primary joys of his heart lie in the functions of the Vedanta Society to which he belongs—in the lectures, the classes, the talks with swamis, the pujas, and the golden hours in which he meditates or is able directly to serve God by participating in the work of the society. But none of these joys can he so much as hint at to his fellow job-holders in the Western world; that world considers him peculiar enough as it is.

In addition to his efforts to live a chaste and restrained life, the semimonastic practises poverty. Not only does he live as simply as possible, but, generally speaking, he has no economic security. Unless he works like everyone else, he will simply die of starvation, for if he is able-bodied, he cannot legally or in decency go on public welfare. But while he must earn his living in one way or another, at the same time—no matter how much he earns—he spends upon himself as little as possible, often living very austerely indeed. The rest he gives to the service of God.

Obedience, or at least the strict observance of certain rules and disciplines, is the third condition of the semi-

monastic. Whom or what does he obey? What Rule does he observe? Since the Third Order of Vedanta has no organization, it has no official Rule; yet there is one person whom the semimonastic recognizes as being in a position to guide him and lay down the law for him—the law that he follows to the letter. This is his spiritual teacher, his guru. The guru's word is the semimonastic's Rule, and obedience to it is, of course, of the utmost importance in this difficult way of life, where the pitfalls are as numerous as craters on the moon, the road unmarked and rocky, the sidetracks many and alluring, and the scope for self-deception vast.

Now, a question arises at this point. If the *mahavir* has renounced the world, if he has dedicated his life to a spiritual ideal; if he is bent on practising chastity, poverty, and obedience, then why on earth does he not enter a monastery? Why does he undertake a more difficult kind of life in which his vows and commitments are exposed on every side to erosion and assault? This is, I believe, a very pertinent question, for in the answer to it lies the justification for, and meaning of, the Third Order of Vedanta.

There are, in fact, a number of answers. A young man or woman may, for instance, be the sole support of his or her parents, or have other dependents who genuinely could not get along without financial help. If such a person should join a monastery or convent, it would cause true hardship to others—not just emotional upheavals, but true physical hardship. As is well known, Sri Ramakrishna was much opposed to anyone's renouncing an obligation (particularly to one's parents) before it had been fulfilled. One legitimate reason, then, for an unmarried spiritual aspirant not to join a monastic community is his duty to his dependents.

Another reason lies in the requirements of some monasteries themselves. The monasteries of the Ramakrishna Order (and, as I have said, it is these with which we are here concerned) can accept only those applicants who can meet certain qualifications of age, education, and health. If one is overage or if one's state of health would impose a

burden on the monastic community, then it is better all around that one forget the whole idea of cenobitic life in Vedanta and go one's own way—'alone like the rhinoceros'. Again, there is the rhinoceros temperament—a natural and intense aversion to the restrictions, tensions, and trials of continual group living, whatever one's age, education, or state of health.

But the most important reason of all for choosing a semimonastic life is, I believe, an individual's drive to develop through unremitting, single-minded practice an exceptional talent or to follow a profession that demands intense training and fulltime attention. Such drives can be very strong indeed, amounting to inherent and very real obligations, and until they are fulfilled they will come in profound conflict with cenobitic monastic life. But while such persistent drives can be the bane of more or less cloistered monasticism, they can be the *mahavir's* glory. Indeed, the life of one who develops an individual talent or special ability and who transforms the pursuit of that talent or ability into a spiritual practice, offering, for instance, its fruits to God, is in itself a life of unique importance. It reveals in its unfoldment its own justification and significance. Such a life cannot be characterized in negative terms—as, on the one hand, unmarried or, on the other hand, nonmonastic. No, the *mahavir* who is making his own unique contribution to the world, however slight, is, as I said earlier, a positive type in himself; he is undertaking his own form of hard spiritual discipline and following his own valid way of God.

Like the monks of the Ramakrishna Order, the *mahavir* has a great twofold purpose—to work for his own liberation and for the welfare of the world. But in some areas of service, the semimonastics is in a more advantageous position to fulfil the latter part of this injunction than is the monk or the nun who in many respects lives a restricted life. This is, I believe, particularly true in the present age and will be even more true in the age to come, for the

varied, broad, and farflung service of the Vedantic *mahavir* is, and will be, imperative to the welfare, indeed the survival, of the world.

Let me try to say very briefly why I think this is so. It would seem that we are only just now entering the new order of civilization for which Swami Vivekananda came, and though the future keeps changing shape as we hurtle toward it, I think certain of its features are clear enough to warrant a few generalizations.

One may say quite boldly, for instance, that the twentieth century has marked the beginning of what can be called the Age of Man—the man, that is, who has no special rank or privilege, who lives his life from beginning to end without making a ripple in the ocean of history and who dies without a headline. He is the man whose numbers compose the masses and who, throughout the entire history of civilization up until the present century, has never been considered a real person with legally assured economic, political, or social rights and liberties. I need not take time here to enumerate the many popular revolutions this century has seen. Throughout the world the common man has arisen in a body, the power of the privileged few has been lessened, colonial strongholds have been broken, governments whose primary motive is the welfare of the people have been struggling into being everywhere. Poverty, oppression, exploitation—all these yokes, once taken for granted as the natural lot (or, in India, the *karma*) of the masses, are today looked upon by increasing numbers of people as ugly, inhuman and, above all, potentially dangerous blots on civilization.

This world, whose parts have become so tightly, intimately, and intricately interwoven, has become intensely sensitive to every cry of pain or hunger; any quiver of its delicately balanced mechanism might easily set off the ultimate explosion. Thus, if only for self-protection, many men have become acutely conscious of their responsibility to their fellowmen. But to be less cynical about it, I think a

new and genuine sense of compassion also has entered the world, and as the common man reaches upward to freedom, many others out of justice and fellow-feeling want to help him. In any event, the upward movement of the common man characterizes the present age, and I do not believe there will be any stop to it until each individual is assured a decent, economically and politically free way of life—a life abounding with opportunity for both work and play. There will be no stopping; but the way will be long, and even with our burgeoning miracles of technology, the task will be enormous. Further, when the desired result has been achieved, to maintain it will require constant and perpetual mutual help between nations and peoples—and this on a global scale.

The wave that has been set in motion will alter the face of civilization in ways we cannot even guess. But we can guess that it will, indeed must, alter man's attitude toward himself, his world, and his fellowman; for its successful and relatively peaceful progress will require a new world outlook, a new psychology, a new religion.

As though by cosmic plan, this new religion has already entered the world along with the wave of popular revolution. If this is the Age of Man, it is also and, I believe, necessarily, the Age of Spirituality. Or, to put it more graphically, it is the age in which the whole world will be engulfed and swept upward by what Swami Vivekananda called 'a huge spiritual tidal wave'.

As Swamiji so often pointed out, there is no other way for mankind to find a measure of peace and freedom than for man to reconstruct his vision of man. There are two basic views of man: one, as a psycho-physical entity, the other, as Spirit. If man's freedom and dignity on every level are the goals of the present age, then it is essential that humanity learns to see itself as primarily spiritual. The oppression of the weak by the strong is an inexorable law on the biological and psychological levels; here there is no possibility of universal freedom. No matter how cleverly

nations dream up and carry out well-intentioned political and economical systems, this fact remains: the strong body and mind will always control and oppress the weak body and mind. As long as man thinks of himself as predominantly a psycho-physical being, his culture will be governed by this law. It is the law of the jungle, and in the present age its working seems particularly ferocious.

On the one hand, the common man is pushing up from below with tremendous force, and though he is being pushed down from the top with an equally tremendous force. As Swamiji once prophesied, the resulting tumult is great and widespread. Nor have the implements of destruction ever been more sophisticated, subtle and diabolical than they are today. And rapidly they are becoming more so. Moreover, the techniques that are being developed for keeping track of, influencing, and manipulating human beings are terrible in their possibilities. Indeed, the strong could acquire the power of gods, and when such power is combined with jungle morality, the result could only be wholesale disaster. It sometimes seems that large sections of human society are bent on achieving that end.

Swami Vivekananda's reiterated solution to this state of affairs is well known; over and over he insisted that man look upon himself and others as Spirit—as infinite and eternal Spirit. This outlook was, to his mind, the only basis for true brotherhood true morality, true service—the only solid rationale for cooperation and mutual help rather than competition and struggle for dominance. Again and again he said that the teachings of Advaita Vedanta, spread far and wide and practised by men and women, even by children, were the only hope for the modern world. But let me quote from Swamiji himself. The following is from a lecture he gave in London in 1896:

> Build up your character, and manifest your real nature, the Effulgent, the Resplendent, the Ever-pure, and call It up in everyone that you see. I wish that everyone of

us had come to such a state that even in the vilest of human beings we could see the Real Self within, and instead of condemning them, say, 'Rise, thou effulgent one...and manifest thy true nature. These little manifestations do not befit thee.' This is the highest prayer that the Advaita teaches....All these ratiocinations of logic, all these bundles of metaphysics, all these theologies and ceremonies, may have been good in their own time, but let us try to make things simpler and bring about the golden days when every man will be a worshipper, and the Reality in every man will be the object of worship.[3]

Here enters the *mahavir*. Living a pure life, imbued with the conviction, and perhaps in some cases with the realization, that man in all conditions, in all his ways of thought and action, is through and through Spirit, is God Himself playing the part of the great and the lowly, of the man who needs help and of the man who gives it—these semimonastics, like drops in that 'huge spiritual tidal wave', will pour over the whole world. Dedicated to Swamiji's ideal of *karma yoga*, endlessly varied in ability, talent, and inclination, they will undertake all types of work, bringing the highest philosophy of Vedanta—the philosophy of the Upanishads—from the forest into the marketplace, just as Swami Vivekananda wanted. They will bring it into public and private schools, into universities, into libraries, into hospitals, into business, into law courts, into journalism, into all branches of the arts and every discipline of science, and they will bring it as well into all departments of government, at home and abroad. Many fields of service, both in underdeveloped countries and in so-called developed but partly rotting countries, will be open for perhaps generations to come. Indeed, the opportunities for service are endless in number and variety because the need for mutual help among all the people of the world is a dominant characteristic of this Age of Man. Swami Ranganathananda

expressed this peculiarity of the present age in one sentence: 'The only valid form of interhuman relationship today is service, and not exploitation.'[4]

Swami Vivekananda inaugurated a new type of monasticism in India whereby the monk, heretofore devoted solely to spiritual practice proper—that is, to practices such as meditation, japa and formal worship—would plunge also into all kinds of humanitarian service, looking upon man as God. So, too, by his emphatic and universal teaching of *karma yoga* as a direct path to liberation Swamiji opened a way for his 'new type' of spiritual aspirant. Indeed, as I mentioned earlier, the semimonastic will in some respects be in a position to carry humanitarian activity even further than the monastic. For one thing, the number of semimonastics will be very large; whereas the flaming core of pure monasticism is, and perhaps should always be, relatively small. Moreover, the training of the semimonastic in his chosen field will generally have been prolonged and intensive; further, his independent way of life will enable him to permeate—one might say, infiltrate—society from top to bottom and in any capacity he chooses. He or she can go anywhere and do anything.

Generally speaking, his influence will be more or less indirect; in some cases, however, he could work directly to spread the teachings of Vedanta. For instance, a Swami who has worked in America suggested to me that in the present shortage of Indian Swamis available for Western work, well-trained Western semimonastics could form and support new Vedanta study groups in cities and towns where there are no established Vedanta societies. But whether the semimonastic directly encourages and directs Vedantic study or not, wherever he lives, whatever he does, his influence will be bound to touch the lives of others. Cumulatively, that influence will lift the whole world into a higher level of thought—the only level from which it will be possible to solve the multifarious and all too inflammable problems of this age. 'Perfect sincerity, holiness, gigantic intellect, and an

all-conquering will. Let only a handful of men work with
these, and the whole world will be revolutionized.'[5] Thus
Swami Vivekananda wrote, and his semimonastics—his
mahaviras—as well as his monastics, are such men and such
women.

He seems to have had both types in mind when he said
in America:

> The real Sannyasin lives in the world, but is not of
> it....Live in the midst of the battle of life. Anyone can
> keep calm in a cave or when asleep. Stand in the whirl
> and madness of action and reach the Centre. If you
> have found the Centre, you cannot be moved.[6]

I should perhaps say something here about household-
ers, for I seem to have excluded them from the Third Order.
Yes, if the Third Order consists of unmarried people, then
it doesn't include householders. But householders, as I
understand it, constitute an order of their own, with unique
responsibilities and duties that not only are essential to the
welfare of society but are a form of yoga and a path to the
highest realization. On the other hand, I do not think these
categories of spiritual living can be rigid. If husband and
wife can both dedicate themselves to a spiritually directed
service of humanity, then they are Third Order people. I
have in mind Captain and Mrs. Sevier, who cut all their ties
and devoted themselves to Swamiji's work. They wanted, in
fact, to take vows of *sannyasa*. But generally speaking, the
responsibilities of marriage constitute a different kind of
austerity and way of spiritual life—not a superior or inferior
way, just a different way—and that way is not what this
paper is about.

There is a good deal more to say in regard to the Third
Order—both as it is today and as it may become in the
future. For instance, in this brief paper I have not touched
at all upon Vivekananda-inspired organizations in India,
which are dedicated to the upliftment of the country. Such

organizations provide marvellous opportunities for service, not only for householders but for *mahaviras*. Indeed, the channels into which Third Order energies could be poured are worldwide and of all kinds and sizes. One might say, moreover, that many an altruistic organization would be benefited and made more effective by the spiritual ideals the Third Order would infuse into it.

But I think I have said enough. I shall close by mentioning just very briefly the question of organization, which may have arisen in the minds of some of you. It is not a pressing question. Most of the semimonastics with whom I have discussed it have expressed a hearty, one might say passionate, dislike of organization in connection with their spiritual life and their individual commitment to service. That dislike is, indeed, one reason many of them have chosen not to join a monastery or convent. Some do not, in fact, want to be labelled at all. Whether there is any practical need for semimonastics to form an organization or belong to one, I do not know. Perhaps there is: It is possible that the *mahavir's* derring-do and independence, admirable though those qualities are, may be overconfident. Most, if not all, spiritual aspirants need support, encouragement, training and guidance for a long time, and an organization headed by the Ramakrishna Order would serve that need, particularly when the going gets rough and the guru is no longer tangibly present.

But however that may be, organized or not, named or not, the new class of spiritual aspirants is not a dream or an idea for some future time; it is a present fact: its members are with us on all sides, and as though to meet a demand that is very great, very urgent, they are increasing in number all over the world. Hundreds of young men and women are hearing the call of Swami Vivekananda, hundreds are inspired to renounce worldly life and to serve man, each in his or her own unique and invaluable way. Thus, it seems beyond question that Swamiji's 'new type' of spiritual aspirants is here not only to stay but to grow

lustrous and strong, fulfilling a very vital function in a very needful world.

REFERENCES

1. *The Complete Works of Swami Vivekananda* (Birth Centenary Edition, 1963) (Calcutta: Advaita Ashrama) vol. 7, p. 222.
2. Swami Budhananda, 'Worldly Duties and Spiritual Life', *Prabuddha Bharata*, February 1973, p. 54.
3. *The Complete Works*, vol., 2, pp. 357–58.
4. Swami Ranganathananda, *The Need of the Hour—A Non-Sannyasi Order of Dedicated Workers* (Madras: Vivekananda Rock Memorial Committee, 1972) p. 17.
5. *The Complete Works*, vol. 8, p. 335.
6. Ibid. vol. 6, p. 84.

INDIA AND FRANCE

Louis Renou

From the end of antiquity until modern times, France, like the whole of Europe, lived on certain ideas of India handed down by Greek and Roman writers. Gradually these ideas had resulted in a somewhat fanciful picture of India as the country of marvels, the originator of which had been Ctesias, Artaxerxs' Greek physician.

There was hardly any direct contact of importance until the sixteenth century. A French missionary of the thirteenth century, Jourdain de Severac, may be mentioned. In the seventeenth century we find less shadowy personalities, such as Tavernier, who paid five visits to India, Bernier, who studied customs and habits attentively, and others. Their profuse accounts do not lack references to the civilization and ancient monuments of the country, but none of them made any real contact with what, following the Greeks, we call 'the wisdom of India'; none of them was in a position to see, even without reading them, religious or profane writings. In the Middle Ages, the Indian fables of the *Panchatantra* were extraordinarily widely known; in oral or written form they found their way into most Western literatures, but they were transmitted first of all in a Pahlavi, and later, in Arabic and Persian versions. The Sanskrit original was still unknown, and when in the seventeenth century, La Fontaine, our greatest fabulist, said that he had drawn many of his fables from those of the Indian sage Bidpai or Pilpay (possibly meaning Vidyapati?), it was in fact an Arabic intermediary, the *Book of Kalilah and Dimnah*, which provided his material; he could have no suspicion of the existence of a Sanskrit collection.

In the eighteenth century, the mystery of ancient India came very nearly to being pierced, and the good fortune of

the discovery might well have fallen to a Frenchman. In France, the atmosphere was favourable for oriental research. Grouped around the *Encyclopaedia*, an active band of writers and philosophers had resolved to attack the Church's pretensions. They wanted to prove that other peoples had had 'revelations' (*shruti*, as you would say), like the Hebrew-Christian people, and at an earlier date; and that those peoples had had religious experience at least as valid as that in which Christians claim a monopoly. The Church on its side sought to defend itself with the same weapons: it wished to prove that the oriental religions were not ancient and that, in any case, they were tainted with idolatry. In short, on both sides, India was, first and foremost, a pretext for religious controversy.

Fortunately, the zealous missionaries from Europe sent to southern India were often occupied with more disinterested aims and took a more objective view of matters than that prompted by the general instructions given them. For instance, several French Jesuits of the so-called Maduran Mission in the eighteenth century had a fairly exact knowledge of Sanskrit. Father Pons wrote a Sanskrit grammar in Latin, translated the *Amarakosha*, and sent a considerable consignment of manuscripts to Paris. That was the first collection of Sanskrit writings established in a Western library. Father Coeurdoux was one of the first to recognize the kinship of Sanskrit with our classical languages. The discoveries of these obscure precursors, however, remained unpublished or lost in little-known publications; only a faint echo of them reached Europe; minds were not yet ready to receive the lessons of the East.

Chance, too, favoured a few travellers. The astronomer, Le Gentil, who visited Pondicherry, gained useful information about Indian astronomy from meeting a Tamil scholar, Maridas Poulle. This same scholar, who had translated into French the *Bhagavadam*, a Tamil adaptation of the *Bhagavata-Purana*, was also in touch with a historian of Central Asia, De Guignes. Thanks to the passages in the *Bhagavata* dealing

with the historical dynasties, the *surya-vamsa* and *soma-vamsa*, De Guignes was able to outline, for the first time, a picture of the ancient history of India. Admittedly, his picture was not free from serious mistakes, but it was difficult to do better with the only available resources. As my friend, Jean Filliozat, has shown, an important discovery, with which William Jones is generally credited, was due to De Guignes. As early as 1772, he recognized in the name of Chandragupta Maurya (which the Tamil text reproduced in the form of Sandragouten), the Sandrakottos mentioned by the Greek historians, the man who had freed India from the dominion of Alexander's successors. As you know, that identification is the keystone of Indian chronology in the earliest periods.

Another traveller, Anquetil-Duperron, set out for India in 1754, at the age of twenty, alone and without an official mission. His object was to rediscover the *Vedas* and the sacred writings of ancient Persia. A firmer and more courageous determination than his has seldom been encountered, but he succeeded in only half of his task. He could not extract from the Brahmins the sacred language, the secret of which they guarded jealously; he could find no means of learning Sanskrit. Failing the *Vedas*, he was able to obtain the Persian translation of the *Upanishads*, of which, fifty years later, he was to publish a Latin version. For long, until the time of Deussen, that version was the fullest, if not the most accurate. As you know, it was through that translation that Schopenhauer came into contact with Indian thought, which decisively influenced his life and work. By that time, however, at the beginning of the nineteenth century, the study of the Indian language and civilization had already had its official beginning with the work of Wilkins and Jones.

In France, however, Anquetil's discoveries were overlooked or challenged. 'A prophet is without honour in his own country', as we say. The text of the *Zend-Avesta*, which he had brought back from the Parsee communities in

Bombay, was considered to be a forgery. Furthermore, although the authentic manuscripts of the *Veda* had been deposited in the Royal Library (the present *Bibliotheque Nationale*) since 1731, the *Veda* had remained a dead letter in France as everywhere else in the West. Our great writer of the time, Voltaire, who was keenly interested in Indian religion and philosophy, doubted the existence of the *Veda* and was easily duped by a missionary of the time, the author of a fake entitled *Ezour-Veidam*. He still believed that Sanskrit (*Sanskretan* or *Sanskroutan*, as it was then called by French writers) was a document.

At the time when the study of India began in Europe with Wilkins and Jones, and, shortly afterwards, with Colebrooke, it was England which was to derive most advantage from the excellent work of these pioneers, particularly as France, following the unfortunate wars of the eighteenth century, lost almost all her political possessions in India. Nevertheless, from 1800 on, France tended to become the centre for Oriental study. The preparation of an inventory of the Indian manuscripts that were being accumulated in the *Bibliotheque Nationale* was begun. The *Asiatick Researches*, published in Calcutta, were immediately translated into French, as were the works of Wilkins and Jones. The Germans, Klaproth, Lassen (the founder of Indian studies in Germany), the Schlegel brothers, both in different ways students of India, and lastly Bopp, who was to originate the study of comparative grammar, all came to Paris.

The *Asiatic Society* of Paris was to be the first established in Europe, some years before London's. The first chair of Sanskrit instituted in the West was that at the *College de France*; it was first held by Chezy, who learned Sanskrit by himself, evolving a grammar and a dictionary for his own use, and who was to be the first to translate and publish *Shakuntala* in France. The moving account in the preface to his book, of his difficulties and his reward when he was at last able to decipher the glorious lyrical

stanzas of the Indian drama, should be read. In spite of his merits, however, Chezy was only an amateur. A great philologist was needed to establish the study of Sanskrit on a firm footing. Such a philologist was found in Eugene Burnouf, who succeeded Chezy in 1832.

Burnouf's name is less known in France and the world at large than that of Champollion. The interpretation of the writings of ancient India is not so spectacular as the deciphering of hieroglyphics or cuneiform; it is not so definitely the speciality of one man or a small group of men. On reflection, however, it demands still wider and more varied gifts. Burnouf, who was also the true founder of Avestic philology, must be acknowledged as the originator of the scientific study of Buddhism. At the age of only twenty-two, in his *Essai sur le Pali*, written in collaboration with Lassen, he showed that Pali was a language derived from Sanskrit by a strict process of evolution. His *Introduction a l'histoire du buddhisme indien* is even more important. It may be said to have opened up for us the whole literature of the *Mahayana*; it is still useful for consultation today.

However, Burnouf did not entirely fulfil his destiny. He died at the age of fifty and left behind an extraordinary accumulation of unpublished writings as evidence of the fruitful fields into which his research and teaching were leading him. His classes on the *Veda* had gathered around his Chair the vital forces of contemporary Indian study—from France, Regnier, who was to be the earliest editor of *Pratishakhyas*; and Barthelemy Saint Hilaire, who, in 1855, was to describe the *Sankhya* in detail for the first time. Among Germans, it is enough to mention the names of Roth, Goldstucker and Max Müller.

If Burnouf had lived longer, and had not, from excessive modesty, stood aside in favour of certain of his colleagues or pupils, he would have had the distinction of publishing the *Rig-Veda*, and possibly of translating it, and would certainly have done it better than the worthy Langlois was able to do. His scrupulously careful philology

did not prevent him from appreciating the human grandeur of his mission. In his inaugural lecture, he said: 'It is India, with her philosophy and myths, literature and laws which we shall study in her language. It is more than India, it is a page from the story of the origins of the world, of the primitive history of the human mind, which we shall try to decipher together.' The excellent *Histoire de la litterature hindoustanie* by Garcin de Tassy also appeared about the same time as Burnouf's works; it is another book which marks an epoch in the literary history of India and, in many respects, is still unsurpassed.

It is difficult today, in our drab world, to imagine the atmosphere of enthusiasm and youthful ardour in which the development of Indian studies proceeded. The scientific interest in India coincided with the Romantic movement and was imbued with the enthusiasm as well as the naivety and excesses of that period. It is not enough to say that it coincided with Romanticism; it was an aspect of it. After the rediscovery of antiquity in the sixteenth century, there followed, as it were, a second Renaissance, the rediscovery of the East. It was thought that the mysterious beginnings of mankind had at last been reached; it was believed that the first halting utterances of the primitive mind were revealed in the earliest writings and earliest speculations. M. Raymond Schwab rendered a real service to learning in our country in a work, combining charm and erudition, in which he outlines the early stages of Indian studies and the deep influence which they had on French writers in the first two-thirds of the nineteenth century.

It is often though that oriental studies began in Germany, because it was there, we are told, that the ground was best prepared for them. Certainly, it is undeniable that the mystical and sentimental foundation of oriental studies and, in particular, of Indian studies, is more obvious in Germany than elsewhere. It was in Germany that the work of the English scholars immediately found the widest audience, in the first place with Herder and Goethe, and later with the

Schlegels, Humboldt, Schopenhauer and many others. Romanticism with an Indian bias or romantic Indian studies, as you prefer, awoke memorable echoes there. Although *Shakuntala* was translated into English by William Jones, the reputation of the drama in the West was possibly established less by that translation than by the famous lyric in which Goethe spoke of it: *Willst due die Bluthe des fruen, die Fruchte des spateren Jahres*....But it is too much hold, like Winternitz and others, on such a basis, that there is a permanent, inherent affinity between the Indians and the Germanic peoples. The well-known orientalist, Von Schroeder, wrote: 'The Indians are the romanticists of antiquity, the Germans are the romanticists of modern times.' And, as common features, he quoted pantheism, *Weltschmerz*, and the love of nature. But those are features found in all the countries touched by the Romantic movement, in France or Italy just as much as in Germany.

There are not a few writers in France, and often writers of considerable importance, who have expressed sentiments concerning India which reflect that spiritual communion to which the Germans lay claim. What must be admitted is that such French evidence is usually rather later than that of the Germans, just as the Romantic movement in France developed later than in Germany. The testimony is none the less instructive. The three principal French poets of that period, Lamartine, Victor Hugo, and Alfred de Vigny, were interested in different aspects of Indian thought and disturbed by the unknown world that was opening up before them. In all three, the idea of an individual soul informing the universe, the aspiration towards an indefinable divinity, the urge to expression sometimes in the form of a hymn, and sometimes in the epic, are all features connecting them by instinct with ancient India. Hence their wonder when they made acquaintance with the great Sanskrit writings in translation.

Several times Vigny describes his emotion, in his *Journal d'un poete* and in his *Letters*. In his *Cours familier de*

litterature, Lamartine acknowledges *Shakuntala* as 'a master-piece of both epic and dramatic poetry, combining in one work the essence of the pastoral charm of the Bible, of the pathos of Aeschylus and tenderness of Racine.' There is justification for the view that Lamartine's poems represented a sort of intuition of the Vedic hymns, with which he could not then have been familiar—an exact comparison drawn by Jules Lemaitre, a critic of the end of the century. As for Victor Hugo, he is often full of respect, an even *Panic* respect, before the literary monuments of India, that race of gods and those vast epics, in which he sensed a universe fashioned in his proportions, or rather to his disproportionate immensity. One of the poems of the *Legend of the Ages,* called *Supremacy,* is a free development of the narrative portion of the *Kena-Upanishad.* In it we see the gods urging their own best—Vayu, Agni, and Indra, to learn the nature of the mysterious power of the Brahma. They try, and the Brahma tests each in turn, showing them a blade of grass and challenging them to destroy it. The following is the passage relating to Agni in the simple terms of the Sanskrit original:

> *Tad abhyadravat-tam-abhyavadat ko'sīty-agnir-vā aham asmīty-abravīt-jātavedā vā aham asmīti. Tasmins-tvayi kiṁ vīryam-ityapīdaṁ sarvaṁ daheyaṁ yad idaṁ pṛthiyvām iti. Tasmai tṛṇaṁ nidadhau-etad-daheti. Tad-upapreyāya sarva-javena tan-na śaśāka dagdhuṁ....*

This is what the passage becomes in Hugo's colourful and somewhat grandiloquent version:

> Le dieu rough, Agni, que l'eau redoute, Et devant qui medite a genoux le bouddha, Alla vers la clarte sereine et demand:—Qu'es-tu clarte?—Qu'es-tu toimeme? lue ditelle. —Le dieu du Few. —Quelle est ta puissance? —Elle est telle Que, si je veus, je puis bruler le noirci Les mondes, les soleils et tout. —Brule ceci, Dit la

clarte, montrant au dieu le brin de paille. Alors, comme
un belier defence une muraille Agni, frappant du pied,
fit jaillir de partout La flamme formidable, et, fauve,
ardient, debout, Crachant des jet de lave entre ses dents
de braise, fit sur l'humble crouler une fournaise; Un
soufflement de forge emplit le firmament.

The red god Agni, the dreaded of water, before whom
Buddha, kneeling, meditates, approached the serene
radiance and asked 'What art thou, radiance?' 'What
art thou?' Was the reply, 'The God of Fire.' 'What
power is thine?' 'It is such that, if I will, I can burn the
sky to blackness, burn worlds, and suns, burn all.'
'Burn this', said the radiance, showing the god a wisp
of straw. Then as a ram will batter down a wall, Agni
beat his foot and all around struck forth the dreadful
flame; he stood in glowing tawny light, spewing
through burning teeth great lava streams, and poured
a furnace flame upon the puny straw; the heavens were
filled with a great forge's roar.

The great historian of the Romantic period, Michelet, no
less poetical than these poets, in 1863 came upon the
Ramayana in the Fauche's mediocre translation. In this
connection he wrote, in his fine book *La Bible de l'humanite*:
'That year will always remain a dear and cherished memo-
ry; it was the first time I had the opportunity to read the
great sacred poem of India, the divine *Ramayana*. If anyone
has lost the freshness of emotion, let him revive it in the
Ramayana, let him drink a long draught of life and youth
from that deep chalice.' Again, in his book on *La femme*,
with all its brilliant immaturities, Michelet advises a young
woman who has just learned the joys of love to have
Shakuntala read to her (there is no doubt that that play was
held in high esteem). 'I leave her fortunate lover the delight
of reciting *Shakuntala* to her in some flowery bower', he
says, and he thinks it possible to sum up the essence of

Indian thought, the *satyasya satyam*, in a short phrase, an *upanishad*: 'The Veda of Vedas, the secret of India is this—man is the eldest of gods; the word created the world.'

Blazac, the great novelist of the same period, introducing one of his favourite characters, Louis Lambert, in the novel of the same name, makes his say this:

> It is impossible to call in doubt the fact that the Asiatic scriptures were anterior to our Holy Scriptures. Anthropogony drawn from the Bible is only the genealogy of one swarm from the human hive which found a resting place between the mountains of the Himalayas and those of the Caucasus. The sight of the swift regeneration of the earth, the miraculous power of the sun, first witnessed by the Hindus, suggested to them the gracious conceptions of happy love, fire worship, and the infinite personifications of reproductive forces. Those magnificent images are not found in the writings of the Hebrews.

Victor Cousin, a philosopher who was widely celebrated at the time, made it his duty to assist the dissemination of Indian philosophy so far as he could; and the famous physicist, Ampere, wrote to Hugo: 'Indian philosophy will occupy the attention of our century and those following, as much as Greek philosophy occupied the sixteenth century.'

This enthusiasm, which naturally was not free from misunderstandings and ingenuousness, was to endure for most of the nineteenth century, taking the most varied forms. At the beginning of the century it was mystical with Ballanche, who, in his *Essai sur les institutions sociales* demanded that Latin should be replaced in primary education by the oriental languages. In his *Genie des religions*, Edgar Quinet, half-historian half-mystic, wrote:

> When human revolutions first began, India stood more expressly than any other country for what may be

called a declaration of the Rights of the Being. That divine Individuality, and its community with infinity, is obviously the foundation and the source of all life and all history.

In his *Discours sur les revolutions de la surface du globe*, the naturalist, Cuvier, uses more scientific terms in his attempt to demonstrate the support found in the ancient writings of India for hypotheses regarding the nature of primitive man and the antiquity of human habits. Later on, Gobineau made a scientific claim when, in his *Essai sur l'inegalite des races humanes*, he attempted to restore the concept of a pure Aryan race, for which purpose he naturally employed the testimony of the Indians of the Vedic Age. We know only too well what tragic impetus Gobineau's doctrines gave to German racialism.

To understand the causes of that enthusiasm, it is first of all necessary to remember that in a short space of time, scarcely more than a few decades, a series of most important Sanskrit works were introduced into France in translations: firstly, there was the complete *Rig-Veda* translated by Langlois (completed only very shortly after the beginning of Wilson's translation); the *Ramayana* translated by Fauche; most of the *Mahabharata*, also translated by Fauche, who was likewise responsible for the whole of the *Kalidasa* and several other literary texts; the *Laws of Manu* translated by Loiseleur-Deslongchamps, not to mention the *Saddharma-pundarika* and the *Bhagavata-Purana* translated by Burnouf. With the exception of the three last mentioned, these translations are very indifferent; they are what used to be called , like certain ladies, 'pretty but unfaithful'. With all their faults, however, they had a stimulating influence and, taken together, they form a much more substantial body than the contributions added by later generations.

At that time there was constant contact between writers, artists, and men of science. Learning had not yet assumed that sometimes frightening aspect which today too

often discourages the non-specialist. Any cultivated reader could profitably follow the work of scientists. The Duc d'Orleans, Louis Philippe, later to be king of France, was the President of the *Societe Asiatique* and gave lectures on the value of oriental studies. In the literary salons the best brains met; we may mention Mme Cuvier's salon, frequented by Burnouf, and that of Mary Clarke, the wife of Jules Mohl, who, for years, was to be the Secretary of the *Societe Asiatique*. Rammohan Roy's visit to Paris, in 1832, roused intense sympathetic curiosity.

Gradually, however, excitement subsided. The advances of science made the public distrustful. France's growing disquiet at the German threat unjustly created a certain distaste for the Orient, of which Germany had been the herald.

However, the decline in enthusiasm was offset by a truer understanding. Towards the end of the century, the religious historian, Renan, reviewed calmly and justly the progress made over a long period. He defended the primacy of the Bible and affirmed that oriental literature could be appreciated only by scholars; he criticized the alleged resemblances between the legend of Buddha and the life of Jesus. In another passage, however (perhaps a remnant of Romanticism), recalling Burnouf's teachings—for Renan too had been one of his pupils—he said of the writings of ancient India: 'There is not one of those works in which I have not found more philosophic elements than in all the writings of Descartes and his school.'

One poet carries on from another. Lecomte de Lisle, a belated Romantic, was to compose a Vedic prayer for the dead and a poem to Surya. It was a survival of Lamartine, inspired not so much by deep feeling as by a taste for the exotic. Exoticism, continually nourished by travellers' tales and popular literature, now tended to take the place in writers of the concern with spiritual things which had inspired the Romantics. Mallarme, a poet of the end of the century, and highly reputed, wrote Indian fables in which

he adapted in his own way stories which had already been translated from Sanskrit into French; for instance, he gave an abbreviated version of the story of *Nala and Damayanti*, adorned with precious conceits and embellishments of style to give it what he believed to be an oriental atmosphere.

Pierre Loti, another descendant of Romanticism, was to write travel books on India under the title of *L'Inde sans les Anglais*. There is a fair proportion of the morbidly picturesque in that work, but there is also, here and there, a note which may be sincere, as when he says: 'It is to India, the cradle of human thought and prayer, that I go to ask peace from the guardians of Aryan thought; I beg them to give me belief in an indefinite survival of the soul.' Another poet Jean Lahor, who was steeped in Indian pessimism and, as it were, intoxicated by the idea of *nirvana*, wrote an *Histoire de la litterature hindoue* with, it must be admitted, more lyrical feeling than competence. More recently, another poet, Maurice Magre, like many others, has fallen under the spell of Buddhism spiced with an admixture of theosophy. More impressive is the admiration inspired in Rodin by the discovery of the temples of pre-Muslim India.

We must go back for a summary survey of the progress of French learning after the death of Burnouf. For about twenty years scholarship marked time, in spite of two or three productions of great merit. In Germany this period between 1850 and 1870 was decisive, tremendous progress being made in most branches of Indian studies.

It is only in the years immediately following the war of 1870, with the desire for regeneration called forth by defeat, that we see a brilliant resumption of study in our country. The establishment of the *Ecole des Hautes Etudes* at the Sorbonne was intended to give France a research institution comparable with the seminars which had been the strength of the German universities. Valuable philological work, Kaccayana's Pali grammar translated by Senart and the *Bhaminivilasa* translated by Bergaigne, date from that time. Barth's description of the *Religions de L'Inde*—merely an item

for a dictionary—is an attempt, which has not yet been improved upon, to summarize the whole religious development of the country, omitting no factual detail and yet, with all that detail, preserving the synthetic character of the work. Even today this handbook can still be usefully consulted. Barth, who wrote no other book or lengthy article, had an unusual and, one might also say, paradoxical career: by nothing more than summarizing and carrying on an active correspondence from continent to continent, he was able for forty years to exercise a sort of supervisory direction over our studies. All writers were concerned and anxious to submit the results of their work to him.

Bergaigne's magnum opus, *La Religion vedique d'apres les hymnes du Rgveda*, also dates from the eighties. It may be considered today that there is an arbitrary element in that work and that it is based on philological material to some extent outdated. Nevertheless, it remains the only comprehensive and systematic attempt up to our time to grasp the very foundations of the speculative philosophy of the *Veda*, the essence of the thought of the old *rishis*. The romantic ideal of the primitive *Veda*, a sort of spontaneous adoration of natural phenomena, gives place to a learned religion, in which the mythical element is explained through ritual. The study of the heroic epochs of India thus loses its chief stronghold, but it must be allowed that the new interpretation appeals less to the imagination than the old. Since the time of Bergaigne, no other writer had had the courage to admit the undoubted beauties in the *Veda*.

On the other side of Vedic literature, Paul Regnaud, who also did good work in the field of poetics, explained how the Upanishads were the preparation for the systematic philosophy of the *Darshanas*. Bergaigne's disciple, Victor Henry, continued the learned tradition of Vedic studies.

On the other hand, Senart carried on the tradition of Burnouf. In his book on Buddha he endeavoured to show how much of the legend had become attached to the biography of the founder. He demonstrated that those

legends were partly of Vedic origin and partly common to Hinduism. The same scholar was also responsible for a great edition of the *Mahavastu*, which is still unsurpassed. Although he possibly gives too large a place to personal conjecture, Senart provides an example of the way in which the critical restoration of a text transmitted in imperfect form may be undertaken, in that particularly ill-defined linguistic region represented by 'Mixed Sanskrit' or 'Hybrid Sanskrit'. Lastly, a further and most important contribution made by this scholar is the first great interpretation of the body of Ashoka's inscription, following the work of the first decipherers. All the considerable work which has been done in this field has consisted mainly of improving Senart's recensions and interpretations.

Lastly, a few years before his death in an accident, Bergaigne had had time to mark out a course which was to have pregnant consequences. French penetration into Indo-China had made possible the discovery of a vast quantity of epigraphic literature in Sanskrit in that country. Bergaigne began to classify it with a view to publication and, after his death, his work was completed by Barth and Senart. These old writings are evidence that Indo-Chinese civilization was derived from India, and that Brahminic culture flourished in Indo-China in the first centuries of our era. This fact, important in itself, fell within the framework of still wider research, largely the work of French savants. Sinological research had taken a completely new lease of life at the end of the century with Chavannes, who was to be followed by Pelliot. Fifty years earlier, French scholars had been responsible for the discovery of the accounts of the Chinese pilgrims, Fa-hien and Hiwen-Tsang, of inestimable value for the study of Indian history.

The sinologists' work on Buddhism in the Far East, and the expeditions to Central Asia (the most famous was that which went to Tuen-Hwang in 1908, its full harvest has by no means yet been garnered)—the ultimate object of all that activity, whether conscious or not, was to restore India to

the central place in Asiatic history, as the link between the great civilizations and the leaven of culture. The basis of the idea of Greater India, on which emphasis is so rightly laid by U.N. Ghoshal and other Indian scientists, was to a large extent laid by these exploring scholars, ceaselessly devoted to the task of discovering the ancient history of India from the starting point of China, Tibet, or South-East Asia. The attraction of the North West Frontier regions, through which all the invading hordes had passed, can be similarly explained. Foucher's research on *L'art greco-bouddhique du Gandhara* introduced a new chapter in the history of art, to be supplemented later by his study of Buddhist iconography.

The third generation of French students of India is represented by Foucher, Finot and Sylvain Levi. Foucher, the only surviving member of the group, is not only noted for his archaeological work and for his historical research concerning North-West India in Indo-Greek and Indo-Scythian times; he is also a philologist familiar with the methods of the *shastra*, and with a thorough knowledge of the *nyaya* and *kavya*. Thanks to his elegant style, he was master of popular exposition. Finot, who died in 1935, made his reputation by the careful editing of texts and learned studies of Sanskrit epigraphy in Cambodia. He was a conscientious scholar, careful not to deal in hypotheses or make statements unsupported by textual evidence.

Sylvian Levi, who also died in 1935 and who will probably be remembered by many of you, was the most famous of our research workers since Burnouf. His written works are as spacious as they are varied, and yet by no means give a complete picture of him as man or scholar, nor of the charm and critical alertness of his mind, his linguistic gifts and his qualities of heart. Only the dullest could be unresponsive to his glowing personality and inspiring ideas. How can I sum up in a few words his contribution to our knowledge? His early career seemed to foreshadow that of a classical student of Indian civilization,

with the *Theatre Indien*, the first attempt to give a complete description of Sanskrit drama from the point of view of dramatic theory, dramatic practice, and literary history. Secondly, there was the small book on the *Brahmanas*, the legacy of Bergaigne's ideas. In that book, Sylvian Levi showed that the only true divinity in those texts was sacrifice and that a sort of 'totalitarian' doctrine (as we should call it today) had been built up around and for sacrifice. Sylvain Levi's expedition to India in 1897 overshadowed the famous expeditions of Buhler, Peterson and Kielhorn in the importance of manuscripts discovered, as the German, Leumann, himself admits. Thus, by force of circumstances as well as by vocation, Levi became the historian and philologist of Buddhism.

The importance attributed to Buddhism is a characteristic of French scholarship as a whole. It may be considered exaggerated: Indian humanism is in no way connected with Buddhism, and Indian spiritual philosophy has few links with it. So far as antiquity is concerned, however, it is only through an interest in Buddhism that the history of India can be profitably approached and that India can be drawn out of her 'splendid isolation'. This was Sylvain Levi's primary concern. Thus he was led to begin the study of Buddhism in the North on a comparative basis, that is, by dealing concurrently with Sanskrit, Tibetan and Chinese. This method bore fruit in India itself in the work of P.L. Bagchi, who was Sylvain Levi's favourite Indian pupil, and in that of many others. In France the work was continued, in particular, by Przyluski, who died prematurely some years ago. He had endeavoured to trace the *Legend of the Emperor Ashoka* from Indian and Chinese sources, and also to define the development of the Buddhist sects in his book on the *Council of Rajagriha*.

Other aspects of Indian studies were not neglected, however. Masson-Oursel summarized the *Histoire de la Philosophie Indienne* and laid the foundation for a comparative study of philosophy in which, for the first time, oriental

thought took its rightful place. Lacote studied with exemplary care the Nepali and Kashmiri version of the *Brihatkatha*, in an attempt to fix the shifting image of Gunadhya and the original *Brihatkatha*. In linguistics, at the instigation of Breal in the first place and later, and principally, of Meillet, French learning bore comparatively rich fruit. The application of the method of comparative study to Indian languages has proved fruitful since Jules Bloch first described the structure of a modern language in his book *La formation de la langue marathe*, or, at a later date, traced the whole development of the languages derived from Sanskrit in his general treatise, *L'indo-aryen du Veda aux temps modernes*.

I do not wish to deal in detail with the work done. Elsewhere I have given a summary of other works. Probably these works are not comparable, either in number or in the wide scope of many of them, with those produced by German scholars. Indian studies in Germany, however, inspired from the earliest days by the fever of Romanticism, were always effectively supported by the Government. Up to the war, Sanskrit was taught in all German universities. In our country, efforts have been made in vain to secure for oriental studies an adequate number of Chairs, made ever more necessary by the growth of research. During the last century an attempt was made by Victor Duruy, a Minister of Education, to introduce the rudiments of Indian history into the syllabus of secondary schools. He failed. Almost all work is still concentrated in Paris. At the Sorbonne, there is a Chair of Indian Literature. At the *College de France*, there is the Chair of Sanskrit which was held by Burnouf, Bergaigne and Sylvain Levi. Lastly, at the *Ecole des Hautes Etudes*, several posts known as *directions d'etudes* are connected with the study either of Indian philology or the history of religions.

Outside Paris there is only one Chair of Sanskrit and Comparative Grammar (to use the now very much outdated title) at Lyons. Very recently, one might almost say, surreptitiously, a Chair of Oriental Philosophy has been established

at Lille. The *Institut de Civilisation Indienne*, founded at the Sorbonne in 1928 under the honorary presidency of Emile Senart, is not an independent teaching establishment. It is a working centre for those interested in India, preferably in the 'classical' aspects of Indian civilization. It is the scene of many of the the lectures and courses provided by the University or the *Ecole des Hautes Etudes*. In it we have a valuable library consisting mainly of gifts or purchases from the private libraries of Senart, Finot, Sylvain Levi and Krishnavarma. The Gaekwar of Baroda's donation enables us to maintain our collections, or at least to supply the most immediate needs. For a long time we have been organizing weekly lectures, in which we deal with problems of Indian study likely to attract the interest of a wider public than the private courses.

What can we do for young people in our country who wish to devote themselves to such study? The French Far Eastern College has its own needs and its own difficulties. It is often but a *pis aller* for the young student of Indian civilization. Today, when the scholars of Germany are—regrettably—reduced to silence, and Great Britain is only just beginning to reconstitute its staff of scientific workers, France might be in a favourable position, if the State understood how valuable may be the study of the fundamental culture of a people representing one-sixth of the population of the world. Cultural centres should be established in Calcutta and Madras for example. Students from France would then be initiated in the work in India itself, and scholars from our country would cooperate with yours; in return, French teachers would deal with Western civilization. Why should not France create in India, as she has done at such expense in Rome, Athens and Cairo, research institutes which would yield results at least equal to those of such renowned institutions?

We talk of closer links between India and France, speeches are made on the subject, yet nothing ever results. At the time of the *Mahabharata*, when the heroes had made

eloquent speeches, they went on to action. The germ of closer relations is nevertheless present in the growing number of personal contacts. Let Indian assistants be attached to our universities and French assistants to yours. Let us exchange intellectual workers and we shall no longer need to talk about the value of closer links between the peoples.

However, we are no longer in the Romantic days and we shall not return to them. I have referred to the sort of cleavage there is between science and culture. Even a highly cultivated man can no longer be asked to follow the advances of modern chemistry. And the same is true in its own proportion as regards Indian studies. In France, however, the effect of the cleavage, if it exists, is reduced because in our country—more, I believe, than elsewhere—the scholar has been careful to adapt the products of his knowledge to the requirements of a fairly large public. Popular textbooks and more or less useful treatises on the history of India, civilizations and religions abound. France is, however, the country of harmonious syntheses (at least it has been said so often that I am beginning to believe it). Without too great a sacrifice of accuracy, our scholars find a means of interesting more than the small public of specialists. The works of Weber, Pischel and Otto Franke, admirable as they are, are scarcely readable. All of Burnouf's and Senart's work, and much of Sylvain Levi's can be read by a person of culture. The *Histoire du Nepal* holds the attention like a good novel, and its author, who wrote *L'Inde et le monde*, that truly romantic book, with a sort of lyrical frenzy, dreamed of ending his career with a collection of Indian fairy tales for French children. Bergaigne was tempted to prepare a poetical version of *Shakuntala*. Senart described *Les castes de l'Inde* with elegance for the readers of the *Revue des Deux Mondes*. In this way, some degree of contact has been preserved with that anonymous mass of readers in which a vocation may one day come to light.

Such contact should not, however, be sought at the expense of truth. It is always, to some extent, an abuse of power to give a decision on doubtful questions to the uninitiated public, particularly in a subject such as Indian studies, where so many problems await solution. It is all a question of proportion, however. What is frankly dishonest is to use India and Indian spiritual philosophy for the construction of idle and extravagant theories for Western illuminati. It must be admitted that in the abundance of its philosophical systems and the strangeness of certain concepts, Indian thought offered some temptation in this respect. The Neo-Buddhist sects and theosophical movements, which have multiplied so rapidly in the West, originated from Indian images and ideas in a more or less distorted form. The success of the lucubrations of such men as Rene Guenon—those self-styled revelations of the Tradition which he believed is confided to him—are a sufficient indication of the danger. Such people claim to draw a distinction between the official or university study of Indian civilization, concerned, we are told, with grammar, and a type of Indian study which alone can penetrate the essence of things. Actually, it is a type of Indian study followed by superficial travellers or journalists, when it is not simply the work of exploiters of the public's credulity, who imagine that they are teaching an ignorant audience about *Vedanta*, *Yoga*, or *Tantrism*.

All that is of little importance. Ultimately only honest and conscientious work survives. A useful, and possibly the most useful, part of such work is the translation of Indian writings. In the last century and a half many Sanskrit works have been translated into French. But there are few which do not require retranslation, either because the versions are inaccurate or because, being too accurate or not sufficiently skilful, they have failed to popularize the original and have thus not achieved their purpose. I shall not dwell on such inadequacies and gaps. I shall simply mention here that *Shakuntala* and the *Mrichchakatika* have been staged in France

several times, not unsuccessfully, in spite of indifferent performance. A well-known poet, Gerard de Nerval, assisted in the adaptation for the stage of the *Little Clay Cart*.

Apart from Sanskrit works, very little—too little—has been done to make familiar in French the best of the Tamil writings as well as those of Hindi, Bengali or Marathi. We shall soon have a partial translation of the works of Tulsi Das. So far as contemporary work is concerned, rather more has been done, but not nearly enough. Several books by Dhan Gopal Mukherji, Sarat Chandra Chatterji and, recently, a sociological novel by Mulk Raj Anand, *Coolie*, have found readers in our country and have enjoyed success. Efforts in the last thirty years have naturally been concentrated on the works of Rabindranath Tagore, in whom we have appreciated the faithful reflection of all the tendencies of the Indian mind. Much of his work has been translated into French; a fine poet, Pierre Jean Jouve, assisted by Professor Kalidas Nag, has translated *The Swan*. Andre Gide, one of the foremost writers of our time, and himself a Nobel prize-winner, has translated *Post Office* and *Gitanjali*. In his preface to the latter, he says, 'I have spent much longer time translating certain of these poems than Tagore spent writing them. It seemed to me that no thinker of modern times deserved more respect, I might almost say devotion, than Tagore. I took pleasure in humbling myself before him as she had humbled himself to sing before God.' One of our recognized critics, Thibaudet, also greeted *The Home and the World*, when it was published in French, with resounding praises.

Indian mystical theology found a genuinely interested mind in the philosopher Bergson, who tried to define the characteristics of Indian mysticism in contradistinction to Christian mysticism. Bergson was familiar with the ancient writings in the English versions, while for modern movements he referred to the works of Ramakrishna and Vivekananda, which have been translated into French, as have the

works of Aurobindo, Gandhi and a few others, in the last few years.

The names I have just mentioned prompt a reference to their biographer, Romain Rolland. Romain Rolland did more than anyone to disseminate the doctrines of Rama-krishna and Vivekananda in the Western worlds. He was able to link them with the doctrines of ancient India from which they are derived and, through them, to popularize Indian thought. Those lyrical works, to which may be added the same author's book on Gandhi, are in the tradition of romantic writings. It is particularly owing to them, I think, that Romain Rolland has been regarded in India as the most representative of contemporary French authors. In fact, his career shows this paradox: that he has been recognized almost everywhere as a great European writer, without being recognized in France as a great French writer. He lacked the gift of style and a certain indefinable feeling for proportion, I might almost say, tact, which would have enabled him to claim the title. In the present connection, however, it is true that Romain Rolland has been the most successful worker, in the spiritual sphere, for a closer union between India and France. I can find no more fitting close to this study than to evoke his memory.

Not only is France, like all other Western nations, a civilized country from the material points of view, as much as, and possibly more than any other, it is a country in which intellectual values, the heritage of classical antiquity, and Christianity have been preserved with their pristine force. In spite of decline, France is a home of literature, art and philosophic thought. How could she fail to acknowl-edge the splendour of Indian culture, as she did previously, when the treasures of India's past first met her gaze?

GERMANY AND INDIA

Helmuth von Glasenapp

Germany got her first information about India during the Middle Ages from the Greek and Latin historians of the wars of Alexander the Great, and indirectly through Christian legends like that of Barlaam and Josaphat which relates the life of Buddha in Christian garb. The first Indian work translated into German was the *Panchatantra*, the famous book of fables. At the instigation of Count Eberhard the Bearded of Wurttemberg, Anton von Pforr rendered it into German (in about 1480) from a Latin version, which itself depended on a chain of Hebrew, Arabic and Pahlavi translations. This so-called *Book of Examples of the Old Sages* had a wonderful success and influenced German fiction greatly, in so far as many German tales are derived from it. Of course, the geographical knowledge concerning India was in these ancient times rather limited. During the Crusades nothing but stories of marvel elephants and unicorns and the legendary priest-King John reached the North of Europe. Only a few occidentals, like the Italian Marco Polo, had obtained firsthand information about India.

When the great Portuguese navigator Vasco da Gama had explored the sea route from Europe to Indian in 1498, the reports on India increased in number and quality from year to year. Abraham Roger's *Open Door to Hidden Heathendom*, published in Dutch in 1651 and translated into German in 1663, gave for the first time an account of Hinduism from the viewpoint of a Catholic Missionary. Some preachers of the Christian Faith such as Father Henry Roth (about 1650) and J.E. Honxleden (died in 1732) did pioneering work in the investigation of the Sanskrit language, and the Protestant Missionary Bartholomaeus Ziegenbalg (died in 1719) wrote works on Tamil grammar and the religion of Malabar.

The men hitherto mentioned lived at a time before the real scientific study of Indology was inaugurated by Sir Charles Wilkins's translation of the *Bhagavadgita* (1785), Sir William Jones' English renderings of Kalidasa's *Shakuntala* (1789) and *The Ordinances of Manu* (1794), and Sir H.T. Colebrook's famous *Essays*.

The first German scholar who knew Sanskrit and wrote a book on Indian religion and philosophy was Friedrich Schlegel. In 1802, during his stay in Paris for the purpose of studies, he made the acquaintance of an Englishman, Alexander Hamilton, who had learnt the Sanskrit language in India. On his return, Hamilton was detained in France, because Napoleon had enforced the isolation of England from the Continent. This circumstance, very unhappy for Hamilton himself, turned out to be a very great boon for German science, because it enabled a brilliant young German poet to study a language for which it was very difficult at this time to procure a teacher or a grammar. After his return to Germany, Friedrich Schlegel published in 1808 a book, *Uber die Sprache and Weisheit der Indier* (*On the Language and Wisdom of the Indians*), which contributed greatly to direct the attention of men of letters to a hitherto almost entirely hidden domain of knowledge. Friedrich Schlegel later on abandoned his Sanskrit studies, but his brother August Wilhelm Schlegel, the famous translator of Shakespeare's plays, made it the study of his life. He published text-editions of the *Bhagavadgita* and the *Rama-yana*. From 1818 he occupied the first chair of Indology established in Germany at the newly founded University of Bonn.

A contemporary of the Schlegels was Francis Bopp, the celebrated investigator of Comparative Philology. He wrote a work on the *System of Conjugation in the Sanskrit Language* (1816), and published critical editions of the story of Nala and Damayanti and other parts of the *Mahabharata*.

At the beginning of the nineteenth century the interest taken in India was very common with German poets and

philosophers. Goethe was a great admirer of *Shakuntala*, *Meghaduta* and *Gitagovinda*; the Indian custom of beginning a play with a prelude on the stage induced him to imitate this in his celebrated *Faust*. The poet Friedrich Ruckert, who possessed a stupendous knowledge of many Oriental languages, acquired fame by his skilful imitation in German verse of even the most difficult passages of Sanskrit *kavyas* such as Bharavi's *Kirartarjuniya*. Wilhelm von Humboldt, who for many years held the office of Minister of Instruction in Berlin, also knew Sanskrit; we owe to him a brilliant paper on the *Bhagavadgita*, which he read in the Royal Academy of Sciences in 1825.

It stands to reason that the German philosophers of the time were greatly attracted by Indian wisdom. Already Immanuel Kant, though indebted for his knowledge only to books of travels, had occupied himself with Hinduism and Buddhism.[1] Now that good translations of original texts had become available, Schelling, Hegel and Schopenhaur dealt explicitly with Indian metaphysics. It is well known that Schopenhauer considered the Upanishads as the 'solace of his life and death' and that he greatly venerated the Buddha, whom he called the greatest philosopher the world has ever seen besides Plato and Kant.

The whole of knowledge on ancient India acquired during the first half of the nineteenth century was in very able form collected and summarized in the four volumes of Christian Lassen's *Indische Altertumskunde* (Indian Archaeology, 1843–1862). A Norwegian by birth, he was a pupil of Schlegel and succeeded him in the Chair of Indology at Bonn, which being then the capital of Sanskrit learning was called the Beneres on the Rhine.

Since the establishment of the first professorship of Indology in 1818, Sanskrit was taught by and by in almost all of the German Universities existing at that time. But so great was the number of scholars who had devoted their life to this study that some of them were called to foreign countries requiring the services of Sanskritists. The most

prominent of these was F. Max Müller. Born in 1825 in Dessau as the son of the poet Wilhelm Müller, famous for his enthusiastic intercession for the Greeks in their struggle for liberty, he was a pupil of the great French savant Burnouf.[2] Still a youth, he began his edition of the *Rig-Veda* with the help of a subsidy by the East India Company, which was published from 1849 to 1875. In 1850 he became a Professor in Oxford where he lived until his death in 1900. Besides his monumental work he wrote many books on comparative religion, the *Six Systems of Indian Philosophy*, on the sayings of Ramakrishna, etc. Further, he edited the fifty volumes of the great collection, *Sacred Books of the East*. Max Müller opened a long line of German scholars in British service, employed either in England (namely, Theodore Goldstücker in London, Theodore Aufrecht and Eggeling both successively professors of Sanskrit in Edinburgh) or in India, namely Kielhorn, Bühler, Hoernle and Thibaut.

Since the time of Max Müller, the study of the Veda has always been a chief object of German Indologists. It is therefore not astonishing that all the four Vedic *Samhitas* have been critically edited for the first time by Germans: the *Rig-Veda* by Max Müller and by Th. Aufrecht, the *Sama-Veda* by Th. Benfey (1848), a scholar who later devoted himself chiefly to the study of the *Panchatantra* and its migrations in world literature, the *Yajur-Veda* by Albrecht Weber (1852, 1871) and by Leopold von Schroeder (1881, 1900), the *Atharva-Veda* by Rudolph Roth (1856). Among the long series of scholars who later on endeavoured to translate Vedic hymns and to unravel the mysteries of Vedic mythology, only the names of H. Grassmann, A. Ludwig, K. Geldner, H. Oldenburg, A. Hillebrandt, and H. Luders may here be quoted.

During the first decades of Sanskrit studies, German Indologists made use of English dictionaries. These being very expensive and not easily procurable, the poet Ruckert had copied out for his own use the whole of Wilson's dictionary. Bopp (1850) and Benfey (1865) composed

German glossaries for the use of students, and Theodore Goldstücker an unfinished Sanskrit Dictionary in English (1855). The first comprehensive great German Dictionary of the Sanskrit language in seven volumes was compiled by Otto Bohtlingk and Rudolph Roth, and published in the period 1852–1875 by the Imperial Academy of Sciences in St. Petersburg. After its completion Bohtlingk wrote another smaller but still more copious dictionary, which also was sponsored by the Russian Academy (1879–89). In these two works Germany possess an exhaustive thesaurus to which generations of Germans owe the best of their knowledge about Indian language and literature. In the years which have elapsed since the completion of the smaller *Petersburger Worterbuch* (abbreviated as 'p.w.', in contradistinction to the larger work, generally quoted as 'P.W.'), many texts have become known whose words are not yet incorporated in these dictionaries. Supplements have therefore been published by Richard Schmidt in 1924–28. As even these supplements are not sufficient, it is to be hoped that the new exhaustive Sanskrit-English Dictionary prepared in Poona will fill up this gap. In 1887 Professor Cappeller edited, on the basis of the Petersburg Dictionaries, a very useful small Sanskrit-Worterbuch of 550 pages for the use of beginners; an enlarged English edition of this was published some years later. It may be mentioned here that the second edition of the Sanskrit-English Dictionary of Sir M. Monier Williams, originally published in 1872, is to a large extent due also to German indologists, for the new edition of 1899 was written with the collaboration of E. Leumann and C. Cappeller.

It is impossible to enumerate here the names of all the German scholars who dealt with Indian classical poetry and drama. Suffice it to state that the most prominent *kavyas* (poems) and *natakas* (dramas) can be read in German translation. Some works have been translated very often: *Shakuntala* more than ten times, *Vikramorvashiya* five times, *Mricchakatika* four times, and *Dasa-kumara-charita* three times.

Of Amaru's and Bhartrihari's stanzas there exist a great number of German renderings. That the Indian books of fables have frequently been translated into German (literally in prose, or alternately in prose and verses, or in children's editions) requires no explanation. Panini's grammar has been translated into German by Otto Bohtlingk (1839, second ed. 1887), and the late Professor Liebich has made a special study of the classical old Grammarians. Several Indian Law Books have been translated into English by Bühler and Jolly in the *Sacred Books of the East* series; some others also exist in German translation. Of Kautilya's *Arthasastra* there is an excellent German rendering by the American-Swiss scholar Johann Jakob Meyer. Even Vatsyayana's famous *Kamasutra* has been translated into German.

The above-mentioned late Prof. Jolly in Würzburg was both an authority on Indian Law and on Indian Medicine. He wrote standard works on both the subjects, for which reason he was awarded the Honorary Degrees of Doctor of Law and of Medicine by German Universities.

The interest in philosophy being very keen in Germany at all times, there have always been many scholars working in this field. There are several translations of the Upanishads and the *Bhagavadgita*. Richard Garbe wrote on Sankhya, Max Müller, E. Roer, A. Winter and E. Hultzsch on Nyaya-Vaisheshika. The greatest achievements in this field are due to a man who was no Indologist proper but a philosopher—to Paul Deussen, who from 1889 until his death in 1919 occupied the chair of Philosophy at the University of Kiel.

Born in 1845 as the son of a Protestant parson, he began by studying theology; deeply influenced by Schopenhauer's teachings he took up the study of Sanskrit and became an enthusiastic follower of Shankara. His spare time as a private tutor in a Russian family he used for the study of Advaita, and he gave the first great exposition of Shankara's system of Vedanta (1883). To his German renderings of the *Sutras of Vedanta with Shankara's Commentary* (1887) he

presently added a translation of *Sixty Upanishads* (1897) and, in collaboration with his pupil Otto Strausz, of the philosophical texts of the *Mahabharata* (1906). Of the six volumes of *History of Philosophy*, the first three deal with Indian philosophy, the remaining ones with the philosophy of Greece, of the Middle Ages, and of Modern Times from Descartes to Schopenhauer. Among German philosophers of his time there was no one who so thoroughly understood the importance of Vedanta for the West. A similar position may be assigned to the Protestant theologian Rudolf Otto. He possessed a fair knowledge of Sanskrit and was a great admirer of Ramanjua. Besides many theological works, he has published several translations of Vaishnava texts and has done much to gain for Hinduism the place in Comparative Religion which it deserves.

Besides these scholars almost exclusively interested in Sanskrit and Hindu literature, there are others who, though also working in this domain, are best known by their studies of Prakrit and Pali and the two great religions whose writings are written in these languages, viz. Jainism and Buddhism. Besides Albrecht Weber, the first editor of Hala's poems, and Richar Pischel, who wrote a Prakrit Grammar, we may mention Hermann Jacobi and Ernst Loumann, who have done much in elucidating the history and dogmatics of the Jains.

Among the many works on Pali Buddhism the first place is due to Hermann Oldenberg, the famous editor and translator of the *Vinaya* texts and author of a book on Buddha, which in its twelve German and three French editions has been for a long time the standard authority on Gautama's life and doctrine. Wilhelm Gieger translated into German a part of *Samyutta-Nikaya*, into English from the Ceylonese chronicles. He supervised also the research work for the new Singhalese Dictionary.

A vast amount of fresh material on the history of Buddhism and its literature has been brought to light by the Prussian expeditions to the Eastern Turkistan led by Albert

Grünwedel and Albert von Lecoq who both have published books on Indian Art and its connection with the West. The most famous of the German scholars who deciphered the manuscripts found in Turfan was Heinrich Luders collaborating with his wife, who succeeded in editing fragments of manuscripts of lost Buddhist texts. It is a regrettable fact that Mahayana Buddhism has till now found only a limited number of research-workers in Germany (like professor Walleser); it has always been the chief domain of French and Belgian scholars.

The German standard work on the history of Indian Literature are the three volumes of Maurice Winternitz, the late professor of Indology at the German university of Prague. The volumes have appeared also in English.

The time from the middle of the nineteenth century to the beginning of the first World War, during which all the above-mentioned scholars lived, is the golden age of German Indology. It was the time in which Sanskrit studies flourished at almost all of the German Universities and conquered for Indian literature a place of honour in the *universitas literarum*. The vicissitudes of two last wars and the time of unrest that followed were not favourable to the development of science in Germany; it is therefore a regrettable fact that a number of Sanskrit Chairs at the German Universities have been curtailed. Nevertheless, the studies are still flourishing, and the number of Professors of Sanskrit is still greater in Germany than in any other country in the Western world, inclusive of the United States. This is the more remarkable because Germany has never ruled over any part of India as other European nations have done. Her aim has always been a purely scientific and spiritual one, following the well-known sentence of the famous poet Heinrich Heine: 'Portuguese, Dutchmen and English have brought home on their great ships the wealth of India. We Germans always took a back seat, but we shall not do without the spiritual treasures of India. Our Universities will be our factories for these.'

The interest of the largest number of German Sanskri-
tists being philological and historical, the study of India's
past, her language, culture and religion, has always been
the chief aim of German Indologists. This explains the fact
that the modern Indian languages have not been adequately
represented. Besides missionaries who translated some
works from the vernaculars there were only a few men who
went deeply into the literature and culture of the new
Indian Aryan and Dravidian peoples. This has been the
work of a few German scholars. I mention the former
foreign Minister Dr. Rosen, a good specialist in Persian, who
translated Amanat's *Indarsabha* and wrote a sketch of Urdu
Literature, Dr. Reinhard Wagner, a well-merited Bengali
scholar, Professor H.W. Schomerus and Dr. Beythan, to
whom we are indebted for a Tamil Grammar and a work on
Shaiva Siddhanta, respectively. It is to be hoped that, India
being now independent, the study of modern Indian
languages will be fostered also in Germany, an aim which
might well be realized by an exchange of professors and
students between German and Indian Universities.

The number of Germans who learn Indian languages,
who read ancient Indian texts in translations, or who follow
the scientific works of the Indologists is, of course, small
compared to those who take a general interest in Indian
literature. The most widely read Indian author is Rabindra-
nath Tagore, whose visits to Germany are still remembered.
Many of his works have been translated into our language,
mostly from English, and some of his plays such as *The Post
Office* and *The King of the Dark Chamber* appeared on the stage.
Dhan Gopal Mukerji and some other Indian writers are also
widely read. The death of Mahatma Gandhi made a very
deep impression on the German public, and there were many
demonstrations of sympathy both in the several German
parliaments and in philanthropic societies. In memory of the
deceased great Indian the University of Tübingen arranged a
special gathering at which the writer of these lines had the
privilege of delivering a lecture on Gandhi's life and work.

Although Germany may be separated from India by large stretches of land and water, yet the bonds of sympathy, formed at the beginning of the last century, continue to unite the two countries in mutual appreciation and friendship. To the Spirit distances are naught, as says a Sanskrit poet:

Durastho'pi na durasthah svajananam suhrjjanah;
Chandrah kumudakhandanam durasto'pi prabodhakah.

Even if he is far away, a friend will not seem remote to a friend; the moon though far away yet awakens the lotus of the night.

REFERENCES

1. The hitherto almost unknown passages of Indian religions in Kant's books and lectures are collected in my work, *Kant and the Religions of the East (German)*, published in 1949 in the *Internationaler Universitatsverlag* in Tübingen.
2. See Louis Renou's article *India and France* in *Prabuddha Bharata*, February 1949.

AMERICA'S INTEREST IN INDIAN CULTURE

Dr. Horace I. Poleman

I consider it a privilege to address you this evening and make some observations on the culture of India, especially since this will be my last pronouncement before returning to America, where I shall pick up the thread unbroken, by the long distance between our countries, in my lectures to American college students at various points on the way back to Washington. To faculties and directors of colleges at which I stop, I shall present the need for their consideration of India in the many branches of their curriculums, which without that consideration are fallacious and inadequate.

It is fitting that my final address here in India should be delivered under the auspices of the Ramakrishna Mission, which has so long maintained fast links with America, in whose principal cities there are strong, active branches of the Mission, devoted not only to spiritual ends but also to the interpretation of India and its culture. *The Cultural Heritage of India* is a publication of which you can be justly proud. Its content is scholarly and exact, and also highly readable. For this reason I am hoping it will prove of great value in the interpretation of India's past to American students. It stands prominently in the bibliographical lists of the Library of Congress, recommended for the acquisition of American libraries. In form, print and paper, it is indeed a work of art. We shall expect still more and even finer works from your organization.

I shall consider the culture of India from two points of view—its past and its future. Doubtless no American interested in the humanities would assert that Indic civilization has been inconsequential in the past and is negligible

in our calculations for the future, yet doubtless few think in an inclusive way of India's accomplishments. Perhaps Americans think exclusively, if at all, of your philosophy and religion. And justly so. For aside from the abortive 'Aryanization' now being promulgated by the German High Command, the Indo-European speaking peoples of India are the only branch of that linguistic stock to have developed and zealously preserved its own religious and philosophical concepts—concepts which have resisted both intellectual and armed invasions, and revolutions throughout historical times. In the *Rig-veda* one finds the well-developed result of profound thinking on the part of your early seers. Much of this thinking demands further clarification. In the *Atharva-Veda* a pre-Aryan folk religion of magic appears, but the sub-structure remained.

Although the Upanishads form an intellectual revolution with little remaining from the Vedas except the adoration of the Pitris, they were still characteristic of Indian thought. And it is in the study of them that the foreign student is impressed by the lightning flashes of truth, which inevitably affect his own evaluation of himself and his world as well as of the early thinkers of India. The Upanishads found their reaction in the still later growth of ritualism on the one hand and the infusion of Bhakti into worship on the other on an ever-increasing scale. How much of these phases are Aryan in their progressive development and how much the adoption of the pre-Aryan ideas is yet to be determined by a study of the primitive and prehistoric. The impact of all this on the West resulted in the German Romantic movement of the nineteenth century together with the scientific study of the history and comparison of religions. Much of the thinking of Schopenhauer emanated from the Upanishads, and the responsibility for the American Transcendentalist School of Thought lies with India.

In the realm of pure literature India's contributions are famous. Although the religious content is prominent, it has

not excluded a massive literature of epic, drama—which perhaps has a first place in antiquity, folk-lore, law and lyric poetry, as well as elaborate studies in linguistics, aesthetics, and the poetic art. No teaching of the history of literature in the West can claim distinction without an adequate consideration of India. The history of dramas is vitally concerned with India. The spread of folk-lore through the West from India, where it goes deep into the subsoil of culture, makes any treatment of that subject ludicrous without constant reference to Indian origins. Not until recent times has any grammatical or linguistic work approached in clarity, exactness and scientific perfection the work of Panini and his followers. The study of rhetorical principles and of all phases of law finds itself in the same relation to India.

Architecture and the plastic arts have had a career in India which we can study since the third century B.C. India's art has had a unique history of theme and technique, and has never been excelled for imaginative power. Schools of art in the West are giving increasing attention to this. Our chief task in the expansion of such study will be to furnish the necessary implementation to the educational system of America.

All phases of science have had a long and independent position in Indian thinking. Medicine, astronomy, mathematics and law need interpretation to the West. To mention one aspect, I was asked a number of years ago by a medical research scientist if there is anything in the history of Indian medicine referring to Caesarian section. As a result of my studies of death rituals, in which this operation has figured, I was able to give him much interesting antiquarian material, which was subsequently considered important enough to be published for the scientific world. Medical science could profit from a careful study of Indian materials.

Any one unacquainted with Indian civilizations in its various departments does not know, or even begin to know, the world history of any one of those phases of culture.

24

It will be my pleasant task in collaboration with certain others presently to persuade American educators to acquaint their students with this civilization on a scale hitherto unknown. The plan for the programme of the development of Indic studies in America can best be stated by quoting from a recent Bulletin of the American Council of Learned Societies on 'Indic Studies in America': The programme will call for the training of two kinds of personnel—'the one to be engaged primarily in Indological research and in due time to fill the present chairs of Sanskrit and similar chairs which may be instituted at other great universities. The second kind of personnel to be trained is one to carry Indological knowledge to a larger audience through the medium of other disciplines. These men, trained in the Indian aspects of their fields—fine arts, history, anthropology, political science, and a number of other disciplines—would present India to the students in our colleges and universities in a far more widely reaching manner than is possible for the present few professors of Sanskrit.

'In addition to the training and placing of personnel, we need implementation, particularly that which makes the study of India possible to the large group peripheral to Indology and dependent upon the Indologists for the scientific standard of the Indic materials it uses. It is true that the implementation for Indic studies is better than it is in most underworked fields, because there is already a tradition (in America) of a century's scientific labour in many parts of the field. But the implementation will not suffice for the expansion of Indic studies beyond their present limits.

'For the production of both the personnel and the implementation, we need a strong American school in India. The American School of Indic and Iranian studies was organized in 1934, primarily for the purpose of assuming responsibility for the excavations at Chanhu-daro. Its very modest pledges of funds, first made in 1930, evaporated

during the depression, and even the excavations which were started on contributed money have not yet been satisfactorily completed. At some time the School will establish headquarters in Benares, where it will serve as a centre of training for younger American scholars, provide a radial point for the use of Americans conducting humanistic research in India, and participate in the revaluation of Indic culture which the Indians are making for themselves.

'The present status of Indic studies sets the problems of that field peculiarly before the humanities, and it is scholars of the humanities who must urge the development of Indic studies in the West. These studies offer a vast and fruitful field for research, they will be a tool for comprehending the world which is now coming to be and for meeting its needs, they will enrich humanistic studies and validate the humanistic approach to understanding.'

So much for the past. It is a rich past. But in glorying in that past do not lose sight of the future. It will be less than futile, it will be degenerate to be content to revel in that past without planning a vigorous future. There have been great thinkers in your past. There are some today. It is reasonable to suppose that the reflective tradition will carry on, but inevitably modified by modern scientific approaches. Much revaluation of this past must be accomplished within India itself as it is to be applied to current and future problems and thought.

Such revaluation is already appearing, but those reactionaries who refuse to revalue, who insist upon the continuance of traditional values without submitting them to a searching, as well as sympathetic, analysis will be discredited in the West. The students of American colleges today are no longer the playboys of the first quarter of this century. They are hard-thinking, determined realists, looking eagerly for real values wherever they can find them. They will not be interested in vague shoutings about the omnipotent *Om*, and secret, mystical interpretations of what may be realistically evaluated. We on our side stand

indicted for many mistakes and false values, so that we must also let ourselves in for evaluations. We need intellectual understanding on each side to make a satisfactory adjustment of East with West. Much patience and co-operation will be needed.

But to get down to specific points. Philosophy and religion must assume a new place in our development. The man of today must be less concerned with whether a Christ or a Krishna were divine incarnations than he must be concerned with whether what they taught will work in the planning of a good and healthy life for himself and fellow-beings. Spiritual fads, creeds and dogmas will not help. They will only embitter and destroy. Ignorance must succumb to education. An old manuscript must be revered not because it is the supposed holy utterance of a seer, but because it is an expression of an intellect, which may have intellectual value for us. Where truth exists it will be recognized, but only when bias and clap-trap have been clearly shorn away from it. I have noticed three kinds of scholars in India: the reactionary who is impatient of all modern scientific methods, who is content with a traditional point of view exclusively; a second type who is still in the grip of medievalism and loves nothing so much as to argue the relative merits of this or that mantra for the attainment of soul-force. (There are similar minds in the West too.) And finally there is the third who, justly dissatisfied with much of the Western evaluation of Eastern learning, carefully searches in his laboratory of technical instruments or in his mind for an unprejudiced and just treatment of his subject. Yes, India is well on the way toward a severe and critical attitude toward herself, but there are still many elements within her which would dissuade her from the work. The eyes of the West will be increasingly upon you, expectant, eager, but critical. Search yourselves well.

Turning from the world of ideas to that of scientific research, I would like to indicate briefly some of the work which remains to be done.

The archaeologist's spade has only begun to turn up the facts necessary for the understanding of the prehistoric as it has affected the historic. So much that is unexplored in the past requires the light of intense archaeological work. To penetrate the secret of the origin of Indian art, for example, will require much delving into the earth-bound past. It may never be penetrated, but a working hypothesis for its origin may be forthcoming.

In the field of languages considerable scientific analysis is still needed, for Sanskrit itself and the literary dialects of antiquity. The monumental work of the Petersburg Lexicon frequently falls short of the requirements of the scholar working in any phase of Sanskrit literature, since so much of that literature remains unexplored. In philosophy and religion there are numerous unpublished texts dealing with medieval theories and practices. Medieval texts on rituals remain almost unexplored. Much of modern religious practices have yet to come under any scientific observation. In the realm of pure literature there are texts to be published for the West. Even of the standard and long known texts, some are still not published in critical editions. For example, *Mahabharata*, which is now receiving such excellent editorial treatment at the Bhandarkar Oriental Research Institute at Poona.

Many of the modern tongues of India remain to be studied scientifically. Dravidian and Munda languages have vast uncharted spaces.

In the fields of anthropology and ethnology the conceptions of the racial history of India will probably be subject to correction as the necessary investigations are pursued.

The history of India will constantly be revised in the light of new inscriptions, numismatics and literary evidence. Not too much is known about political and economic theory and practice in ancient India. Sociology lacks a satisfactory explanation of even so fundamental an element of Indian life as the caste system. The study of Hindu and Muslim cultures in their interrelations is practically a virgin field. If

the world is to know India, it must have much more material from her scholars than what exists at present. We in the West will assist in whatever way we can.

For the pursuit of this work much organization and co-operation must be developed. Each of us has his pet interests, but we must try to consider them as they relate to the work of others, for no one field exists alone. The ethnographical work of a man in Bengal must be considered by a man of Malabar. The archeologist of Eastern India must keep his eye on the man in Sind. Since scholars are also human beings, they find it easier to criticize than to co-operate.

I hope that, as India develops as a nation she will also develop a national centre for the direction of cultural studies, for the collection of the data, and the distribution of it abroad.

The interpretation of India to America will depend more on what you do than upon the small group of its own scholars and educators in the Indic field. Rightly or wrongly your ideas for the time being will be measured by Western standards. It will be a mistake to try to convert us to Hinduism in any of its aspects or to any other ism. (We have too many isms of our own to contend with now). Give us cold, reasoned facts, and arguments without passion or sentimentality. Thereby a sympathy will be created more genuine than any dependent upon other appeals.

I desire India to succeed, to rid herself of apparent deficiencies, to take her place well up in whatever is to be the future of international order, and to command the respect and dignified appreciation of the rest of the world.

SPIRITUAL PRACTICES IN JUDAISM

Rabbi Asher Block

In may synagogues, these words from the 16th Psalm are inscribed over the Torah Ark: 'I set the Lord always before me.' This practice of God-consciousness, in Judaism as in other major faiths, is of the essence of religion. The moment awareness of God comes, religion has begun. And the process is never quite complete until the experience of God is utterly immanent and endless ('always before me').

In Judaism, the process of establishing God-consciousness is illustrated for us by the attention accorded its central prayer, the *Shema Yisrael* ('Hear, O Israel, the Eternal is our God; the Eternal is One'), which is part of every morning's and evening's devotion. All thoughts other than God's Unity must be shut out, the Rabbis taught. There must be *kavannah*: concentration of heart and mind. 'If the words of the Shema are uttered devoutly and reverently, they thrill the very soul of the worshipper and bring him a realization of communion with the Most High. "When men in prayer declare the Unity of the Holy Name in love and reverence, the walls of earth's darkness are cleft in twain, and the face of the Heavenly King is revealed , lighting up the universe" (Zohar).'[1]

In activity, it is only the prophets and saints who attain such realization, through the help of God. Yet they themselves have assured us that we too can merit God's grace by striving earnestly and persistently for his Presence. Thus Moses declared: 'If ye desire the Lord your God, ye shall surely find Him, if ye seek Him with all your heart and with all your soul.'[2]

Though God is ever-present, most of us are continually forgetful of Him. Hence the need for frequent recollection. In ordinary religious practice, rituals serve as reminders

This is presented normatively in the Bible in connection with the wearing of a sacred blue thread, or fringe, upon the corner of one's garment—'that ye may look upon it and remember all the commandments of the Lord, and do them; that ye go not about after your own heart and your own eyes after which ye use to go astray; that ye may remember to do all My commandments and be holy unto your God.'[3]

Most of us have enough knowledge of what is true and good to make us partial saints, but that is not what we habitually think of day after day. Ritual and prayer are therefore necessary aids in remembering the spiritual facts of life.

In the Decalogue we find: 'Remember the Sabbath day to keep it holy'—the Sabbath itself being a memorial to the Power and Purpose behind all creation.[4] The Hebrew New Year is known as a Day of Remembrance—of moral and spiritual truths. The Passover, and a host of related traditions, are observed for the pre-eminent reason 'that ye may recall your exodus from Egypt all the days of your life', and thus learn to live in the consciousness of liberation. So it is with most holidays and observances.

How to overcome spiritual amnesia, is the dominant occupation of religious aspirants. Most effective in this regard is the vivid example of inspiring persons. The *Midrash* (Commentary) on the Book of Genesis offers a striking lesson through the life of Joseph, who was beset with many difficulties while in Egypt. He was subject to temptations of Potiphar's wife, had to undergo the rigors of prison, and was sorely prompted to take vengeance of his brothers. But in all his struggles he found support. He would recall the image of his patriarchal father (Jacob), and as he gazed in imagination upon that presence, strength and conviction would come to him.

The implication of this teaching, as of so many others like it, is quite clear. The ultimate healing for our many ills is to remember who and what we truly are. We are the heirs of Jacob. What is more, we are children of God.

Hence, we must pray, and practice our religion until that awareness becomes 'second nature' to us, until it becomes part of our very being. Spirituality, brotherliness, fearlessness—everything associated with godliness—will eventually be ours, if only we can manage long enough and consistently enough to remember God.

Naturally, a strong endeavour is required to attain such lofty results. That is why the author of the *Shulchan Aruch* ('Prepared Table'—Code of Jewish Law), toward the very beginning of his work, presents this appeal: 'Judah, the son of Tema, said, Be strong as a leopard, light as an eagle, fleet as a deer, and powerful as a lion, to do the will of thy heavenly Father.' (Ethics of our Fathers, V. 23.) 'Strong as a leopard' means that one should not be ashamed of those who mock him when engaged in the service of God. 'Light as an eagle' refers to the vision of the eye; that is, be quick in shutting your eyes not to look at evil. 'Fleet as a deer'—let your feet always run swiftly to do good. 'Powerful as a lion' refers to the heart. The seat of strength to do the service of God (blessed be His name!) is in the heart. 'It is the duty of man to strengthen his heart to do God's will and to prevail over his evil inclination, even as the hero makes every effort to prevail over his enemy, subdues him, and throws him to the ground...If one is eager to be pure, he will be assisted!'

The striving for purity encompasses two basic concerns (two which ultimately are one), corresponding to the two commands of love of God and love of neighbour, or the two tablets of the Law.

In his essay on 'Saints and Saintliness', Dr. Solomon Schechter pointed out:

There is no room in the soul of the saint for those ugly qualities which, in one way or another, are bound to impair the proper relations between man and his fellow-man. These are pride, anger, petulance, despair, hatred, jealousy, dissipation, covetousness, desire for

power, and self-assertion. These make man's commu-
nion with God impossible, and hence are incompatible
with saintliness...Man's love of self is, however, too
deeply rooted to be overcome by reminders few and
too far between. We therefore read of a saint who was
overheard constantly whispering the prayer: 'May the
Merciful save me from pride'.[5]

The nature of the task of training for spiritual life, and
the various stages involved are set forth in a classic text
entitled *Mesillat Yesharim*, 'The path of the Upright'.[6] In his
preface, the author writes: 'Most students concentrate all
their study and thought upon the subtleties of the sciences,
or the arts, or pursue the study of dialectics and codes.
There are but few who study the nature of the love and the
fear of God, of communion, or any other phase of saintli-
ness...The majority of men will conceive saintliness to
consist in reciting numerous Psalms and long confessionals,
in fasting and ablutions in ice and snow.

'Bear in mind that such qualities of character as
saintliness, reverence and love of God, and purity of heart
are not as "natural" as being asleep or awake, being hungry
or thirsty, or experiencing any other physical want. They
can be developed only by means of special effort. Thus we
read in the oft-quoted teaching of Rabbi Phinehas ben Yair,
"The knowledge of Torah leads to watchfulness, watchful-
ness to zeal, zeal to cleanness, cleanness to abstinence,
abstinence to purity, purity to saintliness, saintliness to
humility, humility to the fear of sin, and the fear of sin to
holiness".' (The work that then follows, "intended as a
reminder both to myself and to others of the prerequisites
to perfect piety", is an elaboration of each of the prerequi-
sites and a guide as to how to avoid the hindrances to their
fulfilment.)

The goal of Judaism is *kedushah*, 'holiness', the progres-
sive sanctification of all aspects of life. This is evidenced in
two main ways. First, the physical elements are consciously

made subservient to the spiritual, and never encouraged to become ends in themselves. Thus, eating is to be a 'sacrament', and the table an altar! The choice and preparation of foods, the blessings before and after meals, the special Holiday details—these all reflect a higher purpose. The function of sex is sacramentalized through marriage, and the home, through disciplines of continence and purity. Property is 'hallowed' through its uses for benevolence, through the religious life of the community, and through one's inner consciousness that, in truth, 'the earth is the Lord's and the fullness thereof.'

Perhaps the best application, and symbol, of this process is the institution of the Sabbath, which transcends the work of the week. 'The Talmudic mystics tell that, when the heavens and earth were being called into existence, matter was getting out of hand, and the divine voice had to resound, "Enough! So far and no further!" Man, made in the image of God, has been endowed by Him with the power of creating. But in his little universe, too, matter is constantly getting out of hand, threatening to overwhelm and crush out soul. By means of the Sabbath, called "a memorial of Creation", we are endowed with the Divine power of saying "Enough!" to all rebellious claims of our environment, and are reminded of our potential victory over all material forces that would drag us down.'[7]

Secondly, the goal of holiness is expressed, more directly and affirmatively, through deeds of love, religious study and worship—what tradition denotes as 'the pillars' upon which the world stands.[8]

Dr. Schechter, in his essay,[9] mentions several marks of saintliness stressed in Judaism—self-discipline, truthfulness, non-injury to others, humility, etc.; but among the first are devotion and prayer.

The saint longs for the moments when he can pour out his soul before his God in adoration and supplication. The hours of the day appointed for the three

prayers, evening, morning and noon, are for him, as a Jewish saint expresses it, the very heart of the day. Apparently, however, the saint is not satisfied with these appointed times. He is so full of expectation of the time of prayer, that he devotes a whole hour of preparation to put himself in the proper frame of mind for it, and he is so reluctant to sever himself from such blissful moments that he lingers for a whole hour after the prayer, in 'after-meditation'. It was in this way that the ancient saints spent nine hours of the day in meditation…In the later Middle Ages, a whole liturgy was developed as an 'order of prayers for midnight'.

The attitude of Judaism on this subject is perhaps best highlighted in the story that is told near the close of the Chapters of the Fathers[10]—in themselves a kind of summary of basic ethical teaching.

Rabbi Jose, the son of Kisma, said: I was once walking by the way, when a man met me and greeted me, and I returned his greeting. He said to me, Rabbi, from what place art thou? I said to him, I come from a great city of sages and scribes. He said to me, If thou art willing to dwell with us in our place, I will give thee a thousand thousand golden dinars and precious stones and pearls. I said to him, Wert thou to give me all the wealth in the world, I would not dwell anywhere but in a home of the Torah, as is written in the Book of Psalms. The law of thy mouth is better unto me than thousands of gold and silver; and not only so, but in the hour of man's departure from the world nothing accompanies him but Torah and righteous deeds.

REFERENCES

1. From 'The Pentateuch and Haftorahs', edited by Dr. J.H. Hertz, Soncino Press, London, 1950, p. 922.
2. Deut. 4:29.
3. Num. 15:37–40.
4. Exod. 20:8–11; Deut. 5:12–15.
5. In 'Studies in Judaism', Second Series, Jewish Publication Society, Phila., 1908, pp. 166–67.
6. The author is Moses Hayyim Luzzatto (1707–1747). A critical edition with translation and notes by Mordecai M. Kaplan was published by the Jewish Publication Society, Philadelphia, 1936.
7. 'The Pentateuch and Haftorahs,' above, on Exod. 20:11, p. 298.
8. *Pirke Abot*, 'Ethics of the Fathers', 1:2.
9. 'Saints and Saintliness' in *Studies in Judaism*, above. The quotation that follows is on pp. 154–56.
10. 'Ethics of the Fathers', VI:9.

THE MYSTICISM OF
ANGELUS SILESIUS

S. Subhash Chandra

The history of German mysticism is, undoubtedly, dominated by towering personalities such as Meister Eckhart, Jacob Boehme, and Angelus Silesius. These three mystics unquestionably incarnate the pivots of the mysticism of their country. We propose to deal in this article with the mysticism of the last of the three. He is, in our opinion, the most popular and the most readable of all German mystics. Equipped with lyrical gifts, which he uses in abundance, he has made over to the world a priceless legacy, and mystical literature has been vastly enriched by his writings. Since the life of a mystic often happens to be a valuable guide in the understanding of his mystical thought, we shall begin with a short account of the life of our mystic. We shall then undertake a succinct elucidation of his doctrine, and shall thereby prove and substantiate our view that Angelus Silesius belongs to the rank of the immortals of world mysticism.

Angelus Silesius was born in Breslau in December 1624. His original name was Johann Scheffler, which he changed to Angelus Silesius upon his conversion to the Roman Catholic faith. Our knowledge of the personal lives of the parents of Angelus Silesius is meagre and sketchy. His father, Stenzel Scheffler, a Polish aristocrat, was born in Cracow in 1562. An adherent of the Protestant religion, Stenzel Scheffler was constrained, presumably by the bigotry of the dominating Roman Catholic elements in Poland, to migrate to Breslau. At the age of 62, Stenzel Scheffler married Maria Hennemann, who was then 24 years old. Aside from the illustrious mystic, Maria Scheffler

also gave birth to a girl, Magdalena, and a boy, Christian. In 1637, at the early age of 13, Angelus Silesius lost his father. Two years later occurred the premature demise of his mother.

Our knowledge of the early childhood of Angelus Silesius is gravely hampered by a severe scantiness of information. We know that, from 1639 to 1643, he pursued his studies at the Elisabeth Gymnasium in Breslau. In 1641, he wrote his first major poem in honour of his teacher Chrisostomus Schultz. In 1643, he joined the University of Strasburg. In the summer of 1644, Silesius went over to Leyden, which was then the nucleus of intellectual activity in Europe, and spent two fruitful years there. The University of Padua was the next landmark of the academic Odyssey of the great mystic. On July 9, 1648, after nearly a year's sojourn at this celebrated university, he obtained his doctorate in philosophy and medicine. In 1650, Silesius got acquainted with the renowned mystical writer, Abraham von Franckenberg, whose influence, according to Hans Ludwig Held, has been significant on the mystical thought of Angelus Silesius.[1] June 12, 1653 turned out to be the pivotal day in the life of the poet-mystic. On this day he became a convert to the Roman Catholic Church. On May 29, 1657, he renounced the allures of the mundane life and became a Catholic priest. A protracted illness, involving inflammation of the lungs, led to his demise on July 9, 1677.

Cherubinischer Wandersmann embodies, undoubtedly, the acme of the contribution of Silesius to the mystical heritage of mankind. It is an extraordinary work. Endowed with a rare poetical genius, Angelus Silesius has here succeeded in creating an epic of mystical literature. The book is replete with the profoundest mystical insights. Here occurs a fascinating coalescence of truth and poetry. The convictions of the mystic find expression in rhymes of exquisite beauty. The words are invested with a celestial charm and the syllables begin to sparkle. Rightly has Kuno Francke observed: 'In the whole range of literature, there is no book

in which pantheism has found a more original poetical expression than in the childlike sibylline verses of *Cherubinischer Wandersmann*.'[2] *Cherubinischer Wandersmann*, published in Vienna in 1657, constitutes verily the *magnum opus* of Angelus Silesius. But an equally important work, though lacking the epical qualities of this monumental book, is *Heilige Seelenlust Oder Geistliche Hirtenlieder*, which appeared in Breslau in 1657. If the *Cherubinischer Wandersmann* represents a truly unique espousal of *jñāna-yoga* in the European mystical tradition, then the *Heilige Seelenlust* is perhaps, the most moving documentation of *bhakti-yoga*. In the first work, as we shall show in the sequel, the quintessence of the Advaita Vedanta is enunciated and conveyed to the reader with an indelible impact. In the second work, however, the mystic becomes a devotee and his soul yearns for a blissful communion with Jesus Christ. The two works together comprise a unity and present to us a picture of Angelus Silesius as an extraordinary religious phenomenon in the history of European mysticism, in whom the elements of *jñāna* and *bhakti* find a successful assimilation.

Mention ought, also, to be made of still another work of Angelus Silesius, viz. *Sinnliche Beschreibung Der Vier Letzten Dinge*. In this contribution, the poet undertakes a fanciful, sometimes even naive, description of death, the last judgement, the eternal torments of the damned, and the eternal joys of the redeemed. This work possesses scarcely any philosophical significance. It was clearly meant to serve clerical purposes. That, however, does not detract from it its worth as a literary contribution of a high standard. Angelus Silesius, the poet, is even here very much in evidence. Indeed, his profound poetical genius is a permeative element in all his writings. A sublime exuberance of expression is conspicuous in the compositions of the mystic of Breslau. To cite August Kahlert:

The poetical element asserts itself in all that he contributes, even where it is obscured by unusual admixtures.

Luminous fantasy, glowing emotions—conditioned perhaps by the Sarmatian blood of his father—lend to his language that overwhelming expression, that hall-mark of immediacy, that makes all his writings conspicuous literary monuments.[3]

We have alluded to the fact that the contribution of Angelus Silesius is characterized by a balance of stress upon jnana and bhakti, and that the two elements are, respectively, enunciated in the *Cherubinischer Wandersmann* and the *Heilige Seelenlust*. Surprisingly enough, this has led to a controversy among the Western scholars. The European scholar, predisposed to forcing things into analytical strait jackets, fails to see the unity underlying the mystical knowledge and devotional love. For him, these two trends, when concentrated in a single person, signify a logical discord. Thus, it is contended by some scholars that the kernel of the thought of Angelus Silesius is embodied in the *Cherubinischer Wandersmann* and that the devotional elements preponderant in the other work represent a doctrinal concession to the Roam Catholic religion, whose adherent the mystic became. On the other side, it is maintained, that the foundation of the profound contribution of Silesius rests upon devotional elements and that the pivot of his work is the *Heilige Seelenlust*.

Needless to say, most of the protagonists of the second view are Catholic scholars. The religious schism, which continues even today to paralyse religious thought and opinion in Europe, has exacerbated the controversy. In our opinion, the controversy is irrelevant, if not senseless. The mystical ingredients and emotionally toned approach of the devotee represent no irreconcilable dichotomy, but are two sides of the same coin. The simultaneous presence of these two tendencies in a religious personality, as evidenced time and again in the course of the spiritual history of India, implies no contradiction at all. It merely testifies to the fact that the ultimate truth is capable of being realized in

various ways and that the law of contradiction could become guilty of irrelevancies.

It may not be out of place here to briefly discuss the conversion of Angelus Silesius to the Catholic Church. In 1653, as we have already pointed out, Silesius severed his ties with the Protestant creed and went over to the camp of the Roman Catholics. Why did he change his religion? What were the factors that led to his disavowal of the religion in which he was born? His own explanation of the factors that led to this crucial step fails to carry conviction, although some of these factors could, no doubt, have played a subsidiary role in influencing his decision. In a tract specifically devoted to an elucidation of the *Reasons and Motives (Ursachen und Motiven)*, he offers such reasons as that the Protestantism had allegedly failed to produce a single saint as against the Catholic Church, which (again allegedly) could boast of a host of saints and seers.[4] We are assured that the controversies and clashes inherent in the Protestant movement render it no match for the Catholic Church, founded as it was by the early Apostles and fortified by historical tradition and a perfectly well developed system of dogmas and doctrines.

It will be seen that these and other similar reasons throw no light on the compelling motivations that ought to characterize a genuine conversion. Indeed, in this tract and also, in some other minor writings, the approach is polemical to the verge of being recriminative, if not malicious. This bitterness and intolerance, so utterly in clash with the personality of Angelus Silesius, was perhaps rooted in the aggravated political and ecclesiastical atmosphere then prevailing in Europe. 'The Silesia of the Thirty Years War between Sweden and the Emperor, Protestants and the Counter Reformation of the Jesuits, the Lutherian orthodoxy and the fanatical sectarianism is the soil upon which...the work of Angelus Silesius grows up.'[5] In the absence of a really convincing reason, one must resort to conjuncture. There can be no doubt of the fact that Silesius was not on good terms with the local Protestant dignitaries, and the

Absolutistic tenets expounded in the *Cherubinischer Wandersmann* must have put a considerable strain on' the already tense relations prevailing between him and the other votaries of his creed. Not only Hans Ludwig Held (who is the editor of the three-volume edition of the writings of Silesius), but also Georg Ellinger is convinced that the 'opposition of Lutherism to mysticism had driven Scheffler (Silesius) in the Catholic camp.'[6] In the absence of any other substantial motivation, one is constrained to give a qualified assent to this explanation of the conversion of the great mystic.

Before we begin our exposition of the basic tenets of the contribution of Angelus Silesius to human heritage, the reader will bear with us, if we make a brief reference to the intellectual and spiritual factors that had moulded the metaphysics of our mystic. According to the *Encyclopedia Britannica*, the contribution of Angelus Silesius consists of 'rhymed distichs embodying a mystical pantheism, drawn mainly from the writings of Jacob Boehme and his followers.'[7] The influence of Meister Eckhart is easily discernible in the mystical verses of Silesius. Weigles and Tauler, eminent figures in the mystical tradition of Europe, appear to have palpably influenced his writings. He was acquainted with the writings of Bruno, although the extent to which the latter influenced his thought is not easy to assess.

To facilitate a neat and systematic delineation of the mysticism of Angelus Silesius, we propose elucidating first the groundworks of the *Cherubinischer Wandersmann*, and then we shall deal with the *Heilige Seelenlust*.

The *Cherubinischer Wandersmann* consists of six books, which, respectively, comprise 302, 258, 249, 230, 374, and 263 sublime verses. These verses, most of them couplets, serve to expound a distinctive view of the universe. These verses contain no mere unconnected and disjoined set of mystical fancies, but serve as vehicles to convey a well developed *weltanschauung*. The essence of the mysticism of Angelus Silesius has been brilliantly epitomized by Wilhelm Dilthey in the following words:

He (Angelus Silesius) does not find the abiding principle of life in the autonomy of the individual, but in the transcendence of the self, in the tranquillized desire, in the consummation of suffering, in the peace in God, where no time, no will, no knowledge is, and which, at the same time, is present in every part of the world and in every self.[8]

Angelus Silesius propounded an absolutistic view of the universe, and the kernel of his teaching confirms once more the Indian view that an underlying unity is characteristic of all mystical systems of thought.

God, according to Silesius, is the substratum of the universe. He is the Alpha and the Omega of reality. He is the form and the content of the universe. He constitutes the unity of the finite and the Infinite, of the One and the many. He is beyond the categories of time and space. He is eternal. He permeates every nook and corner of the universe. He is immanent and omnipresent. But this immanence does not fetter him to the fleeting and illusory world of time and space. His immanence is based on the bedrock of his transcendence. He is immanent in so far as he essentially assimilates the multiplicity in his transcendent unity. He is ineffable. In a passage typically reminiscent of the Vedantic doctrine of 'neti, neti', we are told:

What God is, one does not know. He is not light, He is not spirit, not truth, unity, one, not that one calls divinity. Not wisdom, not understanding, not love, will, virtues, no thing, no nothing also, no being, no mind. He is what I and you and any other creature, till we have become what He is, never know.[9]

The God of Angelus Silesius is at once characterized by infinite attributes and is devoid of all attributes. He is not conditioned by the shackles of name and form.[10] He is beyond good and evil, nay, in him the moral norms are

fully transmuted. He is constituted of an inexhaustible plentitude of possibilities.

In God, as we have already pointed out, the finite and the Infinite attain their unity. Indeed, Silesius maintains that there is no difference at all between the finite and the Infinite. Just as the difference between the ocean and the drops in the ocean is idle and fortuitous, so too is the distinction between the Creator and the created a mere appearance. The highest truth is an inalienable unity. And this underlying unity embraces the entire world of appearance in all its manifold diversity. Nothing escapes it. The high and the low, the profound and the profane, the sacred and the sacrilegious find their transmutation in the all-assimilative unity of God. God made not only man in his own image, but he is present even in the most elementary forms of life. Even the meanest insect does not fall outside the divine scheme of the universe, asserts Angelus Silesius.[12]

The mystical universe of Silesius is characterized by a unique phenomenon. Here not only the world of appearance owes its existence to the reality of the unity underlying it (if one may at all speak of the 'existence of the appearance'), but, conversely, the unity too is inconceivable without the multiplicity! Angelus Silesius not only espouses the total unity of God and man ('God is what He is; I am what I am; but if you know one of them, then you know me and Him.'[13]) but opines that this unity is inconceivable without the illusory multiplicity. The reality, we are assured, cannot dispense with appearance, and the unity is inconceivable without multiplicity. Not only is God the substratum of man, but, conversely, is man the *raison d'etre* of God. God and man are mutually inter-dependent. 'I know that, without me, God cannot even for a moment live; if I come to nought, then He (too) must, perforce, abandon His soul.'[14] As a result of this doctrine, even the world of appearance acquires a meaningful place in the universal scheme of things. Perhaps, by this doctrine of the mutual inter-dependence of God and man, Angelus Silesius strove

to bring out the difference between the illusoriness and the falseness of the universe. Like the Indian Vedantins, he too, probably, was an adherent of the view that the world is illusory but not false.

The Supreme Reality, then, is to be located in the inalienable and all-encompassing unity of God. The highest good of life is to strive to regain this unity. Indeed, sin signifies nothing but this ignorance of the essentially divine nature of all things. In the words of Silesius: 'Sin is nothing else than man turning his face away from God and returning (thereby) to death.'[15] Not in various manifestations of iniquity, but in this ontological ignorance of the nature of the supreme Truth are the roots of sin to be located. The logical result of this view is that the extent of the iniquity is to be measured in terms of the ignorance separating the finite from the Infinite. Conversely, the extent to which we are convinced, in word and in deed, of the divine substratum of all reality constitutes the criterion of our spiritual progress.

We should, therefore, strive to regain this unity. The finite must lose himself in the illimitable vastness of the Infinite. Salvation is only to be attained, when the identity of the knower and the known is realized, nay, when this identity becomes the very foundation of life. For salvation connotes not merely theoretical conviction, but actual and living realization of the supreme Truth. Our whole being should be saturated by this realization. The Infinite should permeate fully and absolutely our whole being. All distinctions of name and form are transcended in this mystical union of the soul and God. One is immersed absolutely in the unity. This state of mystical ecstasy has been eloquently summarized by Silesius in the following words: 'I do not know what I shall do! For me all has become one: space, no space, eternity, time, night, day, pleasure and pain.'[16] The key-note of this ecstasy is the total dissolution of the individual ego. The universality of the mystical experience brooks no cramping individualities within its framework. It is all-assimilative.

These, in a compressed form, constitute the fundamental tenets of the *Cherubinischer Wandersmann*. Having dealt with them, we shall now undertake a delineation of the cardinal aspects of the second important work of the mystic of Breslau, viz. the *Heilige Seelenlust*. This great devotional composition is divided into five books and contains a total of 206 songs. The songs are characterized by an unusual devotional fervour. The songs serve to give expression to the yearning of the soul (Angelus Silesius calls it the 'Psyche') for the divine love of Jesus Christ. Some of the songs are also used to extol the Holy Virgin. As a rule, however, Jesus Christ is the object of veneration of the mystic. These songs remind an Indian reader, perforce, of the *bhajans* of Mira Bai and Dadu.

The key-note of these songs, as of all other *bhakti* literature, is the advocacy of a deeply personal relationship between God and his creatures. Love, the most intimate of all possible relationships, is advocated as the surest avenue through which God may be approached and attained. To a devotional aspirant, the intellectual approach of the philosopher smacks of pretension and arrogance. The supreme bliss is to be won by the utter surrender of the heart, and not by the sceptical qualifications of the metaphysician. Humility and reserved faith are the watchwords of the aspirant here. Every glimpse of the divine beloved embodies an incomparable experience suffusing the devotee with an ineffable bliss. Every lapse of this experience is accompanied by the most excruciating pain and suffering. The poet is possessed by his mad infatuation, for infatuation it is, though a divine one.

The deity at whose shrine Angelus Silesius yearns for the grace of divine love is Jesus Christ. He is not merely a great religious personality. He is the incarnation of God himself. He is intransient and replete with compassion. Just, compassionate, benevolent, generous, forbearing, graceful, the great bliss and delight are some of the attributes ascribed to him by Angelus Silesius.[17] The saint goes into

raptures while describing his love for the Jesus of Nazareth. He centres all his hopes around the divine person of Jesus. He yearns to commune with him. He declaims: 'No plea- sure of the world offers me the tranquillity of heart. Your presence alone, O Jesus, is my delight.'[18] Christ personifies the highest joy of life. To commune with him is to feel oneself elevated in a state of unbelievable ecstasy. All earthly pleasures pale into insignificance in front of this supreme bliss. No wonder, then, that the aspirant yearns for him with all his heart. Without Jesus, the soul is restless. The aspiring soul cries out: 'Where is my leading star, my sun, my moon, and the entire firmament? Where is my beginning and end? Where is my joy, my bliss? Where is my death and also my life? My heaven and my paradise? My heart to whom I have so fully surrendered myself, that I am unaware of any other (heart)? '[19] The poet longs to lose himself in his beloved deity.

The love assumes a personal character. Christ is conceived of as the bridegroom. The bride (that is, the mystic) pines for his loving presence. She cries: 'Now I die, if he does not come and fold me in his arms. Ah, ah, what a terrible pain it is to love him and yet not be with him.'[20] Now and then, the bride is taken aback by her presumption. She becomes aware of her insignificance and despairs of ever becoming worthy of the divine love. She then becomes a bundle of restless anguish and hopeless despair. Immense is her sorrow when she falls prey to some earthly seduction. She is shattered and overwhelmed by despondency and remorse: 'Oh thousand woes, oh dead lust, how have you annihilated me! Oh vanity, oh desert of sin, how have I been executed! You, you, oh sin, oh murderess of the soul, you have deprived me of my own self! Because of you, I have lost my father, God, master, friend, and bridegroom.'[21] But the remorse does not permanently overwhelm the aspirant. The spark of hope refuses to be extinguished. Faith in the merciful grace and benevolence of the divine beloved kindles the flame of hope anew. The unflinching devotion

quenches the gnawing doubts. Faith is reinforced by the conviction of success. The yearning begins to mount. The flood of tears washes away the formidable hurdles. The obstacle crumbles. As the goal nears, the aspiration reaches its apex. And, lo! The soul is redeemed in the reciprocated love of the celestial beloved.[22]

With this we complete our delineation of the substance of the mysticism of Angelus Silesius. In this essay, we hope to have succeeded in providing an idea of the monumental contribution of Angelus Silesius to the religious heritage of mankind. Angelus Silesius, like other mystics all over the world, confirms the Indian view, so eloquently advocated by Swami Vivekananda in recent times, that an essential unity is characteristic of mysticism, regardless of the religious tradition in which it happens to take place. Indeed, this universality is not only useful in so far as it strengthens the forces combating intolerance and doctrinal narrow-mindedness in various religions, but also serves as the most compelling proof of the validity of the spiritual Truth. The fact that the writings of Angelus Silesius are no mere theological treatises, but are documents of actual religious experience enables them to take a place among the truly great classics of the religious history of the world. As authentic accounts of personal insights and intuitions, they serve as guide-posts for other aspirants. Indeed, the mystic himself laid stress on this point, and the concluding verse of the *Cherubinischer Wandersmann* (with which we, too, may aptly conclude our article) pertinently avers: 'Friend, it should suffice. In case you would like to read more, then go and embody yourself (as the doctrine of) the writing and become yourself the Real.'[23]

REFERENCES

1. Angelus Silesius, *Werke*, vol. I, edited by Hans Ludwig Held, Carl Hanser Verlag, Munich, 1949, pp. 26–27.

2. Kuno Francke, *A History of German Literature,* Henry Holt and Company, New York, 1916, pp. 195–96.
3. August Kahlert, *Angelus Silesius,* A. Gesohorsky's Buchhandlung, Breslau, 1853, p. 89.
4. Angelus Silesius, *Werke,* vol. I, p. 242.
5. Hermann Heimpel, Theodor Heuss, Benno Reifenberg (ed.), *Die Grossen Deutschen,* vol. V, p. 118.
6. Georg Ellinger, *Angelus Silesius,* Verlag von W.H. Korn, Breslau, 1927, p. 138.
7. *Encyclopaedia Britannica,* vol. I (fourteenth edition), p. 922.
8. Wilhelm Dilthey, *Gesammelte Schriften,* vol. III, B.G. Teubner Verlaggesellschaft, Stuttgart, 1959, p. 52.
9. *Cherubinischer Wandersmann,* IV.21; *Werke,* vol. III, p. 111.
10. Ibid. V.41; Ibid. vol. III, p. 145.
11. Ibid. VI. 171; Ibid. vol. III, p. 208.
12. Ibid. IV. 221; Ibid. vol. III. p. 136.
13. Ibid. I. 212; Ibid. vol. III, p. 30.
14. Ibid. I. 8; Ibid. vol. III, p. 8.
15. Ibid. IV. 69; Ibid. vol. III, p. 118.
16. Ibid. I. 190; Ibid. vol. III, p. 28.
17. *Heilige Seelenlust,* V. 186.8l *Werke,* vol. II, p. 333.
18. Ibid. I.3.3; Ibid. vol. II, p. 34.
19. Ibid. I.12.5; Ibid. vol. II, p. 50.
20. Ibid. III.75.4; Ibid. vol. II, p. 144.
21. Ibid. IV.127.8; Ibid. vol. II, p. 232.
22. Ibid. IV.127.17; Ibid. vol. II, p. 234.
23. *Cherubinischer Wandersmann,* VI.263; *Werke,* vol. III, p. 218.

THE ISLAMIC CONCEPTION OF GODHEAD

Wahed Hosain

I

It is generally said that Islam is severely monotheistic. A critical study of the Quranic texts and traditions of the Prophet will convince the seeker after truth that its texture is interwoven with the threads of abstract monism and concrete theism. The wonderful combination of the two ideas running side by side throws light on the Islamic conception of the Supreme Being. The notion of an Absolute Existence (*dhat-i-mahaz*), and of the Divine Essence endowed with certain qualities often finds expression in the same texts.

In some passages Allah is described as an Absolute One beyond human conception and comprehension. Sometimes the description of the Divine Being gives a vivid idea of a personal God as a Helper, Supporter and Grantor of Peace, as a Beneficent Friend and Vigilant Guardian over all. Sometimes the description rises to the height of poetic effusions in depicting the Deity as a Gracious Being, full of splendour and majesty, beauty and perfection. Sometimes it takes the turn of showing Him as an Intelligent Author of this wonderful Universe directing and regulating all its movements and functions. Sometimes it shows Him as a wise and omniscient Being bringing into existence wonderful beings and things without a design or premeditation. And sometimes the texts portray Him as a Powerful, Just and Wise King dispensing even-handed justice according to one's merit and desert.

The Al-Quran declares: 'Your God is Allah who is one in His personality and without any participator in His

attributes. He is God alone. There is no being which is like Him—eternal and everlasting, nor has any being its attributes like His attributes.'

Another text says: 'The sight comprehendeth Him not, but He comprehendeth the sight. Thy Lord is incomprehensible, gracious and wise' (*Sura* VI).

The Supreme Exalted Being who is called *Haq-Subhanahu*, is conceived as one single entity not capable of division. There is no plurality in Its Essence (*kathrat dar Zat*). If any notion of multiplicity is to be connected, it always refers to Its attributes (*Sifat*). The Muslim metaphysicians (*Mutakallamin*) therefore hold that 'Oneness refers to Its Essence and plurality to Its attributes' (*Wahdat dar Zat wakathrat dar Sifat*).

It will presently be seen that Islamic religion is not monotheism as has wrongly been supposed, but it is monism. The metaphysical significance of monotheism materially differs from that of *Touhid* as used by the Muslim philosophers and logicians (*Mutakallamin*). Monotheism 'makes God single but finite; or supposes that, of the two self-existing principles one is personal and the other impersonal—God and matter. In other words, the tendency of the more advanced thought was to restrict personality to one of the rival powers, and to condense a single God of unlimited goodness, but limited in power by another principle outside of himself, and self-existent like himself, but impersonal.' This is not the conception of Allah or the Supreme Being in Islam. Perhaps monotheism is an unintentional mistranslation of the Arabic term *Touhid* or *Wadhat*. If it is monotheism at all, it is then a concrete monotheism.

II

The real Islamic conception of Allah is monism, which consists in affirming the Absolute Existence of one self-existent Being having self-consciousness (*'Ilm*), self-distin-

guishing and self-controlling power, and potentiality of evolving finite things and minds out of itself (*Zahur-i-dhat*, and *Kul min-indil-Allah—everything from Allah*), and directing and coordinating them for serving some Divine purpose. The idea of monism as embodied in the term *Touhid* may be considered in its several aspects:

(1) The idea of abstract monism is to be found in the Arabic expressions *dhat-i-mahaz* or *dhat-i-bahat*, which means absolute existence, or in *Dhat-i-mutlaq*, that is, Absolute One. These expressions are used in contradistinction to 'relative existences which are finite'. In its abstract sense *Touhid* or monism conveys the idea of one indivisible unity, or indivisible oneness. In this sense God is *Ahad* (indivisible one). In the Al-Quran two words are used in describing the unity of God, viz. *Ahad* and *Wahid*, meaning one. Although the two words convey the idea of unity or oneness, there is a sharp and subtle distinction between their metaphysical and esoteric significance. *Ahad* means such an entity as is not capable of division; while *Wahid* means an entity which is capable of mathematical division, such as half, one-fourth, one-third, and so forth. Thus God (Allah) is *Ahad*, that is, the absolute one, and the nature of the absolute is to be 'indivisible unity'.

(2) The idea of the Absolute One connotes and conveys the idea of completeness in itself, that is, perfection. Consequently Islam holds that the Absolute One is the perfect Being and that perfection or completeness in its very nature.

(3) As a corollary to God's being absolute and perfect, He is infinite—infinite with regard to His Eternal Existence, that is, not limited by time and space; or, in other words, self-existing from eternity without beginning (*azal*) to eternity without end (*abad*); infinite with regard to His power and potentiality (*qudrat* and *Irada*), that is, inexhaustible in His activity and creative energy (*kul yumin hua fi shan*)—'He is at His functions every moment'; and infinite with regard to His nature, that is, not limited by anything outside His own nature.

(4) As a perfect and infinite Being, God (Allah) is unconditioned, that is, His reality is within Himself; and as a Real Existence, He is not dependent on anything beyond Himself. In other words, all finite things and minds are dependent on Him as condition precedent, while Allah is independent of all conditions lying beyond Himself.

(5) The Absolute One being complete and perfect in Itself, exists wholly by Itself; and as such It is aware of Its completeness and perfection. This consciousness has reference not only to Itself but to what is outside of Itself, that is, the Absolute Being is conscious of His own existence, completeness and perfection; He is equally conscious of all those activities and products which spring forth into existence out of His own nature (which are, in the terminology of modern science, called evolution, in that of theology called creation, and in that of the Muslim mystics, *Sufis*, called manifestations).

However, it should be noted that human cognition is sense-intuition, that is, awareness through the senses. But God's cognition is not sense-intuition like ours. It may be called *Intellectual Intuition*, that is, cognition of reality otherwise than through senses.

In describing the absolute nature of the Supreme Being, the author of the *'Awarif-ul-Ma'rif* says: 'The Divine Essence is all purity, completely free from the accidents of form, colour, magnitude, dimension, similitude, union, separation, association, descent, issue, decline, growth, change, alteration and transaction. It is absolute one; there is no plurality in its oneness. His existence is therefore described by unity and known by singularity.'

The Divine Being is said to be an Absolute Existence (*dhat-i-mahaz*); It exists by Itself (*Wajib-ul-wajood-liz-dhatihi*); an Universal Existence (*dhat-i-basit*) pervading the world of phenomena. The author of the *'Awarif-ul-Ma'arif* further expresses the idea of abstract monism by saying that 'the Divine nature is full and exempted from whatever is contained in reason, in understanding, in the senses, and in

conjecture' (Chap. I, sec. ii, on *Touhid*). 'The sight compre-
hends Him not, but He comprehends the sight. He is
incomprehensible and wise', says Al-Quran (*Sura* VI).

Such, then, is the nature of the Absolute Being accord-
ing to the Muslim metaphysicians (*Mutakallamin*). The
problem of *Touhid* may also be considered from another
point of view, viz. of concrete monism, which to some
extent corresponds to the idea of *Wahdat-ul-wajood*. The
doctrines of *Wahdat-ul-wajood* explains the theory of the
unitary system of the Universe. According to Islamic
doctrine, Allah is a concrete reality, a self-conscious Being
with unlimited power of initiative and control. But God
(Allah) being an Absolute Entity (*dhat-i-mahaz*) which is
beyond human comprehension, He, as such, is an intellectu-
al abstraction. How then can the Absolute One be a self-
conscious reality? This difficult problem is solved by the
Muslim philosophers in two ways: According to the theory
of *Wahdat-ul-wajood*, which has been propounded by some
Muslim *Mutakallamin* and worked out with great minute-
ness by Ibu, 'Arabi, Jami, Rumi and some other writers
belonging to the Sufi school of thought, the infinite and the
finite, the absolute and the relative, are not mutually
exclusive, but correlated to each other; and both of them
together constitute one concrete reality. In this view the
Absolute Being becomes the *Becoming* of something. The
infinite Being is an inexhaustible process of creation, more
strictly speaking, of manifestation or evolution. These
manifestations proceed either from the Essence (*Zahur-i-Zat*)
or from its attributes (*Zahur-i-Sifat*). According to their
theory, creation is but a process of evolution or series of
manifestations.

The orthodox section among the Muslim theologians
does not accept this theory in its naked form. They credit
the pure Divine Essence with certain qualities, and hold that
the finite and the relative are the outcome of these qualities
and are products of the Divine attributes of action. But, at
the same time, they cling to the idea of *positive* creation by

the command of God who created all things out of nothing. They reject the view which holds that 'something cannot be created out of nothing.' Their retort is that if the God of the philosophers is not powerful enough to bring out something out of nothing, the world has no need of such a weak and impotent God.

However, the conception of God, as *concrete monism*, is not without its advantages, viz.

(i) it supposes a connection and establishes a sort of relation between God and the world, between spirit and matter;

(ii) it establishes the *necessary existence* of the Divine Being (*Wajib-ul-wajood*), and explains how He can be infinite and absolute and at the same time a concrete Being, as a permanent self-existent reality;

(iii) it avoids the idea of pantheism (*hama woost*—all are God), and conveys the idea of panentheism—all are in God (that is, within the fold of His universal Existence—*Zat-i-basit*);

(iv) it gives a relative reality to the world of experiences, making finite things and minds dependent on His Existence;

(v) further, it makes the Supreme Being to be transcendental (*balantar*) to the universe, and at the same time immanent in it (*'alakul-i-Shayin Mohit*).

III

From what is stated above it will be seen that the Islamic concept of God (Allah) is realistic. Its realism consists in holding that this world of phenomena is not unreal or mere illusion. All finite things and minds are real in the sense that so long as they endure, they have real existence. According to this view, God is a permanent reality—a reality in substance; while anything else than God (*masiwa Allah*) is relatively real; because all finite things and

minds are transient and subject to annihilation (*fani*). God only is *baqi*, that is, everlasting. But finite things and minds exist only for a period. During the period of their existence they are real; or in other words, their existences are not illusory or deceptive. Al-Quran says: 'We have not created the heaven and the earth otherwise than in truth', that is, in reality. This idea is expressed in other verses also. The Quran points out the transient nature of all finite things and minds by declaring that 'whatever exists in this world is subject to annihilation save the personality of the Lord who is exalted and beneficent' (*Sura* XLV). A tradition says: 'Everything is destructible.' From these texts it is clear that this world of experiences is real but transient. According to this view, God is a permanent reality while matter is relatively real and destructible.

IV

The above consideration leads me to examine the question of dualism in Islam. From the realistic points of view it appears that Islam countenances dualism, for it assumes the reality of matter, though not permanently or absolutely like the reality of God. This, it is said, is a qualified dualism. This view is held to be incorrect. The notion of dualism seems to be based on misconception. The arguments that have been advanced to point out the unsoundness of the view may be stated below:

(1) Dualism is an aspect of ditheism, which is not countenanced by Islam. It assumes the existence of two rival powers or principles—good and bad—each equally powerful enough to defeat and frustrate the end and object of the other, such as, *Yizad (Mazdak)* and *Ahriman*—benevolent spirit and malevolent spirit of the Zoroastrians. Islam never looks upon matter and spirit in that light, nor does it consider God and the world as two rival powers in opposition.

(2) From the point of view of realism as explained above, God is a permanent reality, eternal and everlasting; while matter (finite things and minds) is finite, conditioned, and relative. It is dependent entirely on God for its existence. During the period of its transient existence, it is subservient to God who has the complete power to bring it to *non est* at any moment. Consequently dualism has no room in Islam.

(3) It is also contended that by making the world illusory, dualism is not avoided, for the existence of an illusion is itself dualism. The Sufis also try to escape from dualism by making the world a reflection of God. But it is pointed out that the existence of reflection is itself dualism.

(4) They further contend that it is a mental or intellectual aberration to consider the relatively real existence of transient matter as dualism, but not consider the relatively real existence of illusion or reflection as dualism!

This view of realism militates against the idea of qualified dualism in Islam.

I have shown that realism is an important feature of the conception of God in Islam. But the most noticeable feature is its transcendence. According to the transcendence doctrine of Islam, Allah (God) is superior to everything, and is more than this universe. He is transcendent with regard to His Essence, transcendent with regard to His qualities and attributes, transcendent with regard to His holiness and perfection, His majesty and splendour, and transcendent with regard to His nature. In this view, God does not exhaust Himself in this universe, as the theory of immanence supposes. This world is but an infinitesimal part of His transcendental existence. Consequently God is not co-extensive with the world in the sense of being the sum-total of the finite things and minds, because no sum total of the finite can exhaust the infinite.

On the other hand, the theory of immanence makes the Divine existence co-extensive with the world. In this view God becomes limited in the world. But the doctrine of

transcendence as propounded in Al-Quran makes God embrace all finite things and minds within the fold of His all-pervading existence (*dhat-i-basit*), and at the same time makes Him more than what they are (*bala tar*). Thus the immanental idea of the Divine existence is a subsidiary feature of the transcendental conception of God in Islam.

Now, from the foregoing account and explanation, it is evident that the Islamic conception of God includes abstract monism and concrete theism, as well as realism and transcendentalism. Dualism comes in, if it comes at all, as an aspect of and in connection with realism.

All these ideas are to be found vividly portrayed in the Quranic texts and traditions describing the Divine Being and pointing out the nature and characteristics of His qualities and attributes. A summary of these ideas is given below. It may be pointed out that they are accepted by the Muslims belonging to all schools of thought.

Allah is the creator and intelligent author of the whole universe. He is one universal whole (Being), and has no partner or co-equal. He has been in existence from eternity and will continue to exist to eternity. His existence had no beginning and will have no end. His existence is absolute. He exists by His very nature, and has no cause for His existence.

He has need of nothing, but everything has need of Him. He is not confined to body or matter. He does not resemble anything, nor does anything resemble Him. The questions *how* and *what* and *where* have no reference to Him. He cannot be the subject of thought or imagination. The words *great* and *small* are not applicable to Him, and these are the qualities of created beings and things of matter, and He is neither. He has no connection with body or matter. He has no shape, measure or dimension, no form or colour. He is not confined to any space, time or direction. He is nowhere and yet He is everywhere.

He is not liable to change, nor is He subject to birth, growth, decay, death or annihilation. He is unconditioned,

perfect and infinite and not subject to any limit. His power is vast and unlimited. He has the power of initiative and control. The creation discloses His intelligence and profound wisdom. As an intelligent Author, He brings into existence beings and things of diverse forms, shapes, and colours wherein no defect is to be found, and supports and maintains them out of His infinite mercy. His creation is not based on any pre-existing model or measure. He is full of splendour, beauty and perfection.

His attributes are the same at present as they have been in the past, and will remain the same in the future. These attributes do not affect His Essence, and in no way increase or decrease it by manifestations or their withdrawal.

His knowledge is vast, deep and perfect. The whole universe and its happenings are within the grasp of His knowledge. The hidden and the visible, the manifest and the unmanifested are within the compass of His ken. He is omniscient. As His wisdom does not require premeditation or consideration, so His knowledge does not require physical organs or apparent means.

He sees and hears everything, but not through the medium of any organ. Light and darkness are the same for His sight; the far and the near are the same for His hearing. He speaks but not with a mouth or a tongue, nor in words of language. As an idea in the mind of man is a dumb speech without form or language and cannot be heard by men, so is God's word known to those who can understand it.

He is far and near and surrounds everything. The whole universe is within the vast fold of His omniscience. He is not perceived through the senses, yet His presence can be felt through the eyes of faith and conviction; and His voice can be heard through meditation and concentration.

The Divine Essence is all purity—full of perfection. Although the Supreme Being is beyond the ken of perception, yet He is not beyond realization. His epiphany or manifestation can be seen within the heart made free from impurities and imperfections.

VI

The Muslim philosophers do not regard the pure Divine Essence as entirely devoid of any quality. They hold that the Divine Essence has certain inherent qualities which are the qualities of the essence, as distinct from the attributes of action. They are in the essence and not separate from it.

The *Nahj-ul-Balaghat* quotes the opinion of Imam Jafar-us-Sadiq to the effect that 'God is Omniscient, because Knowledge is His essence; Mighty, because Power is His essence; Loving, because Love is His essence...not because these are attributes apart from His Essence.'

The *Sifatias* (lit. Attributists), who claimed to be the direct representatives of the ancient primitive Muslims (*Salaf*), also held similar views. According to Shahristani, these followers of the *Salaf* 'maintained that certain eternal attributes pertain to God, viz. knowledge, power, life, will, hearing, sight, speech, majesty, magnanimity, bounty, beneficence, glory, and greatness—making no distinction between qualities of essence and attributes of action. They also assert certain descriptive attributes (*Sifat-i-Khabria*); as for example, hands and face, without any other explanation than to say that these attributes enter into the revealed representation of the Deity, and that, accordingly, they had given them the name of descriptive attributes.' (*The Spirit of Islam*, p. 382). The opinion of the *Sifatias* is not accepted in its entirety.

On the other hand, according to Shahristani the *Muta'zilas* declare that 'Eternity is the distinguishing attribute of the Divine Being; that God is Eternal, for Eternity is the peculiar property of His Essence. They unanimously deny the existence of eternal (Divine) qualities (*Sifat-ul-qadamia*) as distinct from His being, and maintain that He is Omniscient in respect of His being; Living in respect of His being; Almighty in respect His being; but not through any knowledge, power, or life existing in Him as

eternal attributes; for, knowledge, power, and life are part of His Essence; otherwise, if they are to be looked upon as eternal attributes of the Deity (separate from His Essence), it would lend to the affirmation of a multiplicity of eternal entities.' (*The Spirit of Islam*, p. 385). Such is the view of the *Muta'zilas*.

The followers of Imam 'Ashary and the *Mutakallimin* (schoolmen) belonging to the *Sunni* school of thought hold that there are eight qualities appertaining to the Divine Being, which are qualities of the Essence. These qualities are called *Sifat-i-haqiqia* or *Sifat-i-thabulia*, that is, the true and positive qualities of the Divine Essence. These qualities are: (i) *Hiyat*—self-existence, that is, subsisting and ever living from eternity without beginning (*azal*) to eternity without end (*abad*); (ii) *'Ilm*—knowledge and consciousness, that is, possessing knowledge of what is hidden and what is manifest, and conscious not only of His own existence but of all existences and events of the past, present and future; (iii) *Takwin*—the power of initiative, that is, the Divine Essence is not a passive mass of consciousness, but possesses creative energy; (iv) *Mashiyat-i-Irada*—the Divine will giving rise to the activity of desires; (v) *Qudrat*—innate power and strength; (vi) *Kalam*—power of speech; (vii) *Sama'*—clairvoyance. These qualities are said to be the qualities of the Essence. There are, besides them, other attributes that are regarded as attributes of action.

It appears that there has been some divergence of opinion between the different schools of thought regarding the nature of the Divine attributes. According to one school of philosophers (*Mutakallimin*), the attributes are not of the Essence. According to the *Muta'zilite* school, they are not distinct from the Divine Essence. And according to the *Asharyan* school they are neither of the Essence nor distinct from it. Imam 'Ashary describes them by saying *la'ayna wa la ghaira*, that is, neither of the Essence, nor separate from it. The disputation regarding the nature of the Divine attributes between the *Muta'zilites* and the *Asharyans* throws a

flood of light on the subject. The *Mutakallimin,* belonging to the *Sunni* school of thought, generally agree with Imam 'Ashary. The *Sufi* fraternities as well as the *Sunni Mutakallimin* hold that the qualities, as enumerated above, are of the Essence, that other Divine attributes are neither of the Essence, nor distinct from it. The following instances may be cited in illustration of their views: The flower and its scent. The flower is not the scent, nor the scent is the flower; but they do not exist separately. A thing and its colour. The thing is not the colour, nor the colour is the thing, but one is not distinct from the other. Sugar and its sweetness. The one is not the other, yet they do not exist separately.

The Absolute Being is not, according to this conception, a luminous mass of consciousness—an incomprehensible absolute intellectual blank with excess of light—a rigid, frigid, passive entity without the power of initiative and control, and regardless of human sufferings and entreaties. Such an attributeless and qualityless Being is considered worse than useless. Nobody has a need of such a powerless and helpless Absolute One who cannot do anything for himself, or for anybody else.

The Muslim philosophers and *Mohaddisins* as well as *Ahl-i-Tasawuf* have, therefore, discarded this sort of idea regarding the Absolute One. According to them the Absolute One is not an intellectual void, or a luminous nothing but a mere consciousness. Such an idea of absoluteness seems to be 'a finished example of learned error.' It is, therefore, maintained that the Divine Essence has certain qualities which are in the Essence itself. These qualities do not in the least affect the absolute nature of the Essence. If the Absolute Entity can be conceived of as consisting of consciousness and luminosity, which do not affect its absolute nature, then some more qualities may similarly be attributed as appertaining to the absolute Essence without affecting its nature. Consequently the Supreme Being in the state of absoluteness is conceived of as the Divine Essence

full of splendour and perfection, creative energy and power of control, active will and comprehensive knowledge, inherent power of vision, and audibility.

The Islamic idea of the Absolute Being differs materially from that of the Neo-Platonists and some ancient Greek philosophers on the one hand, and the Absolute of Shankara on the other, according to whom the Supreme Being is a mere intellectual abstraction totally lacking in initiative. But it corresponds to a great extent with Ramanuja's theism with the exceptions of his theory of *Karma*, *Janma* and *Avatara*, that is, laws of action, cycle of birth, and Incarnation. I quote here one passage from *Indian Philosophy*, which will throw some light on the topic:

> The *nirguna* Brahman, which stares at us with frozen eyes regardless of our selfless devotion and silent suffering, is not the God of religious insight. Shankara's method, according to Ramanuja, leads him to a void, which he tries to conceal by a futile play of concepts. His *nirguna* Brahman is a blank, suggesting to us the famous mare of Orlando which had every perfection except the one small defect of being dead. Such a Brahman cannot be known by any means of perception, inference or scripture. If the sources of knowledge are all relative, they cannot tell us of something which transcends experience; if the scriptures are unreal, even so is the Brahman of which they relate...
> The qualities of being (*sat*), consciousness (*chit*), and bliss (*ananda*) give to Brahman a character and personality....God is a perfect personality, since he contains all experience within himself and is dependent on nothing external to him. The differences necessary for personality are contained within himself. The most prominent qualities of God are knowledge, power and love (*karuna*). Out of his love God has created the world, established laws, and helps constantly all who seek to attain perfection. While each quality by itself is

different from the others, they all belong to one identity and do not divide its integrity of being. The Lord's connection with them is natural (*svabhavika*) and eternal (*sanatana*). These attributes are said to be abstract, as distinct from matter and souls which are also called the attributes of God. (*Indian Philosophy*, p. 683, by Dr. Radhakrishnan, M.A., D. Litt.).

In the above extract, we find that Ramanuja's conception of the Supreme Being is almost identical with the Islamic conception of theism, with this difference that, according to the Muslim philosophers in general, matter and souls are not the attributes of God, and that, according to the *Sufis* in particular, they are the manifestations of the Divine attributes. But the Muslim philosophers differ materially from the views of Shankara on the same grounds that Ramanuja does, and for certain other reasons. The points of difference have been very lucidly explained by Dr. Radhakrishnan in the ninth chapter of *Indian Philosophy*. He observes:

Philosophy has its root in man's practical need. If a system of thought cannot justify fundamental human instincts and interpret the deeper spirit of religion, it cannot meet with general acceptance. The speculation of philosophers which do not comfort us in our stress and sufferings are mere intellectual diversion and are not serious thinking. The Absolute of Shankara, rigid, motionless, and totally lacking in initiative or influence cannot call forth our worship. Like the Tajmahal, which is unconscious of the admiration it arouses, the Absolute remains indifferent to the fear and love of its worshippers, and for all those who regard the goal of religion as the goal of philosophy—to know God is to know the real—Shankara's view seems to be a finished example of learned error. They feel that it is as unsatisfactory to natural instincts as to trained intelligence.

The world is said to be an appearance, and God a bloodless Absolute dark with the excess of light. The obvious fact of experience that, when weak and erring human beings call from the depths, the helping hand of grace is stretched out from the unknown, is ignored. Shankara does not deal justly with the living sense of companionship which the devotees have in their difficult lives. He declares that to save oneself is to lose oneself in the sea of the unknown.

Personal values are subordinated to impersonal ones. But the theist protests that truth, beauty, and goodness have no reality as self-existent abstractions. An experience that is not owned by a subject is a contradiction in terms. Truth, beauty and perfection speak to us of a primal mind in whose experience they are eternally realized. God himself is the highest reality as well as the supreme value. Moreover, the innermost being of God is not solely the realization of eternal truth or the enjoyment of perfect beauty, but is perfect love which expands itself for others. The value of the finite world to the Spirit of the Universe lies in the spirits to whom he has given the capacity to make themselves in his own image. The spirits themselves possess a value, in the sight of God, and not merely their degrees of intelligence or virtue, abstractly considered, which they happen to realize. It follows that they are not made simply to be broken up and cast aside.

Such has also been the trend of arguments of the Muslim philosophers (*Mutakallimin*).

VII

I now pass on to another topic. The charming description in Al-Quran of the all-pervading presence of the Supreme Being (*'ala kul-i-shayin mohit*), of the nearness of

man to His gracious Personality (aqrabiat) and of the fellowship of a loving invisible companion (ma'yiat) which has an attraction of its own. Such description creates an impression of a personal God whose help and kindness, and support and sympathy the fervent soul may count upon amidst its trials and tribulations. 'Remember Me and I shall remember you' is a very sympathetic response which produces a balmy effect on the troubled soul. The conviction of the devotee that, he is living in the presence of the Supreme Being who is near at hand and hears his supplications, strengthens his faith and gives a particular zest to his devotional communion. 'Call Me and I shall hear your call' is the soothing assurance given in the Quran.

The impression that the Deity with whom he seeks Union is his true Darling (janan-i-haqiqi) augments the intensity of his desire for the realization of His fellowship. In soft and inaudible voice the Merciful comforts the earnest seeker by saying, 'We are nearer to him than his jugular vein'. Such a voice draws him nearer to the Deity whom he worships in humility and earnestness. When an earnest soul intends drawing near to God, He assures him by saying, 'When a man draws near to Me by one pace, I go nearer him by ten paces', and points out how to realize Him. 'Worship your Lord as if you are seeing Him, but if you cannot see Him, then think that He is seeing you' (Hadith). Such tender solicitude leads the earnest devotee on the path of realization.

Further, such friendly communion with the Deity and His sympathetic response cannot fail to establish personal relationship with the Supreme Being. It is, therefore, said that Allah is a personal God in Islam. The conception of a personal God has given rise to the idea and practice of rendering personal services to God and working out one's own salvation. Salvation through an intercessor is not at all countenanced. The doctrine of the Original Sin and Atonement is discarded in toto. Every man is held directly responsible and accountable go God for his action. The

whole responsibility lies on his shoulder alone. The Quran points out that, 'he who purifies himself, the purification does good to none else but to himself; he who exerts in the cause of truth exerts for himself only; he who does good deeds does so for his own good.' Thus neither priesthood nor intercession through an intermediary has any place in Islam. Even the Prophet was directed to say: 'Preach it unto those who fear that they shall be assembled before their Lord: they shall have no patron nor intercessor except Him.' The Quran further says: 'We have not appointed thee (that is, the Prophet) a keeper over them, neither art thou a guardian over them.' (*Sura* VI).

VIII

In this connection it should be pointed out that Islam sets its face squarely against any anthropomorphic conception of the Supreme Being. The Quran repeatedly asserts that 'there is nothing which can be likened unto Him'. He is regarded as formless and colourless. But there are certain passages in Al-Quran which apparently lend some colour to the anthropopathic description of the Deity. For example, the texts which say:

'Your God is one in person.'

'Wherever you turn your face, there is the face of God.'

'Everlasting is the personality of thy Lord who is exalted and compassionate.'

'Thou exalteth whomsoever Thou desireth, Thou degradeth whomsoever Thou willeth. In Thy hand is goodness.'

'The words of thy Lord are perfect in truth and justice; there is none who can change them; He both heareth and knoweth.'

In such passages it is maintained that the description of the Deity is figurative or metaphorical. The reference to the Divine person, face, hand, eye, ear, etc. is for the purpose of easy understanding through metaphors and similes. It only gives an idea of concrete monism. It is explained by saying that the Divine person and face convey the idea of beauty and omnipresence of the Supreme Being; Its hand has reference to its power of action; Its eyes to Its omniscience; Its ears to Its innate power of clairaudience; and so forth. Such being the predominant ideas, any fictitious figure of the Deity is not permitted to be set up and worshipped. Islam declares that no figure, form, shape, or likeness of the formless Being is conceivable or possible. Hazrat 'Ali, the fourth *Caliph*, condemned in emphatic language all anthropomorphic and anthropopathic conceptions of the Supreme Being. He declared:

> God is not like any object that the human mind can conceive; no attributes can be ascribed to Him that bear the least resemblance to any quality of which human beings have conception from their knowledge of material objects. The perfection of piety consists in knowing God; the perfection of knowledge is the affirmation of His verity; the perfection of verity is to acknowledge His unity in all sincerity; and the perfection of sincerity is to deny all attributes to the Deity. He who refers an attribute to God believes the attribute to be God and he who so believes an attribute to be God, regards God as two or part of one. He who asks where God is assimilates Him with some object. God is the creator, not because He Himself is created; God is existent, not because He was non-existent; He is with every object, not from resemblance or nearness; He is outside of everything, not from separation. He is the Primary Cause (*fa'il*), not in the meaning of motion or action; He is the Seer, but no sight can see Him. He has no relation to place, time, or measure.

IX

The spirit in which the Supreme Being is conceived of is responsible for the diverse devotional moods and mental states for approaching and realizing God. He is generally approached:

(1) In the mood and spirit of 'Ubudiat, that is, rendering active service to God in the spirit of the master and servant or the creator and his creature. In this mood the spirit of serfdom is the predominant feature of devotion. It corresponds to the idea of the Liege-lord and Serf in Christianity, and the Dasya mood of the Vaishanvite sect.

(2) In the mood and spirit of Taslim, that is, performing devotion in humility and tranquillity of the mind in a spirit of entire resignation to the will of God, and patiently seeking His grace and pleasure, without a murmur in adversity or elation in prosperity. It resembles the mood of Shanta-bhakti of the Vaishnavites.

(3) In the mood and spirit of Yari, that is, as a loving friend or True Darling (janan-i-Haqiqi). This is the mood in which the Sufis try to be in fellowship with God or to draw near to Him through their devotion. It corresponds to the Sakhya form of Bhakti.

(4) In the mood and spirit of Ishq or Muhabbat, that is, approaching God through impersonal love as the Lover and the Beloved. This is the favourite mood of worship and devotion with the Sufi fraternity. It corresponds to the idea of the impersonal love of the Bride and Bridegroom of the Christian Mystics, and with that of Kanta-bhakti of the Vaishnava sect.

The conception of God as a Loving Friend and True Darling has furnished the Sufi poets an endless theme for beautiful lyrics, charming love sonnets, and rapturous rhapsodies for describing the Eternal Beauty and Impersonal Love of God. The Sufi poet sings in exaltation:

Every particle that I see, I see in it Thy beauty;
In every place that I walk, it leads me to Thy lane.

To the metaphysical conception of God as pure and
perfect Being and the ethical conception of God as the
Eternally Holy, the *Sufi* superadds another conception
which may be regarded as the key-note of all mysticism. To
the *Ahl-i-Tasawuf* (the people of mystic doctrine), God,
above all else, is the Eternal Beauty (*Husn-i-Azal*) and the
True Beloved (*janan-i-Haqiqi*). To approach God through
impersonal love (*Ishq-i-Haqiqi*) and to get the realization of
His beauty is the solicitation of the *Sufi*. Jami sings of the
Eternal Beauty in the following strain:

In solitude where Being signless dwelt,
And all the Universe still dormant lay
Concealed in selflessness, one Being was
Except from 'I or Thouness' and apart
From all duality; Beauty Supreme
Unmanifest except unto Itself.
By Its own light, yet fraught with power to charm
The souls of all; concealed in the unseen,
An Essence pure, unstained by aught of ill.

The poet then gives a warning to the lover of beauty
and says:

Beware! say not 'He is all-Beautiful,
And we are His lovers.' Thou art but the glass,
And He the face confronting it, which casts
Its image on the mirror. He alone
Is manifest, and thou in truth art hid.
Pure Love like Beauty coming but from Him
Reveals itself in thee. If steadfastly
Thou canst regard, thou wilt at length perceive
He is the mirror also—He alike
The Treasure and the Casket. 'I' and 'Thou'

Have here no place, and are but phantasies
Vain and unreal. Silence! for this tale
Is endless, and no eloquence hath power
To speak of Him. 'Tis best for us to love
And suffer silently, being as nought.

Then the poet points out how to approach God through
the impersonal love and says:

Be thou the thrall of love, make this thine object;
For this one thing seemeth to wise men worthy.
Be thou love's thrall, that
 thou may'st win thy Freedom.
Bear on thy breast its brand, that thou may'st blithe be.
Love's wine will warm thee, and will steal thy senses;
All else is soulless stupor and self-seeking.
Though in this world a hundred tasks thou triest
'Tis love alone which from thyself will save thee.
Even from earthly love thy face avert not,
Since to the Real it may serve to raise thee.

ONE GOOD HINDU AND
ONE GOOD MOHAMMEDAN

A Wanderer

When Mahatma Gandhi went to the riot-affected areas of East Bengal, he said repeatedly that he wanted one good Hindu and one good Mohammedan in each village to bring about communal amity amongst the people. The statement seemed surprising, if not amusing. He did not speak of any big scheme, any peace committee composed of members representing various sections or interests; he did not talk of police or military arrangements or any other precautionary measures; he asked for a very simple thing—one good Hindu and one good Mohammedan. The Mahatma believed that with these two men he could establish sure and lasting peace.

Many times he seems to be an enigma. Herein also he seemed to be one. But who knows, he might be right. Evil has an easy and immediate victory, but the forces of good work slowly but surely. So the influence of two men might be sufficient to break through the wall of fear and suspicion, tension and ill-feeling that have been raised by the acts of violence on the part of the hooligans, ruffians, and goondas. Who knows!

* * *

I left Calcutta by the end of April 1946. At that time the communal disturbances in the city had continued for more than a month. I lived in an area where the curfew was in force for such a long period. Just at seven in the evening I had to be indoors. It was not safe to wait for the clock to strike seven even. Sometimes the police and the military

might come and catch you earlier if their watch happened to keep a different time. So one felt panicky. Even in the free hours one did not dare go out without anxiety. Who knew if there would be no stabbing or acid throwing! The sound of the explosion of country bombs or the bursting of crackers could be heard at any time of the day unexpectedly—in the evening and at night, regularly.

Now and then one would see the military or police lorry running past, or the fire-engine moving at a hectic speed. The situation was tense. Life became miserable if not unbearable. The restrictions of movements and so many limitations of life turned one into a typically 'introvert case'. Constant brooding over the situation roused one's resentment and raised it to a high degree, till one began to think that every Mohammedan was an enemy of the Hindus, every Mussalman was a goonda in the guise of a gentleman, every mosque was a place where knives and lethal weapons were stored and kept ready. As a matter of fact, a Hindu would be avoiding the area where there was a mosque, if he could help it. What the Mohammedans were thinking of the Hindus I cannot say. But the Hindus and the Mohammedans represented two warring camps, as it were, and it seemed there was nothing to be done to bridge the gulf. As time passed the difference was only accentuated.

* * *

I left for a place in the U.P. by a railway train. Fortunately in my compartment there was not a single Mohammedan. But one might expect a hooligan to stop the train by pulling the alarm-chain and do some mischief? That was not altogether an uncommon thing! The main topic of conversation in the train was communalism. All sorts of things with respect to the Hindu-Muslim problem or tension was discussed, as if immediate action was going to be taken; the relative utility of violence and non-violence

was debated, the deeds or misdeeds of Mahatma Gandhi were stated in all earnestness and solemnity.

* * *

My first halt was at Benares. I read in the paper that some days back there was a 24-our curfew in the holy city. In such a case how could one go to one's destination from the railway station! One of my friends had narrowly escaped such a contingency. He arrived at Benares station at seven in the morning and a 24-hour curfew was passed at nine. He went on a pilgrimage to Benares from a distant place in South India. His stay in Benares had to be short. Poor soul, he could hardly see the sacred places in the city and had to return somewhat disappointed.

Luckily I arrived at Benares at a time when the curfew order was relaxed, and it was restricted to a particular area which did not affect the pilgrims. So I could move very freely. But the tension was, nevertheless, great everywhere. People were talking more of communal 'incidents' than of holy things, which were pushed to the background. I had my bath in the sacred Ganges and I visited the important temples, but I frankly confess that I lived mentally in a plane of acute communalism.

* * *

I passed through Bareilly, where I heard that the communal trouble had flared up and stringent measures had been taken by the U.P. Government. Passengers in the train were talking about incidents in connection with that. There was a gentleman in my compartment who looked sedate and sober with a Congress cap on his head; and another who though an Indian was dressed in European style. Both of them were discussing politics—I mean communal politics—one with an English and the other with a Hindi paper in the hand. I was silent, listening to their

talks. The gentleman with European dress was foreseeing a civil war, if things were not set right even at that stage. But was there any chance of the things being set right?

* * *

I arrived at my destination—a city in the U.P. where the Mohammedan population preponderated. Naturally, I expected communal tension, if not an actual communal trouble. But strange to say, the atmosphere was free from such things. People moved about freely—Hindus and Mohammedans—without any fear and anxiety. I could instinctively feel that I had come to a safe zone.

In the evening I went out in a *tonga*. Before I had gone far, I found a motor-car following me, and from that a hand was beckoning to me. I stopped my *tonga* and saw that a friend had come to meet me. He hailed from the Punjab—a place which had suffered tragically from the communal frenzy—and he was Hindu. He was accompanied by a Mohammedan gentleman. When we met, this Mohammedan gentleman also talked with me in a way as if we were close friends. I was not ready to give him so much liberty nor did I think it proper to give vent to my inner feelings. I was just indifferent. My friend took me in his car to his home where I was to stay for the night.

The Mohammedan gentleman also was with us and he was talking with me more and more familiarly. I was a bit surprised. I thought it was so unusual. But afterwards I found that my friend and the Mohammedan gentleman stayed in the same building and they were close friends. It was therefore that the Mohammedan gentleman treated me from the very beginning as if I was their common guest. When I was alone, my friend told me that this gentleman was an exceptionally good man and gave me some concrete instances of his goodness. But I cannot say I was even then off my guard and suspicion. Have we not heard of many stories how certain Mohammedans befriended the Hindus

and afterwards betrayed them most treacherously at the critical hour? So I thought it was better to be at a safe distance from such people. But this gentleman's behaviour was so cordial, sincere and guileless that he over-powered my suspicion, and tiding over my inner difficulties I began gradually to be free with him.

He was a Moulvi, about fifty years of age but looking much older, wearing spotlessly white clothes from his cap on the head down to his *pyjama*, looking dignified but not stylish or foppish. He commanded respect but disarmed fear. He was the pink of courtesy in his talks and behaviour—and it was so spontaneous that even a stranger would at once feel at ease in his presence. In spite of the fact that my host was all attention to me, on his own initiative this gentleman saw to it that nothing was left undone about my comfort and convenience; so much so that I was almost embarrassed and did not know how to thank him sufficiently.

Now it was the time for his *namaj* and he took leave of me. At night when we had finished our dinner, he again came to me and we discussed many things. By now I had completely got over my suspicion of this man and could freely join in the conversation with him.

After some time when the gentleman went away, I sat alone in the veranda looking at the wide open space in front over the top of the rows of buildings, some ancient, some new, some half-dilapidated. It was a moonlit night, and an atmosphere of peace enveloped the area. This was a Mohammedan area. But what is it?—I see a long spire in a building, with an emblem which indicated that it was a Shiva temple. A Shiva temple in such a congested Mohammedan area! In great wonder I enquired of my friend what that building was. He said that it was a Shiva temple, but the Mohammedans honoured it as much as the Hindus of the locality respected the religious sentiments of the Mohammedans. The Hindus, though very small in number, lived

here very safe and without any fear and anxiety. The relation between the two communities was very amicable, and it was not surprising that the temple stood there at a short distance from a mosque. I breathed a sigh of relief. I only wished that such a state of affairs could continue for long.

* * *

I slept in the open under the canopy of the starry sky, with the moon gazing at me. For a long time in the past I had not experienced such peace. In Calcutta I lived in an atmosphere that acted on one's nerves. Amidst the jumbled up sounds of a noisy city like Calcutta, very often I would seem to hear the cry of *Allah ho Akbar* or its counter reply, *Jai Hind*; and though it might be a radio song at a distance, I would hear in it the cry of the two communities fighting each other. In such an atmosphere one was not free from subconscious anxiety even while in one's bed at night. But here everything was still and calm. It was a unique experience for me.

In the morning I found some servants carrying something from the neighbouring quarters to our room. That was some food for breakfast sent by the Mohammedan gentleman—food that was judiciously selected so that it might not go against the caste prejudices of any Hindu. Some children came to see me. They were the little son and the daughter of the kindly Moulvi.

When we had finished our breakfast, the Mohammedan gentleman came, apologized that he could not come earlier, and enquired if I was quite comfortable. My host soon went to his own work and I was left alone with the new-comer. Now the conversation became more free on both sides and soon it warmed up. He was talking in Hindustani and I in broken Hindi. In his talks there was a good mixture of Urudu words, which at times I found very difficult to follow. But he was talking such wise things that I strained

myself to the utmost to catch and understand every word that he uttered. It was at this time that I knew he was a Moulvi and a deeply religious man. Of his own accord he began to say:

Man is born and dies. But everybody wants to cling to his personal possessions. Few men are there who are not selfish. Every one wants to be happy and enjoy the world. But few succeed. The foolish man forgets that the only way to become happy is to try to make others happy; the only way to enjoy the world is to serve others, and that wholeheartedly. We acquire wealth, but it is not for our personal enjoyment, it is for distribution. We get power, but it is not for oppressing others or feeding our vanity, it is for serving others. The rich and the powerful should look after the poor and the weak, just as God—the richest and the most powerful being—protects the rich and the powerful in the world. The more the advantages the greater the responsibilities. We forget this simple fact, consequently there is so much trouble in the world. The rich want more riches and the powerful men want more power. Hence there ensue fight and quarrel between man and man, between nation and nation, till civilization is on the verge of destruction and the whole world has turned into chaos.

The Moulvi Saheb continued,

After all, what does a rich man get from his riches? Rather he is worse because of his riches. He gets plenty of things to eat, the result is he gets stomach troubles and dyspepsia. Whereas the poor man has not much to eat but whatever he eats he enjoys, digests and assimilates, and he becomes healthy and strong. The rich man has got a comfortable bed to lie on, but he gets no sleep. The poor man works hard throughout the day

and sleeps soundly, wherever he lies down—sometimes on the bare earth, sometimes on a wooden plank. Who is happier? The poor man, because of his physical labour, develops muscles and strength, he can stand the strain of life. The rich man becomes a weakling and suffers as long as he is on earth. So the rich man has ultimately no real advantage. On the contrary, if he can forget himself in the service of others, he will become really happy.

The gentleman continued, developing his theme and emphasizing his idea. I found how wonderfully he was giving the solution of the problem which communism is trying to solve through hard and sometimes bloody struggles. And it must be noted that he was not in touch with modern thoughts or the trend of world events.

The Moulvi Saheb gave an instance from the life of Hajrat Mohammed illustrating how the services to others bear wonderful fruit. There came a guest to the house of Mohammed. Though the Prophet had many attendants and followers, he himself looked after the guest—serving his meal, spreading his bed and so on. When his followers remonstrated and tried to take away the works from him, the Prophet said that, because the stranger was his guest, he must personally serve him. Enjoying the hospitality of the great Prophet, the guest ate so much that at night he made his bed unclean. And for fear that he might be found out in the morning, he fled away before it was dawn. But in a hurry he forgot to take his purse which contained a pretty big sum. So he had to return, risking all trouble and embarrassment. When he came back, what did he find but the Prophet himself washing his bed! The guest was so very much impressed and moved that he embraced Islam and became a staunch follower of the Prophet.

'This episode pointedly indicates how love and service pay. And that is the idea which one should follow', the Moulvi Saheb said.

He was talking many other things in this connection which I could not exactly follow. But I wondered what wise words were pouring forth from his lips. I felt serious and was struck with the depth of his thought, though this man did not seem to have any modern education. I could guess that these good thoughts which he had gathered from Arabic literature had coupled with the experiences of his good and conscientious life.

His words made me bold. Especially as I saw that he had no trace of communalism in him, I asked what he thought of the Hindu-Muslim trouble in the country. Till now I had very carefully avoided this topic. When I found that this man was absolutely above any communal spirit, I felt curious to know what his opinion was in the matter. To my query the Moulvi Saheb at once replied: 'This Hindu-Muslim trouble is the creation of British diplomacy in India. The British have created this problem to serve their own interest, and we fools—both Hindus and Mohammedans—have fallen into the trap. And, after all, how much do the so-called leaders feel for the poor and the masses! It is the latter who suffer from the communal disturbance while the leaders live in their citadel of safety.' And he illustrated how the poor were intensely suffering in some places. In the course of conversation, he expressed his strong resentment at the ghastly things that had been happening in the country.

It was time for me to make arrangement for my departure. So the Moulvi Saheb took leave of me. But he left me not without showing much concern for my needs and requirements. And he was so genuine in his feelings! After a long time I found myself in an atmosphere and in the presence of a man who made me feel, 'I am not a Hindu, you are not a Mohammedan. We are all men—fellow-beings—to help one another in this journey of life and then to go to Him who has no communal label.' Literally I forgot that I was before a Mohammedan, the misdeeds of whose community had given rise to so much resentment in me.

And I found myself in an atmosphere in which I could see things from a right perspective and free from all personal prejudices.

I am grateful to this man, whom by a mere chance I met. I bade him goodbye and parted from him, but his words are ringing in my ears and his figure in white dress comes now and then before my mind's eye.

* * *

The problem still remains: what to do with the country-wide communal disturbance? How to tackle it? There may be a good Hindu or a good Mohammedan whose character is ideal, who is above communal feeling, who can radiate peace. But will the influence of such men be able to counter-act the frenzy that is sweeping the country from one end to another? The Moulvi Saheb I had met was perfectly right when he dismissed the whole problem by saying in his clear and unsophisticated words that it was a political question. Political questions can be solved only on the political platform and not on any religious understanding.

It is indeed true that the religious sentiment in man rather than in the masses, is very powerful. When roused it can do wonders or work havoc as the case may be. But religious maxims will avail nothing when political forces are at work. For, religious maxims can be put fully into practice only by a few—very few. Buddha talked of love, Christ talked of charity, but the world is witnessing war after war, accompanied by inhuman acts of brutality. Incarnations have come, prophets have proclaimed their messages, saints have shown exemplary lives, but still there are large numbers of people in every country, society, and community whose criminal instinct necessitates the existence of law-courts, the police, and even the military. No use denying facts. The world is a hard reality. One must face this reality.

So, if the communal question is the by-product of the bigger question, viz. the political problem, that must be

solved first. Some said that a Noakhali and Tipperah were symptoms of the disease that had been injected into the body politic of India by interested parties in England. So the problem can be solved only there.

But that is an issue which is outside my sphere and which I am not competent to discuss. In the meantime it is a great solace and satisfaction to me that humanity has not altogether been shorn of moral virtues and high idealism. Even at a time when the communal tension has gone very high, I came across a man whose innate sense of the true relationship between man and man put to shame my communal rancour and soothed my heart which had been lacerated with communal resentment.

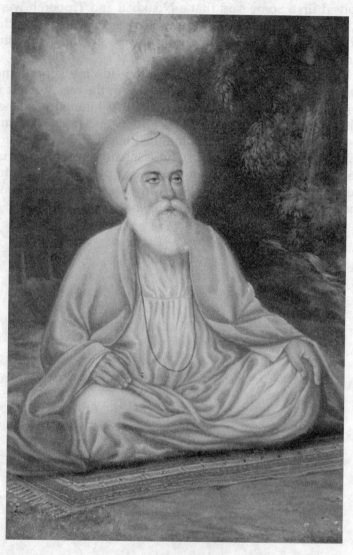

Guru Nanak Dev Ji (1469–1539)

SIKHISM AND ITS PRINCIPLES

Bawa Budh Singh

This grand religion, or sect, whatever you like to call it, was founded by Baba Nanak in the reign of Babar, the first Moghul Emperor of Delhi. The founder of this religion preached Monism throughout India, Ceylon, Afghanistan, Arabia and many other countries,—and many became his followers. The same mission was carried on by his successors, the nine Gurus. Guru Arjan Dev, the fifth Guru, collected the songs composed by the former Gurus, himself and other Bhaktas into one volume, and named it Granth Adi, which has become the religious book of the Sikhs. For this labour, death was his reward from the Emperor Jehangir.

It was the tenth Guru, the great Guru Govind Singh, who transformed the meek and humble Sikhs—disciples, into the brave and courageous Singhs—lions. This change was necessary to save the Hindus from the tyranny of the Moghuls, and it came on a grand scale. This change was, as usual, not without bloodshed and sacrifice. The Great Guru sacrificed his own father, his four sons, innumerable friends and disciples, and ultimately himself, in the cause of Reformation and Defence of Hinduism.

I am not going to enter into details of the different enterprises and hardships which the Great Guru and his followers undertook and suffered—I will only sketch briefly the principles of this wonderful religion. I am proud to say that this is the only existing religion on the face of the globe according to which, supremacy both in the physical and spiritual planes can be attained hand in hand. To say anything about the physical supremacy of the Khalsas is redundant, because their excellent military career is well-known to everybody in the world. What we have now at hand is to show the spiritual supremacy of the Khalsas. I do

not profess to show that there is anything in it other than the true Vedanta, but so much I dare say, that whatever is in the Granth has not been taken from the Vedas, because neither did the early founders of this religion have any knowledge of Sanskrit, nor did they become the disciples of any Vedantist of the time; because Guru Nanak, the founder of this religion, was a born prophet and was the disciple of no earthly man; and lastly, because at that time the study of Vedanta was in eclipse. Whatever is recorded in the Granth is the result of their own investigations on the spiritual plane. As truth cannot vary, so the teachings of the Granth coincide with those of the Vedas.

Again, on the spiritual plane the teachings go on two parallel lines—Dualism and Advaitism. The main portion of the Granth, as is the case with the Vedas, is full of Dualistic teachings. This is because the Advaitic system is not understood by the common people. 'It (Advaitism) is too abstruse, too elevated,' says Swami Vivekananda, 'to be the religion of the masses.' During the time when Baba Nanak appeared, religion in Punjab was in a degraded state. It was necessary to raise it to its natural level, and this could only be done by preaching Dualism to the masses.

According to Dualism, we are to imagine God as someone not human, He (God) being infinite, beyond description, elevated, having no shape or colour or destiny, and free from all *gunas*. Guru Nanak says:

> God is high, unfathomable, boundless; He cannot be described, He is beyond description. Nanak says, Prabhu has the full power to take one under His protection.
>
> He has no shape, colour and destiny. God is free from three the *gunas*. O Nanak! He can make Himself known to him with whom He is well pleased.

This system also states that God is omnipresent, penetrating all things, etc. The chief duty of a person is total

submission and resignation to the Lord. Many passages from the Granth may be quoted to this effect, but only one or two songs will suffice here:

'The Lord is penetrating all things. He is not unequal at any place. Nanak says He is with us in the outer as well as in the inner world.'

True Bhakti or Self-devotion is expressed in the following song by Guru Arjan Dev:

Keep me under thy protection, O Lord! through thy kindness. I know not how to serve thee, I am quite ignorant. I boast on thy account, O Beloved! We wicked err many times. Thou art the forgiver. We sin millions of times. Thou art free from all *gunas*. We live in the company of evil, and abhor thy worship; these are our acts. Thou givest every thing through thy kindness, but we are very ungrateful. We have fallen in love with the things given and have turned away our minds from the bestower. There is nothing outside thee, O Destroyer of sin! We are at your feet, save us, this is what Nanak says.

On the other hand, coming to Advaitism we find the sublime teachings, viz. everything in the world is Brahman. There is no duality, all is oneness; the greatest aim of our existence is to realize the Self. Here a few pieces from the Granth may be quoted with advantage, as showing its affinity to the Advaita Vedanta. Guru Nanak says:

Omkār is pervading all things. In the heart dwells the pure Lord God. There is no difference between Ishwara and Jiva, the saint as well as the thief are Brahman. From the mighty elephant to the tiny ant the one Brahman is pulsating. He is the sole cause and Himself is the effect, yet He does not do anything. He is like the sun by whose energy everything in the universe is done, yet the sun is not the doer....He can know the

arrangements of this universe who believes himself to be the pure Advaitin....One absorbed in Atman is not different from It. How can there exist distinction between two waters when mixed?...There is nothing except the Lord, O Nanak! *Om Soham*. I and Atman are the same Lord Brahman.

In another place it is said, 'He who has known his own self,' says Nanak, 'is the true knower'; or, 'See one in all,' says Guru Arjan Dev. Here we find the highest idea of Vedanta before us. In order to realize this idea one must be raised to the highest stage of spirituality, and this can only be done by passing through the intermediate stages. The attaching of sole importance to one stage or another has been the chief cause of many quarrels and fights among different religious sects. A seeker after truth has to pass through all these different stages, from the lowest to the highest, from the low humility to the high royalty.

Thus can the path to Salvation according to Sikhism be briefly described. The first and the chief thing in this path is to have a strong desire to obtain Moksha. Have a desire and it shall be fulfilled. Sow a seed and it shall bring forth fruit. Not every seed sown is always fruitful, and so not is every desire fulfilled. The seed must be thrown into good ground and should be well cared for. Desire must be created in a calm mind and must be strong in order to bring forth any good result. Everyone may possess a desire to attain Moksha, but everyone's desire is not strong. The desire may be the strongest of all and yet not strong enough to surpass the opposite action of the sum total of other desires. To make the desire strong enough to subdue other forces, help must come from outside. This is the kind of help which is got from the writings of the saints. A candle lights up a dark room where the light is dim; thus the writings of the sages light up the dim minds having the light of craving to obtain Moksha, the craving being already present in a weak state.

First of all let the worldly pleasures be seen to be fleeting and unreal, and one will be tired of enjoying these inconsistent joys. Let the idea of death be brought vividly before one's eyes, and one will be wearied of this life of sorrows. Naturally there will spring up a desire to get perfect bliss and everlasting happiness.

No song puts before our mind's eye the false love of the world more vividly than this:

False love is seen in the world. Every one, be he a friend or a relation, in this world is interested in one's own comfort. Every one says, "It (the world) is mine, it is mine", and every one has given up oneself to its charms. None is our companion at the last moment— that is a strange custom. This ignorant mind (manas) does not accept my advices, I am tired of advising it every moment. One who sings the praises of the Almighty, says Nanak, is beyond all these cares and anxieties.

How beautifully do the following couplets describe the mutability of the world:

Both Rama and Ravana, who had long lines of progeny, have passed away from the surface of this globe. Say, O Nanak! there is nothing permanent, the world is like a dream. Everything that has come into existence will vanish today or tomorrow. Nanak says, sing the praise of the Lord and leave all other bondages.

Spiritual desire has been created in the mind; now is the time for devising some methods to satisfy it. The spiritual Master, the guru, can teach us these methods. It is of greatest importance to take the advice of a guru before walking the road of spirituality. Once the royal road of Jnana is known, one can reach the magnificent town of Moksha. None can reach the town without knowing the

road that leads to it. Many roads may lead to one and the same town, and it is the guru who points out the proper road to an unacquainted person. It is not right for a person to question the accuracy of his guide's words. One who demands for himself, even before starting, the plan of the road will never reach the town. He who tries to find out the true way by himself will wander hither and thither in the wilderness, without success. It is said:

'If there be a hundred moons or a thousand suns (of wisdom), besides so much light still, it is all darkness without a guru.'

Many among the Sikhs are of the opinion that everything needed for a seeker after truth can be found in the religious scriptures, and hence there is no need of a living guru at the present time. No doubt, everything is there. There is Bhakti for one, repetition of the holy names for another, Yoga for the third, Brahmajnana for the fourth, and so on. How can one know which of them suits one best? The religious scriptures are like a medical hall wherein are stored medicines of all description. A patient cannot cure himself by taking some medicine without a doctor's advice. He ruins himself who does so. A good doctor's advice is necessary to get rid of diseases. A religious patient must find out some spiritual doctor who may, after examining him carefully, prescribe the proper medicine for him from those very scriptures, the storehouse of spiritual cures.

The scriptures are like the books of music—wherein are recorded the different tones of the various notes and the different modes of singing the different *ragas*. Can a person learn by himself music from these books? No, never. A master is required to teach the pupil, first by singing himself, the true sounds. Thus a guru is essential to tread the path to salvation. Having found a guru, a Sikh (disciple) must act up to his advice. A Sikh must have the greatest regard for his guru, the greatest faith in him. Let the guru be for a Sikh the representative of the Lord, nay the Lord Himself. Thus can a true Sikh cross the ocean of Maya

safely in the boat of his *prema* (love). A Sikh must resign himself to his guru. It is said:

All actions of a Sikh are useful who sells his mind to the guru. The Sikh who by serving his guru becomes desireless finds the Lord. Transmigration of the soul ceases by the worship of the most high. Resign thyself to the protection of the guru. In this way can the pearl-like life attain perfection.

How to find a guru is now the problem before us. A strong desire for and prayers to the Almighty are sure to help us find a guru. In the Guru Granth there are many prayers, such as:

'If thou be kind to me, help me, O Lord, to get a guru and repeat Thy holy name Hara, Hara.' There are also given the distinguishing features of a guru. The definition of a satguru as given in the Granth is, 'He who has known the Sat Purkh is a satguru.' In another verse it is said:

'He is a satguru in whose company our mind gets happiness, the restlessness of the mind vanishes and perfection is attained.' Through the kindness of the guru— kindness which is the result of the Sikh's own faith in and love for the guru—Brahmajnana, or the knowledge of Brahman, is got and the Sikh becomes a Brahmajnani. It is said:

'One becomes a saint if the guru casts even a kind glance.' Then all duality ceases, the Sikh becomes the guru, nay Brahman Himself, as is said, 'A Brahmajnani is the Lord Himself.'

The Sikhs in the time of the first five Gurus were natural-ly meek and humble, like the ideal sheep of Christ. On the other hand, the Mohammedans were religious tyrants. To destroy the kafirs was their greatest aim. They had recourse to sword and policy. To a great extent they did succeed, as is proved by the fact that the main portion of the Mohammedan population in India consists of Hindu converts.

The great Sikh Gurus were worshipped by the Hindus as Avatars. All went well during the reigns of Babar, Humayun and Akbar, perhaps on account of political disturbances of the first two reigns and the reconciliatory policy of Akbar. But on the accession of Emperor Jehangir to the throne, the fifth Guru Arjun Dev, the compiler of the sacred Granth Adi, was tortured to death. The Sikhs were terrified at this horrible event. Their peaceful spirit was not the only thing wanted at that time; something more was needed.

The next Guru, Hargovindji, was a spiritual guide as well as a warrior. A Pir and a Mir. He was the first Guru who infused some military spirit into the Sikhs. But his successors were not warriors. The tyranny of the Mohammedans was at its zenith in the reign of Aurangzeb. All India shuddered at his name. The Hindus were in the greatest distress. Their lives and property were not safe. The ninth Guru was beheaded in cold blood at Delhi, because he refused to give up his religion. A change was at hand. Guru Govind Singh, the last of the Sikh Gurus, appeared at this critical period on the stage, with a sword in hand to annihilate the tyrants and rescue the oppressed.

With him came the long desired for change. The meek sheep were turned into bloody wolves, the sparrows (to quote the Guru's words) killed the falcons. The humble Sikhs became the great warriors Singhs. The form, the dress and the language of the Sikhs were quite changed. A Sikh was reborn after being baptized in the new fashion. Shaving of the head and face was forbidden. A simple and most serviceable dress was introduced. Their language became a language of war and pomp. A single Singh was called an army of 125,000. Their salute became 'Sri Wah-i-Guruji ka Khalsa, Sri Wah-i-Guruji ki Fateh'; and their war cry, 'Sat Sri Akal'. Insignificant things were given great names in the khalsaized language.

The composition of the tenth Guru was of quite a different material from that of the first Gurus. It was full of

military spirit and vigour. Those very things which had been taught in a peaceful manner by the nine Gurus were preached in a warlike tone by the tenth. The difference becomes quite clear by looking at the first stanzas of 'Japji' of Guru Nanak and 'Japji' of Guru Govind Singh.

The tenth Guru introduced a kind of baptism—*Pouhal*. This baptism was really a charm. As soon as the Sikhs—the Kshetries, Jats, Banias and men of other timid classes, who trembled from head to foot at the sight of a Moghul soldier, were baptized, they became transformed into warriors. Grand were their enterprises and works. It is because of the effect of this *Pouhal* that in the four quarters of the world the Sikh soldier is known.

Baptism is essential for a Singh. A baptized Sikh is ordered to carry five *Ka*'s about his body, viz. (1) Kaish—hair, (2) Kanga—a comb, (3) Katch—a kind of breeches that do not cover the thighs, (4) Karpan—a kind of knife, and (5) Karra—an iron bracelet. He is also required not to smoke or even touch tobacco; to behave like a true knight; to be pure and moral; not to be overpowered by worldly desires and pleasures; to defend the weak, etc. In this way a Sikh is the true type of the Kshatriya of yore. Universal fraternity is preached in Sikhism; no distinction of caste—all are one. Superstitions vanish here. All are free—no chains of any kind bind the Sikhs. They are free.

The leading star of a Sikh's life is that noble example set by the Guru himself by sacrificing his property, his parents, his family and, ultimately himself for the sake of the national good. Thus we see that it is in Sikhism alone that the two extremes—spiritual and material ascendencies, meet.

military spirit and vigour. Those very things which had been taught in a peaceful manner by the nine Gurus were preached in a warlike tone by the tenth. The difference becomes quite clear by looking at the first stanza of Japji of Guru Nanak and Japji of Guru Govind Singh.

The tenth Guru introduced a kind of baptism—Pahul. This baptism was really a stirring. As soon as the Sikhs—the Kshatriya Jats Jeans and men of lower Hindu classes who trembled from head to foot at the sight of a Moghul soldier, were "baptised" they became transformed into warriors, and went their ways and works. It is the effect of this baptism that in the four quarters of the world the Sikh soldiers known.

A pilgrim is requested for a Singh ... Baptized Sikh is enjoined strictly five Kars about his body, viz. (1) Kaish—hair, (2) Kanga—a comb, (3) Kirpan—a kind of bracelet that do not cover the thighs, (4) Kirpan—a kind of knife, and (5) ... From the individual is also required not to smoke or even to ... tobacco. To behave like a true knight or be true and proud, not to be overpowered by worldly desires and pleasures, to defend the weak, etc. are the way a Sikh is the true of the Gurus by real principles, fraternity is preached in Sikhism, no distinction of caste ... all are one cooperation amongst them. All men are no drams of any kind and be like a ... They are one.

The teachings of a Sikh are that he is that noble example ... is by the Guru himself by sacrificing his property, his parents, his family, and ultimately himself for the sake of the nation's good. Little wonder then that in such in short that the two extremes—spiritual and material according to need.

Section IV

THE HOLY TRINITY

WHAT SRI RAMAKRISHNA
MEANS TO ME

Rev. Andrew B. Lemke

Man is born to suffer over the meaning of life and, by deep yearning, to realize God; and the scriptures are both the record of that suffering and the revelation that comes in answer to that yearning.

Each generation of mankind is a repetition of the preceding generations. Therefore, the suffering, the yearning, and the revelation are a continuing process. The record is never closed, the revelation is never once and for all time delivered unto the saints.

In the fullness of this modern day the agelong record has been amplified and a brilliant revelation has illumined the heart of man in the person of Sri Ramakrishna.

The record of this remarkable man's life and sayings is contained in the *Gospel of Sri Ramakrishna,* and in the writings promulgated by the Order of monks which bears his name. Many others, as well, have put their hand to the loving task of creating a record of appreciation, among them such notables as the great Orientalist and Sanskrit scholar Fredrich Max Müller, and the popular French author Romain Rolland.

The record came to my attention fifteen years ago when Swami Nikhilananda of the Ramakrishna-Vivekananda Center, New York, published his thousand page translation of *The Gospel of Sri Ramakrishna. Time*, a weekly newsmagazine, carried a review which hailed *The Gospel* as unique in the field of hagiography, and in the review presented pictures of Sri Ramakrishna and Kali the Divine Mother of the Universe.

What can one say about these pictures of Sri Ramakrishna and the Divine Mother? It is as though one were

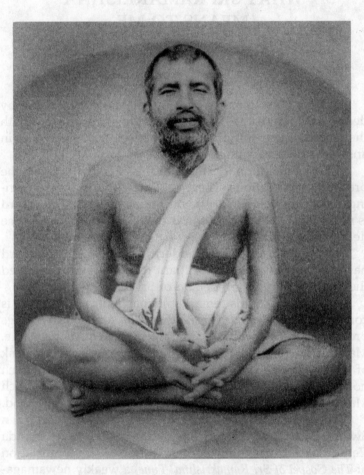

Sri Ramakrishna (1836–1886)

stopped dead in his tracks. The sensation of abrupt and sudden stillness after years of inward turmoil! The overwhelming conviction, 'I believe this is it....you have found what you have been looking for...how strange that the answer to yearning should come so unexpectedly and casually, and from such a great distance as India...you had better send for this book promptly and verify the impression.'

Immediately an order was posted in the mail to a Boston bookstore for a copy of *The Gospel of Sri Ramakrishna*. In due time it arrived, and in the subsequent reading came the fulfilment of every expectation.

Anyone who is attracted to Sri Ramakrishna will feel an instant kinship with Mahendranath Gupta, known as 'M', the author of the *Gospel*. On the very first page of chapter one when he describes the first time he met the Master— this chapter bears the title, 'Master and Disciple':

It was a Sunday in spring, a few days after Sri Ramakrishna's birthday, that M. met him for the first time. Sri Ramakrishna lived at the Kalibari, the temple garden of Mother Kali, on the bank of the Ganges at Dakshnineswer.

M., being at leisure on Sundays, had gone with his friend Sidhu....They arrived at the main gate at dusk and went straight to Sri Ramakrishna's room. And there they found him seated on a wooden couch, facing the east. With a smile on his face he was talking of God. The room was full of people, all seated on the floor, drinking in his words in deep silence.

M. stood there speechless and looked on. It was as if he were standing where all the holy places met and as if Sukadeva himself were speaking the word of God, or as if Sri Chaitanya were singing the name and glories of the Lord in Puri with Ramananda, Swarup, and the other devotees.

...M. looked around him with wonder and said to himself: 'What a beautiful place! What a charming man!

How beautiful his words are! I have no wish to move from this spot.'

The Gospel is a record of the conversations which the Master Sri Ramakrishna held with people of all walks of life on every conceivable subject that is dear to the heart of the religious man. He speaks of the most profound things with utter simplicity and clarity. His parables, anecdotes and imagery are incomparable. The body was fragile, but the fragile body housed a spirit that was sheer compassionate strength. The Master in his life and teachings created a reservoir of grace that will resolve the doubts and conflicts of the honest seeker of truth, and ally all his fears. He is indeed the modern saviour of mankind.

This is the place to illustrate the truth of what we have said about Sri Ramakrishna. We live in an age of scientific wonders, and very likely are troubled about mechanistic philosophies that explain everything in terms of law, and we ask the question, 'Can God violate law?' Or, we see all about us examples of apparent inequalities of wealth and suffering, and we ask the question, 'Is God partial?' And we observe in God's creation that everything that is born must die, and we ask the question, 'Though creation may be God's pleasure, is it not death to us?' These are the very questions which a seeker of truth named Nanda asked the Master. His answers penetrate to the heart of the matter:

Nanda: 'Can God violate law?'
Master: 'What do you mean? He is the Lord of all. He can do everything, He who has made the law can also change it.

'But you may very well talk that way. Perhaps you want to enjoy the world, and that is why you talk that way. There is a view that a man's inner spirit is not awakened unless he is through with enjoyment. But what is there to enjoy? The pleasures of woman and gold? This moment they exist and the next moment they disappear. It is all momentary. And

what is there in woman and gold? It is like the hog plum—all stone and skin. If one eats it, one suffers from colic. Or like a sweetmeat. Once you swallow it, it is gone.'

Nanda remained silent for a few minutes. Then he said: 'Oh, yes. People no doubt talk that way. But is God partial? If things happen through God's grace, then I must say God is partial.'

Master: 'But God Himself has become everything—the universe and its living beings. You will realize it when you have perfect Knowledge. God Himself has become the twenty-four cosmic principles: the mind, intellect, body, and so forth. Is there anyone but Himself to whom He can show partiality?'

After singing a song about the Divine Mother's sweet will, Sri Ramakrishna continued: 'The Divine Mother is full of bliss. Creation, preservation and destruction are the waves of Her sportive pleasure. Innumerable are the living beings. Only one or two among them obtain liberation. And that makes Her happy. Some are being entangled in the world and some are being liberated from it.'

Nanda: 'It may be Her sweet will; but it is death to us.'

Master: 'But who are you? It is the Divine Mother who has become all this. It is only as long as you do not know Her that you say "I", "I".

'All will surely realize God. All will be liberated. It may be that some get their meal in the morning, some at noon, and some in the evening; but none will go without food. All, without any exception, will certainly know their real Self.

'Try to find out what this "I" is . Is this "I" the bones or flesh or blood or intestines? Seeking the "I", you discover "Thou". In other words, nothing exists inside you but the power of God. There is no "I", but only "He". That ego is to be renounced.' (pp. 817–9)

Is not non-duality the heart of the matter? God is indeed the One-without-A-Second. In this unity all questions are resolved.

A few moments of honest introspection will make this abundantly clear. Let the aspirant mentally review his autobiography and then ask himself if his ego-centric experiences are worth preserving for ever, if immortality is desirable for the ego-centric self. In the light of this honest insight, he will rejoice to say, 'Thou! Thou!' To die to the little self, and to merge in the Supreme Self, is surely pure gain. 'That thou art.'

Then let him mentally review the secular biography of mankind which bears the caption 'history', and readily he will see that historical events are 'like the grass which groweth up. In the morning it flourishes, and groweth up; in the evening it is cut down, and withereth.' Nothing exists but the power of God.

However, Sri Ramakrishna did say that there is no harm in retaining the ripe ego, only the unripe ego must be renounced. One must retain a little ego if one wishes to enjoy the glory of the Lord. Sri Ramakrishna expressed it this way, 'I do not want to be sugar, I want to taste sugar.' It is the unripe ego that must be renounced—'That ego is to be renounced.'

What an amazing book *The Gospel of Sri Ramakrishna* is! A thousand pages of inspiration and wisdom. And, behold the man revealed in these pages! Is He not the Lord of the universe? Is he not the modern saviour of mankind?

This is what Sri Ramakrishna means to me.

There remains to say a closing word about the need of a teacher. In order to assimilate the sayings and life of Sri Ramakrishna a teacher is essential. The Master himself said that one can never really know what butter is by merely hearing about it, or even seeing it, that to know what butter is one must taste butter. On his own the student can read the *Gospel*, and rejoice in beholding the Lord, but to assimilate the profound instruction a teacher is necessary.

By the grace of the Master it has been my great good fortune to have for the teacher the same Swami Nikhilananda who translated *The Gospel*, a dedicated monk of the

Order of Sri Ramakrishna, completely at home in both Eastern and Western cultures.

During fifteen years of instruction, he has imparted the knowledge of Vedanta, stressed the importance of an intimate familiarity with the *Complete Works of Swami Vivekananda*, and *Spiritual Talks* of the first disciples of Sri Ramakrishna, the Upanishads, the *Bhagavad-Gita*, the *Brahma-Sutras*; introduced the great epics *Ramayana* and *Mahabharata*; taught methods of meditation and concentration; held up the ideals of renunciation and continence; and, in frequent visits with him at the Ramakrishna-Vivekananda Center, New York city, and Vivekananda Cottage at Thousand Island Park on the St. Lawrence River, Swami Nikhilananda has shared his environment of holiness and devotion to the Lord.

So far no mention has been made of Sri Sarada Devi known by all followers of Sri Ramakrishna as the Holy Mother. This is not an oversight. Her sweet presence is never absent from the mind that dwells on the Master. To think of the one is to think of the other. They who were Rama and Sita, they who were Krishna and Radha, they have incarnated in modern times as Sri Ramakrishna and Sri Sarada Devi the Holy Mother. That which is called Brahman in the attributeless state, that which is known as Mother Kali or Brahman-With-Attributes, that has appeared in the flesh in this modern day as Sri Ramakrishna-Sri Sarada Devi.

What does Sri Ramakrishna mean to me? He is the Lord of the universe who has created in this modern day holy communion for the devotee.

SRI RAMAKRISHNA AND
THE MODERN WORLD

C.E. Street

Sri Ramakrishna is a saint of the modern age; anyone over seventy-one years old was born while he was still alive and teaching. And yet there is an apparent world of difference between the modern world and the quiet God-centred life he lived. What was he to say to an industrial civilization? Not only are western people overwhelmed by mechanical gadgets, but a new industrial revolution is made at least every generation. And this is rapidly becoming the ideal of Asian planners. The modern scientific intellectual climate tends to regard all questions of ultimate reality as meaningless, all questions, in fact, not capable of objective solution.

Moreover, the modern mind does have its idealism, which is adapted to an objective view of things, and which is not yet materialism. Many have high ideals of service to others, and devote their lives to that. Few churches lack persons with genuine religious feeling and saintly character.

What pertinence, then does Sri Ramakrishna have for us, close in time and far distant in culture and way of life? And if his life and words do have meaning, how is that to be adapted to different conditions and problems?

To begin with, it must be seen that there are problems which are problems of the modern outlook, and not simply challenges from outside. This is, in fact, a time of far reaching changes, of clashes of old and new, and an age without an accepted goal of life. The past complacency has been destroyed, first by two world wars, and also by the totalitarian extremes of fascism and communism, both products of the modern west. Many traditional religious

views have been overturned by science, while science, in its turn, has failed to take the place of that which it has destroyed. It offers an austere methodology, which is the final court of appeal for questions of fact. But it cannot answer questions of meaning. Even worse, it has unleashed terrible powers which society is scarcely able to control and direct; that which promised emancipation now threatens destruction. The resulting frustration, born of internal contradictions, hardly seems able to cure itself.

To seek help from a different way of life, then, is more reasonable than a superficial glance might indicate. Let us look at three areas in which the teachings of Sri Ramakrishna may help to resolve modern difficulties.

I

First of all, he gives us a rational mysticism. This involves two things: a goal of life and a mens to reach that goal, both free of dogma and in accord with a rational frame of mind. This is of the utmost importance, for the modern temper is one of violent reaction against mysticism. An extreme scientific agnostic will accept nothing that cannot be explained by objective means, and hence finds a mortal enemy in mysticism. He will give hypnotism and hallucination as explanations, and if that does not suffice, the whole affair of abnormal psychology is put into action.

The churches, while not formally opposed to mysticism, are usually indifferent. The ultra-orthodox wing emphasizes faith rather than direct experience, and is dogmatic rather than experimental. The liberal wing tends towards humanism, and emphasizes social idealism rather than spiritual seeking. Most lie somewhere in between, and only a few consciously engage in the mystical quest, although it must be admitted that there is a growing interest.

The centre of attention is more often fixed without, in science, in the historical side of religion, in the scriptures, in

personal morality, and in social idealism. Seldom is the searchlight turned within. In consequence, as the external things are overthrown or prove insufficient, the shallow foundations are exposed, and the result is disillusionment and lack of faith.

Sri Ramakrishna went straight to the heart of things. he directly said, 'He is born in vain who, having attained the human birth, so difficult to get, does not attempt to realize God in this very life.'

This, then, is the goal. Ramakrishna expressed it in a hundred different ways, and it underlies everything he said. It is not enough to put God first in an intellectual way, or merely through faith. That may be the beginning, but He has to be realized and made one's own. All activities, then, must be related to this goal, and are valuable to the extent that they lead towards it.

Sri Ramakrishna also would often say, using the ancient Vedanta expression, 'Brahman is true; the world is false.'

This expression, if carefully analysed and related to scientific concepts, may well have more modern appeal than talk of God. The formulation, however, is not the important thing. What is meant is that there is an ultimate realty, and there is nothing else to compare with it, nothing else by which we may evaluate it. One may define as rigorously as he pleases, and Sri Ramakrishna will not object if one admits that state beyond all definition, which is to be realized, and realized in this very life. That is the goal of life.

Further, nothing else has meaning except in relation to that One. Sri Ramakrishna's illustration was of the zero. It has no content in itself, nor does a long string of zeros. But when they follow the 1, the result is thousands and millions. Similarly, this multiplicity in the universe means nothing in itself, only in Brahman.

One path, then, is discrimination, with its companions dispassion and renunciation. Sri Ramakrishna taught the necessity of these on many occasions. For instance, he used

the illustration of rice boiling in a pot. One can determine the state of the pot of rice by examining only a few grains. Similarly, one may know the nature of this world by examining a few objects in it. By doing so, it is seen to be ephemeral, with all objects lasting but a short time. This is discrimination. Seeing this to be true, the mind turns from such transitory objects and directs itself to thoughts of God. That is renunciation. By such illustrations, Sri Ramakrishna sets forth the nature of spiritual practice in a vivid way.

He gives a whole course of spiritual practices, geared to individual requirements, and fully acceptable to the rational mind. At every point, one is surprised at his flexibility in meeting the particular needs of an individual seeker.

His exposition of the four main Yogas is well known and need not be described in detail. It may be mentioned how they are likely to impress modern seekers of truth. The practice of Jnana Yoga by means of discrimination will especially appeal to the modern mind. Even the most rigorous of scientific thinkers will be able to ask, 'What is true? What is real?' Thinking and analysing along that line will be sufficient, if done sincerely, and if the actions match the conclusions.

Raja Yoga, or meditation, will also appeal to moderns, as the value of concentration is evident, and as the subject of meditation is a matter of individual choice. The approach is experimental and rational.

Bhakti Yoga will, perhaps, appeal more to the person of religious temperament, dissatisfied by conventional creeds, but untroubled by scientific and intellectual difficulties. Even there, however, Sri Ramakrishna maintains balance and rationality, and complete adaptation to the individual nature. Further, as one begins to think more deeply, the necessity of controlling the emotions and making them co-operate in the search for truth begins to become evident. Also, such practices a japa, when considered carefully, will be acceptable to the modern mind.

Karma Yoga is important to all, since activity is common to all, even the contemplative. Naturally, in an action, conscious society, the right use of action is a major concern, and will be taken up at greater length in the next section. Here, it is sufficient to note that the practice of non-attached work is fully acceptable to the modern mind. It deals with attitudes, not beliefs, and is immensely challenging, as it entails an unending attention to the task.

Sri Ramakrishna's flexibility in meeting individual needs is also illustrated in other ways. Most religious teachers, for instance, would require some belief in God from their students. But Sri Ramakrishna accepted an agnostic, and instructed him to pray in this manner, 'O Lord, if you exist, reveal Thyself to me.' This resulted in the transformation of the man's life. Sri Ramakrishna thus had the most tender concern for each person, and a complete lack of dogma or sectarian spirit.

These teachings of Sri Ramakrishna speak to the situation of the contemporary world, and go to the very heart of the problem. What we have is a rational mystical path, a goal and means, well adapted to modern conditions. People of diverse temperaments, even the sceptical, will find something, some path that will help them to grow spiritually, that is rigorous, yet God-centred. This is the contribution of Sri Ramakrishna.

II

In the second place, Sri Ramakrishna gives us a balanced view of action and service. Here, too, the modern scene is confused. Action justifies thought, and there is an almost universal tendency to be practical, to ask, 'Does it work?' Intelligently applied, this is a valid attitude, but all too often an idea is considered good not because it is true, but because its acceptance gives some desired results. On the idealistic side, we find that doing good to others is the supreme virtue.

This also tends to be true in the churches. An excessive lack of concern in the past brought a reaction, the so-called social gospel, which puts the highest religious value on social idealism, combating poverty, eliminating war, relieving the oppressed, and so on. These are all necessary, indeed, compelling objectives, but that is not what religion means.

The orthodox wing of the church takes a somewhat different view. The emphasis is more on personal morality, which, except for temperance, seldom results in any social concern.

Most people would fall between these two extremes, but there is still a strong tendency to justify theology by action. There is seldom a real reconciliation between spirituality and action, between worship and work, and this easily leads to superficiality.

In Sri Ramakrishna, however, we get a better understanding of action and service, and of the conditions in which they may be of utmost value. As we have pointed out in the preceding section, the goal is always God Realization. Even the best work, the most idealistic service, is of slight value if it does not help those concerned, the helper and the helped, to come closer to God. Therefore, the performance of such activities, while it *may* reveal a spiritual nature, can never be a *test* of spirituality. Action is always a means, never an end.

Sri Ramakrishna said this to one devotee, 'Work is a means, if done unattached; but the end of life is to see God. Let me repeat that the means should not be confounded with the end—that the first stage on a road should not be taken for the goal. No, do not regard work as the be-all and end-all, the ideal of human existence. Pray for devotion to God. Suppose you are fortunate enough to see God. Then what would you pray for? Would you pray for dispensaries and hospitals, tanks and wells, roads and almshouses? No, these are realities to us so long as we do not see God. But once brought face to face with the Divine vision, we see them as they are—transitory things no better than dreams.'

Sri Ramakrishna emphasized two things as necessary for one to do any kind of action safely. First, it must be done without attachment. An illustration which he often gave is that of the servant girl who took care of her employer's children. She would show them great love, and even speak of them as, 'My Ram, my Hari.' But still she would know that they are not really her own, and her mind would be fixed on her village home. Similarly, those working in the world should not claim or think of any object in it as their own, and should fix their minds always on God.

Again, Sri Ramakrishna said, 'You cannot get rid of work, because nature will always lead you on to it. That being so, let all work be done as it ought to be. If work is done unattached, it will lead to God. To work without any attachment is to work without the expectation of any reward or fear of any punishment in this world or the next. Work so done is a means to the end, and God is the end.'

However, work without attachment is a subtle and difficult thing, and this leads us to the second point. All work or service should be preceded and accompanied by devotion, by cultivation of love of God.

Sri Ramakrishna said, 'In this age work without devotion to God has no legs to stand upon. It is like a foundation of sand. First cultivate devotion. All the other things—schools, dispensaries, etc.—will, if you like, be added to you. First devotion, then work.'

It was for this reason, then, that he often advised householder devotees to spend some time in solitude, doing spiritual practices. With a firm spiritual foundation laid, they could safely go into the world and do any work.

It will be seen that Sri Ramakrishna did not condemn work or social service, for he saw that this was necessary and unavoidable for most people. What he insisted upon was a firm recognition of what is the means and what the goal.

He put this clearly when he said, 'Do you talk of social reform? Well, you may do so after realizing God. Remember, the Rishis of old gave up the world in order to attain

God. This is the one thing needful. All other things shall be added to you, if indeed you care to have them. First see God, and then talk of lectures and social reforms.'

It remains to point out that, whatever the value of work and social idealism, there is also a place for worklessness. Some, a few, will be able to spend their time ceaselessly in contemplation of God. Indeed, the value of such a state cannot be gainsaid, if realization of God is the goal.

In this connection, Sri Ramakrishna said, 'Renunciation of work comes of itself when intense love of God swells up in the heart. Let them work who are made to do so by God. When the time is ripe, one must renounce everything and say, "Come, O my mind, let us watch together the Divinity installed in the heart".'

Here again, in the question of action, we see the individual emphasis. There is no 'party line' on work and service, for the needs and capacities of no two persons will be exactly alike.

The modern stress on action does have great value. Much has and will be accomplished because of it. It remains, however, to put it in its true perspective, and to see that it is not frittered away in aimless busyness. This will be accomplished by an understanding of Sri Ramakrishna's teachings on the subject. There is a goal, and there are ways to reach that goal. The right use of action is one of those ways.

III

The third lesson that Sri Ramakrishna has for the modern world is what is usually called religious tolerance. The word tolerance does not express the idea well, as there are important shortcomings in the ordinary belief in tolerance.

It should first be understood that ordinary tolerance, or the freedom to practice the religion of one's choice, is not a small thing. There is too much intolerance to be regarded

lightly. So the remarks that follow are not intended as criticisms of something which is essentially good. They are aimed, rather, at its improvement.

Belief in tolerance or religious freedom does not eliminate the sectarian spirit, and may even go hand in hand with outright fanaticism. This sort of tolerance is of the live and let live variety. Most real fanatics and sectarians are minorities, and therefore might be in danger of persecution themselves. It is safer to allow others to exist, even though they are considered to be dangerously in error.

Even where there is no sectarianism in any narrow sense, there is often a tendency to generalize, to conclude that truth is truth, and therefore applicable to all. The corporate nature of western religions encourages this tendency. This is probably more due to ignorance of other faiths than to actual exclusive attitudes. Even so, the superiority and finality of Christianity is usually taken for granted, even where it is not openly proclaimed.

There is a third support for ordinary tolerance in the religious indifference which is a mark of modern times. Those who have no faith in religion are perfectly willing for anyone to be religious in any way he chooses.

Sri Ramakrishna provides a needed corrective to these ordinary ideas of tolerance, and gives a solid foundation for the relationship between faiths and religions. The basic statement of his view is, 'All paths lead to the same goal.' He gave two main emphases to this statement.

In the first place, the goal is the same, however it may be understood, whatever the name that may be given to it. He gave many illustrations along this line, showing that the substance is the same, though with many variations of name and form.

One of his favourite illustrations dealt with the different names given to water. He said, 'As one and the same water is called by different names by different peoples, some calling it "Water", some "Vari", some "Aqua", and some "Pani", so the one Saccidananda—Existence-Intelli-

gence-Bliss Absolute—is invoked by some as God, by some as Allah, by some as Hari and by others Brahman.

He also used similar illustrations with clay, sugar, and gold, in each case showing that it is the same God that is worshipped in diverse ways, under diverse names.

In the second place, he gave a series of illustrations in which the great variety of paths is sets forth, each leading to the same goal. For instance, he said, 'As one can ascend to the top of the house by means of a ladder, a bamboo, a staircase or a rope, so also diverse are the ways of approaching God, and every religion in the world shows one of the ways.'

The paths are various, but all have the same purpose, the same function, and all lead to a common goal. Another favourite illustration of his was of the great variety of bathing ghats leading to a large tank. They all lead to the same Eternal Bliss, and therefore it is useless to consider one superior to another.

If this is once accepted, the relationship between various religions will become a healthy one. As Sri Ramakrishna said, 'A truly religious man should think that other religions are also so many paths leading to the Truth. We should always maintain an attitude of respect towards other religions.'

Another aspect of Sri Ramakrishna's thought on this is his complete recognition of individual needs and requirements. He often told the story of a mother cooking for her various children. One child, perhaps, could only take soup, while another would like a well spiced curry. Each would need a different dish, which the mother would lovingly cook. Similarly, each person has his own individual spiritual nature, and what serves for another may not be helpful to him. This can be regarded as both the explanation and the justification of his teachings about the fundamental truth of all religions.

Here, again, Sri Ramakrishna gives help for the solution of a current difficulty in modern life, and gives a new

dimension to ordinary ideas of tolerance. This, in fact, is probably the most distinctive of all of his teachings, and certainly is one of the most important. If tolerance can be replaced by respect for all faiths, and the individual nature of spiritual yearning recognized, it will be a giant step forward for modern western religions.

IV

It should be noted that much of the power of his teaching, in all three of the areas mentioned here, comes from the fact that there was an absolute identity between his words and his life. He did not teach a mystical theory; he taught what he had experienced. His life was an object lesson in non-attachment. And not only did he respect all religions, but he actually practised them and realized the truth of each. It was thus that he could speak with such authority and power that his worlds bear fruit in the modern world.

These three contributions, three among many, are indeed pertinent today. More than pertinent, for if understood and applied, they will provide correctives and solutions to many of our modern dilemmas. They deserve deep study and meditation. Then, indeed, there will be that true meeting of east and west, and we may march on together towards the Goal.

THE GOSPEL OF SRI RAMAKRISHNA

Swami Atulananda

There is a popular saying that prophets are not honoured in their own time and in their own land. Like most popular sayings, this one is also only partly true. But that great men often have passed through life unrecognized we have abundant proof of. Perhaps this has been so more often in the past than in our own time.

Geniuses have lived and died in abject poverty and neglect. They have often been persecuted, while their teachings or productions in after-years are recognized and appreciated with an enthusiasm as great as was the contempt with which they were treated during their lifetime. Jesus was nailed to the cross, Socrates was made to drink the cup of deadly hemlock, Loyola was burned alive at the stake.

In this respect the West has sinned more often than the East. In India at least it is not difficult to cite examples in plenty where prophets have been honoured in their own land and in their own time. Sri Ramachandra, Sri Krishna, Buddha Deva, Sri Shankaracharya, Sri Chaitanya, Sri Ramakrishna, and Swami Vivekananda are instances at hand. And when I cite these examples, I do not mean to infer that these messengers of light were universally accepted during their lifetime, but that at least they had a large following even while still on earth.

If it is true that like alone can know like, in other words, that genius alone can recognize genius, then it follows that the higher the genius towers above the run of humanity or above his immediate surroundings, the fewer will be his adherents.

And here we meet with a curious fact. If we look back through the ages and at our present time, what do we find? The records of history show that where the West has

produced a splendid array of recognized geniuses in worldly pursuits, India presents a galaxy of stars in the spiritual firmament unequalled in other lands. Where the West recognizes greatness expressing itself in terms of materialism, the East bows down to and worships spiritual attainment. Spiritual giants are born in the East not by accident, but because in the East alone are they recognized. In the East alone can their advent serve the purpose for which they incarnate. In India they enter upon fertile and cultivated soil ready to receive them.

The West opens wide her arms to inventors, scientists, organizers, kings of trade and commerce. The East welcomes saints and seers—*avataras* with a message from God.

Not long ago I met with a Christian missionary who presented me a curious argument. 'Krishna,' he said, 'makes the statement in the *Gita* that God comes to earth again and again whenever religion declines, to re-establish righteousness. Now, as God is supposed to have incarnated in different times in the East alone, and especially in India, it follows that in India there has always been the greatest need for Him, that in India there has been through all ages more unrighteousness than anywhere else in the world.'

My Christian friend, however, overlooked one fact, namely that the Incarnation does not come to benefit only one particular geographical spot, but comes for the good of the world. The fact that God incarnates in India only goes to show that here He finds the most favourable conditions by way of parents, surroundings, associates and social conditions. These not only make His birth here possible but also His mode of life.

The Incarnation, being born in a land where he could grow into manhood and preach unmolested His message, was not confined to His immediate surroundings. His message travelled far and wide till it reached the corners of the earth. This we see today when the messages of Sri Krishna, of Buddha, of Sri Ramakrishna are accepted even in the western hemisphere.

It may sound like a hard indictment, but had Sri Rama-krishna been born in the West, he would have hardly escaped being locked up in some asylum. It is therefore that he took birth in India, the only country today that would offer him the opportunity to express himself, to live his life unmolested by the people and authorities of the land. But his birth in India did not prevent his world-message from travelling to countries where perhaps it was most needed.

Let me hasten to say, however, that by making this statement about the West I do not mean to infer that the West is necessarily more wicked than the East. Her virtues in many respects often exceed those of the East. India would do well to emulate these virtues. I mean to infer only that spiritual genius is not recognized there as it is in India.

And why is this so? Because, as we have seen, the ideals of the Western nations are different. In the West we want activity, production, improvement, whatever comes under the heading of utility. And utility is used in the material sense. Whatever goes to increase desires and to satisfy these desires is welcomed in the West. The eastern ideal is the reverse. Here we welcome whatever helps to minimize our desires, to simplify life, to give satisfaction independent of material means. In other words, the Indian ideal is renunci-ation. And he who preaches and practises renunciation is honoured in this land, whereas in the West he is scorned.

For example, if we turn to the *Gita* and read the characteristic qualifications of a saint as given there by Sri Krishna, we must confess that these hardly fit in with the western scheme of life.

How can we recognize a man of realization? Arjuna asks. And his reply is: Such a man casts off all desires from his mind, he is satisfied in himself by himself. As a tortoise draws in his limbs, so the wise man draws his mind away from sense-objects. This is the Indian ideal: the man of renunciation, the man with his mind turned inward, firmly fixed on God.

It is about such a man, Paramahamsa Sri Ramakrishna, and about his gospel, that I wish to speak to you today. The

saviours of mankind, Sri Shankaracharya says, come to regenerate the world like the spring which brings forth new fruits and flowers. They come to help those who strive for liberation. They come to steer man across the ocean of this world; to take him to the haven of peace and blessedness. And this they do from a pure, unselfish motive.

The great Master Sri Ramakrishna was such a saviour. At the time of his advent about the middle of the last century (he was born on February 18th, 1836), the eyes of the people in the land of his birth were dazzled by the sight of western civilization. And Hindus, forgetting their own greatness as a spiritual nation, were blinded by the material propensity of other lands. Gradually their attention began to be directed towards physical well-being at the expense of higher ideals. They began to lose sight of the fact that, after all, human civilization to be lasting must rest upon a spiritual basis. For then alone can civilization lead humanity back to the great Reality towards which we must all proceed. Without this, life can have but little meaning or value.

Civilization when built on materialistic ideals will always remain a chaos. For unless the mind of a nation is strengthened and steadied by spiritual ideals, that mind will be subject to passions and selfish ambitions which in the end will work its ruin.

So once more Sri Krishna's promise, that he would come to earth again and again to teach humanity, found fulfilment in the birth of Sri Ramakrishna. For he was, as it were, the embodiment of truth and righteousness, and his whole life was an interpretation of the spiritual teachings which for ages have formed the basis of Hindu culture and civilization.

It was, then, at the time when India was in danger of following in the footsteps of the West, when she was in danger of changing her spiritual ideals for materialistic ideals and ambitions, that Sri Ramakrishna appeared. He led India back to her spiritual aspirations. And thus he not only saved India from destruction, but through her he also

taught all the world the path of truth and righteousness, the path that leads to the highest goal.

The West has always received her spiritual inspirations from the East. And the greatest among the western philosophers have been frank enough to admit this. Wonderful indeed are the philosophies of the West. Kant, Schopenhauer, Hegel, Bergson and others have risen to dazzling heights of intellect. But none of the systems propounded by these great thinkers has attained to the completeness and perfection of Vedanta. And few, if any, of the Western sages and mystics have attained to the realization of absolute Existence where all duality is swallowed up in that supreme attainment, the state of *nirvikalpa samadhi*, where knowledge, knower and known melt into the ocean of Existence, Knowledge and Bliss. That supreme realization belongs pre-eminently to the East. It is through the Indian Rishis that the highest Truth has come to humanity.

Losing all consciousness of the external world, he would be absorbed in absolute Being, the source of all existence and manifestation. Returning from this sublime experience, he would teach his beloved disciples the Truth which to him was tangible as the things of the world are tangible to us. And when his mission was fulfilled, and when by his life he had tested and demonstrated the eternal truths of Vedanta, he departed from this world on August 16, 1886. But he left behind a group of young disciples to spread far and wide the universal gospel of love and wisdom, of which he himself had been the embodiment.

And so it happened that once again the ancient teachings of the Vedas were vindicated, and that these truths were carried to Europe and America, where they were received as a new message of hope and enlightenment.

Truth is eternal, and no saviour claims to have brought a new message. But that eternal Truth at times is greatly neglected and in danger of being forgotten. It is at such times that God incarnates as man to restate, to revive, to popularize that divine wisdom.

Now, let us see what was the special message, the gospel, that Sri Ramakrishna brought to the world. It is not easy to summarize this in a few words. But we may quote the words of Swami Vivekananda, the greatest of his disciples, to get an idea of the sublimity, the practicality, and the far-reaching effect of that message.

Sri Ramakrishna taught that the soul of man is potentially divine; and that it is the aim of life to realize and manifest the divinity that dwells within us. This may be done either by work consecrated to God, or by worship, or by psychic control of nature, or by practical philosophy.

By these means, Swami Vivekananda said, we must surmount nature and become free. This is the whole secret of religion. Doctrines, dogmas, rituals, books, temples and forms are secondary details.

This is the essence, the kernel of religion; and from this statement flows the other message which sounds so simple but of which the world stood so much in need, namely, that all religions are but different paths leading to the same goal.

This is a simple but at the same time a very bold assertion. And the truth of these words will be understood only by those who are free from prejudice and superstition; by those sincere seekers after the ultimate Truth who dare to break through dogma and form, who, putting aside theology and church-bondage, go to the source of all wisdom, to the eternal Light shining within the heart of man.

Every sect holds that the religion it believes in is the only true religion, and that all other religions are false and so many delusions of the mind. Every sect wants to prove that the doctrines held by it are true and that all other sects live in error. They are not willing to accept that other religions as well as their own may lead man to salvation. It is so with the Christians, with the Buddhists, with the Mohammedens, with different sects in all great religions.

But Sri Ramakrishna knew better because his own experience had taught him that all religions lead to God. We do not investigate sincerely, and therefore we remain in

ignorance. When we study other religions, we do so with a prejudiced mind, and in a superficial way. And often the motive of our investigation is not to arrive at the truth of the matter, but to find flaws in other religions, so that with more strength and security we may preach our own.

If we want to test the truth of Sri Ramakrishna's assertion, we shall have to follow a different method. We shall have to do as he did; we shall have to enter deep into the religious consciousness. We shall have to practise what the different religions preach. Then alone shall we find that the difference is only on the surface. The theology, the doctrine, differs, but the practical method is the same in all religions.

But how could Sri Ramakrishna know this? He was not a man of learning; he made no study of comparative religion. No, he was not learned in the ordinary sense, but was most practical. He put everything to the test. And only after having experienced truth for himself did he accept it and teach it to others. By this practical method, he became the possessor of all wisdom. His wisdom was based on experience; it was direct perception.

So after having realized God in his own religion, he tested other religions. And he found that they all lead to God.

When practising Christ's teachings, Jesus in a luminous body appeared before him and his own consciousness mingled with the consciousness of Christ. Then he realized that Christ and he were one. Next, he practised other teachings of other god-men. And in all these ways God revealed Himself to him.

Thus Sri Ramakrishna realized the truth of Sri Krishna's saying in the *Gita* that whoever seeks to realize Him, the Lord, in whatever manner, will realize Him. Thus Sri Ramakrishna also realized the teachings of the different saviours. He realized the inner meaning and unity of the great creeds of the world. Therefore what he taught he taught with authority.

30

And all through his life, he showed a deep and genuine sympathy for all religions. Never did he condemn, never did he speak a word against any creed. He accepted all, and he helped everyone in the path he had chosen. He never said: You are wrong, you are deluded. No. He said: My child, go on in your own religion. Only do not stop, enter deeper into the truth you are struggling to realize. Dive deep, dive deep, into the ocean of bliss. He always pointed out the way best suited to each individual. His advice was that everyone should follow his own religion. It is the easiest method, the most natural way. It matters not what our religion is, so long as we are sincere.

In our own religion, we feel at home; it comes easy and natural to us. But our love and devotion must be intensified. To say that all religions lead to God, and to practise none will do us no good. Let us say: All religions lead to God, but I shall realize Him in my own. I shall not rest till I have seen God, till I know that God exists. Let the Christian worship Christ, the Buddhist Buddha, each one his own chosen ideal.

But Sri Ramakrishna used to say, tremendous determination is required and constant application. Then Truth will reveal Itself. There must be an all-consuming desire to know God. Then alone shall we succeed in coming face to face with Him. As the drowning man pants for a breath of air, even so the soul must pant after God. Cry unto the Lord with a yearning heart. Then Thou shalt see Him.

People, he said, shed a jugful of tears for their wives and children; they shed a river of tears for money. But who cries for the Lord? You will see God, he said, if your love for Him is as strong as the love of the worldly man for the things of this world, or of the mother for her child, or of the chaste wife for her husband. You must love God with heart and soul.

This saying also was the outcome of his own experience. It had become a reality in his own life. For years he prayed and meditated with all the depth and intensity his

soul was capable of. His devotion was so intense, so fervent that he would forget everything else when he was in prayer or meditation. Sometimes he would weep for hours because he could not realize God as perfectly as he longed to. He talked with God as a child talks to his mother. For twelve years his life was one intense struggle and yearning to know God.

About this part of his life, he himself used to say to his disciples that he was not aware when the sun rose or set. Sometimes for weeks he had no other thought but to see his divine Mother, as he called God. Tears would trickle down his cheeks, and only this one prayer came from his lips: Mother, manifest Thyself to me. Thou art the Mother of the universe, see that I may want Thee and Thee alone.

Through severe self-discipline, Sri Ramakrishna crushed within himself all lust of the flesh, all low ambitions, pride and egotism. He renounced all sex idea, he cast aside distinctions of race and colour. He looked upon all men alike as manifestations of God.

It was through struggle that Sri Ramakrishna reached the highest state of consciousness, the supreme vision where all conflict ends and the soul realizes the eternal harmony of things. And having struggled and attained, he became the greatest teacher of the age. He knew that only by having gone the whole length himself can a man show the path to others.

Sri Ramakrishna was a true teacher commissioned by God. Such a teacher, he himself used to say, need not seek for an audience or disciples. They come of themselves. When the lamp is lighted the insects appear in numbers. They are sure to rush towards the light. Nobody need invite them.

So it was with this man of illumination; people came to him of their own accord. His magnetic influence none could resist. The sweet influence of his character was diffused everywhere, and all who sought after Truth were naturally drawn towards him. He had a never-failing supply of

wisdom, the wisdom of life. He drew from the source of all wisdom, and the supply was never exhausted.

The world saviours, Sri Ramakrishna said, are the greatest teachers. As the locomotive engine easily pulls along a train of heavily laden carriages, so the Incarnations, the loving children of God, feel no trouble in passing through all the worries and anxieties of life, and they easily lead man along with them to God. There is a fabled species of birds called the Homa bird. These birds live so high up on the heavens, and they so dearly love those high regions that they never come down to earth. Their eggs, laid in the sky, begin to fall down, and as they are falling they hatch. The young birds, seeing that they are falling to the earth, at once change their course and begin to fly upwards to their home high up in the sky. Divine men, such as Jesus, Buddha, and others, are like these birds. Even in their boyhood, they give up all attachment for this world, and betake themselves to the highest regions of true knowledge and bliss.

The swan, it is said, can separate milk from water. She drinks only the milk leaving the water untouched. Other birds cannot do so. God is intimately mixed with the world of Maya. Ordinary men cannot distinguish God from His Maya. But the Paramahamsas, the great souls, reject the Maya even as the swan rejects the water. They drink of the milk of Bliss, which is God.

Sri Ramakrishna taught in very simple language, through stories and parables. But numbers of earnest men of all sects and creeds flocked to him and sat at his feet to listen to his charming words. His wonderful purity, his childlike simplicity, his profound wisdom, his rapturous love for God made a deep impression on all who came in contact with him. The educated, the uneducated, men, women, youths, all came to him for light and guidance.

Day and night he was surrounded by disciples and visitors. And always he was ready to give freely from his store of wisdom and realization.

THE GOSPEL OF SRI RAMAKRISHNA

There are two kinds of men, he used to say: one class is worldly, the other class spiritually inclined. Men immersed in worldliness cannot attain divine wisdom. They cannot realize God. As muddy water cannot reflect the sun, so the mind that is attached to the world cannot reflect the divine image of God. Such men do not like to hear about spiritual things. They are like the beetle that lives on filth. Such a beetle does not like to enter a fragrant lotus. It prefers filth. Similarly the worldly-minded do not like the company of holy men. They prefer worldly talk and gossip.

Once a fisherwoman on her way home was overtaken by a storm. As it was evening, she took shelter in the house of a florist; the florist received her very kindly and gave her a room full of flowers. But though everything was so comfortable the woman could not sleep. At last she discovered that the sweet aroma of the flowers was keeping her awake. So she took her empty fish basket, placed it near her head, and there was sound sleep. Thus it is with worldly men. They cannot relish the fragrance of a spiritual atmosphere. Now, the spiritually inclined are just the reverse. They like to hear about God. They are happy in the company of devotees, and to hear religious discourses. They perform religious practices and try to know the Truth.

It is for such pure souls that God incarnates in human form. They listen eagerly to good teachings. And applying these teachings in their daily lives, they soon gain in spiritual knowledge. And thus they find perfect peace of mind.

Now there are four kinds of perfect men, Sri Ramakrishna used to say. First, the class just mentioned, those who learn from the teachers. They watch the teacher's life, they follow his example and obey him, and finally they realize their own divine nature.

The second class are those who become perfect through dream inspiration. In dream they see some great soul who gives them instructions. And when they wake up, they remember this and, following the instruction, they become perfect.

The third class are those who become perfect through the mercy of a great soul. They may have been worldly-minded before, but meeting a great teacher they are suddenly changed, and live a holy life ever after. There was just a little worldliness left in them clouding their minds. But through the grace of the teacher, that thin veil of ignorance is suddenly rent, and the full light of wisdom illuminates their minds.

And then there is the fourth class, those who are ever perfect. They are born free. They have reached perfection in a previous cycle of existence. And all their apparent efforts to attain liberation in this life are only to set an example to mankind. They are born with wisdom, and from childhood they do what is right. Instinctively they omit evil. From the beginning, their perfect nature is manifest.

Some of these free souls incarnate when the Lord appears on earth. They are, as it were, His companions. And they always remain with God. They are the disciples of the great saviours of the world. They come to earth to help in the work, and spread the Master's message.

But greater and beyond all these is the Incarnation Himself, for He is always conscious of His perfect and infinite nature.

The Lord incarnates on earth with his disciples. And when he departs, his disciples follow Him when their work is done, and then they enter a state of everlasting Bliss. These disciples are like His satellites. They always are near the Lord—serving and loving Him with all their heart and soul.

Once a devotee asked Sri Ramakrishna, What are Incarnations? He replied: Just as water is formless but when frozen takes different forms, so God also takes different forms to save mankind from the bondage of ignorance. As the wave appears on the ocean, so the saviours appear on the ocean of Existence, Knowledge and Bliss.

Now, let us see what Sri Ramakrishna taught that may be of direct help to us in our spiritual life. How shall we conduct ourselves so that we may gain that divine wisdom that He Himself possessed in such abundance?

We have seen that, Sri Ramakrishna taught that to live a spiritual life we must have an intense longing to know the Truth. Then we must have faith. He who has faith, the Master said, has everything. He who doubts lives in misery.

But is there hope for one who lives a family life? a disciple asked. Yes, Sri Ramakrishna replied, there is a remedy for all. The family man should seek the company of the holy people. He should from time to time go into retirement away from his family, in order to meditate on God. He should remember that the joys of this world are fleeting, and that the spirit endures for ever. He should pray earnestly, O Mother, grant me love and faith. If one gets faith the work is done. There is nothing higher than faith. Have faith in God, and He will save you. Faith is omnipotent, it work wonders. Before it the powers of nature even give way.

And then he told the story of a devotee who wanted to cross a river but had no boat. He appealed to a friend for help. This friend had a leaf on which was written the name of Rama. 'Take this leaf,' his friend said, 'and hold it firmly in your hand. This will enable you to walk on the water and cross the river in perfect safety. But do not look at the leaf. If you do so you will go down.' The devotee took the leaf and stepped out upon the river. All went well. But when he came to the middle of the stream, curiosity got the better of him. He wanted to know what was the mysterious power in the leaf that kept him from drowning in the water. So he took the leaf, and opened it to see what it contained. Then he found there was nothing inside. On the leaf was simply written the name of Rama. He was disappointed and thought, 'Is that all? Why should that have such power?' He began to doubt. And instantly he drowned beneath the water.

One must be simple like a child, Sri Ramakrishna said, in order to have strong faith in God. The Lord is far away from the duplicity of the world. Worldliness brings doubt and scepticism. Where there is no faith, it is idle to look for divine wisdom. If you believe like a child what the guru tells you, then you receive the grace of God.

And then he explained how we should live in the world. When a plant is young, he said, it requires a hedge around it to protect it from goats and other animals that might eat it. But when the plant grows into a tree, it requires no protection; nay, it serves as a protection for the same animals that in its early stage would have destroyed it.

So the religious aspirant must hedge himself in from evil influences and temptations. He must guard his mind from wrong thoughts, and he must avoid worldly-minded people. He must always take shelter in God.

But when full illumination has come, then no protection is necessary; nay, then such a free soul will be a shelter for those who come to him for light and guidance.

Once a disciple asked Sri Ramakrishna, 'How should we live in the world?' He replied: Let part of the mind always rest in God. The tortoise goes about in the water in quest of food. But her mind is always watching the bank of the river where her eggs are laid. In the same way, you may go about doing your work, but take good care that your mind never strays entirely from God.

But to be able to do this, prayer and meditation are necessary, and solitude now and then. First, cultivate love for God, and then you can live in the world free from danger. Look at everything as belonging to the Lord. You are only His steward. Do your duty as loving service to God.

Sri Ramakrishna's personality, we are told, was most attractive. Wherever he went he carried with him an atmosphere of calm and peace and blessedness. His body was well formed, and his face expressed a childlike tenderness, profound humility, and unspeakable sweetness seen on no other face. His smile was enchanting.

In dress and diet, Sri Ramakrishna was not different from other men. He disliked all kinds of show. And when people praised him or showed him exceptional honour, he felt uneasy. He did not like even to be called a Guru. Any form of lionizing displeased him.

He was content to be the Mother's child, to be close to Her, to do Her bidding. The company of the worldly-minded he shunned. But in the presence of devotees he felt happy. He would talk to them about his own experiences; he would encourage and console them. And as he talked, he would suddenly enter into a state of rapturous ecstasy that made further speech impossible. Then the devotees would sit and wonder, and they would be amazed at the expression of bliss that would suddenly illumine his face.

Sri Ramakrishna's words were so simple; they were always sweet and charming. And with all this simplicity there was a wondrous strength. Every word hit the mark. One was aware of a tremendous power behind the childlike appearance. And the cause of his great success as a teacher we find in the fact that he gave every one exactly what he needed. One found one's doubts settled, one's troubles removed, even before they were expressed.

Sri Ramakrishna's love for his devotees was endless. He would go through any amount of trouble to help even the simplest. His life was given for the salvation of man. He came to show man that even in this life God-vision is possible.

Sri Ramakrishna solved all the problems of life, and it is no wonder that his disciples worshipped him with divine worship. In him they saw a man with whom God-consciousness was a habitual state of mind.

In Sri Ramakrishna they saw a son of God, the divine Incarnation, the embodiment of God's love for mankind. They realized that his will was the divine will; that his self was merged in God.

And now Sri Ramakrishna is no more with us in the body. But his gospel is with us, and will endure for ever. And his spirit is with us. And every one who worships the sons of God in spirit and in truth, be it a Christ, or Buddha, or Krishna, or in whatever divine Incarnation, he worships Sri Ramakrishna who was the embodiment of all, for the spirit is one, manifesting itself in many ways.

THE SPIRITUAL IDEAL OF WOMANHOOD

C.T.K. Chari

The position assigned to women is one of the surest tests of civilization. It is the barometer by which the rise and the fall of cultures may be judged. The 4,000-year old Babylonian code of Hammurabi reveals an enlightened attitude to women. Women appear to have enjoyed practically all the rights of men and engaged freely in commerce and the learned professions. Women in Ancient Egypt were, so far as we can determine, no less privileged. They were the equals and the companions of their fathers, brothers, and husbands. They were never secluded in harems. They had equal rights with men before the law, served in the priesthood and even mounted the throne. From the archaic inscriptions discovered on the site of Gortyn in Greece, it would seem that some advanced principles relating to marriage, property and family were recognized quite early. Under 'Gortyn laws', the rights of married women were protected against unscrupulous husbands, and daughters could inherit property like sons. It has been said that the legal position of 'Gortyn' women was 'enviable' save when judged by ultramodern standards.

What is the status assigned to women by the most enlightened kind of Hindu religion? I fancy that the theme of the religion would be something like this: Any assertion of the intellectual, legal, political, and economic rights of women, not rooted in the recognition of their spiritual rights, would eventually result in self-stultification. I suggest that in the life of Sarada Devi or the Holy Mother was enacted a great drama of love and faith that fulfilled the dreams of certain mystical philosophers. Kumud Bandhu Sen, putting down some reminiscences of the Holy Mother, has said that 'one could say that the Mother's place

was neither a household nor a monastery in any exclusive
sense of the terms'. *Neither a household nor a monastery*, for
the great ideals of spirit transcend both and embrace them
in their sweep. The conversion of Father Sederholm of
Russia was brought about by his witnessing a marriage
ceremony in the Eastern Orthodox Church. He was struck
by the fact that, in the service, the bridal crowns were
compared to the crowns of martyrs. The profound idea took
such complete possession of him that a revolution was
wrought in his way of life. He renounced worldly learning
and the university chair he was going to occupy, and, to the
consternation of his relatives, entered a monastery. In the
monastery and yet beyond it, for he had realized the ideal
of sanctifying love which is the consummation of the truest
kind of marriage. Even at a lower level, do we not see that
the sacrament of marriage implies far more than the
ordinary psycho-physiological relationships between the
sexes ? The devotedly constant and honourable lover in
Lovelace's lyric, *To Lucasta on going to the Wars*, says:

> I could not love thee, dear, so much,
> Loved I not honour more.

Sri Ramakrishna must have perceived that Sarada Devi
had to dedicate herself to a grander and nobler task than
that of rearing a family in the ordinary sense. She had to
become a great rallying point for spirit, 'a veritable sanctu-
ary for aspiring souls of every description—men and
women, rich and poor, Indian and Western'. The transub-
stantiation of the relation between the sexes has been
described thus by the great poet-philosopher-mystic of
Russia, Vladimir Soloviev, in his book *The Justification of the
Good:* When there is a true spiritual meeting of man and
woman, the awakened man 'sees his material other—the
woman—not as she appears to external observation, not as
others see her, but gains insight into her true essence or
idea. He sees her as she was from the first destined to be,

as God saw her from all eternity, and as she shall be in the end....She is affirmed as...an entity capable of spiritualization or "deification".' The highest form of love in woman, according to the great Russian philosopher, has a corresponding character. 'The man whom she has chosen appears to her as her true saviour, destined to reveal to her and to realize for her the meaning of her life.'

Surely the words describe not inappropriately the chosen ends of Sri Ramakrishna and Sarada Devi. To those who know Sri Ramakrishna's real stature, there can be no doubt that he saw Sarada Devi 'not as others saw her', but in her 'true essence', 'as she was from the first destined to be', the Holy Mother of the devoted band of disciples that he was gathering round him, the men who were to accomplish, without ostentation, without noise, great things. Not accidentally were they recruited by the Master; not accidentally did the Holy Mother in her later life preside over the curious household in which a Brahmacharin managed the kitchen and the Sannyasin disciples gathered now and then to receive advice and instruction. I have not the least doubt that Sarada Devi saw quite early in the Master the one who was 'destined to reveal to her and realize for her the meaning of her life'. Small wonder that the little shrine in which she worshipped a photo of the Master throbbed and palpitated with an Invisible Presence. In the truest spiritual encounter of men and women, Soloviev declared, 'reproduction becomes both unnecessary and impossible...because the supreme purpose has been achieved, the final goal attained'. The new process 'does not reproduce life in time, but recreates it for eternity'.

Sri Ramakrishna's God was an Infinitely Loving Mother. That was why he could see the image of the Divine not only in Sarada Devi and his women followers, but in all women, even the fallen women on the slagheaps of human society. No *tout comprendre c'est tout pardonner*, but something loftier made the Master's tender concern for the least of them possible. What prompted the love ? An ecstatic

experience of the essential Godhead: an experience on which poets have only speculated in their elevated moods. Mrs. Anna Hemsted Branch once dedicated a few lines 'To a New York Shop-girl':

Poet and prophet in God's eyes
Make no more perfect sacrifice.
Who knows before what inner shrine
She eats with them the bread and the wine?

Yes; who knows? With Sri Ramakrishna, however, it was no guess but an inner certitude. The criticism that by his attitude to fallen women he wiped out all moral distinctions needs no refutation; it is its own refutation. Does the Mother care less—for the least of her children?

Have we then answered the question often posed by psychologists today? Is a sublimation of sex possible? I shall say little here about the pseudo-profundities of those psychologists who assimilate poetry to hysteria and religion to obsessional neurosis. Reik frankly admitted that although a psychoanalytic study of religion could be launched, it could not exhaust religion. Dalbiez, in his critique of psychoanalysis, has shown how inevitable, how fatal, are the limits of all empirical psychological explanations of the higher manifestations of Human Personality. It is no longer possible to write, with the naivete of a Binet-Sangle, *Folie de Jesus* in two volumes: the first dealing with the heredity, constitution, and physiology of Jesus, and the second with his 'delusions' and 'hallucinations'.

Certainly, 'sublimation of sex' is not one of those simple, obvious theorems about human nature that text-books delight in expounding. The sex urge is not conquered by mere obedience, mere disuse, mere repression, mere reaction-formation. Paulhan has warned us of the danger of its remaining incompletely spiritualized. Samuel Lowy has represented its 'sublimation' as a supreme instance of a 'homeostasis'. The non-irruption or non-manifestation of the

urge leads to an 'increased hunger' in other spheres, 'an increased productive potentiality'. Lowy has hinted that the particular conditions of the 'sublimation' of sex are of a highly individualized character and do not permit facile psychological generalizations. 'There must ensue a certain spontaneous thirst or readiness for a particular sphere of creative activity. And the particular substituting activity must be fitted to restore the balance of individual conditions...'.

I suggest that it was this 'spontaneous thirst', this 'readiness for a particular sphere of creative activity', capable of achieving 'homeostasis', that Sri Ramakrishna could evoke in others, sometimes by a mere touch or a glance. Always he dealt with others as living persons. He saw men and women round him, and not merely trees walking. He and Sarada Devi have demonstrated that the vocabulary of love loses nothing of its true import when it is universalized, when it ceases to be a local dialect, a matter of a few strong preferences. Not the disillusionment of love (as Krafft-Ebing and others have suggested), but its fulfilment, is true mysticism. Of the two factors moulding the individual, predisposition (*Anlage*) and experience (*Erleben*), the latter assumes the dominant role.

Rebecca West, in her *The Thinking Reed*, wrote: 'The difference between men and women is the rock on which civilization will split before it can reach any goal that could justify its expenditure of effort.' But if I am right in my analysis, the barque of civilization need not split provided a more spiritual conception of manhood and womanhood takes the helm and displaces 'the solemn clowning about sex' as Rebecca West called it. D. H. Lawrence (at least in his novels) sometimes represented the anonymous mating of animals as far superior to the paltry semi-conscious stirrings and promptings of human beings. I submit that men and women can rise above not only mindless anonymity but also the mere awareness of the biological urges. They need not be enmeshed for ever in the lustful enjoyment of

their isolated individualities, their 'piddling, twopenny-halfpenny' personalities with their 'wretched little virtues and vices...silly cravings and silly pretensions', to use the language of Aldous Huxley's *Eyeless in Gaza*. Not the limpid 'Now, and only Now, and forever Now' of *The Plumed Serpent*, knowing nothing of Yesterday or Tomorrow, but something more overpowering and overreaching can take hold of men and women and steer them to their high destinies. Goethe said that whoever would understand the Poet and inherit his riches must walk into the Land of the Poets:

> *Wer den Dichter will verstehen*
> *Muss in Dichters Lande gehen.*

The test applies not less surely to the great religious experiences of mankind. The life of Sarada Devi is a reminder that the highest ideals of womanhood are not extinct. They await the faithful and the loyal.

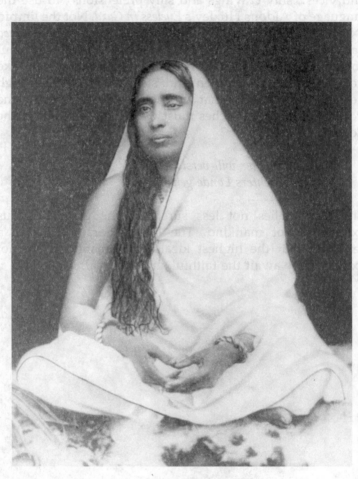

Holy Mother Sri Sarada Devi (1853–1920)

SRI SARADA DEVI
A CENTENARY TRIBUTE

P.B. Mukharji

History does not fail to record the heroism of brave women who have partnered their husbands to victory in different avocations of life where glamour, fame and wealth have been the rich rewards of a lifetime of struggle. But few are the illustrations of those still braver women who shade themselves so completely as Sarada Devi in order to be able to fuse ambition with self-renunciation, where fame, if it came, was not a prize but an attendant. She inspired her great husband Sri Ramakrishna Paramahamsa in man's pursuit after God by a beautiful companionship, sanctified by an abiding love and devotion. Her ideal was a complete identification with her husband's aspiration to realize God on earth and for a total spiritual conquest of the nature of man. That ideal was big and spacious enough for their joint loyalty. It was attractive enough to redeem the paltriness of the common conjugal life.

The world has known and admired the devout celibate and the pious nun who have sought God and realized Him. But here is a unique experiment where both the husband and the wife made God their joint venture. It was a combination rare and glorious and evocative of a great pattern of life which used to animate the lives of the great Rishis and sages of India in the past. Without Sarada Devi's willing sacrifice of the lower felicities of a common wife, and without her active encouragement of one of the greatest spiritual endeavours made by man, the world might not have seen the fulfilment of Sri Ramakrishna's great human conquest of the divine. When she arrived at the Dakshineswar temple to meet her husband, the saint exclaimed,

'Have you come here to tempt me to the common futilities of life?' She replied, true to the genius and ideals of womanhood, 'If that was my object I am no true wife; I have come here to assist you to realize man's highest aspiration, and to that realization both man and wife are alike the heirs. Sri Ramakrishna said later in life about his wife, 'If she were not herself a spiritual aspirant, if she had attracted me only as a woman, I might have deviated from the path of discipline which is the condition of God-realization.' No greater tribute could ever have been paid to a wife ·by a greater husband. She truly was his 'ministering angel'.

Sarada Devi was born on 22 December 1853, into the family of a poor Brahmin, Ramachandra Mukherji, in the village of Jayrambati in the district of Bankura in the State of West Bengal. In May 1859, she was married at the very early age of five according to the prevailing social customs of that time. Sri Ramakrishna was then 23 years old. It is said that he had indicated long before the marriage was arranged that she was to be his wife. For nearly eight years after marriage they hardly met. Then they met only to live for about seven months together, and separated again. After another interval of five years, in the year 1872, Sri Ramakrishna himself baptized Sarada Devi in his path in the holy temple of Dakshineswar. The mantra or the word of dedication that he uttered of the philosophy behind the ideal marriage, when translated read something like this:

> You, my partner, help me to conquer that central reality which binds you and me and the universe. Looking at you I see the Divine immanent in every human soul. You are the symbol that reminds and inspires me to re-enter the forgotten inheritance of man.

That was the consecration and consummation of their marriage. The offspring was not a child but a moving technique to perfect human life, and to redeem its promise and purpose.

The modern man pays lip service to the ideal of independence of man and woman in their married life. No more cant has been written and said on any human problem than on this one of independence in married life. That perversion of independence in married life has become synonymous today with the wife pursuing her own ideals and the husband his. Marriage today does not mean identity of lives and aspirations of ambitions not only intellectually shared and dialectically discussed in the drawing-room at stated hours but also loved together in the daily acts of life. The progressive outlook in modern marriage has miscarried itself under the delusion of independence and has come to mean for millions only a fortuitous and insecure combination of passion and convenience to run a joint mess where the children are regarded as a nuisance and are avoided if that means going without a car or a gadget or some other technological blessing.

Sarada Devi represented and lived that greater and truer ideal of equality and independence by an identity with her husband's principles and ambitions of life. She realized that true independence could only come from the conquest of human nature, and that was only possible when man and his wife shared that ideal, and that the basic economics of a true personality is an economics of donation, not of compensation or calculation. She and her great husband exemplified in their lives that the single state is not alone to be blessed. A true communion between the husband and the wife is the precursor of that communion with the divine. It can be the preview and prelude to that unitive experience with the ultimate reality. This is the more complete life and the more perfect life. It cannot come by sharing the temporalities of life but its spirituality. It is the life which does not insult Nature but asks her co-operation. Such married life is not an inconsequential emotionalism but a rigorous discipline by which one exchanges the vortex of frustration for a boundless harmony potent enough to recreate new universes of fuller existence.

She bent the powerful stream of her entire feminine nature to aid the fulfilment of human existence. She gave meaning to the great Tantras of India and portrayed them in her life. So completely did she live in her husband's life and ideals that when at her age of 33 she became a widow, in 1886, and when about to don the widow's dress of grief, she had a vivid vision of her husband who appeared to tell her that there was no death except in form, and that there was no widowhood for the wife who had chosen God and life eternal as her ideal. For He is the deathless Lord to whom all life aspires and whose brooding omnipresence holds the creation in an eternity of perpetual existence, and the husband is only an institutional approximation to that eternal ideal.

When Sri Ramakrishna was alive, Sarada Devi's life was one of constant service and unflinching devotion to the cause, with complete unanimity on both the ends and the means. She used to live modestly and most unobtrusively in a quiet attic in the temple premises. Her life used to begin one hour before the dawn, and throughout the day and evening it was one long continuous record of service quietly given with enthusiasm, faith and hope. The daily programme was not a mechanical routine but was inspired with an all-consuming zeal to see the fruition of the complete spiritual and moral transformation of the nature of man. It was carried out with a patience that had learnt not to hasten but to wait for good work to come to maturity. No guest in the temple ever returned from the temple premises without being the recipient of her quiet and simple hospitality. No woman guest ever left the temple without being greeted by her with that divine smile that used to light up her face. The modest needs of her husband were attended with scrupulous care as part of the divine adventure. The arrangement for worship in the temple received the perfect sill of her hands in a ceaseless search to divine life and its methods.

Profound was the grief of Sarada Devi on the demise of Sri Ramakrishna. She transcended the great grief. She

sublimated that grief and transfigured it into a new sense of responsibility. She refused to be overwhelmed by sorrow. She lived the rest of her life in continuing the work of Sri Ramakrishna that was left unfinished. It is not sufficiently realized how great in this respect was her contribution. In binding together the disciples of her husband in a common cause, and thereby forging an instrument to serve the ideals of Sri Ramakrishna, and to inspire hundreds and thousands of men and women, she rendered a signal service to the Ramakrishna Movement and Mission of which India is so justifiably proud today.

The death of the great saint cast a deep gloom over the disciples. At that crucial hour it was the quiet strength of Sarada Devi which enabled her to collect herself with fortitude and courage. She called his great disciples together and stood by them. Her strength and stability acted as a magic example and a moving inspiration. Thenceforward she was to become the 'mother' of all these wonderful disciples of Sri Ramakrishna, who had renounced their personal and selfish ambitions to serve the cause of their great Master and uphold the spiritual principles on earth. Having no child of her own, her husband's disciples became her children, and she inspired them with loving care and understanding. From now onwards she became the person responsible for building that nucleus whose efflorescence we see today in the purposeful activities of the Ramakrishna Mission throughout the world. But for her inspiration of this hour of trial, but for her motherly affection when the death of the great Master threatened to spell desolation in the lives of his disciples, and but for her unfailing encouragement, much of the great work would have been lost. She supplied the faith when disciples wavered. She gave the assurance when doubts assailed. She provided helpful advice when indecision prevailed. From now onwards she acquired a holiness of her own and out of that holiness grew that quiet strength which knows how to conquer difficulties and doubts in the crisis of life. She became the

centre from which perpetually stemmed the radiant messages of soul-inspiring hope.

Sarada Devi outlived Sri Ramakrishna by 34 years. She passed away on the 21st July 1920. It was in this period of thirty-four years that she added new dimensions to her personality.

After the demise of Sri Ramakrishna, Sarada Devi went on a pilgrimage to Vrindaban in 1886. Later on again she had occasion to travel widely in India specially with a view to visiting the holy places. Among other places of pilgrimage she went to Gaya, Benares, Puri, as also to Madurai and Rameswaram in South India. A very touching incident is recorded of her visit to the great and ancient temple of Lord Jagannath at Puri. Sri Ramakrishna had a desire to visit the temple of Jagannath, but for some reason or other that journey was never undertaken. When Sarada Devi, as a widow, went on a pilgrimage to Puri, she quietly took a photograph of her husband. When inside the temple of Puri she fondly produced that photograph of her husband, with tears in her eyes, so that the Lord Jagannath could have a look at her husband. Such deep human affection with such dedication was an arresting feature of her wonderful personality. These travels in India added richness to her nature and deepened her convictions in the spiritual ideals.

The first few years that followed the death of Sri Ramakrishna were years of great anxiety, and privation for Sarada Devi. It was only after the Ramakrishna Mission was organized that a new chapter opened. During this period of crisis and uncertainty she stood firm as a rock, helped and aided by the disciples of Sri Ramakrishna. The Udbodhan Office was constructed in 1909 by Swami Saradananda, specially for the purpose of the residence of Sarada Devi who until then had no home. Before that she used to stay in a rented house while in Calcutta, except on the occasions when she lived in the houses of such devotees as Balaram Bose and Master Mahashay. One of her favourite places where she loved to reside was the garden-house of Nilambar Mukherji.

No tribute to the memory of Sarada Devi can be complete without an account of her spiritual ministration, which began somewhere near about 1888 and continued till the last days of her life. Here is another aspect of her personality which is little known. It is often said that the fate of a wife of a great man is not an unmixed blessing. Behind every greatness there is a tremendous sacrifice, not only of the person who achieves such greatness but of many others who help in the fulfilment of that greatness. Every greatness carries a shadow with it, and to be in the shadow of even greatness may be sometimes distressing. But not so in the case of Sarada Devi. She has to her account greatness on her own merits as a spiritual teacher. She achieved high spiritual insight by a life of intense devotion. She gave initiation to many of her disciples both men and women.

The two well-known women disciples of Sri Ramakrishna, Golap Ma and Yogin Ma, were her constant companions. Golap Ma followed Sarada Devi like a shadow and was with her in most of her pilgrimages, and was constantly attending to the internal management of Sarada Devi's household. Yogin Ma was perhaps the most impressive among Sarada Devi's companions, and of her Sri Ramakrishna said, 'Among women Yogin (Ma) is the Jnani (intellectual ascetic).' Many of the records left by both Yogin Ma and Golap Ma speak of the wonderful spiritual ministration of Sarada Devi. The conversations of Sarada Devi that are recorded reveal a remarkable spiritual maturity and a philosophy entirely her own. She herself believed in and practised a life of simplicity as a condition of spiritual progress. She never failed to emphasize that Divine Grace cannot be purchased even by the most rigorous disciplines of Yoga and asceticism. Her philosophy revealed that difficult technique of waiting upon the Lord in our daily round of duties. She was a great believer in the efficacy of japa and the mantra for inducing the state of receptivity when spiritual grace can descend. In the path of Yogic discipline she constantly warned her disciples to avoid the

insidious pride of individual effort, which very often lurks in the heart of the aspirant and delays his spiritual progress.

In concluding this tribute a word is appropriate about her relations with the disciples of Sri Ramakrishna. For everyone she felt that she had a responsibility. She became the centre and source of unbounded love and inspiration, to whom all his disciples could come with their doubts and their worries. To every one of such disciples she had something useful and practical to say. Her guidance was in constant demand and was always given with that wisdom which comes only to those who are spiritually kindled. She not only gave them the symbol of the unity of purpose but also impressed them with the great mission of their lives.

She acted as the equal mother to all the disciples and thus helped to build up the brotherhood of monks in the Ramakrishna Order. That brotherhood of inspiring fellowship, which still animates the members of the Mission, is the result and imperishable record of Sri Sarada Devi, of her love and the devotion of a lifetime. For Vivekananda she showed the same love and solicitude as the great Master. In fact, she used to say that the Master was working through the form of Vivekananda. Her words were: 'Naren (Vivekananda) is his chief instrument.' Sarat Maharaj (Saradananda) and Yogen Maharaj (Yogananda) were her constant attendants. Yogen Maharaj's adoration for Sarada Devi knew no bounds. If anyone made a gift of a few annas to Yogen Maharaj, he used to save them so that Sarada Devi could go on a pilgrimage. After the death of Yogen Maharaj, Sarat Maharaj used to look after Sarada Devi. About Sarat Maharaj she used to say that he had the strength of Shiva. It was he who wrote the Bengali work on the cult of Shakti worship in India. In building the Ramakrishna Mission, Saradananda played a major part. Saradananda's learning, his profound philosophical and psychological equipment, and his vast experience from travels abroad made him a pillar of strength in the growth of the Ramakrishna Order. His great work, *Sri Ramakrishna Lila Prasanga,* is a matchless

production. Both Sarat Maharaj and Yogen Maharaj owed much to the inspiration from Sarada Devi.

Besides the imperishable fragrance of her life that she has left behind, Sarada Devi lives today in the minds of her many disciples who remain as testimony of her handiwork, and in the invisible bond of love and unity that pervades the Ramakrishna Order. Three temporal shrines today commemorate her life and teachings. There is the beautiful small temple at Belur Math on the banks of the Ganges on the spot where her body was cremated. Then there is the shrine of the Udbodhan Office in Calcutta in which her portrait is worshipped. The third memorial is in her own village, Jayrambati, where Swami Saradananda erected a temple and a monastery in her memory. In this village shrine is installed a life-size painting (now an image) of Sarada Devi. Many who are 'heavy-laden' still wend their way to the stillness and the holiness of this shrine and look at a Madonna.

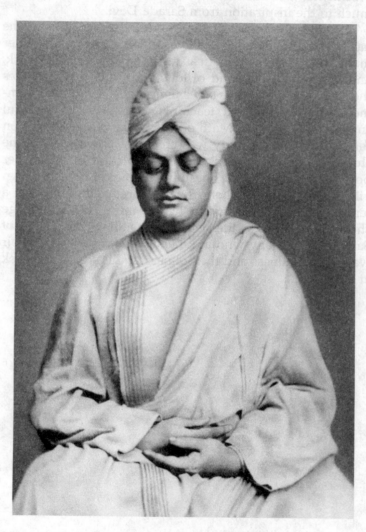

Swami Vivekananda (1863–1902)

SWAMI VIVEKANANDA'S MESSAGE TO THE WEST

Robert P. Utter

In the *Bhagavad-Gita* Krishna says, 'Whenever virtue declines and evil increases, I incarnate Myself to rescue the holy, to destroy evil and to establish righteousness.'[1] History shows that from time to time world teachers have arisen who have done just this. Swami Vivekananda was such a world teacher. He travelled all over the world and taught in both the East and the West. He always taught what was needed by the country and culture he was in. His teachings in the West were formulated to meet the special needs of the West, just as his teachings in the East were formulated for the East.

He admired the West for its energy, its enterprise, its enthusiasm, its accomplishments in practical affairs. But he was not deceived by the fact that the accomplishments of the modern West were mostly in the realm of wealth and physical comforts. He saw that, beneath its mask of easy optimism the West had desperate need of something more than material prosperity and efficiency. He knew that this need was neither physical nor intellectual, but spiritual.

He admired and loved the Orient also, especially India, for it was the land of his birth and he was always a great patriot, but was based on spiritual perception. He loved the Orient for its age-old tradition of renunciation and its whole-souled pursuit of spiritual realization. He knew of its vast accomplishments in that area, of its long line of rishis from time immemorial down to the present who have immersed themselves in the Infinite and turned their backs on the finite. But he saw that this too needed correction, for to turn one's back on the finite completely is to forget the

vow of the world teachers, the Buddhas and the Bodhisat-
tvas, the Ramas and the Krishnas, and the Shankaracharyas
and the Chaitanyas and all the sung and unsung sages, who
have vowed to help all beings attain enlightenment. He
knew that India needed some of the practicality of the West,
and that the West needed the spirituality of the East.

As a world teacher of both East and West, Swami
Vivekananda knew that meditation and realization must be
put to practical use for the relief of the sufferings of the
world, and that the Buddha's basic pronouncement, that all
relative experience is suffering, would be of no avail
without the opening of the gates to liberation or nirvana for
as many illusion-bound souls as possible. He knew that the
Buddha's last temptation under the Bo tree had been to
refrain from teaching anyone what he had realized; for, the
Swami himself had felt the pull of that very same tempta-
tion. He had asked his Master, Ramakrishna, to grant him
the boon of staying in samadhi for many days at a time.
Ramakrishna knew that this desire, worthy as it might be in
itself, was not the destiny of the world teacher Swami
Vivekananda was to become, and that this desire must be
given an even higher direction and turned into the desire to
help mankind achieve illumination. When the future Swami
Vivekananda finally achieved *nirvikalpa* samadhi, Sri
Ramakrishna said, 'Now you know all. But this knowledge
will be locked in a chest, and I will have the key. Not till
you have done my work will you have it again.'[2]

All of Swami Vivekananda's life and teachings must be
studied in this light: he was doing his Master's work. Jesus
said. 'I am about my Father's business.'[3] Swami Vivek-
ananda once said he felt as though divine hands were
holding his and guiding him in everything he did,[4] and
when he was at a loss to find new material to lecture on
while in the United States, he often would hear the voice of
Sri Ramakrishna telling him at great length what to say.[5]
This means that Swami Vivekananda was a world teacher
who was rooted in another world teacher, Sri Ramakrishna,

and that he cannot be understood apart from his Master. It also means that his world-wide work was never merely abstract and theoretical, but was always the intensely practical job of bringing God to man and awakening man to God.

We can see, then, that Swamiji's teachings cannot be studied casually, as isolated lectures, as mere speculative theory, or something occurring in a vacuum, but rather must be understood and related to his whole teachings and to the teachings of Sri Ramakrishna, as part of the world-teachings of the triple world-teacher incarnation we can only call the Ramakrishna-Holy Mother-Vivekananda constellation phenomenon, a phenomenon of incarnated divinity unique so far as we know in the whole history of mankind. Nothing that Swamiji said is a casual remark; everything has the deepest significance, for it is God's voice speaking to our age.

What, then, does he say to us in the West that we urgently need to know, and to act upon and to take to heart so completely that we change the fabric of our lives by ingesting it into our deepest being?

Before we can appreciate the significance of his message we must consider what kind of a man he was, and what the needs of the West were and still are. For, the quality of his being was as much a part of his message as the content, and the needs of his hearers were equally much a part of his message, so that in his case the man, the needs of the hearers, and the message were one.

The Man

To try to describe Swamiji is impossible, for unlike ordinary men he was not a single kind of man but was the totality of mankind in one, the potential of mankind realized in human flesh. Ordinary men realize in their lives only a few qualities of the universal man, but Swamiji realized all possible qualities to the maximum degree.

Ordinary men with their single-track minds can be compared to flashlights, or, at the most, searchlights, that send out a single beam in one direction. But Swamiji was like the sun shining in all directions at once. To our single-track minds he may appear contradictory, but in him these contradictions are only seeming contradictions, complementary qualities and meanings, not outright logical contradictions. Thus he lived and taught not one path or yoga exclusively, not even one path predominantly, but all paths in one. He did not slight one path for another. He was not lacking in reason, nor in emotion, nor in action, nor in mediation, and he taught to both East and West the equal practice of all four paths as far as possible for each individual; and in him this practice became the absolute fusion of the four paths into one. Reason without love is dry; reason without action is impractical; reason without meditation is ineffectual. And so one could go through each path, showing how each lacks something essential if the others are missing. Thus like a four-faced divinity he looked in all directions at once, and was a whole man and taught others to be whole.

There was indeed an air of divinity about him. Everyone who saw him felt it. No one near him could avoid feeling the force of his divine power almost like a shockwave. Yet through all this extraordinary nimbus of vibrant power that seed to envelop him in a cloud of fire, there hovered an infinite gentleness too, like the sleeping sea, like the sunlight, like moonlight on snowy peaks. He was a poised thunderbolt forever humming a song like a murmuring stream. He radiated this singing power as the sun shines. It made his abstract, intellectual teaching visible, almost palpable. When he spoke of the soul and of God, the superconscious experience behind these words could be felt by everyone, and everyone's mind became permanently expanded and changed. Only a divine incarnation could do this as completely as he did.

He was a divine incarnation, as were Sri Ramakrishna and Holy Mother, but he was a divine incarnation in his

own right, not just a moon shining by a borrowed light. Every day and every moment he proved this to his companions, his friends, his hearers, and his disciples. One example will suffice to illustrate his divine powers, which he used only for the good of mankind.

One day in Chicago, in March of 1894, the French opera singer Emma Calve went to see Swami Vivekananda. It was an extraordinary meeting in every way. She was in a state of extreme desperation over several personal tragedies; the most recent being the sudden and untimely accidental death of her daughter by fire. A friend suggested she see Swami Vivekananda, for his fame as a healer of souls had spread, but all that Calve wanted to do was commit suicide. Several times she tried to drown herself in the lake, but some unseen power seemed to turn her steps toward the house where Swamiji was staying. Each time, however, she went away without ringing the bell. Finally one time she did ring, and in terrible agitation entered the room where Swamiji was sitting at his desk. Without raising his eyes he said, 'Come in, my child. Don't be afraid. What troubled atmosphere you have about you. Be calm. It is essential.' He told her things about herself which only she knew, although, as she says, he didn't even know her name. When she expressed amazement at this, he only smiled as though she were a child asking a foolish question. Jesus did the same thing with the Samarian woman at the well.

Swamiji's advice to Calve was to be cheerful, not to brood on sorrow, to build up her health, and to transmute her emotions into 'some form of external expression'. Jesus told the Samarian woman at the well that whoever drank the water he gave would never thirst again. We do not know if the Samarian woman was permanently changed by her meeting with Jesus, though we naturally surmise that she was. But we know from Calve's own account that she was changed, and that she was changed immediately and permanently, for she left him cheered, and she soon became peaceful, vivacious, and happy.[6] Note that Swamiji did not

find fault with her, or call her a sinner, or tell her to give up her operatic career. Instead, he told her to spiritualize her art; and, besides seeing deeply into her life and character by super-normal means, he managed to staunch the bleeding wound of her grief and suffering and to lift her mind upward into joyfulness: not by words of consolation or by abstract philosophy, but by simply the power of his overwhelming spirituality. He put out the raging storm of her grief as water puts out fire. He did not lecture; he gave.

Swamiji gave the vision of God to all who could take it, as much as the small vessels of finite minds could hold. He poured out God in abundance, as a person pours out tea from a pot into cups. Swamiji poured God all over the world on everyone's head. Words were the smallest part of his message.

The Needs of the West

But there was a message in the words for the West as well as a superverbal one. It was a message hand-crafted to meet the special needs of the West. It can be better understood when we understand those special needs in the light of the time, the end of the nineteenth century.

To begin with, the West was ignorant of the vast spiritual and cultural history and heritage of India. The West regarded all Orientals as so-called 'heathens', who worshipped 'idols', and who followed either a godless religion or one with many gods, both of which were high crimes to Westerners, who did not realize that many in the West were godless, and many were polytheists without knowing it. For polytheism takes many forms other than the worship of images in temples; the more common form is that of according the status of reality to the apparent world of multiple sense objects. According to that definition, Western man is just as polytheistic as anyone else. The West, however, did not realize that human beings are

essentially the same the world over, for they knew practical-
ly nothing about Oriental culture. Among the majority of
Westerners at that time, there seemed to be very little
interest in any Oriental culture beyond the fad of collecting
Oriental rugs, dishes, furniture and art.

But there were, of course, some beginnings of knowl-
edge seeping in among a few scholars. Translations of
Chinese and Indian literature were beginning to trickle in
slowly, in small quantities. Max Müller and Paul Deussen
were German Indologists who made translations and wrote
erudite studies of the Upanishads and the *Gita*. Erwin
Arnold also was a Sanskrit scholar who wrote the life of
Buddha in English poetry and made a poetic translation of
the *Gita*. Emerson, Thoreau and Whitman knew the *Gita* and
other works of Hindu religion and some Chinese philoso-
phy as translated into English or other Western languages.
All these men were introducing Hinduism to the West. But
without a living guru to teach it, the ideas remained ideas
only. None of the these men brought the problem out in the
open or seemed even vaguely aware of it. For centuries the
West had taken the word 'mystic' literally and had hidden
their mystics away out of sight. The West had forgotten what
mystics the world over always taught, that God is to be seen,
tasted, eaten, and enjoyed, not just talked about abstractly.

So even these six men, sincere as they were, remained
essentially sleepers unaware of the need to awaken or of the
means of awakening. Only Thoreau stirred uneasily in his
sleep. Whitman and Emerson were too optimistic to feel the
uneasiness of the problem. Thoreau went to Walden Pond
to try to live an ascetic, withdrawn and spiritual life. How
well he succeeded may be judged from his book *Walden*. He
wrote with great insight as well as poetry about his experi-
ences, outward experiences, that is, only vaguely hinting
about possible inward ones. Yet one feels that he yearned
for something he could not quite find. He recognized
Chinese and Hindu religions as revealing unsurpassed
heights of sublime wisdom, but his longing was undirected,

and it remained largely unaware and subliminal. The peace of spirit which he longed for he could not find, not even at Walden Pond. Thoreau longed for more than he knew; what he really longed for, knowingly or unknowingly, was a guru to make the word of God flesh, to bring the living fire from heaven to mankind, to teach him and the world to find true peace. The whole Western world was deep-sunk in its dogmatic slumbers, and it needed a dynamic and heroic prince to awaken it and rescue it from its prison of isolationism. Swami Vivekananda was that prince, and he was sorely needed. But he was not yet born in the flesh at the time Thoreau lived at Walden Pond.

There was, of course, more to it than this. The history of the Western ideas shows that mysticism always took a back seat to empiricism and rationalism in the West. This is not to say that mysticism was not always present in the West, but it was never emphasized. Many a little village church in Europe and in the Americas is to this day vibrant with a spiritual presence that has been invoked by the prayers and meditations of the devout over the centuries. And many a Western saint has realized God without worrying in the least about abstract philosophical problems. But the dominant mood of Western culture has been one of materialism and scepticism, a mood that has prevailed since Western civilization began with the Greeks. From Plato and Aristotle on, reason has dominated Western man's efforts to solve the riddles of life, and sense experience was emphasized by the Greek and Roman materialists, Leucippus, Democritus, Epicurus and Lucretius, but reason was important for them too. There was much controversy as to which was more important, reason or sense experience. In the Middle Ages, though the battle between sense experience and reason went on in the scholastic struggle between 'nominalism' and 'realism', faith replaced reason as the main method or instrument for reaching truth—not a living faith based on mystic experience, but a static faith that led nowhere because it was dictated by the rigid orthodoxy of

a dogmatic church. After the Renaissance and the Reformation threw off that yoke to some extent, reason and sense experience again took up their age-old battle for supremacy. Neither won. The battle only produced a sterile scepticism that resulted in the strange attempt at compromise by Kant.

I call Kant's compromise 'strange' because Kant himself was completely ambivalent about the whole problem, and he produced a monster with two heads pulling in opposite ways from each other. He wanted to construct something positive, but he ended up with something completely negative. What he set out to do was to establish a firm basis for modern science; what he actually did was to cast doubt not only on science but on morality and religion as well. In his search for certainty in all fields, he pulled the rug out from under all certainty. Like a blind man groping for a path in a primeval jungle, he found nothing. In spite of the growing scepticism in philosophy, confidence exuded from every pore of the eighteenth century Western man. It was the age of reason, and of budding science and industry. Kant wanted to produce a philosophy that would justify this optimism in the face of the growing philosophical scepticism. But he couldn't produce it. Scepticism won in Kant's system, but not completely. Reason and sense experience also won limited victories. It was compromise all the way around. And like all compromises, no one was very happy with it.

What Kant finally drew up, like an arbitration agreement among opposing parties, was that sense experience and reason, both, tell us all we know of the external world. But they do not tell us the ultimate truth, since all they reveal to us is moulded by the forms of the senses and reason, like cookie cutters that cut the dough into shapes before we ever see it, so that all we know of the dough is the shapes of the cookie cutters. The dough as it is in itself we can never know. This is a faint reflection of the Taoist, Sankhyan, Buddhist, and Vedantic views. But Kant says that, not only matter or the 'thing-in-itself' is in principle unknowable, but also the soul-in-itself (the 'transcendental unity of apperception') and

God were also unknowable. The transcendental soul we can *postulate* as the unity of the individual knower, and God we can *postulate* as the ultimate ground for all existences and the ground for the moral order as well; that is, as the rewarder and punisher of good and evil deeds after death. But neither the soul-in-itself nor God can be proved or known by reason or experience at all. This view of Kant's left the arrogance of both the empiricists and the rationalists in shambles, as well as the arrogance of Western man.

Kant shocked and changed the Western world, but that world found ways of forgetting him because his picture of human life was too painful to contemplate. The nineteenth century was born into this world of Kant, but already the scene was changing. What Kant's view amounted to was that what cannot in principle be known is only a kind of maya, a vague 'beyond' that can make no conceivable difference to us. If we postulate this unknowable something as reality, then what we do 'know' through the senses and reason is itself only maya and we have no knowledge of anything at all. And if not only matter is in principle unknowable but also the soul and God, then we are indeed reduced to a limbo of total unknowing than which there could be no greater hell. Kant is like one who tries to reach the stars in a spaceship, and voyages into space until his fuel is burnt out, where he drifts forever, a Flying Dutchman of the modern West lost in the outer darkness. Fortunately, perhaps, most men never heard of Kant, and probably could not have understood him if they had. Among intellectuals Kant was soon forgotten, though his effect lingered long. Every philosopher since Kant has tried to answer him, and each one thought he did, but no one succeeded until Swamiji. Science and industry created enough new practical problems to bury him in oblivion.

The romantic movement of the late eighteenth and early nineteenth centuries created a diversion by trying to answer the Kantian problem in a new way: by urging emotion as the primary instrument of knowledge. Through

emotion, the romantics said, we could find truth better than by reason or the sense by themselves. They went far beyond Kant and pointed out the burning question: how can we pierce the veil of nature by the love of beauty and reach God, the indwelling spirit of nature? Shelley's poem, 'Hymn to Intellectual Beauty', and Keats' poems, 'Ode to a Nightingale' and 'Ode on a Grecian Urn', express the romantic yearning for the truth which is beauty, and the despair at not ever being able to attain more than fleeting glimpses of it. It would take a bigger man than any of them to answer that problem, and that man was to be Swamiji, and answer it he did. But what the romantic movement did was to change the rules and play a new game entirely. Kant was thus left behind, 'an old man in a dry month,...waiting for rain', as the poet T.S. Eliot was later to epitomize the modern age.[7] Modern man has forgotten about Kant, but he carries Kantianism to its logical conclusion by finding God to be not needed any more.

But there was much more to the needs of the West in Swamiji's day than this. The God that many in the West felt was no longer needed was not so much Kant's abstract postulate for the possibility of morality, nor the loving Father as taught by Jesus, but the harsh lawgiver, judge, and condemner of souls that has dominated Western religions from ancient times. The religions of the West have always been dualistic religions, not only in the sense of teaching a dualism between God and the individual soul, but in a much deeper sense. All Western religions have always taught the terrifying dualism of both God and the Devil, both Heaven and Hell, both the Holy and the unholy, both white and black magic, and, most terrifying of all, the exclusive alternative of either salvation or damnation, a damnation which lasts—*forever*. No spiritual prospect could be more horrifying. For those who are damned, hell is an eternity of regrets and remorse, to say nothing of unmitigated torture, with no hope of redemption—ever. For the damned and doomed, the Redeemer does not live at all.

Thus for centuries and centuries Western cultures laboured and agonized under this lifelong threat held over them by the various ecclesiastical authorities—lifelong because it was held over each penitent's head from birth to death. Since the human condition is what it is, that is, we are universally vulnerable to temptations of all sorts, who could ever be certain of salvation under the inextricably intricate rules set up by the various ecclesiastical bodies? And without the hope of salvation, what life is worth living? For the whole history of Western civilization the threat of damnation has yawned its earthquake chasms beneath everyone's feet without exception, and no one has felt safe from it. This religious terrorism was above all what the West needed to be saved from.

On the American scene we have the Western preoccupation with sin and damnation exemplified in two writers, Nathaniel Hawthorne and Mark Twain. Hawthorne was obsessed with the Puritanical obsession with sin, particularly that of adultery. He saw no way out of the tangled maze of brooding on sin until the very brooding becomes the worst sin of all. He expresses man's inextricable involvement in sin in his story 'The Birthmark', in which the attempt to remove a symbolic birthmark from an otherwise blemishless face results in the patient's death. Twain, though outwardly antireligious, was inwardly just as religious as Hawthorne, and just as obsessed with sin. But, for him sin was mostly man's inhumanity to man. His vituperative castigations of the whole human race on the cruelty shown by all men to each other is as bitter and obsessive as any of Hawthorne's morbid broodings. His satires on all Western religions reveal that the West taught a cruel Devil and a still more cruel God. Like Hawthorne he saw no way out. Each writer was self-condemned to his own private hell from which he never escaped, for each saw humanity as universally condemned to suffering. Both writers express the total sense of the blindness of the 'lost generations' of the nineteenth century who groped in the

dark without a ray of light to guide them. Light was badly needed in the West, a genuine spiritual sunrise, not a false, phosphorescent marshglow.

Yes, there was a real need, an agonizing need for something. But before Swamiji came, no one seemed to know just what was needed. Many felt nothing was needed—didn't we have everything, such as science and industry, a new continent we Americans had conquered, and conquests and colonies for England and Europe all over the rest of the world? The world-wide picture of the 'white man's burden' was complete—except for just one thing: the West, for all its busybodying around on a world-wide scale, knew not one thing about the cultures and religions of any of the peoples it so cavalierly dominated. Towards the end of the nineteenth century the culture of the West was drifting in a shoreless void and did not even know that it drifted. But drift it did, lost, eyeless, and apparently forsaken.

There are two famous statues in the world. They are famous not only as great works of art but also as highly significant symbols. One is the great Buddha of Kamakura, Japan; the other is Rodin's 'The Thinker'. The Buddha statue expresses the infinite serenity and exalted wisdom and compassion not only of the Buddha but of all oriental religion. Rodin's statue, on the other hand, is very expressive of what meditation means to the West: a strenuous, active kind of discursive thinking, a battleground of ideas. The Buddha is sitting upright, balanced, poised, seemingly floating in the infinite peace of nirvana. The Thinker of Rodin is also seated, but is leaning forward, elbow on knee, chin on a clenched hand, with furrowed brow, eyes staring forward fiercely into space. He is muscular like an athlete, and his attitude of puzzlement suggests the restlessness and the struggle of wrestling with mental problems that perhaps never will be solved. He is a contender, a debater, a fighter, not a man of peace. Buddha represents the ultimate fulfilment, the peace that passeth understanding.

I do not mean to say that the East has not had its share of active warriors—look at Arjuna, and all his friends and relations. But the warriors and kings of the East often had the advantage of the close friendship and wise counseling of some incarnation of God such as Arjuna had in Krishna, or some illumined sage such as King Janaka had in Yajnavalkya. That is the difference: in the East warriors and kings were often guided by illumined seers and sometimes were themselves illumined, as was King Janaka, or sometimes, even, were incarnations of God, as was King Rama. Whether these stories are myths or not makes no difference. They have flown high as the exalted ideals of the East for countless centuries.

Kipling said, 'East is East, and West is West, and never the twain shall meet', and perhaps he was right, up to a certain point of time—but they met, during Kipling's lifetime, in 1893, when Swami Vivekananda came to speak at the Parliament of Religions in Chicago. The Buddha of the East met the Thinker of the West—and what a fateful meeting that was, at least for the West! His coming changed the course of human history, for it revealed that the West was no longer forsaken by hope.[8]

The Message

Though the Orient is symbolized by the transcendental peace of the Buddha, and though Swamiji was every inch the Buddha in his physical appearance, his serene face, his long and deep meditations, his keen mind, his insight into human nature, his boundless compassion, and his attainment of the highest nirvana or samadhi, he came to the West also as a warrior monk, ready to do battle for the greatness of the Vedanta philosophy against the scepticism and narrow-mindedness of the West. Like another great predecessor of his, Sri Krishna, he did battle against the demons of ignorance and prejudice, and slew them right

and left wherever he met them. Swamiji came to conquer, and conquer the West he did, winning it for the establishment of the cultivation of Vedantic ideas from London to San Francisco.

Swamiji's first salvo of shots in this conquest of the West was fired in the very first small handful of speeches he made before the Parliament of Religions at the World's Fair in Chicago in 1893. Few and short as these speeches were, they yet laid down the essence of his whole message to the West. All the rest of his lectures and talks and books simply expanded upon and added details to this basic framework he laid down at the Parliament of Religions.

On the 11th of September, 1893, he made his first speech at the Parliament. Though this was not his first talk in the United States, it was, as Marie Louise Burke makes clear in *New Discoveries*, his first truly public lecture to a large, unselected audience.[9] That first day, as he sat on the platform before the huge crowd among the many other distinguished delegates representing all the major religions of the world, he felt very alone, and very nervous. This was a new experience for him. He kept postponing his address, but finally he could do so no longer. So he rose, and looked over the whole, huge sea of faces outspread before him, and in that moment something happened, as if a vast floodgate suddenly opened: he was inundated by the ocean of the Divine Self manifested in the crowd of people, and he spontaneously addressed them with words: 'Sisters and Brothers of America!' And in that instant the electric contact was made, and it was as if a bolt of lightening had shot between them, for the whole crowd rose as one man and cheered him for several minutes. He had hardly said anything, yet he had already conquered their hearts.

Then the crowd hushed, and the words came, like rain falling drop by drop, faster and faster, on the parched earth.

It was a brief talk, but it opened hearts deep-buried under long ice-ages of griefs and fears and prejudices. He gave two quotations from Hindu scriptures which revealed

what few if any in the audience then knew, that religion is not for the purpose of destroying other men's beliefs, but for the purpose of finding the infinite divine unity underlying all apparent religious differences. He went on to say, 'Sectarianism, bigotry, and...fanaticism...have long possessed this beautiful earth. They have filled the earth with violence, drenched it...with...blood, destroyed civilizations....But their time has come; and I fervently hope that the bell that tolled this morning in honour of this convention may be the death-knell of all fanaticism, of all persecutions...and of all uncharitable feelings between persons wending their way to the same goal.'[10] He thus sounded the main theme of his message: the unity of religions. This was the theme of his second talk, too, a little parable about a frog in a well who met a frog from the sea and who couldn't believe the sea was bigger than his well, an apt symbol for religious and cultural bigotry. The third lecture, however, was much longer, and laid down a magnificent, systematic groundwork for his whole message, and it is here that we get to the essentials.

This lecture was given on the 19th of September, and it began by reminding the audience of what he had already said, that Hinduism is a vigorous and all-inclusive religion that has absorbed and assimilated all the separate sects that have existed in India from time immemorial. This must certainly have been a new idea for his listeners, most of whom probably looked upon India as a land of competing sects and many jealous gods which were worshipped in the form of what the West called 'idols'. To dispel these ideas, Swamiji said, 'From the high spiritual flights of the Vedanta philosophy, of which the latest discoveries of science seem like echoes, to the low ideas of idolatry with its multifarious mythology, the agnosticism of the Buddhists, and the atheism of the Jains, each and all have a place in the Hindu's religion.'[11] He had used the Western term 'idolatry', though later he was to condemn its use and deny there is any such thing as idolatry anywhere, but here he used it

probably because he knew his listeners would understand no other word, and at this point he could not go into details. But the main idea he introduced here was that there need be no conflict among apparently conflicting religious beliefs. He also introduced the idea that there is no conflict between Hinduism and science, because he knew that the conflict in the West between religion and science was one of the main issues of the day, a conflict which must be resolved, but could not be except on the basis of an all-inclusiveness such as that exhibited by Hinduism.

He then said that Hinduism is based on the revelations of the Vedas, an idea that sounds like the Christian belief in the Bible as divine revelation, but he went on to say that the Vedas are not a book but are immutable spiritual laws like the laws discovered by Western science. Here he is illustrating the meaning of divine laws revealed to the mystics by the Western belief in the universal and timeless laws discovered by science. Note that he is not repudiating or belittling science, but rather is using it to show that science and religion are harmonious in that both are engaged in the discovery of immutable laws that exist beyond time and space. This was an appeal to the scientific West to accept Oriental religion on the same basis as it accepted science: experimental proof. Thus in one deft stroke he destroyed the Western idea that science and religion are necessarily at war with one another.

And by introducing the idea that the Vedas are not a book but are the revelations of eternal truths, he made a distinction hitherto unknown in the West between book-worship, which is bigotry, and the acceptance of a higher mystical revelation of truth which is completely beyond all words and books and is open to all who truly seek it. When words are spun on the wheel of the Eternal, they blaze on the skies of the mortal mind as more than words. They shine with a beauty which is truth. Thus was the Western belief in the Bible as revelation at once accepted and enlarged to infinity and taken out of all sectarian bigotry,

for such an interpretation opens the doors to the acceptance of all religions as equally revelations of eternal divine truths.

He then said that the discoverers of these laws in ancient times were the rishis, the seers, the mystics, and that some of the greatest of these were women. Thus did he at once strike a blow for the equality of women in spiritual life and show that revelation means mystical experience. He went on to say that, in Hinduism creation is considered to have no beginning and no end, but is an eternal process. This statement was a decided blow against the Western belief that the world was created once and once only at a particular time of Augustine. Swamiji opened up this insoluble paradox of how God who is eternal could have created the world at a particular time, by saying that according to Hinduism creation is cyclic and never begins or ends, but, from the point of view of time, continues like a revolving wheel forever, with its *kalpas* or aeons forever succeeding one another. Time is thus shown as one with eternity, as eternity perceived in bits, as it were, not something separate from it. In all this Swamiji is not really refuting Western beliefs but enlarging them to infinity.

He then said that the human being is not the body but the spirit, a statement that agrees with the Christian teaching, a teaching which was all but forgotten under the avalanche of materialism that was burying the West. He went on to say that the soul is immortal, which means, according to Hinduism, that the soul is not only deathless but birthless as well. This destroys the barriers erected by Western orthodoxy against the prenatal eternity of the soul, thus giving the soul an all-dimensional immortality instead of a one-way immortality—as does the traditional Western view which says that the soul is created by God at the conception of the body.

Then he solved another problem, the problem of why God seems to create some people happy and others miserable. Swamiji said that we cannot say that God does any-

thing so arbitrary, that the inequalities in happiness and
misery are due to our past actions in former lives, and that
the soul, being immortal backwards in time as well as
forwards, has been incarnated in various bodies for may
lives in the past, and that its past actions, performed under
the veil of ignorance of its infinite and perfect nature, are
what produce in the present life the effects of happiness and
misery. The soul alone produces its own sufferings and joys;
it alone creates its own fate. So was the West introduced to
the idea of karma and reincarnation, so important in Eastern
religions, so long discredited and forgotten in the West.
Heredity, the Western scientific explanation of many
individual differences, Swamiji said, could only be applied
to bodily differences, not to differences of character and
personality, mental differences. We create our own minds,
he said, since they are formed by what we have done in the
past. He disposed of the question of why we can't remem-
ber our past lives by calling attention to the fact that we
also forget much of our present life too. Our conscious
mind forgets, but there is a deeper mind where all our
memories are stored, and these memories can be evoked by
the right means. There are some people, he said, who do
remember their past lives, or some fragments of them. Thus
in a few deft words he placed before the West the whole
theory of reincarnation as a major psychological, philosophi-
cal, moral, and religious theory and experience.

Then he went on to say that the soul is infinite, perfect,
and all-knowing, and compared it to a circle whose circum-
ference is nowhere but whose centre is the body, reincarna-
tion being simply the moving from one centre to another.
Why does such a perfect soul ever think it is imperfect? he
asks. He replies that we do not know, that Hinduism makes
no attempt to answer this question. The idea that some
questions are unanswerable was then and still is, to many
Westerners, too appalling to admit, because the Western
mind has, from Greek times to the present, arrogantly
assumed that reason could know everything (Zeno having

long since been conveniently forgotten). Thus did he deal a blow to the rationalistic bias of the West, though not to the spiritual use of reason, as we shall see.

Yet he repeats the question, rephrasing it slightly, for it is an insistent one: How can the perfect soul be deluded? How can we be anything but soul, and how can soul be anything but perfect? An entirely new approach to the whole problem of selfhood is thus opened up. For centuries the West had writhed under the accusations of sin by which religion flagellated the people. Now Swamiji was saying that the soul is perfect. This was an idea the West had not heard since the days of Plato and Plotinus; it had long since lain buried under the rubble of collapsed civilizations, and now Swamiji brought it forth as vital and fresh as a new-born babe, a spring-born lamb, from the East, where it had never died. The mystery of human life is deeper than the West had dreamed, and Swamiji put it before us. We go up and down, he says, 'a powerless, helpless wretch on an ever-raging current of cause and effect....Is there no hope? Is there no escape?' Here Swamiji's dispassionate reasoning gives place to impassioned poetry and high drama. In presenting this picture he first gives the materialistic view of man as but a cork on the waves of an impersonal, nonconscious matter. He seems almost to be agreeing with it; the law of karma seems to be a cause and effect vortex from which there is no escape.

All this is but prelude to one of his highest flights of poetry and truth. He says: '(This cry) reached the throne of mercy, and words of hope and consolation came down and inspired a Vedic sage, and he stood up before the world and in trumpet voice proclaimed the glad tidings: "Here ye, children of immortal bliss! even ye that reside in the higher spheres! I have found the Ancient One who is beyond all darkness, all delusion: knowing Him alone you shall be saved from death over again."' Swamiji continues, '"Children of immortal bliss"—what a sweet, what a hopeful name! Allow me to call you, brethren, by that sweet

name—heirs of immortal bliss, holy and perfect beings. Ye divinities on earth—sinners! It is a sin to call man so.'[12]

This outwelling of ecstatic love for all mankind as manifestations of perfect divine being struck at the outward form of Western religion, which was primarily concerned with sin and its punishment and had little to say about bliss, and it exploded a large portion of the stern fortress wall of the Western obsession with sin and witch-hunting that had turned much religion in the West into a grim and sadistic affair. For the first time in centuries the West was told by someone who saw it with his own spiritual eyes that the soul is perfect and divine.

One might think that the lecture would end on this high note, but Swamiji had much more to say, all of it extremely relevant. He said that the Vedas did not teach a wrathful and unforgiving God but rather a God of all-pervading power and love, the formless One, yet at the same time the Father, Mother, Friend, and the Beloved who is dearer than all, who is to be loved without bargaining or self-seeking. He said the Vedas teach the essential divinity of the soul though it is held in bondage by matter; but this bondage can be broken through the mercy of God, and this mercy comes only as a result of the soul's having purified itself. Purity of heart, he says, evokes the mercy of God and leads to God-realization.

He says that the Hindu wants God right now in this life, not in some vague future time after the death of the body. For the Hindu, he says, religion is not a matter of formalized creeds but is the actual experiencing of God here and now by the pure soul. When a man realizes God, he says, he lives a life of infinite bliss and perfection. Perfection for the Hindu means oneness with God. Swamiji thus combined the paths of Jnana and Bhakti with exquisite finesse and brevity in this first major lecture to the West. And he added the point he later repeated many times in different ways, that oneness with God through knowledge and love is not a loss of individuality, but is rather the

shedding of the false individuality and the gaining of the only true individuality there is, the Infinite Self.

He made two more important points before he closed. The first was about science. He used the West's intensive involvement in the development of science to show how the Infinite alone is the true individuality and the true reality. He said that science reveals that matter is one unbroken ocean, and that the so-called individual body is a delusion. What I call 'my' body is simply a wave or a bubble in that ocean; through it flows the whole material universe. It has no real boundaries either. Then he made the point he later expanded upon many times. Science, he said, is the search for unity by sorting out particulars into classes, and smaller classes into larger classes. So science consists in the search for and the finding of unity. But why stop before ultimate unity is reached? he asks. Religion is the search for ultimate unity or God, so religion is simply the science of sciences. Thus at one stroke Swamiji destroyed the separating ramparts reared in the West between science and religion. He did not say to stop being scientific. Instead, he said to carry science to its logical conclusion and reach the final unity of all, the Absolute One, which is the goal of all sciences and all religions.

Thus, not only are all religions one, but science and religion as well are one, according to Swamiji, in the sense that all sciences and all religions are seeking the same goal, and in the sense that that goal can be found, Absolute Unity. Since Swamiji spoke these words in 1893, modern scientists in their search for unity have produced results that bear out the mystical view of the final unity of all beings. Einstein's Relativity Theory and his Unified Field Theory[13] broke down many barriers of beliefs that had previously appeared to separate various phenomena that are not really separate. Fritjof Capra, professor of physics at the University of California at Berkeley, has shown the harmony he believes exists between Eastern religions and modern physics in his book *The Tao of Physics*. In an article

of the same title published in the *Prabuddha Bharata* magazine of March 1979, Dr. Capra summarizes his views. Thus we can see that science, using scientific methods, is getting closer and closer to the universal unity behind phenomena as it was urged to do by Swamiji in 1893.

The second important point he made was about idolatry. He discussed not the word but the idea. He showed why image worship is necessary as a preliminary step on the spiritual path. He said that God cannot be expressed in images, words, or ideas; being formless He is beyond all relative things. But that doesn't mean that all images, words, or ideas are wrong. 'Would it be right,' he asked 'for an old man to say that childhood is a sin?'[14] Thus did he show that it is no sin to worship God through images. It is a stage on the path, that is all, a stage that must be sued and transcended. He said that Hinduism recognizes nature's plan of unity in variety; that is, Hinduism is universal and accepts all form of religion if practised with sincerity. He quoted Krishna as saying, 'I am in every religion as the thread through the string of pearls', and pointed out that Hinduism admits Buddhism and Jainism that do not believe in God. What a tumbling of walls was there! To the cradle Western mind, atheism could not have been considered a religion at all, yet here is Swamiji saying that Hinduism includes even atheism in its pantheon of religions.

Now this is the essence of his message to the West, this his first major lecture in the West, at the Parliament of Religions. Whatever he said after that was an expansion of these points. The only subjects he did not introduce in this lecture were the paths of Karma Yoga and Raja Yoga. These two paths he lectured on extensively later and wrote out painstakingly in book form, showing that he considered them just as important as the other two paths of Jnana Yoga and Bhakti Yoga.

He thus introduced Advaita Vedanta, the immortality of the soul and the oneness of the soul with God, the

essential infinitude, eternality, and perfection of the soul, the law of Karma and reincarnation as applied to the apparent self, and the truth that religion and science are not really opposed to one another but are actually seeking the same goal, absolute unity. He also wanted the West to know that sin should not be the chief preoccupation of religion, but he cautioned here that Hinduism is not indifferent to immorality, since it teaches that the mercy of God in granting illumination to the soul depends upon the purity of heart in the apparent self. And, instead of urging the West to give up reason, science and philosophy, he urged it to develop these studies much more thoroughly than it had yet done and to apply scientific methods to religion to find ultimate unity. Above all, he urged the West not to be content with mere verbal theories about God but to translate theories into practice and actually realize God in experience here and now.

In developing later his teachings on Karma Yoga and Raja Yoga, he brought out the fact that he was urging the active, practical West to be active, practical and scientific about religion and treat religion like a science in order to produce practical results in experience by following the rules of practice laid down by the experts, the rishis. The path of Raja Yoga is a series of techniques which if followed correctly will produce certain specific results in spiritual experience inevitably, just like any experiment in science. He was not suggesting irresponsible tampering with higher experiences, any more than scientists teach irresponsibility in the handling of chemicals, but rather he taught an exact, scientific approach which uses specific means to produce specific results.

Thus God can be reached by experience, says Swamiji. Consciousness can be altered, raised, and redirected away from the sense and the mind toward God, not by drugs but by the four yogas. Kant was absolutely right except that he did not go far enough. The senses and the mind are but forms superimposed upon the 'thing-in-itself', and we know things through the forms of the senses and the mind, but

this is not true knowledge. Kant was wrong, says Swamiji, in saying that neither the thing-in-itself nor the soul nor God can be known; they are one and the same all-embracing, infinite non-duality which is what each one of us is and which can be known through identity, not through separative, objective knowledge, which is not knowledge at all. The veil of ignorance hiding reality can be pierced, not by the senses, not by reason, not by the two together, but by consciousness raised above the sense and the mind so that it cuts the veil like a sword of light and dispels all darkness. Consciousness is independent of the forms of the senses and the mind, and when it is freed from these, and from the desires for these forms, it can soar into the infinite, its proper home. The four yogas together give us the means to accomplish this.

All the rest of his teachings to the West developed the details of the four yogas into one yoga. He thus blew up the roadblock that had obstructed Kant. For, as it turned out, Kant, the forgotten Kant, was, or is, in reality, ourselves, each one of us. And all his bumbling doubts and hesitations are ours, and it is we ourselves, all of us Western Kantians, who need the courage to pierce the veil of scepticism we have interposed between ourselves and the reality and to see that reality as our very own inmost Self. Swamiji gave us the power, which is, after all, courage, to realize this. He came to the West and bridged the gap of centuries, a gap that was not so much geographical as mental, and completed the world circle, and thus became the encircling World Serpent, the Serpent with its tail in its mouth, the *kundalini* power awakened and united with itself, the ring symbol of immortality, of Eternal Life. The emblem which we see on every Advaita Ashrama publication symbolizing the unity of the four yogas was devised by Swamiji himself, and it embodies the essence of his message to the whole world. It is magic talisman for our infinite meditation.

What did Swamiji himself say about his work? Two quotations from his letters are of great interest. In one he says:

'To put the Hindu ideas into English and then make out of dry Philosophy and intricate Mythology and queer startling Psychology, a religion which shall be easy, simple, and popular and at the same time meet the requirements of the highest minds—is a task which only those can understand who have attempted it. The abstract Advaita must become living—poetic—in everyday life; out of hopelessly intricate Mythology must come some concrete moral forms; and out of bewildering Yogism must come the most scientific and practical Psychology—and all this must be put into a form a child can grasp. This is my life's work.'[15] In the other letter he says: 'All religion is contained in the Vedanta, that is, in the three stages of the Vedanta philosophy, the Dvaita, the Vishishtadvaita, and Advaita; one comes after the other. These are three stages of spiritual growth in man. Every one is necessary.' He then goes on to show how every major world religion can be classified under one or another of these three stages of Vedanta.[16] The popularization of Hinduism without watering it down, and the teaching of Vedanta as the comprehensive unity of all outward form of religion, as the Mother of all particular religions—these are the important aspects of his work, not only in the West but in the whole world, according to Swamiji himself.

Above all, Swamiji taught renunciation and self-sacrifice. He laid before the West a plea for the sacrificial life in words of eloquence such as had never before been spoken by anyone. Speaking from his own personal experiences as a wandering monk all over India, in the towns, villages and jungles, he said: 'As a result of this intense, all-absorbing love comes the feeling of perfect self-surrender, the conviction that nothing that happens is against us. Then the loving soul is able to say, if pain comes, "Welcome pain."...If a serpent comes, it will say, "Welcome serpent." The Bhakti in this state of perfect resignation, arising out of intense love for God...ceases to distinguish between pleasure and pain in so far as they affect him....Why should our body be saved, say from a tiger? The tiger will thereby

be pleased, and that is not altogether so very far from self-sacrifice and worship. Can you reach the realization of such an idea in which all sense of self is completely lost? It is a very dizzy height on the pinnacle of the religion of love, and few of this world have ever climbed to it....Blessed are they whose bodies get destroyed in the service of others.'[17] He himself was the best example of this ideal; he laid down his body in the service of mankind as a whole, but especially in the service of the West, for he spent his best years in the West and spared no effort to bring to it the whole message of Vedanta as taught by his Master, Sri Ramakrishna.

We are here today to remember him and think about him, and especially to think about his impact upon our lives. I ask you to consider this: if he had not been born, where would we be today? What would we be today? If he had not been born, this Temple would not have been built, and this gathering would not have been held. We cannot begin to comprehend the extent of his influence upon us. He himself was overheard to say, on the last day of his life, 'Only another Vivekananda could understand what Vivekananda has done.'[18] This thought explodes the mind. The finite mind cannot hold the Infinite. Swamiji was that very explosion itself. He made the commonplace world no longer commonplace. He revealed that the streets we walk on are not stone but the very living flesh of God, that the air we breathe is the very breath of the Eternal, that the sunlight is the immortal fire of divine knowledge and vision, that the trees that line the street are all divinities who salute us as we pass, that all the people who walk the streets are divinities we have the opportunity of serving.

The essence of Swamiji's message to the whole world can be summed up in one word: Advaita, non-duality. Not oneness, unity, a bringing together of diverse and separate elements into one homogeneous whole, but rather the opposite principle, the expansion of the finite into infinity. The Infinite is beyond all limited experience, as space is beyond the atmosphere, but yet it is *here* and *now* with no

there or then. It is a lightning flash of vision with no limits of any kind.

That is his message, his message to the world, East and West. Whether he was immersed in the Mother, in Shiva, or in Nirguna Brahman, his message was always essentially the same: the total dissolution of the many into the Infinite, dualism and qualified non-dualism being way-stations on the path to the unqualified non-dual Infinite. His message to the West was simply the particular way he expressed this ascent into the non-dual so as to meet the special needs of the West. He was a Pilgrim from the Eternal who wandered for a time on the shores of our relative world, bringing us a message from that Infinite Sea, stirring us to remember our ancient divine heritage, and then returning to the Infinite once more.

He was himself his own greatest message. He taught us of the West by his own example how to live in our own mechanized society. He meditated in street-cars, in trains, in railway stations, on lecture platforms, and in doing so showed us how to be yogis in the world of daily affairs. He rekindled in the West the flame of God-knowledge. He brought the guru-power in his own person, and in the persons of all the Ramakrishna swamis who have followed, so that now here in the West we have that flame burning that has descended in unbroken succession from Vedic times down to the present. His person is like the ocean, at once powerful, illimitable, sublime, terrifying and peaceful. The ocean has the power to send a strong ship to the bottom in one blow. But it also is the tender, gentle, all-sustaining nurse and mother, sweet, refreshing and ineffably beautiful. In the sigh of the smallest wave one can hear the whisper of infinitude. In Swamiji, as in Sri Ramakrishna and Holy Mother, the Fatherhood and Motherhood of God are ceaselessly and endlessly manifested, so much so that even we who never saw him in the flesh, in this life at least, can never forget him, nor ever cease to think on him day or night. For we have come under his holy spell, where we shall remain—forever.

Our gratitude to him for coming here and giving himself to us, and to all the swamis who carry his flame from the East to the West, is illimitable.

REFERENCES

1. *Bhagavad-Gita*, 4.7–8.
2. *The Life of Swami Vivekananda* (Calcutta: Advaita Ashrama, 1960), p. 145. Hereafter *Life*.
3. Luke 2:49.
4. *Life*, p. 595.
5. Ibid. p. 332.
6. Marie Louise Burke, *Swami Vivekananda in the West: New Discoveries* (Calcutta: Advaita Ashrama, 1966), pp. 120–2; and *Life*, pp. 350–1.
7. T.S. Eliot, *The Complete Poems and Plays*, 'Gerontion' (New York: Harcourt, Brace & World, 1952), p. 21.
8. For a more detailed and scholarly discussion of the general climate of opinion in the West preceding Swamiji's visit, see Gargi (Marie Louise Burke), 'Science, Religion, and Swami Vivekananda', *Prabuddha Bharata*, March, 1979, pp. 95–102, and April, pp. 169–82. For a general history of Western philosophy see B.A.G. Fuller, *A History of Philosophy* (New York: Henry Holt & Co., 1952).
9. Marie Louise Burke, *New Discoveries*, pp. 15–48.
10. *The Complete Works of Swami Vivekananda* (Calcutta: Advaita Ashrama, 1965), vol. 1, p. 4
11. Ibid. p. 6.
12. Ibid. pp. 10–11.
13. See Lincoln Barnett, *The Universe and Dr. Einstein* (New York: Mentor, 1950).
14. *The Complete Works*, vol. 1. p. 17.
15. *Life*, p. 392.
16. Ibid. p. 345.
17. *The Complete Works*, 1964, vol. 3, pp. 82–3.
18. *Life*, p. 749.

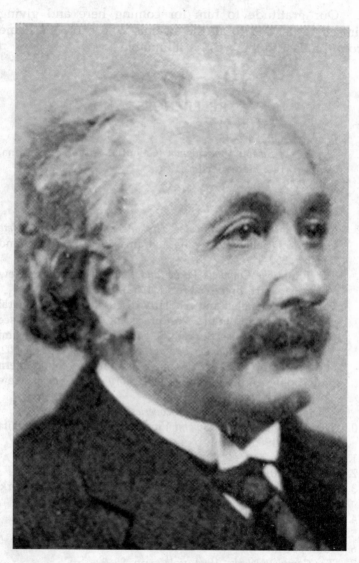

Albert Einstein (1879–1955)

EINSTEIN AND VIVEKANANDA

John L. Dobson

Swami Vivekananda, in 1895 or 1896, asked Nikola Tesla if he could show that what we call matter (mass) was simply potential energy. Tesla apparently failed to show it—and it was not shown till 1900 by Albert Einstein who, at that time, was an unknown physicist working as clerk in a patent office in Bern, Switzerland. Although by now Einstein's equation for the equivalence of mass and energy has become the most famous equation of physics, Einstein himself did not become famous till 1919. Meanwhile, in 1902, Swami Vivekananda had passed away and no one seems to have noticed that his problem had been solved and that Einstein's famous equation, $E = m$ (often written $E = mc^2$), was the equation which he had requested of Tesla nine or ten years earlier.

There are several reasons why no one noticed. The first reason is that the Swamis of the Ramakrishna Order do not usually study physics as physicists. The second reason is that the physicists of Europe and America do not usually study Vedanta. A third reason is that the physicists of Europe and America usually misinterpret Einstein's equations.

Several years ago, at the University of California in Berkeley, I had an occasion to address a large audience of physicists and astronomers, chairmen of departments, directors of observatories, etc., and I asked for a show of hands on the meaning of Einstein's equation, $E = mc^2$. American audiences have not studied 'non-cooperation' under Gandhiji, and they were willing to give a show of hands that 65% of them thought that this equation meant that energy could be converted to mass and that mass could be converted to energy much as, in a swinging pendulum, gravitational energy is converted to kinetic energy on the down-swing and kinetic energy on the up-swing. In that

whole audience only five hands went up to indicate that that was not the meaning of his equation. Then I pointed out that that was not his meaning and that if that had been what he meant, Einstein would have written E + m = K (The sum of mass and energy is a constant), and I wrote it on the board. They all knew how to read equations, and they all knew that that was what he would have written, and they were much embarrassed. (I was later informed that in a meeting of such distinguished people no one asks for audience participation.)

Einstein's equation for the space-time separation between two events, as seen by different observers, is similarly misinterpreted. Usually the commentators say that, where one observer sees more time and less space between two events, another observer, moving with respect to the first, will see more space and less time. But that statement makes time another dimension of space, whereas, in Einstein's equation, space and time enter as a pair of opposites, so that the observer who sees the larger time separation sees also the larger space. Einstein never liked the term 'relativity theory'. He wanted it called the theory of invariance and, if he had had his way, this mistake might have been less usual.

Swami Vivekananda was first and foremost an Advaitin (non-dualist), and he saw that, like Sankhya, the physics of his day was dualistic. It believed in matter and energy. Swamiji wanted that mistake corrected. Had it been corrected by Tesla, while Swamiji was still in America, relativity theory would have been associated with Swamiji's Advaita, and we can well imagine what turn the history of modern science might have taken. But Tesla apparently failed and the task fell to Einstein after Swamiji was gone, and, in those early days, no one seems to have connected Einstein's solution with Swamiji's problem of nine or ten years earlier.

Being an Advaitin, Swamiji also suggested that the chemists would have finished their job when they could show that all the chemical elements could be made from only one of them. It had been suggested by Prout, in 1815, that they were all made of hydrogen, but in those days no one knew

where it could happen. We now know that it happens at very high temperatures in the bellies of the stars and in the brilliant stellar explosions which scatter the heavier elements all through the galaxies, and that the elements of which our Earth and our bodies are made were fashioned from hydrogen by the gravity of massive stars. We must remember that some of the developments of modern science have made the universe very much easier to understand than it was in Swamiji' day, and we may now think of the primordial hydrogen as Swamiji's Akasha ('the first principle of materiality') and of its gravitational energy as his Prana. He used to say that, by the action of this Prana on the Akasha all this universe is fashioned. We know now that he was right. It is much simpler than we thought, and we know now that, since the entire universe is made out of hydrogen, if we can understand the nature and origin of hydrogen we can understand everything.

To understand hydrogen we must first understand what kind of energy makes it massive. If $E = m$, what kind of energy is all this mass? It is important to remember that it is a very sizeable amount of energy. One kilogram of matter is the energy of a thousand atomic blasts. It is enough energy to blow a cubic mile of rock to powder and put it in the stratosphere. That is the energy value of one litre of milk on the open market, and, in the light of modern physics and astronomy, we do understand what kind of energy it is. It is potential energy. It is gravitational, electrical and nuclear energy, and they are all the same thing. They are the two sides and the edge of the same coin.

There are collapsed stars with densities of about a hundred thousand battleships in a half-litre jar. If we were to drop a kilogram of matter, say a litre of milk, to the surface of such a star, the gravitational energy released to kinetic energy in the fall would be about a hundred grams, or one tenth of its rest energy. The splash would be like the explosion of a hundred atomic bombs. If we could put all the mater of the observable universe in one place and pour our litre of milk in,

then the gravitational energy released would be that of a thousand atom bombs, or its entire rest energy. But the rest energy of our milk is also electrical because, like the rest of the universe, it is made of minute electrical charges which have an energy associated with their smallness. For reasons which we are about to investigate, electrical charge, whether positive or negative, is self-repulsive, and the energy associated with the smallness of these self-repulsive charges is, once again, one thousand atom bombs per kilogram. Gravity and electricity are opposites. They are what we call energies of position. To know where a charge is is to know where it is with respect to all other charges in the observable universe, and that gives it its gravitational energy. And to know where a charge is is to know that it is small, and that gives it its electrical rest energy. But to know where something is in space and time is associated, through the uncertainty principle, with an indeterminacy in its momentum and its energy, and, in the case of the hydrogen, the energy associated with this indeterminacy is also one thousand atom bombs per kilogram. These three energies are the two sides and the edge of our coin.

By interpreting Einstein's famous equation as it is written and as he himself interpreted it, we are able to understand the rest energy of the primordial hydrogen. But that equation is simply a consequence of a much more fundamental change which he introduced into our understanding of geometry. Toward the close of the last century it was becoming clear that the universe is not objective in three dimensions. Observers, moving with respect to each other, cannot agree on the measured distances between events, not on the lengths of time that have elapsed between them. In 1905, Einstein pointed out that time must come into Pythagoras' equation of the separation between two events because time is the fourth dimension of the geometry of the real world. But, as I mentioned earlier, the square of the time separation between two events comes into that equation with a minus sign because space and time are opposites. And that equation sets

the separation between the perceiver and the perceived at zero. (If a light beam can get from one event to another in vacuum, then the space and time separations between those two events are equal and the total separation is zero. For any event which we can see, the separation between that event and its perception is zero.) But space and time can be opposites only by being identical. Plus and minus electrical charges are opposites only because they are both electrical charges.

Now this Advaita, introduced by Einstein, makes it possible for us to understand our physics in a new and interesting way. In the last century we thought that the universe consisted of real particles with mass and real energy moving through real space and time. We thought that mass, energy, space and time were all independent entities, and we may conveniently represent it by a diagram.

Mass	Space
Energy	Time

The world view of classical physics

But we just saw that Einstein's geometry takes out the line between space and time, and that his physics takes out the line between mass and energy. That leaves us with a mass-energy discontinuum on the left and a space-time continuum on the right. And, in our investigation into what makes hydrogen massive, we already saw that the vertical line drops out of our diagram, because what we see as the mass-energy discontinuum on the left is simply a geometrical wind-up against the space-time continuum on the right.

Now when the lines of demarcation between mass, energy, space and time are obliterated, we are left, not with a new model of the universe, but only with a new question mark, and with the suggestion that what it represents is

beyond space and time. What exists beyond our physics must, therefore, be changeless, infinite and undivided, because dividedness and smallness can be only in space, and change can be only in time.

It is not that these are three characteristics of the reality beyond space and time (Swamiji's Absolute), but only that, looking from our position in space and time, we look in different directions and give it different names. Seen beyond the changes of time, it is said to be changeless. Seen beyond the smallness of the changes in space, it is said to be infinite. And seen beyond the dispersion of matter through space, it is said to be undivided. It appears to be threefold only from our point of view within space and time.

But if Swamiji's Advaita, introduced into our physics by Einstein, points to Swamiji's Absolute behind our physics, then how do we see it as gravity, electricity and inertia, and why is it associated with this necessary uncertainty? And, if what really exists is undivided, infinite and changeless, why do we see it as hydrogen? Why do we see it as divided into atoms, made of minute particles and continually changing? How can we get from the changeless to the changing?

First, we cannot get there by the causation of our physics without actually changing the changeless. Furthermore, we cannot account for the origin of the causation of our physics, because that causation is governed by what we call the conservation laws. The energy at the end of a change is always equal to the energy at the beginning. Only the form of the energy changes; never the amount. That is why we call it transformational causation. In Sanskrit it is called Parinama. It is like making milk into buttermilk. If you start with one litre of milk, you will end up with one litre of buttermilk. But, unlike the buttermilk, the hydrogen does not arise from something else. The rest of the universe arises from hydrogen by Parinama (the causation of our physics), but the hydrogen itself (Swamiji's Akasha) cannot arise in that way. How then does it arise?

Quantum mechanics suggests that it arises through an uncertainty. The root notion in quantum mechanics is Heisenberg's uncertainty principle, which states that if we know the position of a particle in space we cannot know its momentum, and if we know the position of an event in time we cannot know its energy. In short: if we see something in space and time, there will always be an uncertainty about what it is that we see. It is like mistaking a rope for a snake. There will always be an uncertainty about the snake. Let us call this 'apparitional' causation (in Sanskrit it is called Vivarta), and let us examine the consequences to our physics. If, through an uncertainty, we have indeed mistaken the Absolute for the relative, in what way must that mistake show up on our physics? In what way must the rope show up in the snake?

The Vedantins, long ago, analysed this kind of causation and pointed out that it has three aspects. When we mistake a rope for a snake, first we fail to see the rope rightly. That is the veiling power of Tamas. Then we jump to the wrong conclusion. That is the projecting power of Rajas. Finally we saw the rope in the first place. That is the revealing power of Sattva. Otherwise we might have mistaken it for a rickshaw or a cow. It is the length and diameter of the rope which we see as the length and diameter of the snake.

If, then, we have mistaken the changeless, the infinite and the undivided for something else, it can only be changing, finite and divided. So far, so good; our hydrogen certainly appears to be continually changing, made of minute particles and divided into atoms. But the changeless, the infinite and the undivided must also show in our physics, just as the length and diameter of the rope must show as the length and diameter of the snake for which it is mistaken. Once again, so far, so good. The changeless shows in our physics as inertia. The infinite and the undivided show as electricity and gravity. That is why hydrogen is made of gravity, electricity and inertia and not something else. There are no other ingredients out of which it could be made. There

is only the nature of the reality seen in space and time. Energy is apparitional. Only its changes are transformational, and the gravitational energy can go to zero only if the dividedness goes to zero. The electrical energy can go to zero only if the size of the charges goes to infinity. And the nuclear energy can go to zero only in the absence of the uncertainty.

Our physics itself is evidence that what we have seen is the changeless, the infinite and the undivided. After a lecture in Calcutta I was asked, 'How do you know that it's not superimposed on nothing?' 'No, no, no!' I said; 'Then the zero would show in our physics. That's not what shows. It's the infinitude of Brahman that shows in our physics. The infinitude shows as electricity, the changelessness shows as inertia and the undividedness shows as gravity. If the Advaitins weren't right, our physics would have been different.'

Swamiji wanted Advaita brought into our physics. It was brought in by Einstein's equations and by Heisenberg's uncertainty principle. These are the equations of Vedanta, and with them came the explanation for gravity, electricity and inertia. There is no such thing as matter. There is only energy. It is an apparition. It is a very serious mistake. It is not possible to see this mistake and not have it wound up to one thousand atom bombs per kilogram. Energy is apparitional. Only its changes are transformational. From the Absolute to the primordial hydrogen and its gravity (Swamiji's Akasha and Prana) is through Vivarta (apparition). From that to what we see around us is through Parinama, by the action of that gravity on the hydrogen (by the action of the Prana on the Akasha).

Swamiji said in London, in 1896, 'The Absolute has become the universe by coming through time, space and causation. This is the central idea of Advaita. Time, space and causation are like the glass through which the Absolute is seen, and when It is seen on the lower side, It appears as the universe.'

Section V

SAINTS AND SAGES

SRI ANDAL: THE DIVINE BRIDE

Swami Ritajananda

The rich culture and the spiritual heritage of India will lose much of its greatness if the personality of Sri Krishna is ignored. For he enters into all the aspects of Indian life. His life at Vrindaban has always been given high place by the mystics who saw in that nothing but the sublime relation between God and His devotees. We find that the *Bhagavata-Purana* calls him the Lord Himself. The Gopis (the cowherd girls) stand as ideal specimens of devotees who seek nothing in this world but the pleasure of his company. Saints have appeared again and again in various parts of India, manifesting the same passion for Sri Krishna like those Gopis, and have reached great spiritual heights. Most of us are familiar with the life of Sri Krishna Chaitanya of Bengal, who manifested in himself all the feelings of Sri Radha, a love-lorn Gopi, for Sri Krishna. Many centuries before him a number of Ālvār saints of South India possessed similar divine love, and among these there is the solitary woman—Sri Andal, who shines with a unique brilliance. Her dedicated life to God, even from her childhood, without a tinge of worldliness and with a complete absorption in God, raises her above many other saints.

Srivilliputtur is an ancient town in South India, about fifty miles south of Madurai. There stands an important Vishnu temple. In the eighth century, this town was under the suzerainty of the Pandya kings, who gave special attention to the temple. About that time, there lived a Brahmin, Vishnuchitta by name, who spent his days in supplying flowers and *tulsi* (basil) leaves for the worship of the Lord. Besides this, he composed numerous Tamil hymns, which he sang in the temple. His extraordinary

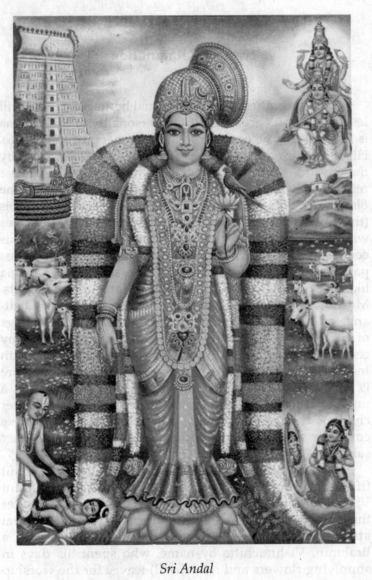

Sri Andal

devotion for Vishnu well brought out the meaning of his name, viz. 'one who has Vishnu always in his mind'.

One morning, while he was busy gathering flowers, he suddenly beheld a beautiful baby-girl lying under the *tulsi* bushes. Charmed by her heavenly beauty, Vishnuchitta lifted up the child and hugged her to his bosom. A devotee like him saw nothing strange in the appearance of the child, and he took it as a gift from God to brighten his lonely life; for, he had neither wife nor children. He carried the child home and showered on it all his affection. The name Goda (Kodai) was given to the child, and under his loving care it grew up into a charming girl. It was noticed that, even in her small games with sand-castles and dolls Goda exhibited her special attention to the worship of the Lord in her daily life. When she grew a little older to receive education, Vishnuchitta entertained her with all the incidents of Sri Krishna's life at Vrindaban, which anecdotes fascinated her. Little by little she began to help her father. She looked after the garden, watered the plants, plucked flowers, and also prepared beautiful garlands for the deity in the temple.

While her tiny hands were engaged thus, the mind often revelled in the thought of Krishna. The picturesque narratives she had heard vividly brought before her mind's eye the scenes of Gokula, the abode of Krishna. The mischievous boy Krishna, always teasing the Gopis, his fighting and killing numerous enemies, and his enthralling flute-play captivated her completely. She felt that she was an unfortunate girl in not having taken birth as one of the Gopis. If she had to choose a husband it must be Krishna and he alone. For, who could ever have such a rare combination of beauty, courage, intelligence and goodness like him? If she was a Gopi, how merrily she would have played with him! She would have dressed herself in all finery and attracted his attention. Jewels, fine garments, and flowers would have surely made her win his love.

While these thoughts were passing through her mind, she saw that the garlands were prepared. Why should she not

try to work out her ideas even now? So, immediately she put on the garlands round her neck, some she used for her hair, and consulted the mirror to see how she befitted the handsome lover. Slowly this act became a daily habit with her, and every day Vishnuchitta, completely ignorant of all this, carried these garlands used by his daughter to the temple.

This went on for a number of days. One day Goda thought that she should dress herself like a bride ready for the marriage. So she put on all her jewels, dressed herself in the best clothes, and used all the floral wreaths to give the finishing touches. While she was thus dressed up and was standing before the mirror, absorbed in her thoughts, who should make his sudden appearance there but Vishnuchitta! Seeing all the flowers meant for the temple on the body of Goda, he was shocked. He had been training her according to orthodox religious traditions and he could not believe that his daughter would do such a sacrilegious act. She never did anything to provoke him and he had no occasion to scold her, but now how to ignore this sinful act? Profoundly moved, at last he found words to say, 'Goda! What have you done? How did you dare to put on yourself these garlands meant for the Lord and Him alone? Do you not know with what care we pluck the flowers and do not even smell them, which are for His worship? My dear child! I never thought you would shock me thus. What shall I offer to Him? How shall I face his divine presence? By your silly act of vanity you have brought on me such a misery....' He could not say more. Goda was violently brought back to this world. She turned round and saw her father. His words of chastisement made her see clearly her crime, how she had pained her loving father. She could give no reply and stood there mute, while tears trickled down her face.

After a while, Vishnuchitta went away. The thought that the ancient habit of supplying flowers to the Lord had to be given a break made him feel very miserable. The foolish girl had, by her desire to look beautiful, brought a rift in the peaceful tenor of his life. He went to bed. But the

day's incident came again and again before him. His daughter's action was like a puzzle for which his brain sought a solution in vain. At last, when the mind became weary of the recurring thoughts, Vishnuchitta fell asleep; and he began to see a glow amidst the surrounding darkness. Slowly the glow became a bright light and in that he saw the deity of the temple, who asked him, 'What is the matter, my son? You have not given the flowers today!' What could Vishnuchitta reply? To tell the facts would only reflect the faulty training he gave to his daughter. But the Lord did not wait for his reply and continued, 'Evidently you have not understood who is in your house as your daughter. She is no ordinary human girl, but one who belongs to me. Bring the wreaths which she uses and they will be gladly accepted by me.' The sight vanished and Vishnuchitta woke up. Now he began to think of Goda in a new light. Slowly he remembered all the actions and games of Goda while she was a child, which pointed out her spiritual development. He began to see clearly that she was really not an ordinary human being to enjoy the pleasures of the world, but one who had the grace of God. So he began to address her as 'Āndāl', the queen of the world.

But Goda was unaffected by the special distinction given to her. She continued to have her thoughts for Sri Krishna alone. As years passed by, her devotion to God also increased. She saw her friends going to their husbands, but why did He not come to take her? Her thoughts went back again to the Gopis. They were performing the worship of the Divine Mother Katyayani, for getting a suitable husband. Why should she also not do the same?

The month of Margashirsha (December-January) is considered to be the best of months. It is the period when the cool hours of the dawn are spent in prayers and meditation by many people. Then the worship of Katyayani is undertaken, which comes to a close on the full moon day. It is said that the Gopi maidens got up in the early morning,

went to the river-side and had their bath, and then performed the worship. Andal thought of doing the worship mentally, considering herself as one of the Gopis, the town of Srivilliputtur as Vrindaban, and the local temple as the house of Krishna. This whole idea she has put in a charming poem, *Tiruppāvai*, which she sang in the temple. Along with this she composed another piece, called *Tirumozhi*, which expresses her longing to meet her beloved Krishna.

While she was thus dwelling in the world of love for Krishna, her father found that she had reached the marriageable age. But he could not think of any young man who was suitable for her. So he thought he might as well take her opinion in this matter. Andal, who had understood his thoughts, told him, 'Father, I have already chosen my husband, who is the Lord Narayana himself. If it comes to my ears that you are planning to give me in marriage to a mortal being, I shall be no more.' What a strange proposal! How could Vishnuchitta get Lord Narayana to marry his daughter? He thought that his daughter was trying to escape a married life. But still he began, 'My child, I agree to your wish. But you know Lord Narayana manifests Himself in the 108 temples dedicated to Him in the various parts of India. Of these, whom are you going to choose?' Then Andal wanted to know the characteristics of each of them. Vishnuchitta began to describe the greatness of each of them. When he began to talk of Sri Krishna of Mathura, Andal felt so full of joy that her hair stood on end. When he began to describe the Lord at Tirupati, she exhibited brightness in her face. But when she heard the glory of Sri Ranganatha, her whole body expressed joy. Now it became clear that she desired her marriage with Sri Ranganatha at Srirangam, near Tiruchirappalli, in Tamil Nadu.

Yet, how to arrange this marriage was still a problem for Vishnuchitta. Just at this time, the priests and other officers connected with the temple at Srirangam heard the commands of the Lord, who asked them to proceed immediately to Srivilliputtur and bring Andal there. A grand

procession was soon arranged, with elephants, gaily decked horses, and fine music, and a big retinue of friends. A beautifully decked palanquin was brought for carrying Andal. On an auspicious day, the whole party slowly wended its way to Srirangam. After walking for a number of days, they at last reached the entrance of the temple of Sri Ranganatha. The people who had heard about the strange marriage assembled in large numbers within the temple. The palanquin was lowered at the entrance of the main shrine. Andal was sitting inside the closed palanquin, constantly meditating on God. She began to feel that at last the day had come when her only desire was going to be fulfilled. So, getting down from the palanquin, she walked straight into the shrine, like a needle attracted by a magnet. The assembled people who noticed her going to the feet of the reclining image of the deity, were eagerly waiting, thinking that after a short while she would come out with her bridegroom. But, to their amazement, no such thing happened.

After a while, Vishnuchitta peeped into the shrine to see what her daughter was doing. But where was she gone? There was no trace of her anywhere. Along with others he searched for her all around, but could not find her anywhere. Poor Vishnuchitta was sorely grieved at the turn of events, for he had none else to console him but the Lord Ranganatha Himself. When he stood there before the deity, Vishnuchitta suddenly heard a voice from the inner shrine, addressing him, 'Vishnuchitta! Your daughter has been accepted by me. You need not search for her any more. Blessed indeed are you for giving your daughter in marriage to me.' These words afforded no solace to his aching heart. For many years he had no children and, at last, Andal came to brighten his household and cheer him in his old age. All his hopes were shattered as she was taken away from him. How could he go back to his empty house? Yet he could do nothing else. The blessed girl had won the grace of God and was united with Him. What better state could he wish for her, although it made his worldly life a bit painful? So he

went back to Srivilliputtur to spend the few remaining years of his life in prayer and contemplation of the Lord.

This is the narrative of the life of the illustrious woman-saint Andal, according to available traditional accounts. This simple life may not have many attractive features. Nevertheless it has a great value in showing the world her one-pointed devotion. Andal is a 'rare flower' among saints. The thought of God pervaded her whole being and the limitations of mundane life only stood as a weak barrier between her and her Beloved. The two immortal poems in Tamil, which she has left behind, give a clear picture of her thoughts. While one of them—the longer one—describes her love-lorn state, the other shows how one can win divine grace by complete surrender at the feet of the Lord.

The poem called *Tirumozhi*, popularly known as *Nāchiyār Tirumozhi*, or the 'Sacred Utterances of Our Lady', consists of 143 stanzas, generally divided into fourteen sections according to the central idea in each.

Andal is intensely longing to meet her Lord, and so her first thoughts are to ask the god of Love, Manmatha, to act as her messenger. She praises him and coaxes him to help her. Now and then she also remembers how the Gopi girls, in their childhood, called on Sri Krishna to witness their games.

> O Narayana! You are with thousand names praised.
> You took a human body, but what a mischievous lad
> you turned out!
> If we are to have you as our husband, O Lord! how
> much shall we suffer in your hands!
> We are now busy decorating our homes.
> O Sridhara! Pray do not spoil our games.
> This whole day, while our backs ached, we worked
> To finish these charming palaces. Won't you come, Lord!
> To see our homes and give us delight?
> We know you once became a baby and lay on a leaf
> to save the world.
> Can you not have some mercy for us?

Manmatha fails as a messenger. Andal next begins to dwell more and more on the divine disport of Krishna at Vrindaban. A good number of stanzas are devoted for this purpose. Andal is left helplessly to think of Krishna, day and night, without any hope of getting him. One night she sees a strange dream which presents the very scene she desired most—her marriage with Sri Krishna. She sees all the paraphernalia of a grand wedding, fine music, and numerous friends who have come to witness the function. Sir Krishna and herself go through all the ceremonies connected with the marriage. Suddenly she wakes up and finds that the Lord, instead of actually marrying, had deceived her by his false appearance in a dream. So she becomes all the more miserable. Just then, as if to satisfy her, the image of Vishnu, with the conch, discus, and other ornaments appears before her. The bright conch, decorating his left hand, draws her attention. 'How strange! An ordinary shell, with poor birth and parentage, raised to such a high status of remaining in his hand, and to have the good fortune of touching his lips, while she, the daughter of a great devotee like Vishnuchitta, and a girl who has no other enjoyments in this world, is never even glanced at by him.' A number of verses are addressed to the conch, asking about the Lord whose company it has always been having.

In the meanwhile, the other girls come to know about Andal's condition, but cannot understand what is really undermining her health. So she feels vexed with them and says, 'Friends! You do not know what my disease is. All our talk so far is like the conversation between a deaf and a mute person, who will never understand each other. I have no patience to listen to you.' Slowly she realizes that Sri Krishna is a great lover of Nature. Then why not ask the cuckoo to be the messenger, or the clouds which merrily glide and travel over many regions? But the messengers do not help her in any way. She turns again to her friends and says, 'Dear girls! My whole being is suffering inscrutable pain from the separation from my Beloved. Will you kindly

take me to him? You say my health is not fit to undertake this arduous journey. Please have mercy on me and lead me to Vrindaban, where my Lord did so many wonderful acts. If it is not possible, try and get a robe which has contacted his body, or even a faded flower of his garland. If you cannot get these, then even the dust on the road which had the good fortune of contacting his sacred feet will do to relieve me of this malady.'

Finally we come to the last section of the poem. This takes a new form of presentation. The love-sick girl at last sees her Beloved. What she sees is not directly mentioned but takes the form of a conversation. Each verse is a question and an answer. But still they form two sections of the same description, namely, Sri Krishna of Vrindaban, who is none but Sri Narayana Himself, and whom Andal sees with her eyes.

While this poem *Tirumozhi* describes the intense love for the Lord, we read in *Tiruppavai*, the other famous poem of Andal, the necessary qualifications one must have to win divine grace. No worldly riches help a person in winning an approach to God. Those who are humble and are fixed in their attachment to the Lord win His grace. The innocent and the meek, who surrender themselves completely at His feet, get from Him what all they want. The Gopis of Vrindaban were able to express these characteristics, and Andal brings them out in *Tiruppavai*.

This poem consists of thirty stanzas, each ending with the term *'Elorembāvai'*, for which no definite meaning can be found. This may be the reason why the whole poem gets the name *Tiruppavai*. Andal takes the role of one of the Gopis and goes out in the early morning, to wake up other maidens, in order that all may go together for their bath and get ready for the Lord's worship. The first five stanzas form a sort of introduction; the second ten describe how those sleeping girls are awakened; the next five deal with awakening the household of Sri Krishna; and the last is addressed to Krishna himself. From the very beginning we

find that Andal stresses the greatness of Krishna, who is
Narayana Himself.

> Blessed is today, the day of the full moon in the
> month of Mārgazhi.
> You girls! Come out, and let us go for the bath.
> You belong to prosperous Gokula, and you are the dear
> ones of your parents.
> He, the son of Nandagopa, with his sharp lance, is a
> fierce fighter;
> And is the darling of Yashoda of beautiful eyes.
> His body is like the black cloud, and the face is bright
> like the sun and cool like the moon.
> His eyes are like lotus petals.
> Such a Lord is Narayana Himself, and he will surely
> give us the drum. Come, dear maidens! Elorembāvai.

> Hark, you dwellers of the world! how we do the worship;
> We sing the praise of the Supreme Lord, who lies in the
> ocean of milk.
> At the break of the day we finish our bath! no food do
> we take,
> No collyrium marks our eyes, nor flowers adorn our hair;
> We do no evil deeds nor carry tales to our Lord;
> We give alms as much as we can and it is our only
> delight, Elorembāvai.

Such worship not only brings the favour of Krishna but
also moves the rain-god. There will be plenty of rain and the
fields will be full of corn. The cows will yield plenty of milk,
and famine will disappear. So Andal asks all the girls to join
her, as it has a twofold gain. Further, the prayer to Krishna is
of very great value, since it purifies one of all sins.

> If we begin to worship him with flowers and meditate
> on his glory, our sins, past and those we may do in
> future, will get burnt like cotton thrown into flames.

Then we read the stanzas specially meant for awakening the sleepers. Here we find what a great poet Andal is. With all picturesque details she presents before us how the other maidens react to her call, unwilling to come out of their warm beds. The following two stanzas stand as illustrations:

> *O foolish girl! Everywhere the bird Anaichattan is*
> * shrieking. Do you not hear?*
> *Or the jingling of the bangles, bracelets and necklaces*
> * of the Gopis.*
> *Busily churning curd,—does it not reach your ears?*
> *Does not the noise of the churning rouse you?*
> *O maiden-queen! Do you not hear even our loud*
> * prayers to Narayana and Keshava?*
> *How are you yet in bed? Wake up, O shining lady!*
> * Elorembāvai.*

The next one, we listen to the conversation between the girl, still in bed, and those outside.

> *'How strange, my parrot-like lady! Are you still in slumber?'*
> *'Maidens! I am coming soon. Do not call me again and again.'*
> *'Enough of your words. We know well of your sharp tongue.'*
> *'Be it so, that you are of better words. Or even let me be so.'*
> *'Come out quick, friend! What else have you to do?'*
> *'But have all come?'*
> *'Yes, all have arrived, and you can come out and*
> * count for yourself.*
> *Let us all sing in praise of the brave one who killed the*
> * mighty elephant,*
> *The strong one who destroyed the wicked, the mysterious*
> * Krishna.'*

In this manner a number of stanzas describe how, one by one, the maidens and the people attached to the household of Krishna are awakened. At last they reach the very

room where Krishna is asleep. After rousing him, they all join in prayer.

O Govinda! You are a person of extraordinary powers,
even those who do not bow to you are conquered by you.
By singing your praise, we get not only the small drum
for worship, but something more.
We shall receive from you fine jewels which will be
marvelled at by the whole world;
Armlets for our arms, wristlets to adorn our wrists,
Ear-rings and anklets and how many more!
Fine robes of silk shall we put on, and have delicious dishes,
Milk and rice, and sweets, dripping with ghee; O Lord!
with Thee shall we feast.

O Govinda! You have no wants. But we are cowherd girls
Who toil the whole day, going behind our cattle, for our
livelihood.
We are ignorant people. And what a great blessing to
have you,
The Lord Himself, in our midst. Our relationship shall
not come to an end.
We are uneducated girls and know not how to address you;
If our words of love are childish, pray mind them not,
and give your grace.

O! Krishna! Please listen to the purpose which brought us
here, at such an early hour and made us worship
your feet.
It is unjust on your part if you do not accept our worship,
we the people of your tribe.
We have come not only to beg of you the small drum,
For eternity we seek your kinship and be your servants
in all our future births.
Please free us from all desires, O Lord! Elorembāvai.

Attempt has been made to give the translations of some

of the stanzas, all of which are in Tamil. It will be clear how a knowledge of Krishna's life is essential to follow the ideas contained in them. Andal has used this setting only to show how the devotion (of the Gopis) of complete self-surrender is the best way of winning divine grace. Sri Krishna stands for God and the sentiments of devotion addressed to him pervade the whole composition. Many centuries have rolled by, but the poems left behind by Andal keep her memory bright. Even to this day, during the month of Mārgazhi, in South India, in temples dedicated to Vishnu, these soul-moving verses of Andal are sung for awakening all sleeping persons and calling them to the worship of the Lord.

ALAWANDAR
THE VAISHNAVITE SAGE

B.R. Rajam Iyer

Few lives are more interesting from a biographical point of view than the one we are now writing, or afford a more striking proof of Divine Grace. It is this Grace which attends us all through the journey of life, though in our ignorance and perversity we do not always perceive it, and safely conducts us to our common goal. Moments there are in almost everybody's life when the dullness of our vision, now blind to spiritual light as the eyes of an owl are to the light of the day, lessens a little, and the sunshine of Divine Grace reveals itself unmistakably. Then we are filled with joy and wonder and awe at the nearness we are in to the august Presence (*sannidhāna*) of the Deity. But soon Maya asserts herself and draws veil after veil over the divine light, until it totally disappears from view as the sun is in winter, and we are hurled back into our everyday life of salt and tamarind.

It was not so, however, with Alawandar. The Voice of God spoke to him, and from that moment he became a changed man. Earthly associations, earthly concerns, earthly joys and sorrows lost their hold on him, and he lived, *though on earth yet in heaven*. This heaven, however, he did not jealously keep to himself, but was anxious to share with others. His endeavours to make it palatable to men of grosser tastes have given him a high place in the line of Vaishnavite teachers (*guru-paramparā*). The particular school of Vedantic philosophy known as Visishtadvaita, or qualified monism, which was founded by his successor, Sri Ramanuja, owes much to him; and to it he was in measure what Sri Gaudapada was to Advaitic school founded by his disciple Sri Shankaracharya.

Alawandar, or rather Yāmunacharya, for that was his first name, was born in about A.D. 1150 at Madura, then the capital of the Pandyan kingdom. His father was Iswara Muni, son of the great Nathamuni Swami. When he was only some ten years old his father died. He was put to school in the usual course, and from the very beginning displayed unusual precocity of intellect, and his teacher, Bhashyacharya, and his relatives rejoiced that his distinguished grandfather was reborn in him. In every class he studied in, he was the monitor, and he was often left in charge of the school. He is said to have mastered all the Shastras before he was twelve years old.

In his twelfth year, there happened an event which all at once made him a king. It so happened one day that the teacher, Bhashyacharya, had to go out on business, and so he left the school in charge of this boy-prodigy and went out. When Yāmunacharya was busy teaching the classes and managing the school, there came in search of his teacher a messenger from a celebrated pundit of the time who was known by the high sounding appellation Vidwajana Kolāhala. This Kolāhala was a terror to all the scholars in the kingdom: there was not one of them who had not been challenged by him and defeated. He was under the special patronage of the Pandyan king, and had been rewarded by the latter with palanquins, umbrellas, shawls, bracelets and a considerable retinue. Puffed up with self-conceit, he had issued an edict to all who pretended to know anything of Sanskrit, ordering them to pay him a certain sum of money every year by way of tribute. The poor pundits had no other go than to obey the order, and the tribute system had been going on for a number of years. Bhashyacharya, the teacher of the boy Yāmuna, was one of the tribute payers. Owing to some pecuniary difficulties his tribute had fallen into arrears, and Kolāhala had now sent a messenger to demand it of him.

The boy Yāmuna asked the messenger who he was and what the purpose of his visit. The messenger replied, 'I

come from him who is the lion of poets, the prince of scholars, the terror of pundits, him who is to all that are learned what a wolf is to sheep, what fire is to a heap of straw, what Garuda is to serpents, him whom all the world glorifies as Vidwajana Kolāhala.' 'That is all right,' said the boy, affecting a tone of disdain, 'But what does your man want of our great teacher.' 'My man?' replied the messenger, 'Yes, your master's master wants of his slave, your master, the tribute he owes.' Yāmuna replied, 'Tell your man not to be so impertinent. Let him know how to behave towards his betters. Bhashyacharya is not the man to pay tribute to self-conceited fools', and sent him away. Shortly after, the teacher came to the school, and on learning what happened, cried in despair, 'I am undone, and my family is ruined. If Kolahala hears this, he will report it to the king. I shall be challenged to a debate with him, and my head will be off. Yamuna, Yamuna, you have ruined me. By your boyish conduct I am undone. I was a fool to have left the school in the care of a boy.' Yamunacharya comforted him saying, 'O sir, fear not. If he challenge you for a debate, I shall go for you and defeat him. Please do not get anxious on that account. I am sure I can defeat that conceited man.'

In the meanwhile the court pundit's messenger had reported to him all that occurred in the school. And the pundit, getting exceedingly angry, obtained the king's permission to challenge Bhashyacharya, who when he received the invitation to debate fell almost senseless on the ground. Yamunacharya comforted him, and accepted the challenge on his account, and sent word that, as it was unworthy of so great a scholar as Bhashyacharya to go in person for a debate with Kolahala, he, Yamunacharya, a student of the former, was prepared to engage in discussion—if invited to the court with the honours due to a pundit; otherwise the debate might be held in the school and Kolahala might come over there.

This message was duly conveyed to the king and the courtpundit. The former, on hearing that the age of the boy

was only twelve, was not for treating it as serious, but looked upon it as a piece of boyish impertinence and desired to punish him for it. The queen, however, who at that time happened to be by him, said, 'Who knows what the boy may be able to accomplish? A spark of fire is enough to destroy a mountain-like heap of cotton. We do not know what serpent may be in what ant-hill. Let us not therefore be hasty. We shall examine the boy, and if he be found to have played with us, we shall then punish him. Meanwhile let him be invited to the court with due honours.' The king agreed to the proposal, as it appeared reasonable, and sent a palanquin and an umbrella to the school boy—this was the way in which pundits were honoured in those days. Soon Yamunacharya was on his way to the court, mounted on the palanquin and honoured by the umbrella. All the school boys followed him, and a man specially appointed for the propose went before him proclaiming in the streets, 'The marvellous Yamunacharya is coming, leave the way. The lion of poets is coming, leave the way. The master of all the Shastras, Tarka (Logic), Vyakarana (Grammar), and the Mimamsa included, is coming, leave the way. Woe to him that dares debate with him.'

The boy proceeded through the street in such a pompous fashion, and naturally a large crowd of men and boys followed him.

On seeing him the king laughed convulsively, and, addressing his queen, said, 'This boy to debate with our Kolahala! A jackal may as well fight with an elephant! I have never seen fun like this.' The queen attentively looked at the boy and said, 'My lord, you are mistaken. I am sure the boy will gain the day. His face tells me that; there is a brightness in it which I have not seen elsewhere. Not merely this Kolahala, but even if it be his grandfather's grandfather, I am sure the boy will defeat him.'

King:—Yes, if a mud horse could cross a river. A calf might more easily kill a lion than this child defeat our court pundit.

Queen:—I am sure it is a bad day for poor Kolahala. The victory is already the boy's. Scholarship and genius do not depend on age. If years were the standard, there is many a broken mud wall much older than us all.

King:—Why do you prattle in this fashion. You will see that the boy is defeated at the very outset. If he so gets defeated, what will you give me?

Queen:—Yes, if he is so defeated, I will become your slave's slave.

King:—Foolish woman! Who would venture to cross the ocean in a mud boat? You speak thoughtlessly. If this boy defeats the pundit, I shall give him half of my kingdom.

Meanwhile Yamunacharya waited to pay his respects to the king, and on the latter turning to him, saluted him in the most dignified fashion and took his seat opposite to Kolahala. With the king's permission, the pundit, addressing the boy, said, 'I am sorry for your impudence, which, however, is excusable as you are a child. What exactly do you want with me?'

Yamunacharya replied, 'I want you to argue with me on any subject you like before this royal court. I warn you out of kindness not to be self-conceited, as you are sure to be defeated by me today.

Pundit:—You to defeat me! A dog may as well catch the moon, silly child.

Yamuna:—Ashtavakra was only a silly child when he defeated Vandin, who was like yourself puffed up with conceit, and threw him into the waters. Do you know the story, you learned man?

Pundit:—What an impertinent lad this! Have you mastered the alphabet? Do you know how to read? Can you

write your name without a mistake? You do debate
with us! A cat may more easily overpower a lion.

Yamuna:—A little spark of fire can burn away a huge heap
of straw. A lion's whelp, though young, can kill an
elephant. A chisel, though small, can break rocks to
pieces. A drop of butter-milk curdles a potful of milk.
A little poison is enough to kill a number of men. Was
Agastya, who drank off the ocean, tall or short? Is this
what you have learnt, to judge men by years? People
used to say you are learned! Proceed to the business.

The pundit then put several test questions in logic,
grammar, etc., but finding that Yamuna was too great a
match for him, said, 'You are a child. So I will no longer
trouble you with intricate questions from the Shastras. It is
unfair, like putting a palmyra fruit on the head of a swal-
low. So I am not for it. You had better propose questions
yourself, and I shall answer them.' Yamunacharya felt the
advantage he had gained over his adversary, and said,
'How merciful you are! how kind! You had not, however,
the prudence to say this at the very outset. Had you done
so, you might have saved yourself all the trouble that you
took to find questions for me and the mortification you
suffered from them being readily answered. No matter,
however—I shall gladly do as you propose. I shall make
three affirmative statements. If you succeed in denying
them, I will acknowledge your success and my defeat. If
not, you must acknowledge your defeat. Do you agree to
this condition?' The king said that the condition was a fair
one, nay, advantageous to the pundit, and the latter also
agreed. But what was his surprise when the questions came!

First question:—We say your mother, O pundit, is not
a barren woman. Can you deny this?

The pundit long thought over the matter, but found no
means of refuting it. 'My mother is a barren woman!' he
reflected. 'Then how was I born? To deny the statement will
be to expose myself to the ridicule of all the people here.

Silence would be much better than that.' So he kept quite. His jaw had fallen and he hung down his head in shame. 'Why do you not reply?' asked Yamunacharya, but the pundit did not open his mouth, and there was a general but subdued appreciation from the miscellaneous audience that had assembled there.

The second question: 'I say that this king is a virtuous man; try and deny it if you can.'

Poor Vidwajana Kolahala was startled at the question. 'To say that the king is a wicked man and that in his own presence! Really this young chap has contrived a very good device for finishing my life. If I keep quite I shall be defeated, but to reply would be much more disastrous, for the king's sword would immediately be at my neck. There is still a third question. I shall see if I can answer that at least', said he to himself and kept quite. The queen's face grew radiant with joy and the crowd of spectators expressed its satisfaction in no mistakable fashion.

Then came the third and last question: 'I say that the queen is chaste; deny it if you can.'

Kolahala was thunderstruck. He saw that he was undone. He hung down his head in shame at having suffered himself to be defeated so easily by a school boy—he that had put to shame and deprived of titles, honours and all, many a renowned scholar. 'What foolishness,' he said to himself, 'not to have known the simple thing that there are many statements which cannot be denied, and to have rashly undertaken to deny anything that might be affirmed. And then such questions—who could have put them except this little mischievous chap who triumphs over my ruin! I worked out my own ruin. Why did I not persist that it was unworthy of me to enter into a discussion with a school boy? Now the event has proved me unworthy to sit on an equal seat with him, and all that I have to do is to get up, deliver over all my insignia as the court pundit, and kiss the dust of his feet.' Accordingly he rose from his seat and stood the very

picture of shame in mute confession of his defeat, to the laughter and ridicule of the spectators, who had all along been wishing for such a consummation. The queen at once called Yamunacharya to her and, embracing him like a mother, covered him with kisses and said: 'You are really Alawandar', that is, one that has come to rule, and henceforth he was called Alawandar by all the people.

The king pitied his ex-pundit's position, and addressing Alawandar said: 'It is true you have won the day. You are a boy-prodigy, a veritable Avatar. I am very much rejoiced at your success, but can you deny at least one of the three statements that you made?' The boy coolly replied 'I can deny all the three', at which the king was exceedingly surprised and asked how.

Alawandar replied, 'In the first place, the pundit's mother is a barren woman according to the well-known saying "One tree is not a garden nor one child a child." To have only one child, as the pundit's mother has, is practically equal to having no children at all, and so she is a barren woman.

'Secondly, the king is not a virtuous man, for according to the Neethivakya—moral saying—"Raja rashtra kritam-papam", the sins of his subjects go to him.

'Thirdly, the queen is not chaste, for, like every other Hindu woman, she is at the time of marriage first dedicated to the Gods Agni, Varuna, Indra and others.'

The king was much surprised and pleased at these replies, and at once ordered Alawandar to be proclaimed, according to his promise to the queen, king over a considerable portion of his dominion, and placed poor Kolahala at his disposal. Alawandar accepted the kingdom, but set Kolahala free.

Alawandar, though so young, wielded the sceptre with wonderful dignity and justice and was very much liked by his subjects. He was thus reigning for may years, and then there occurred an event which has preserved his name from that death which has fallen to the lot of those numberless

other clever scholars and wise kings. This event was even more romantic in character and more important in its consequences than the preceding one which made him a king, and therefore deserves to be described in some detail.

When Alawandar was about thirty-five years old, a certain old Brahmin, Rama Misra, otherwise known as Manackal Nambi, sought admission to the royal presence. Seeing that he was too poor to be treated with consideration, and thinking that, if he introduced himself in the usual way, his message might not be received at its worth, he contrived a curious means of approaching Alawandar. He first acquired the friendship of the head cook of the palace, and requested him to cook and serve the king a particular kind of vegetable which he undertook to bring himself every day. This vegetable is *sattvic* in character and is very much liked by yogis, it being both sedative and medicinal. Nambi supplied this vegetable very regularly and it was cooked and served as regularly on the royal table.

A few months elapsed in this fashion and Alawandar had got accustomed to this article of diet. Then one day Nambi purposely stayed away without bringing it. Alawandar, not finding it on his table, asked his cook why it had not been prepared. The cook, who knew nothing of the plot laid by Nambi, simply said, 'The Brahmin did not bring it today.' 'The Brahmin! Who?' asked Alawandar in surprise and, on being informed that a certain poor Brahmin was supplying it regularly, ordered that he should be brought to his presence the very next time he appeared. Nambi brought the vegetable the next day, and as he had anticipated was taken to the king.

Alawandar experienced a peculiar kind of emotion when Nambi approached him, and felt as if they had been friends for a long time. Rising from his seat, he welcomed Nambi cordially, and inquired what the purpose was of his supplying that vegetable and whether he wanted any favour from him. Nambi replied, 'Yes, I want a favour from

your royal highness. And that is, that you will be pleased to take hold of a secret treasure your grandfather has entrusted to me to be given to you in proper time. I have come to request you to take charge of that treasure and deliver me from the burden of the trust.' Alawandar thought that the thing might be true, as his grandfather Nathamuni Swami was one of the most celebrated men of his time and particularly fond of him. He was but a child when the Swami died. So it appeared likely to him that Nathamuni might have left him a great legacy stored up in some secret place to be taken hold of when he was sufficiently old. Besides he was on the eve of a war with a neighbouring king and sadly wanted money. So he eagerly asked Nambi where that treasure lay and how he might obtain it.

Nambi replied, 'I will show it to you if you go with me. It is between two rivers and within seven successive walls. A huge serpent guards it and a Rakshasa from the south sea comes and visits it once in twelve years. It has been laid in by a mantra, and it can be recovered only by means of that secret mantra and with the help of a peculiar herb of rare virtues, and not by means of mere animal sacrifices which are enough for ordinary treasures. It is a very vast treasure, and by obtaining it you will become much richer than any other king on earth. By securing it, you can easily vanquish all your enemies, and no one can ever defeat you. It is a great legacy which your celebrated grandfather Nathamuni Swami has left for you out of love. Pray take hold of it and deliver me from my responsibility.' Alawandar asked, 'Is it so valuable and vast a treasure?' and said, 'How good of my grandfather! and how good of you not to have appropriated it yourself, but kept the trust. I shall start immediately with my army.' Nambi said, 'The earlier you start, the better; but you must come alone: such even is your grandfather's order.' 'Be it so then,' said Alawandar and set out with Nambi the very next day, making arrangements for the administration of his kingdom during his absence.

Nambi took Alawandar a long way from Madura, and then, when it was dinner-time, opened a copy of the *Gita* which he had with him for *pārāyana* (daily reading) and read out the ninth chapter entitled, '*Raja Vidya Raja Guhya Yoga*'. Alawandar listened with attention to the recital, and after dinner asked Nambi to teach him the *Gita*. For in those remote days it was a strict rule that the *Gita* should not be read except under a teacher, and the numerous translations now in vogue, from which people find it easy to mislearn, were not in existence then. It was sacrilegious to approach the Upanishads, the *Vedanta-Sutras* and the *Gita* without the aid of a proper instructor—an idea which the readers of the modern-day unsympathetic and misleading translations of these sacred books full of divine mystery might perhaps scoff at. But, in the time of Alawandar, to learn and not to mislearn was the ambition of students. So the king requested Nambi to initiate him into the 'supreme mystery and wisdom' of the *Gita*, which the latter readily consented to do.

No sooner was a regular study begun than Sri Alawandar, owing to the accumulated virtue of his previous births, felt himself transported to a new world of 'an ampler ether and a diviner air', where there was neither the pettiness nor the struggle of ordinary mortal existence. It flashed upon him that his 'home, sweet home' was away, far away from the prison house of the sense-world, and when he came to the celebrated verses in the second chapter, beginning with—

There is no existence of the unreal; of the real there is no cessation of existence. The truth regarding these two is seen by the seers of the Real,

and ending with—

This, weapons do not cut; This, fire does not burn; This, water does not wet, and wind withers This not.

This cannot be cut, nor burnt, nor wetted, nor dried up. It is everlasting, all-pervading, stable, firm and eternal. This is said to be unperceivable, unthinkable and unchangeable. Wherefore knowing It to be such, thou hadst better not grieve,

he felt as if he had suddenly recollected something long forgotten. The verses appeared familiar to him and reminded him of a thing with which he had once been very, very familiar. He grieved because he had forgotten it so long, because he had exchanged that everlasting, all-pervading, stable, firm and eternal Atman in him for the fleeting, paltry things of life, and had sold the Kingdom of God for a petty principality on this low earth. He pined to realize that which is unperceivable to the senses, unthinkable by the mind and unchangeable in its essence.

He at once threw off the costly robes he wore, and also the jewels with which he had adorned his body which he now felt to be bubble-like and unreal. He fell prostrate at the feet of Nambi and beseeched to be fully instructed in the deepest mysteries of divine wisdom. He added that he did not require the treasure, however vast and valuable it might be, which his grandfather had left for him, for he was determined no more to return to his kingdom but live as a beggar for the sake of discovering the everlasting treasure which lay concealed in himself. Nambi commended his earnestness and zeal, but advised him not to throw away his jewels and robes, saying, 'True renunciation consists in giving up all desires. But by giving up your wealth and kingdom you do not renounce, *for you desire to be a beggar*. Be as you are in outward appearance, but be unattached in your mind. This is the secret of renunciation. Also do not despise the legacy your grandfather has left for you, for he gave it out of love. However, before going to recover it, we shall, if you so desire, stay here for some time and finish this *Gita* and then proceed to take hold of the treasure.' Alawandar readily agreed and the whole *Gita* was gone through leisurely.

Before it ended he became fully imbued with the spirit of its teaching. Whatever he did, whatever he ate, whatever he offered in sacrifice, whatever he gave in charity and whatever austerity he engaged in, he did all as an offering unto God. In his eyes the pain and pleasure of others became his own, for he saw all things in himself and himself in all things. The words of the Lord—

He who'offers to Me with devotion a leaf, a flower, a fruit, water—that I accept, offered as it is with devotion by the pure-minded (*Gita*, IX. 26),

filled his mind with a new ambition, and he pined to realize the truth of the Lord's promise contained in the following verses—

Fix thy *manas* in Me only, place thy *buddhi* in Me. Thou shalt no doubt live in Me ever after (ibid. XII. 8).
Fix thy thought on Me, be devoted to Me, sacrifice to Me, bow down to Me. Thou shalt reach Myself, truly do I promise unto thee, (for) thou art dear to Me (XVIII. 65).

After the *Gita* was completed, Nambi proposed to his disciple that he should go with him to recover the treasure. Alawandar reluctantly consented, for wealth in however large a quantity had now no temptation for him, and went with his guru in search of it. Nambi led him through several Brahmin villages, crossed the Cauvery, took him into the temple of Srirangam and, pointing to the grand image of Sri Ranganatha, said, 'This is the great treasure your grandfather has left you. Take firm hold of it and relieve me of the trust.'

Alawandar was overwhelmed with surprise. He little knew that his grandfather had left for him the noblest and the best of legacies. He found no words to praise his grace and love, and expressed his gratitude to Nambi by falling

at his feet again and again and wetting them with tears of joy.

Looking at Ranganatha he said, 'O great God, Thou has been in my grandfather's possession, and now that he has given Thee to me, Thou art mine, the God of my grandfather, the God of my family, my own God. I have found Thee at last and shall no longer leave Thee. Ah! what a treasure has my grandfather given to me! How truly did my guru Nambi speak of it as a very vast treasure by obtaining which I will become much richer than any other king on earth. Ah, how vast a treasure! It is beyond time and space, Akhanda, illimitable. By obtaining Thee I obtain all, for everything is contained in Thee. By knowing Thee everything else is more than known. Truly did Nambi say, "By securing it you can easily vanquish all your enemies, and no one can ever defeat you." All my enemies, desire, anger, lust, etc., all get overthrown at Thy very sight. No one can ever defeat me, for, like the old sage Vamadeva who sang, "I am Manu, I am Surya", I am the Self of all.

'Ah, how poetically did Lord Nambi speak of Thee when he said, "It lies between two rivers, and within seven successive walls. A huge serpent guards it and a Rakshasa comes and visits it once in twelve years." Thou liest between the Cauvery and the Coleroon, and in my heart between the ever flowing streams of sankalpa and vikalpa. The thousand headed Adisesha guards Thee, and Vibhishana comes and visits Thee once in twelve years. Truly was this Treasure before me laid in by a mantra, and truly could a mantra alone secure for me this possession. The sacred herb of which my blessed guru spoke is the Tulsi of which Thou art extremely fond. O Treasure of treasures, Thou art mine, mine for ever, mine by birth-right. I shall take firm hold of Thee and shall not leave Thee.'

So saying, he flew meteor-like towards the Sacred Image and, clasping it, swooned away in love. After a long while he recovered, and then, addressing his preceptor and saviour, exclaimed, 'How shall I thank you for having

sought me and taken me under the shelter of your grace, and for having shown me in no mistakable way that *there is no treasure on earth more lasting, more needed and more precious than God, and that that treasure is my birthright.* O best of gurus, in what words could I extol the glory of your love which could look upon my redemption as a burden laid upon you!'

Tradition relates that Alawandar then resigned his sceptre and devoted the remainder of his life in Bhagavannishtha or Yogic contemplation. He wrote a few treatises on Chit, Achit and Iswara, the triad of the Visishtadvaitic philosophy, which was to find its best exponent a few years after in Ramanuja. He had three unfulfilled wishes at the time of his death, and it is said that, in token of that, even after his death the three fingers of his right hand remained closed. They resumed their natural position only when Ramanuja, who almost accidently came to the spot where the funeral was about to take place, promised to fulfil the three wishes which were communicated to him by Yamuna's disciples. The three wishes were that a Visishtadvaitic commentary should be written for the Prasthanatraya (the Upanishads, the *Vedanta-Sutras* and the *Gita*), that the name of Parasara, the old Vaishnavite commentator of the *Vedanta-Sutras*, should be commemorated on earth by giving it to a person worthy to bear it, and that a commentary should be written upon Nammalwar's *Thiruvoymozhi*, which last was done by a disciple of Ramanuja.

Mirabai

THE SADHANA OF MIRA BAI

C.K. Handoo

'I have watered the creeper of love with my tears'—
Mira Bai.

Mira Bai is a much loved poetess, singer and saint of
medieval India. Though the main features of her life are too
well known to bear repetition, the details of her spiritual
struggle are not available to us. There is a tendency of the
human mind to extol the great and make them appear as
perfect beings from the very beginning of their career.
Accordingly we often see that the disciples of saints and
prophets either deliberately suppress, or carelessly forget to
hand over to posterity that most important and interesting
period of their lives when they are still striving for the
desired end. To us, as to the vast majority of mankind who
are less ardent than them, the distance that is thus created
is the cause of much despair; for, though our eyes look up
to the skies, our feet are set in clay, and we anxiously seek
for some common bond of humanity to unite us with the
ennobling lives of the great. To know that they also suffered
from human weaknesses makes them infinitely dear to us,
and we rejoice in thinking that if we but faithfully trudge
on the chosen path, in some far off future life we also may
attain to those heights that seem to be an impossible dream
at the present moment, but are nevertheless the guiding
light of our own prosaic and mundane lives.

However pronounced a talent one may have in a
certain direction, no one is born an artist, a craftsman, or a
scholar, and it is good to remember that all knowledge or
skill is gained by sheer perseverance and hard work. If this
is true in the ordinary walks of life, how true it must be of
life in the spiritual path. It is said in the scriptures that the
act of creation has to be prefaced by the austerities of the

Creator, and even the Incarnations of God have to struggle considerably before they become fully conscious of their Divine nature and mission. It is sufficient to say that greatness acquired in any sphere of life is largely due to self-effort. We would like very much to know what was the effort that Mira Bai put into her life and how she fought against the overwhelming odds that faced her. Did her steps ever falter and did she despair of reaching the end? Not mere idle curiosity impels us to lift the veil of four centuries and peer into a heart while it was still weighted by the frailties of the flesh, torn with different loyalties, and wounded by the insults of an un-understanding husband and the intrigues of the proverbially jealous sister-in-law.

Unfortunately most of our questions will have to remain unanswered, for the very early songs are either lost or not recorded, and the psychological struggle of her life was overlooked or ignored by those who first wrote her biography. Still, common sense may help us to reconstruct to a certain extent a picture which, had it been preserved, would have been of great value to all spiritual aspirants. From her own words such as the following:

'I have made friends with Giridhar since childhood.
The bond has grown too strong to be broken',

and also from stories current about her, we can safely conclude that her deep devotion to God was visible even in early childhood. Later it seems that she became conscious of a continuity of purpose that had been guiding her from life to life as she constantly brings into her songs the well-known line, 'Mira is thy servant since many lives.' It is often said that Mira was an incarnation of one of the Gopis. But while recognizing the similarity in the purity and intensity of her devotion to the blessed milkmaids of Vrindaban, we do not think that such an assumption, in any way, adds to the greatness of Mira. Though the Gopis set up a great ide- al—and far be it for us to detract for it—it is not as if they

were the chosen ones for all time to come for the expression of *madhurya-bkakti*. Infinite are the avenues of approach to the Divine, and infinite is the store-house of the universe which contains in its womb innumerable perfected lives in latent form. It is, therefore, but natural that great saints should appear from time to time to shed light on the path of humanity and inspire earnest seekers of God. It is more in keeping with common sense to believe that, the suffering of Mira was as real as ours would be if we were placed in the same circumstances, and her greatest claim to our love and homage lies in the fact that she went on her path undaunted in the face of all opposition and calumny.

Scholars are of the opinion that Mira might have been influenced by the followers of Nimbarka Swami and the life of Chaitanya Deva. The former was a South Indian who lived in the twelfth century and preached the Radha-Krishna cult from Vrindaban. Mira was an immediate successor of Chaitanya Deva in time, and we can easily imagine how greatly attracted her pure and devoted heart must have been to this living apostle of the Divine love of Radha and Krishna. In one song at least she makes a loving reference to Him when she says:

He whose feet were bound by mother
 Yasoda for stealing butter,
That boy of dark hue became Gora
 whose name is Chaitanya.
In the garb of a sannyasi he depicted the
 emotions of the yellow-clad One,
Mira is the servant of Gaur Krishna, and
 Krishna's name dwells on her lips.

In her *Notes on Some Wanderings with Swami Vivekananda*, Sister Nivedita has recorded that, in comparing the two, Swamiji held that while Chaitanya preached love for the name of God and mercy to all, Mira, in contrast taught submission, prayerfulness, and service to all. The whole of Mira's life is an

expression of her touching and deep self-surrender to the feet
of God. She also says in one of her songs:

> I dress as He dresses me, I eat what He gives,
> I sit when He commands, and I would
> sell myself if He wished.
> My love for Him is of longstanding, I
> cannot live for a moment without Him.

It is evident from Mira's songs that she eagerly sought the
company of *sadhus* and was in her turn greatly influenced by
them. To cultivate the friendship of holy men and serve them
with love and humility is a recognized way of progressing in
the spiritual path. As man is essentially spirit and not matter,
so knowingly or unknowingly his innermost nature responds
deeply to the uplifting influence exerted by the seeker of God.
That an advanced soul like Mira should be devoted to *sadhus*
is therefore nothing to be surprised at. Much of the anger that
her behaviour aroused amongst her in-laws was due to her
mixing freely with the *sadhus* and admitting them to the royal
temple, where she sang and danced in divine ecstasy. The
following conversation with her sister-in-law is typical of the
attitude of both parties.

> Udabai: The Rana is angry with you,
> do not seek the company of *sadhus*,
> People are defaming you,
> and the family name is being abused.
> You roam from forest to forest with *sadhus*,
> and have also lost your *sari*.
> You are born in a royal family but dance to
> the clapping of hands,
> Amongst Hindus your husband shines like
> the sun, but your mind like stagnant
> water is covered with scum.
> Give up the company of Giridhar and the
> *sadhus*, and come home with me.

Mira: The *sadhus* are my parents, family, friends,
 and dear ones, good and wise,
I always say, that day and night I seek
 refuge at their feet.
Please tell Rana I cannot agree to his proposal,
Giridhar is the Lord of Mira, and she has
 sold herself into the hands of the *sadhus*.

There are two *sadhus* to whom she openly owes her indebt-
edness: one is her guru Raidas and the other is the great
saint Tulsidas, who befriended her in time of great perplexi-
ty and trial. Though Mira's surrender to God was direct and
her relationship with Him intimate, yet she recognizes the
greatness of the guru, and pays homage to him in the
following words:

I have surrendered myself at the feet of the guru,
I am attracted to nothing but his feet and
 the world is but a dream,
The ocean of birth and death has dried up for me,
I have no anxiety to cross it, Mira's Lord
 is Giridhar Nagar and my eyes have
 turned inwards.

In other songs she mentions the name of Raidas—for
example, 'I met my *sadguru*, the Saint Raidas'—which leaves
no doubt that he was in fact her acknowledged guru.

 Her letter to Tulsidas is of special significance. It is the
only record of a conflict in her mind, when she seems to
waver on her path and admit of the intense suffering she
was undergoing due to the unkind treatment of her family.
The provocation must have been great to have induced her
to write such a letter seeking for guidance and help. The
letter is as follows:

Sri Tulsi, Abode of happiness, Destroyer of sorrow,
I bow to you again and again; please

destroy the accumulated affliction of my life,
All the members of my family are creating trouble,
I suffer greatly because of my worship and
 association with *sadhus*,
...You are like father and mother to me,
 you bestow happiness to lovers of God,
What is the right path for me, please
 write and explain.

Understanding her mental anguish Tulsidas promptly sent
the following reply:

Those who do not love Sita and Ram,
Give them up like you would a million
 enemies, though they are your dear ones.
Prahlad gave up his father, Vibhishana his
 brother, and Bharat his mother,
Bali gave up his guru, the Gopis their husbands,
 but all of it resulted in joy,
Love and serve those only who accept
 relationship to Ram,
What use of collyrium if it destroys the
 eyes, what more shall I say,
Tulsi says, those only are worthy of respect,
 and are dearer than life,
Who are devoted to the feet of Ram: This
 is my advice to you.

Thus it may be that this letter helped to resolve her doubts
and give her courage and strength to go on in her difficult
path in spite of opposition.

If we are to study the external environment of Mira, the
first thing that strikes us is the complete blindness of the
members of her family to her great spiritual genius. It is
often disputed that the Rana to whom she makes a constant
reference in her songs is not her husband (who, it is alleged,
died early) but is her brother-in-law. But we find there is

nothing in her songs either in support of her widowhood, or of the Rana being her husband's brother. This is a theory which is hard to believe in the face of lines such as the following:

> I will go neither to father's house, nor
> father-in-law's, nor to my husband,
> Mira has found Govind and for guru she
> has found Raidas.

We cannot, therefore, help concluding that the Rana who provided the background to her colourful life was none else than Bhojaraj, her husband. He plays such an important part in the development of her character that he deserves more than passing attention. He was a typical man of the world, deeply conscious of his position and with little or no finer feelings of the human heart. He was neither vicious nor deliberately unkind. Any other problem of life he would have solved according to the tradition of the Rajput race, but here was a situation which his rigid conventionalism and narrow heart could not cope with. Why did not Mira, his queen, dress herself in gay clothes and spend her time in joy and merriment with the ladies of the court? His coffers were full of treasures he could shower at her feet; but the jewellery that Mughal princesses would envy remained untouched. The remark that she was 'the queen who would not be queen but would wander the world with the lovers of Krishna' (Swami Vivekananda) has been very aptly made of her.

She was obedient and loyal to her husband, but in her uncomfortable presence the enjoyments of life turned cold. Unfortunately he did not heed the call of a greater destiny following which he could have been a helpmate and companion to her and thus would have made her life smooth and his own life blessed. Mira never scorned him, but her very meekness and docility exasperated him. Soon his patience wore off, and he who would have been a

devoted husband to a woman of less fine calibre turned harsh and bitter. She tore at the very roots of his heart; she eluded him though he possessed her, and her desire to obey his slightest command and fulfil his whims to the letter baffled and annoyed him beyond measure. Then only he resolved to break her indomitable spirit by means so unworthy and questionable that he excites in us nothing but a supreme contempt for the utter stupidity and meanness of his small and selfish mind.

The best comment we can pass on him is in the words of Somerset Maugham, when he says: 'In the ordinary affairs of life stupidity is much more tiresome than wickedness. You can mend the vicious, but what in heaven's name are you to do with the foolish?' And it is only when we think of the repentance that filled his heart in later life that we are inclined to excuse the blindness that was ultimately the cause of his own sorrow. If we but believe in the maxim of the *Gita* that,

> There lives a master in the hearts of men,
> maketh their deeds, by subtle pulling strings,
> dance to what tune He will,

we shall be obliged to admit that, had it not been for the ordeal that Rana provided, Mira's devotion would have remained untested, and to those of us whose minds are dulled by worldliness the radiant purity of her life might not have been discernible. So let us not weigh his sins in grudging scales, knowing him to be a mere pawn in the Divine *lila*, and a fellow-sufferer in the same spiritual darkness as ourselves.

No character sketch of Mira can be complete without enumerating the horrible ways in which the Rana tried to get rid of her by putting an end to her life by foul and unfair means. Wherever the name of Mira is known these stories are repeated endlessly and yet no one tires of them. They are the wealth of the common man to whom they stand for the ultimate triumph of the forces of good over

evil, and of spirit over matter. Briefly they may be told in the words of Mira:

Rana sent a serpent in a basket,
　　it was delivered into the hands of Mira,
When she examined it after her bath
　　She found an image of the Lord.
The Rana sent a cup of poison,
　　It turned into nectar;
When she drank it after her bath
　　She became immortal.
Ranaji sent a bed of nails for Mira to sleep,
　　At night when Mira went to bed, she slept
　　　　as if on flowers,
The Lord is ever the helpmate of Mira,
　　He removes her obstacles.
Mira moves about absorbed in an ecstasy of
　　love for Giridhar.

Three distinct periods in the *sadhana* of Mira Bai seem to be reflected in her songs. The first is that of a calm and steady devotion which may be likened to a smoothly flowing river. These are the songs that are least known at the present day. A typical song of this period is as follows:

Make Mira thy true servant O Lord,
Free me from the false duties of the world,
My house of discrimination is being robbed,
Though I resist with all my intelligence and strength,
Alas! alas! I am helpless.
Run, O Lord, I die without succour,
Daily I listen to the teachings of religion,
I fear the vagaries of the mind.
I serve the *sadhus* faithfully.
I set my mind to remembrance and contemplation,
Show thy maid servant the path of Devotion,
Make Mira thy true servant, O Lord.

In this song we find that the element of self-effort and struggle is emphasized, and her mode of life is laid down in simple language. Another song which may be classed in the same category, but seems to come later, is as follows:

> Listen to my prayer O Lord, I take shelter in Thee.
> Thou hast purified many sinners and freed
> them from the bondage of the world;
> I do not know the names of all, but only a few
> are known to me,
> Ambarish and Sudama You took to Your abode,
> Dhruva a child of five saw Your vision of deep blue;
> You ripened the fields of Dhana, grazed the
> cattle of Kabira,
> You ate the fruit that Shabari had defiled,
> Your actions please the mind.
> You accepted the barbers Sadana and Sena,
> You ate Karma's khichri and freed the woman
> of ill fame.
> Mira has coloured herself in Your hue, and the
> world is well aware of this.

Here there is a greater awareness of the grace of God, and the main idea is of surrender to Him, which comes only after struggle and effort.

Just as the current of the river, as it nears the ocean, becomes swift and deep, so we find that slowly the quiet prayer and silent meditation of Mira gained in momentum, and calm devotion gave way to the pain of viraha, when the absence of the beloved can no longer be suffered with equanimity. There is an arresting sweetness in the songs of this period. They are also the best known, and are most widely sung by our own generation . The yearning is so intense that it pierces the armour of all mundane interest and occupation, and for a moment even the hardest of hearts trembles in sympathy as it listens to these songs:

O Lord of my house, come home to me,
Cool the fire of my feverishly restless body,
I spend the whole night weeping,
I have lost appetite and sleep, but the wicked
 breath of life goes on.
Make the sorrowing one happy by blessing her
 with Thy vision;
Do not delay any longer, for Mira is suffering
 the pangs of thy separation.

Among the poet-saints of medieval India, no one has
depicted the feeling of *viraha* or *madhurya-bhakti* like
Mira. Surdas has developed a variety and abundance of
emotions, but in poignancy and depth of feeling Mira's
poetry is unsurpassed. In the abandonment of love she
sings:

O Friend, my sleep is destroyed
I spend the night waiting for my Beloved,
My mind is set on meeting Him so I am restless,
Each limb of mine is aching and my lips can
 only utter Piya! Piya!
No one knows the pain of my heart stricken
 with the anguish of separation.
As the *chatak* pines for the rain cloud and
 the fish for water,
So Mira has lost outer consciousness in deep
 yearning for Thee.

In unendurable agony she cries out:

I wander about wounded, no one knows the
 pain of my heart.
...My life is lost through sorrow, my eyes
 are lost through tears.
If I had known that there was so much
 suffering in love,

I would have sent a crier round the town
saying that no one should love.

In our present age Sri Ramakrishna has said again and
again, 'Cry to the Lord with an intense yearning and you
will certainly see Him.' Again he says, 'Longing is like the
rosy dawn. After the dawn out comes the sun. Longing is
followed by the vision of God.' Accordingly Mira's irresist-
ible cry could not be denied for long, and her unendurable
suffering at last changed into the joys of God-vision. Thus
we come to the fulfilment and end of her *sadhana*. In the
gladness of her heart she sings:

Mira dances with anklets on her feet.
People say Mira is mad, the mother-in-law
says she has destroyed the family,
But Mira has found the eternal with ease,
and Giridhar Nagar is her Lord.

As we of lowly understanding cannot properly appreciate the
intense sorrow of Mira in the seeking of God, so in great awe
and wonder we look upon her joy in the finding of Him. In her
songs we now hear the happy murmuring of a river which,
after carving its way through hard rock and flowing through
dry and parched land, finds itself in the embrace of the infinite
and fathomless ocean. We hear her singing joyously:

My friends are drunk with wine,
but I am drunk without it.
I have drunk from the pot of love and
wander night and day in my intoxication.
I have lighted the lamp of remembrance and
renunciation,
My mind is the wick,
The oil has been drawn from the machine of
the Inexhaustible One,
And the lamp burns day and night.

We would fain follow her into that realm of the pure spirit which is as deep as the ocean and as infinite as the sky and having reached which most people are struck dumb. But our earth-bound feet prevent us from doing so, and we are constrained to stand outside this enchanted circle, straining our ears to catch some echo of the ineffable sweetness that now flows through the blessed life of Mira. Before we close we cannot help but hear her sing once again:

> I have coloured myself in the hue of Shyam,
> Decking myself and with bells on my feet,
> indifferent to the opinion of the world I dance,
> In the company of *sadhus*; gone is my
> ignorance, and I am truly transformed
> in the form of the devoted,
> Singing the glories of God day and night,
> the serpent of Time cannot harm me.
> Without Him the world is tasteless and all
> else is fleeting.
> And Mira has developed sweet devotion to
> Giridhar Lal.

Before the last echo of her song dies out we swiftly move across the centuries hoping to catch a glimpse of this vision of heavenly joy, and we are struck by the utter self-effacement of her song and dance as well as the joyful radiance of her personality. With heavy hearts we at last turn back reluctantly, but the tinkling of her anklet bells and her sweet voice linger strangely in our memory. And finding now that she is in a world where our intellectual criticism and comment is of no avail, we end in proper orthodox fashion by laying our hearts and those of our readers in loving homage at the magic of her dancing feet.

Lord Basava

BASAVA, THE FOUNDER OF VEERASHAIVISM

Prof. K.S. Srikanthan

'Life on earth is far happier than life in heaven', said Basava (Basaveshvara) when a secure place in heaven was offered to him by the gods. Basava is, perhaps, the only prophet in the entire gamut of world history who had the courage to prefer earthly troubles to heavenly ease. To Basava this world was the testing house of the Creator. 'Whoever passed here, passed there. He who did not pass here could not pass there.' Thus his attitude towards earthly existence was intensely human and realistic. He did not refuse to live—on the other hand he demonstrated the 'liveableness of life'.

To have come after so many prophets about eight centuries ago was itself a great disadvantage; for apparently there was nothing that the other prophets had not said which Basava could say and thus carve out a place for himself in the galaxy of prophets. But it was the peculiar glory of Basava to have included in his teachings all that was best in the messages of his predecessors and to have anticipated the ideas of many a modern thinker. His message appeals to the modern mind so intensely and applies to modern conditions so vividly that one is almost tempted to forget the wide gulf of eight centuries that yawns between the age of Basava and the modern age. It is, therefore, no exaggeration to say that the message of Basava is like a reservoir into which all pervious thoughts flowed in and all later thoughts flowed out. Kind like Buddha, simple like Mahavira, gentle like Jesus, and bold like Mohammed, Basava strikes us almost as a wonder of creation. But what attracts us to him are those teachings of

him in which he anticipated the greatest of modern think-
ers—Karl Marx and Mahatma Gandhi.

The early life of Basava, like the early lives of all
prophets, is shrouded in mystery. According to *Basava
Purana*, Basava was the son of Madiraja and his wife
Madalambika, both belonging to the brahmin caste and
residing at Bagewadi, identified with the town of that name
in the present Bijapur District. To recompense the piety of
this couple and to resuscitate the decaying faith in Shiva,
Nandi, the bull of Shiva, we are told, was born on earth as
their son at the command of Shiva. Whether one believes in
this legend or not, no one can deny the fact that Basava
struck his parents and his relatives as a boy of extraordinary
intelligence. He was not even eight when he raised his
standard of revolt against the established traditions and
rituals. He refused to wear the sacred thread, considered so
necessary for a brahmin even today, saying that for a true
devotee such external symbols were quite unnecessary.

Like Gautama, he left his home in search of happiness.
After wandering aimlessly for some time, he settled down
in the holy shrine of Sangameshar at the confluence of the
Krishna and Malapapahari. In the beautiful and picturesque
surroundings of that holy place he spent his time in divine
joy, and learnt his lessons of freedom at the very feet of
Nature. To Basava, Nature was pervaded by a divine spirit
and was the vesture of the Supreme Being. 'If Nature flirts,'
says he, 'with the soul and lures it to the false path, it is
only for some time, and that too with the idea of giving
greater strength and energy in its onward march. Nature is
appointed as a material instrument of the soul's salvation.'
Basava was essentially a man of action and had positive
aversion to mere scholarship and booklearning. Says he,
'Real faith and service are greater than mere learning;
service to God is the only thing worth while. Life in the
world is of real value, as it fits us for a higher life.' Again,
'Shall I say the Shastra is great? It praises ritual. Shall I say
the Veda is great? It preaches the taking of life. Shall I say

that law is great? It is still searching. You are not in any of these, my God, and are not to be seen except in the three-fold service of Your servants.' He was, in short, a realist among idealists and an idealist among realist.

It is no wonder, therefore, that when the call came, he came out of his self-imposed seclusion and agreed to serve as the Prime Minister of the then ruling emperor Bijjala of the Kalachurya Dynasty. Biographers of Basava, unfortunately, have not given us an adequate account of his career as a Prime Minister. In fact, Basava has every claim to be included among the best finance ministers of the world. So long as he was Prime Minister, his thoughts were entirely on the poor and he did his best to make the people feel that the State was primarily theirs. He abolished almost all those taxes the incidence of which was on the poor people, and imposed several new taxes on the idle rich. He anticipated those principles of taxation which made many a financier famous in the nineteenth century. It is no wonder that Basava did so, for he was not a believer in private property. To him wealth was for the welfare of humanity, and nobody had any right to live more decently than his sisters and brothers. One may acquire wealth by the sweat of his brow, but he must not hoard it up. He must utilize it in the service of humanity. Says he, 'Give unto the servants of God that which you possess. The house of the man who makes parade and worships and says he is worshipping continuously, is like the house of the public woman.' Again, 'Endurance in whatever happens is discipline; not to conceal what one possesses is discipline; to do without erring is discipline; to speak without uttering falsehood is discipline; when the servants of our God Kudala Sangama come, to give them what one hath as to the owners, that is the discipline of disciplines.'

Like Karl Marx, he hated the capitalists; he saw no justification for interest. In his own words: 'The wealth you earn, give to God's servants, and lend not at interest. If it comes back, well; if it does not, doubly well. Whether it is there or it is here, it is employed in service of God. That

which is God's goes to God, and there is no thought of its having come to you nor pain for its going. Therefore, O my God, except to Your servants, money should not be lent out.' His own salary he distributed among his followers: 'If of my gold a single streak or of my clothing a single thread I want for today and tomorrow, I sin before You and Your ancient servants; except for the use of Your servants I desire nothing, my God.'

Sometimes Basava was generous to a fault. A follower of his, we are told, kept a mistress, who having heard of the magnificence of the attire of Basava's wife, desired it for herself. Hearing of this, Basava directed his wife to strip herself of it and give it to his follower's mistress. When some cows were removed from his house by thieves, he directed his servants to take the calves and hand them over to the thieves wherever they might be.

During his short regime as minister, he put an end to corruption among officers completely, and made every subordinate feel that he had also a soul not in any way inferior to those of his superiors. Like Karl Marx, again, he was a believer in the supreme value of labour. To do one's work and thus serve humanity was far more important than to aspire for heaven. What strikes us most in the teachings of Basava is the fact that he always spoke with his feet on the earth. He never believed in attracting people by creating illusions. He did not ignore the problem of bread. On the other hand, he realized the dignity of labour and raised it to the rank of religious worship. Among his followers were even men who followed lowly professions. One of them was Nuliya Chandayya, who earned his livelihood by making ropes; Madara Channayya was another, who was a tanner by profession; still another was Medara Ketayya, who lived by making and selling baskets. Moliga Marayya was a dealer in fuel. Basava did not stop with making them his followers—but promoted matrimonial alliances between men and women of high and low castes. In short, he did things which people are afraid of doing even today. He

sowed the seeds of the social revolution through which we are still passing. He did not like those who would employ others to do things which they could do for themselves. Says he, 'Is it right to get done by another the duty to one's wife, or the feeding of one's body? A man should perform the worship of his God himself. How can he get it done by another? They do for show, they do not know You, my God Kudala Sangama.'

Basava's ministry was short-lived. He was himself more anxious to improve society than to overhaul the administrative machinery. Society at the time of Basava was caste-ridden and required a good deal of overhauling. People were clamouring for a living and human religion— a religion of the heart and not of the head. Basaveshvara, who was the embodiment of this new spirit, gave such a strong and dynamic impetus to this new movement that ere long he was able to bring about a renaissance. He breathed new life into the chaos of the human heart and brought it to symmetry and order. He infused an undying hope in the minds of the lowly and the downtrodden by scoffing at the idea that God-consciousness could be achieved only by the chosen few. He proclaimed that the gates of Heaven were open to all irrespective of caste and creed, provided one had the will and necessary discipline to achieve Godhead. Under his banner rallied thousands and thousands of men and women, fired with the zeal of holiness, fortified by the eternal faith in the Lord, and nerved to courage by their sympathy for the poor, the fallen, and the downtrodden. These noble heroes of the new order went over the length and breadth of the land preaching his gospel of divine love. Society discovered its soul and surrendered itself to its spontaneity as this new message and the consequent awakening spread to all strata of society. The old order brooked all this as it felt itself helpless against the surging wave of awakened consciousness.

He insisted upon his followers to have an unquestioning faith in God. Says he, 'Dull of wit, I see not the way.

Lead me as they lead the born-blind staff placed in the hand. O God Kudala Sangama, teach me to trust, teach me to love the way of Your true servants.' Again, 'When I have said that this body is Yours, I have no other body; when I have said that this mind is Yours, I have no other mind; when I have said that my wealth is Yours, there is no other wealth for me. If I have known that all these three possessions of mine are Yours, what further thought need I to take, O God Kudala Sangama?' In short, there is no greater exponent of the cult of Bhakti than Basava. To him Bhakti, or real devotion to the Lord, was more powerful than the Lord Himself. Says he, 'Thine illusion surroundeth the creation. But my mind surroundeth Thee. Thou are stronger than all the worlds, but I am stronger than Thee. Even as an elephant is contained in the mirror, so art Thou contained in me, my Lord! Harken ye unto me: there are but two words resounding in the universe. Sayeth the Lord to the devotee, "I shall conquer thee." The devotee draweth and flourisheth the sharp sword of truth and marcheth victorious.'

Basava considered this body the living temple of the Lord, to be ever kept pure and undefiled. To him a truly moral, disciplined, and orderly life was the first step in the realization of God. His compassion for all beings was unbounded. He asks, 'What is that religion that knoweth not compassion? Kindness should there be in all alike. Kindness is the root of all righteousness. Lord Kudala Sangamadeva has naught of aught else.' He vehemently condemned animal sacrifice perpetrated in the name of religion. He pathetically addressed thus the poor animal brought to the altar:

> Weep, weep, thou innocent goat,
> Weep unceasingly that they would kill thee;
> Weep before those learned in the Vedas,
> Weep before those knowing the Shastras,
> Thine wail shall be heard by the Lord and
> He will do the needful.

To him true worship meant service to humanity. He scorns those doing ostentatious worship without bestowing any thought on the poor and the needy: 'What a folly thou should'st worship the image inside the house when the Lord is at your very door with all His insignia!'

He was amused at the incongruous way of men who profess one thing and practise quite the opposite.

> 'Pour milk', they say, seeing a lifeless
> snake of stone,
> 'Kill, kill', they cry, when they
> behold a live snake.
> 'Avaunt!' they cry hoarse when the
> hungry being prayeth for food,
> 'Take food,' they beseech the image
> that hungereth not.

Courtesy and sweetness are virtues indispensable to those who strive for salvation. In fact he goes so far as to say, 'He is a devotee who folds his hands to another devotee. Sweet words are equal to all the holy prayers. Sweet words are equal to all the penances. Good behaviour is what pleases the God of eternal good. Kudala Sangama will have naught of aught else.'

Like other prophets, he was never weary of telling the people about the importance of practising the virtue of truth. To speak the truth, says he, is the world of the gods. To speak untruth is the world of the mortals. Next only in importance to this is purity of heart. Like Gautama he maintained that the value of a service depended upon the motive with which it was done. Says he, 'You may put an iron ring round a pumpkin. It gets no strength from it. It rots all the same. God Kudala Sangama, if a man whose mind is not reformed is given the baptism of Your servants, how will he get devotion?'

Thus, to Basava, man was the architect of his own fortune. His salvation was in his hands.

Guru Gobind Singh Ji (1666–1708).

GURU GOVIND SINGH

Prof. Teja Singh

(Devolution of Full Responsibility)

The purity of Judgment was further intensified and made perfect by Guru Govind Singh (1666-1708). The Sikhs, in the course of continuous discipline, had found themselves and had learned to find their leaders. Their admiration for their leader was so great that they would not stick at any sacrifice, if they could only please him. Once a new musket was brought to the Guru as a present. He wanted to try it, as he humorously said, at somebody's forehead. Several people came forward, thinking it a great fortune to meet death at his hands. The danger of such a personal devotion is that it may warp the judgement of the admirers. Their vision, which is clear enough for finding fault with themselves and others, is dazzled when it meets the brilliance of glory with which the loved person is invested. As long as that was the case, the government of self was not complete, and the granting of full responsibility would have been dangerous. The tenth Guru's task, therefore, was to so train the judgement of his followers that they might never be deceived by appearances, and might find out evil, even if it be lurking in the most sanctified of places.

He began by raising their self-respect: for it is there that true and independent judgement begins. The Sikhs were freed from the demeaning influence of the *Masands*.[1] It was made clear that the Guru also was human, and to pay divine honours to him was the greatest blasphemy. The Guru says in the autobiographical piece, called the *Vachitra Natak*:

> Whoever says I am the Supreme Lord,
> Shall fall into the pit of Hell.

Recognize me as God's servant only.
Have no doubt whatever about this.
I am a servant of the Supreme:
A beholder of the wonders of His creation.

The ceremony of initiation was modified to suit the
changed circumstances. The water used in baptism, instead
of being stirred with the Guru's toe, was now to be stirred
with a dagger, and the Sikhs thus initiated were to be called
Singhs, meaning lions. The mode of salutation was also
changed. Instead of touching one another's feet, as was the
customs before, the Sikhs were to fold their hands and hail
each other as 'the Purified Ones of the wonderful Lord, who
is ever victorious'.

The Khalsa was inspired by a sense of divine mission
to right the wrongs of the world; and, in the discharge of a
Sikh's duties, no fear of earthly power was to stand in his
way. Such was his confidence in the strength of the righ-
teous cause that each Sikh called himself a unit of one lakh
and a quarter. Even now one might occasionally meet a
Sikh was would announce his arrival as the advent of a host
of one-and-a-quarter lakh of the Khalsa.

The Guru himself recognized the worth and dignity of
his nation, and would always refer to the assembly of Sikhs
with great respect and admiration. It was in these terms he
once spoke of his followers: 'It is through them that I
gained my experience; with their help have I subdued my
enemies. Through their favour am I exalted; otherwise
there are millions of ordinary men like myself whose lives
are of no account.' Though a leader, he yet considered
himself a servant of his people: 'To serve them pleases my
heart; no other service is so dear to my soul.' 'All the
substance in my house and my soul and body are at their
disposal.' The readers of history know how literally this
declaration was fulfilled by him. He sacrificed all his sons,
his parents, and lastly himself on the alter of his country's
service.

The raising of the Indian spirit from lowness and servility, which had dominated it for centuries, brought about a great change in the tone of the national character. Even those people who had been considered dregs of humanity were changed, as if by magic, into something rich and strange, the like of which India had never seen before. The sweepers, barbers and confectioners,[2] who had never so much as touched a sword, and who for generations had lived as grovelling slaves of the so-called higher classes, became, under the stimulating leadership of Guru Govind Singh, doughty warriors who never shrank from fear, and who were ever ready to shed their own blood where the safety of a single creature of God was in danger. Even their outward appearance underwent a marvellous change. They came to be regarded as models of physical beauty and stateliness of manner[3] as much as they were respected for their truth and honesty of character.

There is another feature of their character which the Sikhs acquired at that time and which we often forget to notice. In the face of desperate circumstances, they often put on a brave face which Hannibal or Sir Walter Raleigh might have envied—and literally shouted out the difficulty. Once a small straggling detachment of Sikhs was hemmed in by a large force of the enemy. Their friends were far off, and there was no hope of their coming in time to save them. Yet they did not lose heart. They took of their broad white Chaddars (sheets) and spread them over the nearby bushes to make them look like tents from a distance. All the while they kept on shouting every fifteen minutes the famous national cry of Sat Sri Akal. The enemy thought that the Sikhs were receiving many reinforcements, and did not dare to come forward.

As a result of this brave spirit, there grew up among the Sikhs a peculiar fund of words and phrases that came to be called the Vocabulary of Heroes. In it the difficulties of life were expressed in words of cheer and courage, in terms of such cheerfulness and bravado, as if, for the Sikhs,

pain and suffering had lost all meaning. Death was famil-
iarly called an expedition of the Khalsa into the next world.
A man with an empty stomach would call himself mad
with prosperity. Grams were almonds, and onions were
silver pieces, while rupees were nothing but empty crusts.
A blind man was called a wide-awake hero, and a half-
blind man an argus-eyed lion. A deaf man was said to be
one in the upper storey. A baptized Sikh was called a
brother of the Golden Cup, which, by the way, was only an
iron vessel. To be fined by the community for some fault
was called getting one's salary. The big stick was called a
lawyer or a store of wisdom; and to speak was to roar.

There is a superb humour in all this, which breathes
a full and healthy spirit. It shows that our ancestors
knew—how much better than we do at present—that
religion is not incompatible with brightness and vigour.
Nay, explain it how we will, true humour always goes
with ripeness of wisdom, and long-faced seriousness, as
much as frivolity, is a sign of immaturity. Without a sense
of humour, virtue itself becomes self-forgetful and loses its
balance. It is humour alone that can keep our sympathies
well-regulated and in good trim. It is a fine corrective
force in character, and works like an instinct against all
excess. Without it, a man's character is incomplete or
onesided.

It was with this sense of humour that one quiet
morning, at Hardwar, Guru Nanak had begun to throw
water towards his fields in Kartarpur. His purpose was to
disillusion the Hindus, who believed that the water thrown
to the east would reach their dead ancestors in the world
beyond. It was the same humour he displayed at Mecca,
when he said, 'You may turn my feet in any direction
where God is not.' He often announced his coming in a
very strange manner. While coming back to India from
Mecca, he halted at Baghdad. It was yet early dawn, and
the people had not begun stirring for the morning prayers.
Guru Nanak wanted to have a congregation of his own. He

took himself to a high place, and in a loud stentorian voice began to imitate the famous Mohammedan call to prayer. Hearing this new kind of *Azan*, the people flocked round him and listened to his preaching with more than usual eagerness. On another occasion, during his wanderings, he came upon a knot of happy children playing in the street. He at once put off his gravity and began to leap and bound and shout just as the little urchins did. It must have been a sight for angels to see the grey-haired prophet jumping and singing in the company of children![5]

Guru Govind Singh also realized the value of humour and made full use of it in his religious propaganda. Once he dressed up a donkey like a lion and set it roaming about the fields. The Sikhs began to laugh when they heard it braying, in spite of the lion's coat, and asked their leader what it meant. The Guru told them that they, too, would look as foolish as the donkey if, with the Singh's (lion's) name and uniform, they still remained as ignorant and cowardly as before. The same love of the dramatic is exhibited by the way he exposed the futility of the belief in Durga, the goddess of power. When all the ghee and incense had been burnt, and Pandit Kesho had tired himself out by mumbling mantras by the million without being able to produce the goddess, the Guru came forward with a naked sword and, flashing it before the assembly, declared: 'This is the goddess of power.' The same grim humour was shown by him when, one spring morning, in the midst of hymns and recitations he appeared before his Sikhs and demanded a man who would sacrifice himself just then for his faith. He wanted to see whether the people dared to do anything beyond mere singing of hymns and reading of texts.

Along with the development of the sense of dignity and self-respect, the Sikhs imbibed the soul-stirring precepts of the tenth Guru. Imagine the Guru, a young man of thirty-three, seated before his Sikhs and speaking loudly:

False religion is without fruit; by the worship of
stones you have wasted millions of ages.
How can perfection be gained by touching stones?
Nay, strength and prosperity thus decrease, and
the nine sources of wealth are not obtained.
Today and today and today; time is thus passing
away: You shall not accomplish your object; are
you not ashamed ?
O fool, you have not served the Lord, so your life
has been passed in vain.[6]

Why call Shiva God, and why speak of Brahma as
God ?
God is not Ram Chandar, Krishan, or Vishnu,
whom ye suppose to be the lords of the world.
Sukhdev, Parasar and Vyas erred in abandoning
the one God to worship many gods.
All have set up false religions. I, in every way,
believe that there is but one God.[7]

Since I have embraced Thy feet, I have paid
homage to none besides.
Ram and Rahim, the Purans and the Quran ex-
press various opinions, hut I accept none of them.
The Smritis, the Shastras and the Vedas, all ex-
pound many different doctrines, but I accept none
of them.[8]
I do not propitiate Ganesh;
I never meditate on Krishan or Vishnu;
I have heard of them, but I know them not;
It is only God's feet I love.[9]

I am the son of a brave man, not of a Brahmin;
how can I perform austerities ?
How can I turn my attention to Thee, O Lord, and
forsake domestic affairs ?[10]
Hear ye all, I declare this truth;

Only those who practise love obtain the Lord.[11]
They who undergo bodily suffering
And cease not to love their God
Shall all get to heaven.[12]

He is not concerned with celestial appearances or
omens;
This fact is known to the whole world.
He is not appeased by incantations, written or
spoken, or by charms.[13]

On seeing any person in trouble, take compassion
on him, and remove his sufferings to the best of
your ability. Then the Primal Being will be merci-
ful unto you.[14]
The Temple and the Mosque are the same; the
Hindu and the Muslim forms of worship are the
same; all men are the same, although they appear
different under different influences.
The bright and the dark, the ugly and the beauti-
ful, the Hindus and the Muslims have developed
themselves according to the fashions of different
countries.
All have the same eyes, the same ears, the same
body and the same build—a compound of the
same four elements.[15]

He who keeps alight the unquenchable torch of
truth, and never swerves from the thought of one
God;
Who has full love and confidence in God; and
does not put his faith, even by mistake, in fasting
or the graves of Mohammedan saints, Hindu
crematoriums, or Yogis' places of sepulchre;
Who only recognizes the one God and no pilgrim-
ages, alms, non-destruction of life, penances, or
austerities;

And in whose heart the light of the Perfect One
shines—he is to be recognized as a pure member
of the Khalsa.[16]

In this way, the Guru tried to so discipline the judg-
ment of his people that it might not 'be thawed from the
true quality by sweet words, low crooked courtesies and
base spaniel-fawning.' That the Sikhs fully profited by the
training is evident from the following episode: Once, the
Guru, followed by his disciples, was passing by the tomb of
saint Dadu. In order to test the truth of their judgment, he
lowered his arrow before the tomb and waited to see what
the Sikhs would think of it. It is recorded[17] that the Sikhs at
once surrounded their leader and asked him to come down
from his horse and explain himself. They said he had
broken one of the principal tenets of his faith and must be
tried by regular Commission of Five. He was obliged to
confess and exculpate himself by paying a fine of 125
rupees. Verily, the light of the Perfect One had come to
shine in them, when they could detect a flaw even in the
most honoured of personalities in the world.

That their hold on truth was strong, and their sympa-
thies unwarped even by the passion of war is shown by the
following. In a fight with Mohammedans, a Sikh named
Kanaiya was found distributing water to the friends and
foes alike. When asked why he did so, he said he did not
see any difference between Sikh and Mohammedan. 'We
fight against the evil in men, not against their welfare.'

Another episode shows that women, too, had devel-
oped in them the spirit of duty, and would keep to the side
of truth even when their husbands and brothers had
shunned it. For this reason, the sixth Guru has called
woman 'the conscience of man'. When the priests of Amrit-
sar had disowned Guru Teg Bahadur and would not allow
him to enter the Golden Temple, it was the women of
Amritsar who came forward and got their pardon. In the
time of Guru Govind Singh, however, they had to perform

a harder task. While the Guru was hard pressed in Anand-pur, a certain number of Manjha Sikhs had the hardihood to write a disclaimer and forsake his service. When these deserters came to their homes, their women would not let them enter. They refused to open their doors to those who had shown their backs to the national leader. Shamed to desperation, the men consented to be led by a woman named Mai Bhago, who came with them a-colonelling to the field of Muktsar and fought bravely until all her compan-ions were dead. These forty martyrs are conspicuously remembered in the daily prayer of the Sikhs.

The course of discipline was complete, and it was time that the Sikhs were given the full responsibility of their position.

Much of this responsibility had already been vouchsafed to them. When baptizing them at Anandpur, Guru Govind Singh had shown them what their position was to be in future. After administering the ceremony of baptism to his five tried Sikhs, the Guru stood up before them and, with folded hands, begged them to administer baptism to himself in precisely the same manner as he had administered it to them. A poet who was present exclaimed: 'Wonderful Govind Singh! who is Guru and disciple both.' It was won-derful, indeed, to behold the Master clasping his hands in supplication before his own Sikhs and requesting them to initiate him as one equal with them in the ranks of the Khalsa. It meant that the Khalsa was the Guru elect, that after Guru Govind Singh his Sikhs would occupy his position.

He invested them with this responsibility even before their character was fully formed, as he knew that the most effective way of teaching a nation how to wield authority is to allow it to wield authority. Without actually doing a task, a man can never learn the practice of it. The Guru wanted to see personally how the Sikhs would conduct themselves in the newly acquired position. So he still maintained himself as their admired chief, until they had acquired sufficient character to be left alone and guide themselves.

When in the end he saw, as shown above, that the light of the Perfect One had come to shine in them clearly and without intermission, he decided to give up even what was left. At his death-bed, he announced that the Khalsa with the Holy Granth was to be the Guru in future. It was to guide itself by the teaching of the ten Gurus as incorporated in the Sikh Scriptures and also by the collective sense of the community. Wherever there were five Sikhs elected as the best of all present, there was the spirit of the Guru among them.

The Guru had led the Sikhs from generation to generation in the practice of virtues that make ,a conscientious nation; and now that the task was over, the Master merged his personality in the ranks of his disciples. All Sikh history had been moving towards this divine event. The cows had become lions, and there was no need left to protect them from outside. There was to be no personal Guru in future. Wherever there were Sikhs, they were to organize themselves into *sangats* or congregations, and whenever there was an important question, affecting the whole community or any part of it, to be decided, the *sangat* was to elect from among its members five *Pyaras* or Loved Ones, and submit to them the execution of all the work in hand.

When a Sikh committed some fault, it was expected that he should present himself before the nearest *sangat* and, standing with folded hands in the lowest place where shoes are kept, he should make an open confession of his fault. The congregation would refer the question to a duly elected Commission of Five, who would consider the case among themselves and report their decision to the assembly. The assembly would then confirm the decision by a hearty shout of *Sat Sri Akal*. The punishment meted out was willingly received, and was euphemistically called getting a reward or salary. There was no rancour left in the heart of the man punished, for the punishment came from the whole *sangat* represented by the five Loved Ones. The resolutions passed in such assemblies were called *gurmattas*. When a *gurmatta*

was duly carried, it was supposed to have received the sanction of the Guru, and any attempt made afterwards to subvert it was taken as a sacrilegious act.

This constitution worked smoothly as long as there was no disturbing factor of greed for personal power. The Khalsa was forged as an instrument of good for the world. Wherever there was a Sikh, there was a garrison of defence for the weak and the lowly. Though, owing to the exigencies of the time, Sikhs were always prepared for war, yet all of them were not fighters. It is very unfortunate that Clio's ears are more sensitive to the rattling of the sword than to the music of peace, and therefore the military actions of the Sikhs of that time fill all the space in Sikh history. Otherwise, the Sikhs did not always fight. When not under the ban of the Mohammedan Government, they were usually engaged in agriculture, trade and other peaceful professions; and, in the midst of these occupations, they lived the life of pure philanthropy.

We read of Sikhs going to Kabul, Balkh and Bukhara in the guise of faqirs to find out and bring back their brethren who had been taken there as slaves by Mohammedan invaders. Sujan Rai of Batala writes about them in his *Khulasatultawarikh*: 'In their eyes, their own people and others are all alike. They serve their friends and do not ill-treat those who are their enemies. They consider it very meritorious to do social service. If a wayfarer arrives at midnight and takes the name of Guru Nanak, he is treated as a friend and brother, no matter he be known or unknown, provided he is not an evildoer, a thief, or a robber.'

There was no pride of position or servility born of poverty. All were brethren of the same family. Even in these days of its decadence, the Khalsa still shows some glimmering signs of old glory. One may still find at big Sikh gatherings millionaires taking simple food on bare ground with the poorest of men; reises and Sirdars serving barefooted in the common kitchen. Not many years ago, His late Highness, Maharaja Sir Hira Singh of Nabha, was seen

fanning the Sikh assembly at the Khalsa College, Amritsar. These and similar other ennobling instances still left remind us of what the Sikh character must have been as the Gurus made it.

But there is no denying the fact that many of these characteristics vanished within a hundred and fifty years; the reason being that the leaders trained in the school of Guru Govind Singh were soon put away or martyred, and the Sikhs, with the establishment of *misals*, began to fight for dominion and power for themselves. Moreover, the Sikhs having been driven out of their homes, their temples, which had been organized as the main sources of Sikh teaching, fell into the hands of non-Sikhs and became the means of spreading un-Sikh principles. It is thus that the stream, which had started from ten main-heads to cleanse and fertilize the earth, has remained a sub-surface current for such a long time. But it has not lost itself for ever. It will rise again and give its old song, its old dance, and will again be a beautiful sight to see.

REFERENCES

1. Originally, religious men who were appointed to preach religion and collect the offerings of the Sikhs for the Guru. By the time of the tenth Guru, they had become very corrupt and tyrannical, and the Guru was constrained to abolish the order, after making an example of them.
2. Macauliffe, V. 42.
3. Cunningham's *History of the Sikhs*, 84. Also, Eliphinstone's *History of India*, ii. 564.
4. This cry has on occasions done more wonders than any national anthem in the world. Jassa Singh, a Sikh captain, fell away from his party on account of some quarrel, and went over to the Nawab of Lahore. The latter sent him with a body of soldiers to attack the fort of Amritsar. When he came before the fort, he heard that cry

of *Sat Sri Akal* coming from inside. As soon as he heard the familiar shout, his blood tingled in his veins, he rushed to the gate of the fort, and begged his brethren to pardon him and let him enter as one of them. For another instance, see Macauliffe, V. 163.

This full-throated shout, which is called the cry of victory, is a great symbol of Sikh power and dignity. There is nothing else like it. The cheering of a joyous English crowd is grand; and the Mohammedan call to prayer, heard in the stillness of the night, is most beautiful and awe-inspiring. But those who have attended the religious and educational meeting of the Sikhs will bear witness that the *Sat Sri Akal* stands by itself. In fact, few people on earth can shout their national cry with so much emotional effect as the Sikhs, who so stir one another's blood and soul by shouting, that the rush of their collective voice sounds like the ring of their whole history, with all its standards waving at once, from Guru Har Govind's downwards.

5. Macauliffe, I. 174.
6. Thirty-three *Swyyas*, XXI.
7. Thirty-three *Swyyas*, XV.
8. *Ram Avatar.*
9. *Krishan Avatar.*
10. *Krishan Avatar.*
11. *Swyyas.*
12. *Vachitra Natak*, 6.
13. From the Guru's introduction to the translation of the Puranic tales.
14. Macauliffe, V. 160.
15. *Akal Ustat*, 86.
16. *Swyyas*, 2.
17. Macauliffe, V. 228. In later days, too, the Sikhs showed this courage of conviction in many critical movements of their history. Bhai Mani Singh was a most revered Sikh of his time, for learning as well as for character. He was the high priest of the Golden Temple. But when he tried to rearrange the text of the Holy Granth, an act of unprecedented effrontery to the spirit of the Gurus, he was publicly censured and had to ask pardon.

Banda had been appointed leader of the Sikhs after the tenth Guru, who had asked him to remain humble and considerate towards the Sikhs. But he soon began to deviate from the path chalked out for him and set himself up as a Guru. The true Sikhs

at once raised a voice of dissent, and finding him obstinate in his career of rapine and conquest, renounced their allegiance to him. These dissenters were called the Tat Khalsa and the rest the Bandai Khalsa.

Even in the beginning of the nineteenth century, when Ranjit Singh's imperialism had destroyed the democratic spirit, there were some signs of the old discernment still visible. When Maharaja Ranjit Singh, in spite of remonstrances from his community, still continued indulging in certain evils, he found his corrector in one of his own devoted captains. As he was pacing in the precincts of the Golden Temple, he was pulled up by Baba Phula Singh, who severely rebuked him in the presence of all and said that he was unfit to be the leader of the Khalsa until he had mended his ways. He at once confessed his guilt and submitted that he was ready to pay any fine that a Commission of Five might impose upon him. Phula Singh said that fine was no punishment for him; he should be flogged in public. The Maharaja at once bared his back and offered himself for being flogged.

SRI ALASINGA PERUMAL

M.G. Srinivasan

The name of Alasinga Perumal, familiarly known as 'Alasinga', may not be widely known today as one of the pioneers of the Indian renaissance movement in South India. But those who are closely acquainted with the events of the illustrious life of the great Swami Vivekananda, especially his *parivrajaka* days in South India, and the early history of the Ramakrishna-Vivekananda movement (in South India) cannot but have become aware of the remarkable personality of Alasinga Perumal. Though very little is known about his pure and noble life owing to non-availability of sufficient recorded biographical material, he was undoubtedly one of the greatest and most devoted followers of Swami Vivekananda.

Alasinga was born of humble but respectable Sri Vaishnava brahmin parents in 1865, in Chickmagalur in Karnataka. His father, Narasimhachariar, hailing originally from Mandya village in Karnataka, was a clerk in the local Municipal office. Later he took employment in Madras, where Alasinga came to be educated. Alasinga had his education first at the Madras Presidency College and then at the Madras Christian College, where he was one of the best and dearest pupils of the then well-known educationist Dr. William Miller. After graduating in science in 1884, Alasinga joined the Law College, where he studied only for a short time. Unexpected circumstances compelled him to leave the Law College before completing the course and seek employment at an early age. Among the few careers open to university educated men even in as late as the nineties of the last century was teaching. Alasinga first became a teacher in a private school at Kumbhakonam. As it was not a permanent post, he soon gave it up and, in

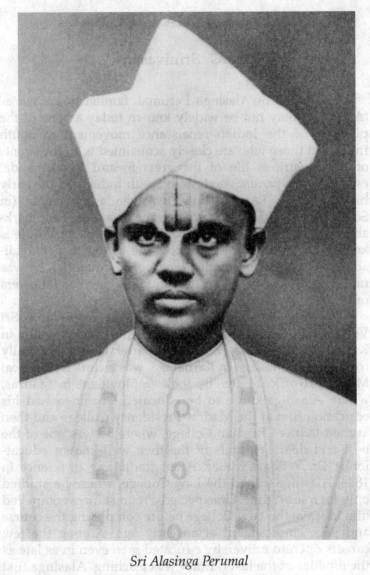

Sri Alasinga Perumal

1887, joined the staff of the Pachiappa's School at Chidambaram as a science teacher. In three years' time, in view of his efficiency, he was appointed Head Master of the Pachiappa's High School at Madras, which post he successfully held for a long time, almost to the end of his short life. He was appointed on the staff of the college department in Physics in the Pachiappa's College a short time before his death. He loyally served the Pachiappa's Trust to the end of his life, and won the regard and love of his students as well as colleagues.

But it was not in the field of secular education that Alasinga accomplished his most enduring achievement. Nor did he choose to appear in the role of a political hero. He did much more than that. Being a true son of Mother India, he had realized, early in life, where her real greatness lay. He decided to dedicated his life to a higher cause—of striving to resuscitate the essential spiritual values in life. He felt extremely dissatisfied at the rate at which spiritual degeneration was increasing all round—the educated becoming votaries of Western 'scientific' materialism, and the uneducated becoming victims of priestcraft and superstition.

Western education was tending to impart an antinational bias to the outlook of the educated Hindus, many of whom started imitating Western modes of life and conduct and looked upon their ancient national religion and culture with ridicule and disregard. Misrepresentation of the Hindu religion by the less scrupulous among the Christian missionaries from the West served to augment this drift of Indians away from the moorings of their national cultural heritage. The excrescences and shibboleths that had crept into the complex fabric of Hindu society were adhered to with unthinking ignorance so as to make Hinduism degenerate into a bundle of unspiritual and often meaningless forms and observances. The situation demanded a new spirit and a new light to rid Hinduism of its dead wood, to restore to their true place of primacy its vital spiritual

truths, and to reiterate India's message for the world at large.

Young Alasinga's sensitive soul was quick enough to perceive this need of the hour, and he threw himself heart and soul into his self-chosen mission in life. But his course was by no means smooth. Considering the obstacles and ridicule he had to face and the scanty resources he could command in working for the realization of his ideal, one cannot but deeply admire his marvellous achievement.

When Alasinga was in his teens he little knew that another great soul, also in his teens, destined to kindle the fire in Alasinga's heart and guide him through life, was passing through a period of intense *sadhana* in distant Bengal. This was no other than Swami Vivekananda, the foremost disciple of Sri Ramakrishna Paramahamsa. The divine hand of the Master which prepared the way for the fulfilment of the Swami's mission brought the two kindred souls into intimate contact. In the course of his wanderings as a *parivrajaka*, from north to south, Swami Vivekananda came to Madras in 1892. After his historic visit to and divine experience at Cape Comorin, the Swami arrived at Tiruvananthapuram. It was here that he met the late Prof. Rao Bahadur M. Rangacharya, a Sanskrit scholar of repute of those days. Prof. Rangacharya was a close relative (the brother-in-law) of Alasinga. This occasioned the meeting between the great master and the great disciple—Alasinga met Swami Vivekananda—an event full of significance for India in the years that followed.

The news that a great Parliament of Religions was meeting at Chicago in the United States in the latter part of the year 1893 came to be known in India. Dr. Barrows, one of the leading organizers of the Parliament, had written to Dr William Miller about the Parliament of Religions. Yogi Parthasarathi Iyengar, Alasinga's uncle and a great Vaishnava scholar, connected with the Hindu League of America, coming to know of the Parliament of Religions going to be held at Chicago, informed Alasinga about it. Even an event

of such great significance going to take place in distant America would arouse little interest or enthusiasm among Indians, in those days, with the exception of a few scholars most of whom contented themselves with sending written contributions only. But Alasinga realized the importance of this international convention of all religions and strongly felt that it was a fine opportunity for sending a worthy representative of India to represent Hinduism at the Parliament of Religions. He requested Prof. M. Rangacharya to go to Chicago and attend the Parliament of Religions. But Prof. M. Rangacharya did not agree. Alasinga felt very much disappointed, but did not lose hope. He was determined to do his best to persuade some eminent person or other to agree to represent Vedanta at the Chicago Parliament.

Meanwhile Alasinga learnt one day from his younger brother, M.C. Krishnamachar, that a young sannyasi, well versed in English and in the Hindu *shastras,* had arrived at the house of Manmathanath Bhattacharya, Assistant to the Accountant-General of Madras. Alasinga felt curious to know who this English-knowing sannyasi might be and went to meet him, accompanied by G.G. Narasimhachar, R.A. Krishnamachar, and some others. At the very first meeting Alasinga instinctively felt that here was the person for whom he was seeking. There arose in him an irresistible urge to love and revere the 'unknown' young Swami as his spiritual Master. The Swami's magnetic personality, spiritual greatness, and intellectual brilliance made a deep and lasting impression on every one of that small band of young men who accompanied Alasinga. The light that shone from the eyes of the Swami cast a spell on Alasinga. The charm of the Swami's words transformed him. Alasinga became a devoted follower of Swami Vivekananda and remained ever steadfast to him to the end of his life.

Unlike the others around him, Alasinga quickly discerned the supreme spiritual and intellectual attainments of the Swami and realized that he was no ordinary person.

Alasinga was immensely glad he had come into intimate association with an extraordinary genius whom he could persuade to proceed to America to represent India at the Parliament of Religions. With all the sincerity and earnestness characteristic of him, Alasinga approached the Swami and asked him the momentous question, 'Why not go to Chicago, Swami?' 'Why not, indeed!' the Swami thought over. It had not occurred to anyone before. The few who had known of the Parliament of Religions to be held in Chicago never for a moment thought it possible for an Indian representative to be sent to Chicago. But Alasinga was unlike the others. He proposed to the Swami that he should attend the World Parliament of Religions at Chicago.

At first the Swami did not give his consent to this proposal. But the sincerity and earnestness with which Alasinga began to persuade him to go to Chicago made the Swami think more seriously about it. Alasinga, who used to frequent the house of Sj. Bhattacharya in Mylapore where the Swami was putting up, took every opportunity constantly to put into the Swami's mind this idea of the Parliament of Religions. Alasinga had felt that in the Swami's visit to Chicago lay India's only chance of representing her Sanatana Dharma before the World Parliament of Religions. Alasinga's pure desire did not remain unfulfilled. It was the Shivaratri night in the year 1893. Throughout the day and night the Swami spoke little, and was immersed in deep meditation. It was on this holy night that the Swami finally decided to go to America. Alasinga's joy knew no bounds.

It was not easy to find the money for the Swami's passage and other expenses. Alasinga, an ordinary schoolmaster, and his friends were of moderate means and could subscribe only a small fraction of the money required for the Swami's passage fare to America. The major portion of the money had to be collected from the public through subscriptions. Alasinga lost no time in applying himself to this difficult task of collecting funds. He shouldered the entire responsibility, and with the assistance of some young

men under him took up the task of raising subscriptions for the Swami's passage money to America. At one time a zemindar assured Alasinga that he would contribute the entire sum needed for the purpose. Alasinga naturally trusted him and had slackened his efforts to find subscriptions. But only two months before the Swami's departure this zemindar suddenly changed his mind and gave only a small part of the money.

Alasinga, though somewhat disappointed at this, did not feel disheartened in the least. With redoubled effort and with his characteristic perseverance and devotion to duty, Alasinga literally went begging from door to door, approaching mostly the members of the middle classes. This was in accordance with the wishes of the Swami, who had expressed, 'If it is the Mother's will that I go, then let me receive the money from the people! Because it is for the people of India that I am going to the West—for the people and the poor.' Alasinga and his friends went out of Madras city, even as far as Ramnad and Hyderabad for subscriptions, and they received the full co-operation of the Swami's disciples and admirers in those places. Thus a sum of nearly Rs. 3,000 was collected within three or four days! Alasinga went to Bombay and himself deposited the amount with Thomas Cook and Sons as passage fare for the Swami's forthcoming voyage to the United States. He now felt greatly satisfied that all arrangements were complete for the Swami's departure.

Finally the sailing date arrived—31 May 1893. Alasinga came from Madras to Bombay to bid farewell to the Swami. The Swami's heart was consumed with various emotions. Alasinga accompanied the Swami up the gangway and remained with him till the very last moment. When the time for parting came, Swami Vivekananda, with tears in his eyes, warmly embraced Alasinga. Alasinga took leave of the Swami after prostrating at his feet. Simple Alasinga was hardly aware of the great significance of the step he had so unobtrusively persuaded the Swami to take. At this distance

of time it is evident that it was no small service that Alasinga had rendered to the country and to humanity at large.

The World's Parliament of Religions, held in Chicago in September 1893, was undoubtedly one of the greatest events in the history of the world. India learnt amidst American applause of Swami Vivekananda's brilliant and unparalleled success at the Parliament of Religions. There was great jubilation throughout the country and Alasinga's joy was beyond description. Though he felt elated that his object in persuading the Swami to go to America had been fulfilled, yet he took no credit for anything that he had done. He silently prayed that the Swami's work in America be crowned with success. Soon after the Parliament of Religions, Swami Vivekananda commenced his real task of expounding the Vedanta to the Westerners through writings, lectures, class talks and conversations. As part of his preaching work the Swami started Vedanta centres in the United States of America. Reports in greater detail of the activities of the Swami in America were regularly reaching India through his Gurubhais and disciples in Madras and Calcutta, who received communications from the Swami himself and others in America.

In Madras and Calcutta, large meetings were held in which distinguished citizens took part. Addresses were sent to the Swami applauding his noble work in the cause of Hinduism in America. The Swami took due notice of these appreciations and sent suitable replies, the most notable of which is his stirring, 'Reply to the Madras Address'. Ever since the Swami commenced his work in America, Alasinga keenly felt the need for starting an English periodical in which he could bring out the valuable lectures and writings of Swami Vivekananda on Vedanta delivered in America, for the benefit of Indian readers. Also he wanted to make the journal a medium through which the life and teachings of Sri Ramakrishna Paramahamsa and other saints, as well as the essence of

the Upanishads and other scriptures could be propagated in the English language. In his efforts in this direction, Alasinga received valuable help and encouragement from the Swami. After Swami Vivekananda started systematic preaching work in America, he constantly urged his disciples in Madras, through stirring and stimulating letters, mostly addressed to Alasinga, to launch a magazine on Vedantic lines. He even helped them with funds from the proceeds of his lectures in America to carry out this project. The Swami expressed his great confidence in Alasinga's capability, and charged him with the task of conducting the proposed monthly journal.

Accordingly Alasinga started the *Brahmavadin*, an English monthly, with himself as editor, in the year 1895. He threw himself heart and soul into this work of editing and managing the *Brahmavadin*, and carried it on bravely and ably until his death. He spared no pains to make the journal a complete success, and won the admiration of one and all for the devotion and perseverance with which he undertook the work. In one of his letters to Alasinga, Swami Vivekananda wrote: '...entire devotion to the cause, knowing that your *salvation* depends upon making the *Brahmavadin* a success. Let this paper be your Ishtadevata and then you will see how success comes....' Alasinga followed the Swami's directions with perfect obedience and actually looked upon the *Brahmavadin* as his 'Ishtadevata'. His connection with *Brahmavadin* may be said to be his life work. He kept it up at a high level and in perfect order notwithstanding his preoccupations with college work and family difficulties. For the first two years his talented brother-in-law, Prof. M. Rangacharya, contributed articles regularly to the *Brahmavadin*. During the next ten years his cousins G.G. Narasimhachar and R.A. Krishnamachar, and some others helped Alasinga in the work of conducting and contributing to the *Brahmavadin*. After this, for four years, till his death in 1900, he conducted the journal singlehanded. After Alasinga's passing, his sons carried on the

Brahmavadin for a period of five years, till 1914, when it ceased publication.

The *Brahmavadin* was the first and foremost Indian monthly journal *in English* in its days. At a time when Western secular and scientific education had completely enslaved the minds of Indians and made them fight shy of their ancient religion and culture, it needed no small effort on the part of Alasinga to popularize and find subscribers and readers for a religious and highly philosophical magazine like the *Brahmavadin*. Alasinga succeeded in fulfilling the trust placed in him by Swami Vivekananda. This success was mostly due to two factors, viz. the Swami's guiding hand as expressed through his inspiring and illuminating letters to Alasinga, which had almost the same value as his presence; and secondly, Alasinga's sincerity of purpose, selfless sacrifice, and intense devotion to the Swami. Even today a perusal of the back numbers of the *Brahmavadin* bears ample testimony to the labour of love so characteristic of its worthy editor.

Swami Vivekananda repeatedly gave directions to Alasinga concerning the ideals for which the *Brahmavadin* should stand and the policy and procedure for its conduct. The *Brahmavadin* had made its influence felt in the field of Indian journalism as a constructive force in the new-Hindu renaissance. In his Editorials, Alasinga always adhered to what the Swami specially stressed in his own lectures and writings, viz. not nationalism only but internationalism, not Hinduism only but Vedanta, the universal religion. In addition to contributed writings, the *Brahmavadin* regularly recorded the progress and activities of the Ramakrishna-Vivekananda movement in various parts of India and the Western world. Whenever the Swami found anything published in the *Brahmavadin* that smacked of sectarianism or propaganda, he immediately warned his disciples. Once he wrote to Alasinga: '...I have been smelling something since last few issues of the *Brahmavadin*....No hypocrisy with me....I shall have one man only to follow me, but he

must be true and faithful unto death....I must keep my movement *pure* or I will have none....I am very decided on this point. The *Brahmavadin* is for preaching Vedanta and not—.'

The *Prabuddha Bharata* also owes its origin to Alasinga. It was he who first proposed that as the *Brahmavadin* was of a more advanced standard, generally suitable to Vedantic scholars and elderly persons, another journal in English should be started for the benefit of youths and less educated persons, containing simpler and less scholarly contributions. It was Alasinga who selected B.R. Rajam Iyer as the first editor of the *Prabuddha Bharata*, which was started in the year 1896 through the joint efforts of Alasinga, Dr Nanjunda Rao, and G.G. Narasimhachar. Alasinga's literary capacity was of a high order, though he has not been known to be an author. In addition to his close connection with *Brahmavadin* and *Prabuddha Bharata*, he was directly or indirectly associated with many other journal such as *India*, *Weekly Review*, and *Native State*. His intensely active life left him very little leisure to do any literary work of a permanent nature. His language was chaste, simple and clear. His writings clearly revealed the depth of his inner convictions and the living faith he cherished in the spiritual destiny of mankind.

A striking feature in Alasinga's life is his unique relation with Swami Vivekananda. The Guru bestowed the greatest amount of affection and care on the disciple, and the disciple, in his turn, completely surrendered himself at the Guru's feet. Of the band of young men who were drawn to Swami Vivekananda during his first visit to Madras, Alasinga was the first to be kindled by the touch of the Swami's fire. From the first meeting till the last, Alasinga remained the favourite lay disciple of the Swami from among his Madras disciples, purely by dint of his extraordinary merit and devotion (Guru-bhakti). Swami Vivekananda's gospel of man-making and character-building, his ideals of renunciation and service, found ready response

and practical expression in Alasinga. Swami Vivekananda spoke very highly of his dear Alasinga and admired him for his sincerity of character and unselfishness. When the Swami left the shores of India for the Parliament of Religions, he kept on writing inspiring letters to Alasinga, giving him all possible guidance and encouragement in order to be able to carry on the work at Madras and also conduct the journals *Brahmavadin* and *Prabuddha Bharata*. In one of his early letters, the Swami wrote: 'Now organize a little society....You will have to take charge of the whole movement, not as a *leader*, but as a *servant*....So far you have done well, indeed, my brave boy. All strength shall be given to you....' '...Have faith that you are all my brave lads, born to do great things!' In another letter from the United States, he wrote: '...Take heart and work. Let me see what you can do....Be true to your mission. Thus far you promise well, so go on, and do better and better still....' Referring to the *Brahmavadin* the Swami once wrote to Alasinga, '...The journal must not be flippant but staid, calm and high-toned....Be perfectly unselfish, be steady and work on. We will do great things, do not fear. One thing more. Be the servant of all,...go on. You have worked wonderfully well. We will work it out, my boy; be self-reliant, faithful, and patient....' In a remarkable letter to Alasinga from London, the Swami wrote: '...My child, what I want is muscles of iron and nerves of steel inside which dwells a mind of the same material as that of which the thunderbolt is made. Strength, manhood, Kshatra-Virya and Brahma-Teja....' In the *Complete Works of Swami Vivekananda* and in the separately published *Letters of Swami Vivekananda* can be found a number of such letters addressed to Alasinga by Swami Vivekananda. These inspiring and elevating words produced the desired effect on the disciple. *Āścaryo vaktā kuśalo'sya labdhā, āścaryo jñātā kuśalānuśiṣṭaḥ.*

Alasinga was intensely earnest and sincere in thought, word and deed whenever he set his heart on anything. He exhibited an abundance of healthy wisdom and a capacity

to get things done smoothly and speedily. He was unosten-
tatious and full of self-abnegation. He never pushed himself
forward to the exclusion of others, nor did he seek any
credit for any act of his. Like fire hidden under ashes or a
fruit shaded beneath leaves, he lived a silent unobtrusive
life. He was an ideal Karma Yogi and a great Bhakta. He
was ever ready to be taken out of his house in the midst of
his work in order to render some help to somebody.
Throughout his life he lived for others and felt he was duty
bound to serve others without expecting any return. His
innumerable, little acts of kindness in relieving individual
distress, even at the risk of his own discomfort, had earned
for him the gratitude of one and all.

His affable and obliging disposition served to create for
him a large circle of friends of all classes and communities.
He had great influence with the rich and the poor, the high
and the low, officials and non-officials alike, all of whom
cherished great regard for Alasinga. He was a worthy
champion of every good cause however insignificant it
might be. His co-operation was sought after even by the
leading men of his day because he would work sincerely,
keeping himself in the background. He never harboured ill
will against any person, and uttered nothing but godspeed
to every one whether he agreed with him or not. He was
intensely national in outlook and deeply loved the mother-
land, thereby setting an example of how a man could love
his country. He held liberal and progressive views on social
and political matters, and it is no exaggeration to say that
he was far in advance of the times he was born in. Though
he was never directly connected with politics, his spirit of
true nationalism flowed in various other channels.

He was intimately associated with Mrs Annie Besant
and the Young Men's Indian Association of Madras. The
patriot-poet Subramanya Bharati of Tamilnadu was one of
Alasinga's good friends. Poet Bharati has paid a glowing
tribute to the memory of Alasinga, and has acknowledged
that he had received immense help from Alasinga as

occasions arose. Alasinga was not looked upon as a mere schoolmaster. He was considered an authority on many subjects on account of his ripe experience and deeply religious life. Once, poet Subramanya Bharati asked Sister Nivedita, 'There are in Madras no patriot leaders old enough to supervise and guide youths like us; what are we to do?' Sister Nivedita replied, 'Alasinga is there. If you have doubts regarding public affairs, you may have them cleared by him.'

Though never above want, Alasinga remained self-satisfied with what little he earned himself. Love of money and power was foreign to his nature. Once a rich American disciple of Swami Vivekananda, sympathizing with Alasinga in his pecuniary difficulties, expressed to Sister Nivedita his intention of making a gift of a lakh of rupees to Alasinga so that he may be placed above want. When Alasinga was informed of this by Sister Nivedita, he thought for a while and replied to her thanking the gentleman for his generous offer but regretting his inability to accept the money. Later he told his friends that he was unwilling to sacrifice his independence for a little personal gain.

Alasinga was a perfect product of Indian Vedantic thought. Though he had done nothing during his lifetime with a view to perpetuating his memory, his life's work will go down to history as the worthy contribution of those rare souls who have sincerely striven to serve mankind with no selfish motive in them. He carried the conviction of the grandeur of Indian philosophic thought in his daily life, which was a practical application of the ideal of Karma Yoga as taught in the *Bhagavad-Gita*. Alasinga has left a memory which is cherished with loving regard by every one of his numerous friends. None returned from him without being better for the visit. His premature death on 11 May 1909, at the age of 44, after a protracted illness, was a loss not only to those who knew him but also to the country as a whole. If the end had not come so early, the world would

certainly have witnessed greater manifestation of the divinity that lay enshrined in the person of Alasinga Perumal. Though living in the world as a householder, he was not of the world. Alasinga Perumal lived an exemplary life worthy of emulation by every Indian youth who is fired with the determination to 'Arise, Awake, and stop not till the goal is reached!'

There can be no better tribute to Alasinga Perumal's memory, as a fitting conclusion to this life-sketch, than the following description of him by Swami Vivekananda. (When Swami Vivekananda reached Madras on his way to the West for the second time, Alasinga travelled with the Swami from Madras to Colombo on board the ship with the intention of consulting the Swami about the *Brahmavadin* and the Madras work):

'...Alasinga, Editor, *Brahmavadin*, who is a Mysore Brahmin of the Ramanuja sect, having a fondness for "Rasam" (pungent and sour *dal* soup), with shaven head and forehead overspread with the caste-mark of the Tengale sect, has brought with him with great care, as his provision for the voyage, two bundles, in one of which there is fried flattened rice, and in another popped rice and fried peas! His idea is to live upon these during the voyage to Ceylon, so that his caste may remain intact. Alasinga had been to Ceylon before, at which his caste-people tried to put him into trouble, without success....A Madrasi by birth, with his head shaven so as to leave a tuft in the centre, barefooted, and wearing the dhoti, he got into the first class; he was strolling now and then on the deck and when hungry, was chewing some of the popped rice and peas!...*However, one rarely finds men like our Alasinga in this world—one so unselfish, so hard-working, and devoted to his Guru, and such an obedient disciple is indeed very rare on earth.*' (Italics ours.) (*The Complete Works of Swami Vivekananda*, vol. 7, pp. 333–4).

SISTER NIVEDITA

Kalpalata Munshi

The act of plucking a flower for worship is lovely. With the tenderest care a fresh blossom is chosen from amongst budding and withering flowers. In its natural perfection it is then laid on the altar, at the feet of God. Nivedita—the Dedicated, chosen by her Master—Swami Vivekananda—to be offered at the altar of this country was such a flower of perfection.

Born in a far off land, brought up in European traditions, and educated and trained according to Western ideas, she was chosen as the transmitter of the Swami's ideals and dreams between him and his own people. In this selection the glory goes to the elect, but more to the Master. For Nivedita, when summoned to accept the onerous task of serving this land, was already a qualified and experienced teacher, a keen reader and thinker, proud, determined and self-possessed, a lover of her own country to the core, experimenting with her own ideas on education, and building up a mission in life. It is not by a magician's wand that overnight a Westerner forgot the memory of her own self and became a Hindu. It was a conscious and willing process of self-transformation, a conquering of life inch by inch, before Nivedita reached the ideal of being Nivedita, the Dedicated One.

It was in 1895 that Sister Nivedita, then Miss Margaret E. Noble (of Irish parentage and birth, born at Dungannon, Co. Tyrone in 1867) first met Swami Vivekananda in London. 'The time was a cold Sunday afternoon in November, and the place...a West End drawing-room.' The Sister, in her book *The Master as I Saw Him*, describes her attitude and reaction after the first meeting. Confident not to be influenced by another person's ideas, prepared not to be

convinced by another's propaganda, and watchful of guarding her own judgments, she, with the others, expressed her opinion that all these things that had been discussed had been said before and they were not new.

But the intellectual honesty of Sister Nivedita did not allow her to dismiss either the person or his message with indifference. As she pondered over his words, she discovered a new and powerful thought-current flowing under the apparently common words. Three points struck her most:

> First, the breadth of his religious culture; second, the great intellectual newness and interest of the thought he had brought to us; and thirdly, the fact that his call was sounded in the name of that which was strongest and finest, and was not in any way dependent on the meaner elements in man.[1]

But it must be remembered that Swamiji's *words* alone did not act as a stimulus to invigorate her potential powers and make her accept his mastership. To speak in her own words:

> But it was his *character* to which I had thus done obeisance. As a religious teacher, I saw that although he had a system of thought to offer, nothing in that system would claim him for a moment, if he found that truth led elsewhere. And to that extent that this recognition implies, I became his disciple.[2]

Her intellectual and ideological acceptance of her Master's teachings made her take the first step in the direction of her new life of adopting India as her motherland, offering her services in her cause. She writes: 'It was in the course of a conversation much more casual than this, that he turned to me and said, "I have plans for the women of my own country in which you, I think, could be of great

614 ART, CULTURE AND SPIRITUALITY

help to me"—and I knew that I had heard a call which would change my life.[3]

More time and thought are usually expended in the attempt to take the initial step which changes one's life, but the irony of it is that the real struggle begins after that. For till there is identification between the ideals of the teacher and the taught, peace is not found. Clash of wills and personalities, efforts at protecting one's own judgments and upholding of egoistic and assertive opinions cause much suffering before profound peace is found in resigning to the master's will without bitterness, and with fullness of faith. Sister Nivedita passed through this struggle and felt it very keenly as she unreservedly says:

> My relation to our Master at this time can only be described as one of clash and conflict. I can see now how much there was to learn, and how short was the time for learning to be, and the first of lessons doubtless is the destroying of self-sufficiency in the mind of the taught. But I had been little prepared for that constant rebuke and attack upon all my most cherished prepossessions, which was now my lot. Suffering is often illogical, and I cannot attempt to justify by reason the degree of unhappiness which I experienced at this time.[4]

But, due to the Master's love and grace, she soon overcame the difficulty, and once devoting herself with perfect passivity, did no longer feel the strain of totally absorbing his ideas and working them out with a passion. It is noteworthy how the Sister grasped and unfolded the subtle paradox on the part of the taught in this case. The taught, the disciple, is passive—'serenely passive', but under this attitude lies the greatest of creative acts a human being strives to accomplish, namely, complete dedication. This life-experience and experiment enabled her to speak forth in definite terms how after one meets a guru perfection in

education is reached. In her 'Paper on Education-II', she states the three elements necessary for a perfect education, and while discussing the third element she says:

> But when the guru comes, or the idea that is to dominate the life is apprehended, there may be a keen initial struggle, but after it there is a period of profound apparent quiet. To see the thing as it appears to the mind of the master is the one necessity. To serve him, acting as his hands and feet, as it were, in order that one's mind and heart may be made one with his; to serve him silently, broodingly, with the constant attempt to assimilate his thought, this is the method. Throughout this period, there is no room for rebellion. Eventually the guru emancipates: he does not bind. It would be a poor service to him if we felt compelled in his name to arrest the growth of an idea. Eventually we have to realize that the service to which he has called us is not his own, but that of Truth itself, and that this may take any form.[5]

This is how, we find, Nivedita beautifully understood the lofty ideal of *guru-shishya* relationship and paddled her own canoe to the shores of perfection. Thus perfected as a dedicated worker, she gave propriety to her own name 'Nivedita'—given by the Master, and became truly an altarblossom. Her dedication and devotion cannot be measured. Only her life shines like a beacon-light for all dedicated workers, and her words convey her heartfelt yearning for a life of perfection:

> Shall we grudge a life, with its hour of toil, that we may feast our eyes upon some symbol of perfection? Shall we measure the devotion that, given without stint, is to make of us the *puja* flowers laid before the feet of God? In a world of infinite variety the vision of Reality ends every road. Let us then push on with

brave hearts, not fainting by the way. Whatever we have taken in hand to do, let us make the means our end. Let us pursue after the ideal for the ideal's own sake, and cease not, stop not, till we are called by the voice that cannot go unheeded to put away childish things and enter the city of the soul.[6]

Before Sister Nivedita came to India, she was already a professed educationalist. Having obtained a teacher's training, she gained practical experience as teacher in various schools in London. In 1892, she opened at Wimbledon a school of her own, and strove to give expression to her ideals of girls' education with which she later came to be identified.

With this *locus standi* in the field of education, it was natural that she evinced interest in Swamiji's educational plans for Indian women and accepted his invitation to come to India. Early in 1898 she reached the shores of India. From May to October of the same year Sister Nivedita had the opportunity to travel with Swamiji in the North-West, Kumaon, and Kashmir regions of the country. These months of travel with her Master proved to be intensively formative in her training in discipleship. For, the close contact with the Master helped her to understand and evaluate the nation; to appreciate its culture and traditions; to judge its heights of greatness and gauge its abyss of weakness; and, above all, to love it as her own motherland, loyally and passionately.

It was at the end of that summer[7] that she discussed with Swamiji her plan of work. He was confident that he had laid the trust and responsibility of the work on capable shoulders and, therefore, gave her freedom to work out her own plans. When asked to criticize her plans, the Master quietly said, 'You ask me to criticize; but I cannot do that. For, I regard you as inspired, quite as much as I am.'

To make a beginning, the Sister had planned to open tentatively a girls's school in Calcutta—'To learn,' as she

says, 'what was wanted, to determine where I myself stood, to explore the very world of which my efforts were to become a part'. With this idea in view, a Girl's School (which it seems she proposed to name 'Ramakrishna School for Girls', but which, after her death, was named 'Sister Nivedita Girls' School') was formally started in Baghbazar (in Calcutta) on the 12th November 1898, with the blessings of the Holy Mother and in the presence of Swami Vivekananda and Swami Brahmananda. The School was founded on the kindergarten system and included the teaching of English and Bengali language and literature, some elementary science, and handicrafts. The aim of teaching these subjects was not for enforcing a disciplined training only but also enabling the pupil to bring out the best in her. In other words, it was not only to be informative but formative. Due to various difficulties the School stopped functioning after some months. Sister Nivedita went abroad to collect funds and popularize her ideas. It was at this time that she put on paper her 'Project of the Ramakrishna School for Girls' before the public in America. In 1902, she returned to India and was joined in her work by another ardent American disciple of Swamiji, Sister Christine. Together they reorganized the School.

Having obtained a sincere collaborator like Sister Christine, who looked after the organization of the School, Sister Nivedita was left free to widen the platform of her activities. She gave inspiring lectures to the student world and contributed a series of articles in the leading magazines of the day. Her lectures on education have now been compiled in the book entitled *Hints on National Education in India*. National education, which meant according her, 'a training which has a strong colour of its own, and begins by relating the child to his home and country, through all that is familiar, but ends by making him *free of all*, that is true, cosmopolitan, and universal.'[8] Education, in its broadest sense, according to her, meant the scope or opportunity given to an individual to canalize and develop his parts. It

was not to be a privilege of a few in society. It was a sacred duty of the learned to teach, it was as much a duty of the unlettered to learn. That is why she says,

> ...education, to be of any avail, must extend through all degrees, from its lowest and humblest applications, up to the highest and most disinterested grades. We must have technical education and we must have also higher research...We must have education for women, as well as education of men. We must have secular education, as well as religious. And, almost more important than any of these, we must have education of the people and, for this, we must depend upon ourselves.[9]

The Sister's ideas do not put forward any original system of training or schooling. She gives expression to familiar thoughts which have yet a dynamic force, as they carry with them the force of her conviction. They strike at the very fundamentals of our lives, gradually rising to higher and nobler sentiments. They reflect the purest thought on *Vidyā* that our ancient teachers held and yet abound in the modern ideas of the necessity of manual and technical training accompanied by higher researches. They aim at developing the personality of an individual and, at the same time, making him fully conscious of his duty towards his nation. But though the primary aim of such an education lies in making him stand on his own legs, the Sister never cherished the idea that acquisition of knowledge was for that end only. On the contrary she fiercely denounced it:

> There is nothing so belittling to the human soul as the acquisition of knowledge for the sake of worldly reward. There is nothing so degrading to a nation as coming to look upon the life of the mind as a means to bread-winning. Unless we strive for truth because we

love it, and must at any cost attain, unless we live the life of thought out of our own rejoicing in it, the great things of heart and intellect will close their doors to us.[10]

Sister Nivedita touches upon two problems which are vexing our educationists even today, namely, the problem of the language and the place of foreign education, in a true scheme of education. With regard to the first question, the Sister writes: 'Nor need we regret that we fall back, for this, upon our own strength. Education for the people is, in the first place, reading, writing and arithmetic. As long as we carry the burden ourselves, there need be no juggling with the geographical distribution of languages....We must do all we can for the simplification of the language problem.'[11] Regarding the second point, she opines that in a true education the place of foreign culture is never at the beginning. Beautifully she makes a difference between pure knowledge, which is science, and the emotional expression of talents, which is art. And she concedes that, for the former there can be neither native nor foreign, while the latter is purely local.

These thoughts breathe life into the paralysed ideals of our nation and, even though written four decades ago, are useful for our renascent national life. For this Sister Nivedita's name will always shine bright in the firmament of our national thinkers.

The greatest lesson that Sister Nivedita learnt from her Master was to understand the country which she was prepared to serve. In the heart of Swami Vivekananda raged, day and night, the fire of love for the country, and a spark of it was sufficient to inflame the noble soul of the Sister.

After coming to India with the spirit of service, her Master once asked her to which nation she belonged then. Candidly she spoke of her passionate loyalty to the English flag, 'giving to it much of the feeling that an Indian woman

would give to her *Thākoor*.[12] But gradually, as she began to understand the Indian way of life, she became inflamed with a burning love for the country and, as was characteristic of her, surrendered herself utterly to it. So much so that she used to tell the young girls, 'Take up the rosary and let the mantra "Bharat-varsha, Bharat-varsha, Bharat-varsha, Ma, Ma, Ma" be on your lips always', and she herself would do that. She saw through the significance of the rituals and customs—Dharma (National Righteousness, as she preferred to translate it)—and reinterpreting them, revitalizing them, inspired the youth of the day to follow them up. She defended the social customs of our country against the slanders of the missionaries,[13] upheld the national ideals, and translated them into modern equivalents.

Bearing in mind that Sister Nivedita did all this at a time when the Hindu mind had lost its balance of judgment between the orthodox and the Western influences pulling in opposite directions, it would be difficult to measure the immensity of the service rendered by her. With her incisive intellect, strengthened by a glowing faith, she attacked and at the same time built up all the fronts of life, political, social, literary and artistic. Many great men of Bengal such as Sri Aurobindo, Abanindranath Tagore and J.C. Bose were, to some extent, influenced by and received encouragement and help from Sister Nivedita in their respective spheres of work.

Admiration of the country, however, did not blind her to the country's imperfections. Her diagnosis was correct when she said that 'the Indian people as a whole, for the last two generations, have been as men walking in a dream, without manhood, without power to react freely against conditions, without even common sense.'[14] And still India lives and hopes to rise again. Many have tried to find out the source of her revitalizing force. Is it her geographical position? Is it her huge sea of humanity? Is it her cultural heritage? Or is it her philosophy and religion? The critics

who say that India today basks only in the sunlight of past glory and never thinks of the future and of marching forward with the other nations of the world are grossly mistaken. They lack a proper understanding of the country. Only a few like Swami Vivekananda, who held the pulse of the nation in their hands, could understand India's potential powers. India has always built the future on the past. In darkness she has always thought of light and that is why she still lives.

With this eye of a historian, who visualizes the future prospects of a nation by the study of its past, Sister Nivedita expressed hopes in the rise of a New India:

> The mind of our civilization is awake once more, and we know that the long ages of theocratic development are perfected, while before us lies the task of actualizing those mighty ideals of the civic and national life by which the theocratic achievements of our fathers are to be protected and conserved. We are now to go out, as it were, into the waste spaces about our life, and build there these towers and bastions of self-organization and mutual aid, by which we are yet to become competent to deal with the modern world and all its forces of aggression. The bricks lie there, in abundance, for our work. The elements abound, in our history, our literature, our traditions, and our customs, by which we can make ourselves a strong and coherent people. It needs only that we understand our own purpose, and the method of its accomplishment.[15]

Almost all her writings echo the same sentiments of national renaissance. Her writings have been more or less compiled in different volumes, of which the following are permeated with the thoughts of the country, namely, *The Web of Indian Life, Religion and Dharma, Footfalls of Indian History, The Studies from an Eastern Home, Civic and National Ideals,* and *Aggressive Hinduism.* These writings bring to our

mind her complete identification with this country, and it would not make us hesitate to call her 'the Daughter of Ind'.

Having thus served her country for fourteen years, Sister Nivedita lay down to eternal rest in the lap of her Motherland on the 13th October 1911, only to inspire and arouse many of India's daughters to serve the country likewise.

REFERENCES

1. *The Master as I Saw Him* (6th ed., 1948), p. 16.
2. Ibid. p. 12.
3. Ibid. p. 34.
4. Ibid. p. 106.
5. *Hints on National Education in India* (3rd ed., 1923), pp. 17–18.
6. *Religion and Dharma* (1st Indian ed., 1952), pp. 114–15.
7. On July 24, as she records it in her *Notes of Some Wanderings with the Swami Vivekananda* (3rd ed., 1948), p. 113.
8. *Hints on National Education in India*, p. 29.
9. Ibid. p. 1.
10. Ibid. p. 11.
11. Ibid. pp. 2–3.
12. *Notes of Some Wanderings with the Swami Vivekananda*, p. 20.
13. Vide *Lambs Among Wolves*, pp. 19–29.
14. *Aggressive Hinduism* (3rd ed.), p. 20.
15. *Civic and National Ideals* (4th ed.) pp. 4–5.

SOURCES

The articles have been taken from
Prabuddha Bharata

*This article appeared under the authorship of 'M. Ranganatha Sastri', a pseudonym of B.R. Rajam Iyer, the first editor of the *Prabuddha Bharata*. His premature death on 13 May 1898, at the age of 26, threatened the continuance of the journal. However, under the instruction of Swami Vivekananda, the publishing office of the journal was shifted from Madras to Almora, with Swami Swarupananda as the editor. Later the office was moved to its present location at Mayavati.